harold
rosenberg

harold rosenberg

a critic's life

debra bricker balken

THE UNIVERSITY OF CHICAGO PRESS Chicago and London

The University of Chicago Press, Chicago 60637
The University of Chicago Press, Ltd., London
© 2021 by The University of Chicago
Published 2021
Printed in the United States of America

30 29 28 27 26 25 24 23 22 21 1 2 3 4 5

ISBN-13: 978-0-226-03619-9 (cloth)
ISBN-13: 978-0-226-74020-1 (e-book)
DOI: https://doi.org/10.7208/chicago/9780226740201
.0001

Library of Congress Cataloging-in-Publication Data

Names: Balken, Debra Bricker, author.
Title: Harold Rosenberg : a critic's life / Debra Bricker
 Balken.
Description: Chicago : University of Chicago Press, 2021. |
 Includes bibliographical references and index.
Identifiers: LCCN 2021012758 | ISBN 9780226036199 (cloth) |
 ISBN 9780226740201 (ebook)
Subjects: LCSH: Rosenberg, Harold, 1906–1978. | Art
 critics—United States—Biography.
Classification: LCC N7483.R655 B355 2021 | DDC 709.2 [B]—
 dc23
LC record available at https://lccn.loc.gov/2021012758

♾ This paper meets the requirements of ANSI/NISO
Z39.48-1992 (Permanence of Paper).

to the memory of
Scott Kerr Bricker Sr.
and Arthur C. Danto

contents

prologue

Harold Rosenberg always resisted the in-crowd. From the moment he entered Erasmus Hall in 1919, an elite high school in Brooklyn, he felt ostracized by the rivaling cliques of students who dominated the social scene. Many came from rich families — Jewish and non-Jewish alike — but he found no common ground with even the few freshmen who lived in his own dreary neighborhood of Borough Park. His father, while intellectually inclined, was a lower middle-class tailor who had moved the family from Harlem when Harold was eight to settle in a Jewish community where the way of life was decidedly conformist. Religion became anathema to Rosenberg — he hated the long, ritualized Saturday services — along with his father's bourgeois aspirations. By the time he attended Erasmus Hall, his anti-authoritarian streak was intact. The only place he felt at home was on the baseball field or when rowing on the lake in Prospect Park.

To compound his sense of difference, Rosenberg grew to be 6 feet, 4 inches tall. By the time he was an adolescent, he towered not only over his family but also over his teachers and fellow students. With his radiant dark eyes capped by black, bushy brows and a prominent forehead, he came across as a colossus, a sort of oddity (fig. 1). To add to his eccentricity, his high-pitched, nasal voice always seemed out of sync with his height. He lumbered through the corridors of Erasmus Hall, where he became more and more introverted and had little interaction with his classmates. As a result, studying became his primary outlet. In today's terms, he was a nerd. But once

Fig. 1. Elaine de Kooning (1918–89), *Harold Rosenberg #3*, 1956. Oil on canvas, 80 × 59 × 1 inches. National Portrait Gallery, Smithsonian Institution.

Rosenberg graduated, his disdain for the in-crowd intensified, as did his requirement for independence. These traits defined him and later seeped into his intellectual life, where he became known as a loner. He may have encountered many like-minded, progressive thinkers in New York, but there were few occasions on which he became part of a community or cohesive social group, except when he was in the company of artists.

Although Rosenberg would become one of the foremost American intellectuals of the mid-century, he was constitutionally incapable of fitting in. His aversion to the status quo had been ingrained since childhood, but as his success as a writer grew, his self-confidence soared. He became not only assertive but also combative, undaunted by power. Many of his peers were put off by what they perceived as his arrogance. Others, however, viewed his willful opposition to conformist culture as a strength, particularly when he stood up to the bullying of the American Communist Party (CP), which attempted to infiltrate publishing circles during the Great Depression just as he came of age as a writer. But even his detractors knew that Rosenberg possessed a certain brilliance—particularly Clement Greenberg, the art critic for the *Partisan Review* and *The Nation*, who became one of his primary adversaries. As Greenberg admitted, Rosenberg's erudition was astonishing. Even though he himself would never take to the philosophical thrust of Rosenberg's essays, he came to feel undone by Rosenberg's prominence and reputation.

the intellectual captains of thousands

Most readers of the mid-century knew Rosenberg as an art critic and only by one essay. When "The American Action Painters" was published in *ARTnews* in late 1952, it caused an enormous stir. Yet Rosenberg had actually written few tracts on art. He got his start by writing poetry, short stories, reviews, and literary commentary, in the early 1930s—just as the Depression set in—and this carried his career for more than three decades. In the "little mags" of the day, such as *transition*, *Symposium*, and *Poetry*, he expounded on his signature trope

of *action*, an idea he inherited from Karl Marx but revised decade by decade until he finally abandoned the conceit when he began to write the Art Column for the *New Yorker* in 1967.

Rosenberg's plan from the outset was to rewrite socialist theory by granting the individual, or "hero" as he called him, a central place in Marx's dialectical take on history. Although he was an admirer of the German philosopher, and of disciples such as Lenin and Trotsky, he had little truck with collective *action*, such was his contempt for the CP, especially once it infiltrated the Federal Writers Project where he was employed during the Depression. He was interested more in the drama of human *action*, or resistance to mass conformity: the ethos he believed drove the modernist period and its core investment in originality. Many of these ideas were elaborated in essays that were eventually published in *Partisan Review*, *Commentary*, *Kenyon Review*, and later in *Dissent*, where Marx is fused with trenchant, yet eloquent analysis of the trials that beset self-expression. Some of Rosenberg's tracts, such as "The Herd of Independent Minds," written in 1948, became scorching indictments of his peers whom he felt had forfeited their intellectual independence by remaining oblivious to "social thinking."[1] They had capitulated to the dogma of the New Criticism to explain authenticity in art and literature, with the result that their writing became disaffected from its context and succumbed to banality and sameness. It was no wonder that Rosenberg failed to secure a full-time appointment at any of these journals until he was approached much later by William Shawn to write for the *New Yorker*.

Rosenberg had been anointed the first New York correspondent of *Les Temps modernes*, the journal launched by Jean-Paul Sartre shortly after Paris was liberated from the Third Reich. By the late 1940s, his writing had become associated with the international dimensions of existentialism. He was known for his uniquely American spin on subjectivity. But the affiliation with the French periodical was short-lived, lasting less than four years. Rosenberg's morality intervened when Sartre endorsed the French Communist Party in 1952. He quit, just as he had walked out on the *Partisan Review* a few years earlier after its editors, William Phillips and Philip Rahv,

adopted a prowar stance when the United States joined the Allied Forces in World War II. Rosenberg had turned down their offer to serve as the Washington, DC, correspondent while he lived in the nation's capital working on the Federal Writers' Project. He felt there was no literary life in the city to expound upon: just a government machine that churned out conventional prose that stifled the writer's singularity.

For all of his association with some of the foremost intellectual publications of the mid-century, Rosenberg remained an outlier. He was never part of a core literary group or publication, even once he began to write for an upscale magazine like the *New Yorker*. Editors such as Phillips and Rahv knew that he could never be assimilated and expected to adhere to their editorial program. They may have solicited his reviews and essays, but they did not want his ideas imprinting *Partisan Review* on a routine basis, particularly once he accused them of succumbing to the "herd" instinct by depoliticizing the journal. Rosenberg wanted no connection with a periodical that had given up on Marx and whose cultural coverage abided by a neutral formalist outlook. It shunned the social histories that cradle writing and what goes on in the studio: these agencies, he felt, were key to understanding the meanings of the modernist period in the postwar United States. He believed *action* could account not only for the writer's choices but also for the alienation experienced through interaction with the new bureaucracies and marketplaces as cultural production escalated in the late 1940s.

Rosenberg's principles directed his professional life to the extent that they limited his publishing options. Though his independence was essential, diplomacy was never his strong suit. He thought it was his duty to point out the myopic mindset of the "intellectual captains of thousands"[2] who oversaw magazines such as *Partisan Review*. It was a matter of integrity. However, he never felt unmoored by the lack of a permanent home for his writing: the edge was where he wanted to be situated. From this distanced position, more could be gleaned about the changed historic circumstances that weighed upon self-expression after 1945, particularly as mass culture spread. As a result, he had strong champions in Hannah Arendt, Saul Bel-

low, Paul Goodman, and Mary McCarthy, among others, who responded to his autonomy and risk taking.

It was an ironic stroke of fate that the most prolific phase of his career came late and was associated with art criticism. Rosenberg's social world had always included artists. He had a short stint in the Works Progress Administration (WPA) as Willem de Kooning's assistant before being transferred to the Writers' Project. He loved the company of painters and sculptors, and in 1948 became an early member of The Club, an artist-run gathering place that ran a lively schedule of lectures and panel discussions in which he actively participated. In the interim, he had sustained friendships with Arshile Gorky, Hans Hofmann, Barnett Newman, and Jackson Pollock. He also teamed up with Robert Motherwell as the literary editor for the short-lived *possibilities,* and wrote brief introductions for exhibitions such as *Six American Artists* at Galerie Maeght in Paris and *The Intrasubjectives* at the Samuel Kootz Gallery. Many artists who became associated with the New York School responded to Rosenberg's metaphor of *action* with its core emphasis on subjectivity. Most were averse to the evaluative approaches of formalist writers, such as Clement Greenberg, especially as that tack made no provision for subject matter. When *Les Temps modernes* invited Rosenberg to write on the preoccupations of contemporary American artists, *action* became not only his conceit, but something he incorporated into his title. If Sartre had not gravitated toward the communists, "The American Action Painters" would have appeared in his journal. Instead, it ran in *ARTnews,* where it ignited an extraordinary response and became part of the identity of artists who emerged at mid-century.

For all the discussion that surrounded Rosenberg's key essay, he penned few subsequent tracts on art until the early 1960s. Although Thomas B. Hess, the managing editor of *ARTnews,* provided him with ongoing opportunity, he remained committed to writing on cultural, literary, and political themes, such as the postwar phenomenon of the "orgman" who so slavishly devoted himself to the corporation that nothing remained of his own self or individuality. To Rosenberg, such conformity amounted to a profound dehuman-

ization, akin to totalitarianism. Originality, as a result, had become profoundly threatened and vulnerable. The "intellectual captains of thousands" were mostly to be blamed. They provided no radical alternative—just dreary Orwellian prophecy that failed to grasp the undercurrents of American culture where social change was frequently articulated. If only they had consulted Marx!

Still, "The American Action Painters" continued to frame Rosenberg, and by the time he brought out a short biography of Gorky in 1962, his image as an art critic was molded, at least in the public imagination. Once the Art Column for the *New Yorker* became his beat, he knew that his idea of *action* was spent, and the term ceased to be a mainstay of his vocabulary. Its basic tenets were no longer relevant. Yet Rosenberg knew the opportunity existed to take on the new American art establishment that emerged in the 1960s: the "herds" of writers, curators, collectors, and tastemakers who canalized the interpretation of painting and sculpture. His writing remained consciously pitted against the discourse of a new generation of formalists who, in his estimation, set back criticism by avoidance of social history. Their analysis was never hard-hitting, nor did it get to the crux of an artist's work, driven as it was by theories of stylistic continuity. It was all flaccid thinking, he felt, too mainstream and focused on connoisseurship. No wonder it became appropriated by the marketplace.

Rosenberg remains one of the most original critics to have emerged in the postwar United States. His ideas are deeply connected to the early twenty-first century, when the museum has become a contested site, its programming deemed exclusionary and narrow. He took on these issues more than sixty years before, first in "The American Action Painters" and later in the pages of the *New Yorker*. His notion of a "herd of independent minds" made him a prescient thinker. His corpus of writing yields razor-sharp insight into our current cultural predicament. No other writer on art of his generation was as fluent on the end of the modern period.

1
never had any dreams
borough park

his argument involved both word magic
and economic determinism

During the summer of 1928, Harold Rosenberg, who was twenty-two years of age, encountered Harry Roskolenko (a future journalist, poet, and novelist), on the steps of the New York Public Library. It was the start of a friendship that would last a lifetime. Roskolenko recalled that their conversations from this period were heady, a crucial part of their intellectual development. He described the scene at the library that summer, with its mix of students, soapbox orators, academics, misfits, and radical thinkers, as "our Roman circus and our Greek forum."[1] Everyone was there, he recalled, "from Kenneth Burke to Sidney Hook, philosophers, critics, grammarians, Marxists, Trotskyists, Stalinists, technocrats, vegetarians, free lovers—everybody with a talking and a reading mission."[2]

Roskolenko vividly remembered that their talk centered on Karl Marx and his followers, which in the summer heat occasionally forced a few dialecticians off the steps of the library and into the third-floor reading room to consult references to bolster their contentions. Later, in the evenings, they imbibed bootleg whiskey to excess while continuing to fold Marx into their political discussions. Rosenberg plunged into these exchanges with alacrity, while forming close relationships with Roskolenko and Burke. Burke, who was an editor at *The Dial,* a literary publication founded in 1840, was up on the intricacies of Marxism and could recount how Lenin and Trotsky had reshaped the doctrine in the 1920s to incorporate both literature and art.

During the summer of 1928, Rosenberg was recuperating from osteomyelitis, a debilitating bone infection that left his right leg permanently immobilized. He would require a cane to walk for the rest of his life. He became afflicted with the disease shortly after graduating from Brooklyn Law School[3] in 1927 and was hospitalized for more than a year before returning to his parents' home in the Borough Park neighborhood of Brooklyn to recuperate. Despite his schooling, he would never express interest in the law. Once he took up writing, he used his first major essay, "Character Change and the Drama," to dispel any identification with the profession, announcing that "the law is not a recognizer of persons."[4] Unlike literature, he felt, legal tracts did not offer empathy or insight into human behavior. Rosenberg was fundamentally unchallenged by law school and spent his time in class "drawing portraits of people to keep from being bored to death by the lectures."[5] Looking back, he concluded that he "really studied art in law school."[6]

During his long illness, in which his leg was in constant danger of being amputated, Rosenberg continued to draw and to paint. He also read novels for the first time. He zeroed in, especially, on Thomas Mann's *The Magic Mountain*[7] with its setting in a sanatorium in Switzerland. Mann's tale became a symbolic means for Rosenberg to come to grips with his prolonged rehabilitation, his mortality, and isolation. After he fully recovered in 1929, whatever desire he had to work in a profession that could provide him with a stable income dissipated. May Natalie Tabak, whom he married a few years later, recalled "that the practice of law had many social and financial appurtenances he might never acquire by his writing was never discussed."[8] The summer of 1928 and its prolonged engagement with Marx had brought him alive after a dormant four years in law school and a subsequent enfeebling ailment. In short, it defined him, providing him with a sense of intellectual purpose he had not previously been able to imagine.

Rosenberg's take on the tedium of his education was exaggerated, however, offset by his introduction in law school to philosophical readings that were later useful.[9] The early tracts of Plato's *Dialogues*, for instance—which emphasized the primacy of questioning in the

acquisition of knowledge—came in handy on the steps of the New York Public Library when Marx surfaced as his go-to figure. Rosko-lenko viewed Rosenberg as someone with enormous analytical acumen who "started out as an artist and became a writer. His critical faculties forced him to change over."[10] While Rosenberg would continue to paint into the mid-1930s, even taking life drawing classes at a settlement house, he realized that he was more predisposed toward writing, and the debate that surrounded Marx was enthralling.

As he continued to argue Marx with Roskolenko and Burke, Rosenberg began annotating a copy of Lenin's pamphlet *What Is to Be Done*. He wanted to be versed in every aspect of Marxism. In one note he stated that "Marx's collective hero was overtaken by [the] concept of process . . . Lenin [was the] receiver of Marx's action-thinking but on planes of organized intellectuals instead of social classes."[11] Lionel Abel, an essayist and playwright who met Rosenberg a few years later, just as the effects of the stock market crash of 1929 set in, remembered that once Rosenberg took up writing, he developed a resistance to doctrinaire Marxism. The party line holding that independent thought was self-indulgent in the wake of widespread unemployment became a platitude to him. However, he retained a lifelong interest in Lenin and Trotsky, as they had incorporated the individual into communism's core belief in the equitable distribution of capital. Sometimes, he brought a sense of whimsy to these exhilarating subjects that occasionally marked his writing. During the early years of the Great Depression, Surrealism—which Roskolenko described as "closer to Trotskyism in France"[12]—made inroads into their conversation, subtly shifting its emphasis. Abel recollected with amusement Rosenberg's unorthodox approach, noting, "Harold . . . took the view that Marxism was two things: it was Talmud, to be sure. But it was also Cabala. And he thought that the role of literary men should be to develop the arcane, caba-listic side of the Marxist doctrine. In his conversations, at least, he gave instances of what he had in mind; I shall never forget the evening when he proved that Helen of Troy—his argument involved both word magic and economic determinism—was really a loaf of bread."[13]

never had any dreams, ambitions, ideas of being anything

The sense of rejuvenation that Rosenberg experienced in the late 1920s marked a change from the inertia that pervaded his childhood and early adult years. Law school, to be sure, had been a monotonous episode. Even late in life, he never mentioned his elementary school education, such was his ennui. He most likely enrolled at the public school in Borough Park before attending high school at Erasmus Hall, which was known for its excellent teaching and strict admissions policy. He later conceded that he "never had any dreams, ambitions, ideas of being anything."[14] He entered the elite school in 1919 at the age of thirteen, but felt awkward and was unable to fit in (fig. 2). As a kid from a lower-middle-class family, he had to grapple for the first time with privilege and dominant social groups. Or, as he depicted them, "the beautiful girls, raccoon coats, hip flasks, and terrific parties from which the likes of me were more or less excluded."[15]

Rosenberg's sense of ostracism affected him emotionally. He revealed, "There was a lot going on in which I could not participate. These kids were very sophisticated, they were up on all the latest movies." He responded by retreating. The disparities in class were too difficult to negotiate, the territories of affluence a mystery. In fact, Rosenberg felt snubbed by the social factions at Erasmus Hall, alienated by what he referred to as "the Flatbush League and also by the rich Jews who did have . . . their own gang." Although raised in a Jewish family, he lacked the requisite worldliness to enter their circle. Unlike the parents of the "rich Jews," his father was a tailor with a low-level position in a large company. (Rosenberg withheld many details of his biography, including the name of his father's employer, such was his apathy.) He found his classmates' attitudes irksome, their poise too mannered: "Even though they were a little too conventional, they went along with the style of the Flatbush aristocrats." However, the few students in his year whose backgrounds were similar to his provided no acceptable social option either. He described them as too "serious," desirous only of a secure job after college: the

Fig. 2. Unknown photographer, *Harold Rosenberg as a Young Man*, n.d. Photographic print. Harold Rosenberg Papers, Getty Research Institute, Los Angeles (980048).

kind of legal career that he himself eventually spurned. Rosenberg thought they had no "style." He viewed them as a group of dweebs. In sum, he was a misfit who eschewed contact with his peers.[16]

Rosenberg considered himself a street kid, unlike them. Although born in the Williamsburg section of Brooklyn, he lived until he was nine in a tenement in Harlem where he was weaned on gang warfare and ethnic rivalry among the Italian, Irish, and Jewish constituencies. While these clashes did not carry over to his life in Borough Park—which to this day remains an enclave of Orthodox Jews—he found his new surroundings on 45th Street and Fort Hamilton Parkway oppressive and bleak. Rosenberg remembered living in a nondescript apartment building near a field amid a sea of empty lots where he and his friends spent their spare time playing baseball and punch ball. They also made occasional forays to Prospect Park to

row on the lake. Although Borough Park was more pedestrian than Harlem and offered more traditional boyhood experiences, he always retained the scrappiness he had developed in Harlem. As one of the few students from Borough Park admitted to Erasmus Hall, Rosenberg knew he would have to repress his rebelliousness, but still it would resurface after his formal education ended.

In high school, Rosenberg diverted his attention from the in-crowd by focusing on his grades. He learned to survive by "keeping out of trouble so that nobody would bother him."[17] He recalled that he had wanted to become "invisible,"[18] a state that would contrast with his adult assertiveness. Although he later boasted that he had made little effort to achieve academic distinction at Erasmus Hall,[19] and that his high grades had come easily, the need for self-protection induced introspection as well as a painful sense of difference not only from his classmates but even from his own family. These early feelings of exclusion eventually contributed to the independence of his intellectual outlook, issuing from his intense scrutiny of the herd instincts that breed conformity and the limitations of "style" to engender originality.

Once he graduated from high school in 1923 at the age of seventeen, Rosenberg knew that the last thing he wanted was a regular job. His negative view of work had been exacerbated by the blandness of the menial positions he held as a youth, the first of which consisted of working as a "picker" at the Charles Williams Stores, a mail-order house in Brooklyn, where he literally skated from aisle to aisle collecting merchandise for other employees to pack and mail. His mother was opposed to her son working, but Rosenberg lied about his age to gain the job when he was just twelve and a half years old. His considerable height was an advantage. However "revolting and . . . a destruction of time,"[20] the position took him away from home where he felt stifled, at odds in his parents' world, with its rigid politics and Orthodox Jewish values. But he was fired from his job after a few weeks, when a supervisor from the Stores caught on to his real age.

When Erasmus Hall adjourned for the summer, Rosenberg worked six days a week and long hours (in jobs that, again, he never

named in interviews),[21] all of which invaded his cherished time to play baseball. His experience of labor left him averse to regular employment, especially after his illness. The reflection provided by lying in bed and reading for a year led him to surmise that "the primitive impulse which generated an artist or a writer is the feeling that under no circumstances will you devote your life to the theme of earning a living."[22] His anti-authoritarianism—which he later theorized within Marxist discourse, eventually landing on the loss of the individual in a burgeoning corporate culture in the postwar United States—emanated from these early encounters with boredom, and the insipid routine of enacting the same task daily. When juxtaposed with the economic freedom that the "Flatbush aristocrats and rich Jews" knew, and the advantages that permitted them to travel to Europe when Erasmus Hall was in recess, his lower-middle-class existence felt particularly confined and joyless. It induced the lethargy that he succumbed to in school.

After high school, Rosenberg spent a year at City College of New York (CCNY) in Harlem, "really for no reason at all; just to have something to do."[23] Anything to avoid a job. At City College, which was known for its progressive curriculum,[24] Rosenberg was part of a generation of students that included Barnett Newman as well as other notable leftists, anarchists, and Marxists such as William Phillips and Sidney Hook. Nonetheless, he soon opted out and enrolled in Brooklyn Law School (fig. 3), only to remain equally dispirited.[25] He was unambitious until he met Harry Roskolenko and Kenneth Burke, and took up writing.

Like many of his contemporaries who would later become connected with *Partisan Review*—the foremost literary publication to emerge in the United States in the late 1930s—Rosenberg was caught between two worlds and social strata. He would never settle into the normalcy of middle-class life. The unquestioning acceptance of a complacent existence was abhorrent to him, as it was to many writers who came of age in the Depression. For Rosenberg, as a Jew, this sense of unrest involved a specific anxiety. He stated in hindsight that he could never abide by his father's "bourgeois aspirations."[26] Nor could he abide by his identity as an Orthodox Jew,

Fig. 3. Unknown photographer, *Graduation from Brooklyn Law School*, 1923. Photographic print. Harold and May Tabak Rosenberg Papers, Archives of American Art, Smithsonian Institution.

someone for whom religion was paramount. Although his father introduced him to Torah and Talmud at the age of five, and taught him Hebrew, he loathed going to synagogue in Borough Park on Saturdays. The ritual of services he endured as another form of tedium. He found the choirs in the synagogues "extraordinary," having the "most magnificent music,"[27] but the length and didacticism of the sermons were unbearable.

Rosenberg described his father, Abraham, as an intellectual and a poet, regardless of his occupation as a tailor.[28] "He was a quiet, meek little man who believed in honesty as the best policy," Rosenberg recounted, "a man who loved his children . . . [and who] was full of clichés, all of the highest moral character."[29] Abraham loved to read and to write verse in Hebrew in his spare time. The interior spaces of the family apartment were banal and outfitted with prosaic furniture, but at home Abraham was "devoted to literature, ideas, and

study."[30] Yet however learned and principled a man, he could never become a "modern person."[31] Abraham carried with him the weight of the Polish ghetto where he grew up before immigrating to the United States at the age of eighteen.[32] He was hemmed in by tradition and an immutable set of beliefs. Hence, his need to live and remain in Borough Park. Above all, Rosenberg deemed his father incapable of allying his erudition with new fields of thinking, such as "psychology."[33] From his standpoint, Abraham remained obtuse to the sensitivities and intelligence of his children, stifling rather than encouraging their inquisitiveness, despite his personal imperative to be a good father. Family visits to the Metropolitan Museum of Art in New York each Sunday only compounded Rosenberg's impression of his father being caught in a bygone world. While he and his brother, David, were taken with the installations of "medieval armor and Japanese swords, which we had read about in fairy tales,"[34] his father gravitated to the ancient Egyptian section. The museum, Rosenberg apprehended, was a place of "silence," where the "past isolated itself and proclaimed the sacredness of Other Times."[35] In short, he thought it a place that impeded curiosity.

Outside of the surfeit of religion in his household, and Abraham's conventional approach to fatherhood, Rosenberg became distanced from his father's Zionist politics and advocacy of an independent Jewish nation. He realized that he had never encountered among his father's friends a single socialist, intellectual, or secular Jew, let alone a Gentile,: that is, people for whom religion was not essential or who had alternative political views. His father's generation had been divided on the issue of Israel long before statehood was achieved in 1948. Still, Rosenberg declared, that "whole subject bored me to death. I was never interested in it as a kid."[36] The idea of an entire country organized around one faith seemed to him too limiting, a duplication of Borough Park from which he longed to escape. To compound his self-righteousness, he derisively proclaimed that the "Young Zionist Organization [was] filled with climbing lawyers"[37]—the profession he himself disavowed.

By contrast, Rosenberg's maternal grandfather was a bear of a man named Edelman from whom he inherited his height.[38] Edel-

man worked at a slaughterhouse operated by the United Dressed Beef Company located on the East River and 42nd Street, near the present-day site of the United Nations. Whatever Edelman's day job entailed, Rosenberg described his grandfather as a craftsman by disposition, who in his retirement repaired antique watches as a hobby and became a landlord of a complex of buildings he had purchased in Williamsburg. Evidently, Edelman was an impossible man— vituperative, stern, disagreeable, and antisocial. He instilled fear in his family as well as in most people whom he knew. Despite his formidable, overbearing presence, "everybody was under the general spell of this enormous bull who did everything the way he wanted it and brooked no opposition from anybody."[39] Rosenberg came to identify with him rather than with his own father.

Although Edelman was religious, he considered all synagogues corrupt and refused to become part of a congregation. Instead, he celebrated the Sabbath in his home in Williamsburg with a few disciples where he doubled as rabbi and cantor. Although he chose Abraham to become the husband of his daughter, Fannie, because of his doctrinal conviction, after their marriage he became suspicious of his son-in-law's position on Zionism, believing that he was unduly forcing the issue of a Jewish homeland. From his perspective, that entity still awaited the fulfillment of Old Testament prophecy. In his grandfather's literal adherence to biblical texts, Rosenberg recognized not only an aversion to politics but also a desire to uphold the purity of the scriptures, a trait he considered to be generational. He stated of him and his friends, "They felt you had to wait until the Messiah arrived on a white horse and summon[ed] the Jews to Israel at the end of days. The notion that some secular individual like Theodor Herzl, who was practically a Frenchman and wasn't even a Jew from their point of view, turned up with a political idea of bringing the Jews back to Israel struck them as absolute heresy."[40]

Rosenberg knew Edelman was more of a throwback to a premodern period than his own father, to a past that predated Herzl's formation of the World Zionist Organization in 1896. Yet, he was charmed by his grandfather's eccentricity and likened him to characters in Herman Melville's *Moby-Dick*. He thought of him as an avatar of

both the whale and Captain Ahab, his girth folded into one expansive metaphor. Unlike his rejection of his father's bourgeois longing, Rosenberg was held by his grandfather's independence as well as his defiance of organized religion. That he denounced the institution of the synagogue, while serving as the local mohel who performed circumcisions for family members and friends in Williamsburg, added to Rosenberg's estimation of the mythic dimensions of his individuality. Like Lenin, Edelman was an archetypal figure to Rosenberg, a "hero" who stood out from the masses.

Rosenberg himself never became a Zionist, although he understood the wish to be connected to a homeland. He might have been bored by the issue as a child, but when he pondered the implications of the new state of Israel in the late 1940s, and its outgrowth from the barbarity of anti-Semitism—which he wrote on for *Partisan Review* and *Commentary*[41]—the example of his grandfather reemerged. He was now able to articulate that Jewish identity emanated from "the sense of living within a cycle of repetitions that time after time brought Jews to re-enact, individually and collectively, certain characteristic events of their history, such as the return to the Land of the Fathers."[42] Such reenactments he knew were personal, as well as psychologically complex, "deeper than religion . . . and deeper than political and social ideology," as he wrote in 1950, "and could not be represented monopolistically by any 'organized group.'"[43] For him, these *actions* were emotional, expressed through connections with Jewish history.

He may have been at odds with his grandfather's religious practice, but Rosenberg read his "eccentricities and old-fashioned"[44] ways as prototypically nineteenth-century American. Edelman's individuality was enabled, he thought, by a romantic culture that sometimes tended toward the bizarre and quirky. Through the process of acculturation, he became a "pioneer."[45] Rosenberg noted that none of his grandfather's children, most of whom were born in Vilna, Lithuania,[46] retained a foreign accent. Instead, they became integrated into the fabric of American life and resisted Orthodox Judaism—except for Fannie, his mother. Fannie was bound to the prescribed gender roles of her faith and lived to serve her husband. Her broth-

ers, by contrast, inherited Edelman's anti-establishment views and acted on their own moral authority. One of them became a painter whom Rosenberg credited as having introduced him to art. Rosenberg wrote off another of his mother's siblings—their names were never passed on by Rosenberg to his own family—as a "con man"[47] who made the rounds of the fairs and circuses orchestrating scams, and who ironically became a member of the Elks Lodge, a fraternal order. Another of these "adventurous pranksters,"[48] as he called his uncles, rode with the US Cavalry hunting down the Mexican leader Pancho Villa following his raid for arms in Columbus, New Mexico, in 1916.[49] Like Edelman, they were all nonconformists.

As Rosenberg later thought about Jewish identity in the wake of the Holocaust, he recognized that his own reenactment of history was caught up with his grandfather. He found parts of himself in this "venerable"[50] ancestor. He also thought of himself as a modern American and wrote, "Few of us are duplicates of our grandfathers, in either thought, feeling, speech, or appearance. Very often we even differ from our fathers, too, in most respects. We are, to a large extent, new people—as everything in America, and in many other parts of the world, tends, for better or worse to be new."[51] Through the process of self-actualization, he dissociated himself from his father's religion and his own childhood in Borough Park, with all its ethnic homogeneity. But in his grandfather Edelman he found, much as he did in his uncles, a mesmerizing eccentricity, a trait that he emulated, knowing it was the means to get beyond the conventionality of his upbringing.

talk at siegmeister's studio

Rosenberg may have objected to his father's formality, but the older man's intellectual interests imprinted him, and he eventually decided to take up writing poetry. Abraham's verse was written in Hebrew and given to biblical themes. Yet that was inconsequential to Rosenberg. He knew that the Hebrew language, with its crisp, staccato rhythms, was deeply emotional and lyrical. His only sibling and older brother, David (fig. 4), had become a poet and continued

Fig. 4. Unknown photographer, *Portrait of Brother David*, 1929. Photographic print. Harold and May Tabak Rosenberg Papers, Archives of American Art, Smithsonian Institution.

writing until his death in 1962.[52] When Harold was in high school, David introduced him to the works of English poets of the seventeenth to nineteenth centuries, including the poems of Robert Herrick; Samuel T. Coleridge's "Kubla Khan," the opium-induced reverie that inaugurated the Romantic movement in the late eighteenth century; and Francis T. Palgrave's *Golden Treasury*, a volume published in 1861 that became wildly popular during the Victorian period. Near the end of his senior year at Erasmus Hall, the metaphysical dimensions of Coleridge's poem had, as Rosenberg recalled, "a magical effect on me . . . up until then I didn't know what was going on."[53]

While Harold was in Brooklyn Law School, David introduced him to the West Village, where he was living and doing odd jobs to support his poetry. There, Harold for the first time met writers and painters (outside of his wacky uncle). He came to love the bohemian

neighborhood and its countercultural scene. Through his weekend visits to the Village, he now understood understand that Borough Park also had its own "advanced group"[54] of poets, painters, and musicians who met regularly to discuss modern art at the studio of Elie Siegmeister, an aspiring conductor and composer. (Siegmeister left Brooklyn in 1927 for Paris to study with Nadia Boulanger.) Harold was brought into the circle around 1926 or 1927 by Harold Baumbach, a painter, and David Arkin, a poet (who became the father of Alan Arkin, the actor).[55] He knew Arkin from Erasmus Hall. Arkin was, as May Natalie Tabak described, an "individualist,"[56] suggesting that he was unusual. He similarly had known Baumbach from childhood and Baumbach introduced Rosenberg to painting.[57] After listening to performances of Stravinsky and Schoenberg on the top floor of the cottage on the grounds of Siegmeister's parents' "beautiful mansion"[58] in the "plushy" district that he once thought closed to him, they discussed writers who appeared in *transition*—the monthly literary journal founded by two American exiles, Eugene Jolas and Elliot Paul, in Paris in 1927.[59]

It was through *transition* that Rosenberg became acquainted with the work of André Breton, André Gide, Gertrude Stein, William Carlos Williams, and James Joyce. Although he started to write poetry during this period,[60] he claimed he "didn't do much about it,"[61] which suggests some hesitation to enter a public arena. That professional transformation came about a year later, when he met Roskolenko and Burke on the steps of the New York Public Library in 1928. But with his new understanding of modernist literature formed by the talk at Siegmeister's studio, and the intense reading he did while recovering from osteomyelitis, Rosenberg felt fortified to abandon the legal career to which he had halfheartedly committed.

2
in the landscape of sensibility
east houston street

don't be too heavily impressed
by rosenberg as an artist

Writing, as Harry Roskolenko observed, become Rosenberg's *métier* once he had fully recovered his health in 1929. While he painted intermittently into the mid-1930s, after his introduction to *transition* magazine he began composing short stories, literary commentary, and poetry. Three years after Siegmeister's salon had disbanded, he published "A Fairy Tale" in *transition*, setting in motion a career and a new sphere of contacts. The piece, published in June 1930, is a witty, Surrealist-tinged tale of a homosexual man's ill-fated encounter with the law.[1] The man remains undone by an arrest for loitering because it is "the unveiling of [his] soul"[2] that he seeks. The story was immediately noticed by Parker Tyler, who had just become associate editor of *Blues: A Magazine of New Rhythms*. *Blues* was a short-lived yet highly influential magazine founded a year earlier, in 1929, by Charles Henri Ford in Columbus, Mississippi, where Ford had lived since childhood. At the outset, Ford enlisted William Carlos Williams and Eugene Jolas as contributing editors. Upon reading Rosenberg's spoof of the legal system, Tyler tracked him down through Harold Anton, a painter who lived in the West Village and who knew David Rosenberg.

Both Tyler and Ford were gay, and they probably assumed that Rosenberg was, too. At least, the gist of "A Fairy Tale" might have suggested a queer identity. After meeting Rosenberg, Tyler wrote to Ford—who moved to New York in 1930—to convey that "I had an interesting talk with Rosenberg, who is (not attractive but brilliant). He has done a book on esthetics, of which *Hound & Horn* is

contemplating printing one chapter . . . Rosenberg will send several things [for *Blues*]."[3] Most people found Ford to be extraordinarily handsome, and his refined, chiseled features were a lure for photographers such as Cecil Beaton. Tyler was similarly fetching, his aquiline profile later captured by the avant-garde filmmaker Maya Deren (fig. 5). Despite Tyler's flippant description, Rosenberg was arresting, his height not only formidable but his face later likened by Saul Bellow to that of a "king, of an odd kind. A New York-style king."[4] To Tyler, who was notoriously catty, Rosenberg may not have been glamorous, but his imposing stature, piercing dark eyes, and arched brows projected an image of intellectual authority. There

Fig. 5. Maya Deren (1917–61), *Parker Tyler*, c. 1944. Gelatin silver print, 13 13/16 × 8 1/8 inches. Philadelphia Museum of Art, Purchased with funds contributed by Donor's trust, 2015.

was only one anomaly to his bearing, besides his enfeebled right leg: Rosenberg's towering bulk was at odds with his high-pitched, nasal voice that never deepened as he got older. Still, Tyler was dazzled by Rosenberg's literary commitments and the professional connections he had begun to forge.

Hound & Horn was another of the "little magazines," like *transition* and *Blues,* that formed part of a publishing movement that coalesced organically in the late 1920s, just as Rosenberg embarked on his career as a writer. The collective aim of these journals was to provide a platform for avant-garde literature that could not be absorbed by mainstream periodicals, such as *New Republic, Harper's, The Nation,* and the *New Yorker. Hound & Horn* was established by Lincoln Kirstein and Varian Fry in 1927 while the two were students at Harvard University, and was patterned on T. S. Eliot's *Criterion.* In its seven-year run, the magazine featured work by Kenneth Burke, Malcolm Cowley, Marianne Moore, Ezra Pound, Gertrude Stein, and William Carlos Williams, as well as illustrations and photographs by artists such as Charles Burchfield, Walker Evans, Gaston Lachaise, and Ben Shahn.[5] (Numerous writers overlap in the "little magazines" of the period, given that publishing outlets were scarce even for known figures, such as Eliot, Pound, and Williams.) Rosenberg's chapter on aesthetics never appeared in *Hound & Horn.* Nor has a manuscript surfaced in his papers.[6] But he did subsequently publish in *Blues* after meeting Tyler.

If anything distinguishes the short story, "A Relative Case of Absolute Collaboration," that he submitted to *Blues,* it is the clumsy and incomprehensible prose, even though the piece was intended to be enigmatic and whimsical. The tale centers on two scientists, Sousa and Jaquot, whose research on time and space unfolds in a laboratory in Prospect Park, Brooklyn. The characters are polar opposites: one (Jaquot) is a dreamer, the other (Sousa) analytical. Jaquot ponders how he can ally his imagination with his profession, believing it the only way for a scientist "to act,"[7] or make a breakthrough. Rosenberg implies that reverie is the best agency for science and sides with Jaquot, the visionary. Whatever the literary shortcomings of the story, it left Tyler convinced of Rosenberg's sagacity. His

appreciation, however, was not shared by Ford, who reluctantly capitulated to Tyler's enthusiasm and published the fable.

Nevertheless, Tyler did turn down two poems that Rosenberg sent to *Blues* along with his story. As he wrote to Ford, they were not "pleasing or successful"[8] enough. As their friendship intensified during the early 1930s, Tyler compared Rosenberg to a "father,"[9] even though he was only two years older. Tyler had also referred to Ford as a parent and himself as a "son,"[10] since Ford had provided his introduction to literary modernism. But once Ford left New York for Paris in 1931 and the *Blues* team disbanded, Tyler was in want of another patriarch who could oversee his maturation as a writer. Enter Rosenberg. Tyler and Ford continued to work together and collaborate via mail on a *roman à clef* of the New York gay demimonde that was composed partially of passages from Tyler's letters.[11] After the book, *The Young and the Evil*, appeared in 1933, Tyler began to probe the narrative distinctions between the essay and the novel. As in Rosenberg's "A Relative Case of Absolute Collaboration," he thought that these differences hinged on analysis and creativity.

Rosenberg helped shape Tyler's evaluations of literature and became a role model for his work. Tyler cast him in his unpublished memoir, "Acrobat in the Dark: A Metaphysical Autobiography," as "the epitome of the essay . . . The man whose veins are as the rivers of reason in the landscape of sensibility."[12] Ford admonished Tyler not to "be too heavily impressed by Rosenberg as an artist. Ask him to let you see his imagination."[13] Yet Tyler continued to defend him. In their transatlantic correspondence, he declared, "what makes you think Im deceived in Rosenberg; its his intellect not his imagination Im fond of."[14] Ford was irritated by Tyler's admiration of his new friend, suspicious not only of Rosenberg's writing but of the threat he posed to their relationship. When Rosenberg launched *The New Act, A Literary Review* in 1933 with H[offmann] R[eynolds] Hays, a translator and writer, Ford reported to Tyler that the journal's title was plagiarized from his own (unpublished) novel, "The Acts." Tyler reprimanded him, stating that Rosenberg got to his tag through "philosophical speculation"[15] and not by theft or appropriation.

Through Tyler, Rosenberg met Lionel Abel, a poet and rabbi's son with whom Tyler was involved in a clandestine affair. (Their relationship was not made public until after Abel's death, when he was outed by Ford. Abel had wanted to maintain a heterosexual identity.)[16] Unlike "father," the pet name that Tyler conferred on both Ford and Rosenberg, Abel was his "fetich," or fetish.[17] Abel was a slippery, dark figure who could be brutish, but he had a deep interest in literature.[18] He also became close to Rosenberg. Their friendship, while frequently competitive and quarrelsome, was rarely set back by envy, unlike Ford's divisive strategies. Tyler, Abel, Roskolenko, and Hays became part of Rosenberg's inner circle in the early 1930s, along with Kenneth Burke. While Abel was perennially homeless during this period—at least that is how he is pictured in *The Young and the Evil*—the four writers lived together with Rosenberg and Tabak in a building of cold-water flats at 230 East Houston Street, near Avenue A, for a brief stretch from mid-1932 through late 1933. There, in a building across the street, Hays and Rosenberg put out their literary pamphlet, *The New Act*. Tabak, who married Rosenberg in 1932, remembered with fondness life in this near-derelict building: "On Sunday mornings, as our friends woke up on the various floors, they'd drop in on us for breakfast. During these lazy sessions unexpected trivia were more likely to be mentioned than at other times."[19] No matter that their quarters were spare, the toilets shared, and the bathtubs plumbed alongside their kitchen sinks, the warmth of their conversations offset the dingy digs heated during the winter only with kerosene heaters. Money was tight, and their belongings few, but the rousing talk transcended their accommodations.

east houston street

East Houston Street was actually a step up from Rosenberg and Tabak's first abode on Paradise Alley, off 11th Street near Avenue A (fig. 6), where they lived for a few months after marrying. They had to enter their apartment complex through a large iron gate that

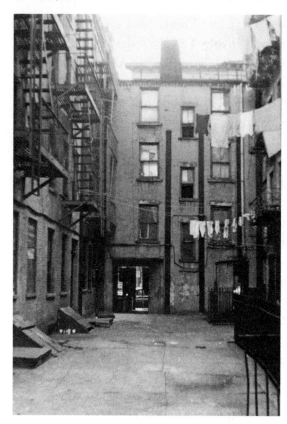

Fig. 6. Unknown photographer, *Courtyard of Paradise Alley*, c. 1930s. Photographic print.

opened onto a courtyard framed by their tenement and several smaller buildings. (The site was later immortalized by Jack Kerouac in *The Subterraneans*.) The staircases were narrow and rickety, and the laundry was hung to dry from the interior windows. The temporary residence was tiny in comparison to the sprawling loft building they occupied with Tyler, Roskolenko, Hays, and Abel.

Tabak thought Tyler was "beautiful," unlike the more "All-American" Ford who could have been a "Hollywood star," as she described.[20] Rosenberg was similarly taken with Ford's elegant sister, Ruth, a model and actress, whom he pursued in the dance halls in Greenwich Village on the weekends shortly after his wedding. The flirtation set in motion a lifelong string of infatuations and affairs. Rosenberg's dalliances were known to almost everyone except Tabak until the early 1950s. For all his rejection of his parents' staid life-

style and the ongoing violation of his marriage, he remained loyal to his wife, however tempted to leave. From the outset, he felt entitled to his trysts and viewed them as a response to the bourgeois institution of matrimony.

Unlike Ruth Ford, who became a muse for photographers such as Cecil Beaton, Man Ray, and Carl van Vechten, Tabak was decidedly bohemian, her zaftig figure clothed in dirndl skirts and shawls that she bought on the Lower East Side and adorned with peasant jewelry. Her dark, shoulder-length hair—sometimes swept into a bun—framed her broad face and soulful eyes capped by curved brows. Though she was of medium height, she barely reached Rosenberg's chin; he towered over her as he did over almost everyone. Tabak was enthralled by the bohemian world to which Rosenberg introduced her. Yet she was perpetually insecure, and frequently at sea socially. She considered herself bright, but many of Rosenberg's friends, especially Lionel Abel, questioned whether she was her husband's equal. Her self-doubt intervened at notable junctures as Rosenberg's career escalated. Although she remembered the scene on East Houston Street as a vibrant crucible for literary ideas, her role was primarily domestic, even though she was the breadwinner and supported the household through a part-time job as a social worker.

It was on East Houston Street that Parker Tyler acquired the literary education that he wanted, largely through Rosenberg's dissemination of "trivia" during their leisurely Sunday mornings. Although Tyler's modernist sensibility had been informed by a mix of writers, such as Mallarmé, Proust, and Freud,[21] his reading became better moored through Rosenberg's extemporaneous lectures. Despite his shyness in high school, Rosenberg now became accustomed to presiding over conversations. He was particularly adept at expounding on Old and New Testament subjects, as well as on Plato and Dostoevsky. Tyler was held by his knowledge and ability to link characters in these texts to the "dames and the guys"[22] they knew from the street. But like Abel, who had steered Tyler to Mallarmé and Rimbaud during their affair,[23] Rosenberg frequently became exasperated by Tyler's presumption that he could write about

these authors without in-depth study. He was galled especially that Tyler deigned to apply Marx to one of his essays, protesting, "You haven't really read all that much Marx, you know."[24] While Rosenberg had become steeped in Marx during this period, Tyler skirted close reading and presupposed he could grasp any author through intuition. As Tabak observed, "He believed that as a poet he could understand—intuit—without any of the crutches scholars and politicians required."[25] Ultimately, Tyler would remain more a disciple of Freud than of Marx, drawn to his theories of the Oedipus complex and libido.

Much to Rosenberg's chagrin, Tyler wrote about many of the same figures as he himself did during the 1930s and the 1940s, such as Shakespeare, Dostoevsky, and Gide. He had little faith in Tyler's reliance on instinct as he more methodically mapped out the crises endured by his subjects and their determination to "act." Despite their like interests, there was no unity of approach.[26] While Tyler would chip away at the psychological dimensions of his characters, declaring Hamlet to be "his author's whipping boy,"[27] Rosenberg dispensed with Freud, believing psychological methods a projection of the writer's own neurosis onto a novel. Shortly before Tabak and Rosenberg began to live on East Houston Street, Rosenberg weighed in on psychology as an analytical tool in a review of Kenneth Burke's first volume of literary criticism, *Counter-Statement,* in *Symposium. Symposium* was a bimonthly publication co-edited by James Burnham, a young Trotskyist and professor of philosophy at New York University, and Philip E. Wheelwright, his former teacher at Princeton. (Burnham, most likely, was part of the "circus" of radicals who convened at the New York Public Library in 1928.) During its three-year run, *Symposium* featured work by John Dewey, Sidney Hook, and Dwight Macdonald, among others.

Rosenberg thought that Burke's book was filled with "brilliant insights"[28] but pulled down by the assumption that psychology affected human "action," a word Burke used in the context of Thomas Mann and André Gide.[29] Rosenberg listed his misgivings in notational format, with one entry reading: "The idea that a work of art is a successfully constructed psychological machine deliberately

designed to arouse emotions."[30] Psychology would never provide Rosenberg with access to character. No matter Burke's disclaimer that it was the "psychology of the audience"[31] that determined literary form, thereby making the reader an equal partner in generating a text's meaning, Rosenberg always considered such analysis opaque. Unlike Burke's radical restructuring of the author/reader relationship, he demanded a more straightforward explication of the emotional life of protagonists in any novel.

However, Rosenberg found Burke's writing to be disciplined and lucid in contrast to Tyler's. Tyler's impassioned renderings of Shakespeare were alien to Rosenberg: too subjective, and written in campy, overbaked prose. Yet his reservations did not interfere in his decision to include two of Tyler's poems and a review of recent books by Sherwood Anderson, William Faulkner, and John Herrmann in *The New Act* when it was launched in 1933.[32] Although Tyler did not feel his poems represented his "best"[33] work, as he explained in a letter to Ezra Pound, he thought the review would "knock their 2 eyes out"[34] (Hays being one set of these "eyes," Rosenberg the other). One of his poems, "Shipshape Climber," an ode to Hart Crane, had been rejected by the editors of *Hound & Horn*. But Rosenberg felt that it stood out among Tyler's works, endowed with singular syntactic clarity.[35]

Rosenberg remained loyal to Tyler, Roskolenko, Burke, and Abel, even though he would occasionally disagree with them in print. He went out of his way to include them in most of the journals he edited. There were notable exceptions to this pattern, however: Rosenberg's association with H. R. Hays became strained through collaboration on *The New Act*.[36] His increasingly assertive personality became daunting, impossible to negotiate. Still, his feelings of loyalty overwhelmed most quarrels relating to literary judgment. Outside of his unrestrained pleasure in dominating discussion, there was more like-mindedness between these friends than Rosenberg initially let on. As the decade of the 1930s wore on, they all became opposed to an "art for art's sake" ethos that extended the solipsism of symbolist poets whom they had once read with interest. This opposition directed their work. Burke had been the first to declare, in

Counter-Statement, that the "the purity of . . . Epicureanism"[37] was no longer viable, especially given the class and economic disparities italicized by the Great Depression.

the real focus of a poem is never the particular person or thing

Although Parker Tyler had had doubts about publishing Rosenberg's poetry in *Blues,* as they became tight friends, he probably recommended Rosenberg's work to Richard Johns, the editor of *Pagany: A Native Quarterly,* who published his first poem, "Prayer for a Prayer," in 1931.[38] Another of the fleeting "little magazines," *Pagany* was founded by Johns in Boston in 1930 before he relocated to New York in 1932, where it folded a year later. Johns was an ardent defender of "native" literary expression and had an editorial mandate to focus on contemporary American writing. His mission was to correct a bias toward British and European writers within the publishing community. To reinforce his American credo, each issue of *Pagany* featured work by Williams Carlos Williams, who was recognized as one of the country's foremost poets. Williams's autobiographical novel, *A Voyage to Pagany,* inspired Johns's title, with *pagus* a metaphor for the still small community of American writers. In addition to Williams's poetry, *Pagany* also serialized his novel, *The White Mule,* over the life of the publication.[39]

Johns had approached Williams to become a co-editor of *Pagany,* an offer that he declined. Williams remained a fierce advocate for the magazine and steered many writers to Johns. *Pagany* quickly gained a reputation for its highbrow content, won in large part through the continual presence of Williams, and featured work by Tyler, Ford (who also acted as an unofficial advisor), Abel, Burke, Erskine Caldwell, John Dos Passos, Pound, Kenneth Rexroth, and Gertrude Stein, as well as Louis Zukofsky, a poet who was part of Tyler's circle. Zukofsky was veiled in Tyler's correspondence with Ford as "Miss Z" and "Elsie," a controlling yet "suave politician"[40] whom both Rosenberg and Abel "detested."[41] According to Tyler, Rosen-

berg was undone by the volume of material that Zukofsky sent to *Blues* and vowed to outmatch his submissions.[42]

Rosenberg was unable to convince Johns to take another poem of his for *Pagany* after pursuing him for two years and never receiving a response, let alone a letter of rejection.[43] Tyler had experienced the same frustration, although his rebuff was partly induced through provocation. He scolded Johns at one point by writing, "I know that superficially you have exhibited a gentlemanly tone toward a certain acrimony on my part toward what I honestly think is a flabby editorial consciousness."[44] Rosenberg, at least, spared Johns the expression of any ill will that he might have harbored during his silence. All the same, around this time. he established a more productive relationship with Harriet Monroe, the founder and editor of *Poetry: A Magazine of Verse,* which she had founded in Chicago in 1912. Rosenberg subsequently published many of his poems and literary reviews with Monroe until her death in 1936, thereby gaining a national platform for his work.

3
a capacity for action
poetry: a magazine of verse
and the new act

my dear little fellow

Rosenberg met Harriet Monroe in Chicago in 1931 where he hitch-hiked to spend time with Tabak, who had enrolled in the Graduate School of Social Work at the University of Chicago for the spring quarter. He was there to court Tabak but made use of his visit to acquaint Monroe with his work. He spent an afternoon with her in early June, a meeting he characterized as "a grand pleasure."[1] The trip represented the first time Rosenberg had traveled beyond New York. The Windy City was a revelation to him. Not only was the metropolis distinguished by modernist architecture, but Monroe herself had emerged as one of the foremost literary voices in the United States, contributing to Chicago's reputation as a literary hub.

Tabak had lived in Chicago until the age of ten. Not long after her mother died, her father, an electrician, moved the family, including her maternal grandmother, to New York. As Tabak described, her grandmother had "yichus"[2] or "good stock," a trait that her father wanted replicated in her mother's absence. She learned Yiddish from her grandmother, and the conviction that learning was an ennobling pursuit, paralleled in significance by devotion to the homeless and dispossessed. Acting on her grandmother's expectations, Tabak volunteered from the age of thirteen at both a clinic and Settlement House in Manhattan before she eventually graduated with a teaching diploma. However, she entered the work force just as the Depression set in and was unable to land a job. The opportunity to return to Chicago and to work at a social service agency while on a fellowship was taken as a godsend.

Tabak and Rosenberg had been seeing each other for over a year but were "disturbed"[3] by their mutual attachment. Even though they had met through friends in the West Village—a stronghold of bohemia—she could not imagine a life with a man who was not financially secure. When she arrived in Chicago, Rosenberg encouraged her to meet an old friend from Borough Park named Jules, to test the waters. She found Jules, a writer with independent means, cultured and a "dazzling talker" but too "superficial."[4] His rambling lectures on literature were pedantic and silly. She missed Rosenberg and "his Bohemian band with their singular positions on everything."[5] Rosenberg was similarly ambivalent about Tabak. While he referred to her as "my dear little fellow" in his letters and cautioned her that drinking might be "harmful to her soul," the most affection he could muster in his letters was a parenthetical "I like you."[6] Yet Jules's attraction to her set him wondering, and he thumbed rides to Hyde Park, where he lived with her for more than a month. He had hoped to secure a fellowship in the English Department at either Northwestern or the University of Wisconsin. When both failed to materialize and he was unable to nail down a job in a bookstore in the Village, Chicago became more enticing.

They stayed in a bleak room with worn furniture that Tabak had rented a few blocks from Lake Michigan near the University of Chicago campus. The space was dark, with a single window that overlooked the wall of a light shaft. To add to the grimness, the bathroom was communal and the shared telephone in the hallway rang continuously. (Tabak later learned that one of her neighbors was a pimp and his johns called hourly.)[7] With a single hot plate to cook on, they made do on her fellowship. Money was tight, but provisions were provided by her distant cousin Michael Tabak, who was the manager of a Hyde Park supermarket. Her classmates lived even more frugally, yet Tabak was able to contribute groceries to their dinner parties through the bounty extended by Michael.

During the day, while Tabak attended classes and met with her caseload of clients, Rosenberg wrote. However brief, it was a productive period for him. Tabak recalled that he "enjoyed arguing with the old lady [Harriet Monroe] and listening to her stories about all the

great contemporary American poets."[8] He stressed to Tabak that his days were to be undisrupted: he was also there to write. She gave up on her education and on Chicago, however. Her profession required clinical distance from her clients, and she could not disentangle her empathy from their despair. She was profoundly unhappy, undone by the stifling bureaucracy of the social services agencies that could not effectively process the hardship brought on by the Depression. Without reflection, Rosenberg supported Tabak's position to leave graduate school. She should feel fulfilled, he thought, just as he did after his decision to forego a legal career. Still, she felt inadequate around him, even though they ended up returning to New York and marrying. She was painfully aware that her work failed to interest him and his friends. "Evidently I was no Dostoyevsky,"[9] she allowed. Nor did she possess his prowess in conversation.

the open door policy

By the time Rosenberg met Monroe, she had made *Poetry* into one of the leading literary publications in the United States by repositioning verse—after a long period of dormancy—on par with fiction, music, architecture, and painting.[10] Poetry was in want of a comeback in 1912, having receded from periodicals such as the *Atlantic Monthly, Century, Dial, Harper's, Scribner's,* and *Smart Set,* where it once was a prominent genre. By the 1880s, its authority had dwindled, perceived by most editors as academic and the province of a genteel tradition that had settled into American culture after the Civil War.

Monroe's magazine became part of a "poetry renaissance" in the United States, and a forum for innovative work. She enlisted Ezra Pound—who had taken up residence in London in 1908 after finding few outlets for experimental writing in America—as her foreign correspondent, and *Poetry* quickly became international. Within its first three years, the journal published a mix of recognized figures, including Richard Aldington, H. D. (the poet Hilda Doolittle), T. S. Eliot, Rabindranath Tagore, and William Butler Yeats, all of whom were either British nationals or American expatriates. In addition,

Poetry featured emerging writers, such as Robert Frost, William Carlos Williams, and Pound, as well as scores of unknown poets, few of whom, other than Vachel Lindsay, Amy Lowell, and Alfred Noyes, made a significant impact on poetics or contributed to poetry's revival. (Monroe and her associate editor, Alice Corbin Henderson, were also poets who published their own work in *Poetry* but remained perpetually in the latter category.)

Pound was responsible for choosing most of the vital writers who appeared in the early issues of the journal, until his relationship with Monroe became embattled around 1914–15.[11] She refused to indulge his autocratic nature and his demands that she heed all his recommendations. He had advocated for *Poetry* to become an organ for the new Imagist movement, the trend that he had named and which included T. S. Eliot. With a goal to restructure verse through the use of colloquial language and concrete, spare statement, Imagism shunned symbolist obfuscation. As far as Pound was concerned, Monroe had missed an opportunity to publish Eliot on a regular basis, losing him to H. L. Mencken's *Smart Set*, as well as other "little magazines," such as Alfred Kreymborg's *Others*, which was based in Boston and devoted exclusively to poetry. In frustration, he brought out the *Imagist Anthology* in 1914, but quickly abandoned the term after tussling with Amy Lowell, who published her own collection, *Some Imagist Poets*, on the heels of Pound's volume. Pound moved on to new definitions for the renewal of verse yet continued to be put out by Monroe's focus on an audience for *Poetry*, which to him remained an unknowable if not hostile entity.

Monroe knew that the success of her publication depended upon engaging a wide public not only in the form of patrons and subscribers, but also through what she referred to as the "Open Door" policy: an assurance to her readers that *Poetry* was ecumenical, inclusive of all poetic tendencies, and not shackled by "muzzles and braces,"[12] or by one set of critical standards, such as Pound's Imagist movement. With the "best work"[13] of living poets as her yardstick, she felt she could mold a publication that would attract a wide readership while reviving a stagnant literary form, a feat that she accomplished through her business acumen and considerable knowledge

of the field. Monroe prided herself, furthermore, on treating her writers as professionals by paying them a nominal fee, something few of the "little magazines" could offer, especially those initiated during the Depression.[14]

Pound balked at Monroe's democracy by characterizing the American public as "that mass of dolts" in his poem "To Whistler, American," which was printed in the first issue of *Poetry*.[15] He was constitutionally incapable of abiding Monroe's diverse array of international, regional, and minor writers. Eventually, in 1917, he resigned as correspondent to *Poetry* to work as a foreign editor for the *Little Review*, founded by Margaret Anderson in Chicago in 1914 and transplanted to New York three years later. Pound could better exercise his interests at the *Little Review*. He steered major writers to the publication, such as Eliot, Yeats, Joyce, Gertrude Stein, and Djuna Barnes. John Quinn, a noted New York lawyer and collector, paid for their contributions primarily because of Pound's input. But Pound's didacticism and vituperative outbursts also became intolerable to Anderson after a nearly two-year period. Beyond his grandiosity and need for control, he respected few editors of American publications, particularly those directed by women whom he could more easily manipulate and bully. However, he continued to scout work for *Poetry* and send Monroe suggestions long after his position as foreign correspondent had officially ended. Despite their falling-out, she still regarded him as a shrewd arbiter of contemporary poetics.

Monroe was favorably predisposed to Rosenberg, what with her "Open Door" policy. Soon after their meeting in Chicago, she commissioned him to write two book reviews, both of which appeared after a quick turnaround in the December 1931 issue, even though they were characterized by the same malformed sentences as his submissions to *transition* and *Blues*. He criticized Dorothy Parker's third volume of poetry, *Death and Taxes,* for its "technical glibness" in his piece while vaunting Helen Hoyt's *The Name of a Rose,* an elegy composed for her mother-in-law, which he described as possessing "an honesty of appraisal which is definitely of today."[16] Hoyt, a former associate editor of *Poetry*, delivered what Rosenberg wanted

from a poem, or so he alleged. It contrasted sharply with Parker's compact, unflinching verse that addressed soured trysts with irony, humor, and sarcasm. Parker's work was too banal for Rosenberg, not directed enough from her inner life, a seemingly coy trivialization of quasi-tragic events. As he explained to Morton D. Zabel, Monroe's last associate editor, "I had really not expected that Parker's mixture of cuteness and 'frail cups within' would irritate me so much . . . I did, however, try to be fair, though it was hard to stand up even for a good phrase in such a melange."[17]

Parker's volume coincidentally opened with "A Prayer for a Prayer,"[18] the same title as Rosenberg's poem that had appeared in *Pagany* a few months earlier.[19] Yet there was no other resemblance between their work. Her plea for no "tenderness" from her lover upon her death is at odds with Rosenberg's romantic ode, which beseeches Deus to take pity on him as he tackles life's adversities. Rosenberg's reservations about Parker's verse were not motivated by feud over their identical titles (which may have been happenstance). He could not get beyond her mordant wit, feeling it had no place in poetry. As if to apologize for Hoyt's maudlin subject matter, he construed that "the real focus of a poem is never the particular person or thing celebrated, but the great underlying implications":[20] Or, he implied, the grand themes of life's cycles. Nonetheless, he responded more to the "slender and typographically exquisite"[21] design of Hoyt's self-published volume, a feature that allowed him to skirt her poems and remain in Monroe's good graces. It was far easier to pan Parker, a writer and contributor to the *New Yorker* who had no stake in *Poetry,* rather than Monroe's former editor and friend. Monroe was invested in a favorable review of Hoyt's work, having published a few of her poems from *The Name of a Rose* in an earlier issue.[22]

It would take Monroe a year and a half to warm to Rosenberg's poetry, revealing the same hesitation that Parker Tyler had. Moreover, she asked him to rework stanzas and titles of several offerings before they were printed.[23] Rosenberg was convinced of the clarity of his writing, feeling that it was handicapped only by his almost illegible and minuscule handwriting. To compensate, he purchased

a typewriter in 1932 with the hope of appeasing his editor.[24] Monroe was notoriously exacting and had infuriated the likes of Eliot, Pound, and Williams by demands for changes. One of her most audacious requests was to ask Eliot to lop off the last stanza of "The Love Song of J. Alfred Prufrock," believing it too bleak (although she did relent after Pound intervened, and published the poem in its entirety in 1915). Three of Rosenberg's poems were eventually published in the February 1933 issue of *Poetry*. One of these was titled "Brain of Happy Fable," the third stanza of which read:

> I shall invent an apple
>> that will force me to love you.
>> And between my violins
>> and twirling acrobats
> we shall be quite unseen for many hours.[25]

The poem, with its surrealist touches, was dedicated to May, who was by now his wife. As such, it represented a corny homage to a new union, not unlike Hoyt's mawkish elegies. As Rosenberg's presence in *Poetry* soared, his relationship with Tabak became thorny, frequently aggravated by his need to attract women, sometimes in considerable numbers. That he apparently needed a magic "apple," or aphrodisiac, to land her in bed, became a recurrent feature of their marriage. He dominated her from the outset by preying on her vulnerabilities. But she willingly deferred to his nimble intelligence and voluble manner, and supported their household until Rosenberg was able to contribute to their finances some six years later.

he is workin' on local scene

Parker Tyler was impressed by Rosenberg's connection to *Poetry*. The magazine had a serious readership and continuous history that had outdistanced most of its rivals through longevity. When Rosenberg first appeared in Monroe's journal, Tyler wrote to Charles Henri Ford that "Rosenberg had two reviews in the current poetry good ones."[26] The alliance with Monroe added to his view that Rosenberg

was a type of "Socrates," someone he thought Ford should appreciate. Tyler continued to chastise Ford for his qualms about Rosenberg. In one letter, he touted Rosenberg as "an intellect you should know even if you had to learn not to run away from him."[27]

Although *Blues* was defunct and could no longer provide Rosenberg with a platform, Tyler included nine of his poems in an anthology of contemporary American verse that he edited in 1934, titled *Modern Things*. The number exceeded those of contributions by luminaries such as Eliot, Pound, Gertrude Stein, Wallace Stevens, and Williams, in addition to the work of his friends, Abel, Ford, and Hays. *Modern Things* reprinted "Brain of Happy Fable," as well as a poem titled "Ode," a paean to carnal love, both of which had first appeared in *Poetry*. Yet Tyler was quick to throw out a disclaimer in his introduction that Rosenberg's submissions were overly swayed by Marxism rather than being the result of felt experience. "While I do not suggest that Mr. Rosenberg's work lacks the quantity of individuality in the more fundamental sense," he averred, "I do suggest that his necessary interests have apparently prevented him from evolving (consciously or unconsciously) a style by which he is easily recognizable."[28] There was nothing overtly Marxist about Rosenberg's poetry—no allusions to labor, class action, or strife—just Tyler's misreading and eccentricity. Clearly, Tyler remained tentative about Rosenberg's potential as a poet, regardless of the amount of space he gave him. He was hesitant to proclaim him a major, emerging talent.

His indecision never interfered with his professional devotion to Rosenberg—at least not immediately. He defended Rosenberg's work to Ezra Pound, who had written off Rosenberg's writing in a letter to Tyler in 1933 where he stated, "Rosenberg so far hasn't told me anything I hadnt heard before. Thass nowt agin him. He is workin' on local scene."[29] Tyler was not cowed by Pound's snub of his friend, and replied that Rosenberg was an essential fixture of a small coterie of writers in New York who sustained him: "If I hadnt been lucky and met—within the last four years—certain individuals of personal charm, information and high-powered problematism (Rosenberg, Abel, Rocco) I should consider my personal contacts

here a flat loss."[30] (Joe Rocco was a poet whom Tyler met in New York in the late 1920s and who published in *Blues*.) Rosenberg would have been wounded by Pound's derision, with its class inferences and condescending mock twang, especially since he later printed a short "note" by Pound on Rimbaud in *The New Act*, his collaboration with H. R. Hays.

a capacity for action

Shortly before he teamed up with Hays in 1933, Rosenberg published his first major essay, "Character Change and the Drama," in *Symposium*. The article was "the basic piece,"[31] as he called it, that directed his output as a writer. After a long preamble on the legal discrepancies between "being and action,"[32] and the law's predisposition to view human behavior as routinized, devoid of idiosyncrasy, and without possibility for transformation, Rosenberg landed on Shakespeare's Hamlet, a "new kind of hero,"[33] who had discovered a capacity for *action* by owning up to his fate after avenging the murder of his father by his uncle. Hamlet, just like the Brothers Karamazov in Dostoyesky's novel, Captain Ahab in Melville's *Moby-Dick*, Valéry's Monsieur Teste, and Settembrini in Mann's *The Magic Mountain*, was one of the fictional figures to whom Rosenberg returned throughout his career, responding to the pathos implicit in the will to act and the self-awaking that ended in death. They were the imaginary equivalents of a maverick like Lenin, who had overcome an upper-middle-class upbringing to effect social revolution for the downtrodden proletariat. As Rosenberg explained in *Symposium*, individuality grew from a radical impulse to defy conformity and the status quo. From the beginning, *action* would become his scale to determine the effectiveness of a poem, a play, a novel, or a work of art.

Rosenberg built on his idea of *action* with Hays, to situate the word in a contemporary context, in *The New Act*, their short-lived venture that ran through three issues. He had already reviewed William Carlos Williams's *The Knife of the Times and Other Stories* for the *Fifth Floor Window*, a journal that Hays also co-edited. He con-

sidered Williams's stories not nearly as "bare"[34] as his poems but still incisive, with the downside that his narratives tended toward moralizing. Marianne Moore wrote to Ezra Pound that *Fifth Floor Window* was an undignified title for a journal, as pedestrian as "the fire-escape or the pollard rubber-tree."[35] She got the gist of the title right: the magazine was produced in the same dingy edifice that Hays shared with Rosenberg and Tyler on East Houston Street. Despite the dispiriting title of Hays's magazine, Rosenberg's treatment of Williams "interested"[36] her. She must have responded to his insight that Williams's characters were incapable of *action*, their conventional lives too tightly woven into the staid fabric of small-town New Jersey life. Rosenberg found nothing virtuous in their constricted interactions and behavior.

Pound needed no introduction from Moore to Hays's journal. He was already a subscriber[37] and had been mentioned by Hays as a writer who was "not yet properly appreciated"[38] in the same issue in which Rosenberg assessed Williams's tales. Louis Zukofsky, who sustained a lengthy correspondence with Pound during this period, had written off the *Fifth Floor Window* as "shit,"[39] its Surrealist underpinnings evidently an affront to his taut, precise language. Yet Zukofsky's description did not deter Pound from submitting work to *The New Act* after it was launched in 1933.

Although their offices were initially located on East Houston Street, Rosenberg and Hays were soon forced to vacate the building, and the last issue of *The New Act* was brought out from 39 Christopher Street, a nondescript, six-story, red-brick walk-up with tiny, claustrophobic rooms. It was one of the many addresses at which Rosenberg and Tabak lived as they bounced around every few months during the Depression, perpetually chasing cheaper rent. Even though Tabak had given up on her graduate degree, when she returned to New York she worked for the Home Relief Bureau, where she oversaw welfare clients in the early years of the Roosevelt administration. Their poverty and suffering still got to her, but Harold's writing and *The New Act* needed financing. Tabak thought her job would be temporary, not knowing the severity and length of what would become the worst economic downturn in American history. She con-

tinued with the bureau for three years while she and her husband moved in and around the West Village. After long days on the job in Hell's Kitchen and Harlem, she would come home to cook and find Rosenberg and his cronies, like Abel and Hays, playing cards and debating Marx. She justified her role as a breadwinner: "Suddenly it was possible for two to live as cheaply as one on a salary that would have barely passed muster as a schoolgirl's pin money a year or two before."[40] All for the love of Harold and bohemia!

the new act

In their opening statement to *The New Act*, Hays and Rosenberg averred that "a review, even when it devotes itself solely to literature, is not a literary review when it incites to action of some sort, whether it be joining the Socialist Party, or taking hashish and imitating [the Surrealist poet] Aragon."[41] *The New Act* was not to be confused with a political broadside, then. It made no claims that collective *action* could result in social change. Rosenberg and Hays retained writing as an individualistic practice, dissociated from the proletarian literature found in journals such as the *New Masses*. Ironically, their mandate came from Rosenberg's ongoing reading of Marx—the figure he delved into in 1928. In hindsight, he noted, "in the clichés of 'my' generation, I found in his writings a new image of the drama of the individual and of the mass, as I saw in Lenin a new kind of hero, a sort of political M[onsieur] Teste."[42]

Harold Baumbach, Rosenberg's childhood friend from Borough Park, recalled that Rosenberg and Hays differed on the content of *The New Act*. Hays insisted the review contain no political discussion, as it would distract from submissions by writers such as Pound and Tyler.[43] Even though Hays could be perfunctory and terse, his manner occasionally intimidating,[44] Rosenberg prevailed and penned an article for the first issue that focused on the relationship between the writer and class conflict, knowing that the word *action* had become topical and was being used in the context of new social protest movements and the growing alliances of workers who had become unemployed during the Depression.

Hays led a far less stressful economic life than Rosenberg: he had attended Ivy League schools and taught English at City College of New York from 1927 until 1929, while he was still a graduate student at Columbia. He was also distantly related to the Sulzberger family of the *New York Times*. However, he was not immune to hardship after the collapse of Wall Street. Far from it: he went through a lean period after he ceased teaching that resulted in his joining the Communist Party. Although he was dedicated to Marx, and later wrote poetry for the *New Masses* that engaged class conflict, he was unconvinced that an explanation was needed in *The New Act* to differentiate the individual from proletarian culture. Nonetheless, Rosenberg wrote in their first issue, "Literary vision was something else—it trys to see completely."[45] The writer, as Rosenberg saw it, had the potential to bring about change for himself by drawing on the imagination and placing literature and politics in dialectical tension.

Unlike Hays, who also gravitated to Surrealism and devoted an entire issue of the *Fifth Floor Window* to the movement, Rosenberg still held Marx as the primary catalyst for his thinking, even though Marx's writings offered no accommodation of the individual. Where Marx professed that consciousness was socially determined, not incumbent upon self-knowledge,[46] Rosenberg inserted the individual into that dictum. He admitted that this realignment might be far-fetched, a projection, even. "I don't know if I superimposed this on Marx or whether it's there," he stated. "It's one of those hallucinatory conditions that the mind gets into where you do research and always discover what you have in mind."[47] He capitalized on what he considered to be a contradiction: Marx's inability to reconcile the unique traits of human existence. Class struggle was an "abstract identity,"[48] Rosenberg concluded, not only anonymous but limited in its explanation of tragedy.

Rosenberg turned to John Dewey, the American philosopher and educational theorist, to find a way to revise Marx's notion of *action* and situate the individual at the forefront of history. In the next issue of *The New Act*, he invoked Dewey when he took on the popular (mis)perception that the artist was a misfit, an alienated romantic whose neurosis was expressed through an unorthodox lifestyle.

By drawing on Dewey's emphasis on the "individual's sensitivity," Rosenberg asked why "society, wherever it has not been apotheosized into a shining though vague deity, is still the dull custodian of sanity."[49] He knew that contemporary writing had moved on from Rimbaud, Mallarmé, and symbolist poetry of the late nineteenth century, and from its self-indulgence, ambiguous language, and opposition to bourgeois culture, by adjusting to society. To his mind, the poetry of Ezra Pound and T. S. Eliot was less hermetic, more accessible. As a result, he believed their work was more at ease with the modern period.

Dewey was not attuned to the social reforms sought through class revolution. Nor were Pound and Eliot. But that did not matter to Rosenberg. He was attracted more to Dewey's belief that the individual's "sensitivity" could function within society. Rosenberg knew that poetry had run the risk of becoming overly specialized, devolved into "a patient of different schools of *mass-interpretation,* behavioristic, psychoanalytical, marxist, neo-catholic, the soil-novel photography of degenerate local types."[50] If literature was to retain its edge, the self had not only to be foregrounded but also to be immersed in history. Through combining Marx with Dewey, Rosenberg grafted a new paradigm for *action* in the early 1930s.

Rosenberg was probably introduced to Dewey's writings by Kenneth Burke, who had known Dewey's work since he was as an undergraduate at Columbia University where Dewey taught. Moreover, Sidney Hook—who was part of the group that had congregated on the steps of the New York Public Library—had been Dewey's doctoral student and became an enthralled promoter of his pragmatist theories of knowledge. Rosenberg, like Burke, felt that human experience could not be explained solely in terms of its practical applications, however. After all, he had given up law school to become a poet. His idealism did not mesh with Dewey's reasoning, but he was taken with the philosopher's belief in the dynamic traits of self-inquiry—the missing ingredient in Marx's radicalism.

A rift quickly opened up between Rosenberg and Hays over their interpretation of Marx; that breach was never repaired, and *The New*

Act dissolved in 1934. Even though Tabak had introduced Hays to his future wife, Juliette, a designer, and they all continued to see each other at meetings of the Artists' Union[51] — a leftist organization founded the same year — Hays was more ideologically invested in socialism. That he became a communist was an identity Rosenberg could not countenance. Eventually, they ceased to socialize at the bars and cafeterias in the Village, especially once Hays became a noted translator of Latin American writers, such as Pablo Neruda, in the early 1940s. Neruda had aggrandized Stalin as a political reformer in his writing, rather than representing him as a tyrant, which was odious to Rosenberg.

"epos"

Rosenberg commissioned a short piece on Rimbaud from Ezra Pound for the second issue of *The New Act*. He hoped the "note" would be read as an extension of his essay in which he linked Rimbaud to the problem of "sanity." Pound referred to his submission as a "confirmation"[52] of Rosenberg's ideas but thought they needed his clarification. Despite the nod, the two figures were at literary cross-purposes. Outside of the contrast between Rosenberg's rambling analysis and Pound's economic, bullet-type phrasing, Pound emphasized Rimbaud's "objectivity," a trait acquired through perfection of a symbolist style that subsequently become exemplary for modern poetry. Rosenberg read Rimbaud for his literary excesses and was unconvinced of his relevance in the early 1930s. Rimbaud might have been one of the originators of free verse, with his supple delving into the unconscious, yet his work had become "old-fashioned," Rosenberg contended, possessing a "personal freakishness"[53] that was extravagant, particularly during the Depression. Pound had figured prominently in Rosenberg's essay on sanity, as did Eliot and Joyce, part of a movement he called the "new individualism" that was more "sane" than Rimbaud's hallucinations and personal hieroglyphics. The term "new individualism" was a bit of misnomer, however: their work effected objectivity through emo-

tional restraint and assiduous word choices that stressed more the architecture of the poem than the prolonged description of their subjectivity.

Rosenberg subsequently engaged René Taupin, a French literary critic and translator whose career unfolded in New York, to write on Pound's poetry for the third and final issue of *The New Act*.[54] He wanted Pound positioned as one of modernism's major innovators. Taupin rose to the occasion, as he was keen on Pound's Imagist movement. (Taupin was professionally associated with Zukofsky and also maintained a lengthy correspondence with Pound.) Yet Pound never reciprocated by extending an invitation to Rosenberg to publish in one of his ventures. He did not consider Rosenberg's poems and essays as part of an essential discourse: they were too mired in peripheral influences, such as Marx and Dewey. Hence, the "local scene" slur that he passed on to Parker Tyler. Pound devalued the work of most American writers who chose to remain in a country that he thought inimical to poetry and that had a skimpy modernist history. He questioned, for instance, Wallace Stevens's "self-imposed isolation."[55] Exceptions were acolytes, such as Zukofsky. Even so, Rosenberg relished his connection to Pound, unaware of Pound's dim view of his work, and dedicated a poem to him titled "Epos" that was published in *Poetry* in 1935.[56]

Pound wrote to Rosenberg about the word "epos" (epic), wondering why he had not used it in his essay on "sanity." Why had he resorted to the more colloquial expression "drama" to discuss the revelation of a writer's inner life ? Rosenberg wrote back to Pound with the assuredness of an equal—writing to someone in need of a lesson, even—and apprised him that he believed "drama" was a more current term, that "epos" had passed out of usage and become pretentious, stuck in the nineteenth century where it was "mixed with confession, with science, with psychology, with morality, with the 'sense of Beautay.'"[57]

None of Rosenberg's erudition seduced Pound, who overlooked Rosenberg's work for the *Active Anthology* that he edited in 1933, the title a stab at another umbrella term for new verse. He had written to Tyler for recommendations of poets working in the United States.

It did not occur to Pound to include Rosenberg despite their contact on *The New Act*. Tyler, ever loyal, passed on Rosenberg's name. Pound eventually limited his selections "to poems Britain has not accepted and in the main that the British literary bureaucracy does NOT want to have printed in England,"[58] forgoing even Tyler's work in which he had an interest, though he was turned off by its frequent homoerotic content.[59] In the end, the collection highlighted poets such as Basil Bunting, E. E. Cummings, Eliot, Ernest Hemingway, George Oppen, Williams, and Zukofsky, a largely like-minded group who propounded the "objectivity" he deemed the hallmark of Rimbaud's poetry. (The appearance of Hemingway in the volume was anomalous. Pound thought his verse had been neglected by most editors, especially in Britain.)

Although Rosenberg failed to make the cut, Tyler excused the omission. In a rare moment of acquiescence, he acknowledged to Pound that "Rosenberg with his heavily accented shiftings of the logical body is as listless in his lucidity as a simple lazy man; I guess his poems are lazy too . . . but you wanted something from America and they DO have a kind of judgement."[60] However, the admission was not serious enough to hold Tyler back from making Rosenberg the centerpiece of his own collection, *Modern Things*, where he weighed the odds that Rosenberg might "be approaching a style."[61]

tending towards pure decoration

Rosenberg soon caught on to Pound's aesthetics. As the decade of the 1930s wore on, he was better able to decipher Pound's "objectivity" and the elegant way in which *The Cantos*—Pound's project that continued for more than fifty yearss, from the 1910s into the 1960s— with its monosyllabic words and brisk sentences that veiled an embrace of fascism and of the Italian dictator Benito Mussolini, with whom Pound had a brief audience in 1933, just as Rosenberg was extolling Pound's work in *The New Act*. Following Rosenberg's dedication of "Epos" to Pound, he realized that the exiled poet's writing, as well as Eliot's and Marianne Moore's, was "tending towards pure decoration," that its "reign [had come] to a close with the revival of

the American labor movement"[62] in the mid-1920s. The juncture, for Rosenberg, now represented a setback for modern poetry.

In the late 1910s, with the rise of populists such as Carl Sandburg and Vachel Lindsay—whose work lauded the midwestern heartland and its agrarian landscape, stockyards, and stalwart folk—the exploration of formal languages became secondary in American poetics. Rosenberg wrongly thought these regional expressions were unable to become "the medium of the masses,"[63] and to hold the considerable audiences that Walt Whitman's work had done. In his revised take, both the free-verse movement of Pound and the American School fell short by forsaking a connection to the self. Poetry had begun to lose its authority, he thought. Where Whitman had submerged himself in American culture, and had drawn on its diverse imagery in *Leaves of Grass* and *Song of Myself*, poetry had since become less integral to America life. In an article for *Partisan Review* in 1936, he explained that in Whitman's realm "every detail of American life, every wheelbarrow, every word in every book in the library, every machine, everything cast off and floating away, was lifted to the level of poetry by what America was doing and would do in the future for the liberation of the Human Being."[64]

Rosenberg knew there were other explanations for the fractured state of American poetry. After its entry into World War I, the United States had become a modern state and leading industrial power. One of the outcomes was that native literature became simultaneously international and parochial. The dislocation of the "human being" and the increased tendency toward "decoration" during this transition nagged at Rosenberg, suggesting that verse had become too narrow. He was dismayed, moreover, by Pound's and Eliot's refusal to acknowledge Whitman, especially since Whitman's poetics offered a perfect amalgam of invention and ego. During this period, Rosenberg must have begun to doubt his own poetry, sensing that it was too self-conscious to affect the ease of Whitman's jubilant hymns through his quasi-Surreal themes. His "Brain of Happy Fable" was just such a gangly conflation. As he thought about the predicament of contemporary poetry, rejections from editors became frequent. His inclusion in Tyler's *Modern Things* had failed to

attract notice. When Harriet Monroe died in 1936, even *Poetry* magazine became less of an option for his work.

By contrast, Rosenberg's essays on literature and politics had begun to generate more attention. They appeared not only in *Poetry* but also in the *Partisan Review & Anvil*, an offshoot of the John Reed Club, as well as in the *New Masses*, a Marxist magazine that would become infiltrated by the Communist Party. He gradually gave up on verse, feeling that its modernist iterations could not respond effectively to the crisis of the Depression. It ceased to be relevant to him. Poetry's demise, Rosenberg contended, was brought about largely through material circumstances: "[When] poetry became pure and detached from social activity and social responsibility, it was not through an act of perverse will or human callousness. The poet and his art were pushed into a corner by economic forces which he long ago recognized and hated."[65] This corner represented the academy where the poet was compelled to eke out a living. The outcome, Rosenberg wrote in *Poetry* in 1936, was "an internationalism of mediocrity,"[66] whereby Pound's and Eliot's prescriptions for purity became ubiquitous. Six years later, in 1942, just as the United States became part of the Allied forces, he declared to a colleague, "I'm the guy who doesn't think that poetry will win the war!"[67] capping his doubts on its future. The realization was slow to unfold. Rosenberg still wrote verse for almost a decade longer and occasionally hedged his bets on its renewal.[68]

the politics of purity

After 1936, Pound surfaced infrequently in Rosenberg's writing. Despite his earlier desire for Pound's recognition, he had moved on. Rosenberg now treated Pound as a historic figure rather than someone with whom he was once aesthetically aligned. When Pound was awarded the Bollingen Prize in Poetry by the Library of Congress in 1948 for his *Pisan Cantos*—the poems he wrote while interned at an American military detention center in Pisa for his broadcasts on Italian radio against US participation in the war—Rosenberg failed to weigh in with an opinion. The *Pisan Cantos* represented a

turning point for Pound: his poems became more doleful through the brutality he experienced as a prisoner. Except for the members of the Bollingen Committee, which included Conrad Aitken, W. H. Auden, Eliot, Robert Lowell, Katherine Anne Porter, Allen Tate, and Robert Penn Warren, few writers, including Rosenberg, could respond to the elegiac content of his verse.

The *Pisan Cantos* were also patently racist, as were Pound's strident broadcasts, a feature that some writers, such as William Carlos Williams, could not ignore. The poet was deported to Washington, DC, to stand trial for treason after the war but was declared unfit to stand trial (the opposite attribute Rosenberg ascribed to his writing in *The New Act*) and institutionalized at St. Elizabeths Hospital in Bethesda, Maryland, for a twelve-year period. The selection of Pound for the Bollingen Prize was widely condemned in the literary press. William Barrett, for example, expressed indignation in an editorial in the *Partisan Review*, as did Irving Howe, as well as Clement Greenberg, the publication's art critic. These were followed by responses from Auden and Tate, defending their votes.[69] Rosenberg stayed out of the controversy, however. The politics of purity was not the locus of his inquiry until much later, when he began to write about art.

miss z or elsie

Even though Rosenberg had enjoyed contact with Pound through *The New Act*, his "objectivity" was fundamentally at odds with his own intellectual outlook. So, too, was the reductivism of one of Pound's prize disciples, Louis Zukofsky, the poet whom Parker Tyler irreverently referred to as "Elsie." Rosenberg had no interest in Zukofsky's experiments that wielded language into object-like forms and featured cadences that were sensual and musical.

Pound had introduced Zukofsky to Harriet Monroe when Zukofsky taught at the University of Wisconsin in the early 1930s. Taken by his commitment to stretching known modernist territories, Monroe subsequently invited Zukofsky to guest-edit the February 1931 issue of *Poetry*,[70] just as Rosenberg established his relationship with

the journal. While writers such as William Carlos Williams figured in Zukofsky's assemblage, he was more interested in the new objectification expounded by Charles Reznikoff, Carl Rakosi, Norman Maclean, George Oppen, Kenneth Rexroth, and Basil Bunting, all younger poets, who focused, as Zukofsky wrote, on "the detail, not mirage, of seeing, of the thinking with the things as they exist, and of directing them along a line of melody."[71] Parker Tyler and Charles Henri Ford were shunted from the main lineup but included in an addendum to the issue. Their entries were too laden with personal symbolism despite their rethinking of the structure of poetry. (Both were valued by Zukofsky primarily as the editors of *Blues*.)

Zukofsky surely knew Rosenberg's short stories from *Blues*, but Rosenberg had yet to publish a poem and hence was not a candidate for the special issue. Moreover, once his own poetics evolved, Rosenberg failed to uphold Zukofsky's mandate for formal innovation. Rosenberg was also put off by Zukofsky's ambition to be omnipresent on the literary scene, which similarly irritated Tyler, who moaned, "He'd like to lead the whole damn herd and nurse the tiniest lamb."[72] Rosenberg never commented in print on Zukofsky's work, but he revealed privately to Tyler that he thought "the wiseguy attitude in poetry was despicable."[73] Zukofsky's aesthetics had built on the avant-gardism of E. E. Cummings, another "wiseguy" whose spare, ruptured style abandoned conventional syntax to craft verse that was visually inventive. Shortly after Zukofsky's issue of *Poetry* appeared, Rosenberg and Tyler laid out his "corpse"[74] one evening, a metaphor for his conception of modernism having culminated in a dead end.[75]

Zukofsky and "objectivist" poets, such as Oppen, would later appear in the *Partisan Review* once Clement Greenberg became an editor in 1940—another sore point for Rosenberg and Tyler. Greenberg had early aspirations to become a poet. His hopes were dashed when it was revealed that his only published piece, "Sacramento, 1935," had been plagiarized.[76] William Phillips and Philip Rahv, two of the founding editors of *Partisan Review*, must have known about the incident, as it induced incredulous letters to the *New Masses* where it was printed. Some five years later, when Greenberg was

made poetry editor of *Partisan Review,* the infraction did not seem to matter. Literary modernism was largely explained as a historic project at the *Partisan Review*: the past was the journal's primary interest. There were notable exceptions, such as Delmore Schwartz, who was named an editor in 1943. Still these inclusions never amounted to a programmatic thrust. It was largely T. S. Eliot, and the Southern Agrarian poets, such as Allen Tate, who held sway at *Partisan Review,* leaving little room even for the experiments of Zukofsky and his cohort.

poets who spoke american best

After Pound's fascist outbursts were revealed, William Carlos Williams spared no restraint in stating, "I can't write about Ezra Pound with any sort of composure. When I think of the callousness of some of his letters during the last six or seven years, blithe comments touching on 'fresh meat on the Russian steppes' or the war in Spain as being of 'no more importance than the draining of some mosquito swamp in deepest Africa,' 'Hitler the martyr,' and all that—I want to forget that I ever knew him."[77] Still, Rosenberg refrained from mentioning Pound even obliquely in an article on "The 'Jew' in Literature," commissioned by *Commentary* in 1949 as part of a "symposium" of essays, fueled in part by the Bollingen controversy, on the representation of the Jew in Anglo-American writing.[78] Williams had more at stake than Rosenberg in distancing himself from Pound's racism, indebted as he was to Pound for promoting his work in Britain in the early 1910s and later with Harriet Monroe at *Poetry.* (He eventually felt compassion for Pound, resumed their correspondence, and visited him almost annually at St. Elizabeths.)[79]

Rather than spotlighting Pound, Rosenberg reserved his scrutiny for T. S. Eliot, a member of the Bollingen Committee, whose prejudice had leached into poems such as "Burbank with a Baedeker: Bleistein with a Cigar," "Gerontion," "A Cooking Egg," and "Sweeney among the Nightingales," all written by the early 1920s and setting the stage for disparaging references to Jews in *The Waste Land* and later prose pieces, lectures, and plays, such as *Sweeney Agonistes.*[80]

Rosenberg was not offended by Eliot's portrayals, believing his representations to be fictive: the Jew was an ethnic type who, like Shylock in *The Merchant of Venice,* becomes "brother to those other Shakespearean pigsters, Iago, Claudius, Macbeth. One is labeled Jew, the others Italian, Dane, Scot."[81] He remained unperturbed by lines in poems such as "Gerontion," where Eliot writes, "My house is a decayed house. / And the Jew squats on the window sill, the owner." Like several other Jewish writers of his generation,[82] Rosenberg responded:

> Why should I resent Eliot's poem for its Jewish landlord repulsive to the aristocrat who lost his property? Alas, says Eliot, in the modern world there is no entailed real estate, no integrated culture, no "roots," no high ritual, nothing but capitalism, Jews, and progress, tsk, tsk. I take this music as I do that of a Hungarian string trio in a restaurant with atmosphere (the very restaurant of "Rachel *nee* Rabinovich"). So aristocrats, dancers in genuine ermine. What if the waiter is a White Guardist and an ex-pogromchick? Another chilled vodka please.[83]

What Rosenberg objected to in Eliot was his real-life offenses— not his poems or plays but his literary criticism, works such as *After Strange Gods,* written as a lecture for the University of Virginia in 1933 just as Hitler's fascist regime was escalating. Here he found plain evidence of Eliot's contempt for the Jew, whom the poet characterized as part of a "free-thinking" community that was "undesirable," having disrupted a "unity of religious background"[84] in largely Protestant America. Rosenberg responded: "it is a quite different thing when Eliot puts down his harmonica, mistakes himself for the dispossessed Prince Romanoff, and proposes communities with NO JEWS signs on them. Here we face the fact that there is no cultural tradition that does not contain an enormous amount of stupidity, to say nothing of dope-taking, sexual infirmity, and actual madness."[85] Rosenberg got in his revenge by attacking Eliot's masculinity, his known fear of women and his terror in the bedroom, as well as his mental collapse in 1921, just as he completed *The Waste Land* and

developed his journal, *Criterion.* (As for Eliot's "dope-taking," I can only assume that Rosenberg referred to the tranquilizers that Eliot took after his breakdown, which the poet makes oblique reference to in "Dry Salvages," the third section of *The Four Quartets.*)[86]

Rosenberg continued to attack Eliot and made him into a scoundrel in "French Silence and American Poetry," an introduction commissioned by the Documents of Modern Art series for Marcel Raymond's *From Baudelaire to Surrealism* in 1949. Eliot now became the "Pied Piper of *The Oxford Book of English Verse*" who had "succeeded in making poetry appear as a thing with a life of its own."[87] Although he abstained from touching on Eliot's portrayal of the Jew in poems such as "Gerontion," he now went after Eliot's formalism: his perfection of a naturalized, seemingly effortless language that deflected intolerance. Although Eliot was the main target of his essay, Pound appeared in surprising affirmation as one of the few "poets who spoke American best."[88] Unlike Rosenberg's treatment of *After Strange Gods*, in which he reprimanded Eliot for his "stupidity" and belief in racial purity, he avoided any discussion of Pound's enmity toward the Jews. Rosenberg must have known of the gist of Pound's radio speeches. By the time the Bollingen Prize was awarded, the broadcasts were widely discussed in the press, even though the full transcripts were not published until 1978, the year of the poet's death. Pound's anti-Semitism aside, Rosenberg was more interested in rendering him as a retro figure, someone who had no connection to the mid-century.

"French Silence and American Poetry" was a throwback for Rosenberg, representing one of his last essays on verse after a long "silence" on the genre. The piece made no mention of recent developments. It was more of a eulogy, his swan song to a literary medium in which he had once invested his professional future. Still, the resurrection of Pound was somewhat baffling. Praising him as one of the few "poets who spoke American best" came from Rosenberg's assumption that Pound's work remained rooted in homegrown experience. Unlike Eliot's total English conversion, the lingering native references in Pound's work evidently redeemed him. His poetry

had not been totally washed of his birthplace by his living abroad. Rosenberg must have been thinking about poems such as "Patria Mia"(1913), in which Pound vividly captures the spectacle of the New York skyline at night and ties its abstract array of lights to the effects of modern verse: "Squares after squares of flame, set and cut into ether. / Here is our poetry, for we have pulled down the stars to our will."[89] In the later *Cantos*, Pound also alludes to Revolutionary War figures, such as Benjamin Franklin, Thomas Jefferson, and John Quincy Adams, whose democratic model of government contrasted with what he saw as the corruptions of the Medici and a banking system that amounted to usury (something he thought Mussolini would work to correct).[90] His conflicted relationship with his home-land and sense of dissimilitude must have endeared him to Rosenberg. Even though passages from Eliot's "Dry Salvages" were based on his reminiscences of his childhood summers at his father's ances-tral home on Cape Ann, Massachusetts, they were too peripheral for Rosenberg, too suffused with Eliot's private life and deepened rela-tionship to the Church of England.

Rosenberg modified his praise for Pound in "French Silence" with an oblique statement that the United States could never enable a "Fascist ideology,"[91] implying that its system of government was stable. Pound would have been better off staying at home, or so Rosenberg implied, despite the antagonism to avant-garde poetry. At least, there were fewer outlets for fascism to set off his mental in-stability! It was only in the late 1950s that Rosenberg finally took a stand on Pound's bigotry and declared that he had placed "the horo-scope of Imagism on the calendar of Mussolini's March on Rome."[92] As he obliquely admitted, racism had been embedded in Pound's thinking all along.

While Rosenberg had been lenient on the "social responsibility" of poetry in 1936, knowing that poetry had been hemmed in by the Depression, in the late 1940s he had no truck with a growing formal-ist movement. Its methods seemed deluded and escapist, account-able for a conformist intellectual culture of which T. S. Eliot was an unwitting leader. Rosenberg thought that both Eliot's poetry and his

publication, *Criterion*, had inspired too many imitators in the United States. Part of his disdain was imbricated in Eliot's moral "criterion" for literature and criticism: the reasoned, middle road that spurned even liberal politics. He was left wondering why Eliot's fear of the lower classes becoming ascendant had resulted in an elite intellectual preserve to ensure the permanence of art.[93]

4
we write for the working class
the american writers' congress

a piece of propaganda

Rosenberg ended up publishing fifteen poems in *Poetry* between 1931 and 1936. Yet his reviews outnumbered his verse, suggesting that Harriet Monroe preferred his critical analysis to his creative contributions. Most of his submissions went unacknowledged by Monroe, prompting frequent inquiries as to their status. Notwithstanding these frustrations, Rosenberg's relationship with Monroe was largely cordial. Like many other poets who published in *Poetry*, he objected to her editing, but these squabbles were relatively minor. There was one skirmish that involved a request for advance payment for his work. Rosenberg needed to buy a new "overcoat"[1] for the winter. Monroe interpreted the request as an impropriety.[2] Overall, there were few altercations between them. Their politics were widely divergent, however, which was underscored in the spring of 1935 when Rosenberg lobbied Monroe to review the proceedings of the American Writers' Congress. She acquiesced, a rare concession from an editor of a nonsectarian journal, especially as the event was sponsored by the American Communist Party. In this instance, her editorial tampering became unbearable and ignited fierce differences on the meaning of the term "Marxist."

In early 1934, Rosenberg spent nearly six months working on the Mural Division of the Public Works of Art Project (PWAP), a short-lived, government-sponsored arts project that became the precursor to the Federal Art Project of the Works Progress Administration (WPA). Both were offshoots of President Franklin Delano Roosevelt's New Deal and were designed to employ artists during the

Depression. Rosenberg had not given up his studio practice and still
attended weekly life drawing classes at Greenwich House, a West
Village settlement house, where he had access not only to a model
but also to free materials. All the while, he continued to work on his
poetry and put out *The New Act* with H. R. Hays. Writing was his
real priority; the PWAP, which he took lightheartedly, represented
a source of momentary financial security. Rosenberg learned of the
PWAP through Greenwich House. He took one framed painting to
the interview and was admitted to the Mural Division, much to his
surprise. As he recounted with bluster, the interviewers, who had
been hired by the College Art Association, could easily be conned,
as they viewed the PWAP, especially the Mural Division, as a sham.
He found their understanding of contemporary art limited. When
asked by an agent, "Did you ever paint murals?" he quipped, "What
do you mean? . . . Nobody's ever painted a mural in America, in-
cluding me." He thought he was hired primarily because the inter-
viewer "could see that I knew what was going on,"[3] meaning that no
employment record or proof of proficiency was required for the job.
But it was also Rosenberg's education that was wanting: murals had
been integral to late nineteenth-century American painting, com-
missioned from artists such as John LaFarge, John Singer Sargent,
and William Hunt.

The PWAP provided Rosenberg with a paycheck—$5.50 a day—
that supplemented the income that Tabak made as a social worker at
the Home Relief Bureau. The additional funds helped, but their life-
style remained crimped by small quarters and minimal means to so-
cialize. Throughout their unending moves, Tabak remembered the
foods from their various neighborhoods: the exotic produce that
she bought from peddlers with pushcarts and stalls on the streets
on the Lower East Side, the German butchers and Irish fishmon-
gers, and the ethnic "joints"[4] where they would sometimes eat in
the evening. She felt that she and Rosenberg had been introduced
to a world of cuisines during the Depression. There were pastries,
delicacies, cheeses, and seasoned meats never served in their par-
ents' homes, which brought them closer to the foreign writers, such
as Dostoyevsky and Gide, whose imaginations they inhabited in the

evenings. After a long day of working at the Home Relief Bureau, it was possible to have a meal at their local restaurant for twenty-five cents. Stewart's Cafeteria on Sheridan Square was a favorite hangout where they encountered friends and like-minded bohemians.

For Rosenberg, who had thought working as a lawyer would impinge on his lifestyle and values, the PWAP was a different universe, populated with denizens of creative worlds for whom conventional careers were a bore. During this period, Rosenberg and Tabak (fig. 7) met numerous artists, including Alice Neel, who had signed up for the PWAP and later worked for the WPA. Rosenberg

Fig. 7. Alice Neel (1900–1984), *Portrait of May Rosenberg*, c. 1933. Pencil on paper, 9 ½ × 8 5/8 inches. Collection of Barry Sloane.

routinely visited Neel's studio, and she claimed that the painting he took to his interview was lent by her. Neel recounted, "I thought everyone had the right to live, and he was such a theorist."[5]

the role of the writer

Rosenberg adored his interactions with artists such as Arshile Gorky and David Smith on the PWAP, but recalled that his assignments yielded little actual painting. The sketches that he drew for murals "ran into trouble because they didn't like how they were being executed."[6] He had few painting skills, after all. By the time he moved over to the WPA in 1935 and worked with Lee Krasner and Max Spivak, his output on the project was negligible. Harry Holtzman, the assistant supervisor of the Mural Division, decided to make him Willem de Kooning's assistant rather than toss him off the project. Holtzman knew that Rosenberg was more interested in writing than in executing designs for the government and that de Kooning would balk at enforced help. De Kooning's requirement for isolation and the opportunity to work full time on his painting surmounted interest in teamwork. He told Holtzman, "I don't want anybody hanging around my studio."[7] A compromise was made, and as Rosenberg remembered, "Harry, who was always looking around for the boys, said [to de Kooning], well, why don't you make Harold your assistant because he's a writer anyway and he probably would rather sit at home and write than paint. So he can be your assistant and you meet him in the Jumble Shop."[8] In the end, Rosenberg stayed in his apartment to write, while drawing a salary. He met de Kooning infrequently at either a downtown restaurant, such as the Jumble Shop, a favorite haunt of artists on Waverly Place, or at his home in the Village. The two men were a study in contrasts, what with de Kooning's blond, youthful good looks, athletic frame, and abundant charm, and Rosenberg a lumbering, dark goliath with little knack for diplomacy. But they became fast friends, and de Kooning would later embody the concept of *action* Rosenberg set forth in "The American Action Painters."

Rosenberg was eventually reassigned to the Federal Writers' Project, where he was commissioned by Henry Alsberg, the national director, to work on *American Stuff: An Anthology of Prose and Verse*. A better fit, to be sure, but during the time he worked on the PWAP, he wrote to Harriet Monroe that he had completed an article on the *"social situation of poetry"* that asked whether "the reading and recitation of poetry [is] a significant social ritual? At least as significant as a Sunday afternoon visit to an art-gallery?"[9] The article was never published in *Poetry*, and has disappeared, but Rosenberg had evidently gleaned a deep sense of contemporary art by working on the PWAP. As he told Monroe, "during the past months, great movements have been begun to plant painting firmly in the life of the people; and this brings into sharp outline the peer place of poetry."[10]

His sketches may not have resulted in murals, but they were exhibited at the Municipal Arts Gallery and Center along with work by his confreres. The opening drew a huge crowd of five thousand people, as well as the mayor of New York, Fiorello LaGuardia. The spectacle reinforced to Rosenberg that painting was socially relevant, that it was time, moreover, for poetry to reclaim such power. Yet after the PWAP, he never pursued painting again, aware of his deficits as an artist. While his drawings from this period were never kept,[11] casualties of a transient life, he did become involved in what he described as "the role of the writer in the social movement."[12]

the american writers' congress

By the time Rosenberg wrote his report on the American Writers' Congress for the July 1935 issue of *Poetry*, he had already made Lenin his "hero."[13] Although his allegiance to Marxism never resulted in political commitment, he was strenuously opposed to the inequities of capitalism. The American Writers' Congress grew from a call published in the *New Masses* to create a League of American Writers and took place in late April 1935 over three days at Mecca Temple, a Masonic Hall, and the New School for Social Research. The *New*

Masses was a weekly publication founded in 1926 by liberals and radical leftists. Its coverage extended beyond politics to cultural and social issues, as well as to satire and criticism, and it featured copious illustrations, caricatures, and cartoons by artists such as Stuart Davis, Alfred Dehn, Wanda Gag, William Gropper, Louis Lozowick, Jan Matulka, Ad Reinhardt, and Louis Ribak.[14] When Michael Gold became its chief editor two years later, it quickly emerged as a rival to the *Daily Worker*, an organ of the American Communist Party. Gold was keenly aware of his competition and imposed his own proletarian interests on the *New Masses* by eschewing the balance of modernist and social realist literature and art that had once unified its contents. As a member of the Communist Party, he made the predicament of the worker and class oppression an overarching editorial thread. His socialist interests were so pronounced that the John Reed Club launched the *Partisan Review* in 1934 to mollify modernist writers aligned with the Communist Party who felt Gold's magazine had become too doctrinaire.

By January 1935, many contributors to the *New Masses* were concerned with the rise of fascism abroad, as well as widespread poverty brought on by the Depression, and had become members of the Communist Party. Among them were Nelson Algren, Erskine Caldwell, Jack Conroy, Malcolm Cowley, Theodore Dreiser, James T. Farrell, Joseph Freeman, Langston Hughes, Alan Trachtenberg, Nathanael West, and Richard Wright. They signed a petition authored by Granville Hicks, an editor of the publication, to press for a professional organization that could provide them with not only a collective voice but an affiliation with the International Union of Revolutionary Writers. Its call to arms was based on the

fight against imperialist war and fascism; defend the Soviet Union against capitalist aggression; for the development and strengthening of the revolutionary labor movement; against white chauvinism (against all forms of Negro discrimination or persecution) and against the persecution of minority groups and of the foreign-born; solidarity with colonial people in their struggles for freedom; against the influence of bourgeois ideas in Ameri-

can liberalism; against the imprisonment of revolutionary writers and artists, as well as other class-war prisoners throughout the world.[15]

The League of American Writers was founded on the first day of the Writers' Congress. Waldo Frank was appointed its chairman, described by his nominators as "the symbolic leader of the new era."[16] Outside of Kenneth Burke, Frank was the only figure on the Executive Committee who was not a member of the Communist Party and who maintained his distance as a fellow traveler (someone sympathetic to the ideals of communism but unaffiliated with the party). Frank was an odd emblem for the league—a writer who got his start in the mid-1910s as a novelist and who reviewed exhibitions of artists associated with Alfred Stieglitz's circle. He became radicalized nearly a decade later though melding his interests in Freud and American transcendentalism with fervor for social revolution. Frank had traveled to the Soviet Union in the early 1930s where he found a "whole humanity,"[17] as he dubbed Stalin's enactment of Marxism, seemingly oblivious to the dictator's brutality.

While the Communist Party succeeded in dominating the League of American Writers, it needed a titular head such as Frank (who would be ousted by 1940) to follow orders from Stalin to implement a worldwide popular front of liberal and left-leaning groups (which the party had overlooked). Through expanding its base of members, and popularizing the communist cause, Roosevelt's New Deal became a target, largely because its programs proved easy to infiltrate. Diana Trilling, who was a fellow traveler in the early 1930s along with her husband, Lionel, remembered the party's ability to prey on unsuspecting leftists: "All the magazines, the artists, the musicians, the clergy, the schoolteachers, students, all were organized by the Communist Party, and the Communist Party had a ready field from which to pick people. The whole culture, the whole intellectual culture . . . they had this incredible power to propagandize."[18]

In his review of the Writers' Congress for *Poetry*, Rosenberg observed that the first day of sessions attracted more than four thousand people, two hundred of whom were writers, which underscored

a "recognition of the unbreakable connection existing between the course and the fate of culture and the art of writing, and the course of and fate of society." He was divided as to whether any consensus obtained on "what exactly is the role of the writer in the social movement, and what was his best method of performance?" "All of the speeches at the Congress were directed towards this point," he reported, "Earl Browder [a writer and the Secretary of the American Communist Party], advocated repudiation of the common left-wing notion, that by calling oneself a 'Marxist' one can be converted automatically into a literary genius. Revolutionary art, he maintained, can succeed only through achieving superiority as art, not through politics."[19]

Rosenberg attempted to be neutral in his coverage of the congress, knowing that *Poetry* was an independent magazine. However, he was aghast to see, when his piece appeared, that Monroe had tagged on an editor's note calling attention to the oppression of writers in communist countries. He bristled at the addendum and wrote to her as soon as he received his copy that "in strange contrast to the character of the report itself, [it] leaps forth as a piece of propaganda, directed against the Soviet Union . . . all of which creates a distortion."[20] He clearly felt that Monroe's disclaimer had sullied his account of the congress. The suppression of the writer's voice in totalitarian regimes was not a topic that was addressed at the event. He demanded that his letter be published in a subsequent issue of the journal. Monroe declined to print his rebuttal, apprising him that "August is in press, and controversies pursued too long are tiresome."[21] He persisted, writing that he was not assuaged by her "soft answer."[22] She had violated his text. But Monroe had also deleted a key sentence in Rosenberg's article where he identified Earl Browder as the secretary of the Communist Party.[23] She deemed mention of his political affiliation was extraneous, even though the party had sponsored the congress.

Rosenberg was undone by Monroe's fiddling, feeling that the omission of Browder's status, along with the insertion of her editor's note, constituted "a propagandist act."[24] He pushed again for an airing of their differences in *Poetry*. Whatever the magnanimity

of her "open-door policy," it did not extend to politics. She would not relent. Rosenberg's conviction that poetry was affected by social circumstances and events, such as the American Writers' Congress, was not to be discussed in *Poetry*, at least not during her lifetime. Monroe considered writing a private act: her journal was to be regarded as a preserve for its sanctity. During the Depression, *Poetry* had been berated, as Monroe wrote in a 1934 editorial, "as decadent in language almost *unprintable*."[25] She considered that her concession to cover the Writers' Congress was generous, and that Rosenberg would handle the conference with propriety.

Rosenberg hoped that their tiff would not disturb his relationship with *Poetry*. But he also issued Monroe an ultimatum: he demanded deference when it came to politics in future submissions. As he wrote to her, he had "very little expectation that political propaganda will be given a place in my contributions." Further, he "should therefore like to feel that a keen sense of responsibility will exist on both our parts with respect to any occasions when a political question might arise."[26] Political propaganda? With her minimal editing, Monroe had not significantly altered the gist of his piece or skewed its meaning. Rather, she had exercised her editorial prerogative and responded to provocation from the *New Masses*, which had initiated the Writers' Congress. Unlike Rosenberg, she sensed that the Communist Party had a hidden agenda to control the newly established League of American Writers. And she was right. Rosenberg's indignation at her excisions and tag-on were overblown, a reflex of his wounded ego.

Monroe died the following year, and was briefly succeeded as editor by Morton Dauwen Zabel. Rosenberg's altercation with Monroe did not affect his association with Zabel, who entertained the possibility of Rosenberg covering the second American Writers' Congress in 1937 if a "tentative agreement"[27] with another writer fell through. Rosenberg informed Zabel that "it would be a good idea to have such a comparative report"[28] so that he could outline the contrasts between the two proceedings. He no doubt wanted to set the record straight and correct Monroe's insertions. Zabel stuck with his earlier plan and published a brief summation by David

Schubert,[29] a young poet, who steered clear of the intensified discussion on proletarian literature at the gathering. Rosenberg was rattled by the focused agenda of the second congress, as were writers such as William Phillips and Philip Rahv, who were about to launch their reconceived *Partisan Review* after wrestling with the Communist Party, which had continued to sponsor the journal after the demise of the John Reed Club in 1935.[30]

Unlike Monroe, Zabel was not alienated by the insistent tone of Rosenberg's letters and published several of his reviews until 1938, when he stepped down and George Dillon took over as editor. However, the disagreement between Monroe and Rosenberg over the first American Writers' Congress touched on a land mine of unresolved controversy. There had been overt friction at the meeting relating to the expansion of communism nationally, its so-called "groupthink," and the populist tone that Rosenberg's temperate narrative glossed over. He had written that "no red uniforms were donned"[31] at the proceedings, but some of his friends had contrary experiences. Kenneth Burke, who was a speaker at the congress, felt personally attacked by Joseph Freeman, a poet, trade unionist, and one of the founders and editors of the *New Masses*, as well as by others from the floor.[32] Despite Browder's belief that the writers' voice could be preserved within a communist collective, Burke felt that literature was fast becoming prescriptive in the hands of the Communist Party, too centered on the worker.

Burke, who had been radicalized after the stock market crash of 1929, was a vocal opponent of capitalism but averse to Mike Gold's rhetoric of proletarian struggle.[33] In his paper entitled "Revolutionary Symbolism in America," he announced that words such as "masses," "workers," and "proletarians," amounted to a type of "propaganda," the term that Rosenberg had hurled at Harriet Monroe. They failed to adequately incorporate his own economic class, the "petty bourgeois."[34] Instead, Burke proposed the word "people" as a substitute, which he thought was "richer as a symbol of allegiance"[35] with the writer. To some members of the panel, such as Freeman, Allen Porter,[36] and Frederic Wolf, an émigré playwright from Germany, his substitution smacked of Adolf Hitler's "das Volk" and was

freighted with fascistic overtones. Burke was ultimately written off as an elitist. His tackling of their nomenclature was evidently lost on the trio. Burke always remembered the violence of their outburst, exclaiming: "Joe Freeman gets up, throbbing like a locomotive and shouts, 'We have a snob among us!' Then Mike Gold followed, and put the steamroller on me . . . And so, and so on—until I was slain, slaughtered."[37]

Burke was understandably alienated and wounded by the event.[38] His remarks had amounted to a scandal that was widely discussed beyond the conference, even though he was subsequently appointed to the executive committee of the League of American Writers. As he conveyed to Rosenberg, he was never able to overcome the trauma of the heckling from the audience and the nightmare that his "own name had become a curse word. I'd wake up and finally, my god, just this side of an absolute hallucination: my tongue . . . shit dripping from my tongue. Horrible."[39] However, he made only a passing reference to his entanglement with the "Party's most demonic orators" in his review of the congress in *The Nation*, where he observed "that all of these writers must somehow enlist themselves in a cultural struggle: that however meager their individual contributions may be, their work must be formed with relation to historic necessities."[40] Like Rosenberg, Burke never became a member of the Communist Party, disillusioned by its bureaucratic approach to literature and distrust of rhetorical devices, such as irony and paradox, that detracted from the advancement of socialism and the worker.

Burke was not the only writer put off by the American Writers' Congress. Richard Wright, who had traveled from Chicago as an official delegate, and who later wrote an article for the *Atlantic Monthly* called "I Tried to Be a Communist,"[41] also recalled the ideological bent of the sessions.[42] Six months before the gathering, Wright had been let down by the Communist Party's decision to dissolve the John Reed Club. As a result, he lobbied for the formation of the league, hoping it would squelch regional dissidence and ensure the broader goals of the Popular Front. Although Wright had been frustrated by the club's requirement for absolute loyalty to the party, he had become executive secretary of the Chicago chapter in

1933, and subsequently served on the editorial board of its journal, *Left Front*.

As Wright put it in *American Hunger*, the second installment of his autobiography, "the Club was my first contact with the modern world. I had lived so utterly isolated a life that the Club filled for me a need that could not be imagined by the white members who were becoming disgusted with it, whose normal living had given them what I was so desperately trying to get."[43] For many writers outside of New York, particularly African Americans, the John Reed Club became a means to move beyond literary and economic ghettos, a place to congregate with other poets and novelists, and a place where racism was not tolerated, at least not in the Chicago chapter.[44] He considered making the dissolution of the club the focus of his talk at the congress. But after casting the sole vote for its continuation, the loneliness that he felt as a writer became his topic.[45]

Although Wright had joined the CP, his idea of revolutionary literature was at odds with the party. He sided with modernists, such as Rosenberg and Burke, both of whom he knew. Like Rosenberg, he later became a vocal opponent of communism's disdain of "intellectuals, anybody who tried to think for himself."[46] His paper, which emphasized "human results," was not nearly as charged as Burke's recommendation to revise communist semantics. But unlike Rosenberg's sanguine account of the congress in *Poetry*, there had been significant fallout and division, after all. Rosenberg had confined his comments to the first day of the sessions, primarily because they were open to the public, whereas Burke's and Wright's presentations were available only to delegates, guests, and members of the press. Still, he was more attracted to Browder's message that "the first demand of the Party upon writer-members is that they shall be good writers, constantly better writers, for only so can they really serve the Party."[47] It was worth wrangling with Monroe to distill how Marx could have a place in experimental literature.

Toward the end of his life, Kenneth Burke acknowledged that Rosenberg had helped him come to terms with the American Communist Party's manipulation of the Writers' Congress and Stalin's behind-the-scenes Machiavellian workings. He disclosed that his

"whole devotion to Harold Rosenberg stems from that time on. He turned up when I was lost. He thought it was funny! He took me down to a bunch of super, of sub, sub-splinters of a splinter group. To take me into reality. On the basis of it, I saw so damn much about the psychology of the trials [of Soviet intellectuals in 1936–38] . . . I didn't believe the goddam charge against Stalin at the time. I really didn't. I thought the guy was straight."[48] Rosenberg may have conveyed to Burke that he considered the Writers' Congress to be "funny," yet his own involvement with the Communist Party in New York did not amount to comedy.[49] Unlike Burke's incredulity, Rosenberg was not naïve about Stalin. Outside of the neutral tone of his report in *Poetry*, he was known to publicly sneer at the party while upholding his position as a nonaligned Marxist.

one of the boys

Shortly after the first Writers' Congress convened, Ibram Lassaw, a sculptor who met Rosenberg on the WPA in August 1935, recalled an incident in Max Spivak's studio when Rosenberg regaled them with a particularly incendiary text by Stalin. While they worked on a mural, Rosenberg sat in an armchair reading, exclaiming, *"Did you ever hear anything so stupid?!"*[50] (Spivak was a mosaic artist who worked in the Mural Division from 1935 to 1943, the entire duration of the project.)[51] Rosenberg's antipathy to Stalin was welcomed by most modernist artists on the project, especially those of the Mural Division, which represented a stronghold of resistance to the Communist Party, unlike the Easel Division, which was pervaded by Stalinist sympathizers with the notable exceptions of Mark Rothko, Ilya Bolotowsky, and Balcomb Greene.[52] He became admired for his independence and freewheeling pronouncements on the inane aspects of fascist leadership, as well as for his ability to spin vanity and power-mongering into caricature. As Lassaw remembered, "he was looked up to by all the Trotskyites."[53] That Rosenberg drew a paycheck without painting incurred no enmity from the artists. Lassaw added, "We didn't care. We knew he was a writer and respected his opinions."[54] Through his pontifications against communism in the

studios at the WPA, and in the city's parks, friends' apartments, and neighborhood bars, Rosenberg became thought of as "one of the boys."[55] They did not have the "dough"[56] to buy a beer at the Jumble Shop—only established artists such as Stuart Davis could afford its liquor—and sought cheaper watering holes, but their talk stretched beyond the confines of the Mural Division, such was its zeal.

Rosenberg identified as a "poet, critic, and painter of murals"[57] long after he had moved over to the Federal Writers' Project, even though his output as an artist had been negligible. However, Lassaw's portrayal of Rosenberg as kin did not extend to Clement Greenberg, with whom Rosenberg also socialized in the Village. Greenberg did not work on the WPA, but he had landed jobs at various federal government agencies, including the Veterans Administration and the Customs Service of the Port of New York.[58] His dealings with artists were more patriarchal and guarded, and rarely gave rise to the camaraderie that grew from Rosenberg's uninhibited conversations.

Rosenberg's ramblings on Stalin engendered trust during a period when the Communist Party induced trepidation in many leftist thinkers who had witnessed similar taunting to what Kenneth Burke had endured at the American Writers' Congress. Spivak and Lee Krasner, for example, were targeted as "Trotskyites" at the meetings of the Artists' Union of New York, an offshoot of the John Reed Club. Even though Spivak joined the party, he soon learned, like Krasner, that it would not countenance ideological difference.[59] Rosenberg brazenly acted on any opportunity to question the tactics of the CP, especially during the era of the Popular Front. He became part of a small preserve of Marxists linked to the WPA, such as Stuart Davis, James Brooks, Gorky, Gottlieb, Holtzman, Lassaw, Krasner, and Spivak, all of whom had Trotskyite leanings and countered the antimodernist position of the party. Krasner recalled that Rosenberg was a "central figure"[60] in their professional lives, responsible for providing them with a sense of political unity.

Around 1936, Rosenberg also met Barnett Newman, who worked as a substitute schoolteacher, teaching art, during the Depression. Newman was a Marxist who had run as a write-in candidate for

mayor of New York City on an anticommunist platform three years earlier. His primary pitch was "the Need for Political Action By Men of Culture." After he lost to LaGuardia, he began a lifelong conversation with Rosenberg that pivoted on art and politics. Annalee, his wife, recounted, "Harold and Barnett talked a lot. Both of them were great talkers. Barnett would say, 'Well, I met Harold. We disagreed a lot but what a lot of action!'"[61] Newman had used the word *action* in a manifesto for his mayoral campaign, as a synonym for political change. The trope was widely used throughout the Depression. (Mark Rothko also deployed *action* as a title to an unpublished essay in 1940, underscoring its prevalent usage.)[62] Unlike many of the artists on the WPA who imbibed Rosenberg's monologues on Stalin, Newman was an intellectual match for Rosenberg who admitted that for Newman "verbal conflict was neither distasteful . . . nor beyond his capacities."[63]

De Kooning could also compete with Rosenberg in exchanges on writers such as Søren Kierkegaard, a subject of mutual enthusiasm, but he had little interest in politics.[64] He absorbed the spectacle of the communist and socialist rallies, public protests, and strikes, passively from the streets surrounding his studio on Union Square, where political life was situated in New York during the mid-1930s. His one concession was to build floats for the annual May Day parades.[65] Like most artists of the Mural Division, de Kooning was taken by Rosenberg's agile intellect and garrulous manner — although he periodically complained that Rosenberg's preoccupation with Marx was obsessive. Rosenberg countered that "Bill would always accuse me of being too political. Even though I wasn't talking about politics at all, he'd always say, well, you're too political."[66] What was he talking about, then? Rosenberg's interest in Marx was disabused of class *action*: change was the territory of the individual. Still, the events of the Depression weighed on his understanding of the social marginalization of the artist and writer, as they did for Barnett Newman.

By the fall of 1936, Stalin's debasement of Marxism had become profoundly disturbing to Rosenberg, just as it had for writers such as Phillips and Rahv at the *Partisan Review*: it implicated their idealism.

He had described in *The New Act* how "the best literature, wherever it arises, will be known by its successes in . . . terms of irony through and within class-struggles and in spite of them."[67] But the revelation of the Moscow Trials in the American press was for Rosenberg the first of a series of Soviet perpetrations that divided him and the Communist Party, enabling his declaration that Stalin was "stupid." James Farrell, the author of *Studs Lonigan*, whom Rosenberg met at a party in New York at the time of the Moscow Trials, noted in his diary that Rosenberg "referred to the Communist Party as having become a job hunting and a job finding agency. He said that the Party had more influence in the WPA here than Tammany Hall."[68] The same year, Rosenberg recounted to Lassaw that he was disillusioned by the setbacks to the resistance movement in Spain and subsequently eulogized the events that led to the civil war in a poem, "Spanish Epitaph." As the American Communist Party rejected modernist experimentation for social realism, Rosenberg was forced into an intellectual quandary. He pondered how he could tether Marx to the radical properties of vanguard poetry by upending its cadences and architecture. Humanism, he told Farrell in September 1936, was no longer a viable literary proposition. Its advocates had become "champions of ignorance,"[69] academics who denied the connections of art to a wider culture.

we write for the working class

Most of Rosenberg's friends on the WPA, as well as Barnett Newman, were either nonaligned Marxists or Trotsky sympathizers. Yet it took Rosenberg more than a decade to convince Kenneth Burke that the American Communist Party was a bureaucracy mired in corruption. Publicly, its agenda was to establish a Popular Front through a coalition of workers, independent leftists, and progressive liberals who opposed fascism. But its ultimate goal was to infiltrate Roosevelt's New Deal. Burke may have been injured by the jeering at the Writers' Congress, but it did not immediately change his view of Stalin. He continued to presume the dictator was "straight" even after the Moscow Trials were reported in the mass media. Contrary to

his memory of an epiphany after Rosenberg's rescue, Burke treated Stalin with equanimity in his two-volume book, *Attitudes toward History*, where he announced that "Stalin and the people are synonymous . . . the tendency to such identification . . . is in itself profoundly human."[70]

Rosenberg impugned Burke's description, asking, "What's the idea of writing a defense of the Stalinist trials!"[71] He had already taken Burke to task for "placing too much emphasis on the magical power of attractive words,"[72] following a heated conversation on Hitler's political grandiloquence and its tie-ins with his psychology.[73] Burke had not mentioned the persecution of Russian intellectuals in *Attitudes toward History*, but Sidney Hook, who had just taken up an appointment in the philosophy department at New York University, openly questioned in the *Partisan Review* his role as an "apologist . . . [for] the latest piece of Stalinist brutality."[74] An exchange of letters subsequently took place in the journal, in which Burke declared his "sympathy with the momentous tasks confronting the USSR and admiration for the magnitude of it attainments."[75]

Burke never retracted his appreciation for contemporary Russian society until long after the Nazi-Soviet Non-Aggression Pact had been negotiated in 1939. By then, *Attitudes toward History* had become part of his long string of defenses of Stalin.[76] When he reviewed Henri Barbusse's biography of Stalin for the *Book Union Bulletin*, a monthly journal sponsored by the League of American Writers, he lauded "Soviet success [as] . . . the one country in the world blessed with an economic system rational enough for a national surplus to be a national asset to date."[77] These encomiums added to Rosenberg's and Hook's cumulative ire. After Rosenberg continued to press him on Stalin, Burke flippantly conceded, "All of the other explanations were so stupid and unconvincing; I was only trying to present a more credible story."[78]

Burke probably felt coerced by the League of American Writers, which had been penetrated by a small but dominant group of figures affiliated with the CP. He affirmed much later, "I didn't want to do anything in any way that would be considered wrong. I had a terrific desire to belong . . . you know, 'togetherness.'"[79] One of

his closest friends, Malcolm Cowley, who was an editor at the *New Republic* and a member of the party, construed the CP's attacks on Burke as an expression of solidarity. He remembered that Burke's "dream of fellowship was shattered" after the first congress, that he was "innocent at the time, unused to speaking before an audience, especially one with strong political convictions."[80] Still, the crushing experience did not alter his toeing the line on Stalin until the onset of World War II. Burke announced after the 1935 congress, "I take religion and Communism to be alike insofar as both are systems for binding people together—and the main difference at the present time resides in the fact that the Communistic vocabulary does the binding job much more accurately than the religious vocabulary."[81]

Unlike Burke's delayed reaction, Cowley believed that Burke's speech at the congress had been "more daring than he recognized ... He was exposing himself as a premature adherent of the People's Front."[82] (The term "People's Front" was used interchangeably with Popular Front until the red scares and the McCarthy hearings eviscerated the American Communist Party in the early 1950s.) Cowley was right when it came to Burke's gravitation to the Popular Front. However, like Rosenberg's, his relationship to Marxism was complicated by the recognition that his aesthetic interests could never be reconciled within a social collective.[83] The difference was that Burke could move more fluidly than Rosenberg in a circle of writers that included Gold, Freeman, Hicks, and Trachtenberg. He even wrote for the *New Masses* on a few occasions. His writing was not solipsistic, which was preferable to the editors of that publication.

Rosenberg also wrote four reviews for the *New Masses* in 1937. In "What We Demand," a twist on the catchwords on the placards carried by the trade-unionists, nonaligned socialists, antifascists, antilynching groups, and communists in and around Union Square, he continued to link Marx to contemporary writing: "At the least we demand from literature that it equal the best political and historical writings of our time in the consciousness of its own subject matter."[84] But he gave up on the *New Masses*, estranged by its endorsement of Stalin, who had executed his political opponents, including

most surviving members of Lenin's politburo, as well as members of the Red Army. Moreover, in an editorial that ran in early 1937, Mike Gold not only corroborated that the Moscow Trials were under way but deemed them necessary to move the Soviet regime beyond the utopianism of Lenin and Trotsky.[85]

In the years that led up to the Dewey Commission—an independent investigation chaired by John Dewey in March 1937 for the American Committee for the Defense of Leon Trotsky, who sought refuge in Mexico—Rosenberg attended at least one May Day parade, as well as labor strikes and demonstrations in Union Square that were orchestrated by the Communist Party. His participation suggested that he retained an open mind on the question of whether modernist movements could be perpetuated within the American Communist Party, at least in the early stages of the Popular Front (which peaked around 1937).[86] He had hoped Earl Browder's pronouncement at the first Writers' Congress that "revolutionary art would achieve its superiority as art and not as politics" would influence the course of writing. In his report for *Poetry*, Rosenberg had noted the absence of sloganeering at both the congress and the May Day parade that followed. He felt continuity between the events was established by "Edwin Markham [the poet and labor activist who] stood on the reviewing stand at Union Square and spoke into the loud speakers his greetings for the May Day marchers. In the same way, though the Congress turned its face towards the left, it donned no red uniform."[87]

But sloganeering there was. Norman Podhoretz, who later wrote for *Commentary*, and who knew Rosenberg from the mid-1930s, remembered seeing both Rosenberg and Burke at the May Day parade:

Kenneth Burke . . . was marching through Union Square in downtown New York in a May Day parade sponsored by the Communist Party. A fierce little man, Burke was calling attention to himself by energetically waving a placard, both sides of which bore the inscription WE WRITE FOR THE WORKERS. Another critic, Harold Rosenberg, towering in his great height over the dense crowd lining the parade route, spotted Burke and his placard.

"Kenneth," the anti-Stalinist Rosenberg yelled with all the sarcasm he could get into his voice, "you write for the workers?" To which Burke yelled back, "It's an ambiguity in the preposition *for*!"[88]

Rosenberg was at the parade not as a bystander, as Podhoretz wrote, but marching and shouting along with Burke, William Phillips, Philip Rahv, Richard Wright, and other writers who had lingered in New York after the congress, as well as with artists such as Stuart Davis, Alice Neel, and John Graham. May Natalie Tabak recalled that she and Rosenberg were caught up in the euphoria of the parade: they "were all bellowing WE WRITE FOR THE WORKING CLASS!"[89]

Tabak also remembered that at one point, after marching for eight blocks or so, Rosenberg regained his sense of clarity and turned to Burke to ask, "Do we *really* write for the working class?" Burke replied, "I've been wondering about that myself. Of course it could be said that we write *in behalf of* the working class, wouldn't you agree?"[90] The response underscored Burke's ambivalence about how his middle-class background could be reconciled with the labor movement. He recognized, "That's precisely what they got after me for: I said I couldn't write for the working class. That was the irony of the case."[91] William Phillips, who retained an image of Burke festooned with his placard in the procession, was also struck by the incongruity of Burke's identification with the proletariat and asked him: "I remember your joining in the shout, 'We write for the working class,' and I remember wondering whether Kenneth Burke really thought that he wrote for the working class. How many workers read Kenneth Burke?"[92]

Burke's participation in the parade represented a form of "symbolic action," as he called it: a declaration of unity with a social movement whose revolutionary dimensions were equated with the traits of modernist art and writing. Rosenberg's own public alliance with the protesters was more conflicted, never prolonged like Burke's alleged fraternity. He frequently wondered, as he wrote to Burke in

January 1936, "Why do we say the worker is enslaved under capital-
ism and free under communism?"[93] These questions belied skepti-
cism that intensified six months later, hardened by his recognition
that affiliation with the CP was untenable after the news of Stalin's
purge of Soviet dissidents and the party's collaboration with the
fascists in Spain. Rosenberg had always harbored contempt for the
party, believing its leadership and most of its members were "dum-
mies,"[94] incapable of independent thinking. However, for a brief two
years, he thought that the crisis of capitalism, which had resulted
in massive unemployment, factory shutdowns, and food shortages,
had provided communism with a viable shot in the United States. It
was not all propaganda. Some of its economic programs might have
been workable, especially if the self-determination of the writer was
permitted.

In contrast to his palaver on Soviet Marxism, Rosenberg had seen
through Hitler's regime from the beginning. He told Burke that Nazi
Germany represented "a defeat of the Commune, a retrogression, an
anti-climax, a reversal of the situation."[95] Although the Führer en-
tered Rosenberg's diatribes and conversation, and popped up occa-
sionally in his correspondence, reviews, and poetry, he failed to hold
Rosenberg's interest—at least until after the occupation of Paris in
1940, and once the enormity of the Final Solution was known. His
response was typical of many intellectuals who lived in New York
during the war. Hitler's concept of National Socialism did not draw
from a close reading of Marx. During the Depression, Rosenberg
concentrated more on the distortions of Marx's key texts such as
Capital and *The Communist Manifesto*. Hence, his focus on Stalin.
As he saw it, Hitler had harbored an "enmity towards the intellect"
and was a "mediocre artist."[96] But he was not nearly as mindless
as the subjugated members of the Nazi Party, whom Rosenberg
thought demonstrated little capacity for *action* by willingly imple-
menting their leader's anti-Semitism and violence. He was aware
of Hitler's racism, and of his campaign to rid Germany of the Jews,
dissident artists, academics, scientists, and engineers. He also had
a clear sense of Hitler's "shamelessness."[97] But these denunciations

were peripheral until after the war, built into larger discussions such as the "obstacles to individual freedom"[98] in totalitarian states and the defeat of Paris as the epicenter of modernism.

the men on the wall

Rosenberg's view of Hitler was largely informed by the writings of Leon Trotsky. Although exiled by Stalin from the Soviet Union in 1929, Trotsky remained a keen observer of the foibles of the Comintern, or Third International. He observed that the German Communist Party (KDP) was so dominated by Stalin that it could not achieve alliance with the Social Democratic Party. The drawback eventually empowered Hitler and ensured his victory in 1933. Trotsky's pamphlet, "Germany, What Next?" was crucial for Rosenberg's understanding that "Hitler would get in and that he would smash the whole Social Democratic as well as the Communist structure and institute this kind of terrible dictatorship."[99] In Rosenberg's retelling, it was Stalin who loomed over the rise of German fascism, what with KDP doctrine indifferent to the revolutionary politics displaced by the Weimar Republic. Although Rosenberg knew that the Nazi government was an aberration, dependent upon rehabilitation of the German middle class, he told Kenneth Burke that "Hitler is bound to be overcome."[100] His prophecy was washed in optimism and belief that some iteration of the Commune would result in Hitler's demise.

Rosenberg probably marched with Tabak again in the May Day parade in 1936, along with Burke and other friends from the Village, much to the disbelief of a former neighbor, Jean Pucelle, a writer and socialist who had just returned from spending four years in Paris. She recalled, "There was Harold Rosenberg marching along," which astonished her, "because these were all esthetes . . . who had turned their back on social problems."[101] Before Pucelle left New York in 1932, Rosenberg had flirted with Surrealism, as his stories in *transition* and *Blues* attest. In the interim, he had engaged with Marx, and the theater became an analogy for the drama of hu-

man existence. These interests had merged to fit the imagination into political life, with Rosenberg no longer convinced of their separateness.

During this period, Rosenberg reviewed a variety of books for both *Poetry* and *Partisan Review*. They included Muriel Rukeyser's first volume of verse, which he thought had "a will to warm itself against the major human situations of our day,"[102] as well as Granville Hicks's biography of John Reed, which he praised as a "persuasive study," albeit one that fell short on a "Marxian analysis of the ideological background of Reed's motives."[103] Additionally, he wrote poems that aggrandized the working class. However, his imagery frequently capitulated to the same stereotypes that he thought set back social realist literature and painting. "The Men on the Wall," which was published in *Poetry* in 1934, reworked the ubiquitous trope of a clenched fist used in illustrations and posters from the time of the October Revolution:

A raised arm has many meanings.
Convictions falter with desire; the arm remains.

You have seen a sword
in the hand of the arm
flower from a sleeve of gold brocade . . .

. . . and that arm's fist,
whose khaki cuff is stained with grease,
is yours, and clasps the hammer of your old resolve
And whose contending tendons flex with threat
against the background factories and glass?
A raised arm has many meanings.[104]

Similarly, "1776," which appeared in the May issue of *Poetry*, just as the annual labor parades took place internationally, merged the American Revolution, the Siege of Paris, and the Bolshevik Revolution into one overloaded *crise d'esprit* for the proletariat:

1776
stands in their throats,
like iron it'll
choke them.

Nothing to
sneak back to —
no king
like Greece,

no tyrant
like Germany,
nothing
but a People's

Revolution . . .

between their
jaws, turning
hot again.
It's all

red
with the sparks of
the Commune,

with the fire
of October.[105]

In 1936, after his verse had appeared in *Blues, Pagany, Poetry,* and the *Partisan Review,* William Phillips and Philip Rahv, the editors of the *Partisan Review,* characterized Rosenberg as part of a younger generation of poets—he was still only thirty—committed to "revolt within the tradition of poetry rather against it."[106] The accolade was a statement more of their own growing modernist tilt than of Rosenberg's aesthetic preferences. Both editors had increasingly

prized contemporary literature that suffused politics within inventive forms. That equilibrium changed when *Partisan Review* was relaunched in late 1937. After concurrent waves of fascism in Europe, refinement to the languages of poetry seemed paradoxically more at stake, and figures such as T. S. Eliot became their mainstay.

5
you would have to be recluse to stay out of it
art front

we put out the magazine, they are a bunch of dummies!

Rosenberg never became a fellow traveler, let alone a member of the Communist Party, whatever his disposition toward Socialism.[1] His prevarications about communism during the Depression inhibited a commitment to the CPUSA. For every affirmation of revolution that appears in his verse, there exist contrasting themes that related to love, consciousness, and subjectivity. In December 1935, Rosenberg was appointed to the editorial board of *Art Front* (fig. 8), a publication launched jointly by the Artists' Union and the Artists Committee of Action, just as the Popular Front began to gain strength through its bloc of industrial unions, protest groups, and community activists. He wrote his first critical pieces on art for the periodical, while becoming immersed in public battles with some of the union's fiercest communist members, all of which he waged with insouciance, just as he had jocularly handled Stalin in Max Spivak's studio.

His first piece for *Art Front* was a satire on the incarceration of eighty artists and educators who had protested wage and benefit cuts by the WPA. He described not only the "circus-element in the arrest . . . [but] the memory of the wall of the 54th Street Jail decorated with rear-views of jackasses, labelled with the names of prominent personages," all of which enhanced the picketers' social understanding of municipal architecture. It was "not with murals alone that the interiors of some public buildings are decorated." Although he sided with the agitators, and described the police as "grotesque," the levity and farce that pervaded his report deviated from

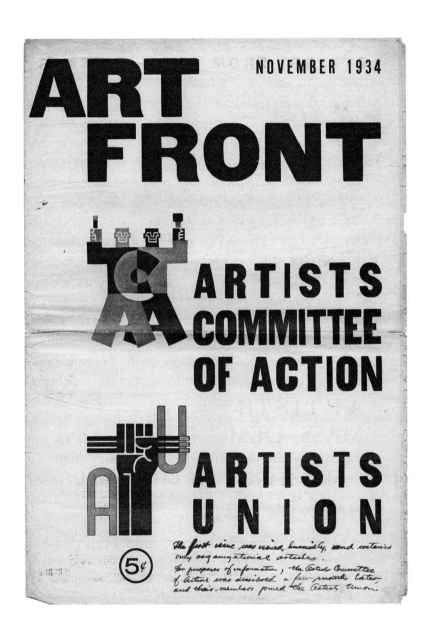

Fig. 8. Cover of *Art Front*, November 1934. Harry Gottlieb Papers, Archives of American Art, Smithsonian Institution.

the mirthless realism of the writing by members of the party in the same issue.[2]

After its first two issues, *Art Front* severed ties with the Artists Committee of Action and became the property of the Artists' Union.[3] It strayed, however, from the predominantly communist politics of its new sponsor. With Stuart Davis, who had an erudite interest in Marxism, as editor-in-chief, the articles and reviews in *Art Front* drew on a democratic mix of political and aesthetic viewpoints. Initially, the union had been founded as the Unemployed Artists Union through the John Reed Club in 1933. But in the wake of the WPA, it was reconstituted to arbitrate labor issues on behalf of WPA employees. The Artists' Committee, by contrast, was chartered in the spring of 1934 and overseen by an advisory council, chaired by John Dewey, which had a mandate to renegotiate the terms of the union and establish a permanent exhibition space at the Municipal Arts Gallery and Center. Unlike the committee, the union was not impervious to penetration from outside political organizations.

Rosenberg was not a founding member of the Artists' Committee of Action, nor did he become involved in its activities.[4] But, as he described in a letter to Harriet Monroe, he did participate in its first show at the Municipal Arts Gallery in March 1934. He was also drawn to the mission, and to the name, and much later distilled the organization's effort to spurn political ideology when he penned "The American Action Painters." As he wrote to Mary McCarthy in 1959, when his essay was reprinted in *The Tradition of the New*, "Action Painting came right out of the '30s and its slogan of art as action . . . by way of a purge."[5] *Action* painting, as Rosenberg had it, was born of opposition to fascism and dictators such as Stalin. Although artists such as Jackson Pollock and Willem de Kooning were never committed to any of the organizations absorbed by the Popular Front—unlike Mark Rothko, who was a member of the Artists' Union—most artists took part in political demonstrations, such as the annual May Day parades. Once the modernist movement regained traction with the onset of World War II, and upstaged realist painting, the question of an audience became central to the artist's independence. How to develop a new body of patrons? The "act

does turn into art," as Rosenberg rhetorically put it to McCarthy, admitting that painting had ceased to exist in relationship to social struggle and had become primarily "interesting."[6]

When Rosenberg was appointed an editor at *Art Front*, he joined a board that was almost wholly composed of members of the Communist Party or fellow travelers—even though the union was officially nonpartisan—with the sole exception of Max Spivak. Spivak, to whom Rosenberg was briefly assigned as an assistant on the Mural Division of the WPA, probably brought him into the publication, impressed by his tirades against communism. Beyond its overt political bent, Rosenberg encountered a board riddled with shortcomings, the foremost being the laziness of board members. He recounted that when it came to "putting the magazine out these editors all vanished,"[7] allowing Spivak, Clarence Weinstock (a writer who appeared on the masthead under the pseudonym Charles Humboldt), and himself to all but take over. As May Natalie Tabak observed, it enabled them to shape a journal "which reflected their points of view rather than *the Party line*."[8] Although Rosenberg considered Stuart Davis among the idlers, Davis's activism had migrated to planning the first American Artists' Congress, of which he was chairman, and which took place in New York in mid-February 1936.

Outside of Rosenberg's attitude toward the editors' lassitude, there were fractious divisions relating to the content of the magazine. Many artists who were members of the union, including Ilya Bolotowsky, Bryon Browne, Balcomb Greene, George McNeil, Joseph Solman, and Rothko, were disgruntled by articles that covered social scene painting, and by opinion pieces and features on labor and wage disputes that grew out of friction with the WPA. They felt these overshadowed discussion of the avant-garde.[9] Soon after Rosenberg joined the board, he was able—with Spivak, Weinstock, and Solman, the latter of whom became managing editor in March 1936—to steer the monthly toward increased treatment of aesthetic issues. In the process, they revamped the tabloid format and printed the publication on a higher grade of paper that included reproductions and introduced color into the cover. Rosenberg felt that he and Spivak were responsible for the lion's share of the changes at

Art Front, but Solman probably had the greatest hand in revising the look and content of the magazine. He was not only more adept at handling an unruly membership, but less derisive of the intelligence of the magazine's readership.

Rosenberg was incapable of withholding his contempt for the Artists' Union, although he had to become a member to serve on the editorial board of the journal. He was perceived as an elitist who had little interest in labor politics or the welfare of the artist. In fact, he approached his role as an editor with condescension, proclaiming: "We put out the magazine; they are a bunch of dummies!"[10] In a review of Salvador Dalí's book *Conquest of the Irrational,* for example, he flatly stated that Dalí's work was "not recommended to those readers of *Art Front* who have complained of the obscurity of some of the articles in these volumes."[11]

Tabak alleged that the board of *Art Front* was pervaded by mediocrity, which seeped into the diminished expectations of its subscribers. She related in her memoir that "many members of the magazine's board were rabid semi-literates,"[12] an opinion no doubt inherited from Rosenberg. In his estimation, Davis was part of the problem. Despite Davis's inclusion of multiple outlooks in the journal, Rosenberg felt that his separation of art from political activity was contradictory and seeded mixed messages. Why could Marx not be aligned with the avant-garde? Could *action* not take the form of solitary endeavor, worked out through writing or painting? Davis's division of interests was incomprehensible to many of his peers, including Arshile Gorky, who worked on the Mural Division of the WPA. Moreover, he attended meetings of the Artists' Union and occasionally lectured to large crowds in its hall on Sixth Avenue.

Gorky never wrote for *Art Front;* nor did he become a member of the union, let alone participate in its demonstrations, despite Davis's urging.[13] A self-declared leftist, he was also a closeted champion of Stalin, something he hid from most of his colleagues, including Rosenberg. As an Armenian, Gorky felt tied to Stalin, who was Georgian. He refused to acknowledge the mass executions, the work camps, and the Gulag. In addition, his status as an illegal alien in the United States brought on fears of deportation.

Davis and Gorky became friends during the mid-1930s. Yet their relationship never transcended the trials of the union meetings. Davis was dedicated to, as he phrased it, a "serious situation [that] demanded . . . much time to the organizational work." By contrast, he felt that "Gorky . . . wanted to play."[14] Rosenberg sided with Gorky on "play." Unlike Davis, he believed answers to international pandemonium could be found in the studio:

> Stuart retreated behind the idea of forms in power. Now what kind of an idea is that? On the one hand he was running his ass off for the Communist front organizations, he's talking about form and color, and he doesn't let it matter what he did by another painting . . . But he broke with Gorky, because Gorky said well, "I'm going to go on painting until I find the answer to the question in painting" . . . Davis said . . . if he wanted to play, he didn't want to have anything to do with him.[15]

During the seven months that Rosenberg was active as an editor at *Art Front*, the paradoxes of reconciling political engagement with aesthetic commitment consumed him. As he viewed it, Davis's reaction was hypocritical, less tolerable than Gorky's option to find an analogous explanation for world events by shutting out the dissonance of the Communist Party and the ceaseless fights at the Artists' Union. Rosenberg reckoned that Gorky had arrived at a more daring realization: that the pursuit of pure form was problematic in the face of social upheaval. As he wrote years later, Gorky had an intuitive understanding that "the bankruptcy of a rationale of progress in regard both to art and to social history had to be acknowledged."[16]

As Rosenberg thought about Davis's role in the Artists' Union, he concluded that he had become blinded by faith in "progress," a word that rarely entered Davis's diction, although there were equivalents, such as "continuation and expansion."[17] Davis construed art and politics as irreconcilable, yet he supposed they both moved on parallel tracks, driven by notions of growth and betterment. Rosenberg began to think that this line of reasoning was outdated, nostalgic even, and that it deprived *Art Front* of credibility, especially if its

pages were to be filled with articles that elaborated on modernist preoccupations.

Through contact with Gorky, Rosenberg gained a sense of how humanism's precepts of progress were no longer viable as an interpretative model. In Gorky's borrowed imagery—largely taken from Picasso, Matta, and Miró—Rosenberg located an analogy for the frailty of the autonomous self and the difficulties of renewing art's vocabularies in the face of fascism. Gorky's reworked Picassoid prototypes were veiled references to the collapse of modern art in Europe. Rosenberg placed Gorky's work "on the borderline of social action."[18] Although he considered that de Kooning, Pollock, and Newman, among others, had more fully digested the events of the 1930s, he believed Gorky had responded to the "challenge to action in the streets."[19] Stuart Davis was another story: he had dissociated his painting from his involvement with the Artists' Union. Hence, he was written off by Rosenberg as an old-school modernist who still idealized the Left Bank of Paris as an oasis of artistic independence. Davis had committed other, more egregious offenses in Rosenberg's view. That he supported Stalin after the Moscow Trials became public and the Dewey Commission reported its findings on Trotsky's murder[20] was troubling to him: this was the antithesis of progress, a naïve presumption that the reformist traits of socialism could still hold. Davis never became a member of the CPUSA, and his fidelities to communism were always altruistic. However, after the invasion of Finland in 1939, he reexamined Stalin's sovereignty and his hand in Trotsky's assassination, and his socialist interests withered.

the new realism

Rosenberg's contributions to *Art Front* included his review of Dalí's book and occasional features on work by William Gropper and Vincent van Gogh that had been recently staged as exhibitions in New York.[21] He also translated a lecture by Fernand Léger on "The New Realism" that was delivered at the Museum of Modern Art (MoMA) in the fall of 1935 to inaugurate the first survey of his painting in the United States. This array was in part the response of a novice critic

still familiarizing himself with art. But he was also fulfilling his editorial role to cover a broad range of topics and ensure evenhandedness within the journal. He did have certain criteria, however: he wanted evidence of consistency in art. While he described Gropper as a "revolutionary artist,"[22] the latter's political cartoons and caustic put-downs of American politicos were deemed uninventive, unlike his painting. Léger, whose talk Rosenberg rendered into bungled English, fared better, and exerted subsequent influence on the critic's writing. (Rosenberg was wholly self-taught and had little feeling for the nuances of the French language.)

Rosenberg's translation was unaccompanied by a note, nor did he elaborate on the text in any subsequent commentary. That task was left to Balcomb Greene[23] and Clarence Weinstock, who wrote editorials on the piece for *Art Front*, with the last word from Stuart Davis, who objected to Weinstock's charge that Léger's painting revealed a "semi-idealistic relationship to the visible world."[24] Davis had a vested interest in Léger: his own collages and paintings from the early to mid-1920s were drawn from the advertising industry, especially his *Tobacco* series, which echoed the French artist's flat, precisionist style. Both artists were also engaged in elevating the imagery of mass culture by rethinking its low-grade status. In the late 1950s, Davis continued to refer to Léger as "the backbone of modern art,"[25] which affirmed to Rosenberg that Davis's aesthetics had stalled in Paris decades earlier.

Davis must have assigned Rosenberg the translation of Léger's lecture. As the American Artists' Congress inched toward realization, the demands on Davis's time precluded such labor-intensive work, even though Rosenberg mishandled the piece through his clumsy English approximation. Still, few of his peers on the WPA would have noticed. Outside of his own interest in Léger, Davis's decision to run the lecture in *Art Front* was calculated to jolt the members of the Artists' Union, the majority of whom were wed to the figure in art. While Léger also held onto the body in his work, he had called for an end to "subject-matter,"[26] the opposite of the resurgent social narratives in American painting. Rosenberg would have supported Léger's panacea, reading it as a way out of the strictures

imposed on artists by the Communist Party. Yet the potential that Léger saw for new media, such as film, exemplified by his *Ballet mécanique* (1923) and *Entr'acte* (1924), left no palpable mark on Rosenberg's writing. Moreover, the artist's ecstasy over Radio City Music Hall, which he described as an icon of "social luxuriousness through which crowds circulate,"[27] would have eluded him. He could never uphold Léger's equation of a "new realism" with the languages of industry, even though Davis thought it appropriate to the union that ceded to the Popular Front and made alliances with trade unions and labor consortiums.

Léger's aesthetics were too removed from the self for Rosenberg, especially his glorification of the "crowd" with its connotations of anonymity. There was the vexing notion of progress in Léger's proposition that an elixir of art and commerce could transform society. Such synthesis was too quixotic for Rosenberg. There was also the risk that film could be exploited as propaganda.[28] Soon after its release in 1934, Leni Riefenstahl's *The Triumph of the Will* was screened in New York, although banned in most areas of the United States. Rosenberg must have known of her aggrandizement of Germany's new nation of soldiers, their pageantry, and Hitler's oratory.[29] While he only occasionally referenced Léger in his later reviews for *Vogue* and the *New Yorker*, the *Ballet mécanique* represented to him "an atmosphere of glamour around modern inventions akin to that of the Wonders of Science Pavilions at an international fair."[30]

Idealism aside, Rosenberg could relate to Léger's argument in his MoMA lecture that new materials were perfect conduits for the "analysis of the isolated object [which] can go beyond simple artistic and pictorial relations."[31] At least, his "new realism" had left the door open to explain why the Radio City Music Hall had become an "American feat"[32] as the country approached the mid-century. During Rosenberg's stint at *Art Front*, the artist weighed on his mind, reinforcing that all contemporary art existed in relationship to material histories. In a review of Alfred Barr's landmark exhibition, *Cubism and Abstract Art*, assembled at MoMA in 1936, and composed of works by Léger, Picasso, Georges Braque, Juan Gris, Piet Mondrian,

and numerous other Europeans—Alexander Calder and Man Ray were the only Americans included—Rosenberg hammered on "design," as Léger had called it in his talk, and stated, "The artistic process whereby the image becomes a design always tends to reach a termination and to reverse itself so that design becomes part of a larger image or function."[33]

Rosenberg's explanation must have come from the hours that he had spent combing through his English dictionary to find the right words to elucidate Léger's "new realism." The artist provided him with the heft needed to rebut Barr's historic schema for abstract art and the logic in his vectored diagram that was reproduced on the catalogue's cover. Unlike the interrelated stylistic paths that Barr had mapped into a tidy monolith—with Cubism at the apex— Rosenberg argued that modern art was part of a "variegated movement in history,"[34] characterized by fissures and endpoints, not by coherence as Barr proposed.

Rosenberg had lobbied for a public discussion of "the *social situation of poetry*" in his unpublished article for *Poetry* a year earlier. After his translation of Léger's lecture, he finally went on record to state that Barr's "design" features meant little without a social hook. There were contradictions that got in the way of his airtight reasoning. Five years later, when he sat down to write "The Fall of Paris," another of his major essays, Rosenberg asserted that there were too many disrupted and aborted movements within modern painting to establish aesthetic hierarchy as a format.[35]

the militants were in favor of bouncing us off the board

When Rosenberg, Spivak, Solman, and Weinstock revised *Art Front* with a new graphic look and reduced the reports on labor issues, many of the members of the Artists' Union became agitated. Angry rows ensued at their weekly meetings that related to the publication's new modernist focus. Unlike his colleagues, Rosenberg exercised no savoir-faire at either editorial or union meetings, where he aggressively propounded his disdain for narrative painting. At

one of the Wednesday-evening gatherings held in January 1936, Joe Jones, an artist from St. Louis, rose to protest the new, narrow focus of the publication and its failure to report on the political activities of the union. He announced that he had delegated himself to act on behalf of the midwestern states. Rosenberg responded to Jones's declaration by asking, "Who the hell made you the representative of the artists of the Midwest?"[36] His bluster was immediately drowned by heckling from the large crowd of more than five hundred people who had assembled in the hall of the union. Rosenberg never flinched during the bellicose exchanges, sure of his position. The members were "dummies," after all! In fact, he seemed to revel in these altercations, viewing them as theater.

As Jones's outburst underscored, it was apparent to the union membership that few concessions would be made by the editors of *Art Front*.[37] Modernist subjects continued to predominate, skewing whatever balance Davis had earlier brought to the table. Rosenberg, Spivak, and Weinstock—the last of whom frequently sided with the dissidents on editorial decisions despite his own interest in realist painting—were at one point accused of "Robespierrism"[38] during the meeting, which caused Weinstock to fall off his perch on a window ledge where he had been seated during the proceedings. But as Rosenberg explained it, he and Spivak constituted the real trouble. They had become a "powerful minority of two," capitalizing on the passivity and absenteeism of their editorial colleagues. The union was disgruntled by their takeover and wanted them removed:

We . . . had seized power somehow. We were putting out our kind of magazine in spite of the fact that we were a minority. So they got up one after another and denounced us . . . So I got up and said: well how can we possibly run this magazine, we have eleven people voting against us all the time. We're obviously a minority . . . The place was packed because it was a big occasion; they had the editors brought up on charges . . . The militants were in favor not only of bouncing us off the board, but kicking us out of the union for this political crime, seizing power . . . It was a great meeting.[39]

Tabak, who attended many of the union meetings, remembered that the board had put Rosenberg and Spivak through a mock tribunal orchestrated in advance, with some speeches prepared and read, rather than delivered spontaneously. They were charged with factionalism. She recounted that the indictment was driven primarily by the members' allegiance to the Communist Party: the "sadism of a lynch mob [was] easier to comprehend than this crazed crusade that ran hot or cold when turned on by an ideological switch."[40] She was equally aghast at Rosenberg's indifference to the hostility of the event and his trivialization of their incriminations. As she described the climax to the evening:

> The last speaker for the prosecution was an ad salesman of *The Art Front* . . . In the name of the working class, of Marx and Lenin, of the responsible Socialist realist artists, and of the Party, he denounced everyone who would contaminate "our magazine" with *their* "elitist capitalist values."
>
> Harold rose. His rebuttal was not calculated to restore brotherly love. "Now you've listened to this illiterate nonsense," he said jovially . . . His manner infuriated the crowd. They brandished fists. They aligned themselves on the side of ignorance, which they equated with the virtue of the proletariat. Perversely Harold responded to their most bitter charges and threats with quips and laughter . . . He seemed unaware that he was antagonizing them; that they might go berserk at any moment.[41]

Rosenberg's association with *Art Front* ended six months later. His name ceased to appear on the masthead after June 1936, when his last review appeared. After the fracas, Davis and three other board members resigned immediately. Their roles in the first American Artists' Congress were too demanding, although Davis continued to write for the journal until its demise in 1937. He was replaced by Joseph Solman; later, Clarence Weinstock became managing editor. As a card-carrying member of the Communist Party, Solman was more acceptable to the union, better skilled at negotiating the dual aesthetic interests of the membership, and more likely to imple-

ment the CP's political line. At least, that is what the Artists' Union thought initially. Within a few days of the meeting, an edict was issued, as Tabak recalled, *"from Moscow, itself,"*[42] which required the Popular Front to effect solidarity with nonaligned artists and writers. It was a ploy, she explained, for the party to surreptitiously infiltrate cultural organizations and journals such as *Art Front* that had remained largely impermeable to the institutionalization of socialism.

While Rosenberg might have been an ideal decoy for the CP, given his continuing rants against Stalin, he and Spivak were no longer able to maintain their "power of two." Too many editors defected in the wake of the meeting: the harassment from the union had been too wearing. Moreover, Moscow's covert strategy to recruit members for the Communist Party was in the process of drifting to the formation of the Artists' Congress.

Spivak was ousted by the board of the union, which acted on the advice of a French representative of the Comintern who was visiting New York at the time of the meeting. As the proceedings had become too rancorous, he urged them to make a token concession to the membership. Spivak became the fall guy. He was glad to be relieved of his responsibilities, worn down by the power plays and acrimony. While Rosenberg was not forced out, he resigned a few months after Spivak's dismissal, aware that he would have to give up his dominion, even though Solman, the new editor, was a modernist painter. Just as the furor at *Art Front* unfolded, Solman became a member of "The Ten," with Adolph Gottlieb, Mark Rothko, Ilya Bolotowsky, John Graham, and others, all of whom banded together in late 1935 to exhibit as a group. They saw themselves, as Gottlieb stated, as "outcasts in the art world, struggling against the Establishment."[43] Rosenberg failed to achieve unanimity either with Solman or with The Ten. He was undone, like Spivak, by the activities of the union, despite his indifference to their catcalls and the bravado he had displayed at meetings.

Rosenberg did not sign the petition to create an American Artists' Congress,[44] even though *Art Front* ran several calls in the fall of 1935 outlining the group's position against fascism and war. One announcement focused on "no Hitlerian burning of the books . . . no

burlesque Caesar marshaling Fascist legions to make Rome the mistress of the world at the price of extermination of mankind."[45] The congress was too dependent upon the CP to hold Rosenberg's interest, even though Alexander Trachtenberg, the party's representative for cultural affairs, had assured Davis that there would be no interference from the Central Committee.[46] Also, Rosenberg did not qualify for membership. He was not a "recognized artist of standing,"[47] even though he had been Spivak's assistant on the WPA. So he stayed away from the event. His affiliation with *Art Front* was about to dissipate, moreover, and there was no opportunity for him to write a report on the sessions, as he had on the Writers' Congress for *Poetry*. He had no connections to the art press or another magazine in New York. While he had written occasional pieces for *Partisan Review*, Phillips and Rahv, its editors, knew him to be a poet and not an art critic.

to preach exclusive internationalism, though not so bad, is still a great danger

Most of the papers delivered at the first Artists' Congress reworked the same themes of frustration aired at the Artists' Union meetings. Even though, as Davis recounted, the congress "took in a broader thing"[48] and drew on a wider spectrum of artists than those on the WPA—including Paul Manship and Leon Kroll, whose careers had been established before the Depression—it succumbed to ideological tyranny, just as Rosenberg predicted.

Joe Jones had signed the petition and was invited to speak at Town Hall, where the congress convened on the first day. His remarks echoed the union's position when he contended that "art with a social bearing"[49] had become the subject of repression in America. In his view, the mural as an artistic genre was particularly imperiled, a target of censorship unlike easel painting. His defense was a circuitous way to stab modernist painting. Jones's harangue was in the minority, however. Most of the talks at the congress stuck to fascism and its racist foundations. Aaron Douglas, for example, maintained that fascism could be understood by querying any African Ameri-

can: "if there is anyone here who does not understand Fascism let him ask the first Negro he sees in the street."[50]

Apart from Meyer Schapiro's talk on the "Social Bases of Art," a didactic tone pervaded most of the sessions at the congress. Schapiro had studiously distanced himself from the nationalist language in most of the papers and skirted the issue of race entirely. His lecture was one of the few to argue that the abstract features of modern art represented a counterpoint to "repressive institutions and beliefs, like the church or the state or morality, to which most individuals submit."[51] Invention should be understood as an act of liberation, he thought. Schapiro knew that the "social bases" of abstract art had been given short shrift by most art historians. Rather, the emergence of new pictorial forms in the modern period had to be considered in tandem with the artist's acute sense of marginalization. As he wrote:

> The social aspect of his art has been . . . obscured by two things, the insistently personal character of the modern painter's work and his preoccupation with formal problems alone. The first leads him to think of himself in opposition to society as an organized repressive power, hostile to individual freedom; the second seems to confirm this in stripping his work of any purpose other than a purely "aesthetic" [one].[52]

Schapiro's distinctions were made just as Rosenberg began to question the *"social situation of poetry."* He must have known of Schapiro's lecture: there were clear connections in their thinking. He himself was just about to give up on poetry, put off by its hermeticism, but held out for the possibility that the artist might be able to redirect history through consciousness of his alienation.

There were many attacks on Schapiro's paper: apparently, the combative tone of the meetings at the union had carried over to the Congress. Some of the respondents called for a more impassioned account of American art. Nat Werner, a figurative sculptor, thought that Schapiro's take was "completely negative."[53] Louis Lozowick rebutted, "To preach exclusive internationalism, though not so bad, is still a great danger."[54] As Lozowick implied, Schapiro had

not addressed the United States in his lecture. In fact, he had lifted his discussion beyond the local to the isolation of the artist under capitalism, adamant that all modernist art existed in response to repression from audiences and patrons.

Schapiro followed up on the congress with an article on "Race, Nationality, and Art" for *Art Front*. He had been struck by a paper delivered by Lynn Ward, a graphic artist, illustrator, and writer from Chicago, who had tackled ethnic stereotyping in regionalist art, a trait Ward ascribed to patronage. For *Art Front,* Schapiro lifted Ward's title and widened his observations on identity to incorporate economic class, without which he deemed any discussion of art had the potential to lapse into propaganda: "The character of an art at a given moment cannot be said to reflect the psychology of a whole people or nation," he wrote. "It reflects most often the psychology of a single class, the class for which art is made or the dominant class which sets the tone of all artistic expression."[55] Schapiro, who had been appointed a lecturer in art history at Columbia University in 1928, became a fellow traveler four years later. He voted a straight Communist Party ticket in 1932, although he never enrolled in the party.[56] He had lectured at the John Reed Club in New York before it was dissolved in 1935, and many of his early articles were published in journals such as the *New Masses, Marxist Quarterly,* and *Partisan Review.*

Davis attempted to draw Schapiro into *Art Front* by inviting him to attend editorial meetings. Although Schapiro never served on the board, he did contribute two essays, one of which, "Race, Nationality, and Art," was published while Rosenberg was an editor.[57] (Schapiro's second submission, "The Public Uses of Art," enlarged on a lecture on Mexican Muralists that he had given at a convention of the Artists' Union in May 1936; it appeared almost six months after Rosenberg stepped down from the board.) He was present at many of the weekly gatherings of the union, and it was there that he and Rosenberg struck up what became a lifelong friendship.[58] Rosenberg retained a memory of Schapiro being vilified at a union meeting shortly after the Moscow Trials got under way. As he recalled, the episode replicated his own encounters with the member-

ship: "Somebody got up and denounced Meyer Schapiro for being a Trotskyite and some hot-head began to shout, let's go to his house and kill him."[59]

Schapiro subsequently became an independent Marxist, but not initially because of the squabbling at union meetings and his differences with the Artists' Congress. Rather, the Dewey Commission that exposed the rank complicity of the Communist Party in the assassination of Leon Trotsky was the main factor. After the Moscow Trials were revealed, these findings assumed urgency for Schapiro, just as they did for Rosenberg and numerous other New York intellectuals. Schapiro stated in hindsight, "When I read accounts of the trials and of the slaughter of party members, comrades, old revolutionists; when I read books by people who had escaped from the Stalinist prisons and work camps, it was a real shock for me. Many party members and sympathizers here in the United States refused to believe these reports."[60] Subsequent annual gatherings of the congress proved to be just as fraught and contributed to his growing antipathy to the organization. He remained a member until 1940, when he was no longer able to countenance the congress's unwillingness to extricate itself from the CP as well as its endorsement of the Soviet invasion of Finland. He had hoped to reform the organization by redirecting its mission through an understanding of the dialectical relationship of modern art to social history, the interest that he and Rosenberg shared.

Although John Dewey never became a proponent of Marx, he had a dim take on laissez-faire capitalism, maintaining that it had limited redress for the working class. As of 1935, he had developed a reformist notion of "social action" that radically reversed liberalism's early emphasis on socioeconomic strategies to ensure individual freedom, and he carried these ideas with him to the commission.[61] His term "social action" was alluring to Rosenberg. However, he was never able to cotton to Dewey's liberal politics. Like Schapiro, Rosenberg held on to his socialist values and believed some wisdom could still be had from Marx. After all, Marx's *Eighteenth Brumaire of Louis Bonaparte* had hit upon the same absurdity and

spectacle of political theater that he himself encountered at meetings at the Artists' Union!

greenberg's ur-source

Despite the bellicose reception of Schapiro's paper on "the social bases of art" at the Artists' Congress in 1936, his ideas subsequently proved influential. For one, they marked the early thinking of Clement Greenberg, who became an art critic for *Partisan Review* once the journal was untethered from the CP the following year. But Greenberg's Marxist politics were always lumpy at best, unlike the savviness of Schapiro and his fellow editors.[62] In "Avant-Garde and Kitsch," his second article for *Partisan Review*, he wrestled with the social construction of art, concluding that the modern artist had become a nonconformist distanced from political life, at least in the studio. Greenberg's representation followed from his own identification with bohemian culture, which he deemed an oasis of independence.[63] Like Rosenberg and Schapiro, he was enmeshed in the ideological battles of the late 1930s, when many thinkers on the left reflected on the peripheral social status of the artist and the writer. Stuart Davis's bifurcated response to his painting and the Artists' Union underscored a conflict that many intellectuals felt needed clarification. However, unlike his peers, Greenberg quickly drained his writing of Marxist allusion, leaving behind any debt to Schapiro.

It never mattered to Greenberg that Jackson Pollock, in whose work he would take a deep interest, had attended meetings of the Communist Party in Los Angeles while still in high school in the late 1920s.[64] Pollock had taken part in the May Day parade in New York in 1936, along with Rosenberg and Tabak, and built the armature for a float designed by David Alfaro Siqueiros, the revolutionary Mexican muralist and communist who traveled to New York to attend the first Artists' Congress. Pollock had equated the artist with the worker, a connection made for him by Thomas Hart Benton, his teacher at the Art Students League where he was enrolled in 1930. In one of his last communications with his (largely

estranged) father, who was a Bolshevik sympathizer and avowed socialist, he declared that painting "had a common meaning to the masses."[65] These analogies evaded Greenberg, even in an obituary that he wrote for the artist.[66]

Greenberg's reading of Marx was never deep enough to treat the situation of the artist during the Depression. He gravitated more to modernism's continual wariness with the figure, rather than with the consequences of its repudiation.[67] Unlike Rosenberg and Schapiro, he had no desire to ferret out the nuances of Marxist doctrine. His interests were buttressed more by study of Immanuel Kant's *Critique of Aesthetic Judgment*, particularly the philosopher's explanations of beauty and the way taste is ineffably rooted in subjectivity, not capable of objectification. Kant was Greenberg's Ur-source; his *Critique* provided a hook to substantiate his artistic preferences. Within a few years of writing "Avant-Garde and Kitsch," Greenberg touted Kant's *Critique* as unsurpassed wisdom: "There has been no greater thinker on art."[68]

Kant presumed the artist was estranged from society, which allowed Greenberg to dwell on the vicarious pleasures proffered by painting, such as its enticing material effects. In "Towards a New Laocoön," published in *Partisan Review* in 1940, he went on to state that "the history of avant-garde painting is that of a progressive surrender to the resistance of its medium."[69] His essay appeared just as Meyer Schapiro was about to sever ties with the Artists' Congress and Rosenberg was speculating on the repercussions of the occupation of Paris. Greenberg's political views were still aligned with theirs: he knew that Hitler and fascism had to be eliminated. But he was also politically naïve, if not confused. In the British publication *Horizon* he professed that "a Socialist revolution in the West would send an answering thrill through the German workers. It would come with idealism and sincerity; it would invite the world to join in it in fraternity and love—yes, *love*."[70] Rosenberg's and Schapiro's grappling with socialism was never sanguine or giddy. Through their interactions with organizations such as the Artists' Union, they knew Marxist doctrine had been defiled by dictators such as Stalin.

Greenberg's socialist leanings rarely seeped into his analyses of

art after 1940; they were reserved more for the occasional book re-
view or literary commentary, such as when the Bollingen Prize was
awarded to Ezra Pound. In this instance, he asserted his anger as a
Jew, unlike Rosenberg's ambivalence and silence. Greenberg knew
that Pound's fascism was the outcome of delusion; but he blamed
the committee for "its absolute acceptance of the autonomy not
only of art but of every field of human activity."[71] He still thought
that art should be immersed in history. But after the Cold War, it
ceased to matter to him. As the United States entered into a standoff
with the Soviet Union, he ironically evoked Marx in a review of the
posthumous release of Paul Valéry's essays, *Reflections of the World
Today*. Valéry had surfaced in Greenberg's writing as a major poetic
innovator, on par with Mallarmé and Apollinaire.[72] He had consid-
ered him a "littérateur,"[73] but once Valéry took on politics, Green-
berg passed him off as hopelessly misled: he did not have the intel-
lect to explain political transformations in the modern era. If only he
had imbibed Marx, he would have landed on terra firma.

Reflections of the World Today represented a collection of essays
and lectures on the threats to European democracy after 1895 that
the author pursued through conceptions of history such as the state,
freedom, destiny, politics, and the dictator. The book was avowedly
neutral: Valéry rarely mentions obvious perpetrators, such as Hitler,
Stalin, Mussolini, and Franco (although Oliver Cromwell is provoc-
atively foregrounded as "that most profound of dictators," with no
explanation).[74] Greenberg deemed Valéry's ruminations too ab-
stract and vague, unmoored from historic specificity and prone to
psychology: his approach yielded to verbose pontification on the
plight of France, his homeland. Greenberg wanted more social treat-
ment from the poet, less airy speculation. He felt Marx was compul-
sory for any contemporary analysis of the fate of Europe. Toward the
end of his review, Greenberg pronounced Marx to be as essential to
political theory as Kant was to philosophy.

Valéry had declared in *Reflections* that "[the] mind has trans-
formed the world . . . it has endowed us with a power for action
which is enormously greater than any individual's powers of adap-
tation."[75] However, *action* as individual agency was too romantic for

Greenberg. He thought revolution had to be fixed in the material world: hence, his juxtaposition of Marx and Kant. Tellingly, there was no mention of Valéry's biography in his short review: the type of dates, place names, and events that he accused the French writer of excluding. Greenberg left out Valéry's refusal to collaborate with the Vichy regime during the occupation, a stand that affected his livelihood, his teaching position at the University of Nice, and his long-standing association with the Collège de France. He may not have been a Marxist, but his morality grew from political conviction. This type of omission was the recurring downside of formalist analysis, troubling to critics drawn to Valéry's belief in *action,* such as Rosenberg.

Greenberg may have been high on Kant, but he also took license with the philosopher. He had violated, for example, Kant's transhistorical conception of art, especially when he marshaled modernist precedents to account for the legacies of favored artists, such as Pollock, who was part of a genealogy that began with Picasso. This is where Marx came in handy. To Greenberg, painting existed in direct relationship to art history, perpetually given to revision of its compositional forms. The medium became the locus of revolution, metaphorically linked to the proletariat. Greenberg depoliticized Marx, a move that connects him to the ideas of Hans Hofmann, whose lectures he attended at Hofmann's school in Greenwich Village in 1938–39. Hofmann preached the primacy of painting's languages, just as Greenberg construed in "Avant-Garde and Kitsch." But he was reduced to a footnote in Greenberg's article, not situated prominently alongside T. S. Eliot. Greenberg was still tentative about Hofmann's status as an artist; he characterized him more as a teacher. It was not until 1944, when he first saw his work, that he gave him fuller credit as a painter; still, his teaching was always presented as his main accomplishment.[76]

Rosenberg had also become acquainted with Hofmann's ideas through Lee Krasner in the mid-1930s. Krasner studied with Hofmann at his West 8th Street atelier while she worked on the WPA. He remembered she "was always talking about him."[77] Around 1937, he also met Clement Greenberg, whom he soon introduced to Kras-

ner, who in turn urged Greenberg to take in Hofmann's talks. The introduction added to their new but complicated allegiances: by the late 1930s, New York's art scene was fast becoming schizoid. During the years Rosenberg was active on the WPA, he never attended Hofmann's classes. The two eventually met at Hofmann's first exhibition at the Samuel Kootz Gallery in 1947 and subsequently become friends. After "The American Action Painters" was published, Rosenberg devoted his first monographic article to the artist, where he was designated "an Action Painter (not in all modes) to whom an action implies responsibility to the mind."[78] The description echoed Valéry's stance in *Reflections*. The parenthetical remark must have related to the artist's "push and pull" theory that representation was not the sole avenue to illusion but could be pulled off through contrasting planes of color. Only later, in the early 1960s, did Hofmann become the full embodiment of an *action* painter. Rosenberg realized that his abstractions emanated from a will to maintain modernism, when fascist leaders and the Communist Party had denigrated its expressions.

Rosenberg had better understanding of Hofmann's role as a teacher than Greenberg did. He described the academy that Hofmann transferred from Munich to the United States as "an anachronism."[79] Unlike Greenberg, who consumed Hofmann's metaphysics wholesale, Rosenberg was never able to overlook the latter's worn modernist ethos. As he had it, "to blunt minds it represented the discredited cult of art for art's sake, to others mere old-hat vanguardism."[80] He acknowledged that Hofmann had not imposed his methods on students such as Carl Holty, Alfred Jensen, Krasner, Mercedes Matter, George McNeil, Louise Nevelson, and Wilfred Zogbaum. No overarching aesthetic emerged from his school, nor an art star such as Pollock—just the resolve to preserve abstraction as the alternative to social realist painting.

you would have to be recluse to stay out of it

As Rosenberg looked back on his clashes at the Artists' Union, he reflected, "You'd have to be a real recluse to stay out of it."[81] By the

time he resigned from *Art Front* in 1936, there were few outlets for his writing. He had made little headway with Mike Gold and Joseph Freeman at the *New Masses*. Their encounters had been too incendiary.[82] For a brief period, he worked as an external reader of art books for trade houses, such as Crown Publishing. However, by the spring of 1937, he was rescued by Henry Alsberg, the national director of the Federal Writers' Project, who hired him to edit the single edition of *American Stuff* and to work on a series of travel guides to New York City. The Communist Party had also infiltrated the Writers' Project, and Rosenberg's fierce interactions with pro-Soviet sympathizers soon forced his relocation to Washington, DC. He would live in the capital with Tabak for more than four years in relative seclusion, a place where the party had little presence.

Art Front folded just as Rosenberg became involved with the Writers' Project, capping a brief but critical moment in his professional life. While his writing on art receded for more than a decade, his idea of *action* always recapitulated this period. In the last phase of the magazine, Clarence Weinstock, who succeeded Joseph Solman as editor, turned the tables on Rosenberg's and Spivak's modernist program by larding his editorials with communist fidelities and expanding coverage of social realist painting. Despite his siding with Rosenberg and Spivak at union meetings, these loyalties dissolved, even though the CP urged more transparent union with the Popular Front. As Tabak put it, no one was "capable of neutrality and indifference."[83] Weinstock went on to write for the *Daily Worker*, but Spivak never overcame the tribulations of the Artists' Union, becoming a scapegoat and victim. His association with *Art Front* later affected his membership application to The Club, where none of the modernists, especially Willem de Kooning and Philip Pavia, would admit an artist who had been invested in the union. Rosenberg recounted, long after the decade was over, "Even though Max was not a Communist . . . he was constantly fighting with them, they didn't want him around. And Bill himself would accuse me of being too political. Even though I wasn't talking about politics at all."[84]

6
american stuff

the milieu of avant-gardism

Just after joining the editorial board of *Art Front* in mid-1936, Rosenberg and Tabak began to live with Lee Krasner and her boyfriend, Igor Pantuhoff, in a cold-water flat on the top floor of a building at 333 West 14th Street that overlooked the Hudson River. Tabak recounted that the apartment was spacious: it had eight rooms, much like their old space on Houston Street, although more finished and conventional. Even though they shared the space, it was much larger than the string of places that Rosenberg and Tabak had inhabited for short intervals. The couples doubled up on the bathroom, kitchen, and telephone, but their lives remained otherwise private. They would sometimes host dinner parties together or entertain separately, but the relationship was always civil, and the two women, Tabak and Krasner, became close. On summer weekends, the couples occasionally drove out to Jones Beach, where they would swim and surf, and Rosenberg and Pantuhoff would play handball.

Rosenberg had met Krasner through Lionel Abel around 1933–34, when she worked as a waitress at Sam Johnson's, a nightclub and restaurant on 3rd Street. When the WPA was formed, she left the haunt to work on the Mural Division. Krasner retained a distinct memory of Rosenberg, "because he never tipped."[1] Her income was derived solely from gratuities as well as meals provided by Morton Deutsch, one of the proprietors. In defense, Rosenberg explained that Deutsch freely indulged many of his bohemian clients with food, and occasionally liquor, because they "provided local color,"[2] a lure for his middle-class patrons. His parsimony aside, their shared

accommodations lasted for almost two years, until they were forced to seek cheaper rental options again. The lease on West 14th Street amounted to $23 a month, a sum that stretched Rosenberg's and Tabak's combined earnings. They had wanted to remain roommates with Krasner and Pantuhoff, but when no alternative to West 14th Street emerged, they decamped to a duplex in Brooklyn Heights for a few months. There they finally had hot water and a garden, but were unable to tempt any friends to visit. Although they were only a few subway stops from the Village, the isolation became unbearable. They returned to Manhattan on the weekends to spend evenings at the cafeterias and cafés where life was more convivial.

Pantuhoff abruptly left Krasner in 1939 without warning or farewell. One of their many differences centered on Hans Hofmann, with whom they had both studied after leaving the National Academy of Design. As Tabak explained it, "Igor couldn't understand what Hofmann was doing. Hofmann would look at Igor's work and say, 'No, that's wrong' and put a scratch across it . . . Igor just decided one morning that he was taking a bus across the country and going to become a great portrait painter."[3] But other issues had intervened: Pantuhoff was not only a womanizer but an alcoholic and spendthrift who drained their resources by spending extravagantly at restaurants, on clothes, and a Lincoln convertible (which carried them to Jones Beach in the summer).

Shortly after Rosenberg joined the editorial board of *Art Front*, Pantuhoff's work appeared on a cover. Yet his aspirations to succeed in portraiture never materialized, at least not on the scale he imagined. His subjects had included Grace Kelly and Laurence Rockefeller, but he eventually became a painter of doe-eyed, doll-like female figures, some eroticized as nude pin-ups, suggesting that Hofmann might have had a point. Before he departed, Krasner had moved into a rental unit on East 9th Street, just as Rosenberg and Tabak prepared to return to Washington, DC. Tabak remained tight with Krasner through the mid-1950s and was a witness at her wedding to Jackson Pollock, whom she took up with in 1945. Rosenberg was not invited to attend the short ceremony or the celebratory lunch afterward at Schrafft's. Pollock had never trusted him, feeling diminished by his

constant displays of erudition. Tabak's first impression of Pollock was also underwhelming: she thought the painter, who frequently dressed in overalls, was a "handyman . . . who had come to frame [Krasner's] paintings or stretch her canvases."[4] He was not nearly as attractive as the urbane Pantuhoff, whose elegance was striking. At 6 feet, 2 inches in height, Pantuhoff towered over Krasner, who was short and noticeably less handsome, compounding the incongruities in their attraction. Although Pollock was diffident, he was also a raging alcoholic, a trait that aroused Krasner's protective instinct.

Tabak claimed that, with the exception of Rosenberg, there were "very few people who could talk about Heidegger in the art world."[5] Pollock's limited verbal skills became a target of Rosenberg's scorn. Tabak mistakenly assumed their friendship was akin to "a brother relationship."[6] Yet Rosenberg was openly contemptuous of Pollock's inability to hold his liquor, compared to his own ability to drink through the evening with little noticeable effect. Pollock took a certain glee in taunting Rosenberg, whose thick skin resisted goading, even when Pollock maligned his writing as "full of shit."[7] Pantuhoff, by contrast, had kept his insecurities under wraps: his class pretensions extended to claims to being a cousin of the last tsar. He and Rosenberg never sparred because he was a less servile partner in conversation. As a Russian, he was up on Marx and Dostoevsky, and had read French symbolist poetry, the writers whom Rosenberg consumed.

Despite the need to perpetually chase cheaper real estate, Rosenberg and Tabak in their early married life in New York made numerous long-lasting friendships. Parker Tyler, Kenneth Burke, Harry Roskolenko, Lionel Abel, and Krasner were staples of their group, which was soon enlarged by de Kooning, Newman, and Hofmann. Burke had moved from the West Village with his family to a farm in Andover, New Jersey, around 1922. However, between 1934 and 1937, when he was active as a writer at *The Nation* and *New Republic*, he rented an apartment on the same floor in one of the buildings Tabak and Rosenberg inhabited on Greenwich Avenue.[8] There, his exchanges with Rosenberg relating to the American Writers' Congress and the Communist Party unfolded.

Their circle also included Clarence Weinstock, whom Tabak had met before her marriage to Rosenberg. Weinstock began his career as a poet, like Rosenberg. He had left the University of Wisconsin shortly after enrolling, largely because he was regarded as "an oddity."[9] His wardrobe of Navajo costumes acquired on summer visits to the reservation in New Mexico were evidently too outlandish for the Midwest. While he still lived with his parents and a maiden aunt in a brownstone furnished with remnants of an affluent past, he became a ubiquitous fixture at Rosenberg and Tabak's parties. They valued his take on "new books and ideas that were being talked about."[10] Additionally, "he knew famous people in all the arts . . . performing an intellectual cross-pollination."[11] Rosenberg felt that Weinstock's poetry was "old hat," but considered him part of the "milieu of avant-gardism."[12]

Tabak in her reminiscences never mentions Weinstock's commitment to the Communist Party. His political views were public by the time he became an assistant editor of the *New Masses* in 1934 and later at *Art Front*. His political affinities and outmoded poetry, however, were redeemed by his unorthodox dress, lifestyle, and notable sphere of contacts, as well as his loyalty during the trials of the Artists' Union. By 1938, however, Weinstock recedes as a friend and never appears in Rosenberg's tales of his entanglements with the union. His idealization of the Soviet Union eventually became insurmountable, with the Moscow Trials taking a toll on many of his relationships.

Sometime in late 1937 or early 1938, while Rosenberg and Tabak still lived on West 14th Street, Tabak met Clement Greenberg at a party his cousin, Sonia, gave in the West Village.[13] Rosenberg had stayed at home to write. Greenberg offered to escort Tabak back to their apartment. She found him shy, but when he claimed to admire Rosenberg's work and expressed interest in meeting him, she invited him up for tea.[14] Tabak recounted that their initial exchange was brief: "He shook hands . . . but he didn't sit down. Clem said that he had to go home because he lived in Brooklyn . . . and had to take a subway."[15] Like Weinstock, Greenberg lived with his parents. Tabak reprimanded him for the arrangement, knowing that he came from

a middle-class family and worked as a clerk for the US Customs Service. He could afford a place in Manhattan.

Just as Rosenberg and Tabak were about to leave for Washington, DC, Greenberg moved to a room on West 17th Street. At the time, he conceded that he had "not a single passion. Only the Moscow trials bring me alive, and social intrigue in Greenwich Village as between the Stalinists and the Trotskyites."[16] His apathy soon abated with access to a politically like-minded group of writers. He socialized with Rosenberg and Tabak in the few months before they left New York, stating that he "sat at Harold's feet . . . I'd sit enthralled by him . . . He was a great conversationalist, a great monologuist."[17] By this point, Rosenberg was established professionally, and his contributions to *Poetry, Symposium, New Masses, Partisan Review*, and *Art Front*, as well as *The New Act*, were all known to Greenberg.

Greenberg must have made a favorable impression on Rosenberg, for he introduced Greenberg to William Phillips and Philip Rahv, as well as to Lionel Abel and Lee Krasner, before he left town. Tabak asked Krasner to look out for Greenberg, as he "was very lonely." Krasner initially balked at her request, finding Greenberg repugnant and "too ugly."[18] With his bald pate and less agile form, he was no match for the Adonis Pantuhoff, let alone his charm. But Krasner kept her promise to Tabak and saw that Greenberg was integrated into her circle by introducing him to Hans Hofmann. Greenberg not only attended several of Hofmann's Friday-evening lectures but enrolled in life drawing classes that Pantuhoff gave that were sponsored by the WPA, just as his disappointment with Hofmann's pedagogy was mounting. Greenberg was held by Krasner's ambition, her avid study of art, and her keen eye. But he found her to be "self-centered" and "uncouth,"[19] her assertive nature off-putting, obstacles he could never reconcile.

intellect forbids party bias in literature

In the spring of 1937, Rosenberg was reassigned to the Federal Writers' Project. His stint as de Kooning's assistant on the WPA ended with the artist's decision to leave the Mural Division when Martin

Dies, a militant anticommunist congressional representative from Texas, acted to regiment the WPA by forcing its employees to punch a time clock to eliminate truancy. As a foreigner, de Kooning did not want to risk deportation. The following year, Dies's initiative was officially incorporated as the House Committee on Un-American Activities (HUAC, also known as the Dies Committee), which he chaired, to probe the backgrounds of artists, writers, and actors with suspected links to the CPUSA.

Henry Alsberg, a noted journalist and playwright, was the founding director of the Federal Writers' Project. He approached Rosenberg to work as an editor on an anthology of writing by WPA members that became known as *American Stuff*. Alsberg, who was connected to radical politics in the 1910s and 1920s, and a friend of Emma Goldman, had once openly advocated anarchy. But his aversion to any expression of conformity was mitigated by the onset of the Depression. As Jerre Mangione, the coordinating editor of the Writers' Project, observed, Alsberg "softened his antagonism toward middle-class values, [which] enabled him to take a job with the inner core of the American establishment, the government itself."[20]

American Stuff was conceived by Alsberg to offset the "semi-utilitarian character"[21] of the American Guide book series, the showcase of his division, which employed writers in each state to document the cultural histories of their state's cities, industries, topographies, and scenic attractions. Unlike the American Guide books, *American Stuff* was composed of short stories and poems by a regional cross-section of fifty writers that included Abel, Roskolenko, Weldon Kees, Kenneth Rexroth, and Richard Wright, in addition to "Americana" taken from recordings of Negro spirituals and square dance calls. The volume represented the combined efforts of Alsberg, Mangione, and Rosenberg, with each editor contributing equally to the content to ensure the "creative element."[22] *American Stuff* was a considerable success and generated positive critical reviews, largely by appeasing contentious factions within the Writers' Union through its judicious, national spread of entries. Alsberg felt encouraged to launch a namesake magazine to span the life of the project and draw on the same geographic and ethnic diversity. He made Rosenberg

the editor of the new serial. However, the first and only issue incited considerable dissent within the union, which forced Rosenberg's departure from New York and the demise of the magazine.

Under Rosenberg's direction, the *American Stuff* magazine immediately became a site of conflict. A rift developed when the Writers' Union demanded that he publish socially conscious literature that would appeal to a broad audience. At stake was Rosenberg's literary model for *American Stuff*—the "little magazine" that had been his introduction to publishing. As a modernist entity, it rankled the populist factions of the union. But in this case, unlike his enforced departure from *Art Front*, Rosenberg had a powerful protector in Alsberg, who remained on the job until he was pressured to resign in 1939. (His agenda for the project became too leftist for the Roosevelt administration.) Before the sole issue was published, Rosenberg was accused of cronyism for appointing Abel and Roskolenko as associate editors. The union, which closely monitored the activities of the project, insisted that all three men be removed from the masthead. Yet their objections had more to do with the trio's Trotskyite leanings than with their camaraderie and tight friendships.[23] What the union really wanted was representation from the Communist Party on the editorial board.

Alsberg intervened and retained Rosenberg, but installed Fred Rothermell and George David Petry, who were both novelists, in the associate positions. Petry, an African American mystery writer originally from Louisiana, was a communist sympathizer and endorsed by the union, but unknown to them he was also a friend of Rosenberg's. (Petry's writing was never published, unlike that of his wife, Ann, who later become a distinguished author: her first novel, *The Street,* sold over a million and a half copies, setting a record for a work by a Black woman.)[24] Rothermell, by contrast, was described by Rosenberg as a "republican WASP"[25] whose work was shaded by Sinclair Lewis. Alsberg calculated that the threesome could assuage the various constituencies of the Writers' Project. They proved to be a congenial team, but continued to induce the wrath of the union, whose real agenda was to gain control of the magazine. The union had never been able to produce a publication such as *Art Front,* even

though the first American Writers' Congress had a mandate to finance the venture; its internal rows always stymied agreement on editorial appointments and content.

The single issue of *American Stuff* appeared in the spring of 1938 as a special edition of *Direction*, another "little magazine," edited and published in Darien, Connecticut, by Marguerite Tjader Harris, a former secretary of Theodore Dreiser. Rosenberg managed to weave Abel and Roskolenko into the volume, as well as Kees and Rexroth—all carryover writers from the anthology. In addition, several slave narratives were included that had been recently transcribed by Elizabeth Lomax, a folklorist employed by the WPA (who with her husband, Alan, was responsible for recording the songs of many musicians from the South to preserve a rapidly disappearing area of American culture). The combination of texts in *American Stuff* was meant to test the prevailing canon of literature. In his editorial, titled "Literature without Money," Rosenberg focused on the noncommercial nature of the "little magazine" by snubbing mainstream writing and the textual changes made by mass-media magazines to gain wider readership. He bemoaned that subversive subjects lay outside their purview, arguing that "a tie-up exists between the progress of literature and the continued vitality of the non-profit periodicals."[26] As evidence, he noted that James Joyce, Ezra Pound, Gertrude Stein, and William Carlos Williams still wrote for "little magazines" while deriving their income from outside sources.

Response to his salvo was explosive, and the Federal Writers' Local of the Workers Alliance of America called for his removal as editor. Dorothy Kaufman, the executive secretary, formally complained to Alsberg that Rosenberg's editorial and overall orchestration of *American Stuff* "was inconsistent not only with our literary standards, but with our trade union position." She protested that "Mr. Rosenberg embodies within one person not only certain methods of work which make cooperation impossible, but also a social point of view toward literature and especially toward this type of magazine, which is inconsistent with our forward-looking policy of building cultural strength through cooperative and collective methods."[27] Rosenberg's unwillingness to collaborate with the union, and

publish the social realist writing that the Communist Party favored, was not the sole cause of the magazine's failure, however. He had made a concession to the party by including a poem by A. T. Rosen, a young, pro-Stalinist writer, much to the chagrin of Alsberg, who bridled at Rosen's title, "Proletarian Spring," and his political innocence. His communist awakening was an embarrassment to Alsberg. Notwithstanding its rhapsodies, Rosenberg felt that the poem was decent enough for publication, providing a needed counterbalance to Kees, Rexroth, and others. Despite his disinclination to print the work, Alsberg reluctantly acquiesced to Rosenberg.

Rosen became aware of their differences and carried the news back to a union meeting where Rosenberg was denounced as a "dictator."[28] Rosenberg conceded, "That lousy kid was the one that put the finger on me,"[29] and who was responsible for his downfall as editor. Whatever the fallout, he liked the description "dictator." As an editor, he felt entitled to print what he wanted. He had already made a few grandiose claims about the journal's novelty and marketing potential in a letter to Kenneth Burke, when he wrote that he had produced "something new . . . almost one might say a popular literary magazine."[30] As editor, Rosenberg thought the schism with the union was necessary, that its membership was much like the "dummies" he had encountered at the Artists' Union. Alsberg stepped in to contain the ruckus by offering to appoint Burke as editor-in-chief of *American Stuff* and demote Rosenberg to deputy or managing editor on the second issue. Even though Burke was not employed by the project, Alsberg knew that he would be embraced by the Trotskyite and Stalinist factions of the union, having survived his initial ordeal with the Communist Party at the first American Writers' Congress. His proposition failed to placate Kaufman and the Federal Writers' local, however, who tried to sabotage the first issue by blocking its distribution in Manhattan (with its large concentration of writers). Rosenberg's modernist predisposition would still prevail, they countered; he could not be controlled by any superior, let alone Burke.[31]

Burke was deluged with threatening letters from members of the union who urged him to maintain public solidarity by resisting affil-

iation with the magazine. While he left amid the skirmish to take up a teaching position at the University of Chicago for the spring quarter, he admonished Rosenberg to adopt a more judicious editorial position for any subsequent issue and set aside his differences with the C.P.[32] Burke's advice was another installment in their ongoing discussions on Stalin. He still yielded to the Soviet Union, not ready to admit to the damage the Moscow Trials had caused within an international community of intellectuals. Rosenberg would never let up on the rigidity of the party, particularly its refusal to assent to the writer's subjectivity. He shot back a disclaimer to Burke that his standoff with the union was an act of conscience, rather than an ideological clash:

> You impartially accept the idea that this is a political controversy — the C.P. on one side, myself acting politically on the other. Nothing could be further from the truth. You know to what extent my political notions, not tied to any discipline or organization, being purely a function of contemporary thinking, of contemporary intellect, could influence my literary selections. Intellect forbids the acceptance of C.P. domination over itself, but this time intellect forbids also political bias in literature.[33]

Even though Alsberg could not convince Burke to serve as Rosenberg's boss at *American Stuff*, he felt that he could rescue the magazine from the aggressions of the union. He took the initial steps to move the magazine to Washington, DC, where the Communist Party had few members, most of whom were silenced into posing as Roosevelt loyalists on the New Deal. (Any smattering of solidarity between the Roosevelt administration and the party had dissipated by 1937. The Popular Front was unable to make a dent on FDR, who no longer required its votes to sustain his political appeal.) Mangione recounted in his memoir of the Federal Writers' Project that Alsberg "would have persisted in his effort," but in September 1938 the Dies Committee interceded and targeted the Theatre and Writers' Projects for links between employees and the party. So he

"quietly abandoned his plans for the magazine,"[34] not wanting to subject any writer's politics to public scrutiny.

one vast flatbush

Rosenberg's job became impossible to endure in the adverse surroundings of the New York office of the Federal Writers' Project, and he was relocated to Washington, DC, in spring 1938. As he explained long after the furor subsided, "the only way out for Alsberg was to kick me upstairs."[35] In the wake of Representative Dies's communist probes, he was appointed the national arts editor of the American Guides book series. The hostile reaction to the sole issue of *American Stuff* had resulted in a flood of intimidating letters and calls, much like the threats from the Artists' Union to subdue him and Meyer Schapiro. He had to leave town if he was to maintain his livelihood as a writer. Rosenberg's brother, David, who was a member of the Communist Party and a supervisor on the Federal Writers' Project, recalled that he phoned Harold at work one evening in early 1938, shortly after *American Stuff* was released, to warn him that he had "better not go home the usual way. Some of the guys from *New Masses* are laying for you at 34th Street."[36] As the New York offices of the Works Progress Administration were located on East 42nd Street, he found a circuitous route to the Village.

Rosenberg had published a few reviews and poems in the *New Masses* after he had left *Art Front*. However, his relationship with its editor, Granville Hicks, also unraveled during this period. He had favorably covered Hicks's biography of John Reed for the *Partisan Review & Anvil*,[37] but felt the author's commitment to the party was indefensible after Trotsky's assassination. Hicks had also meddled with a review Rosenberg wrote of Jules Romains's *The Boys in the Back Room*, a book that Rosenberg praised for its punchy title and the idealism of the collective *action* of seven friends who plotted to undermine bourgeois institutions, such as the church and the army. Rosenberg's piece was evidently too euphoric for Hicks, too enamored of self-actualization, and he lopped off the concluding para-

graph that expounded on the "poetry of actual living."[38] Compared to Rosenberg's altercation with Harriet Monroe over his handling of the first American Writers' Congress for *Poetry*, which had also grown out of an editorial intervention, the episode with Hicks was more deeply partisan. Not only was Hicks an avowed communist but he was also physically aggressive. He dispatched the goon squad to meet Rosenberg at 34th Street, their goal to extract revenge for his modernist sins as the editor of *American Stuff*.

David Rosenberg was antipathetic to *American Stuff*, unable to uphold his brother's emulation of the "little magazine" to his pro-Soviet colleagues on the Writers' Project.[39] While he did not want to see Harold harmed, their political differences weighed on their once close relationship and shared interests in poetry. David could never transcend his communist fealty; he remained perpetually marked by the politics of the 1930s. While he continued to write until his death in 1962, his work went unpublished, a circumstance that also added to the distance between the two brothers, especially once Rosenberg became the ascendant sibling. Regardless of their mutual childhood enthusiasm for books such as Palgrave's *Golden Treasury*, modernist preoccupations with subjectivity ironically intervened in their relationship. The Writers' Project had given David his only shot at recognition, especially in his role as a supervisor. With the collapse of the agency in 1943, there were few subsequent professional outlets for him. He struggled at odd jobs, including a stint at the Camino Gallery, but was largely supported by his wife, Teresa, until they divorced.

Apart from his brother, Rosenberg's independence from the CP tested many of his other relationships, causing breaches not only with Stuart Davis and Clarence Weinstock, who had abetted his career as a critic, but also with Mike Gold, Joseph Freeman, and Granville Hicks at the *New Masses*. He left New York to remain employed and to keep his identity as a writer intact. The project represented his only option, especially as he had Alsberg's back. His relocation to Washington, DC, drew down the contacts that he had made in the literary community in New York. With the demise of *transition, Blues, Symposium*, and *The New Act*, none of which survived

the Depression, opportunities for publishing his poetry and reviews dwindled. Leaving Manhattan meant that Rosenberg went into literary exile, a dispiriting recourse for a young writer whose work had just acquired visibility. *Poetry* magazine, under the brief stewardship of Morton Zabel, would remain an occasional home for his writing. Zabel's successor, George Dillon, would also keep Rosenberg on as a periodic contributor into the early 1940s. But in the end, Monroe emerged as his primary patron, responsible for publishing most of his submissions to the journal. Still, he met few of *Poetry's* stable of writers, most of whom were scattered internationally. The publication had provided him with a forum but not a network.

Just as Rosenberg was about to leave New York, *Partisan Review* rematerialized after a brief period—rethought, recapitalized, and disconnected from the John Reed Club largely through the initiative of William Phillips and Philip Rahv. As the Moscow Trials wound down and Trotsky fled to Mexico—events that would break the Popular Front—Phillips and Rahv, with Dwight Macdonald, Mary McCarthy, George L. K. Morris, and Fred Dupee, hoped to establish a niche for a political and cultural organ that could withstand the onslaught of the Writers' Union. Rosenberg left the city at a critical juncture, then, just when he might have assumed a role at *Partisan Review*. Although he had alienated a huge faction of the Communist Party, Phillips and Rahv were agile mediators, particularly since they had their own misgivings about the ideological thrust of the party. They had known firsthand its willful misuse of the *Partisan Review & The Anvil* when they were editors. Once their new journal was launched in December 1937, they were exposed to the tabloid vitriol of the *New Masses* and the *Daily Worker*, where they were denounced as "lackeys of capitalism, informers, running dogs of imperialism, literary snakes, enemies of the working class, and Trotskyites"[40]—the same type of epithets hurled at Rosenberg. (Dupee had defected as literary editor of the *New Masses* and Macdonald from *Fortune* magazine, which brought on clichés relating to them being turncoats and minions of big business.)

Rosenberg seemed to fit with their ethos, especially given their mutual hostility to Stalin and the local chapter of the CPUSA. The

editors had stated in the first issue that their goal was "to represent a new and dissident generation in American letters; [that] will not be dislodged by any political campaign against it . . . [and] will be open to any tendency which is relevant to literature."[41] Ostensibly, Rosenberg would have been able to conform to their editorial mandate with no sense of violation to his Marxist credo. But he had had earlier innings with Phillips and Rahv before their epiphany about communism in late 1936. (Rahv had been briefly a member of the Communist Party in 1934, which continued to fuel Rosenberg's suspicions.) He had an ally, however, in Dwight Macdonald, who wanted to bring him into the fold, believing him to be kin. Macdonald responded to a letter that he received from Rosenberg soon after the latter arrived in Washington, DC, affirming:

> I know how you feel about Rahv and Phillips and I know why you feel so — since, to a large extent, my reactions are the same. But I don't think you would deny they are extremely intelligent (admitting serious limitations), and I have lately found that, with a certain amount of tact, patience and persistence, one can work with them quite satisfactorily. And it seems a great pity, considering how really good minds "our" group (I say "our" since, politically and intellectually, you seem to have much the same outlook as we of PR do) can command — it seems too bad to have you split off from us by personal animosities.[42]

Rosenberg met Macdonald in New York just before he left to take up his post at the American Guides series. He must have conveyed his loathing of Phillips and Rahv, and cast doubt on *Partisan Review*'s combined literary and political emphasis, wondering how Marxism would fare since it had been sprung from Soviet-style communism by the editors. He wrote to Macdonald to ask about the summer schedule, curious about the publication's headway and its "general outline."[43] His letter also dwelled benignly on his reactions to Washington, DC, which he pictured as "America's white collar splashed with a gravy of negro slums . . . an Uncle Sam version of the Magic Mountain — crazy weather, mildly feverish bureaucrats, rou-

tine and peace. Of course, without metaphysics—that's the Uncle Sam part."[44]

Rosenberg had last seen Macdonald and Phillips at a lecture delivered by Thomas Mann at Carnegie Hall to a huge crowd and standing ovation in May 1938. The German author had immigrated to the United States a few months earlier to teach at Princeton University as a visiting scholar.[45] Rosenberg retained a vivid image of Macdonald with his wife, Nancy, who was the business manager of *Partisan Review*, Phillips, and Eleanor Clark (a novelist and friend of Mary McCarthy's from Vassar who became a contributing editor of the magazine), in a box at the venue. It was one of his last nights in Manhattan. The phalanx of writers and editors from *Partisan Review* imparted an aura of intellectual power and solidarity that was new to him. Macdonald may have written for *Fortune* magazine before *Partisan Review*, but his ardent commitment to literary criticism was palpable, something that Rosenberg had not experienced at *Art Front* or *American Stuff*. That he was genteel, had been educated at Yale, and had grown up in privilege on Riverside Drive in Manhattan was inconsequential to Rosenberg; Macdonald had been radicalized during the Depression, in part by tussling with the editors at *Fortune*, who had tampered with a four-part essay he penned on U.S. Steel that indicted its huge monopoly. They had wanted a more uplifting account of corporate ingenuity, not one that brought Karl Marx to the table. He quit the magazine, and his considerable salary, out of principle. To Rosenberg, that demonstrated integrity. (During this transition, Macdonald began to sport a mustache and goatee, which made him look like Trotsky.)

Rosenberg had attended the lecture with Parker Tyler and Lionel Abel. Characteristically, Tyler wrote off Mann that evening as an "uninteresting thinker, might as well be dead, though he's a nice reassuring ornament as a propaganda for art."[46] His reservations no doubt built on conversation after the event, and the fun the threesome always had in mocking mainstream literary figures. A few weeks later, however, once Rosenberg arrived in Washington, DC, Tyler was struck by how Rosenberg felt isolated and cut off from his friends and contacts in Manhattan. He depicted the city to Tyler as

"one vast Flatbush,"[47] a trope for the desolation that he had felt as a child in Brooklyn.

Rosenberg's allusion to Mann's novel *The Magic Mountain* in his letter to Macdonald was more than literary shoptalk, or a simile for the nation's capital. The reference was telling, part of a dialogue that he wanted to initiate to keep his discourse with Macdonald alive and running. He had been at work on an essay on Mann that was kindled by the extraordinary press coverage of Mann's exile and lecture tour. He had submitted the piece without success to the *Virginia Quarterly*, *Life & Letters*, and the *Southern Review*. Macdonald was undaunted by these setbacks and felt he could act as an intermediary for the article at *Partisan Review*. He recognized that his own political views were closer to Rosenberg's than to those of his editorial colleagues. Macdonald's Marxism had become more reform-based and original during the late 1930s, not nearly as doctrinaire. He had found, like Rosenberg, some accommodation for the individual within Marxism. As he paved the way for Rosenberg's reintegration into the journal, he admonished him that "whatever may be said about Rahv—and a great deal can be said—he is intensely interested in the same things that you are, and I have never known him to let his personal feelings interfere with his editorial judgement."[48] He later amended his characterization of Rahv's ascribed objectivity, when he learned that Rahv's growing aesthetic interests were accompanied by endorsement of American intervention in World War II. He could not square Rahv's position with his own pacifism. Some contradiction existed in Rahv's revised discussion of beauty, he thought, that deflected promotion of the allied forces abroad.

Shortly after the magazine was remade, friction erupted between Macdonald and Rahv that related to *Partisan Review*'s identity. Could a balance of art and politics be achieved in the journal? The conflict stretched over five years, allowing Macdonald to successfully pull Rosenberg back into the journal and become his editor and ally.

7
myth and history
partisan review

partisans reviewed

William Phillips and Philip Rahv had carefully crafted an editorial
position for *Partisan Review* (or *PR,* as it was colloquially known)
that asserted the magazine would retain its Marxist stance and keep
the discussion on socialism alive. But little of the analysis of art and
literature continued to be dialectical after the journal was revamped
in 1937. For one thing, George L. K. Morris, an artist, writer, and
collector, as well as a founding member of the American Abstract
Artists group (chartered in 1936), had been brought into *PR* as an
editor and art critic, as well as its silent financial backer. He funded
the periodical until 1942. Through his exhibition reviews and inter-
views with artists such as Charles Demuth, Jean Hélion, Fernand
Léger, and Georgia O'Keeffe, Morris openly acknowledged his ap-
plication of the British theorist Clive Bell's idea of *significant form*
to their work. He took it for granted that the modernist artist was
devoted to extending Cubist pictorial inventions, and that art was a
self-referential object, cut off from a wider culture.[1] Morris's writ-
ing would set the tone for most of the art coverage in the magazine,
paving the way for the formalism of Clement Greenberg. Moreover,
other contributors, such as James Johnson Sweeney, a curator at the
Museum of Modern Art, adopted the same tack.

Morris was not a Marxist, let alone one whose faith had begun
to lapse, like Phillips and Rahv. As a member of a prominent New
York family, whose forebears included General Lewis Morris—a
signer of the Declaration of Independence—he had no interest in
unsettling American history by becoming a socialist. As he justified

it, "at that point none of the artists, even the most radical ones had any interest in politics."[2] With his patrician background, fashionable apartment on Sutton Place, and homes in the Berkshires and Paris, Morris's lifestyle was notably at odds with the hardscrabble upbringing of his peers, save for Macdonald who had been his classmate at Yale. Morris was married to Suzy Frelinghuysen, an opera singer and artist, who also was descended from a prerevolutionary political dynasty. (Her grandfather had served as secretary of state under President Chester Arthur, and she came from a long line of senators and congressional representatives.) They staged elegant dinner parties that drew on the likes of A. E. Gallatin, who founded the Museum of Living Art at New York University, Geoffrey Hellman of the *New Yorker*, Piet Mondrian, and James Johnson Sweeney. But their social lives rarely overlapped with the *PR* editors, who congregated in the noisy bars and downtown cafeterias where liquor, even at five cents a shot, was expensive. Rahv, in particular, had experienced the breadlines of the Depression and had slept on park benches, a sharp contrast with Morris's privilege.

As Rosenberg's correspondence with Macdonald unfolded, *PR*'s commitment to Marxism was questioned by Leon Trotsky, who played a brief role in the journal's overhaul. He had been invited by Macdonald to publish "Art and Politics," which ran on the eve of his assassination in Mexico in 1938. Trotsky's tract was avowedly anti-Soviet, just what the editors wanted. But it also braided politics to culture, as his earlier book, *Literature and Revolution*, had done. "Art, which is the most complex part of culture," he wrote for *PR*, "the most sensitive and at the same time the least protected, suffers most from the decline and decay of the bourgeois society."[3] To Trotsky, movements such as Cubism, Dada, and Surrealism had achieved little outside of illustrating the decadence of the middle class. They possessed a pictorial "violence"[4] that was incapable of revolutionary change. The artist's best shot, he concluded, was to forge connection with the working class, which still awaited its political moment.[5]

Trotsky was baffled as to where Marx seeped into the journal. In a letter to Macdonald in early 1938, he demurred that "the editors of *Partisan Review* are capable, educated, and intelligent people but

they have nothing to say."[6] Phillips and Rahv would never admit that their Marxism was becoming academic. Unlike Trotsky, they argued that contemporary literature had experienced a setback through attempting an alliance with politics during the Depression.[7] Although both editors were with him on the issue of Stalin, Trotsky's political utopianism, especially his expectations for the working class, had little impact on their thinking. As they refurbished *PR*, they turned to T. S. Eliot to advance their embrace of an intellectual elite. Rahv now claimed that most left-wing literary movements in the 1930s had wrongly accommodated the Communist Party: vanguard literature had been made an unnecessary villain because it rebelled against preexisting conventions. Where he and Phillips had once written articles on Eliot for the *Partisan Review* that attacked, as Phillips put it, Eliot's "ecstatic espousal of the church, the state, an aristocracy of intellect, racial purity,"[8] these assaults eased into approvals of Eliot and literary modernism. In the wake of the Moscow Trials, they reversed course and admitted that Trotsky's idealism had been corrupted by Stalin after he put away and murdered thousands of Bolshevik intellectuals and writers. Stalin had failed to make the revolutionary components of art integral to his program. His only concession to culture was a dreary regionalism that exalted the proletariat. However, Trotsky failed to convince Phillips and Rahv that working-class culture was a site of invention, in large part because it yielded to populism.

Eliot was not the only figure that *PR* resurrected as the journal embarked on its anti-Stalinist crusade. By 1939, just as Rosenberg reemerged in its pages, the magazine began publishing the work of Allen Tate. Tate, who later served on the Bollingen Committee—when the award was made to Ezra Pound—was a Southern Agrarian poet-critic, a self-described reactionary, whose political views were regressive, just like Eliot's. He expressed his views with less subtlety, however: for example, he had questioned the wisdom of abolition and upheld the institution of slavery in many of his poems and essays from the late 1920s onward.[9] As an adherent of formalism, where racism was easier to hide, Tate became associated with the New Criticism, which was patterned after Eliot's model

to expunge biographical references from literary interpretation. He was also a convert to Catholicism, adding to his symmetries with Eliot's pieties.[10]

Phillips and Rahv had taken a swipe at Tate's work in the mid-1930s, bemoaning its detachment and concentration on textual issues. Yet, by the end of the decade, their quandary over politically engaged writing, at least in the sense of realpolitik, gave way, and Eliot's literary classicism and moral *criterion* became part of the journal's refashioned editorial mission. In 1939, Rahv averred, "From *René* [by de Chateaubriand] to *The Waste Land*, what is modern literature if not a vindictive, neurotic, and continually renewed dispute with the modern world."[11] The real revolution, as it turns out, had always been private and internal. While *Partisan Review* took on several new poets and writers in the late 1930s and early 1940s, such as Delmore Schwartz, Elizabeth Bishop, Saul Bellow, Karl Shapiro, Randall Jarrell, Robert Penn Warren, and Robert Lowell, the "souvenirs of past experimentations"[12] continued to appear in the journal. Older figures, such as Eliot, Marianne Moore, Wallace Stevens, and Tate, were published with equal frequency, establishing a continuum with the younger authors. Consequently, Macdonald, a self-proclaimed Trotskyite, would leave *Partisan Review* by 1943 to found *Politics*, a publication that retained discussion of the intersections between radical thought and culture. With Macdonald no longer present as a counter-voice in their editorial meetings, *PR* settled into conceptual sameness. There was little difference of outlook in its pages.

thomas mann: a traveling salesman for democracy

Shortly after moving to Washington, DC, Rosenberg began corresponding with Macdonald on the contents of *PR*. Their letters initially centered on a new editorial section, "This Quarter," which was inaugurated in the fall of 1938 when the journal was forced to become a quarterly, having exceeded the funds that George L. K. Morris had pledged for the year.[13] Their letters also touched on Rosenberg's unpublished essay on Thomas Mann. Rosenberg was curious

about Macdonald's reaction. As it turned out, Mann became the agency for his comeback at the journal.

Unknown to Phillips, Rahv, and Dupee (who left the journal in 1940 to teach, eventually landing at Columbia University), Rosenberg operated as a sub rosa reader for Macdonald's first opinion piece for "This Quarter." His feedback extended well beyond Macdonald's solicitations. In short, he was unable to stifle his instincts to redo the journal entirely. Macdonald handled Rosenberg's recommendations with equanimity. He apprised him of some of the topics that he and his colleagues entertained for the section, such as Neville Chamberlain's betrayal of Czechoslovakia to the Third Reich through the Munich Agreement of 1938, and the implications of this concession for vulnerable borders, such as those of France. Additionally, the humanism of Thomas Mann and Albert Einstein, both of whom had made the refugee problem or "Jewish problem" part of their antifascist crusade in America, were floated as possibilities. The opportunity to castigate the US Immigration Service and its inflexible quotas was not lost on Macdonald, who considered it worthy of a column for "This Quarter"—although nothing on the subject ended up in the journal.[14] He became too embattled with his colleagues, unable to bring about consensus.

As Rosenberg now lived afar, he was not privy to the infighting at the editorial meetings at *PR*. His sense of the journal was shaped largely by the issues that Macdonald sent him and from information passed on in his letters. In the fall of 1938, as the journal embarked on its new short opinion pieces for "This Quarter," it was ready to jettison long-form political coverage. Moreover, both Phillips and Rahv wanted to enact the literary standards outlined in their inaugural editorial that tied radical politics to literature. The journal had been forced to abandon its monthly format, and space for articles was at a premium. Their original mission now became urgent.

Rosenberg approved of *PR's* new subtitle, "A Quarterly of Literature and Marxism." He also anticipated meaningful connection between the two areas. However, he complained to Macdonald "that the magazine has a long way to go in the field of editing."[15] He was particularly put out by an article in the June issue on Thomas Mann

by William Troy, a literary critic for *The Nation* and faculty member at Bennington College. He wrote to Macdonald that Troy's piece was "inappropriate to a left-wing magazine,"[16] implying that its aesthetic treatment of Mann's writing diluted the journal's politics.

When Macdonald asked Rosenberg for comments on a draft for his first round of columns for "This Quarter," Rosenberg responded that the editorials were too freestanding and unrelated. Moreover, they had no bearing on the articles that followed. Instead, he suggested, an overarching narrative should be adopted that could stitch together and "root up ingenuously the major mounds of horseshit in current happenings."[17] As it was, there was no linkage between Chamberlain's actions and Mann's humanism. He threw out a theme, such as "illusion and delusion in public affairs, from semantics to the refugee problem."[18] Macdonald replied that his

> critique was extremely good . . . but extremely impractical. I pirated shamelessly a couple of your comments on the semantics piece and added then as grace notes, enriching no end the main theme . . . But beyond that, I'm afraid that your considerable pains were wasted so far as concrete results went. Your conception of having each issue's editorials center around a dominant theme is a brilliant one — and I can even imagine something very nice being made on the specific theme you suggested. But, alas, the edifice was practically built along other lines, and short of tearing it down and beginning from the ground up . . . I see nothing that at this date could be done.[19]

Although Macdonald had little use for Rosenberg's suggestions, he pressed his associates on Rosenberg's article on Thomas Mann, and for his renewed presence in the journal. Rosenberg had difficulty finding a home for "Myth and History," his account of Mann's corpus after rereading *The Magic Mountain*. He never disclosed his setbacks with other publications to Macdonald, however. Instead, he conveyed that his piece "would do more good in one of those mags [*Virginia Quarterly, Southern Review,* or *Life and Letters*] than in the Partisan, which seems to be featuring Mann essays anyway,"[20]

a stance that enabled him to retain his pride while averting rejection from Phillips and Rahv.

Macdonald had written to Rosenberg that he "was very much impressed by [his] Mann article. It seems to me by far the best thing I've ever read about Mann, as well as one of the most brilliant pieces of Marxist criticism I've yet seen."[21] He informed Rosenberg that he had shown it to Dupee and Rahv, who were "equally enthusiastic."[22] Still, the journal held off making a commitment to publish the article. As Macdonald explained, Phillips had just completed a piece that "covered much the same ground as yours," although he thought it was "incomparably less adequately."[23] Rosenberg knew there had been a surfeit of coverage on Mann in the *Partisan Review*. Not only had Phillips written an essay, but the editors had commissioned a two-part series by Troy, the initial installment of which prompted Rosenberg's dim reaction. But aside from Macdonald finding Phillips's text deficient, there was overlap with Rosenberg's handling of Mann, making another contribution seem redundant. Both writers were disdainful of Mann's "high-minded humanism,"[24] as Phillips called it, and demanded a new literary paragon liberated from myth and symbolism. Unlike the diseased characters who were the stock of Mann's fiction, both Phillips and Rosenberg wanted evidence of transcendence, rather than defeatism, in contemporary writing. Additionally, they both focused on Mann's disregard for history, which Phillips felt made Mann's work prey both to communist leaders and the middle class who had taken up his rhetoric of humanism. (Rahv had announced in 1934 that the middle class was in "decline,"[25] an observation that continued to inform the editorial position of the *Partisan Review*.)

Rosenberg never commented on Phillips's article to Macdonald, at least not in his letters, not wanting to admit to any duplication. Still, he chided Macdonald on his management of both Mann and Einstein in his draft for "This Quarter." He cautioned that his take was "too journalistic," that he had he failed

to come to grips with the intellectual situation of these men . . . instead you take a kind of respectful "Come now, gentlemen,"

attitude of repudiating their politics—great men, but politically cockeyed; and this doesn't prove anything . . . Mann wants to restore culture to Europe by preaching barbarism (war) in America. Einstein lays the blame for war on the masses and gives credit for creation only to great men: but great men are scarce in America compared to, say, Germany.[26]

Einstein was left out of Macdonald's column in the end, but not through Rosenberg's urging. His political views were anything but "cockeyed" and, apparently unknown to Rosenberg and Macdonald, left-leaning. Dupee, Phillips, and Rahv must have questioned the attribution in one of their meetings. Einstein, as they no doubt understood, had openly opposed World War I, had an in-depth knowledge of the writings of Lenin and Trotsky, and had not disguised his antagonism to the militarism of the *revanchist* factions of the New Germany in 1933. (He did, however, become a patriot during the war, long after Macdonald's proposed editorial.)[27] Despite Macdonald's takedown on Einstein, and Rosenberg's equally naïve response, the "refugee problem" was never addressed in the debut of "This Quarter." For an intellectual journal such as *PR*, this constituted a grave omission.

Macdonald confessed to Rosenberg that his colleagues concurred that his columns on Mann and Einstein were "too journalistic," that more critical analysis was in order. He wanted Rosenberg to know: "I'm afraid however that I talked them into letting me run a toned-down version of the Mann piece . . . I feel that since we've printed so much on Mann of a laudatory nature and since he occupies a commanding position in the intellectual world, when he lines up with the warmakers, we must try to warn people off him . . . by direct attack."[28] For all Rosenberg's reservations, Macdonald described Mann as a "traveling salesman for democracy."[29] Outside of his flip description, he deftly unpacked the political inconsistencies that ran through Mann's American lectures, as well as his earlier published statements. On Germany's annexation of Czechoslovakia, for example, he quoted Mann as stating, "I was always for peace . . . But I must confess that it would mean a defeat of the ideas of democ-

racy to accept this crime against Czechoslovakia without the strongest resistance."[30] Macdonald tagged his editorial "Reflections on a Non-Political Man," a twist on *Reflections of a Nonpolitical Man,* which Mann had written on the eve of the new Weimar Republic in 1918 when he refrained from supporting the new parliamentary government.[31] For Macdonald, the contrasting stances were too paradoxical.

Macdonald's witty title must have grown out of an editorial meeting that ransacked the ambiguities in Mann's politics. It also rebuked the German author's humanism, which Macdonald felt had devolved into "political doctrines of the most dubious kind."[32] Mann was guileless about politics, at least by the standards of the *PR.* His deference to mythology had provided no realistic assessment of contemporary political issues. With no structure in place such as Marxism, his writings and lectures were overly fatalistic, never positing a dynamic for social change. For many American intellectuals, this limitation was disappointing. His disdain of fascism in the late 1930s was never taken seriously by *PR,* construed as too abstract and sketchy. Modernism had moved on, the editors reasoned, radicalized by the example of the working class. Mann's Old World stance was but a romantic dead end.

Mann became one of *Partisan Review*'s more prominent victims. As the journal sorted through its commitment to "literature and Marxism," his vindication of capitalism and regard for American democracy triggered a more than yearlong tirade from the editors. He was an easy mark, however. As Rosenberg put it, his celebrity in the United States made him a "sacred cow."[33] In short, he was someone upon whom the editors of the *PR* could hang their antipathy by reducing his speeches to a withering morality.

Mann never did respond publicly to the coverage in *PR.* The journal was probably too peripheral. He did, however, write to Macdonald after the latter sent him a copy of the fall issue. Macdonald conveyed to Rosenberg that Mann's letter contained "a long argument against my editorial therein."[34] In the extensive publicity that attended his American lectures, Mann had been forthright about being uncomfortable in his role as a champion of democracy, knowing

that his own political awakening happened through aversion to the Weimar Republic. Moreover, his identity as a democrat had come about reluctantly, through a desire to preserve a golden age in German culture.[35]

scapegoats for a schizophrenia society

In addition to Macdonald's editorial, *PR* published four articles on Mann, Phillips's included, as well as a few rebutting letters, in the short span of four months. The intense focus on a single author accounted for Rosenberg's hesitation to partake in the fanfare, even though he had yet to find a publisher for "Myth and History." He wrote to Macdonald shortly after the first of William Troy's two-part essay appeared in the June 1938 issue:

> I shall be indecent enough to say that I consider Troy's article on Mann as a fairly worthless piece . . . Troy has the academic habit of subjecting his terminology to that of the writer he is criticizing and translating his "philosophy" into more specific and less ambiguous terms. In order to evaluate these ideas it is necessary to cut across them with new values, and this T seems incapable of doing.[36]

Rosenberg got to the nub of Troy's adulation of the exiled writer and was unsparing in his disapproval. However, unknown to him, Troy had also become a scapegoat for *PR*.[37] His two lengthy contributions on Mann were used to sequence the "Mann debate," with the outcome that Rosenberg would be brought in to cap the polemic, his clear-headed essay on "Myth and History" the endpoint.

Phillips clearly read Troy's reverential two-part study before he launched into his lead article for the May issue.[38] His own piece on Mann was driven by an agenda to underscore the new ideological thrust of the journal with its dual emphasis on literature and on social history. Like Rosenberg, he felt grappling with Mann was the responsibility of the public intellectual, especially in the face of widespread submission to Mann's literary authority in the American

press and his status as a Nobel Prize winner. The Nobel Committee was no doubt derided by Phillips and his fellow editors as a middle-brow institution, given that Marxist analysis had never been part of its criteria. That Mann's eminence was due to the robust bourgeois reception of his work had to have been alarming to Phillips, as a reversal for contemporary literature. It did not matter to him that Mann himself was equally uneasy about the audience for his work. After all, his image of the artist in novels such as *Death in Venice* doubled for his own conflicted relationship to social democracy.[39] This irony only inflamed the editors at *PR*. As Phillips argued in his essay,[40] Mann's mission to safeguard literature had ceded to pessimism that inhibited endorsement of any political party opposed to military insurgency in Europe in the early 1930s. His activism against Hitler and fascism was too stuck in the morass of metaphysics to be effective.

When it came to the refutations of Troy's admiration of Mann, Phillips stayed out of the fray, and let James Burnham take over. Burnham was a co-editor of the defunct *Symposium*, a noted Trotskyite, and one of the founders of the Socialist Workers Party. (He would give up on communism by 1940, however.) Burnham wrote off Mann's literary symbols as "both false and dangerous,"[41] wanting, like Phillips, more from Troy than justification of the writer's ailing characters. He felt a deeper probing of Mann's novels was needed, one that combined "psychological, anthropological, sociological, economic, phenomena."[42] As it was, Troy's tribute to Mann barely got beyond the "anthropological." Troy objected to Burnham's depiction, especially since the word smacked of the plodding methodology that Mann had studiously avoided. In his published reply, he countered that "literature had long been suffering from the ravages of what might be called the Scientific Fallacy in criticism."[43] Although Troy had used Freud to explicate the psychopathology of characters such as Hans Castorp in *The Magic Mountain* and von Aschenbach in *Death in Venice*, apparently his application was not vivid enough for Burnham.

The coverage on Mann at *PR* had been muddled from the beginning. Phillips had conflated Mann's novels, American lectures,

antifascist statements, and Troy's interpretation into one confusing bundle. Troy had focused on the author's understanding that his characters were substitutes or "scapegoats for a schizophrenic society, "[44] rather than on his wanting politics. Although Burnham had launched a major invective against Mann, his own target was the writer's revival of myth, and similarly one-sided. His hard-hitting questions aside, the connection between Mann's writing and diffuse politics remained unresolved and tied together.

Macdonald thought that Rosenberg could settle the score and cut through the assaults on Troy. He believed that Rosenberg could lift the discussion through analysis of the politics buried in Mann's fiction and the literary allusions in his lectures. Macdonald convinced his fellow editors to publish "Myth and History." But the essay did not appear in *PR* until the December 1939 issue, long after the Mann fracas had receded. It became more of a coda. Macdonald had thought that Rosenberg's lumbering prose style still needed work, delaying release of the article. He advised him to "erect more journalist signposts in the form of simple, clear expository paragraphs."[45] This time there was little quibbling with his editor.[46] Through the process, Rosenberg learned a great deal from Macdonald about writing: his language became more fluid, less stilted and clumsy. As they inched toward publication, Macdonald told Rosenberg that Mann had communicated that he was "looking forward to reading Harold Rosenberg's article in your winter issue,"[47] probably hoping for justice!

By the time Rosenberg's text was published, *PR* had moved on to topical issues, such as the Soviet invasion of Finland and the onset of the war. Ironically, it also now gravitated toward writers such as T. S. Eliot whose references to totalitarian governments were obtuse and devoid of censure. The literary criterion at *Partisan Review* was undergoing change, no longer enmeshed with politics. Even though Phillips and Rahv knew Eliot's lecture, *After Strange Gods*, was peppered with racist clichés of the Jew, they disregarded his right-leaning politics and hatred.[48] Eliot's far-reaching formal inventions were all that mattered. (Eliot later tried to suppress the publi-

cation of his lecture upon learning that it had been misused by the Nazi government.)

Rosenberg did rise to the task to settle the debate on Mann (fig. 9). Unlike his peers at *PR*, he found there were aspects of Mann's writing that were still relevant.[49] He was untroubled by the writer's repetitive symbolism and Freudian patterning (despite his own contrarian view of psychology). Rosenberg was drawn to Shakespearean archetypes, as well as to characters such as Settembrini and Hans Castorp whose *actions* he thought were still meaningful. Mann's analogical way of linking his fables with contemporary life, moreover, had "the intermittence of all forms of poetic and metaphorical insight."[50] Where he blundered was in his unwavering absolutism, which by the late 1930s had succumbed to "metaphysical propaganda."[51] If only he had considered a dialectical tack, his characters would have become more palpable and real.

There were also features of Mann's politics that Rosenberg considered radical and that teetered toward socialism. Unlike his colleagues at *Partisan Review*, he recognized that Mann had a lived experience of Hitler's manipulation of revolutionary politics. Their attempt to discount his early political neutrality was insensitive, too bent on undermining his retrograde romanticism. Rosenberg had read Mann's foreword to the first issue of *Mass und Wert*, an antifascist periodical he launched with a number of German émigré writers in Zurich in 1937, shortly before he was exiled to the United States.[52] The text, which had been translated and reprinted in the English literary journal *Life and Letters Today*, had also been consulted by Phillips to formulate his perspective on Mann's politics. But unlike Phillips, Rosenberg felt that there was credibility to Mann's contention "that culture is menaced with destruction by Pure Politics."[53] That Mann had equated "purity" with the Nazi government made sense to him. As Rosenberg stated in his article, purity was a moralistic notion that had recently resulted in governments cleansed of the "human spirit"[54] through the enforcement of homogeneous standards for identity and race. He believed, like Mann, that in so doing, fascist leaders had twisted the modernist conceit of progress

PARTISAN REVIEW

PR

WINTER, 1939:

JOHN DOS PASSOS
Red, White and Blue Thanksgiving

ANDRE GIDE Pages from My Journal

HAROLD ROSENBERG
The World of Thomas Mann

DWIGHT MACDONALD
Soviet Society and its Cinema

LIONEL TRILLING
Hemingway and his Critics

R. P. BLACKMUR Nine Poets

LEON TROTSKY Letter to André Breton

WILLIAM GRUEN
What Is Logical Empiricism?

•

ALLEN TATE · WILLIAM STEPHENS · FRANZ
KAFKA · ELIZABETH BISHOP · ERNEST NAGEL
GERTRUDE STEIN · CLEMENT GREENBERG
THEODORE ROETHKE · DELMORE SCHWARTZ

2

40c A COPY

Fig. 9. Cover of *Partisan Review* 6, no. 2 (Winter 1939).

into propaganda. He could relate to Mann's conclusion that the artist could never operate successfully within any political organization: it reinforced his recent travails with *Art Front* and the Federal Writers' Project.

In contrast to his peers, Rosenberg acknowledged the eloquence of Mann's political thinking in "Myth and History." But his praise came with reservations about the writer's faith in culture to quell the Third Reich. Mann had envisaged a *conservative revolution* that restored social stability in Germany through the implementation of Christianity as a state religion (and, by extension, a metaphysical movement in the arts). Rosenberg responded to Mann's idealism; yet its nebulous spiritualism presented too many contradictions. If only the author had acknowledged Marxism, his plan to resituate the individual at the forefront of German cultural history might have been viable.

Notwithstanding the pitfalls in Mann's idea of a *conservative revolution*, Rosenberg continued to reference the author in his reviews and essays well into the early 1970s, unlike Macdonald who was thwarted by his naïveté. In the early 1960s, soon after he began writing for the *New Yorker*, Rosenberg noted that Mann had connected German Expressionism to Nazism, claiming they "sprang from the same root of emotional self-abandonment."[55] Mann's analogies could effectively explain the cooption of modernist expression for political gain, after all. Rosenberg was also perpetually taken with *The Magic Mountain*. He pondered in a review of Joan Miró's work at the Solomon R. Guggenheim Museum in 1972 whether Mann might have based his description of a parlor game performed at his fictional sanatorium on Miró's painting *Sourire de Ma Blonde* (1924). The game involved patients drawing a pig with their eyes shut, with the upshot that "the pig disintegrates into a chaos of lines and shapes."[56] Mann's passage, he suggested, resembled the disembodied arms and legs in Miró's composition, produced the same year that *The Magic Mountain* was published. The comparison might have been far-fetched, but it reinforced his lifelong attraction to Mann. The author was not the political simpleton that *PR* made him out to be.

Such literary juxtapositions later populated Rosenberg's discussion of most prewar art. Even so, he never summoned up Mann when considering the Abstract Expressionists. Mann's novels, like Miró's painting, were too locked in symbolism. Or, as Rosenberg would explain it: "Action-painting spontaneity projects a new world."[57]

8
partisans and politics

the unlearning

Dwight Macdonald saw Rosenberg's "Myth and History" as "one of the most brilliant pieces of Marxist criticism,"[1] a reaction that was shared by Fred Dupee and Philip Rahv and secured a foothold for Rosenberg in the *Partisan Review* that lasted until around 1944. Rosenberg needed the association with the journal. His hopes for reviving *American Stuff* never materialized once he moved to the District of Columbia. He told Macdonald that the magazine was "dead for the time being,"[2] caught up in the ruckus of the Dies Committee, which had singled out the Federal Writers' Project for its ties to the Communist Party. Also, Henry Alsberg lost his job in mid-1939, making any extension beyond the first issue unthinkable. Rosenberg's reduced publishing prospects were also compounded by George Dillon, Harriet Monroe's successor at *Poetry*, who would move on to younger writers, especially once the war erupted.

Dillon had worked as an associate editor of *Poetry* from 1925 to 1927 while a student at the University of Chicago. He must have read Rosenberg's work in the journal. However, once he took over in 1937, Monroe's "open-door policy" began to operate in a more limited way. He was responsible for introducing lengthy prose pieces that promulgated the New Criticism, in addition to poetry by Randall Jarrell, James Merrill, Kenneth Koch, Robert Lowell, Karl Shapiro, John Frederick Nims, John Ashbery, and Howard Nemerov (many of whom were recommended by Peter de Vries, who served as a part-time reader at the journal). Under Dillon, Rosenberg became a less frequent contributor to the magazine. Dillon hired him

to write a few pieces, among them an opinion piece on Maxwell Anderson's relationship to poetry: Anderson's blank verse had carried over to the structure of his plays, a device that seemed fitting, especially, for his Broadway productions. Rosenberg felt Anderson's ingenuity floundered, nonetheless, because his "rhetoric [was] lacking in inner tone."[3] It was the last review that he wrote for the magazine. Dillon was never enthusiastic about Rosenberg's poems. He found room only for "Ode," which appeared in the same issue as the Anderson review (and which Parker Tyler reprinted in *Modern Things*). Thereafter, Rosenberg gave up on verse almost entirely.

Rosenberg had little luck in placing his poetry in *Partisan Review*, even after his association with the journal was cemented through its publication of "Myth and History." He had sent Macdonald one piece, "The Unlearning," which *PR* published, establishing what Rosenberg anticipated would become an ongoing relationship with the poetry section. But "The Unlearning" became caught up in an ideological shuffle at the journal that would eventually lead to Macdonald leaving the magazine. There was no place in *PR* for his existential lines like "The Mirror of our age is loneliness / And nonbeing; and the flocks walk down in it / And disappear"[4]—especially once Clement Greenberg became an editor in late 1940 and did double duty as art critic and overseer of verse.

Greenberg was brought into *Partisan Review* in part to fill a vacancy opened by Mary McCarthy, who stepped down after a love affair with Philip Rahv ended badly. (She stayed on as theater critic, however, into the early 1960s.) Greenberg's stint as editor was also short-lived: he would leave his post in 1942 to write the art column for *The Nation*. Yet he continued to be a presence in the journal by writing essays on art and culture for more than a decade. He had a decisive voice in determining the content of the journal as the division between politics and culture was drawn by his colleagues. Rosenberg left New York during this period and was not privy to the internal dissension over the editorial thrust of the magazine, all of which redoubled his sense of isolation. While Greenberg had once been in awe of Rosenberg's rising stature within the arena of the "little magazine," their relationship became combative after Rosen-

berg left for Washington, DC, and was played out publicly once *Partisan Review* appointed Greenberg editor. Greenberg would lord it over Rosenberg whenever provided with an opening, which occurred with some frequency.

Toward the end of his short tenure, Greenberg wrote a "note" for *PR* that accounted for his choice of younger poets. It ignited the ire of Rosenberg, who responded with a letter to the editors, protesting that Greenberg had mentioned "'himself,' his tastes and opinions in no less than 10 times on 1 1/4 pages."[5] Greenberg replied with a curt one-liner: "Mr. Rosenberg seems to read my stuff rather closely."[6] The exchange escalated an animosity that neither could ever temper. Outside of a difference in prose style—Rosenberg rarely used the first person as a voice, hence his annoyance at Greenberg's immodesty—was Rosenberg's intense objection to Greenberg's claim that poets such as Dylan Thomas had "accepted form as something to be emphatic with, not surrendered to."[7] There were too many compromises to subjectivity in this approach, Rosenberg reasoned.

What really rankled Rosenberg, however, was Greenberg's investment in T. S. Eliot, evoked in the first sentence of "Avant-Garde and Kitsch," the article that established Greenberg's connection to *PR*.[8] As Greenberg had it, the graceful cadences and aloof phrasings of Eliot's verse represented a foil to the "mass products of Western industrialism,"[9] such as Broadway show tunes and Hollywood productions, as well as publications like the *New Yorker*, all of which forced the avant-garde's retreat to the margins of society. Rosenberg and Greenberg agreed on the menace of mass culture. They both accepted that artists and writers had to form their own communities to retain their individuality and resist conformity.[10] This unanimity aside, few correspondences obtained in their outlook as they matured as writers. There was a certain inevitability or fatalism built into Greenberg's thesis of kitsch, Rosenberg thought, that made the structure of the poem the only recourse, all the while diluting subject matter. (Louis Zukofsky was a case in point.) This fatalism, it seemed, unconsciously inched toward the foreclosure of poetry.

Unlike Greenberg, Rosenberg in 1936 had taken the more dras-

tic step to question poetry's social function—its narratives had become too private, its forms too dominant. The answer, he realized, was to give up on verse completely. Although Greenberg had been exposed as a plagiarist five years earlier, he continued to derive pleasure from writing verse. None of it was published, however, even in *Partisan Review*. Greenberg idolized T. S. Eliot, and as the competitiveness between Greenberg and Rosenberg mounted, Eliot became a touchstone for their aesthetic differences.

rosa luxemburg and the worker

Once Macdonald succeeded in effecting Rosenberg's reentry into *PR*, Rosenberg sensibly refrained from any further attacks upon Philip Rahv, at least for a while. Instead, his complaints were confined to editorial policy and individual reviews, and these were mostly expressed privately in letters to Macdonald, except for his takedown of Greenberg's narcissism and poetics. Rosenberg queried him, for instance, on the publication's handling of Rosa Luxemburg, who he thought had not been treated as a true revolutionary hero. *Partisan Review* had accentuated her personal life at the expense of "burying her ideas,"[11] he felt, which trivialized her major contributions to Marxist creed. Rather than concentrate on one of her political treatises, such as the *Junius* pamphlet of 1916, the editors had reprinted Luxemburg's "Letters from Prison."[12] Rosenberg believed the choice demeaned her as an activist and thinker. It made her look too vulnerable and fragile, especially as she had written the letters while incarcerated in Breslau, a year before she was murdered for orchestrating a workers' uprising in Berlin in 1919. The *Junius* pamphlet had "more art in it,"[13] even though it was also composed while she was in jail. It represented a more eloquent call for opposing the German Social Democratic Party, which was stymied by bureaucracy and, worst of all, supported the Great War. The editor's choice to publish her "Letters" was further evidence to Rosenberg of a dwindled commitment to Marx.

Rosenberg had identified himself as a "Luxemburgite"[14] in the late 1930s, even though he maintained a lifelong interest in Lenin.

Luxemburg had tangled with Lenin on the issue of social democracy by toeing a more radical line on the implementation of communism. What captivated Rosenberg, though, was the emphasis she placed on the "ethical existence"[15] of the workers, or their revolutionary acts. During this time, he had begun work on an article on Luxemburg that was never completed. But she surfaced in his writing occasionally through the mid-1950s. Her martyrdom—not unlike Lenin's—represented a poignant symbol for him. Still, for all of his admiration of Luxemburg and the proletariat, and for their rattling of middle-class authority, popular culture evaded him, just as it did Greenberg. As the primary territory of the working class, its art was too banal and hokey, dependent on more authentic or original expressions, such as modern painting.

the fall of paris

Just as Rosenberg began to appear in *Partisan Review*, Paris was occupied by the Third Reich and eviscerated as a cultural center. What were the implications for the modernist movement, he wondered? Rosenberg convinced Macdonald to let him grapple with this quandary. Unlike "Myth and History," over which the editors deliberated for more than a year, "The Fall of Paris" was published within a few months. Rosenberg's association with the journal was momentarily secure. Rosenberg knew the School of Paris to be a cosmopolitan entity, composed of manifold foreign figures, such as Picasso, Modigliani, Mondrian, Diaghilev, James Joyce, Wyndham Lewis, Alexander Calder, Man Ray, and Gertrude Stein, in addition to its homegrown radicals, who were drawn to Montparnasse and the Left Bank—a hotbed of formal experimentation. But through Hitler, himself a failed artist, he wrote, "the laboratory of the Twentieth century had been shut down"[16] overnight. Was there opposition from the avant-garde? he asked in his piece. If so, what form did it take?

As Rosenberg thought about Paris for his article, he recognized that it had been in decline for a decade before the Nazis exerted their might. Its bohemia had become intellectually flabby, a mirage of the past; its former propensity for resistance, whether to the academy,

the church, or the state, was no longer urgent. Anticonformity had once been readable everywhere. But that ended with the rise of totalitarian regimes in the early 1930s and the city's modernity operated poetically in a vacuum thereafter. Not that Paris remained aloof from the sting of fascism, but its Popular Front was unimaginative, Rosenberg observed, and deployed a style of unity that recycled old rhetoric and revolutionary imagery. It allowed for Hitler to infiltrate Paris, he felt. Hitler's malevolent strategy was at least current, up on the tactics of Stalin. The city was an easy target, in part, because its writers and artists had ceased to ask the right questions: why was not more made of the Moscow Trials in its press? Paris evidently had lost its edge, and had been "lowered steadily toward the soil of France,"[17] like a coffin, especially after many members of its avant-garde defected to the United States.

Rosenberg was struck by the contrast with left-leaning New York intellectuals, many of whom had renounced the Communist Party and their allegiance as fellow travelers when the news of Stalin's murder of Lenin's deputies unfolded over a two-year period. It gave them an advantage as critical thinkers, he reckoned. While he stopped short of declaring that Manhattan would supplant Paris as a center, in 1940 he sensed that possibility was imminent. Paris could no longer count on its genius to maintain its clout. That prospect had withered because its "dream of world citizenship" presumed that "history could be entirely controlled by the mind."[18] Its pictorial inventions had been construed as liberation from the past and successive political tyranny. However, when the Führer seized Paris, this notion of progress collapsed. The city's claims to eternity could be experienced only through sentimentality. Rosenberg concluded that the City of Light had become a relic.

Four years later, when Rosenberg revisited the theme of bohemia in *Partisan Review*, he gave the French more credit when it came to withstanding fascism. In a review of Konrad Heiden's *Der Führer*, he noted that France had never signed on to the fascist bandwagon, unlike a few of its neighbors. Rosenberg continued to concentrate on its bohemian culture and rational tradition that prized, above all, intellectual endeavor. It was part of the downfall. Hitler was clearly no

philosopher and had, along with his officials, demonstrated "an enmity toward intellect."[19] Germany also had its nonconformists and free spirits, but their modernist thinking tended to gravitate more toward extremism, unlike the French. Rosenberg argued that the sinister traits of Expressionist painting and cinema were a case in point. Significantly, Hitler had employed extremism to fashion his political language. The harsh militancy of his oratory worked successfully to galvanize a new nation of warriors.

By contrast, Paris had become too caught up in the preservation of its originality and lifestyle to avoid subjugation to the Nazis. As a result, its political movements and symbolism had become hackneyed. In "The Fall of Paris," Rosenberg had intoned, "Fascism was not to be stopped by clichés."[20] But by 1944, he knew the moment was ripe for New York to appear on the world's cultural stage. Not through the likes of T. S. Eliot who had freely imbibed from the modernist waters that flowed from Europe. To Rosenberg, Eliot was too identified with foreign technique. He had expounded that poetry's sole obligation was the perfection of its diction: "the criterion" that was also the name of his London-based journal.

Partisan Review reprinted Eliot's "Notes towards a Definition of Culture" in the same issue as Rosenberg's "Notes on Fascism and Bohemia" in 1944—a stark juxtaposition, for Eliot attributed the current European political crisis to an overall disintegration of Western culture. New, secularized societies within authoritarian regimes had become the threat, he felt. He suggested that a shared faith, such as Christianity, could remedy the situation: not only would continuity and tradition be maintained, but culture would be kept lofty, the ongoing preserve of the "superior individual."[21] Eliot's ideas were conservative at best, based on his veneration of England's class system and its Anglican faith. He supposed that culture was the property of an educated elite, a view that ruffled writers such as William Phillips, who declared in a subsequent issue of *PR* that Eliot's orthodoxy was "regressive."[22]

Clement Greenberg also had a response. He was less unsettled by Eliot's belief in an intellectual aristocracy than by his reasoning. While Greenberg thought Eliot's argument could benefit from spec-

ificity, or "concrete proposals,"[23] he himself, as a secular Jew, was undone by the role that religion played in Eliot's argument. It was too ecclesiastical, as well as too confident that culture was renewed only by those born into the upper crust. The avant-garde had jettisoned the church in the name of aesthetic freedom. If anything, the world had become more profane during the modern period. What was to be feared, Greenberg thought, was the spread of international capitalism that debased and commodified writing and painting. In his response, he returned to the motif of kitsch that he had written about in *PR* five years earlier. In Henry Luce's publications, such as *Time* and *Fortune,* as well as the *Saturday Evening Post* with its covers by Norman Rockwell, there were copious examples of compromised expression. Greenberg was not averse to the hierarchy that stratified culture. But religion had no place in the controversy.

Rosenberg, unlike Greenberg, had little truck with Eliot's belief in an intellectual caste system. He was intransigent when it came to class distinctions. A pecking order was not part of his worldview. Later, he would have plenty to say about criticism devoted to the effects of kitsch, when it emerged in the late 1940s. But the products of mass culture would always lie outside his interest. By the time *Partisan Review* ran Eliot's "Notes," Rosenberg's relationship with the journal had begun to wane, and he was not invited, as Greenberg was, to respond to the poet's anglomania. After the war was over, Eliot's known anti-Semitism became too offensive for Rosenberg to give him his due as a writer, let alone to rebut his ideas about English literary authority.

the henry james delicatessen

In 1943, Dwight Macdonald left *Partisan Review* to found *Politics* with his wife Nancy (née Rodman) who had worked as the journal's business manager. Macdonald had been radicalized by Rodman when she introduced him to Marx and the *Communist Manifesto* shortly after their marriage in 1934. She herself had become immersed in socialist literature during the Depression through attending gatherings at her brother Selden's apartment. Selden Rodman was a poet and

collector, who co-edited *Common Sense,* a liberal magazine, where Marx was frequently discussed. A member of a prominent colonial New York family—her mother was a Gardiner—Nancy Rodman attended Vassar, where she was a year ahead of Mary McCarthy, and majored in art history. It was Rodman's family money that enabled Macdonald to leave *Fortune* to take up his editorial position at *Partisan Review.* Although bashful and reticent, she had abundant intellectual curiosity, as well as an administrative ability that served *PR,* and then *Politics,* where she became the managing editor.

Politics was launched as a monthly but had become quarterly by the time that it folded in 1949. Macdonald conceived of the journal as an alternative to *Partisan Review* through promotion of a leftist commitment to political and literary analysis. Still, there was considerable overlap between the two publications, and their offices were even housed in the same building on Astor Place in the East Village. Macdonald featured writers such as Lionel Abel, Bruno Bettelheim, Nicola Chiaromonte, Lewis Coser, Paul Goodman, Mary McCarthy, the sociologist C. Wright Mills, and Niccolò Tucci, as well as George Orwell (who was *Partisan Review*'s London correspondent). Additionally, he enlisted Simone de Beauvoir, Albert Camus, Maurice Merleau-Ponty, and Jean-Paul Sartre, who had appeared in *PR* in 1946, to contribute to a special number on French politics the following year. However, Macdonald's bent was more pointedly anti-Stalinist, directed by his moral convictions and sense of anarchy.

Macdonald was no longer able to abide Rahv and Phillips's drift toward the center, especially once they adopted a prowar stance in 1941. His pacifism exhausted a relationship that had been continually tested by his insistence that Marxism be accommodated within the journal. Once he defected, Rosenberg was left without a champion for his own opposition to the surge of apolitical modernism within *Partisan Review.* Where was the evidence of their alleged radical politics? he wanted to know. Each new issue's table of contents had become increasingly paltry when it came to hard-core examination of contemporary political events.

Rosenberg had some inkling that an editorial coup was under way

at *Partisan Review*, even from his distant safe haven in Washington, DC. He wrote to Macdonald as the situation unraveled: "What's happening with you and P.R. now? Something must be up, since I've heard not a word about you from my spies."[24] The altercation between Macdonald and his peers remained hidden to most members of the journal's community. Shortly after Phillips and Rahv took over, Rahv courted Rosenberg to continue as a contributor. Rosenberg remained noncommittal, albeit curious, wanting clarification on how the impasse with Macdonald would affect the periodical's future. He replied to Rahv's overture with a series of questions: "I am mainly interested in knowing more about the issues between the 'editorial staff' and Dwight. I don't mean as gossip—but the breaking point in attitudes . . . So a new element must have intervened to make matters decisive. And what changes—you say I can 'expect quite a few' . . . And what do you mean 'I'd like you to cooperate.' What would you like me to do? And who is on the board now?"[25]

After Macdonald resigned, Rosenberg published one further piece in *PR*: an evaluation of Arthur Koestler's *Arrival and Departure*, in which he located numerous connections to Thomas Mann.[26] Koestler's novel was the last in a trilogy that included his much-lauded *Darkness at Noon*. It dwells on an ex-communist who undergoes psychoanalysis in the wake of escaping from an unnamed fascist country, where he had been tortured for refusing to comply with the party. Peter, the hero, discovers that his wartime courage, and desire for both punishment and martyrdom, emanates from guilt repressed since childhood (for wounding his brother in an accident). Rosenberg found the explanation ludicrous. Just like Castorp at the end of Mann's *The Magic Mountain*, Peter's fate remains uncertain: he returns to the front and parachutes onto enemy soil, rather than seeking refuge in the United States. Rosenberg, who was never big on Freud, could not square the "extremely superficial"[27] way in which Koestler engaged psychic conflict. He had similarly suspended judgment on perpetrators such as the Gestapo and Stalinist henchmen in *Darkness at Noon*. Why had Peter not arrived at a deeper understanding of fascism through therapy? In a novel about history, Koestler's script was too inwardly directed.

In the end, Rosenberg's contributions to *Partisan Review* amounted to only a few essays and book reviews, as well as one poem, most of which were published through Macdonald's lobbying. His seminal contributions were "Myth and History" and "The Fall of Paris." Like Macdonald, Rosenberg found that his opposition to US intervention in the war would affect his relationship with the magazine. He periodically fed the editors a proposal, but with Rahv at the editorial helm, his association with *PR* became worn. William Barrett, who became an associate editor in the mid-1940s, recalled that Rahv "was always uncomfortable with an intellectual like Harold Rosenberg because of Rosenberg's dazzling facility with ideas."[28] However, he also observed that Rosenberg was deeply impractical, that he "was brilliant if you cared for that kind of thing . . . [but] he lacked a base, whereas Rahv had that base in a magazine for whose policies he had to take responsible and sober judgment."[29]

Although Rahv contacted Rosenberg once Macdonald departed, he cut Rosenberg off after his review of Koestler's *Arrival and Departure* was published. Rosenberg would not appear in the *Partisan Review* again until the late 1950s, and by that time the journal was primarily run by William Phillips, who became editor-in-chief once Rahv left to teach at Brandeis University. Like Macdonald, Rosenberg found his battle lines were drawn by the increased anti-Marxism of the journal and its unwillingness to countenance that Lenin, Trotsky, and Rosa Luxemburg had articulated an ethical socialism that could accommodate the artist and the writer.[30] He was also alarmed by the imprint of Eliot's ideas on the editorial program, a process that began after the journal was restructured in 1937 and resulted in the gradual flight not only of Macdonald but of writers such as Paul Goodman.[31] As *PR* became less tolerant of dissent, Rosenberg no longer construed the economy as responsible for the marginalization of the poet. It was now the surfeit of formalist writers in the United States who contributed to this alienation. Poets and critics, such as Allen Tate, Randall Jarrell, and John Crowe Ransom, all Southern Agrarians, along with Eliot, had become a homogeneous literary movement. Their writing was fast becoming mainstream, set forth as a modernist canon in *Partisan Review*.

Rosenberg held off on broadcasting his doubts about Rahv's commitment to social history until Rahv released an edited collection of short stories by Henry James in 1944. In one of his more notorious gaffes, he dissed the volume as the "Henry James delicatessen."[32] The put-down was widely circulated and got back to Rahv, who exacted revenge by never again publishing Rosenberg on his watch. James, as Rosenberg blithely saw it, had produced no heroes with a capacity for *action*. His characters were victims of their social circumstances, unable to surmount their material advantage, and immobilized by emotional paralysis. The revival of James seemed irrelevant, if not escapist, to Rosenberg, as World War II inched toward a close. He considered the timing of the anthology frivolous. But even after the end of the war, James's overarching theme of the loss of American innocence abroad failed to interest him. The author's protagonists were too naïve and callow, unlike Ahab in Melville's *Moby-Dick* who had more vigorously come to terms with his fate.

to make the revolution in america

Although the editorial infighting at *Partisan Review* remained under cover, there were several incendiary episodes prior to Macdonald's leaving in 1943 that emboldened Rosenberg's bruising remarks about Rahv. By the time Germany declared war against the Soviet Union in mid-1941, and the United States paired with the Allied forces in December, the political divisions at *Partisan Review* had exploded into intractable factions, with the outcome there was no editorial position in situ to report on these events. Macdonald and Clement Greenberg, who were opposed to US military intervention, took the lead and proclaimed, in "10 Propositions on the War," that "all support of whatever kind must be withheld from Churchill and Roosevelt."[33] Rahv responded two issues later with a seething rebuttal attacking their isolationism. In a dramatic reversal, he stated that their manifesto represented "the same old orthodox recommendations [that] fail to recognize the world as we know it."[34] The fallout confused an already bewildered readership, as well as the journal's contributors, who were at a loss as to how to interpret

Rahv's about-face on revolutionary politics and this new affirmation of the United States.

While Macdonald had always advocated for critical debate at *Partisan Review*, the promotion of patriotism was nonnegotiable. He believed the United States was a repressive capitalist entity, intolerant of socialism and a three-party system.[35] Mary McCarthy, whose brief tenure as editor ended with the demise of her romance with Rahv, averred, "The rest of us were deeply shocked" by Rahv's shift, "because we regarded it as a useless imperialist war."[36] She used the incident to satirize the "realists," as she called the new exponents of war, in *The Oasis*, her thinly disguised *roman à clef* of the *Partisan Review* circle, in which Rahv played an obvious role. She thought his turnaround on Trotsky was bereft of language that could articulate a democratic alternative. She mercilessly jabbed him and his accomplices:

> The failure of socialism in their time, the ascendancy of the new slave state were for them . . . an excruciating personal humiliation. To identify their survival with the aims of Western capitalism had been a natural step, but one which they took uneasily and with a certain semantic embarrassment—they showed far less constraint in characterizing the opponents of this policy as childish, unrealistic, unhistorical, etc. than in formulating a rhetoric of democratic ideals.[37]

Rahv had marshaled backers before he took on Macdonald and Greenberg's "10 Propositions" in late 1941. A few of the "realists" lined up behind him, including William Phillips and Sidney Hook, with whom Phillips had studied at New York University. Hook was the primary political commentator for *Partisan Review*, along with Macdonald, although he never became an editor. He had given up on Marxism by then, even though he converted many prominent New York intellectuals, including Lionel and Diana Trilling, into becoming fellow travelers in the early 1930s, such was his personal magnetism and his strong socialist convictions. (Diana Trilling remembered him as "very, very brilliant and a rising star in philosophy.")[38]

Hook was unable to snatch Rosenberg, even though they had argued over Marx before Hook left for Moscow to augment his studies at the Marx-Engels Institute. However, by 1933, the emergence of the Third Reich cut into his ardor for the international communist movement. He became contemptuous of Stalin's manipulations of the Kommunistische Partei Deutschlands and its inability to unite with the Social Democratic Party, which accounted for Hitler's victory. Still, Hook was a committed leftist and transposed his Marxist faith to Trotsky and the Dewey Commission. But he broke with the Trotskyite factions in New York over US participation in the war, believing force was the only way to thwart totalitarianism. He subsequently leaned on Phillips and Rahv to adopt his position, urging them to write an editorial for the journal. Even though Rosenberg was living in Washington, DC, he had little truck with Hook's renunciation of Trotsky and advocacy of an American military alliance. He always remained wary of Hook's political reversals, especially when Hook later embraced conservatism.

It took both Rahv and Phillips months to adjust to Hook's idea, as initially they were cowed by Macdonald and Greenberg's statement. They were queasy about forgoing their opposition to the domestic and foreign policies of the US government and losing their independence as leftists. Hook was relentless, and pressed his Marxist erudition on the two ambivalent editors. He knew that Rahv had considered leaving *Partisan Review* as early as 1940. He was spending more time in Chicago with his wife, Natalie Swan, an architect and former college chum of Mary McCarthy, who he married after his relationship with McCarthy had ended. However, the altercation with Macdonald and Greenberg over their "10 Propositions" reinvigorated Rahv, who wrote to Macdonald, "I think our controversy is exciting."[39] His hesitancy to abandon socialism was overcome by pragmatism. He scolded Macdonald for the impracticalities of his idealism: "to make the revolution in America is a much more difficult task than to win the war against Hitler on the present basis—hence your position amounts to saying, let's do the more difficult thing first. There is no logic in such a policy."[40] Had Rahv actually left *Partisan Review*, Macdonald would have been able to implement the leftist

agenda that had driven its refounding in 1937. He would have been able to fully integrate Rosenberg into its program, perhaps even appoint him an editor. With Rosenberg on board, the "10 Propositions" would have run without a rebuttal from Phillips and Rahv.

The stalemate that resulted in Macdonald leaving *Partisan Review* was a response he wrote to a speech by Vice President Henry Wallace, who vindicated America's military intercession overseas. Rahv and Phillips wanted to stifle the piece, contending that there had already been too many antiwar statements in the journal. Macdonald prevailed by mustering George L. K. Morris, who had remained otherwise neutral on the editorial direction of *PR*. (Morris was a Republican, as was his older brother, Newbold, who had been appointed president of the New York City Council by Mayor LaGuardia from 1938 to 1946.) As Morris was the financial backer, Rahv and Phillips were stymied, unable to prevent Macdonald from expounding on what he considered Roosevelt's hidden agenda: by joining the Allied Forces, he wanted to revive the domestic economy and see the United States surpass Great Britain as a global player. Macdonald speculated that the United States "would emerge with a world position analogous to England's in the last century."[41] Both liberal democracy and capitalism were threatened by Hitler. When he wrote to Morris about his colleagues' objections, Macdonald cautioned him, "they claim it is 'anti-war propaganda,' and think that to print it will damage the magazine and possibly lead to its suppression."[42]

Macdonald won the first round in the standoff. But once Clement Greenberg left *Partisan Review* to write for *The Nation*, his prospects for wresting control of the journal from Rahv and Phillips were undone. (Dupee had already left for Columbia University.) By 1942, Macdonald was boxed in, a lone crusader for arbitration on the war and creation of a third party that could realign the polarized debates relating to US military intrusion abroad. However, Phillips and Rahv's fears of the "suppression" of the journal were more real than Macdonald knew. While there had been earlier trials that nearly brought down the magazine—in 1940 Macdonald tried to work surreptitiously through Morris to have Dupee and Phillips

replaced, believing their contributions too lightweight—this time the deadlock was insurmountable.

Morris's support of Macdonald's stand against Vice President Wallace constituted a rare instance of activism. Morris had always navigated editorial friction through avoidance. Wallace was a Democrat, a factor he did not take lightly in backing Macdonald. Macdonald sardonically titled his tract, "An American People's Century," which must have appealed to Morris's patrician interests and disdain of popular culture. (The title of Macdonald's article was a spin on Henry R. Luce's "The American Century," an editorial that appeared in *Life* magazine in 1941; it announced that the United States could achieve global ascendancy if it overcame isolationism by becoming part of the war effort, and export its democracy.[43] Luce's editorial was an influential monument mined by the Roosevelt administration for its expansionist rhetoric.)

Morris was still not ready to jettison the *Partisan Review*, however much challenge it posed to his civility. Yet by late spring of 1943, he withdrew funding. His modernist interests had migrated to the American Abstract Artists group, of which he was a founding member. Although he never conceded that the journal had become "cliquish," he bemoaned that Macdonald had no "aesthetic understanding."[44] His writing had not reflected on art, let alone as an object of beauty.[45] Had their quarrel become public, Rosenberg would have sided with Macdonald, having little interest in Morris's revival of Clive Bell, the British proponent of formalism. He would have reckoned that Morris's emulation of Bell amounted to a sparse imagination, much like the traits of Greenberg's writing.

Phillips and Rahv found their own backer for the journal, a mysterious Mrs. Norton, who wanted her patronage hidden. Her funding came with a catch. As her husband was enlisted in the army, she requested that the journal downplay politics and highlight literary and arts coverage to ensure more editorial unity. The proviso released the editors from defending Roosevelt and Wallace. Macdonald lost his foothold in *Partisan Review*, outwitted by his colleagues who found a more politically aligned backer. His new journal, *Politics*, was decidedly more sectarian, just as its title suggested.[46]

"the herd of independent minds"

Ideas were always paramount for Rosenberg, but cerebral indulgence had its professional toll and he was unable to secure a "base," as William Barrett noted, until his appointment to the *New Yorker* two decades later. Rosenberg was perpetually oblivious to issues of propriety. He expected his offenses to be overlooked, that some elusive meritocracy protected him. He naïvely submitted his manuscript for "The Herd of Independent Minds" to *Partisan Review* in 1948 wherein he sized up the journal's contributors as "intellectual captains of thousands,"[47] a sea of like-minded men who made claims to originality through opposition to mass culture. To him, it was a baffling redundancy. However, his presumption that *Partisan Review* would publish the tract was astonishingly hubristic, given that it poked at the depoliticized direction of the journal after Macdonald's exit. Phillips and Rahv were not about to be humiliated on their own turf. Delmore Schwartz, a former student of Sidney Hook who became an editor in the mid-1940s, was assigned to reject Rosenberg's essay. He concluded, "We are sorry to say that we cannot see your essay as anything more than playing with ideas."[48]

Rosenberg proclaimed in "The Herd" that

a literary magazine no matter how "little" does not escape being a mass culture organ simply by investing itself in those writers [Kafka, Mann, Gide, and Valéry] when in discussing their work to formulas of common experience. This reduction is the very method by which Hollywood or the Church or the Communist Party appropriates the artist and his creation to its own uses — e.g. the capture of Dostoevsky by Hollywood, Rimbaud by the Church, Van Gogh by the CP—under the pretext of "bringing culture to the people."[49]

Rosenberg was a devoted reader of *Partisan Review*'s list of literary greats. But he was turned off by the journal's conviction that high art was a self-contained object impervious to external manipulation. Such consensus was a sign that most New York intellectuals had lost

their way. It was not enough to lay claim to the superiority of the creative act. Politics was always at play in the reception of literature and art. As a result, Rosenberg thought *Partisan Review* had made itself vulnerable to imitation. It was at risk of forfeiting its independence from mainstream institutions, such as the film industry, that it decried. The editor's failure to consider the artist's consciousness had been a grave mistake.[50]

"The Herd of Independent Minds" found a home in *Commentary* magazine, for which Rosenberg began to write after Macdonald left *Partisan Review*. In the wake of World War II, the bimonthly had become a leading leftist journal that rivaled *PR* as an intellectual platform, even though it focused on Jewish subjects after the Holocaust. *Commentary* had reprinted Jean-Paul Sartre's "The Situation of the Jew" in 1948, which Rosenberg defended even though he differed from the French writer on the issue of Jewish identity. He invoked Sartre in "The Herd of Independent Minds" to contrast the editors of *Partisan Review* with a writer who was savvy about the ways mass culture absconded with literature. Sartre was accustomed to reaching large audiences for his work and regularly appeared on the radio — another instrument of mass culture. But he always foregrounded his political beliefs in his broadcasts, as well as in his writing, a big difference for Rosenberg. As a result, ideas were shielded from being diluted and disseminated as "common experience,"[51] armed with context and history that the writers at *Partisan Review* thought unnecessary.

i never saw anything on mann that i liked better

Rosenberg never did write for Macdonald's periodical, *Politics*, finding its pacifism too wobbly, bordering on antiwar, anti-Soviet screed.[52] Besides, Macdonald could not secure the financing to sustain the publication. The planned monthly had become erratic by the time it folded in 1949. But his disagreements over Macdonald's editorial position did not immediately result in a setback to their friendship. That break came in the late 1950s, long after Rosenberg and Tabak had returned to New York.

Macdonald had been responsible for Rosenberg's renewed lease as a writer in the late 1930s, after *Poetry* ceased to be an option and *American Stuff* failed. The reception of "Myth and History" was far-reaching and consolidated his reputation. When the editors of *Commentary* contacted Rosenberg about a submission for their first issue, it was for a review of Thomas Mann's *The Tables of the Law*, an analysis of the story of Moses. Rosenberg felt that Moses was a dubious subject for a book. He argued that after Joseph, "the children of Israel were no longer a family of epic individuals but a nation, a mass."[53] Moreover, when Randall Jarrell, who was a literary editor at *The Nation*, wrote to Rosenberg about contributing a piece on Tolstoy, it was with praise for his treatment of Mann in *Partisan Review*: "I never saw anything on Mann that I liked better."[54] The *Partisan Review* may have no longer been viable for Rosenberg after Macdonald left, but alternatives did emerge because of him.

9
a totally different america
washington, dc

anyone who could read english

When Rosenberg arrived in Washington, DC, in mid-1938, it was the first time he had ventured beyond Manhattan since he hitchhiked to Chicago to visit Tabak, almost a decade earlier. While his friendships with artists such Gorky, de Kooning, Krasner, and Barnett Newman became episodic—limited to infrequent weekend trips to New York—the tradeoff was that he began to travel nationally as the art editor of the American Guide book series. As the centerpiece of the Federal Writers' Project, the series published more than four hundred travel guides for every state, numerous cities, and various regions, and employed six hundred fifty writers, becoming the American equivalent to the Guide Bleu or Baedeker guides.[1]

The American Guide series got under way in 1935 when the WPA was founded. Rosenberg was brought in midway through the project. His primary role was to troubleshoot imperiled volumes, and the states of Washington and Missouri required his immediate attention. Rosenberg adored traveling to Seattle. The experience was revelatory: his memories of Elliott Bay, its houseboats, the cultural life, food, bookstores, gardens, and Pike Place Market became folded into one abundant, lasting memory. He exclaimed long after his first visit, "it was a very radical town," with "a big newsstand that was a block long that sold every conceivable piece of radical literature: Anarchists, Trotskyites."[2] Although he and Tabak felt like a "couple of Commissars from Moscow who didn't know how to speak Hindustani or whatever the hell it was,"[3] the state of Washington entranced them. It was the most exotic trip they had taken. He

complained about the "old-fashioned, crummy"[4] rooming house they stayed at, but the experience was mitigated by their renting a roomy apartment near the University of Washington that had a view of Mount Rainer, the Cascades Range, and lush parks of Capitol Hill.

Rosenberg never met Mark Tobey or Morris Graves on any of his trips to the Pacific Northwest for the project, but he would later wonder how such an "absolutely picturesque city produced rather mystical and negative artists [as] the place is simply color, natural color."[5] The religious overtones of their work also stumped him. He later wrote in his first review for the *New Yorker* that Tobey wanted "to fix his twentieth-century experience into a message brought down from the mountain."[6] Whatever the local color, there were parts of the culture, with its deep ties to Asia, that evaded him. Tobey and Graves were artists who bridged both Eastern and Western aesthetic traditions to reinvigorate modernism, a strategy that Rosenberg could not comprehend in the late 1930s. He was still learning about the nation's disparate cultural geographies.

Rosenberg overlooked many of the failings of the field workers employed on the American Guide series in Washington state. He saw them as characters rather than as misfits, fixtures of the frontier mentality that animated the place. Even though one employee had fabricated population statistics and never visited the remote regions to which he was assigned, and his findings were later adopted by the Census Bureau, Rosenberg thought his deviance acceptable: "As soon as you start counting, you make mistakes."[7] When he was called upon to finesse an imbroglio between state and county officials who wanted to shut down the project, he passed off the discord as typical of Seattle's outlier culture, more amused than irritated by the shuffle.[8]

However, Rosenberg had grave misgivings about the way the Missouri Guide had been handled, and was unable to see beyond the conflicting ideologies of its team of writers and the Washington office that had brought the project to a standstill. The prairie landscape, moreover, did not elicit the same emotional response as Seattle. He expressed in a letter to Parker Tyler that, when he visited

the St. Louis Art Museum on a trip in the late summer of 1940, he was "halted on leaving . . . by five detectives who were suspicious—because I was a lone visitor to a place which, as a rule, attracts only *couples*."[9] Rosenberg retained a distinct memory of being in St. Louis "when Trotsky was murdered."[10] The coincidence became emblematic of the political turbulence on the American Guide book series. He saw Missouri as a reactionary, buttoned-down place with an antipathy to modernism, especially after the heartland's reclamation of Thomas Hart Benton as an artistic icon.[11] (Benton resettled in Kansas City in 1935.) It did not help that Rosenberg spent his time in St. Louis in a "small, murky hotel in Forest Park," that his social life was barren, and his few outings were confined to a museum that regarded his visits as potentially seditious.

Rosenberg was entrusted with overseeing the rewriting and production of the Missouri volume after it had been shut down in 1937 through a strike led by Jack S. Balch, its first director, and local politicians who opposed editorial direction from Washington, DC. The WPA's "Fantasy of One America,"[12] as Rosenberg called it, had strained Balch and his team of writers, who felt their regional identity and avowed socialism had been disregarded. (Jack Conroy, a proletarian writer, was one of the early contributors to the Missouri Guide. Little remained of his input after the volume was reworked.) Rosenberg had already tussled with Joe Jones, the communist painter from St. Louis, at *Art Front* and at meetings at the Artists' Union. Through these interactions, he established an aversion to literature that addressed labor and political collectives. The CPUSA had no place in determining the content of art, he believed. Yet, unlike his altercations with the Artists' Union, in this case Rosenberg did not have to contend with the earlier strife, as Balch was ousted before his arrival.

Despite his misadventures in St. Louis, Rosenberg believed that the revised text for the Missouri Guide was "one of the best books in the whole series."[13] He gave most of the credit to Charles van Ravenswaay, who was brought in to rehabilitate the project after Balch left. Van Ravenswaay, a historian, was far more conservative than his

predecessor, a self-described traditionalist who had worked as the business manager of his family's medical clinic in Boonsville. (He later became the director of the Missouri Historical Society in St. Louis.) Rosenberg was initially offended by his "Republican" politics and condescension to the socialist writers who served on the project. But he came to view van Ravenswaay as a "very angelic, principled guy."[14] That his family's clinic never turned away the poor, especially during the Depression, made an impression on Rosenberg. Van Ravenswaay also developed an affection for "Rosie," as he nicknamed Rosenberg soon after his arrival. There were only negligible issues that related to Rosenberg's style of editing: "Sometimes I complained about his long and involved sentences," he recounted, "and he had deleted some of my treasured passages, but such differences were minor and we became good friends."[15] However, "Rosie" did incur the wrath of van Ravenswaay's assistant, Billie Jensen, who found him autocratic. Evidently, his revisions to the book engendered "a crisis a day"[16] as he wielded his authority. Still, the low-level friction on the Missouri guide never approximated the fractious debates that erupted over the editorial selections for *Art Front* and *American Stuff*.

Rosenberg left the WPA feeling that "almost any person on relief who could read English might qualify"[17] for a position. The problem, as he saw it, originated with the format that Henry Alsberg had established for the guide books. His sanitized portrait of American culture left out references to economic and racial disparity, while deemphasizing the writer's voice, all of which imparted uniformity through a string of facts, many of them actually spurious. The result was a nationalistic gloss. In hindsight, Rosenberg questioned the contribution the WPA made to American writing during the Depression. Outside of the employment it offered, "the Project assigned writers to mindless trivialities . . . it promoted the belief that the mere assembling of American data could be the equivalent of the great collective creation."[18] Unlike the art project, the Writers' Program did little to elevate the status of the writer. The American Guide books required no imagination; their narrative model was

too rigid and fixed. (After Alsberg was removed from the WPA in 1939, the Writers' Project was renamed the Writers' Program, signaling a subtle shift in emphasis.)

a cause célèbre

Rosenberg was initially bewildered by Washington, DC. Although the contrast with New York generated lively experiences and descriptions in letters to friends and family, his sense of the city as "one vast Flatbush" stuck with him. If anything, his isolation was redeemed only by new feelings of empowerment. Rosenberg arrived in the city before Tabak, as she had to finish teaching at an elementary school in Lower Manhattan (she had abandoned social work two years earlier). He was immediately introduced to many of the Roosevelt administration's power brokers, encounters whose like he had never had in New York. He recalled that on his first night in town, he was taken by Jerre Mangione, the coordinating editor of the Writers' Project, to a cocktail party where he met Thurman Arnold, the assistant attorney general, who called him a "cause célèbre."[19] Apparently, stories of Rosenberg's altercations on *American Stuff* had reached Washington ahead of his appointment there.

Rosenberg lived for two months before Tabak's arrival in the front room of Mrs. Grey's boarding house where the "food was so awful."[20] Other residents included writers, such as John Cheever, who were also employed on the Federal Writers' Project. Cheever introduced him to the boarding house, but once Tabak arrived, their addresses changed almost as frequently as they had in New York. They moved to various apartments around Capitol Hill, as Rosenberg's relationship to the project was always in flux, never stable. Within a few days of joining him in the summer of 1938, Tabak wrote to his parents that the city had wonderful parks and a zoo with "all sorts of animals . . . which none of us have ever seen anyplace else, weird, colorful animals from every part of the world."[21] But the wildlife never seeped into the culture. These two young political dissidents yearned for more vigorous intellectual exchanges and for their friends in New York. Rosenberg learned to drive a car to navigate the

city and to make occasional visits home to Manhattan. He acquired a secondhand Ford but overwhelmed his instructor, believing that after one lesson he was "an accomplished driver,"[22] even though he managed to pull out the stick shift while negotiating Dupont Circle!

Rosenberg was more guarded and cautious in his social and professional interactions in the District of Columbia, mindful of the investigations of the Dies Committee that got under way soon after he arrived. Later, he liked to boast that his name had been invoked on the floor of the House when Dies described him as that "red poet from New York,"[23] a misnomer that revealed no awareness of his clashes with the Communist Party in New York. While Rosenberg observed that there were "plenty of C.P. sympathizers around,"[24] he knew that he had to maintain his distance. Nearly two years after he moved to Washington, he asked Nancy Macdonald to hold off adding his name to the printed list of subscribers to *Labor Action,* of which Dwight was an editor. "For all lists in their time," he wrote to her, "if not at once, fall into the hands of the investigators—and the way things are going now, with spies already reported in most divisions, a name on a list is as good as a hammer in the fist."[25] Even though he paid for the subscription, he wanted the publication sent to his home address rather than to his office at the WPA, fearful his colleagues would associate him with the party.

After arriving in the national capital, Rosenberg recounted to Macdonald that he was astonished by the political innocence of the Writers' Project staff. "My main activity here," he conveyed, "is learning about America, and it's amazing. A dumb girl in the office, who comes from New England, and whose art ceiling . . . is Errol Flynn in Robin Hood, thought *American Stuff* was too revolutionary!"[26] He had yet to travel to New England—where literature was not mediated exclusively by the film industry!—but the "red scares" added to his distrust of anyone who was not already a friend. Anxiety began to pervade the national community of left-leaning thinkers, anxiety that sometimes bordered on paranoia. In the case of Rosenberg, it also extended to his reservations about the intelligence of his co-workers.

Just as his stint with the government was about to end in 1942,

Rosenberg was asked by Macdonald to submit his "Washington impressions" to *Partisan Review*. The idea was to create a "Washington Letter" for the journal, "which would do for the Washington scene what Orwell's letters did for London."[27] Rosenberg replied that "the political and intellectual atmosphere of Wash[ington] is not only not representative of the U.S. but has less importance than that of Topeka or Salt Lake."[28] His reaction summarized his disillusionment not only with the Writers' Program but also with its literary standards. The city seemed oblivious to the ideological rhetoric and showy nationalism of each successive White House regime. So he walked away from Macdonald's offer.

a totally different america

Henry Alsberg brought many promising writers to the Washington offices of the Federal Writers' Project. Among them was Gorham Munson, a poet and once editor of *Secession*, another "little mag" that had a limited run in the 1920s and featured work by Malcolm Cowley, William Carlos Williams, Hart Crane, Wallace Stevens, and others. Alsberg thought of the national office as a think tank, the brilliance of which overshadowed the regional branches. But most of these men, like Rosenberg and John Cheever, were incapable of conforming to his model of "one America." They were just biding their time before returning to their writing careers or landing academic positions. Mangione recalled that Alsberg "made the Washington office a haven for talented field workers who were in one difficulty or another"[29] and required protection or literary asylum. Their artistic temperament or leftist views were always a handicap in the subversive milieu of Depression-era New York.

Cheever was as uncharitable as Rosenberg when it came to his descriptions of his colleagues. As a junior editor on the American Guide book series, his job was to rework, as he phrased it, "the sentences written by some incredibly lazy bastards."[30] After six months in Washington, he was able to return to New York to oversee the final stages of the New York City guidebook. Cheever made no enduring friendships in Washington. The tedium of the job and his

contempt for the staff had left him bored and edgy. He was eager to relocate to a city where writing was prized, rather than serving as a momentary diversion of the government. All the same, he was ambitious about his social life in the nation's capital: he took in all the parties he could attend.[31]

Cheever could never overlook the mediocrity of his co-workers, unwilling as he was to compromise his ideals and authority. Rosenberg was better able to negotiate the project's administrative obstacles and more strategic in maneuvering his fellow employees, having gained insight from his tribulations with the CPUSA. His dim view of the staff of the Writers' Program was counterbalanced by his geographical and cultural discovery of the United States. He admitted that Washington at first was "a new world, a totally different world."[32] His initial sense of wonder soon dissipated, however, and he communicated to Macdonald that the District of Columbia had no authenticity—its populations were too transient, tied to other cultural centers.

Rosenberg also tussled with Alsberg at the Federal Writers' Project. For starters, Alsberg had failed to apprise the Washington office of Rosenberg's arrival and to explain his role on the project. He wrote to Tabak that "when I got here nobody knew whether I'd actually been hired."[33] Alsberg made him an editorial assistant on the Guide book series, a title that was eventually changed to assistant editor to reflect his enlarged responsibilities. From the beginning, he reported to Roderick Seidenberg, an architect, who was the art and architecture editor of the series. Seidenberg, who had designed the New Yorker Hotel, was an old friend of Alsberg's and one of the first staff members of the Washington office. Rosenberg resented his authority and demanded a promotion once his job came up for review within a few months. He wanted a title on par with his boss. The gambit backfired, however, with the outcome that Seidenberg sabotaged him and "got Alsberg to rescind my raise."[34] As the more senior employee, Seidenberg, who had contributed articles to *American Mercury* when H. L. Mencken was an editor, as well as to *The Nation* and *New Republic*,[35] wanted his own rank as editor preserved. He was unwilling to share his position with Rosenberg, who

was more than fifteen years his junior. Rosenberg remained an editorial assistant until Seidenberg left Washington in 1939 for Bucks County, Pennsylvania, to resume his architectural practice.

Although Seidenberg prevailed, Rosenberg always resented his own lesser status and alleged that "Alsberg sacrificed me."[36] His feelings of deprivation were compounded by knowledge that Seidenberg's salary increased as a result of their altercation. Seidenberg's responsibilities had actually doubled through overseeing the work of an assistant. As a result, Rosenberg deemed Seidenberg loathsome: he always thought that his literary ambitions outweighed his ability, whatever his association with Mencken. That Seidenberg had blocked his advancement "really was appalling for a guy with such pretensions . . . he was absolutely nothing," he thought.[37]

Unlike many of the editors on the project, Seidenberg achieved success as a writer once he left Washington, and published two widely reviewed books on the social context of architecture. In both, postwar design was explained as bound to dehumanizing technologies and materials that displaced the architect's individuality.[38] Outside of their dystopian tone, his views actually intersected with Rosenberg's, especially when it came to his observation that the architectural profession had offloaded originality for more conventional notions of built structures. Lewis Mumford singled out one of these volumes, *The Post-Historic Man*, as a book that should have been "more widely discussed":[39] its disturbing account of the blandness and conformity that beset architecture in the 1950s was, he believed, far-reaching.

Seidenberg's writings were never fully known to Rosenberg. Seidenberg had an overbearing, Germanic personality—he immigrated to the United States from Heidelberg after World War I and was incarcerated at Fort Upton as a conscientious objector—and, to Rosenberg, the contest over his own raise preempted consideration of his superior's publications. Once Seidenberg left the WPA, Rosenberg continued to view him as a cipher. He poured his fury into a poem, "The Bureaucrats," published in his only collection of verse, *Trance above the Streets*, just after he left Washington to return to Manhattan. While he thought Seidenberg had a knack for

"abstract bureaucratic language,"[40] the functionary became a trope for the officialdom of government, someone who was effective only in enacting Roosevelt's agenda. Like Seidenberg, the bureaucrat was too bent on protocol, incapable of independent decision-making. Most of the poem dwelled on this parochialism, with one passage reading:

Is it time already
For the experts?
Will they
Really complete it,
Those cool paid men
Who have just arrived?

The clerks polite and busy
In the remote offices
They do us honor.
Our vice-presidents shining
At dinners of great men
Do us honor. Generals
And foreign visitors
Are pleased with us. Yes,
Women too already
And automobiles
Up there

But the organization[41]

Rosenberg described Seidenberg in an interview as "the supreme bureaucrat of all time,"[42] especially as he got the better of Rosenberg by retaining his dominion. Although Alsberg was allegedly "appalled"[43] to learn that Seidenberg had behaved duplicitously—he could have given Rosenberg a raise without a change in title—the issue was moot by mid-1939, when Alsberg was fired in the throes of the investigations of the Dies Committee, which claimed he had sheltered too many communist writers. Consequently, Rosenberg

was left momentarily without a protector and fending for his own position on the Writers' Program.

put anyone you want on the damn project

Soon after Alsberg left, Archibald MacLeish was made the Librarian of Congress and the Federal Writers' Project was deprived of its federal status and brought under his jurisdiction. Gorham Munson was named the new editor-in-chief of the American Guide books—one of the few carryovers from the Alsberg regime, even though he had served only one month in the Washington office before MacLeish took over. MacLeish, who had worked for *Fortune* magazine alongside Dwight Macdonald, immediately set to work restructuring the project by eliminating numerous editorial positions and writers to address the inefficiencies that had beset the series. Rosenberg became one of those staff members whom MacLeish considered unnecessary.

Rosenberg and Tabak had spent part of the summer of 1939 in Truro on Cape Cod, expanding their sense of America; while there, they probably saw Hans Hofmann, who had established a summer school in nearby Provincetown in 1934.[44] On the Cape, he met up with Clement Greenberg, who was reworking "Avant-Garde and Kitsch" for *Partisan Review*. Greenberg had complained to Harold Lazarus, his classmate from Syracuse University, that Dwight Macdonald wanted his tract restructured as it suffered from "unsupported & large generalizations."[45] He had written a draft of the piece before he left for a trip to Europe, never expecting that it would be accepted without editing, "afraid of [his] own flights of spun theory."[46] When Macdonald asked for a complete overhaul, Greenberg put the task on hold until he returned from his trip, almost preferring, that it be "turned . . . down, for the question of organization is always the most difficult problem of all in presenting ideas—for me at any rate."[47]

Greenberg abided by Macdonald's editorial specifications. Still, he was put off by the feedback. "These people," he wrote to Lazarus, "with the best intentions do as much to smother American culture

as the Roman church ... Macdonald has a journalistic notion of per-
fection."[48] Rosenberg also felt that Macdonald's editorial on Mann
for *PR* was overly "journalistic" and detracted from the "intellec-
tual"[49] context of Mann's work in the late 1930s. That Macdonald's
"journalistic notion of perfection" elicited greater clarification in
their prose was a notion that initially evaded the two, who were still
adjusting to what it meant to write for an audience rather than for
themselves.

During this period, Greenberg kindled an intense rivalry with
Rosenberg, even though Rosenberg had moved away from Man-
hattan. Greenberg now saw him as competition, what with the di-
minished publishing opportunities for critical essays on art and pol-
itics, as the Depression wore on and the "little magazine" faced fierce
odds in attracting investment capital. As he retooled "Avant-Garde
and Kitsch" on the Cape, he wrote to Lazarus, who had relocated to
Washington, DC, in 1936 to take up a job in the Civil Service Com-
mission,[50] that "the Rosenbergs passed a couple of days around here
before moving up to Provincetown, and I found him unbearable:
the sublime presumption with which he told me how I should have
travelled to Europe, and what was wrong with me."[51] Rosenberg
had dismissed Greenberg's travel stories as pedestrian and dreary,
but then so, too, had Mary McCarthy, who mocked his foreign ad-
ventures at many of her dinner parties during the summer by para-
phrasing the giddy observations that filled his postcards to *Partisan
Review* editors. Her spoofs of his trip dripped with hauteur and sar-
casm. On one occasion, she mimicked him to her guests: "Oh my
God. It's so beautiful ... Did you know they have water in the streets
of Venice ... In Rome, I discovered the Spanish Steps and I discov-
ered that place that is called the Sistine Chapel."[52]

For all of Greenberg's agitation over Rosenberg's visit to the
Cape—exacerbated by his need to restore Macdonald's confidence
in his work—Rosenberg's travels were cut short by the news that
he had not been reappointed to the Writers' Program. His oppor-
tunity to continue to spar with Greenberg, and to deflate his Eu-
ropean stories, ended as he had to salvage his own job. According
to Mangione, MacLeish had instituted a thirty-day waiting period

for employees who had not been immediately terminated from the project;[53] hence, Rosenberg decided to spend a month vacationing in New England, biding his time on the beach before an anticipated reassignment. Mary Barrett, a staff member who was a loyal friend, traveled to Truro to apprise him that his job was not only in jeopardy, but that he had been fired. Rosenberg responded with habitual self-righteousness, believing that MacLeish had acted out of vengeance, that his decision to dismiss Rosenberg was personal rather than from a need to downsize the program.

MacLeish's decision to discharge Rosenberg was, in fact, tinged with retribution, an unvarnished response to a rebuttal that Rosenberg had written to an essay MacLeish had published in *Poetry* in 1938 titled "In Challenge Not Defense." In one of three lectures that both repudiated Karl Marx and questioned the modernist emphasis on the self, MacLeish argued that literature had to become less private if it was to be effective. Like many writers in the 1930s, he had become a populist by reversing his early antipathy to social responsibility. He now believed more concrete imagery in poetry was in order, accessible themes that could cut through the seemingly recondite obsessions of T. S. Eliot and Ezra Pound.[54] Although no fan of Eliot's, Rosenberg took issue with MacLeish's new requirement for representations of breadlines and the dispossessed, evidence of the "social crisis"[55] that confronted the United States. Unlike MacLeish, who grew up in privilege in Glencoe on the north shore of Chicago, and attended the Hotchkiss School before graduating from Yale and from Harvard Law School, Rosenberg thought such treatment of the disenfranchised was retro, dated by too many religious tie-ins.

As Jerre Mangione remembered, when Rosenberg learned that he had been released from his job, he "sped back to Washington to talk with Gorham Munson . . . [and] told him his explanation for MacLeish's action: he had once written an unfavorable review of a lecture by MacLeish for *Poetry* magazine." During his long trip home, Rosenberg's temper escalated at the thought that MacLeish had exercised his power unfairly. When he reached the Writers' Program, he directed Munson to tell MacLeish, "I won't stand for that kind of crap."[56] Munson confronted MacLeish at their next meet-

ing, with the upshot that MacLeish immediately backed down, exclaiming, "Put anyone you want on the damn project ... and get out of this office."[57]

Long after his post had been restored, Rosenberg referred to MacLeish as a "sybaritic son of a bitch."[58] Although he and Tabak moved to B Street to be in proximity to the Library of Congress where the office of the Writers' Program's were relocated—he now had a room that he described as "hot stuff"[59]—his standoff with MacLeish endured even after the project was dissolved in July 1941. That MacLeish had attempted to even a score was only part of his hostility. The primary wedge was their respective interpretations of Marx—the recurring rift in Rosenberg's literary relationships—and their divergent readings of texts such as *Das Kapital*. Or, as MacLeish referred to it, Marx's "anti-individualism."[60] To Rosenberg, MacLeish's humanism prevented recognition of their like-minded understanding of fascism's violation of Marxist texts.

Through the ordeal of regaining his job, Rosenberg found an intermediary in Munson, to whom he now reported and who promoted him to general field editor, a position that not only incorporated Seidenberg's old responsibilities but also affirmed his authority on art and architecture within the program. Rosenberg had relied upon bluster when it came to asserting his (limited) expertise. As he wrote to Tabak, before she joined him in Washington, "I'm sitting at a desk going over art copy from Iowa ... At 4, I have already given my expert advice."[61] That he had little or no acquaintance with the arts of the Midwest, outside of Chicago to which he had traveled only once, was inconsequential.

The job at the Writers' Program afforded Rosenberg the opportunity to travel to states such as Washington and Missouri, and to "See America First," as he wrote in a letter to his parents.[62] Yet, he never presumed his livelihood was securely moored, knowing that it could be set adrift by the pressures exerted by the Dies Committee on the federal government to expose the political ties of its employees. Then, MacLeish eventually brought the program to an end. MacLeish was dissatisfied with the results of the American Guide book series. But his attention had been diverted by the reorganiza-

tion of the Library of Congress, which, as he saw it, entailed greater "contact with the scholarly community."[63] The mandate was a contradiction for someone who had recently decried the introverted subjects of modernism. While an editor at *Fortune*, MacLeish had moonlighted as a poet. His divided professional life forced reconsideration of culturally relevant verse. It also made him a prime candidate to be the Librarian of Congress, and the occasional ghostwriter of President Franklin D. Roosevelt's fireside chats. "Ours is a public age," MacLeish averred, "the events that concern us are wars, the dangers of wars, the dangers of growing civilizations, and the destruction of the earth—nothing private about these views, objects, problems!"[64]

When it came to the Library of Congress, these directives were frequently overlooked. The scholar was released from the expectations that MacLeish had for a popular audience for poetry. His revisions to the Library of Congress were modeled on the repositories that he had known as a student at Yale and Harvard. He aimed not only to upgrade the nation's collection of books but to replicate an academic community. MacLeish succeeded in both areas by vastly expanding the Library's holdings, as well as by establishing a residency program that brought internationally renowned scholars to Washington. In addition, he made the newly created post of "Consultant in Poetry to the Library of Congress" (now the Poet Laureate Consultant) a one-year rather than a two-year position that rewarded recipients with a relatively carefree year to devote to their work, as well as to oversee a lecture program. But however deep his democratic impulses (which spared the scholar), they did not incorporate the American Guide books. He did not inaugurate the series, and its end product was too uneven for him. By the time MacLeish took office in 1939, there was little left to finish on the series, outside of the few troubled volumes that Rosenberg rescued and routine editing of those that awaited publication. The period became a fallow spell for Rosenberg, allowing him to investigate mergers with other government programs, such as the Index of American Design that Holger Cahill embarked on in 1935 for the Federal Arts Project and

which employed "commercial artists"[65] who did not qualify for the Mural and Painting Divisions.

The Index was a major undertaking—exceeding the scale of the American Guide books—and was organized as a visual archive of vanishing material cultures from regions of the United States that fell under collective terms, such as "Americana" and "folk art." The artists employed on the Index worked from photographs to produce minutely rendered watercolors that were beguiling in their trompe l'oeil effects. The project afforded Rosenberg the opportunity to travel to the Southwest, where he spent time viewing churches, monasteries, indigenous textiles, household implements, furniture, and pottery to cap one of the many unfinished phases of the Index. But, unlike the American Guide books, the Index, with its broader scope, proved too unwieldy to finish. It required a more flexible time frame than the finite lifespan of the WPA. Eventually, the shifting political interests of the Roosevelt administration spelled its end, when the WPA was aborted in 1942. With the Japanese raid on Pearl Harbor in December 1941, an expanded workforce was needed for the armed services as the United States teamed up with the Allied Forces. The government estimated that artists and writers on the WPA would constitute part of this workforce.

The Index was one of the many casualties of this outcome. Its eighteen thousand watercolors were transferred to the National Gallery of Art. (The photographs were scattered and are known primarily though museum publications.)[66] Rosenberg and Holger Cahill had entered into a publishing partnership that conjoined the national office of the Writers' Program and the Federal Arts Project to produce a six-volume series of the Index that would highlight many of the watercolors by region. They were to be united with captions that each artist had written according to a format prescribed by Cahill's staff. Rosenberg was to have assumed the role of general editor.[67] But the project was never realized, even though Rosenberg remembered that a contract had been negotiated with Crown Publishing to distribute the books. Their plans were impeded by the urgency for new government agencies, such as the Office of War Infor-

mation and the Office of Strategic Services, both of which depended upon artists, filmmakers, and architects to develop propaganda.[68]

Despite these blows, Rosenberg referred to his limited work on the Index as "fascinating."[69] He was held by the sociological dimensions of the materials that he studied, the way that the work of anonymous artisans was knit into local economies and alluded to a class structure, as well as by the convergences with modern art and design. These links had also been made by Cahill, a former director of exhibitions at the Museum of Modern Art. However, like most other phases of Rosenberg's government employment, his interactions with Cahill never yielded a permanent editorial position in publishing. Despite his enthusiasm for the Index, and the psychological distance it provided from MacLeish, he remembered that "after the war . . . I wasn't interested in bothering with it."[70] He moved on to the Office of War Information (OWI) when the Federal Writers' Project was dissolved in March 1942; at OWI, he worked as a radio script editor, writing copy for overseas transmissions. Archibald MacLeish, his nemesis, also served as the agency's assistant director while continuing to fulfill his duties as librarian of Congress.

those with high standards

Archibald MacLeish erroneously thought of Rosenberg as "a rigid doctrinaire Marxist."[71] He was never able to square Rosenberg's socialist leanings with his stance on alienation. Nor was he able to accept, as Rosenberg complained in a letter to George Dillon at *Poetry*, that it was "necessary to be a Marxist in order to recognize that classes exist and that their struggles govern political and social events."[72] Rosenberg's clarifications had little effect on Dillon, who had minimal interest in class struggle. During Dillon's tenure at *Poetry*, the publication increasingly became devoted to the New Criticism, paralleling the editorial direction of *Partisan Review*.

Poetry was never a leftist publication, a fact that Rosenberg learned firsthand through his review of the American Writers' Congress in 1935. Its editors always drew the line on partisan advocacy. Ezra Pound had successfully coerced Harriet Monroe into includ-

ing his *Canto XXXIV* and *Canto XXXVII* in the publication in 1933, poems that patently stated his disillusionment with the US government. All the same, she subsequently balked and informed him, "I regret that the latter is the last of your political manifestos which *Poetry* will care to have the honor of printing."[73] Dillon's gravitation toward the New Criticism thus reflected a long-standing editorial policy. The literary movement provided coherence for a magazine that had sometimes faltered toward idiosyncrasy. In the progression from Pound to Eliot and the New Criticism, there could be little accommodation of Rosenberg's voice, however. The trajectory was the same at *Partisan Review* after Dwight Macdonald left in 1943.

Rosenberg never imagined that MacLeish would become the director of the Federal Writers' Program, and certain professional costs would grew from his rejoinder to the latter's "In Challenge Not Defense." But he never contemplated the consequences of any of his polemical responses. His intellectual principles always overrode practicality. He could not stomach MacLeish's uplifting prophecy that "only poetry can deliver us."[74] To him, such idealism was bunk. He had jumped at the opportunity to have his opinions about MacLeish made public in *Poetry* in 1938. But there had been more behind MacLeish's vendetta to have Rosenberg removed from the Writers' Project than his views on Marx.

Unknown to Rosenberg, Dillon had contacted MacLeish about submitting a piece to *Poetry* before he took over the Writers' Project, not wanting to miss the opportunity to publish one of the foremost poets in the country.[75] Despite their ideological differences, Dillon probably looked upon MacLeish as a brother: they were both awarded the Pulitzer Prize in direct succession in 1932 and 1933. It did not matter to him that Morton Zabel had lamented in *Poetry* that MacLeish's exuberant patriotism had become a rallying cry for the Roosevelt administration.[76] Nor did it matter that after Dillon published MacLeish, and he became the librarian of Congress, Zabel castigated him as the "poet of capitol hill."[77]

It took MacLeish more than a year to respond to Dillon's request for a submission. "In Challenge Not Defense" took the form of free verse, where he repented for his solipsism in the past tense: "Those

who tell us the eternal poetry is the poetry written about the feeling of being dreadfully alone. Those with High Standards."[78] In his reply, Rosenberg concentrated on MacLeish's role at *Fortune* magazine, implying that it had tainted his liberalism: "One might say that he had glanced at society from an economic point of view before applying to its dilemma the solvent of his poetic will."[79] MacLeish thought Rosenberg's interpretation revealed a misunderstanding of socialism. He was incensed by the rebuttal and decried it in a final salvo in *Poetry*: "When you run into a blast like this you look for the animus. The animus is stated. It is insolence in me to suggest that the poets of this century must give form and shape to the imagination of the people because this has already been done . . . by the Marxists."[80] As he privately related to Dillon, "Think of being called an unconscious Fascist again! What does he think economic determinism is?"[81]

After he submitted his counterargument, Rosenberg explained to Dillon that "any harsh notes with respect to certain of MacLeish's pronouncements are . . . free of any personal motivation."[82] Dillon acted as a mediator, although he was hardly impartial. He realized MacLeish's newfound populism was unaligned with his objectives for *Poetry*, but his professional prominence could not be overlooked. Soon after Dillon became editor, MacLeish nominated him for the Shelley Memorial Award,[83] a prize bestowed biannually by the Poetry Society of America, which MacLeish himself had received in 1931 in advance of the Pulitzer. Dillon was never presented the honor, but MacLeish's gesture accrued in ongoing support. Later, in 1942, when *Poetry* suffered a financial reversal, it was relieved by an infusion of cash from the Carnegie Corporation that MacLeish had a role in facilitating.[84] MacLeish modestly stated that he had "played a very small part in all of this, but I am delighted to know that *Poetry* has been saved."[85]

Dwight Macdonald referred to MacLeish as a "power guy"[86]—an opportunist who could never mine the depths of modernism, and whose goal to link middlebrow sentiment with progressive literary forms was shallow, easily adopted by the Roosevelt administration. As Macdonald pressed for Rosenberg's renewed presence in *Parti-*

san Review, maneuvers that resulted in the publication of "Myth and History" and "The Fall of Paris," MacLeish's overtures to the working class became read by both as philistinism.

such a blacktown fashion show you never saw

Outside of Rosenberg's fracas with MacLeish, there were few other literary skirmishes while he lived in the District of Columbia. Although his name was brought up on the floor of Congress during the Dies Committee, where he was labeled a "Red," most of his aesthetic battles were waged in New York.[87] During the time that he and Tabak lived in the nation's capital, they made very few acquaintances, and relied upon visits from friends from New York, such as Parker Tyler, their old roommate from Houston Street. Tyler described attending Marian Anderson's performance at the Lincoln Memorial in the spring of 1939 with Rosenberg and Tabak, after she had been barred from singing at Constitution Hall by the Daughters of the American Revolution because she was African American. Tyler recounted that "Anderson's voice seemed to be traveling for miles across the trees and the greensward and the War Department and above her hovered the brilliant ghost of Lincoln ... there were thousands and thousands present ... Such a blacktown fashion show you never saw: hysterical purples, yelping greens, brainfever pinks, splitting yellows, shocking blues, congealed turquoises."[88]

Beyond the concert's uplift and sartorial spectacle, the weekend was memorable for their conversations about writers. Rosenberg relayed to Tyler that he wanted to tackle Marx again. After Tyler returned home, he reported in a letter to Charles Henri Ford, who was always weary of Rosenberg, that "conversations with Harold are blooming like slow fireworks in formal gardens."[89] Tyler's metaphor of a "garden" hinted at the clarity Rosenberg had gained through his reworkings of "Myth and History," and at the rigor that Macdonald required of all of manuscripts submitted by writers.

Rosenberg had hoped that Dwight and Nancy Macdonald would make the trek to Washington to spend a weekend. His letters to Macdonald were filled with mentions of anticipated visits. He wished

they could relieve his feelings of isolation and a social life constrained by secrecy during Dies's odious reign. Rosenberg extended numerous overtures to Macdonald—"May & I are looking forward to yours and Nancy's arrival. If you don't come this week end or next, at the latest, we shall be very disappointed"[90]—but these trips were always postponed, Macdonald's writing deadlines too pressing. Rosenberg playfully teased him about his workload, particularly a report on "monopoly investigating"[91] that consumed Macdonald in the winter of 1939 and focused on the failures of Roosevelt's Temporary National Economic Committee (or Monopoly Committee, as it was called in the press) to reform industry. The president, he proposed, had ignored the worker in favor of shareholders.[92]

Rosenberg did see Macdonald on the occasional trips he made to New York, desperate to maintain contact with colleagues and friends. When he and Tabak moved back to the city in 1943, they rented an apartment in the same brownstone as the Macdonalds, on East 10th Street, where they picked up their exchanges initiated through *Partisan Review*. Macdonald let him know there was a unit available on the second floor of the four-story row house. He and Nancy lived on the top floor of the walk-up, and the Rosenbergs became frequent guests at the parties the Macdonalds hosted. By that point, Macdonald had left *Partisan Review* to found *Politics*. Both writers opposed US involvement in the war, which made for like-minded discussion. However, unlike Macdonald's pacifism, Rosenberg's reservations about military aggression did not extend to doctrines of nonviolence. Although *Politics* had a mandate to spurn dogma and concentrate on new interpretations of Marx, Rosenberg eventually became uneasy about the moral underpinnings of the journal. As a result, their relationship became tense, their talk more heated. Rosenberg told Lionel Abel that "what appalled me was the article"[93] that Macdonald had written in the late summer of 1945 on the American bombing of Hiroshima.[94]

Rosenberg was dismayed that Macdonald had compared the huge death tolls in Hiroshima to Hitler's atrocities in the death camps in his article. He felt the connection was gratuitous, that Macdonald was unable to grasp that the use of the atomic bomb in Japan repre-

sented a different tragedy: the Allied Forces had been put in an eth-
ical quandary and had no option. As a dove, Macdonald had zeroed
in on the government spin-doctors, or "Authorities,"[95] who had jus-
tified the bomb as a deterrent against future military provocation.
He was aghast to find that socialists and conservatives alike were
united on the necessity of its use.

Shortly before Macdonald's polemic appeared in *Politics*, Rosen-
berg had weighed in on Hitler's "crimes"[96] in *Partisan Review*, where
he examined the Führer's relationship to bohemia. He had proposed
that Hitler and his followers were never true moderns; that their
fascism was less a manipulation of Marxism than a reenactment of
an anachronistic aristocratic model. Where Macdonald had empha-
sized the perversion of new technologies implemented by the mil-
itary to kill enemies, Rosenberg believed that Nazi brutality was an
isolated case. He was averse to Macdonald's suggestion that corrup-
tion of Marxist idealism had a hand in explaining the Final Solution.
A rift slowly developed between the two men, and their social inter-
actions became less frequent after the late 1940s.

clem

Rosenberg saw Clement Greenberg (fig. 10) at least once in Wash-
ington, DC, when Greenberg visited his son, Danny, who occasion-
ally traveled from California to spend time with his mother, Edwina.
Greenberg introduced Rosenberg and Tabak to Harold Lazarus,
his "soul mate,"[97] who moonlighted with little success as a literary
critic and translator after his day job at the Veterans Administration.
Greenberg had warned Lazarus to "watch out for" Tabak, whom he
described as "a nasty customer,"[98] lest she try to dominate their con-
versation. His advice proved unnecessary: Lazarus was undaunted
by her forthright nature. (While frequently submissive in the pres-
ence of Rosenberg, Tabak could take over when he was not around.)

Lazarus was grateful for the chance to expand his intellectual life.
He found Rosenberg "nice,"[99] although "childish,"[100] and regarded
his need to educate as unnecessary—although there were clear con-
trasts in their lifestyles. Lazarus thought of Rosenberg and Tabak

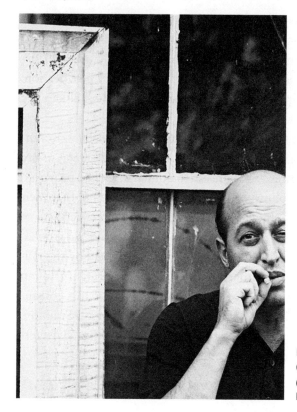

Fig. 10. Hans Namuth
(1915–90), *Untitled
(Greenberg)*, 1950.
Photographic print.

as "bohemians,"[101] which clashed with Tabak's characterization of
Greenberg and Lazarus as "bourgeois."[102] Tabak could never under-
stand why Greenberg held a position as a clerk at the US Customs
Service in New York, appraising wine and liquor, when he could
have joined the WPA. Lazarus helped the Rosenbergs find their
first apartment in Washington, but was unable to convince them to
settle in a Victorian building that had charm. They opted, as Tabak
said, for a "dull but comfortable flat on the top floor of a policeman's
home"[103] and furnished it with a few odds and ends they brought
with them from New York. All Rosenberg required was a place to
write; the look of his surroundings was irrelevant. The Federal-style
row house that he and Tabak later occupied in the East Village was
similarly short on splendor, unlike the more elegantly appointed
apartments that Greenberg occupied as his career escalated. Rosen-
berg and Tabak remained true to their bohemian identity, prizing

the clutter of books and jumble of paintings by their friends on their walls rather than fashionably appointed interiors. The same applied to their dress: Rosenberg always looked rumpled, and Tabak turned out in her peasant-type garments. His daily attire was generally casual—a plaid shirt and loose jacket for daytime, with a tie reserved for events in the evenings.

Greenberg's letters to Lazarus were laced with jealousy and malevolence toward Rosenberg, even though Rosenberg had been largely responsible for acquainting him with radical politics. Rosenberg had introduced him to Lionel Abel and Lee Krasner before he left New York, and they in turn engineered many professional contacts for the budding writer. Greenberg cautioned Lazarus that Rosenberg "always had a desire to be right, correct,"[104] implying that his verbal facility was off-putting. "This is why," he preached, "these guys, brilliant, don't amount to anything in the end."[105] His bitterness was ignited by feelings of inadequacy, the self-doubt that he felt when Macdonald had him rewrite "Avant-Garde and Kitsch." Rosenberg's unwavering confidence was disconcerting to Greenberg.[106] As both writers vied for prominence at *Partisan Review* and hoped to be made associate editors—a carrot that Macdonald continually dangled—Greenberg recognized that Rosenberg had a formidable intellect that was undeniable. To some degree, Rosenberg was an imposed adversary, especially once Macdonald sought to wrest control of the publication from Rahv and Phillips, and take over himself.

Greenberg conceded to Lazarus that he "liked" Rosenberg's piece on "Myth and History," that it was "brilliant in fact."[107] He complained about "the irksome fuss about Mann"[108] at *PR*, but suggested that Rosenberg had outdone the earlier articles by Phillips, Macdonald, Troy, and Burnham. Yet there would be few such admissions, what with his constant harping on Rosenberg's "egoism."[109] As they both angled for Macdonald's attention, Greenberg conveyed to Lazarus that he, Rahv, and Macdonald, were largely indebted to Rosenberg but saw him as a threat: his reflections on socialist politics and modernist culture were too intimidating.

During this period, Lionel Abel was drawn into Greenberg's com-

petitiveness with Rosenberg. Greenberg knew that Rahv believed Abel was expendable at *Partisan Review,* and that he was close to Rosenberg. However, as the editors jockeyed to take over the journal, Rosenberg became their main target. Greenberg recounted in a particularly puerile letter to Lazarus an evening spent with Rahv in 1939 that implicated Macdonald:

> Philip Rahv has been over to see me and he seized the moment to jump on Abel and Rosenberg. I joined in with a lot of relish. We went to town. Rahv is intelligent but not wise; but he is sensitive and full of interior awkwardness like me. He did them up brown. To a turn, to a crisp. Clowns, innocent, mountebanks, frivolous egomaniac, Philistines of humility, hypocrites of boastfulness, is what we called them. They are all that. As a matter of fact, even Macdonald seized the first loophole when I saw him attack Rosenberg. That was surprising, even though Macdonald is nobody's fool, least of all Rosenberg's.
>
> But what was surprising was that he resents Harold, as I do, for both teaching us so much and having at the same time taken him in.[110]

Greenberg and Lazarus could never abide Abel's boorish nature: they referred to him as a "poolroom shark"[111] whose leftist posturing seemed unsubstantiated by any real grasp of Marx. Around 1945, after Greenberg was no longer able to be civil to Abel, his aggression become physical.[112] He pummeled Abel at a party at Abel's apartment after Greenberg mistakenly accused a guest, Jean Wahl, of being an anti-Semite. (Wahl had been interned at Drancy, a deportation camp northeast of Paris before escaping to the United States, where he taught at Mount Holyoke College. He resumed his position as a professor at the Sorbonne once the war ended.) Macdonald, ever the pacifist, had no truck with Greenberg's pugilistic behavior. He had witnessed the incident, and thereafter their interactions were limited.

Greenberg's sense of self-importance became wildly inflated once he was appointed associate editor of the *Partisan Review* in

1940. His conduct frequently devolved into violent outbursts that he felt were justifiable. Outside of his reluctant respect for Rosenberg, he never engaged him in a fight, however: Rosenberg's physical stature was too intimidating. "I'm not going to tangle with that guy, he's too big,"[113] Greenberg told William Barrett just as Rosenberg abandoned the publication.

In his letters to Lazarus, Greenberg let on about his affair with Jean Connolly, the wealthy American wife of Cyril Connolly, who was the editor of *Horizon*, a London-based publication that had reprinted some of Greenberg's essays—most notably, "Avant-Garde and Kitsch." *Horizon* had also commissioned new pieces from Greenberg such as "An American View," which dealt with the British and French hesitation to go to war against Germany. The fling with Connolly was intoxicating, leading Greenberg to exclaim that he "must become a great man"[114] and embark on numerous such dalliances. He wondered with no sense of anxiety if *Partisan Review* might fold, or be editorially remade, confiding to Lazarus that "Dwight, who controls the Maecenas—Morris—is disgusted with the rest of the editors & blames them for the characterlessness of the mag. He wants either to push Rahv, Dupee & Phillips out & replace them with me & 1 or 2 other people, or to expand the board by adding me & ditto, or, failing that, to kill PR & start over again with himself & me as the guiding spirits and as *writing* editors . . . It may come to nothing."[115]

Rather than worrying about whether Rosenberg was part of Macdonald's plan to take over *Partisan Review*, Greenberg perversely fantasized about what Rosenberg would make of his relationship with Connolly and her sophisticated world. He bragged to Lazarus that his new hedonism went with the territory of highbrow culture. Yet, he also revealed himself to be a novice by exclaiming, "You shd smell the world I've just been smelling, where buggery, beggary, cuntsucking, blackmail, lechery, money, frivolity, poetry & fistulas are all mixed in one glorious knauel. Oh these fortunate Anglo-Saxons who live face to face with the ultimates at all times."[116] He could not resist comparing his own glamorous encounters with the Rosenbergs' glum life in Washington, DC. If only Rosenberg recognized

that his circumstances could be altered by self-improvement—that is, if only he attended to his appearance, residences, clothing, and choice of acquaintances—he could become more socially mobile, like him. Greenberg was hardly an Adonis, with his premature baldness and unathletic frame. He had resorted to arrogance. Still, he obsessed over Rosenberg, unable to reconcile his intellect and his candor. Rosenberg's defiance of authority likewise eluded his understanding. Greenberg came to think of Rosenberg and Tabak as an unattractive couple, unworthy of his association. There was no aesthetic dimension to their lives. As he fulminated in one crude missive to Lazarus, "The Rosenbergs are of course pustulent [*sic*]. For their malice & envy they should at least have grace & beauty. They should make some demand on one's capacity to enjoy & for the enjoyment, to forgive their sins. But I'm becoming a snob. I want beautiful people & grace."[117]

Greenberg's liaison with Connolly and his growing international reputation as a writer only intensified his grandiosity. He may have decided to extricate the Rosenbergs from his life, but his fixation on them erupted at numerous subsequent junctures. Once his ambition took over, Rosenberg, and also Lionel Abel, were subject to routine anti-Semitism in his letters to Lazarus. He wrote off Rosenberg's parade of knowledge as "what Hitler thinks Jewish intellectuals are."[118] Rosenberg's erudition clearly gnawed at him and got under his skin. In one pathetic response, he took revenge on one of Rosenberg's poems when he was made associate editor at *Partisan Review*, finding it too unsubtle to print.

Macdonald insisted that Rosenberg's riff on loneliness, "The Unlearning," be published shortly before Greenberg came on staff, which exacerbated internal tensions within the journal.[119] Once he was on board, Greenberg focused his uncertainty about Rosenberg's poetics on his refutation of formalist models. Although Macdonald prevailed, Greenberg implied that "The Unlearning" did not measure up to monuments such as T. S. Eliot's "East Coker"—which, of course, it did not. *Partisan Review* had run Eliot's long poem in 1940, in the same issue as Greenberg's "Towards a Newer Laocoön," the essay in which Greenberg announced that "poetry subsists no

longer in relations between words as meanings, but in relations between words as personalities composed of sound, history and possibilities of meanings."[120] "Laocoön" was a parable of "decline,"[121] an argument for retreat from mass culture as well as from the illusionistic devices that art had depended upon.

When he was made associate editor of *Partisan Review*[122]— winning a hidden contest that Macdonald waged between him and Rosenberg—Greenberg seized upon Rosenberg's schema of history, the ruptures described in "The Fall of Paris," characterizing it as wrongheaded, bordering on fallacy. He told Lazarus the article was "badly & dishonestly written & yet was good. Good in spite of the things that made me grit my teeth, in spite of the rotten pretentiousness that came through and of the utter lack of feeling for language."[123] In other words, there was no evidence of grace in Rosenberg's writing that could redeem his reasoning. Beauty was never his beat or territory, however. As "The Fall of Paris" illustrated, his interests gravitated to the political exigencies that pressed on artistic expression, especially in the wake of the Occupation. Greenberg, by contrast, had withdrawn into aestheticism to try to decelerate the "decline" of modernist art by focusing on its core decorative values.

The editorial fissures at the *Partisan Review* strained Greenberg's relationship with Rosenberg beyond reconciliation. He boasted to Lazarus that once Rosenberg had heard "that I'd become an editor, [he] denounced me far and wide in violent, slanderous terms. Friday morning he called me up at the office, wanting me to see him, & I was embarrassed. I really don't know what to say to an enemy."[124] Rosenberg was mystified by Greenberg's elevation to the masthead and queried Macdonald about the appointment: "Confidentially, why? I consider him a friend, but working with him? Isn't he crotchety, eccentric in judgement, a trivia magnifier, time waster?"[125] He countered that there were more credible choices and forwarded Macdonald names of a few fellow contributors, such as Meyer Schapiro and Edmund Wilson, as potential candidates.[126] Schapiro, a supporter of Macdonald and a fellow Trotskyist, was subsequently invited to serve as an editor, but he turned down the offer.[127]

Although Greenberg got the promotion, his grousing about

Rosenberg never ceased. He continued to complain to Lazarus that Rosenberg never adequately congratulated him on his writing, that his praise was backhanded and stinting.[128] Despite his frustrated desire for recognition, Rosenberg never solicited Greenberg's opinion of his own work. Yet as Greenberg's affair with "La Connolly" ended, and she returned home to her husband in London—only to rebound and crash again—his pretensions momentarily receded. He was brought back to the debilitating infighting at *Partisan Review*, moaning to Lazarus, "I'm so disgusted with intellectuals, with impersonal, inorganic people like Dwight Macd. & Rosenberg (to some extent). I loathe them, I'm sick of them."[129]

The trials of rewriting his essays for Macdonald, along with demands from Phillips and Rahv to shorten his submissions, had resulted in frustration. Greenberg's stint at *Partisan Review* was short, lasting only until 1942, when he moved over to *The Nation* (although he continued to write on art for *PR* with almost the same frequency). By that point, Rosenberg was plotting his return to New York. When Greenberg became the managing editor of *Commentary* in 1944, a magazine to which Rosenberg would actively contribute, their relationship became more normalized, less exacerbated by acrimony. While Greenberg had once spewed his anti-Semitism freely on Rosenberg, Abel, and the editorial team at *PR*, once his love life with a WASP (White Anglo-Saxon Protestant) icon ended, his vitriol faded.

Greenberg had similarly located a "Jewish self-hatred"[130] in Lionel Trilling, another writer who, like Rosenberg, questioned his journalistic integrity. The accusation complicated his relationship not only to Judaism but also to an aesthetic agenda that made no provision for ethnic expression.[131] He was conscious, however, that his charge against Trilling amounted to self-projection. By 1950, he attempted to reconcile the repression of his identity in *Commentary* when he wrote, "I am projecting upon others faults that I find in myself; it is only reluctantly that I have become persuaded that self-hatred in one form or another is almost universal among Jews ... and that it is not confined on the whole to Jews like myself."[132] Still, his allegiance to formalist analysis rarely permitted these insights to be

applied to art: when Ezra Pound was awarded the Bollingen Prize in 1948, Greenberg was offended by the choice, not only as a Jew, but by Pound's "chronic failure"[133] to produce a poem that he thought was deftly structured.

rosenberg's ego was as large as his body

Rosenberg's tenure in Washington, DC, ended in 1943, and once he relocated to New York, his saga of negotiating the bureaucracies of the Federal Writers' Project ended—only for him to find that *Poetry* and *Partisan Review* were no longer prospects for his writing. The New Criticism infiltrated both publications in the early 1940s, and his ideas migrated elsewhere. These vicissitudes were explained by William Phillips less as ideological than as a quirk of Rosenberg's personality, part of the threat that Greenberg sensed he had posed to all of the editors of *PR*. As Phillips had it, "Rosenberg's ego was as large as his body. He always thought issues of *PR* that contained something by him were particularly good. In the forties, Harold wanted to be an editor of the magazine and he tried to persuade me by saying that it is not fulfilling its cultural mission, which it could only do if he was editor. The assumptions were overbearing, the manner genial. One day I brought these proposals to an end by suggesting that with his editorial vision he could start his own magazine, which would immediately outshine others."[134] Rosenberg's ego was huge. He was never prone to self-doubt, as Greenberg and Rahv were. But his ego, however colossal, would constantly interfere with his professional associations, forestalling any editorial appointment until the 1960s.

10
the profession of poetry
trance above the streets

many of the poems do not come off

When the Federal Writers' Project ended in March 1942, Rosenberg found himself without a job.[1] As Tabak was pregnant, they left their furnishings in storage in Washington, DC, and spent a month at her father's house in Brooklyn before availing themselves of an apartment in Cooperstown, New York, which a friend had offered while he served in the war. Rosenberg had hoped to land a position in New York, but when nothing surfaced, he returned to Washington in December to work in the domestic radio bureau of the Office of War Information, a new government agency responsible for promoting patriotism and disseminating American propaganda. In the interim nine months, he spent time in Cooperstown editing and securing a publisher for a collection of his poetry, *Trance above the Streets*, for which he enlisted William Carlos Williams to write the introduction.

Rosenberg was still skeptical about the future of poetry. He now talked about a "profession of poetry," questioning whether the genre had succumbed to "craft."[2] He concluded that poetry could be less moribund if it focused on "man":[3] the only viable subject in an era filled with anxiety. Rosenberg wrote to his old friend Harry Roskolenko—whose work had appeared continuously in *Poetry* during the 1930s—about his frustrations in bringing out the volume. Greystone Press had commissioned the book but had gone out of business on the eve of publication. The collection was eventually released by Gotham Press (an imprint of the now defunct New York bookstore of that name). "The only reason I came near publish-

ing the book was that I didn't have to do anything about it," he told Roskolenko. "Now it's becoming the usual poet's bareback—which has always struck me as a bit ridiculous. I mean, why take so much trouble to put out something that no one really wants."[4]

Part of his diffidence stemmed from Williams's preface, which was not the congratulatory intro he anticipated. The poet acknowledged that Rosenberg "knows how to use the language, how to attack the problem, how to make the words do what they must do to enter an expressive modern patter," but concluded that the poems did not amount to "genius."[5] His summation was also ambiguous: "Many of the poems do not come off," he wrote, "they seem all drawn from one model. This is, of course, an exaggeration but it is the feeling I get from the book."[6]

Williams was known for his candor, as well as for his unsparing assessments of younger poets' work. He also occasionally used the preface as a confessional platform. In the case of Rosenberg, he declared, "I'm not satisfied with him, probably because he exhibits too many of the incompletions I see in myself."[7] Rosenberg knew that he could not risk any possible misinterpretation of Williams's self-projection, especially as he had been hard on him. He did not want his contributions to *Poetry*, from which *Trance above the Streets* was largely drawn, diminished. By the time the book finally went to press, Rosenberg admitted to Roskolenko, "I'm sick of it. Don't read it. The hell with it."[8] Roskolenko later referred to *Trance* as "a collector's item."[9] It had become a relic, an attribution Rosenberg presupposed even before the volume was printed!

Roskolenko reviewed *Trance* for *Voices: A Quarterly of Verse,* where he noted that Rosenberg was a critic who brought a certain detachment to his poems, pursuing them as "cosmic parody."[10] The description was a stretch, a cover for the literary inadequacies of a friend. There was little caricature in Rosenberg's verse. He had hoped Roskolenko might cover *Trance* for *The Nation* or *New Republic,* where he was also a contributor.[11] However, both venues were uninterested. Rosenberg also backhandedly solicited Philip Rahv at *Partisan Review,* asking, "Is my book being reviewed in the next or current PR?"[12] He reminded Rahv that Lionel Abel was willing to

write the piece. But without Macdonald on staff to intervene on his behalf, the book was ignored.

Besides Roskolenko's tribute, Alan Swallow—a poet who gravitated toward under-recognized writers—was the only reviewer to effuse over Rosenberg's verse. He expounded in the *New Mexico Quarterly* that Rosenberg "writes with the accomplishment of the two or three best poets today."[13] The accolade failed to reverberate in literary circles. Nor did it satiate Rosenberg's ego. Except for *Poetry*, no major literary journal took notice of his book. Even there, H. R. Hays, Rosenberg's former partner at *The New Act*, dithered on Rosenberg's performance, noting that his work was "eclectic"[14] and that it wandered from sociopolitical to Surrealist themes, all of which accounted for its "unevenness."[15] Hays held out for Rosenberg to produce something "bigger,"[16] acknowledging that he had it in him. However, Rosenberg had had it with poetics, no longer invested in its destiny. When it became clear that these appraisals would not amount to a critical mass, he conveyed to Roskolenko, "So far all the reviews I've seen have been paragraphs written by tired portmanteau carriers afflicted with the compendious versification of the first six months of 1943. No book of poetry is worth a review all alone—unless it's by one D[elmore] Schwartz."[17]

The reference to Delmore Schwarz was telling. Schwartz had published his loosely autobiographical short story, "In Dreams Begin Responsibilities," in the inaugural issue of the restructured *Partisan Review* in 1937. It later became the title of his first book of poems, which was lauded by Wallace Stevens, Allen Tate, and even William Carlos Williams. In 1939, he became an associate editor of the journal, overseeing the poetry section with Clement Greenberg. Yet Schwartz had a half-hearted interest in the publication, never fully aligning himself with its political directives. He was absorbed in the revolutionary content of Marxist theory but never became caught up in the debates that related to Stalin and communism. Whatever admiration Rosenberg expressed to Roskolenko about Schwartz's work, and its terse, unembellished forms, he soon trivialized Schwartz's achievement, thinking that its inventive features were prone to the literary fashions that descended from Eliot's for-

malism.[18] After *Trance* was overlooked by *Partisan Review*, Rosenberg conveyed to Schwartz's wife, Gertrude Buckman, who was a reviewer for the journal, that he felt Schwartz's poetry was "glib";[19] poetry as a project could no longer reinvigorate literature.

the rhythm of my experience is broken

Delmore Schwartz had always thought of Rosenberg as a "luftmensch" whose work had "no fictional texture, let alone roots in Jewish or American life."[20] Schwartz was right in assuming that Jewish culture evaded Rosenberg's poetics. He never alluded to his upbringing in Brooklyn, to his conflict with his parents' Orthodox beliefs, or the trauma of reconciling his identity with the Anglo-Saxon and German-Jewish cultures at Erasmus Hall where he felt ostracized. These subjects, Rosenberg conceded, were better probed in "critical moments,"[21] or the essays that he later wrote on the representation of the Jew for *Commentary*. Even there his biography was withheld.[22]

The only family member whom Rosenberg ever mentioned in his prose was his grandfather, largely because he admired his independence. He almost wholly dissociated himself from his past. "We are, to a large extent, new people," he wrote, "as everything in America, and in many other parts of the world, tends, for better or worse, to be new."[23] While Schwartz, like Saul Bellow, whom Rosenberg met in the early 1940s, made the assimilation of the American Jew a recurring trope, genealogy was never a part of Rosenberg's program. He wagered that ethnicity was more compellingly explored through criticism, where he could objectify his place in the Diaspora, especially after the dissolution of the Third Reich and the revelations about Hitler's Final Solution. As he would state in "The Herd of Independent Minds," the essay that Schwartz passed over for *Partisan Review*, "The rhythm of my experience is broken and complicated by all sorts of time-lags, symbolic substitutions, decayed absolutes, experimental hypotheses."[24]

Schwartz was wrong to declare that "American life" had failed to preoccupy Rosenberg, however. His comparison of his grandfather

to the whale in *Moby-Dick* was based on a childhood memory of the older man's large body afloat on the East River where he frequently swam. The image indelibly shaped both his own identity and his sense of American literature. He may not have depicted the spectacle of Americana in his work, and its occasional bizarre overlay on immigrant cultures, but then he was a third-generation American Jew, freer to immerse himself in the history of vernacular writing. Where Schwartz had found too many imperfections in Rosenberg's prose, Bellow, by contrast, brought insights, along with reverence, to Rosenberg's essays.

saul bellow

Saul Bellow met Rosenberg through Philip Rahv, soon after Rosenberg returned to New York. He remembered that their first conversation was overwhelmed by Marxist theory, which failed to interest him. Still, their talk was anything but off-putting. Bellow was immediately taken by Rosenberg, sensing that he was "a most significant person, who did not . . . behave as significant persons generally do."[25] Initially, their mutuality hinged on aversion to T. S. Eliot, whom Bellow considered a mandarin with too much influence. His poems hung on the "doom of the west"[26] and had resulted in too many imitations. Their bond was also shaped by Bellow's relationship to his own ethnicity, which leaked into his fictional characters, such as Herzog, Humboldt, Augie March, and Sammler, who straddled two worlds, never wanting or able to shake off their upbringing yet acutely aware of their American infusion. Like Rosenberg, he resisted being labeled a Jewish writer, affirming that he was an "American of Jewish origin,"[27] acknowledgment that his fiction was equally beholden to non-Jewish figures such as Mark Twain and Edgar Allan Poe.

Rosenberg's friendship with Bellow deepened over his lifetime. Almost a decade older than Bellow, he became one of Bellow's mentors soon after they met.[28] (Rahv, Macdonald, and Meyer Schapiro were also among the writer's early idols.) Bellow had read Rosenberg's essay "The Fall of Paris"[29] in Chicago after it was published in

1940, and was taken by its descriptions of the French city "where it was possible," as Rosenberg wrote, "to shake up such 'modern' doses as Viennese psychology, African sculpture, American detective stories, Russian music, neo-Catholicism, German technique, Italian desperation."[30] Eventually, Bellow was let down by postwar Paris, where he lived for nearly a year and a half in the late 1940s, realizing that "it was Chicago before the Depression that moved my imagination . . . not misty Paris with its cold statues and its streams of water running along the curbstones."[31] But part of his abhorrence of the literary establishment that revolved around Eliot was indebted to "The Herd of Independent Minds," where Rosenberg assailed intellectual conformity in postwar America and the existential threat it posed to *action*, or assertion of the writer's individuality. The article marked Bellow's discourse on the blunting of the imagination, a faculty he knew could not be theorized, unlike the endless elucidations on modernist forms.

What Bellow was attracted to most in Rosenberg was the independence of his thought. He knew that Rosenberg had fallen out with Rahv and *Partisan Review* in 1944. But the breach had no effect on his estimation of Rosenberg's intellectual standing. After Rosenberg's death, Bellow made him the subject of one of his short stories, "What Kind of a Day Did You Have?" where he portrayed him as "so commanding that he often struck people as being a king, of an odd kind."[32] As he effused in his *roman à clef*, "even his bitterest detractors, the diehard grudgers, had to admit that he was still first-rate. And about how many Americans had leaders of thought like Sartre, Merleau-Ponty and Hannah Arendt, say '*Chapeau bas!*' This is a man of genius."[33] Even though Bellow considered Jean-Paul Sartre and his co-editors of *Les Temps modernes*—where Rosenberg began to publish just as Bellow left for Paris—and their Marxist politics silly, frivolously dabbling in class oppression,[34] he recognized that Rosenberg could penetrate French intellectual culture with little effort. His burgeoning theory of *action* surmounted the pretension that Bellow associated with existentialism.

Delmore Schwartz also appeared in Bellow's fiction—as did many of his friends—assuming the lead role in *Humboldt's Gift* true

to form as a self-destructive figure who after his early literary suc-
cess was incapable of *action*. Bellow captured him just as he became
psychologically impaired and unable to write: "The noble idea of
being an American poet certainly made [him] feel at times like a
card, a boy, a comic, a fool."[35] By contrast, his vivisection of Rosen-
berg never strayed from his image of the "king," who was eccentric
and who had many foibles, not the least of which was the desire
to "be up half the night drinking and talking."[36] But then, unlike
Schwartz's case, Rosenberg's sanity remained intact: he had given
up on poetry!

what is americanism?

Delmore Schwartz was not the only prominent poet who incurred
Rosenberg's wrath as *Trance above the Streets* floated across editors'
desks in 1943. So, too, did Karl Shapiro. To Rosenberg, Shapiro rep-
resented a *parvenu*, or upstart, whose writing peddled a soft intro-
spection that followed from his self-definition as *The Bourgeois Poet*,
the title of his collection of poems.[37] Rosenberg thought there was
too obvious a concession to the middle class in Shapiro's work.[38]
Shapiro was stationed in New Guinea and Australia during World
War II, and the verse he mailed home made him a literary luminary.
He won the Pulitzer Prize in 1945, and Archibald MacLeish subse-
quently installed him as a Fellow in American Letters at the Library
of Congress.

Rosenberg felt that Shapiro's work was voguish, not unlike
Schwartz's. As he said to Roskolenko, who served as a private in the
US Army in New Jersey before he was posted to Australia in late
1943, "I am getting bored hearing the name Shapiro. Two years ago it
was Schwartz. Next year it will be Schweitz, then Schneezy. Not that
the kid is bad. But the way he writes and the way he thinks is a ret-
rogression. And as poetry goes down, the Poet, or the War Poet, be-
comes an absolute public need. Feh!"[39] Rosenberg was resistant to
the war as well as to literal references to its violence. These themes,
he thought, were best distilled through abstract modes. Shapiro's

spotlight on his Jewishness, moreover, was also an impediment for Rosenberg, too prosaic a declaration of his background.[40]

Rosenberg had been summoned before the draft board in Cooperstown for a physical examination and was designated 4F—not fit for service—due to his game leg and his height. He was incredulous that he was even considered for induction into the army and commented to Roskolenko, "Are they crazy enough to regard me as good for something?"[41] Guilt overwhelmed the luxurious sense of time he was afforded in writing and putting out his book before he returned to Washington, DC. He questioned, "Here I sit without barracks, without routine, without crap games and radios. By a magical accident, I am freed from serving my country. Shouldn't I then serve my friends by becoming clear about something."[42] He half-heartedly proposed to Roskolenko that he might become a "warden of values."[43] He was serious, though, about a renewal of ethical issues in contemporary discourse. But Shapiro's writing was not the answer. He regarded Shapiro's populism and war imagery as backward. Once Roskolenko's battalion was posted to Sydney, Rosenberg wrote to apprise him that "Karl Shapiro is in Australia. He's been made the find of Poetry . . . The Army seems to be Shapiro's muse."[44] Rosenberg now dubbed him the "war poet," and conjectured that he did not have "the mental equipment"[45] to redirect verse. He was too out of step. Rosenberg fell back on a comparison with Shakespeare and wittily lamented, "Falstaff was a soldier. But today it would take a genius to get fat on it."[46]

Rosenberg made his antipathy to Shapiro's poetics known in an argument they had at a party on one of his excursions from Cooperstown to New York. Shapiro was offended by Rosenberg's "judgements"[47] of his work, not approving of the unsolicited intrusion in a social setting. Rosenberg was oblivious to the affront, and responded, "Your experience moves in minute, dissociated lumps."[48] He justified his outburst to Roskolenko: "He writes poetry the way Harriet Monroe and other old ladies did. Let the image do the work."[49] Despite their bickering, he suggested that Roskolenko contact Shapiro in Australia, and gave him Shapiro's address. Rosko-

lenko longed for Jewish company in Sydney, where he faced considerable racism in the bars he hung out at each night with other servicemen. But the meeting never materialized.[50] Shapiro thought of Roskolenko as "the American avant-garde nut,"[51] and clearly did not want any association with him. Roskolenko later reviewed Shapiro in *Accent: A Quarterly of New Literature*, a mid-century "little magazine," where he pegged his poems as overwhelmed by "vulnerable ecstasies."[52]

William Carlos Williams had also read Shapiro's poems and deduced that he "is all right."[53] That Shapiro had not made the grade with America's foremost poet must have been cold comfort to Rosenberg. It must have been hard to be thrown into the same company. He never let on his disappointment when Williams rejected *Trance above the Streets*, not even in his letters to Roskolenko. He remained curiously reticent about Williams, just as he was mute on Ezra Pound's Bollingen Prize in 1948. The circumstances surrounding each silence were different—however, he never broke his allegiance to writers who informed his modernist outlook.

In 1943, when Williams took part in a symposium in *Partisan Review* on "What Is Americanism? Marxism and the American Tradition," and queried whether political commentary had a role in monitoring democracy, Rosenberg did not take a stand when Williams responded with a firm no. The editors of *PR* thought that he had "succumbed to anti-intellectualism that has long played fast and loose with the American literary mind."[54] They wondered why Stalin or Hitler should be exempt from censure. Still, Rosenberg refrained from participating in the imbroglio.

Phillips and Rahv had tried to embarrass Williams, perceiving that his naïveté stemmed from a distaste for revolutionary politics. They had earlier imposed "sanctions"[55] on publishing his work, but reneged for their symposium, finding his claim that "the American tradition is completely opposed to Marxism"[56] useful. The charge induced a round of replies, none of which sided with Williams despite his support of leftist causes and pro bono care of his many out-of-work patients during the Depression. But once *Partisan Review*'s socialism was made to co-exist with cultural pieces that had few or

no ties to politics, Rahv and Phillips rethought Williams's participation in the journal. They welcomed his poetry, but his politics was treated as hopelessly ingenuous.

Rahv showed both Parker Tyler and Rosenberg the proofs for the symposium, giving them a heads-up on its potential provocation. Tyler became irritated with both parties. He wrote to Williams that his interest in muzzling political commentary bore "resemblance to Stalinism."[57] He also disapproved of the editors' counterstatement, maintaining that it existed "on the lowest plane."[58] Tyler recounted that Rosenberg had assumed "a neutral attitude"[59] in a heated discussion that unfolded at Rahv's apartment one evening shortly before the issue of *PR* appeared. Rosenberg concurred on "the senselessness of Williams argument,"[60] but exercised uncharacteristic restraint for someone prone to disputation. He had been unable, after all, to curb his contempt for Karl Shapiro's resuscitation of tradition!

action writing

Rosenberg never disclosed to Tyler that Williams had written an injurious introduction to his book of poetry. He had remained "neutral" when it came to Williams's bungled concept of democracy, not permitting his feelings of rejection to impinge on his exchange with Rahv and Tyler. He never let on about the dismay that Williams's piece must have caused him. Tyler, who was notoriously catty and intrigued by literary gossip, would have conveyed the setback to Charles Henri Ford, unable to contain his outrage on behalf of a friend. Rosenberg penned only a few stanzas after *Trance* was released, but he never severed his connection to Williams. Once he began to write art criticism in the early 1950s, his idea of *action* painting paralleled Williams's idea of the "poem as a field of action," the drift of which Williams expounded in a lecture at the University of Washington in 1948. He argued, "Our poems are not subtly enough made, the structure, the staid manner of the poem cannot let our feelings through."[61] He targeted T. S. Eliot's highly crafted, elegant compositions as an example, a view Rosenberg plainly shared. How-

ever, the correspondences in their views of *action* had not grown from conversation and were generalized. Rosenberg's use of the term initially came from the nomenclature of labor politics until he landed on the word in texts associated with existentialism, the philosophy that became vogue in the United States in the mid-1940s. These arenas were of no interest to Williams, as he revealed in *Partisan Review*'s symposium. He had discussed his ideas about *action* with a younger generation of poets, including Robert Creeley and Charles Olson, in the late 1940s, but his lecture at the University of Washington was not published until 1954.[62] By then, Rosenberg had distanced himself from discussions on American poetics and had written "The American Action Painters."[63]

Williams spawned a whole category of "action writing" that incorporated not only Creeley and Olson but also the improvised and performative verse of the Beat Generation of Jack Kerouac, Neal Cassady, and Allen Ginsberg. The work of these writers was largely unknown to Rosenberg: his understanding of modernist poetics derived primarily from journals such as *Poetry*. When Olson twisted Williams's "action aesthetics" into his idea of "projective verse" in 1950, similar analogies abounded with Rosenberg's "*action* painting."[64] But these linkages remained rhetorical, not the result of cross-pollination. Olson asked the poet to countervail T. S. Eliot and "work in OPEN, or what can be called COMPOSITION BY FIELD, as opposed to inherited line, stanza, over-all form."[65] Rosenberg would similarly have the "canvas . . . as an arena in which to act—rather than as a space in which to reproduce, re-design, analyze or 'express' an object."[66] The comparisons were resonant, part of mid-century discourse to renew the American traits of painting and poetry by making the biography of the artist and writer a top priority.

Both Rosenberg and the Projectivist or Black Mountain poets, such as Olson and Creeley, became involved in the revival of Herman Melville and Walt Whitman in the late 1940s, after a period of neglect. (Olson and Creeley taught at Black Mountain College, near Asheville, North Carolina, along with Franz Kline, Robert Motherwell, and Willem de Kooning.) Olson's first book, *Call Me Ishmael*, a

study of *Moby-Dick*, was largely responsible for this restoration and read widely at the college, along with Melville's *The Confidence-Man* and *Benito Cereno*.[67] Rosenberg was probably introduced to Olson's tome through de Kooning, who had met the poet in Asheville in 1948. Fielding Dawson, a student at the college, who later became a poet and painter associated with the Beats, recalled that de Kooning later asked him in New York if he had read "that book on Melville."[68] Dawson was taken by de Kooning's "eagerness to express how it interested him ... because it was touching an intuitive area DeKooning [*sic*] was familiar with."[69] Once Rosenberg and de Kooning began to meet for weekly discussions after the artist returned from Black Mountain, the convergences Olson established between Melville's novels and "projective verse"—the place where the poet planted his own "drama"[70]—seeped into Rosenberg's thinking on the territories of *action*.

Robert Creeley, who helped refine Olson's essay on "Projective Verse" for *Poetry New York*, made tie-ins with Rosenberg's signature term, *action*. He later noted that "Action Painting and Projective Verse are parallel languages, major pushes in the definition of what it means to be 'American,' a locating of that particular idiom. They grew ... under the shadow of existentialism but totally rejected its abstract language and its physical paralysis."[71] Spontaneity might have resulted in greater clarity, yielding more palpable imagery in poetry, but the opposite transformation took place in painting, where the figure disappeared. Their ideas were connected by the same emphasis on process, or the "act of the poem," which took precedence over outcome while silencing its prospect as commodity. Creeley first encountered Rosenberg's ideas on *action* when the latter's article appeared in *ARTnews* in late 1952. A few years after, Creeley approached him for a contribution to the *Black Mountain Review*, which he edited from 1954 to 1957. In a letter, he stated that he had "little luck as far as 'art criticism' goes ... it's been all the usual hogwash, and there's little use in printing that."[72] For Creeley, this bunkum was the formalist approaches that downplayed subjectivity.

Creeley hoped Rosenberg would provide "some notes on art (as opposed to art criticism)."[73] Rosenberg responded by asking him

to look at his verse, sensing a bond with the younger poet. Creeley wrote back to tell him to send the poems along. Nothing materialized in the *Black Mountain Review* by Rosenberg, however. Creeley, who was unacquainted with Rosenberg's poetry, no doubt immediately saw that he was not a Projectivist poet, that his ideas about *action* were confined to criticism. Rosenberg's one attempt to resurface as a poet failed. He still wanted to be identified as a poet when he wrote his author's bio for "The American Action Painters" when it was published in *ARTnews*. Later, when the New York School of poetry coalesced around 1960, James Schuyler expanded on Creeley's interdisciplinary connections and ascribed Rosenberg's metaphor of *action* as a catalyst for the movement. He wrote that "Rosenberg's Action Painting is as much a statement for what is best about a lot of New York poetry as it is for New York painting. Poets face the same challenge, and painting shows the way, or possible ways."[74] Schuyler tagged on the disclaimer that "writing like 'painting' has nothing to do with it,"[75] implying that immediacy was more important than fussing with the architecture of a poem.

Schuyler also worked for *ARTnews* writing reviews, while serving as a curator of circulating exhibitions at the Museum of Modern Art. His career path paralleled that of Frank O'Hara, another key member of the New York School. O'Hara was the front man at the information desk of MoMA until he became an editorial associate at *ARTnews* and a curator in the International Program.[76] Both poets met Rosenberg during the late 1950s. Not only did Rosenberg write for the magazine during this period, but his ideas of *action* exerted influence on the interpretation of painting within the publication. O'Hara's monograph on Jackson Pollock, written in 1959, deferred to his signature conceit: "The artist's action," the poet stated, "is immediately art, not through will, not through esthetic posture, but through a singleness of purpose."[77] The lines echo Rosenberg's adage that "the big moment came when it was decided to paint . . . just to PAINT."[78] Rosenberg may not have left his mark on American verse, but his critical analysis of art hung in the background of New York School poetry, bridging parallels with painting.

critical bets

Thomas B. Hess (fig. 11), the executive editor of *ARTnews*, hired many poets to review exhibitions, including James Schuyler, Frank O'Hara, and John Ashbery, feeling that their writing possessed greater lucidity than the prose of art historians. As Bill Berkson, who began writing for the magazine in 1960, observed, "his policy was that the art historians mostly didn't know how to write and so required a lot of editing, whereas the poets' contributions should be mostly left as-is."[79] Hess admired Rosenberg's identity as a poet, and during the 1950s their friendship deepened. Hess had graduated from Yale, where he studied art, literature, and French history. These combined interests left him predisposed toward a synthetic response to contemporary art. He was also a self-declared francophile, and while the culture of Paris was an abiding interest, the new American painting absorbed his criticism.

Frank O'Hara's idea of process, or *action*, allowed for a more

Fig. 11. Rudy Burckhardt (1914–99), *Portrait of Thomas Hess*, c. 1960s. Photographic print. Thomas Hess Papers, Archives of American Art, Smithsonian Institution.

malleable approach to form that fused subjectivities, sometimes
through collaboration with artists that verged on hybrid expression.
In 1957, as part of a panel at The Club devoted to "The Painter as
His Own Poet," which was moderated by Rosenberg, O'Hara stated,
"Works of art don't compete. They are either exemplary or not."[80]
His statement underscored an inherent relationship between art
and literature, that the languages were communal and born of over-
lapping aesthetic interests as opposed to shoptalk that focused on
craft and media. O'Hara contended that the poet, above all, could
come up with the right words to account for these similarities; the
poet was best equipped to assume the task of mediator. He believed
that writers such as Charles Baudelaire and Guillaume Apollinaire
had the greatest sense of the hybrid aspects of modern culture. In
his combined role as poet, critic, and curator, he purposefully cut
through the formalist mandate to keep the arts separate. O'Hara also
defended the frequent silence of artists with respect to elucidating
the meanings of their work. The poet was friendlier to painting, he
surmised, having experienced the same social marginalization. That
is, he was receptive to a dialogue initiated in the studio that could
shape interpretation and ensure that intentionality was never left
out of critical writing. At The Club, he elaborated:

> When they talk, painters immediately declare that they are inar-
> ticulate. That's charming. Many painters talk in paradoxes, and
> this too is nice. Poets are just as inarticulate as painters when they
> talk about how it is done. Poets who have distinguished them-
> selves as critics—Baudelaire, Apollinaire—talked it over with
> painters first and made a work of it. It was not just jotting things
> down. It was work. Baudelaire was critical. Apollinaire wrote
> prose poems. To whom should artists talk? You can talk to the
> wrong person, but it doesn't matter. What's important is what the
> artist didn't say. Everyone knows this. The rest is propaganda.[81]

Rosenberg had also written in "The American Action Painters"
that criticism was in large "propaganda." Commentary on art could
degenerate into arcane description that rarely got beyond visual

properties, dangerously fueling new "taste bureaucracies."[82] Like O'Hara, he felt that the poet could tease out the right meanings from a painter's work. But Rosenberg rarely invoked or acknowledged O'Hara in his writing. His unaffected style, which drew from both high and low culture—such as the jumble of allusions to Rembrandt, the Frick, Duchamp, Impressionism, Leonardo and Michelangelo, and a quotidian cup of "yoghurt" or a Coke in his poem, "Having a Coke with You"[83]—differed from Rosenberg's pondered verse. Popular references and wordplay were always bothersome to Rosenberg. Moreover, he could never relate to the self-exposure in most of O'Hara's improvised, nonmetrical pieces that blew apart conventional notions of the stanza. There was not enough "silence" or space around O'Hara's words to entice him. O'Hara's verse was too localized in the routines of his daily life, rather than being based in abstractions that grew out of existential thinking. Despite O'Hara's investment in poetry, he too questioned its utility, stating at the end of his delivery at The Club, "No one reads poetry. Who needs poets?"[84] echoing Rosenberg's own epiphany.

Unlike O'Hara, Rosenberg skirted the "correspondences" that Baudelaire thought obtained between painting and poetry, not completely won over by his declaration that "the best account of a picture may well be a sonnet or elegy."[85] O'Hara had purposefully evoked Baudelaire in the panel at The Club, becoming one of the first American writers to respond to the French poet's dual role as a poet and a critic. Hess took a similar position, when he and Rosenberg later took part in a conference dedicated to the 100th anniversary of the death of Baudelaire in Paris in 1968—two years after O'Hara was accidentally killed on a beach in Fire Island. Hess argued that "all art criticism in that it translates visual information into a verbal code is a trans-action in imageries,"[86] reinforcing that O'Hara's interpretation was unencumbered by agenda.

Rosenberg responded to the absence of "jargon"[87] in Baudelaire's writing, his clear diction, and his use of metaphor. He also depended on a trope—*action*—to construe the work of mid-century artists. He noted that Baudelaire dispensed with visual analysis and had even bragged that he reviewed the Salon of 1859 without seeing it,

Fig. 12. Willem de Kooning (1904–97) and Harold Rosenberg, *Revenge*, 1957 (published 1960). Etching in black on Rives wove papers, 11 7/8 × 13 6/16 inches. Prospero Foundation Fund. National Gallery of Art, Washington 1997.6.5.

such was his intuitive sense of its relationship to modern life. But Rosenberg thought that O'Hara's and Hess's "critical bets"[88] to revive Baudelaire had not paid off, that Baudelaire had squandered his insight on a minor figure, Constantin Guys, at the expense of Ingres, Courbet, and Manet. Where Baudelaire had excelled, Rosenberg maintained, was in the connections he forged with "contemporary life and his capacity to relate those insights to concrete aesthetic thinking."[89] At the root of his appreciation was Baudelaire's gravitation to the subjectivity of the artist. This attribute also attracted O'Hara, who while a student at Harvard College on the G.I. Bill in the late 1940s, had begun to read Baudelaire to get beyond T. S. Eliot.

Baudelaire had represented Guys as a *flâneur*—a recurring metaphor in his writing—who experienced modernity from the vantage point of the street. His sense of cultural dislocation had become so acute that retreat into his self to find authenticity was the only option.[90] As Rosenberg grappled with these reverberations in the mid-twentieth century, the *flâneur* was no longer a meaningful emblem of urban life. The preservation of the artist's interiority was now more at stake. O'Hara and Hess had little interest in the ruptures that Rosenberg had located in the unspooling of history after Paris was occupied. Still, Rosenberg suggested that Baudelaire was one of the first critics to identify how modern life had become fragmented, something that few subsequent critics developed.

O'Hara's pact with modernism centered more on the offshoots of painting and poetry where originality could be emboldened, sometimes through collaboration. He had engaged in manifold collaborative projects with artists such as Jasper Johns, Robert Rauschenberg, Joe Brainard, Norman Bluhm, and Philip Guston. In all, the lines

Fig. 13. Philip Guston (1913–80), *Smoking and Drawing*, c. 1972–75. India ink on paper, 19 × 24 inches. The Guston Foundation.

of his verse were broken into non-sequiturs by each artist that en-hanced their enveloping, abstract compositions. They had become "poem-paintings." Additionally, O'Hara inspired numerous paint-ers such as Guston, Elaine de Kooning, Fairfield Porter, Alice Neel, and Alex Katz to capture his elegant visage and profile in portraits, adding to the mid-century crossover between poetry and painting. Even though Rosenberg later handed poems to Robert Motherwell and Willem de Kooning (fig. 12) to embed in their work, he wrote off these cross-disciplinary projects as merely witty. They did little to extend the serious business of art, and criticism.

After Frank O'Hara's death in 1966, Philip Guston eulogized him as "our Apollinaire."[91] O'Hara had been attracted to Apollinaire's twin role as a poet and art critic, to his mingling of visual descrip-tion with subjective response.[92] Guston was not as close to O'Hara as he was to Rosenberg, whom he had met in New York around 1949. All the same, he never elevated Rosenberg to the stature of an Apollinaire. He thought of him primarily as an art critic. Rosen-berg's poetry must have represented a sideline to him. Guston later embarked on a series of *Poem-Pictures* in 1970 that included stanzas from Stanley Kunitz, Clark Coolidge (fig. 13), Bill Berkson, Gus-ton's wife Musa McKim, and others.[93] It must not have occurred to him to team up with Rosenberg as a collaborator. Instead, he de-picted him as an *action* critic in a caricature that was reproduced in *ARTnews* in 1955. The broad swathes of ink that define Rosenberg's mustache and eyebrows connote "The American Action Painter," his major essay.

11
death in the wilderness
the OWI and the american ad council

i'm the guy who doesn't think that poetry will win the war

Soon after Harold Rosenberg published *Trance above the Streets*, he moved back to Washington, DC, to work for the Office of War Information, a new government agency created shortly after the United States became a partner in the Allied Forces. He worked under the direction of George P. Ludlam in the Special Assignments Division of the Domestic Radio Bureau after a brief, month-long stint in the Overseas Branch in New York.[1] When the WPA dissolved in early 1942, Rosenberg required a job. He now had a family to support: his daughter Patia was born during this transition. He left Cooperstown with Tabak and their infant child, and the family stayed in Washington for nine months before they finally made their home in New York on East 10th Street.

Rosenberg remembered that "all the leftists . . . everybody you knew from the Village"[2] worked for the OWI, including Langston Hughes, who was assigned to the same division, as well as André Breton, the French surrealist writer, who had as Rosenberg remembered, "a magnificent voice and would broadcast on the international transmitters [for the Voice of America] to France."[3] Rosenberg had no experience writing scripts for radio plays, but after reading a manual that he took out of his local library, he felt assured enough to jump in.[4] He admitted that he never listened to the radio when he was at home, except for the news and the Sunday-afternoon symphony. But he figured that he had developed enough expertise through editing the American Guide books that he could easily write a short feature for the OWI's "The States United" program.

His first assignment was to come up with a narrative on the state of Georgia for the agency's Overseas Branch, the data for which he culled from the Guide and set to a musical score that included "I Wish I Was in the Land of Cotton" and African American spirituals. There were mandated descriptions of Georgians in the broadcast whom Rosenberg rendered as "slow-moving—like the slow roll of their land,"[5] and the script included clips from members of the armed forces who yearned to introduce their allies to southern food and culture. He also represented war as ingrained in Georgia's history, part of an unending, repetitive cycle from the period of the American Revolution onward. As Rosenberg wrote, "Guerrilla fighting ain't nothing new to Georgia folk."[6] His rhetoric climaxed in a transparently patriotic image of American militaristic might, an expression of *esprit de corps* for US servicemen and overseas listeners in English-speaking countries, such as Britain and Australia, in addition to Canada.

Rosenberg was initially wary of working for the agency. He told Leonard Lewis Levinson, who was employed briefly at the OWI, and who wrote *The Great Gildersleeve*, a long-running, hugely popular comedic radio program that was a spin-off of *Fibber McGee and Molly*, "I don't think much of this whole fucking advertising business, or the radio business either. Maybe I am out of place here."[7] There were too many Madison Avenue types who queried his role on the project. He "couldn't understand their jargon."[8] Levinson convinced him to meet Ludlam, who was a former announcer for the National Broadcasting Corporation (NBC) and a "Harvard man,"[9] as Rosenberg euphemistically described him. It turned out that they got along and worked together for more than twenty-five years in various capacities beyond the OWI. Even though Ludlam was a member of the Sons of the Revolution, a hereditary society high on patriotism, and maintained his undergraduate ties through the Harvard Club, he became fiercely protective of Rosenberg, convinced of his innate talent for marketing. Although a year younger, he was paternalistic and concerned about Rosenberg's economic welfare.

Rosenberg had political reservations about the Radio Bureau. He arrived just as Archibald MacLeish vacated the organization,[10]

which eased some of his anxiety about its crusading mission. How-
ever, like Langston Hughes, Charles Olson, and many other poets
and artists employed by the OWI, he was opposed to American en-
try into the war—the position that would diminish his interest in
writing for *Partisan Review*. By the time he got to the OWI, the Voice
of America was in place, which would outlive the agency when it
was folded a year later. In a pretelevision era, radio was the primary
mechanism to proselytize American patriotism. Despite worries
about being perceived as a censor, the Roosevelt administration ac-
tively engaged in counter-spin and disinformation, and had installed
a Radio Division within its Bureau of Public Relations in mid-1941,
shortly before the bombing of Pearl Harbor.[11]

The Radio Division was populated almost wholly by members of
the broadcasting industry who were adept at forging alliances with
commercial outlets that were needed once the OWI kicked into
gear. The Domestic Radio Bureau, a subset, was but one function
of the OWI, which included, in addition to the Overseas Branch,
a Bureau of Motion Pictures and Bureau of Graphics among other
wide-ranging components that collectively worked to disseminate
the war message. It proved to be the least contentious and most col-
legial branch of the agency, all of which accounted for its efficiency
under Ludlam's direction. In his capacity as assistant chief of the
Special Assignments Division, Rosenberg wrote press releases and
speeches for the *Alias John Freedom* program that were produced
and distributed by the Blue Network, a subsidiary of NBC before it
was sold in 1943 and eventually rebranded as the American Broad-
casting System.

The releases took the form of agitprop, nationalistic communi-
cations meant to instill fervor and hope in the listener. A typical
passage from these "messages," as they were called, went like this:
"THE LONG HARD STRUGGLE OF THE PATRIOTS OF GREECE,
HOLLAND, NORWAY, BELGIUM, FRANCE—THE SUPERHUMAN
COURAGE AND ENDURANCE OF THE FIGHTERS FOR FREEDOM
ARE ABOUT TO BEAR FRUIT. SOON THEY WILL BE MARCHING
UNDER THEIR OWN FLAG AGAINST THE AXIS SLAVE DRIVERS."[12]
In addition to writing heavily indoctrinated publicity, as Ludham's

assistant, Rosenberg interacted with public figures to land interviews and spots on radio programs, such as *Vox Pop*, which became a fixture of NBC after a run on the Blue Network in the summer of 1935. In one instance, Rosenberg attempted to book J. Edgar Hoover, the founder and director of the Federal Bureau of Investigation (FBI), to appear on *Vox Pop* in Schenectady, New York, along with the mayor and local officials.[13] (Hoover declined; his clandestine manner of running the agency became legendary.)

Other than to plant propaganda "in a selected list of 72 transcontinental programs,"[14] part of Ludlam's job was to contact nationally known radio celebrities with syndicated programs, such as Jack Benny and Fred Allen, to provide them with "war information material [to adapt] . . . to their specific program formats."[15] Benny and Allen, as well as *The Bob Hope Show* and *Fibber McGee and Molly*, became part of his propaganda machine and readily exhibited exuberant patriotism to effect national unity, especially after the bombing of Pearl Harbor. The writers for these shows incorporated pitches from the OWI on war-related themes, such as rationing and the bond effort, most of which were rewritten as gags and jokes. Occasionally, OWI announcements appeared undiluted midway through their broadcasts, but with little success. Listeners tended to ignore the plugs and responded more to the humor that was spun from national setbacks.[16] Much of this comedy traded on subversion and upheld the newspeak of the OWI, with the exception of skits performed by Fred Allen, who sometimes overtly condemned war initiatives, such as the point system that the US government implemented when it came to rationing of food.[17]

As Ludlam's assistant, Rosenberg encountered a wide range of politicos, advertising executives, media consultants, writers, and producers, all of whom enlarged his sphere of contacts beyond the small community of poets, artists, editors, and critics who had composed his professional life. (His interactions on the American Guide books had been limited to the literary community, never broadened to include designers or marketers.) This expansive experience informed his growing view of the rarefied context in which poetry operated. In one disclaimer to Nat Wolff, who handled the Hollywood

end of the Radio Bureau, Rosenberg introduced himself as "the guy who doesn't think poetry will win the war."[18]

Rosenberg offered Wolff unsolicited editorial advice on how to rewrite a "PLAN FOR TWELVE NETWORK RADIO SERIES" that he deemed was short on "truth," or bottom-line information. He admonished Wolff, who left the OWI in 1943 to work as a writer and producer for commercial radio, and later for television and films, to "talk the vernacular; entertain, don't preach."[19] Wolff's plan, he felt, could be better implemented with minimal embellishment. In lieu of his apparently uninspired propositions (which have gone missing), Rosenberg made a few suggestions, such as a patriotic quiz show and a weekly series based on Paul Gallico's *Adventures of Hiram Holliday* (1939) for which he thought Edward G. Robinson would be ideal. The latter story involved a diffident proofreader who spares his newspaper a major libel suit and uses his reward to take a trip around the world. As the tale unfolds, it is revealed that he has closeted skills as a sleuth that enable him to combat evil, such as rescuing a princess from the Nazis!

Rosenberg proved to have a canny understanding of popular culture: Gallico's book was eventually made into a television series, produced by NBC in 1956, alas not with Robinson but starring Wally Cox in the title role. But when it came to his own literary criticism, he maintained a studious distance from the talking points and spin that he wrote for the OWI. This was his day job; the headier enterprise was writing for publications such as *Poetry* and *Partisan Review*. After Ludlam was promoted to the deputy chief of the Domestic Radio Bureau at the OWI, he reorganized the division and relocated it to Manhattan in 1943, a move that resulted in the reconfiguration of Rosenberg's duties and a new title of principal liaison officer.[20] Once back in New York, Rosenberg was to maintain ties with commercial radio networks and advertising agencies to ensure that major campaigns relating to the war effort were realized. With the bureau's new presence on Madison Avenue, his interactions with ad men, writers, and programmers became even more frequent.

Rosenberg was elated to return permanently to Manhattan. He had not realized until he "got back to New York how alienated that

Washington scene really was."[21] He complained that the five-year stint had cut into his productivity and represented a "very dry period."[22] While seemingly fallow, he had produced major essays, such as "Myth and History" and "The Fall of Paris," in addition to reviews for *Poetry*. He had, moreover, established new affiliations with burgeoning publications, such as *View*, considered the primary organ for Surrealist literature and art in New York. His input amounted to a few mostly whimsical submissions, such was the journal's programmatic emphasis on the unconscious, a realm that Rosenberg could not reconcile as a vehicle for *action*.[23]

creature of an unyielding modernist

Rosenberg's job at the Domestic Radio Branch in New York was short-lived, eliminated along with the entire division of the Office of War Information in the fall of 1945, following the German surrender. There was one carry-over agency from the Roosevelt administration, however, with which he would become affiliated: the War Advertising Council (WAC), which was eventually renamed the Advertising Council and became a national consortium of leading ad agencies, broadcasting outlets, and print media.[24] Ludlam was one of the founding co-creators of the Ad Council. He knew that the advertising industry had suffered major reversals during the Depression, such was mass suspicion of its marketing strategies for consumer goods in a stalled economy. But through the formation of the WAC, the beleaguered business community experienced quick renewal. The WAC orchestrated numerous public service campaigns written on a pro bono basis by major advertising firms that furthered all aspects of industry. Its success had an added bonus: direct access to the White House.

When Harry S. Truman succeeded FDR—who died in office five months before World War II ended—his administration soon perceived communism as a threat to free enterprise, especially once the Cold War began in 1947. A nonprofit propaganda arm that could advance democracy was now deemed essential. Hence, the Ad Council. The many in-house, confidential memos written by the coun-

cil to promulgate Truman's agenda reveal transparent intent: "the United States is frankly engaged in a world-wide struggle against the spread of totalitarianism, a fight to contain the communist ideologies at least within their present sphere of influence and control."[25] The council would amp up the rhetoric of fear to counter "anti-American forces"[26] especially after the European Recovery Program, or Marshall Plan, was implemented in 1948. As a result, American corporations gained ground in European countries ravaged by the war.

The Ad Council became instrumental in refashioning the US image, both domestically and abroad, as it transited from an isolationist nation to a superpower.[27] Significantly, after the WAC was reconstituted as the Advertising Council, it was no longer constrained by the content restrictions once imposed by intermediaries, such as the OWI. In its makeover as a nonprofit structure, the council required that it have complete jurisdiction over the public service announcements that it oversaw, and that it no longer be compelled to work on all government proposals sent to it. The projects the council enacted now became competitive. While the agency continued to coordinate campaigns that were written and designed by national firms, such as Young & Rubicam, the J. Walter Thompson Agency, and McCann-Erickson, its public relations agenda was now to achieve consensus for both business and the foreign policies of the Truman administration.

Just before the Ad Council was formed, the WAC, along with the Domestic Radio Bureau of the OWI, was petitioned by the Treasury Department to work on the Victory Loan, the final bond drive to finance the war, and the Clothing Collection campaign for the relief of overseas victims. Rosenberg was assigned to both programs but felt underutilized: he felt he was just biding time on projects that required no input from him. (There were eight War Bond drives, commencing in 1942, that partially underwrote American participation in the Allied Forces.) The war was almost over, and he was now living in Manhattan, eager to leave the agency and resume his life as a writer. Still, he was uncertain about his economic future. He had experienced financial stability in Washington, DC, unlike the days

before the Federal Writers' Project when he had to beseech Harriet Monroe at *Poetry* for a few extra dollars, and to pay for his work upon submission. As he was already set up in an office at the WAC, and had revealed a flair for organization, as well as a knack for developing wartime spin into potent sound bites and one-liners, the council approached him with a position. He initially hesitated, not sure that he wanted to continue to work a forty-hour week, knowing it would rob him of time to write. He was also concerned that he would experience constant downtime at the council, just as on the Victory Loan campaign, where he was implementing government propaganda.

Rosenberg recalled that the council proposed, "why don't you think of something to do" at which he balked. He could not fathom "this business of thinking of things to do . . . If you're doing something, you can do it and finish it, but if you're faking work, your working all the time."[28] His instinct was to brush them off until Ludlam intervened and implored, "don't do that, think of something for god's sake."[29] It was then that he had "the brilliant idea," as he put it. "I invented the three day work week . . . it occurred to me why should I either quit or work."[30] He realized that the council's proposition could actually liberate him, even though he took a pay cut. He could spend time in his office on West 45th Street near Fifth Avenue working on his literary reviews, such was his efficiency to meet council deadlines. As he reconciled his new role as a program consultant, "it doesn't matter if I do anything . . . this really saved me because I needed the money to live on."[31] He had just survived another bout of osteomyelitis in early spring of 1945 that had briefly hospitalized him, reinforcing the need for a steady income. The function of a consultant was initially specious to him. But he used the opportunity, and his pristine, quiet office, to advance his literary ideas.

Rosenberg worked at the Advertising Council from 1946 to 1973. Initially, his duties were similar to those at the OWI. He continued to work under Ludlam's direction on radio fact sheets and bulletins, and was responsible for screening applications for public service announcements from advocacy organizations before making recommendations to the council's president and administration.[32] He also

sat on the Radio Committee of the American Heritage Foundation "in an informal capacity."[33]

The American Heritage Foundation (AHF) was incorporated in 1947 primarily to develop the Freedom Train that toured the United States, visiting three hundred cities, for a two-year period. The train was installed with documents assembled from the National Archives, such as the Mayflower Compact, Thomas Jefferson's draft of the Declaration of Independence, George Washington's copy of the Constitution, the Bill of Rights, Lincoln's Gettysburg Address, the Emancipation Proclamation, and the flag raised at Iwo Jima. The undertaking was patently utopian, high on democracy, and meant to renew the continuity of American patriotism after a period of intense doubt. To punch up the theme of allegiance, it invoked Soviet totalitarianism as a threat to the national security of the United States and its core values of individual liberties. Part of the mission of the Freedom Train was also to instill tolerance, especially as it related to race, class, and religion. This area of the program fell short, however, and aroused considerable protest from Langston Hughes and the NAACP. They contended that the project's image of national unity was a gloss: it failed to acknowledge segregation within its installations and at the stops throughout the South where Jim Crow laws still prevailed.[34]

The archival exhibitions on the train were financed by Paramount Pictures, as well as by individuals such as John D. Rockefeller, various labor organizations, and corporations such as General Electric, Eastman Kodak, U.S. Steel, and R. J. Reynolds Tobacco Company, all of which legitimized them as business leaders, especially in the wake of the new status of the United States as a global power. The train was accompanied by a radio program that was broadcast in most of the cities where it stopped. As a member of the AHF's Radio Committee, Rosenberg wrote a monthly fact sheet for an accompanying radio kit. He had a small hand, then, in shaping the ideology that boosted the train's program to instill racial compassion while countering Soviet-style communism.[35] However, he was not involved in determining the strategies of the Advertising Council, let alone those of the AHF. Nor did he sit in an advisory capacity

on the council's Public Policy Committee, which was composed of eminent figures, such as James B. Conant, the president of Harvard University; George Gallup and Elmo Roper, who became leaders in public opinion polls; as well as the theologian Reinhold Niebuhr, and Helen Hall of the Henry Street Settlement in New York. He may have composed a fact sheet for the train's radio kits, and for other council campaigns, but he had little input into the focus of these programs. They remained the domain of the advertising agencies that devised the conceptual hook for each campaign they selected to take on.

Soon after he arrived at the Ad Council, Rosenberg and another staff member tried to float an idea for a radio program to be called "The Inventors Club." The show had a target audience of boys between five and eleven, and the goal of "telling the story of scientific discoveries [that] will make listeners want *to go out and buy* electric, construction, chemical and other scientific toys and kits."[36] The appeal of the program, they reasoned, stemmed from the "*astounding apparition of the atomic bomb [that] has raised public interest in science and inventions to a feverish pitch*."[37] But the proposal was considered unmarketable by the council, too hard a sell, even though it aped the language and tone the council had prescribed during the Cold War. (Many of the in-house memos and confidential policy statements at the council fell under the broad rubric of "ADVERTISING — A NEW WEAPON in the world-wide FIGHT FOR FREEDOM"[38] and evoked democracy and American ingenuity as the counterpoint to communism.) Ironically, the British Broadcasting Corporation aired a similar series on television the following year aimed at adults.[39] The rejection echoed the advice that Rosenberg had parceled out to Nat Wolff to adopt *Adventures of Hiram Holliday* as a radio play.

Rosenberg never advocated the use of atomic power to end the war. But within the council, his politics was considered irrelevant. Besides, his position on Madison Avenue was but a means to stay afloat financially. In his proposal for "The Inventors Club," science and technology were a way to kindle a child's imagination by introducing a stream of "heroes"[40] whose discoveries marked the world. The wartime applications of the bomb were not addressed in his

plan, just its hovering "apparition."[41] Still, there were seeming contradictions posed by Rosenberg's day job and articles such as "The Herd of Independent Minds" where he mined the "isolation of the artist" who worked against the "makers of mass-culture."[42] Had he traded in his own imagination for the stereotypes of advertising at the council?

Although he tried to keep his vocations separate, antipathy to communism stratified his dual professional lives. His essays prior to 1945 had been partially given to the tirades of dictators like Stalin and Hitler. Even so, pursuing a stance contrary to officially sanctioned government dogma would have been impossible on Madison Avenue. He could pour his beliefs into "The Herd of Independent Minds," but he participated in the making of American ideology at the Ad Council, specifically, its representation of a Cold War. However, his experience at the council affirmed, as he wrote in "The Herd," that the Soviet Union was a "political force that checks the creation of any other kind of culture."[43] Rosenberg valued working at the council. As he explained it, it augmented his sense of social history and provided an advantage that few other inhabitants of New York's literary scene had:

> I was very pleased to be in touch with the world to a degree . . . with all of us old bohemians we have a tendency to creep into our own holes and not pay much attention to what was going on . . . In that sense I think being involved with this . . . organization whose main function is to be conscious of what is going on in society . . . had a lot of value to me . . . In the Council you run into chairman of boards of huge corporations and the head of networks . . . all very interesting to have a clear tactile sense. I'm not sorry about it at all.[44]

"death in the wilderness"

When it came to the council, Rosenberg had his detractors, most prominent among them Sidney Hook, who became a strident anti-communist after the war and questioned Rosenberg's commitment

to radical politics once he accepted Ludlam's offer. Hook quarreled about the seeming paradox, especially since Rosenberg "headed public relations for the Advertising Council of America celebrating the virtues of American business and at the same time was a 'closet revolutionist' or a 'parlor social nihilist' attacking everyone for selling out."[45] Rosenberg never "headed" a department at the council, but Hook's hyperbole underscored the irony that surrounded his snub of conformist institutions, such as the academy where Hook worked. Hook thought Rosenberg was a "shameless political opportunist."[46] He knew him to be a facile writer and adept phrasemaker, which worked in his favor, and resulted in tags such as "Herd of Independent Minds," "Action Painting," and later catchalls such as "orgmen" and "couch liberalism."[47] But Rosenberg was never involved in the jubilation of American business. If anything, he remained a wry observer in the postwar years of the "new American scene [in which] everyone has won a fairytale luxury and lost himself."[48] After he settled into the council, such statements became the stock-in-trade of his writing, revealing that his day job did have an impact on his thinking. Contrary to Hook's rebuke, his source of income revealed no backpedaling on his earlier political dissent. If anything, he intensified his commitment to Marxism.

By the early 1950s, Hook had become active in organizations funded by the Central Intelligence Agency (CIA), such as the American Committee for Cultural Freedom (ACCF), of which he was a founder and chairman.[49] He had gradually drifted away from the left, and by the late 1960s was a neoconservative and a fellow at the Hoover Institution at Stanford University. Hook was put off by Rosenberg's depiction of him as a "Confidential Clerk"[50] in a rumination on intellectual styles titled "Death in the Wilderness," written in 1957 for *Midstream*, a Zionist journal that drew initially on a range of political inquiry. In this delayed response to the industry of which he was a part, he drew on the aphoristic language of advertising to cut through the pretense and groupthink of his accusers. That is, he updated his idea of a "herd" mentality, expounding on his earlier metaphor of intellectual antagonism to mass culture. Rosenberg reckoned Hook was not capable of autonomous thought. His

debt to his teacher, John Dewey, overrode evident originality in his writing. Although committed to Dewey's philosophical pragmatism, Hook was just another figure who operated through "disillusion," according to Rosenberg.[51] Hook gave up on Marx, and on the labor movements of the 1930s, and settled into a position at New York University, where his political activism became confined to covert cooperation with the government—he served as an informant to the FBI during Joe McCarthy's campaign to out artists, writers, playwrights, actors, scientists, and public intellectuals involved with the American Communist Party.[52] This was sufficient for Rosenberg to doubt his independence as a thinker, even though his fusion of Dewey and Marx had once been porous enough to posit that class revolution could result in change for the individual. Eventually, Hook embraced the Nixon and Reagan administrations, as well as the war in Vietnam, all in the name of anticommunism. Rosenberg was never able to follow how Hook could transit from a radical past to repudiate Marx and blame the absolutism of Stalin and Hitler for his conversion to conservative pragmatism. Hook maintained, even at the end of his life in 1989, that his political trajectory was affirmation of nonconformity.[53]

Rosenberg may have worked for the Ad Council, but he never gave up on, let alone repented, his infatuation with Marx. The misuse of Marxism by despots in Europe had prevented him from joining the CPUSA, as well as from becoming a fellow traveler in the 1930s, unlike Hook, whose devotion at the outset was total. Yet once he became a fixture at the Ad Council—after his tiff with the editors of *Partisan Review* over their centrist politics unfolded—his ire migrated toward a younger generation of writers whose politics he considered flaccid. Daniel Bell, an American sociologist and journalist who wrote for *Fortune* and whom Rosenberg met in the mid-1940s, also appeared in "Death in the Wilderness," where he was dismissed for his contention that "ideology had come to an end."[54] Rosenberg thought the suggestion ridiculous, surpassing "comedy,"[55] the product of a thinker who yearned for a middle-class if not a cosmopolitan life, who now wore a suit, like men on Madison Avenue and Wall Street. He had been largely spared the economic crisis that beset the

Great Depression. (Bell was born in 1919, and while he endured a difficult, penniless childhood, his intellectual maturation took place after the war, unlike Rosenberg's.)

Bell's skepticism disappointed Rosenberg: he represented another iteration of the herd mindset where careerism resulted in abandoning a life of *action* for one that took place "in the weeds behind the billboard of American life."[56] Bell's political views were never as radical as Hook's, although he was a founder of the neoconservative movement and of *The Public Interest*, a publication that he co-edited with Irving Kristol in the mid-1960s. It was more the symbolism behind his blithe declaration that ideology had expired that got Rosenberg. He knew that Marx had lost his relevance, but in the absence of an equally potent surrogate thinker to explain alienation, he could never acquiesce to the sanguine lifestyle that Bell proposed. In short, he could never adhere to the mentality of what he called the "Orgman," a social type who Rosenberg thought was "deficient in individuality,"[57] like the company guy, civil servant, or academic who toes the party line and either begrudgingly or unquestioningly enacts policy, not wanting his illusion of American life unsettled.

As Rosenberg saw it, Bell's disavowal of Marx capitulated to the middle-class desire to fit in. In his incarnation as a neoconservative, Bell worked in the 1960s to preserve a free-market economy, believing that it was the only corrective for social problems; government initiatives such as Lyndon Johnson's "Great Society" that addressed poverty and racial injustice were but reformist gestures, the brainchild of liberal big spending.[58] Another neocon who made an appearance in "Death in the Wilderness" was Norman Podhoretz, who later became Rosenberg's editor at *Commentary*. Notwithstanding their age difference—Podhoretz was born in 1930—Rosenberg argued that it was not their youth that separated him from this postwar generation of intellectuals, but their pragmatism and the monotony of their argument that the modern age had ended with botched attempts at revolutionary politics in Europe. Marx, Rosenberg noted, was relevant enough for them to spurn, their writing driven by *"position-taking"*[59] that erected communism as a bulwark of fear. As

he averred, "without Marxism this generation is not only dull—it is *nothing*, it does not exist."[60]

Bell and Podhoretz never used Rosenberg's position at the Ad Council to try to his writing. Their glide over his association with Madison Avenue suggested indifference. Bell got his start at the *New Leader*—an anticommunist publication co-founded by Eugene Debs—as a socialist writing on the labor movement in the early 1940s. He never addressed Rosenberg's politics, however. Rosenberg's eventual role as an art critic was more interesting to him.[61] By contrast, Irving Howe, who had graduated from City College in 1940, a year later than Bell—both were members of the Young People's Socialist League—thought that Rosenberg's connection to the council was marvelous. Howe, who began writing for *Partisan Review* in the early 1940s, never relented on his socialism, unlike Bell, and maintained intellectual continuity with the 1930s. His encounters at *PR* were not dissimilar to Rosenberg's: he was also discontented with the editors' initial equivocation over not taking a stand against the war.[62] Howe held on much longer as a contributor, but eventually departed to found *Dissent* in 1954. His last piece for *Partisan Review*, "This Age of Conformity," was a stinging attack on the complacency of the American left and its drift into "accredited institutions of society [where] they not only lose their traditional rebelliousness but to one extent or another *they cease to function as intellectuals*."[63]

Howe, like Rosenberg, wondered about this process of assimilation. What were the implications of relinquishing intellectual independence and cooperating with corporations and government? The route from bohemia to mainstream culture was an unthinkable sellout. Howe identified with Rosenberg, who never gave up on his anti-authoritarianism, unlike the *PR* crowd. He knew that Rosenberg's job at the Ad Council preserved his writing from hardening into dogma. Howe believed that Rosenberg had an "enviable part-time job at the Advertising Council, where he created Smokey the Bear (the sheer deliriousness of it: this cuddly artifact of commercial folklore as creature of an unyielding modernist!)."[64] Rosenberg may have made a practical move to work for the council, but

he was never responsible for the creation of Smokey the Bear. That campaign, like all others, was crafted by an outside agency (in this case, Foote, Cone & Belding of Los Angeles)[65] and subsequently reworked as it became one of the most successful and longest running public service announcements in the history of the organization. (Wildfire prevention, with the Smokey mascot, is still a campaign of the Ad Council today.) But Howe's portrayal of Rosenberg as an "unyielding modernist" was resonant, capturing his defiance and intransigence.

The Ad Council allowed Rosenberg to straddle the world of advertising, where the policies of postwar government were shaped, with his reflections on American culture. Within these juxtapositions, abundant insights emerged that later informed essays such as "The American Action Painters," where the "canvas became as an arena in which to act," and "Death in the Wilderness," where authenticity was forfeited by Hook and company for conventional lifestyles not unlike the illusion of American life displayed on a billboard. Although Rosenberg's role at the council was to execute ideas sprung by guest ad agencies and to see that their audiences were maximized through radio and television, he honed a deep sense of contrast that imprinted his work and stayed with him.

12
notes on identity
VVV and view

but tell me this. do you think he is an artist?

May Natalie Tabak recalled that she and Rosenberg rarely encountered refugee writers and artists from France on their "unpremeditated one-night stands"[1] and the weekends they spent in New York while living in Washington, DC. But once ensconced on East 10th Street, these foreigners now seemed omnipresent, part of their rejuvenated milieu of colleagues and friends. Tabak was struck by their sophistication. Despite their flight from Paris, she noted that "they seemed to be having a good time, an intellectually suave time,"[2] in Manhattan. Their social ease and fashionable clothes contrasted with her own dirndl skirts, bohemian garb, and blunt manner. Tabak knew that she was not a stylish dresser, that her look was at odds with their elegance and flair. She had little interest in designers and fashion trends. It was not until the end of Rosenberg's life, decades later, that she "planned to go to a new hairdresser and acquire a wardrobe befitting [his] station,"[3] a poignant admission that her image was no match for the company that he now began to keep. Clement Greenberg had been harsh about Tabak's and Rosenberg's attire, believing it set him back professionally. But Rosenberg had no problem fitting in within the international set of refugees before they migrated back to France after the war.

Just as the Rosenbergs took up residence in the East Village, Peggy Guggenheim opened her gallery, Art of This Century. Her stable was made up of displaced artists, such as Max Ernst, Roberto Matta, André Masson, Salvador Dalí, and Yves Tanguy, whose works were shown alongside those of Americans like Jackson Pollock, Wil-

lem de Kooning, Clyfford Still, Ad Reinhardt, William Baziotes, and David Hare. Rosenberg was immediately integrated into the group, what with his wry observation of the vulnerability of the avant-garde established through his article, "The Fall of Paris." As modernist art regained footing, the question of American debt to foreign aesthetic models resurfaced. Artists associated with the circle of Alfred Stieglitz, such as Arthur Dove and John Marin, had been perennially compared to their Parisian counterparts in the 1910s and 1920s with the upshot that their work suffered constant setback. They were frequently derided in the press as secondary.[4] This time, the discussion was waged within a community of largely exiled French artists who pressed the question: had America taken the lead, as Clement Greenberg would later proclaim?[5] Rosenberg had already calculated that the "laboratory of the twentieth century had been shut down" with Hitler's seizure of Paris.

Guggenheim's Art of This Century became a showcase that had a hand in transforming the cultural scene in Manhattan. Another of these transatlantic outlets was Charles Henri Ford's magazine *View*, which he brought out with his partner Pavel Tchelitchew, a Surrealist painter, after they left Paris in 1939. Although Rosenberg was not in New York for its launch in September 1940, he was made Washington correspondent.[6] In May 1942, the publication morphed from a modest tabloid of six pages that carried interviews with "cult poets,"[7] as Ford called them, to a glossier commercial format with covers by artists Man Ray, André Masson, Pavel Tchelitchew, Alexander Calder, Georgia O'Keeffe, Fernand Léger, Jean Hélion, Marcel Duchamp, and others.

Rosenberg's most prominent piece for *View* was a short story of a tribunal that drew from André Breton's revisions to his Surrealist agenda while in exile in the United States. Through a fictional "dialogue"[8] between three near-identical leftist intellectuals, rhythmically named Rem, Hem, and Shem, Rosenberg pondered whether Breton could continue to maintain his role as the leader of the Surrealist movement after the trials of displacement. Speculation had circulated in New York as to whether Ford would be willing to give his journal over to Breton, or even share it with him. But once they

reconnected in New York, their relationship became freighted with difference. Ford was never invested in Breton's mingling of Surrealism and Marxism, whereas Breton was parochial when it came to Ford's homosexuality. Ford, additionally, had been weary of the uses of myth by fascist regimes, a response that resulted in his rejection of politics after he was forced to leave Paris.

Breton had not made Ford a member of the Surrealist movement in Paris because of his waffling on Marxism, yet they tried to remain congenial in Manhattan. Like Rosenberg, Breton pursued Marxism more as theory after the rise of Stalin, even though he was committed to Trotsky. (Breton had spent four months in Mexico in 1938, where he met Trotsky and they co-wrote "For an Independent Revolutionary Art," an anti-Stalinist treatise that was published in *Partisan Review* that fall.)[9] Rosenberg's "Dialogue" for *View* played on Breton's "Prolegomena to a Third Manifesto to Surrealism or Else," which appeared in the first issue of *VVV*, a Surrealist broadsheet that Breton launched in June 1942 with David Hare as editor, and which ran through four issues. The "Dialogue" represented a reply, imagined variations on Breton's plan to reconstitute myth after the combined failures of Marxism and capitalism during the Depression.[10] In one section, Hem notes that Breton "seems to be in favor of a new myth."[11] Hem, who is a stand-in for Rosenberg, concludes that "to live is to act, and action is possible only when one has achieved the coherence and firm outlines of a fiction."[12] There are diluted references to Trotsky here, underscoring his elegiac yet fading relevance, just as in the "Prolegomena" where the Russian revolutionary is no longer mentioned by name but characterized as "the fine nervous hand that had controlled some of the greatest events of our time."[13]

Ford never did defer to Breton as the kingpin of Surrealism when Breton temporarily took up residence in New York; nor was Breton made an advisory or consulting editor of *View*. Breton appeared in the publication on several occasions, but his musings on Trotsky had no effect on Ford. Breton had remained loyal to Trotsky's belief that art was an addendum of revolutionary politics. He had unsuccessfully attempted to convince Ford to abandon *View* and take

over the editorship of *VVV*. Ford was not seduced by the offer, reading it as a move to eliminate competition.[14] He had already granted Breton enough coverage, he thought, especially in the first few issues of *View*, and through Rosenberg's "Dialogue." Besides, his ambition was directed toward unseating *Partisan Review*, a magazine that irked him more than the ubiquity of Breton in Manhattan.

Rosenberg had contributed a short story to the first installment of *VVV* entitled "Life and Death of the Amorous Umbrella." The piece was wholly inscrutable. Still, there was enough imagery to ferret out some meaning. The umbrella, for instance, was the embodiment of the "free, pure, beautiful and revolutionary,"[15] who has a mechanized affair with a sewing machine. Rosenberg's narrative played on the anachronism of Bolshevik politics while referencing the poetics of the Comte de Lautréamont (Isidore-Lucien Duchesne, a near contemporary of Baudelaire), who had exerted a major influence on Surrealism through Breton's resurrection of his work. Breton had used Lautréamont's line from *Les Chants de Maldoror*, "as beautiful as a chance meeting on a dissecting-table of a sewing machine and an umbrella,"[16] to both expound on the uncanny and generate absurd juxtapositions between poetry and painting. But Rosenberg was never an adept Surrealist. The movement's free associations and ambling sensibility largely evaded him. While his story was layered with subversion and double entendre, it was too clumsy to succeed as fiction. As with his poetry, which was beholden to Surrealism's startling contrasts, Rosenberg in his fiction was never able to grapple with the movement's grotesque features. There was no equivalent in American literature, Poe notwithstanding, to guide him. Besides, his title, with its evocation of death, suggested that Surrealism's sexualized rhetoric and disdain of bourgeois conformity had lost its grip on contemporary writing.

Breton was puzzled by Rosenberg, not able to entirely dope him out. (Although Breton lived in New York until 1946, he never learned to speak English, a drawback that impeded his grasp of the culture. He claimed that he wanted to preserve the purity of his French accent.) He asked Lionel Abel, who had introduced him to Rosenberg when they both worked for the OWI, "I know you think Rosenberg

is very intelligent. But tell me this. Do you think he's an artist? This is *very* important."[17] Abel responded in the affirmative, but he himself was not completely sure. Nor did he think that it mattered. He wondered why "if it wasn't important to be an artist, then why were they getting out a magazine devoted to art."[18]

Breton's "Prolegomena," which was translated by Abel for *VVV*, was not only a revision to how Surrealism could recast socialism after the trauma inflicted by Hitler and Stalin, but in equal part a rant on Salvador Dalí, who was known to Americans through his exhibitions at the Julian Levy Gallery in New York as of 1934. Breton felt that Dalí had gone overboard in his quest for wealth and fame, and his refusal to denounce the totalitarian governments that had ransacked Europe. The combined effect demeaned the spirit of the Surrealist movement.[19] While poetry topped the masthead of *VVV*, the plastic arts, anthropology, sociology, and psychology also had a role. Claude Lévi-Strauss made his American entrance here with two short pieces, one of which elaborated on tribal cosmetics and the body painting of the Kaduveos in southern Brazil.[20] (Breton and Lévi-Strauss had met on the boat from Marseilles to New York in 1941.) Charles Henri Ford was also represented by a poem, "Lullabye," that signaled a public allegiance to Breton whatever their *sub rosa* rivalry.

VVV was redirected to exclusively advance Surrealism after Trotsky was gunned down in Mexico, unlike *View*, which was devoid of politics and made poetry its editorial mission. Ford thought that "now, more than ever contemporary affairs should be seen through the eyes of the poets."[21] As he construed it, an opportunity was presented for the poet to project his vision onto a culture that had been beleaguered by the war and the Great Depression. Still *View*'s pages were filled with numerous reproductions of works by artists such as Matta, Masson, Picasso, Joseph Cornell, Jean Dubuffet, Florine Stettheimer, and Leonora Carrington, and special issues were devoted to Max Ernst, Tanguy/Tchelitchew, and Duchamp. The publication also carried interviews, articles, reviews, and fiction by writers such as Abel, Paul Bowles, Sidney Janis, Henry Miller, Meyer Schapiro, and James Johnson Sweeney. When *View* was conceived

by Ford, Rosenberg was about to give up on poetry. Although an ad was placed for *Trance above the Streets* in the same issue as "Dialogue," his own poems never appeared in the magazine. Moreover, he was not part of its core group of writers, which included Ford, Parker Tyler, Abel, and Nicolas Calas, a poet, art critic, and devotee of Breton, who published in almost every issue.

Calas was a veteran Surrealist who had lived in Paris before immigrating to the United States in 1940 and settling in Manhattan. He was also a Trotskyite, one of *View*'s few writers to maintain fealty to Breton, until the latter composed the "Prolegomena."[22] Calas was crucial to Ford's program, having edited a collection of Surrealist tracts for a special number of *New Directions* shortly after he moved to New York.[23] In sum, he was a warhorse who knew Surrealism's literary corpus intimately. His insider status assured his continuing presence in *View*. By contrast, Ford associated Rosenberg largely with *Partisan Review*, the journal he thought had done nothing to recognize the poet as a visionary who could reimagine culture.

Ford's political detachment stemmed from his assumption that "the left can take of its self."[24] It required no help from his publication. With a mandate to differentiate *View* from "the boring Partisan Review,"[25] no editorials appeared in the journal with a one-sided position on the war. References to world events, when made, were abstruse, absorbed within idiosyncratic and obscure texts. Even Calas, who had taken on Dalí in an early issue, dubbing him a "renegade" and "stinking Don Quixote,"[26] skirted the artist's aversion to Marxism.

Parker Tyler recalled a disagreement with William Phillips at Rosenberg's apartment in mid-1944 where the distinctions between the two publications were drawn and Tyler lobbied for the superiority of *View*. He tore into Phillips, exclaiming, "YOU have no sense of human dignity . . . No one could have who'd admit politics is more important than literature."[27] His indignation was set off by Phillips's dismissal that "if any culture worth the name existed today, *View* couldn't have lasted but two numbers because everyone would have SPIT on it."[28] Outside of his fury at Phillips, Tyler was perplexed

by Rosenberg's response to the exchange. In a letter to Ford, Tyler wrote that "Harold's thesis was a strange one: even though *View* 'stinks,' it's organized on the right principles as a magazine for it has some cohesion: PR, he thinks, has none."[29] The editors of *Partisan Review* had ensured that literature and the arts got the same amount of coverage as political analysis, but the journal's leftism had been tested by America's entry into the war. As Ford and Tyler continued to bait Phillips and Rahv over the identity of *PR*, its contradictory treatment of art as immune from politics became transparent. Hence Rosenberg's reservations about the periodical's "cohesion." He may have found the contents of *View* to be narrow, but at least it had a consistent editorial platform.

Partisan Review never took *View* seriously, and never perceived it as a threat. Clement Greenberg speculated that it would have a limited run largely because Surrealism was already moribund. "From it we gather that the surrealists are unwilling to say goodbye to anything," he wrote, "and that the American species identifies literature and art with its social life, and that this social life is complicated and satisfying. The gossip is good if you know the names; if you know the people I imagine it might get a little too much."[30] Weldon Kees, the poet, artist, filmmaker, and critic who lived on the ground floor of the same building as Rosenberg and Dwight Macdonald in the East Village, had a more offhand reaction. As a regular contributor to *Partisan Review*, he observed that Ford and his editorial group, including Calas, composed the "International Homosexual Set,"[31] a description that enlarged Greenberg's ambiguous reference to the "complicated" intersections between their professional and social lives. (Kees's account is also ironical: he is thought to have led a dual sexual life.) Greenberg's put-down of *View* was but another expression of the fractious divisions within the literary scene in New York in the early 1940s. Even though Calas had dissed his writing in the second issue of *View*,[32] which compounded Greenberg's fidelity to *PR*, the gaiety of the Surrealist parties and balls with their elaborate cross-dressing must have seemed silly to Greenberg, affecting his estimation of the magazine's clout.

"notes on identity"

Rosenberg was never fully integrated into the *View* circle, even though Tyler remained a close friend. But in 1946, when the journal casually absorbed French existentialism by running articles by Albert Camus, Jean Genet, and Jean-Paul Sartre, Rosenberg was invited to weigh in with "Notes on Identity," a piece that elliptically referenced Søren Kierkegaard, the proto-existentialist thinker. On the subject of the authentic self, Rosenberg declared that "the problem of individual identity is the dilemma of philosophy. If it confronts the problem, philosophy begins to move in the direction of action and past the borders of generalization."[33] "Notes" was more a takedown of the practice of psychiatry than a rumination on Kierkegaard. Rosenberg never had much faith in the mediation of self-knowledge through an intermediary such as a shrink. It was grappling with tragedy and life's setbacks that induced human *action*, he thought. His stance further alienated him from the early Freudian extensions of Surrealism, its myth making and allusions to ancient Greek mainstays, such as Oedipus and Narcissus. (Breton had studied medicine and later practiced psychiatry, and Calas was married to a therapist.) Here he was more in line with writers such as Kenneth Burke, who also bristled at such inflection. Burke and James Laughlin, the editor at *New Directions* who published Calas's Surrealist collection, discounted psychology before Rosenberg's "Notes" appeared.[34] Laughlin had tagged on two rejoinders to Calas's selections, including one by Burke, which were critical of Surrealist reliance upon myth.

Rosenberg had a hand at the Ad Council in overseeing a proposal for a campaign from the Group for the Advancement for Psychiatry, which was spearheaded by Dr. William C. Menninger of the Menninger Clinic and Foundation in 1949.[35] It had no impact on his thinking, however, and he remained perpetually averse to Freudian principles, believing that the therapeutic process, as he writes in "Notes," makes the patient "passive and begins to have his suffering wiped out . . . As a result, the 'cure' consists in emptying him."[36] He abided by this position throughout his career, having little truck with

any facilitation in the "path to identity."[37] Confusion, he believed, was the outgrowth of psychiatry's early attachment to Greek tragedy as a route to "catharsis."[38] He was unconcerned, unlike Breton who fretted that with the death of Freud in 1939 the liberating aspects of psychoanalysis were left hanging by a thread, capable of simplification by charlatans such as Dalí. (Dalí was an avid reader of Freud and attracted to his emphasis on dreams as a way to access the unconscious.)

Even later, as Rosenberg began his research on Arshile Gorky in the early 1960s, he disentangled the artist's painting from Surrealist talk relating to erotic longing, dreams, waking moments, pathology, and oppression. He admitted that the arrival of émigré artists and writers in the United States after the Occupation was key to Gorky's "transformation"[39] as an artist. But it was not their mimetic imagery that captured him so much as their resistance to formalist compositional approaches: the type of methods Greenberg advocated. These involved acts of appropriation and borrowing from preexisting sources to reconstitute modernism in the wake of a new world order. In Rosenberg's view, these gestures represented a profound affirmation of identity, the statement of which was not dependent upon psychological literature.

As adumbrated in his "Notes on Identity," Rosenberg's bailiwick would remain the philosophical dilemmas that encumbered mid-century American art. He acknowledged that Breton and artists such as Matta and Ernst had stirred the pot, especially when it came to marking the work of artists such as Gorky. But as he saw it, *View* was not up to the task of handling the existential depth of what it meant to be an artist during the war. What were the implications of the disintegration of Paris as an art center? Was New York about to take over? Unlike Ford and Breton, who abandoned their publications and returned to Paris, and Peggy Guggenheim, who folded Art of This Century and moved to Venice, Rosenberg was left to grasp the meanings of their brief wartime interlude. How to explain the consequences of their exchanges with American figures? How to read an altered art scene, if not by the footprint of their imagery?

Rosenberg's answer was not to repudiate Surrealism, as Green-

berg had done, but to cut through its swollen metaphors relating to unconscious desires and immobilizing nightmares. He thought there was no room for the languages of neuroses in "Notes," especially as American artists sensed they were about to make history. Breton, by contrast, considered madness part of what drove the Surrealist project. Healing, he believed, could never reinvigorate its narratives. Rosenberg was not big on healing as a metaphor either. Before Breton had even landed in Manhattan, Rosenberg had argued in "The Fall of Paris" that the rupture of history occasioned by the Third Reich must account for any analysis of contemporaneous art, making political madness, rather than psychological disorders, a fixture of cultural discourse,

existential emphasis

View was not entirely bereft of submissions that skirted politics. Jean-Paul Sartre, for instance, was invited to reprint a piece from *Les Temps modernes* that took on "the decline of France"[40] and a new postwar government that pushed for national unity within culture. The move, as Sartre told it, had resulted in the institutionalization of the Surrealist movement, a hitch for Breton, who never regained his edge as a writer in the postwar period. Admittedly, this was an atypical article for *View*. It tacitly acknowledged the drift of intellectual thought after Surrealism and how existentialism was fast becoming a mid-century fad. Ford had arranged for Sartre to speak at Carnegie Hall on his second trip to the United States, in early 1946, a stop in a lecture tour that included Harvard, Yale, Columbia, and Princeton universities. (His first trip, in 1945, came through the invitation of the OWI. Although he wrote five articles on America for *Combat*, a journal launched by Camus, he did not seek out the community of New York intellectuals.) The event was timed to coincide with Sartre's piece that ran in the March–April issue of *View*, which Ford devoted to the city of Paris. William Barrett, who by that time was on the staff of *Partisan Review*, attended the event and recalled that it "was absolutely jam-packed and there were quite a few American Surrealists."[41] The crowd included Marcel Duchamp and artists who

exhibited at 57th Street venues such as Art of This Century, Betty Parsons Gallery, and Charles Egan Gallery, as well as writers who worked for *Partisan Review*.

Time magazine had hyped Sartre's trip, designating him the "literary lion of Paris."[42] Ford had been thinking of Sartre's work for at least six months in advance of his return to Manhattan. He discussed his relevance with Parker Tyler in July 1945 as they planned the Paris issue. Sartre had just published "The Case for a Responsible Literature" in the summer issue of *Partisan Review*, and Ford wanted to top the piece with something more current, intensifying his competition with the journal. Tyler responded to their conversations in a letter that spelled out his own tie-ins with existentialism, stating: "I ALWAYS wrote with an existential emphasis . . . I think Sartre must be very clever but with something phony about him. I am not an admirer of Kierkegaard (though Harold has fallen for him.)"[43] That Tyler made the case for his own early existential leanings echoed Rosenberg, who had similarly felt his work predated the movement.

Tyler's defensiveness belied not just ambivalence about Sartre but his ballooning discontent over Ford's editorial direction of *View*. By 1945, he had become embittered that he had not been made a full editor, even though he had scouted material for Ford and was responsible for bringing in writers such as Rosenberg.[44] It was a sore point, in fact: he wanted more credit. The fuss over Sartre might not have occurred if Tyler had had more of his way at *View*. He was clearly at odds with Ford's notion that the French philosopher could shake up the foundations of Surrealism. John Bernard Myers, the managing editor of the magazine, noted around the time of Sartre's lecture that Ford contended that "Surrealism is on its way out,"[45] and had been superseded by existentialism.

Sartre had little interest in Breton's program, and their exchanges had always been unfriendly, strained at best.[46] There were few connections between their ways of thinking: Sartre later referred to Surrealism as "a phenomenon from after the other war, like the Charleston and the yo-yo."[47] Rosenberg never mentioned in his correspondence that he attended Sartre's lecture at Carnegie Hall, but it is hard to imagine he was not there. He did meet Simone de

Beauvoir the following year, on her first American trip, and he later described Sartre as a "very good friend,"[48] a description that grew out of an alliance that Rosenberg eventually forged with *Les Temps modernes,* which became a home for his writing in the late 1940s. Although he never called himself an existentialist, he identified with the magazine's politics and reflections on human consciousness. He may have come up with a few, half-hearted Surrealist attempts for *View* and *VVV,* as well as for *Instead,* a literary broadsheet with a very erratic run that was co-edited by Lionel Abel and Matta, but he could never identify with the movement's self-indulgence and playfulness.

Instead picked up on existentialism's sense of the absurd through its offbeat, haphazard format, typography, and table of contents. But it existed more as a quirky mix of poems, artists' statements, drawings, and essays by both New York–based and French figures, including Rosenberg, Antonin Artaud, William Baziotes, André Breton, Maurice Blanchot, Andrea Caffi, Marcel Duchamp, André Gide, Arshile Gorky, and Parker Tyler. The content was generated largely at parties by, as Abel said, "people who were not entirely sober,"[49] an approach that was ultimately too loose and transgressive for Rosenberg. Writing, he insisted, had to address the gravity of world events with sobriety. He would become drawn more to Sartre and de Beauvoir, who had no use for the Surrealists, their Freudian props, and dependence on the subconscious. To Rosenberg, *Instead* was too silly.

Once Breton, Ford, and Abel left Manhattan for Paris starting in 1946, Surrealism ceased to have any relevance in New York. Even in France, there was no comeback for the movement. It had been usurped by existentialism and its intellectuals, such as Sartre who remained in France during the Occupation grappling with the meanings of alienation. In painting, Surrealism's fantastic forms were eclipsed by abstract, gestural work made by artists connected to Art Informel, a new direction that paralleled the emergence of the New York School. Only Dalí, or Avida Dollars, continued to find outlets and audiences for Surrealist hyperbole.

the springs

May Natalie Tabak might have been taken by the Surrealist presence in New York and thought that they were having a good time in exile and coping with the exigencies of the war with great style. And, outwardly, they were. Their parties had carried over to Long Island, where many of them had summer and weekend homes. Once the Rosenbergs returned from Washington, they followed suit and bought a house on Neck Path in The Springs, a hamlet near East Hampton. Their cramped apartment near Saint Mark's Place, where they lived with Patia (fig. 14) in a large room that doubled both as a living space and curtained-off bedroom, was confining, especially for a family of three. While their quarters abutted a community garden, and the walls of the interior were lined with bookcases, the kitchen was tiny and tucked into an alcove, which made for tight living. Lionel Abel apprised Rosenberg that a house rented by Ralph Manheim, a translator, had become available in The Springs. He had never thought about owning a country home, but Tabak was seduced by the idea, and he purchased it with little deliberation, feeling that its price of $1,000 could be paid over time. Rosenberg referred to the modest shingled structure, which was secluded in five acres and had no indoor plumbing, as a "hunting lodge."[50] It was sited in a mix of tall grasses and low shrubs, and was a twenty-minute walk to the beach.

Although the house needed work—it had a leaky roof and a broken water pump—Rosenberg initially held off on any repairs. But as their summers stretched into off-season weekend visits, and life on Long Island became a refuge from the intensity of the city, he added a bathroom and a screened-in porch and eventually built a separate writing studio. For someone who identified with the metropolis. Rosenberg even came to enjoy barbecuing. His social life in The Springs was initially leisurely, unlike the combative evening gatherings in Manhattan.

Rosenberg had known about the lively social scene in the Hamptons through Abel and Matta, and through the Surrealists' attrac-

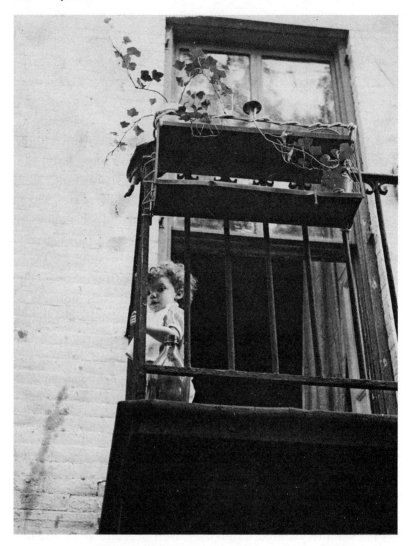

Fig. 14. Unknown photographer, *Portrait of Patia at Saint Mark's Place*, n.d. Photographic print. Harold and May Tabak Rosenberg Papers, Archives of American Art, Smithsonian Institution.

tion to the beaches. "They were always looking for beautiful places and ways of life,"[51] Rosenberg remembered of the exiles' summer settings. Once he and Tabak got out on Long Island in 1944, they cavorted with Max Ernst and Peggy Guggenheim, Isamu Noguchi, Charles Henri Ford, Pavel Tchiletchew, and the dealer Julian Levy,

as well as with Abel and Matta. However, once Paris was liberated and the Surrealists returned home, the dynamic changed. Their beach community became dominated by the emerging Abstract Expressionist artists, and the talk drifted to new subjects. A year after the Rosenbergs bought the "hunting lodge," Jackson Pollock and Lee Krasner acquired a place nearby on Fireplace Road. Pollock and Krasner felt that if Rosenberg and Tabak could afford it, so could they. (Pollock by this point was receiving a monthly stipend from Guggenheim.) Eventually, Robert Motherwell, Mark Rothko, Willem and Elaine de Kooning, William Baziotes, Franz Kline, Conrad Marca-Reilli, Perle Fine, and Saul Steinberg became part of their summer community.[52]

The scene in The Springs incorporated families and children, which mitigated the intense competitive zeal played out between rival literary factions in Manhattan. Eventually, in the mid-1950s, the camaraderie among neighbors grew to include a softball team that would assemble on Sunday mornings on a field owned by Barney Rosset, the publisher and founder of Grove Press and, later, the *Evergreen Review*. After a few years, the League, as it was called, became loosely divided between writers and artists. Rosenberg served primarily as pitcher because his feeble left leg impeded running. When he was up to bat, Patia would dash on his behalf between bases that were demarcated by telephone books. The event was eventually moved in the 1960s to Syd and Annie Solomon's home as their field was more even and flatter.[53]

Rosenberg liked to think that he had reinvigorated an art settlement that had thrived in East Hampton since the late nineteenth century. He was a honcho here, at least among painters and sculptors. With the exception of occasionally visiting Pollock and Krasner, Clement Greenberg never summered on Long Island. The absence of their strife added to Rosenberg's sense of well-being, allowing him to enjoy the casual lifestyle that unfolded over picnics at the beach, on the baseball field, and at dinners in the backyards of neighbors. Both The Springs and East 10th Street would remain Rosenberg's domiciles for the rest of his life. After the numerous moves that he and Tabak had made from the outset of their mar-

riage, and their long interlude in Washington, these homes became the backdrop for an abundant literary life.

There was no primary core to the East Hampton scene, especially after the Surrealists departed for Europe. Despite the mainstays of Krasner and Pollock, the groups of artists constantly shifted, and the fallings-out soon became as frequent as they were in New York. For instance, Rosenberg's relationship with Rothko turned sour, as would his relationship with Motherwell, by the late 1940s. Rothko had written to Barnett Newman after meeting Rosenberg in 1946 that he "has one of the best brains that you are likely to encounter, full of wit, humanness and a genius for getting things impeccably expressed. But I doubt that he will be of much use to us."[54] Rothko's impression was right when it came to him. Rosenberg later dismissed his exhibition at the Betty Parsons Gallery in 1949, contending it "stank."[55] After being exhilarated by the paintings that Rothko produced during the summer of 1948, Rosenberg was disappointed that "he went back to New York and painted a whole new show . . . They were simplified versions."[56] He had responded favorably to Rothko's distillation of quasi-figurative vessels and totems into dense chromatic patterns: the squiggles and skeins of paint were read as a lifeline to the artist's interior life. However, he objected to the economy of Rothko's new hovering rectangles and bands of luminous paint, and their serial implications. There was not enough variation in these repetitions to hold Rosenberg's interest, especially when they became a lasting project. Thereafter, the two men's friendship crumbled, and Rothko never returned to Long Island.

Rosenberg's quarrel with Rothko was but one instance of the many aesthetic skirmishes that erupted as the New York School coalesced into an entity. There were personal clashes as well. Parker Tyler, who had been a loyal friend who defended Rosenberg against Charles Henri Ford, also became estranged from him for a few years beginning in 1949. Tyler felt that Rosenberg had done nothing to support one of his recent unpublished novels.[57] The breach was wounding to Tyler, who wrote to Ford that "I never did a more self-making thing than break with Harold, who never was my mentor as you say, only a cicerone."[58] While their relationship was eventually

restored, and Tyler remained a friend until he died in 1974, he and Rosenberg were never as close again.

Lionel Abel, who left with the Surrealists for Paris, observed that "in the late forties almost everyone I knew in New York got sick of the person nearest to him or her . . . It was during this period that people began to give up on the values they had held to, also their friends."[59] Rosenberg never wavered when it came to Marxism, even though Sidney Hook felt Rosenberg had sold out when he was hired by the Advertising Council. But Rosenberg was perpetually headstrong and needed to preside over any conversation, an off-putting trait for many acquaintances. Abel, who saw Rosenberg on his first trip to Paris, in 1951, complained to Tyler that Rosenberg had not changed since they had seen each other in New York. He was still possessed of his considerable ego: "It is the same old story, only older and less interesting. He can scarcely talk about any subject without blowing his horn, and all of his ideas sound like advertising slogans — for what?"[60]

he is big enough to bear a bit of lampooning

During this period of collapsing friendships, Ralph Manheim wrote a loosely disguised parody of the Rosenbergs' marriage that incorporated Abel as a character. Manheim had become one of the foremost literary translators of the second half of the twentieth century: he was commissioned by Houghton Mifflin to translate Adolf Hitler's *Mein Kampf*, and later Günter Grass's *The Tin Drum*, in addition to essays, journals, and letters by Thomas Mann, Freud, and Martin Heidegger. The piece in question was written in 1948, a few years before Manheim relocated to Paris. Even though Rosenberg bought the house Manheim had rented in The Springs, the latter continued to spend time in the area after the war. However, he became rattled by the fierce exchanges that he witnessed between some of his eminent neighbors on Long Island and in Manhattan.

Manheim had a wry take on the Rosenbergs' domestic partnership, which he expounded in the form of a short story, "The Perspectors"[61] (a made-up term derived from "perspective" or point of

view). As he stages it, Harold, (whom he names Rupert), is await-
ing dinner after a long day at the office, and the chance to pontifi-
cate in front of a rapt listener, Nellie (Tabak), before retreating to
his desk to "work out a perspective or two, and split a bottle with
Norman, who admired him."[62] Abel, or "Norman," is a thief in this
tale, a perpetual houseguest at the Rosenbergs' apartment in New
York who constantly intrudes on their matrimony. In this thinly dis-
guised biographical story, he has stolen money from Nellie because
she is a fixture of the "bourgeoisie."[63] As a fellow "perspector," Nor-
man feels entitled to her cash, as he is still living hand-to-mouth as
a disenfranchised writer. She becomes indignant about the missing
money and complains to Rupert—, but receives no empathy. Insen-
sitive to her feelings, Rupert displays his "brilliance"[64] as he tries to
delve into Norman's motive by applying Marxist thinking to his pil-
fering; his rationalizations become more rewarding than supporting
Tabak's feelings.

Manheim had planned to publish his satire in Dwight Macdon-
ald's *Politics* but vacillated over a four-month period, concerned that
he had behaved in an "utterly unprincipled manner."[65] He fretted
over his portrayal of Tabak as a pedestrian but defiant wife who is
no longer seduced by her husband's learnedness, whatever her pre-
marital enchantment. Manheim had "been under pressure," as he
told Macdonald, "from various quarters to withdraw 'The Perspec-
tors' from publication."[66] He had resisted the notion that his spoof
was "an attack on intellectuals."[67] He was fond of Tabak and did not
want to injure her, even though he felt his description of her as "ordi-
nary" was "true."[68] However, he thought that Rosenberg could take
his sarcasm: he was "big enough to bear a bit of lampooning."[69] In
the midst of equivocation, Manheim showed the manuscript to the
Rosenbergs, who took no offense,[70] giving him license to run the
caricature. Abel, however, felt vulnerable, as he knew he would be
exposed, especially to the *Partisan Review* editors who continued to
publish his work. The journal was one of his few literary homes be-
fore he left for Paris.

Manheim had represented Abel true to form as both a pariah and
a bohemian adrift in the postwar culture of "The Perspectors." (Abel

later redeemed himself as a prize-winning playwright in the mid-1950s.) Although he privately exercised malice toward Rahv and Phillips, he needed *Partisan Review* for income, unlike Rosenberg who had a part-time job at the Ad Council. Within his derisive saga of a domestic quarrel, Manheim had landed on the soured utopian beliefs that emerged after the war. Even though the piece was never published, Tabak came to regard both Manheim and Abel as vicious.[71] She was hurt by their contempt for her.

Macdonald was annoyed that Manheim chose to withhold his spoof from *Politics*, believing that he had been too circumspect. Abel, he thought, had set himself up for ridicule:

> I do think that you give too much weight to Lionel's feelings in the matter. For one thing, he's dished out plenty of venomous gossip about others in his day, and it seems unreasonable of him to claim immunity now. (Of course, no one is [more] thin skinned about the aggression of others than the aggressive person.) For another, if the PR boys don't have this peg to hang their malice on, they'll have another. For a third, it seems unlikely to me that another, and perhaps even more vivid reason Lionel doesn't want the story to appear is that it satirizes most shrewdly and funnily (and one thing L cannot stand is to be laughed at) the intellectual type he and Harold belong to. And I see no reason such censorship should be permitted. For a fourth, against your friend's outraged feelings (and he is easily outraged, and frequently, so what's one more nail in his cross between friends?) have you sufficiently weighed the loss in pleasure and understanding which the readers will suffer if the story is not published, not to mention your own interest as an author, or mine as an editor?[72]

Macdonald had defended Abel against Clement Greenberg, one of the "PR boys," after Greenberg punched Abel for failing to believe that Jean Wahl was an anti-Semite. As the yarn goes, Macdonald relented and apologized after Greenberg recounted that Abel had also impugned *Politics* during the brawl.[73] The New York literary community had become deeply polarized by 1948, with few loyalties

remaining. "The Perspectors" was one of many trenchant representations of this fractured scene.

anarchist conservative

Once Macdonald founded *Politics*, he became even more opposed to *Partisan Review*'s support of the foreign policies of the Roosevelt and Truman administrations. While Rosenberg was allied with Macdonald, he never countenanced the article Macdonald had written on the bombing of Hiroshima in 1945, in which Macdonald posited that Marxism was oblivious to the wartime misuses of new technologies.[74] Rosenberg was also horrified by the atrocity but thought that Macdonald had wrongly implicated Marx. Both men had been drawn to the basic humanism of Marxism, despite their quibbling over its applications. Nonetheless, Macdonald gave up on Marx, and by the late 1950s he referred to himself as an "anarchist conservative."[75] The self-description denoted a radical individualism divorced from political ideologies like socialism. Mistrust of the establishment became his new credo.

Rosenberg had a similar anti-authoritarian streak. His willingness to forgo *Partisan Review* was a case in point. He was fiercely independent but never became weary of Marx who would always hover in the background of his thinking, even in the 1960s when he began to write for the *New Yorker*. During the height of the Korean War, when the United States came to the assistance of the South, Rosenberg told Lionel Abel that "the Americans were the only ones who understood modern politics."[76] By now, he had reversed his position on the US role as one of the Allied Forces in World War II so that it came more in line with his essay "The Fall of Paris," where he had written that the city's " decline was the result not of some inner weakness but of a general ebb."[77] New York had become a cultural leader, he now understood, through Truman's deft political maneuvering of the nation's international dominance. His insight benefited from his work for the OWI and Ad Council.

There were other rifts that separated Rosenberg and Macdonald. Once Macdonald began to write film criticism for *Esquire* and

the *New Yorker* in the early 1950s, their positions on the interpreta-
tion of popular culture diverged. Rosenberg was acutely aware of
the "herd" instinct that the film industry engendered: little was de-
manded of audiences, he felt, other than identification with the sen-
timent of story. Macdonald was actually on the same wavelength
and had argued that the studios in Hollywood had too much in-
put into the works that they financed. Their directors had made too
many concessions, unlike the more independent European auteurs
who were not subject to the same degree of interference.[78] But with-
out the apparatus of Marx, Rosenberg felt Macdonald was on shaky
ground; it seemed that his film reviews had devolved into exclusive
discussions of experimentation and of earlier moments in film his-
tory. He was too alienated by Macdonald's rejection of Marxism to
acknowledge any common ground.

de gaulle

Once Rosenberg settled into The Springs, he began work on trans-
lating *I Accuse de Gaulle* by Henri de Kerillis, a journalist and former
member of the French Parliament who now lived in Southampton.[79]
The volume was an impassioned critique of de Gaulle's political am-
bitions that grew from the author's profound disappointment over
having supported the general and his exiled government. De Kerillis
was the only noncommunist who voted against the Munich Agree-
ment in 1938 — which resulted in the Vichy regime — and had be-
come an active member of the Free French Forces. He eventually
opposed de Gaulle, believing that he was a fascist whose real aim
was to install himself as the president of the Fourth Republic and
dismantle the French empire of its colonies, republican machinery,
and elite upper-middle-class culture.[80]

Rosenberg had met de Kerillis through Pierre Chareau, a French
architect and designer who also lived in exile in both New York and
The Springs, and with whom he later co-edited *possibilities* with Rob-
ert Motherwell and John Cage. Rosenberg was taken by de Kerillis's
opposition to de Gaulle's compromises to effect France's liberation
and his dubious associations with the Cagoulards, a right-wing mil-

itaristic and fascistic group.[81] Through his translation of de Keril-
lis's tome (his skills as a translator had improved!), de Gaulle be-
came a feature of "The Resurrected Romans," the first of two articles
Rosenberg wrote for *Kenyon Review* on the corruption of Marxism,
in which he depicted the French leader as "an undistinguished brig-
adier."[82] De Gaulle was a false hero to Rosenberg, an aberration like
Stalin and Hitler, who redoubled on the stereotype of the revolu-
tionary.

While working at the OWI hyping war campaigns, writing press
releases, and radio plays, Rosenberg came to perceive clearly de
Gaulle's inability to emerge as an authentic protagonist in the war.
In "The Resurrected Romans," he built on President Roosevelt's
mockery of de Gaulle as a self-fashioned savior who had taken his
cues from Joan of Arc (who later became canonized as a saint for
her role in reclaiming French territory during the Hundred Years'
War). Rosenberg quoted Roosevelt as saying, "the trouble with
[de Gaulle] is he doesn't know the difference between a man and
a woman."[83] Rosenberg did not recognize de Gaulle's exiled regime
because he was not an elected official; hence, the allusion to a con-
fused sexuality. The reference not only undermined de Gaulle's mas-
culinity but underscored an ambiguous identity incapable of *action.*

13
possibilities

the space between art and politics

Rosenberg met Robert Motherwell in East Hampton around 1944 as they were both settling into life on Long Island.[1] Motherwell was about to stage his first solo exhibition at Peggy Guggenheim's Art of This Century gallery in New York. He had just hatched an idea with George Wittenborn and Henry Schultz for a series of low-priced books on artists' writings that became the Documents of Modern Art series for which he served as founding editor. As he eased into the social scene in the Hamptons, he acquired two acres of undeveloped land on the corner of Jericho Lane and Georgica Pond where he built the first modernist house in the area. He enlisted Pierre Chareau to repurpose two prefabricated naval Quonset huts for his living space and studio. In exchange, Chareau constructed a cottage on the property composed of the leftover salvaged materials, and they became neighbors.

Motherwell continued to spend time on Long Island until 1950, when Chareau died suddenly and the loss became unbearable. (Chareau was more than thirty years older than the young artist; Motherwell thought of him as a father figure.) Motherwell had recently gone through a divorce, which compounded his sense of upheaval. He soured on the Hamptons and moved to East Islip, which was closer to Manhattan. However, Rosenberg was also implicated in Motherwell's need for relocation, as he was in the demise of their short-lived joint project, *possibilities*, which ran through one issue.

Wittenborn and Schultz had asked Motherwell to also oversee a second series of books, Problems of Contemporary Art, into

which a new magazine, *possibilities*, was to be folded. As he recalled, they wanted "to put out an annual about the current art scene."[2] He brought Rosenberg, John Cage (who spent time nearby in Amagansett), and Chareau into the venture in early 1947, believing that "it should be broader than just painting and sculpture and that it was too great a responsibility and too great a demand on my time to do . . . singlehanded."[3] Motherwell solicited artists' statements and images for the publication, and Cage and Chareau took on music and architecture. Rosenberg was left to glean the literary submissions. Nonetheless, his role quickly became ascendant, much as it had with H. R. Hays on *The New Act*. For starters, the title of the publication — *possibilities* — was his idea, a revision of an earlier suggestion, *Transformations*, that was intended to improve upon Motherwell's more stodgy proposition, *Notebook of Painters and Writing*. Besides conjuring a name for the magazine, Rosenberg was largely responsible for the editorial statement. Cage and Chareau were not consulted, nor did they work on the note's content, and their names did not appear as part of the editorial team, altering Motherwell's notion of collaboration.[4]

When Motherwell and Rosenberg sat down to compose their joint statement for *possibilities* (fig. 15), they felt that the relationship of art to politics had to be addressed. Their response was part disclosure, part affirmation, much like what Hays and Rosenberg had earlier written in *The New Act*. As they had it, "political commitment in our times means logically — no art, no literature. A great many people, however, find it possible to hang around in the space between art and politics."[5] With socialism regarded as a failed experiment by many mid-century writers, Motherwell and Rosenberg were guarded about bringing out a journal that was tied to political thought, feeling there would be little room for the individual's voice. They opted instead for a mix of writings from, among others, Lionel Abel, William Baziotes, Paul Goodman, Oscar Niemeyer, Jackson Pollock, Mark Rothko, David Smith, Virgil Thomson, and Ben Weber, as well as the nineteenth-century writer Edgar Allan Poe. Politics, however, was subtly stitched into the program.

Motherwell was nine years younger than Rosenberg but like

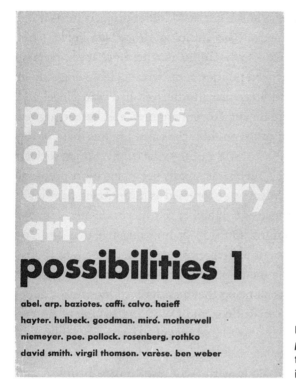

problems
of
contemporary
art:
possibilities 1

abel. arp. baziotes. caffi. calvo. haieff
hayter. hulbeck. goodman. miró. motherwell
niemeyer. poe. pollock. rosenberg. rothko
david smith. virgil thomson. varèse. ben weber

Fig. 15. Cover of
possibilities 1 (1948),
the first and only
issue.

him had no interest in joining a communal organization such as the
CPUSA. He came from an upper-middle-class family—his father
had been a president of Wells Fargo—with no direct experience
of the Depression. His politics had grown not from hardship but
from rage against totalitarian regimes that aimed to squelch mod-
ernism, particularly Franco's Spain. After graduating from Stanford
and spending a subsequent year at Harvard, where he focused on lit-
erature and philosophy, Motherwell studied both in Grenoble and
at the Académie Julian in Paris in the late 1930s as fascism took hold,
cutting short his foreign education. The nebulous "space between
art and politics" described in their editorial statement alluded to
a creative practice that defied conformity demanded by the state.
However, the line was Rosenberg's, further underscoring the seep-
age of his ideas into the journal.[6] Within this "arena," as he later
called it in "The American Action Painters," existed possibility for
articulation of the artist's subjective life.

Motherwell was busy at the time with other projects for Wittenborn and Schultz, especially his anthology, *The Dada Painters and Poets*, as well as with work in his studio. Furthermore, it was primarily Rosenberg who evoked politics in his writing, believing a tie-in obtained with art and literature. Motherwell had read Hegel and Marx around the time he and Rosenberg met, and he had argued that "the materialism of the middle class and the inertness of the working class leave the artist without any vital connection to society, save that of *opposition*."[7] Yet he was rapidly becoming more preoccupied with how modernism was expressed as invention in painting.

Rosenberg's presence was tangibly felt in *possibilities*. He was more than a joint editor. Outside of finessing the title and co-authoring the introduction, he contributed three pieces to the issue. Motherwell's sole inclusion was a minuscule reproduction of *Indians* (1944), an ink drawing that was dwarfed by spreads allotted to Baziotes, Pollock, Rothko, and David Smith. One of Rosenberg's submissions was a reprinted introduction to an exhibition, *Six Young American Painters*, at the Galerie Maeght in Paris, where Motherwell appeared along with Baziotes, Romare Bearden, Byron Browne, Adolph Gottlieb, and Carl Holty. (The show was arranged by Samuel Kootz, the artists all part of his stable.) Rosenberg never mentioned any artist by name, a tactic he later repeated in "The American Action Painters." He noted that although these painters were not part of a "school," they were united through "a unique loneliness that is reached perhaps nowhere in the world."[8] By loneliness, he meant defiance against imagery of "cowboys, country stores, cornfields, lighthouses, and oil wells,"[9] or the stock of regionalist painting. The motif became part his evolving language of *action*. It also braided Motherwell's concept of a New York School, the term that he later coined for a new generation of abstract artists who emerged in the wake of the war.

Outside of the Maeght piece, Rosenberg wrote a few paragraphs to accompany a short statement by Baziotes in *possibilities*. Baziotes announced that his subjects were "elusive,"[10] but in the "silence" between his hazy shapes reminiscent of ancient Greek art, Rosenberg found plenty of mystery that approximated the "medium of sleep."[11]

However, Rosenberg's larger article, "The Stages: A Geography of Human Action," dominated the publication. Comprising almost twenty pages, it overshadowed the other contributions by artists, writers, and composers. "The Stages," like the journal's title, grew out of his exchanges with Motherwell and their frequent nightlong, inebriated conversations either on Neck Path or later in Motherwell's studio in East Hampton.

the demon of possibility

Rosenberg's discussions with Motherwell were characterized by intensity, and tested and disputed the ideas of manifold thinkers. The two had a mutual interest in French symbolist poetry, and Motherwell was responsible for introducing Rosenberg to many new texts during the late 1940s. He had studied French literature in Paris after finding the pedagogy of the Académie Julian, which emphasized life drawing, too stifling and passé. However, both men were outwardly a study in contrasts: Motherwell was elegant, his demeanor the reflex of a refined upbringing on the West Coast in both Seattle and the Bay area, unlike Rosenberg's scrappy childhood on the streets of Harlem and Brooklyn. But when it came to literary modernism, the two were of one mind.

In early 1947, as *possibilities* got under way, Motherwell sent Rosenberg a copy of a book by Paul Valéry "with a sweet inscription," as Rosenberg recalled, that must have been the newly released English translation of *Monsieur Teste*. In his note of thanks, Rosenberg replied, "I am a little afraid of getting to know 'the man' Valéry so well, and yet I want to know him."[12] The sentiment suggested that the volume was something other than a collection of Valéry's poems or essays, that it was autobiographical, albeit disguised as fiction.[13] *Monsieur Teste* is a novel, as Valéry described, about "the very demon of possibility,"[14] an inquiry into what self-knowledge can yield or effect. Avowedly personal, the book can be taken as a *roman à clef*, at least of the author's intellectual life. Rosenberg clearly focused on Valéry's use of the word "possibility" in the preface to the volume and mentioned it to Motherwell. It must have become part of their

dialogue, the origin of the title for their journal, and a substitution for Rosenberg's more pedestrian *Transformations*. Although both words—"possibilities" and "transformations"—were extensions of Rosenberg's *action*, synonyms for change, "possibilities" was more nuanced and elastic, adumbrating the "drama of consciousness," as Valéry had it in his novel.

Rosenberg's enthusiasm for books such as *Monsieur Teste*, and terms such as "possibilities," enlarged his sense of what *action* meant. He had been attached to the word from the early 1930s when it first surfaced in "Character Change and the Drama," the article that he wrote for *Symposium*. *Action* also appears in the title of "The Stages," which he wrote for *possibilities*, where he embarked on a fuller analysis of Hamlet's tormented psychological state. Rosenberg now claimed that Shakespeare's protagonist knew that "it is possible *not* to act—and then he will not exist."[15] By this point, he had tinged his theme of *action* with existential sobriety, the outcome of attending Jean-Paul Sartre's lecture at Carnegie Hall on his second trip to New York, in 1946.[16] In the face of "nothingness"—one of the words that Rosenberg lifted from Sartre for "The Stages"—he states that a life without *action* has no relevance. "The human being," he wrote, "is nothing else than the situation in which he is acting. To the extent that he engages himself in it he achieves existence; in evading it though he sinks to non-being, an actor between engagements."[17] Five years later, when he sat down to write "The American Action Painters," Rosenberg made the artist the focus of this maelstrom, a protagonist like Hamlet who was capable of effecting possibility within the postwar United States.

Motherwell had a contrary memory of the origins of Rosenberg's soon-to-be signature term. He claimed that his metaphor of *action* was appropriated from the German poet Richard Huelsenbeck's *En Avant Dada: A History of Dadaism*, a manifesto from which they recycled a key passage in *possibilities*. He remembered showing the piece to Rosenberg while he was working on *The Dada Painters and Poets* and that Rosenberg alighted on a passage where, as Motherwell paraphrased," Huelsenbeck violently attacks literary esthetes, and says that literature should be action, should be made with a gun

in hand etc."[18] The excerpt portrays the artist as a revolutionary, a Dadaist, whose provocations were to upend art's passivity as an object through publicly staged performances. The process was what mattered, not the aesthetic outcome. As Huelsenbeck told it, "the Dadaist should be a man who has fully understood that one is entitled to have ideas only if one can transform them into life—the completely active type, who lives through action only."[19]

As the literary editor of *possibilities*, Rosenberg did not need to convince Motherwell to publish Huelsenbeck's proclamation, such was their mutual enthusiasm. However, he juxtaposed Huelsenbeck with a fragment from Edgar Allan Poe's *Marginalia*, where Poe expounds on the power of words to convey the passage from sleep to wakefulness to memory (not unlike Rosenberg's spin on Baziotes's painting). There was no connection between Huelsenbeck and Poe, not even in their responses to the horrors of modern life. But that was precisely Rosenberg's point: to contrast the metaphysical dimensions of Poe's prose with Dada's rebuke of aesthetic complacency. The gap between this forged alignment, he suggested, could be applied to the new American art featured in *possibilities*. It was another way to metaphorically explain the "space between art and politics."

Motherwell was largely unacquainted with Rosenberg's earlier literary work. Unknown to him, *action* had long since been part of Rosenberg's vocabulary. Rosenberg must have been thrilled to find that writers such as Huelsenbeck had construed Dada as *action*. It reinforced his sense of the possibility for the artist to rethink the primacy placed on the material or formal components of expression.

a terrific battle

Motherwell and Rosenberg, along with Cage and Chareau, planned a second issue of *possibilities* in 1948.[20] It got as far as Motherwell producing a drawing that incorporated a passage from a poem by Rosenberg into a black-and-white composition (fig. 16), and a table of contents that considered, as Motherwell wrote, the journal's "relation . . . to politics, society, aesthetics."[21] But the publication

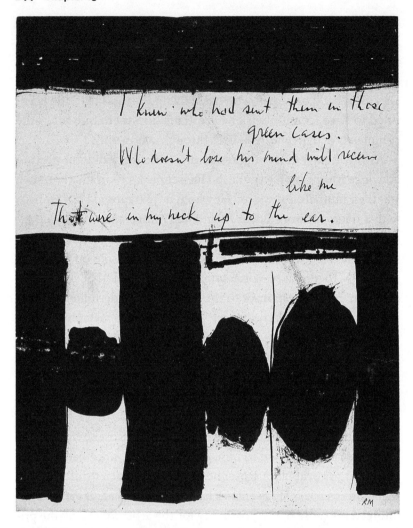

Fig. 16. Robert Motherwell (1915–91), *Elegy to the Spanish Republic #1*, 1948. Ink on paper, 10 ¾ × 8 ½ inches. The Museum of Modern Art. Gift of the artist.

was never realized. Various conflicting accounts exist regarding its demise. Motherwell claimed that its financing was cut off when Schultz was killed in an airplane accident, leaving Wittenborn without a partner.[22] Contrary to Motherwell's memory, Schultz did not die until 1954, six years after the publication was abandoned. Rosenberg, with some sense of guilt, had a specific recollection of strife: the end of *possibilities* "was attendant on a terrific battle more than

anything else … I think that the major reason it did not continue was a certain stubbornness on my part … Without meaning to wreck it, but I resented that what John Cage did in the magazine seemed to me a kind of put-on and I didn't like the idea of using Dada tactics on people who were sophisticated."[23] Cage's long list of contemporary composers and their works that was unaccompanied by any explanation, in the first issue, irritated Rosenberg, who felt it undercut the seriousness of the journal. He had spent a great deal of time on his exegesis of being in "The Stages" and did not want it brought down by what he considered a joke.

Lionel Abel, who met Motherwell in East Hampton around 1944, had a different version of the journal's failure that built on Rosenberg's memory of his overbearing behavior. As Abel wrote much later, "Rosenberg told me with some glee … that Motherwell had decided to undergo psychoanalysis, and his analyst had found Rosenberg bad for his ego."[24] Abel added that "it struck me that someone who would drop you for the sake of his ego would have to be someone who had taken you up for his ego's sake."[25] Motherwell had attempted an equitable approach to the publication, allowing each editor autonomy. But in the end, he was overwhelmed by Rosenberg's personality. With resignation, he admitted, "My philosophy is to let everyone be what they are. This is different from the philosophy of New Yorkers. They tend to want to impose everything, rather than letting everyone be themselves with no imposition of their private opinions about it."[26]

Rosenberg was the only New Yorker on the editorial team. Motherwell's assertion that he was intolerant of differing aesthetic positions and had forced his ideas on the journal was part of a behavioral pattern and Rosenberg's persistent desire to hold forth. Motherwell never mentioned that his psychoanalysis resulted in repudiation of Rosenberg, at least not in print. But their friendship did not survive the single issue of *possibilities*. Their contact, whatever its original intensity, became less frequent. Privately, Motherwell conveyed in a letter to Joseph Cornell that he had "been through a long period of depression and anxiety, moreover the editors of 'Possibilities' can't agree on anything—which I think is true to life."[27] However

taxing the experience of fending off Rosenberg's ego, both figures marked each other's work. The drawing that Motherwell made for the aborted issue that embedded Rosenberg's poem spawned his *Spanish Elegy* series, which he worked on from the 1950s until his death in 1991.

Within the constraints of composing an abstraction without color, Motherwell's oval, black muscular forms set against a white ground fed from "the brutality and aggression of [Rosenberg's] poem."[28] Motherwell had planted the last three lines of Rosenberg's verse, "A Bird for Every Bird," in the midsection of his abstraction. Yet the absent middle stanza more directly informed his composition: "The Two Marquis, the white and the black / Were crying like gulls out of my throat." He clearly wanted to avoid any literal connection with Rosenberg's verse. After completing his drawing, he remembered thinking that he "should make some paintings on the basis of that kind of structure."[29] But as they multiplied into a series, Motherwell decided any reference to Rosenberg was no longer relevant, and painted a black band over his name below the couplet on the drawing. Instead, the *Elegies* became lamentations for Federico García Lorca, a favorite poet who died in the Spanish Civil War.[30] Rosenberg eventually got his licks in, too. He surmised that Motherwell's monochromatic variations amounted to a branding device just like the prominent use of his signature. There was not enough compositional diversity in his output—just repetition. His identity had been pulled off by "lightness"[31] rather than tough thinking.

Motherwell offered Rosenberg a gift of one of his "black-and-white ones"[32] in 1953 (which has gone missing). At the time, he noted his debt to Rosenberg's poem, referring to it as an "equivalent" to the *Elegy* series—and a tangible outgrowth of *possibilities*.[33] By then, Motherwell was on *terra firma*. He had worked through his depression, was remarried, and had a string of annual exhibitions at the Kootz Gallery, in addition to a teaching appointment at Hunter College. He occasionally alluded to Rosenberg in his subsequent lectures and interviews. He had been particularly taken by "The Herd of Independent Minds," the article that Rosenberg published just as their work on the second number of *possibilities* stalled.

That Rosenberg took on a new generation of American intellectuals who guarded their individuality through enmity to mass culture was a position that Motherwell shared.[34] However distanced they had become socially, the "space between art and politics" remained a shared value.

As the director of the Documents of Modern Art series, Motherwell commissioned Rosenberg in 1949 to write an introduction to Marcel Raymond's *From Baudelaire to Surrealism*. He responded with "French Silence and American Poetry," an article that induced a plea from Clyfford Still for a similar treatment of American painting. Rosenberg expounded on "silence" to illustrate how poets after Baudelaire had "restored freshness to language"[35] through delving into the self. He noted that this wellspring had resulted in renewed appreciation of Poe and Whitman, and their experience of American life, a trait that T. S. Eliot renounced when he moved to England and capitulated to the patterns of British thought and its institutions, such as the church. French poets of the modern period, Rosenberg believed, had taken revolution seriously by muting tradition. Consequently, the Americans, such as Pound, Williams, Moore, Stevens, Cummings, Stein, and even Eliot, were indebted to their trailblazing inventions. They caught on quickly, however: their own adventures with language were intended to shake up the past while retaining the unique culture of the United States, save for Eliot. (Although Pound and Stein were expatriates, their homeland was a frequent focus of their verse.)

Motherwell knew that Rosenberg could endow Raymond's book with greater currency by tagging on the American extensions to experimental poetry. But when he penned "The American Action Painters," Motherwell's enthusiasm for his writing ebbed. He later cited Alfred Barr, Meyer Schapiro, with whom he had studied at Columbia for a year (after his trip to Paris), and Clement Greenberg as the preeminent writers on art of his generation.[36] Their friendship became frayed by the urgent issue of a name or portmanteau for the new American painting. What to call it? Just as *possibilities* failed to materialize into a second number, Motherwell floated "New York School" as a term to describe the work of his generation. He also

drew on the theme of isolation that Rosenberg had voiced in his introduction to *Six Young American Painters* at Galerie Maeght, underscoring the early unanimity of their ideas.

the intrasubjectives

In the fall of 1949, once Wittenborn and Schultz conceded that *possibilities* would not move to a second number, Samuel Kootz reopened a gallery on Madison Avenue after a yearlong hiatus. He gave his opening exhibition an elusive title, *The Intrasubjectives* (fig. 17), and commissioned Rosenberg to write a short essay to pair with his own explanation that "intrasubjectivism is a point of view in painting, rather than an identical painting style."[37] However arcane, it was one of the many names advanced after Robert Coates had suggested Abstract Expressionism a few years earlier in a review in the *New Yorker*.

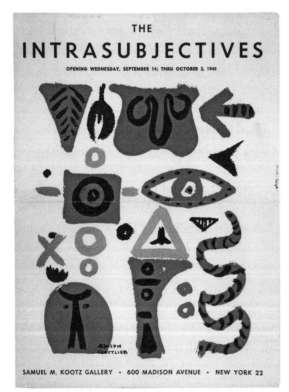

Fig. 17. Cover of the catalogue for *The Intrasubjectives*, 1949, featuring a drawing by Adolph Gottlieb (1903–74). Exhibition at the Kootz Gallery, New York, September 14– October 3, 1949.

As Rosenberg told it, Coates's appellation was too "academic"[38] to deliver the meanings of the art that had emerged in Manhattan in the mid- to late 1940s. As a term, it was too bound to the retro style of German Expressionism, with which the new American painting had few links. Kootz had qualified that the work of Baziotes, de Kooning, Gorky, Gottlieb, Motherwell, Pollock, Reinhardt, Rothko, Tobey, and others who appeared in his show had less to do with aesthetic cohesion than with a like-minded, subjective position.

The word "intrasubjective" had been employed by José Ortega y Gasset in a recent essay in *Partisan Review*. It seemed to Kootz and Rosenberg like a good catchall to describe the collective aims of the artists who made up the exhibition. Moreover, it provided Rosenberg with the opportunity to elaborate further on "nothingness," a word he had used in "The Stages: A Geography of Action." In the context of the exhibition, it now denoted the space where the artist's subjectivity unfolded, the blank canvas where emptiness was a primal condition until filled by the marks and gestures of the artist's emotion: the core trait of *action*.

A month before Kootz organized his overview of "subjectively" driven art, Motherwell—who remained with his gallery until 1955 (when he left for Sidney Janis)—wrote a lecture that he delivered in Provincetown, Massachusetts, to an audience composed largely of artists. "I had never had the sensation of belonging to a community," he stated. "It was difficult for me to imagine being wanted. This is not wholly true; we modern artists constitute a community of sorts; part of what keeps me going, part of my mystique is to work for this placeless community."[39] Motherwell ventured to call this nebulous alliance the "school of New York," a place that existed in ethos only, a latter-day school of Paris, its titular forebear. He might have pinpointed this "placeless community" in Manhattan but was adamant that geography had no role in determining its uniqueness. Like Paris, "these two handfuls of individuals are closer to each other in their essential acts than either is to the herd of individuals who constitute his national culture, French or American."[40] With nationalism a fixture of the totalitarian state, Motherwell submitted that collectives or groups ran the risk of squelching the artist's voice. He was

also thinking about the impassioned populist rhetoric of regionalist painting that held sway during the Great Depression. By contrast, his school originated from "protest"[41] and was assertively nonconformist, critical not only of government but also of cultural complacency. This "protest" issued from the "space," as he and Rosenberg had described in their joint editorial statement in *possibilities*, "between art and politics," the gray zone where subjectivity took center stage.

Motherwell's configuration of a "school of New York" was based on a collective "act," a word that Rosenberg had long since used.[42] Just like "herd," which he had also borrowed from Rosenberg's essay for *Commentary*, Motherwell's designation of an enclave of artists in Manhattan was layered with language that grew out of their shared convictions in the late 1940s.

the artists' sessions at studio 35

A few months after Rosenberg and Kootz had weighed in with *The Intrasubjectives*, Robert Motherwell and the sculptor Richard Lippold moderated a three-day roundtable at Studio 35 — a short-lived program of Friday-night lectures by artists, operated by New York University — to address the issue of a community and a name. The concern over identity had mounted to the point where artists assumed they ought to intervene in the ongoing speculations of critics. Called "Artists' Sessions at Studio 35,"[43] the assembly quickly alighted on the idea of a school to probe whether their convictions were shared (fig. 18). Barnett Newman opened the discussion by asking, "Do we artists really have a community? If so, what makes a community?"[44] David Hare, a sculptor, was not ready to admit to any connection with his peers, responding, "I see no need for community. An artist is always lonely. The artist is a man who functions beyond or a head of his society."[45] Ad Reinhardt thought some kindred sensibility tied the artists together and pondered, "Why can't we find out what our community is and what our differences are, and what each artist thinks of them?"[46] Little clarification, let alone consent, grew out of the discussions. They remained largely discursive,

Fig. 18. Max Yavno, *Artists' Sessions at Studio 35*, 1950. Photographic print. Estate of Max Yavno.

either skirting the topic of a community or disavowing the possibility entirely.

During the second day, Alfred Barr, the director of collections at the Museum of Modern Art, and the only nonartist invited to attend these closed sessions (and for one day at that), pressed for a name, hoping to force unanimity. He questioned, "What is the most acceptable name for your direction or movement? It has been called Abstract-Expressionist, Abstract-Symbolist, Intra-Subjectivist, etc.? . . . Is there any unity here?"[47] Barr felt the choice of a term should be theirs, such had been the wrangling. "We should have a name for which we can blame the artists—for once in history!" he countered.[48] But resistance to being considered a group persisted. David Smith concluded, "I don't think that we have unity on the name."[49] Willem de Kooning went one step further, contending, "It is disastrous to name ourselves."[50] The business of a name was thrown back to the critic or curator, a willing concession of a dubious property.

Not all artists who congregated at Studio 35 believed their aims were disparate. Most artists expressed an acute sense of isolation, triggered by the realization that their work no longer maintained ties with Europe. Rosenberg had earlier drawn on the profundity of this isolation in *Six Young American Artists*, Kootz's show in Paris, mining it as a metaphor to describe progressive American painting. He had long since proposed that a historic rupture had been occasioned by the Occupation. While he would hesitate to refer to the artists who gathered at the "Sessions" as a community, violating as it did his primacy of individuality, he later sited this fount of activity on 10th Street, in the heart of Greenwich Village, an old-world bohemia or counterculture that had "entered into a kind of metaphysical retirement, a dissident self-insulation from as many areas of social contact as possible."[51] He knew that 10th Street, like Paris, had a limited future. Its art scene would be annihilated not by fascism but by the agents of capitalism, such as developers and landlords. With its demise, he predicted, modernism would expire.

The sense of a fractured history also redounded at the "Artists' Sessions." Allusions were made to the alienation of the artist, and to a melancholy arising not only from the fall of Paris but also from

feelings of separation from mainstream culture. The sculptor Herbert Ferber wondered if there was "any difference in what is happening in America and what has happened heretofore, and what is happening in Europe. There is some difference which is not a question of geography but of a point of view."[52] Although Ferber wanted to retain Paris as a nucleus, he recognized that historic circumstances had made New York the new leader. His position was shared by many artists who attended the "Artists' Sessions," as well as by writers such as Rosenberg, shaping public perception that some semblance of a community of artists actually existed.

By the third day of discussions, Motherwell responded to Barr's challenge by attempting to force a name on the group. He volunteered three possibilities: "Abstract-Expressionist; Abstract Symbolist; [and] Abstract-Objectionist." While he did not present the "school of New York" as a prospect, he subsequently reworked the phrase into a crisper label, christening the group "The New York School" in a lecture six months later. Motherwell went as far as to identify a list of key players, segregated by media, that included Gorky, Gottlieb, Hofmann, de Kooning, Pollock, Reinhardt, Rothko, Bradley Walker Tomlin, and himself, along with sculptors such as Louise Bourgeois, Mary Calley, Ferber, Hare, Seymour Lipton, Theodore Roszak, and David Smith.[53] This inventory provided a clear image of a community as well as a term that would be used by Motherwell and by numerous other writers.

Motherwell had become impatient with the artists' indecision over a name. But he had also tired of the critical reception to their work, and the hostility and misunderstandings that could have been avoided by a conceptual hook. He responded with indignation that these artists "had been bitterly attacked in many quarters and on other occasions praised."[54] He wanted a more methodical, searching investigation of the New York School, a sustained take on its origins and subjects.[55] He lamented, much as Clyfford Still would to Rosenberg, that "this work has never been regarded analytically or with any knowledge of its history."[56] But he also laid the groundwork by likening the aims of his contemporaries to the "symbolist aesthetic of French poetry," such as Mallarmé, Rimbaud, and Verlaine, and to

later poets who picked up on their immediacy and use of free verse, such as Joyce, Yeats, Eliot, Cummings, and García Lorca.

Although Motherwell claimed he could not demonstrate any equation of art with poetry, implicitly leaving that job to a critic or scholar, he noted in his lecture that he had recently commissioned the English translation of Marcel Raymond's *From Baudelaire to Surrealism* for the Documents of Modern Art. (He never mentioned, however, that he had invited Rosenberg to write the introduction.) He reckoned that few American artists were aware of the correspondences between their work and the legacy of French symbolist poetry; this needed to be explicated. Clyfford Still subsequently wrote to Rosenberg that he believed Rosenberg was up to the task of establishing these parallels. But he did not bargain on "The American Action Painters," an essay that would send him fuming.

Motherwell's term "New York School" and Robert Coates's term "Abstract Expressionism," would both eventually acquire lasting usage. Both epithets were used interchangeably from the early 1960s onward. ("Intrasubjectives" was a fleeting term, which did not survive Kootz's exhibition.) Motherwell continued to refine his phrase and expound on its meanings, writing in a preface for a show, *Seventeen Modern American Painters,* at the Frank Perls Gallery in Beverly Hills in 1951 that the new work was "lyrical, often anguished, brutal, austere and 'unfinished,' in comparison with our contemporaries of Paris; spontaneity and a lack of self-consciousness is emphasized."[57] As a term, "New York School" initially remained loaded. Clyfford Still, who appeared in the Perls project, objected to Motherwell acting as a spokesman for the group (and, as legend goes, so did Rothko and Tomlin).[58] Still must have felt that Motherwell's essay was prompted by self-interest: naming was the purview of the critic. Motherwell later clarified that "the School of New York is less an aesthetic style . . . than a state of mind."[59] It was wrongheaded to enlist style as a critical method, he implied.

As Still told Rosenberg in 1950, a more historical explanation of postwar American painting was needed. However, a dispassionate narrative was not to be had from Rosenberg either. When he finally acted on Still's request, he delivered "The American Action Paint-

ers," an essay that was devoid of artist's names and organized around an ineffable trope. As Rosenberg entered into one of the most contentious debates in American art, Still retracted his initial praise, accusing him of "motives." His tirade was repeated by Jackson Pollock in 1952 and later by Clement Greenberg in the 1960s.

14
les temps modernes

the "action complex"

During the period that Rosenberg worked on *possibilities*, he con-
nected with *Les Temps modernes*, the monthly journal launched by
Jean-Paul Sartre, Simone de Beauvoir, and Maurice Merleau-Ponty
in 1945 in the wake of the liberation of Paris. Rosenberg had met
Sartre in New York in 1946 and de Beauvoir the following year, when
she toured America for four months on the lecture circuit. These en-
counters prompted the French editors to reprint Rosenberg's "The
Stages" in *Les Temps* (as it was colloquially known) in 1948 (fig. 19).
which led to a professional association that lasted until 1952, when
Rosenberg finished "The American Action Painters." Rosenberg's
friendship with de Beauvoir was warm, a contrast to his more com-
petitive relationship with Sartre. Unlike most of the American writ-
ers she met on her trip, de Beauvoir was taken by Rosenberg's "intel-
ligence,"[1] which she compared, in a letter to Sartre, to the "American
imperialism" of Clement Greenberg, William Phillips, and Philip
Rahv of *Partisan Review*. After meeting them at a party at Dwight
Macdonald's apartment in Manhattan, she decided that "dollars
count far more than all the blood shed by others . . . they don't give
a shit about anything, except . . . their worthless rag."[2]

There had been a great deal of buzz about Sartre and de Beauvoir
in the American press as they toured the United States and appeared
in publications such as *Life, Time, Vogue,* and *Harper's Bazaar*. For
a brief period, existentialism became fashionable, inhabiting the
popular imagination. Most readers were interested in their lifestyle,
their open sexual relationship, and Simone's manner of dress. Their

Les Temps Modernes

3ᵉ année REVUE MENSUELLE n° 31

Avril 1948

Rédaction, administration : 5, rue Sébastien-Bottin, Paris

Fig. 19. Cover of *Les Temps modernes* 31 (April 1948).

writing had been featured in "little mags" such as *View, Partisan Review*, and *Politics*, as well as in the *Atlantic Monthly*. But their ideas became linked to their personalities and the free-thinking café society of Paris's Left Bank. De Beauvoir could be elegant, especially when she posed for photographers; her wraps, head scarves, and jewelry by Alexander Calder all enhanced her crisp profile and radiant eyes. But she also exuded a steely self-control that made her a match for her (largely male) colleagues in tough exchanges. With the fetching attire that she wore throughout her American trip, she countered not only the scrappy demeanor but also the frumpishness of most of the *Partisan Review* boys with aplomb. She and Sartre had accepted an invitation to appear in *PR* in 1946, prior to her visit; however, she was aghast to find them cocky and arrogant.

De Beauvoir's reaction to the inner circle of *PR* aligned with Rosenberg's feelings of estrangement from his former associates. He was at odds with their essentialist views, not willing to accept that literature and art were bound to a discourse that had style as a driving mechanism. In de Beauvoir, he found a kindred thinker who was averse to their art-for-art's sake attitude and perpetuation of a late nineteenth-century mindset. Rosenberg and de Beauvoir talked about *action* on her trip to America, probing the differences in cultural perception, especially when it came to the relationship of *action* to politics. "Harold Rosenberg is stunned by what he calls our 'action complex,'" she wrote in her diary from New York, paraphrasing their conversation. "Of course, he's not preaching a yogi's attitude. Throughout history there have been moments when action has been possible. Lenin is an example of this. But today, the objective situation allows no effective individual intervention in France, or in America either. The will to action is now just a subjective attitude, a malajusted [*sic*] attitude that begs to be psychoanalyzed — especially among intellectuals, given that, for the moment, they have no role to play."[3]

By "yogi" de Beauvoir referred to an article by Merleau-Ponty, "The Yogi and the Proletarian," published in *Les Temps*,[4] that rebutted both Arthur Koestler's recently released collection of essays, *The Yogi and the Commissar*, and *Darkness at Noon*, his novel that

condemned Stalinist Russia and the institution of communism. Where Koestler was deeply critical of the Moscow Trials of 1936–38 and Stalin's so-called enemies, Merleau-Ponty wondered if "revolution could emerge from terror."[5] He had stated that terror was an "inevitable"[6] outcome of political insurgency. He was not ready to reject Marxism as Koestler had done, knowing that many liberal democracies in the West were born in violence. His article created a furor in both Paris and New York. De Beauvoir was pressed to advocate for her colleague's position while in the United States.

She complained to Sartre that Greenberg, Phillips, and Rahv "attacked [her] about Merleau-Ponty and came out with two real gems; 'It wasn't Stalin who fed you, but UNRA, and Stalingrad? Of no importance! We're the ones who won the war for you.'"[7] De Beauvoir was off, however, in assuming that Rosenberg was not a "yogi," someone who believed that social injustice could be curbed through nonviolent means. Unlike Merleau-Ponty, Rosenberg never attempted a justification of communism, its power struggles, bureaucracies, and use of force, especially after its fascist turn under Stalin, such was his antagonism to the party. When he reviewed *Arrival and Departure* for *Partisan Review* in 1944, he objected more to Koestler's psychoanalytic take than his anticommunism. De Beauvoir may have read his piece and presumed he was on her side, especially as she knew him to be a Marxist.

Where de Beauvoir and Rosenberg were at odds on communism, their thinking intersected on the pervasiveness of formalism as a critical method. Prior to her trip, she had written a philosophical essay on "Pyrrhus and Cynéas" that *PR* reprinted in 1946 in a special issue on French existentialism (which appeared in tandem with the *View* number on Paris). De Beauvoir contended, "It is the error of such theories as of those of art for art's sake to imagine that a poem or a picture is something self-sufficient and inhuman; it is an object made by man, for man."[8] To Rosenberg, who was suspicious of all formalist interpretation, particularly Greenberg's honed visual analysis, her stance synced with his sense that painting and writing were suffused with some degree of social consciousness. De Beauvoir's characterization of *Partisan Review* as a "worthless rag" imme-

diately after meeting its editors in New York and her vow never to respond to another request for a submission were fodder for Rosenberg, confirmation that the journal had become effete. Its art-for-art's-sake doctrine was irresponsible, waffling on the artist's anxiety in a Cold War culture where individual liberties were still at stake.

Rosenberg and de Beauvoir had similar takes on how *action* was linked to consciousness. She argued in "Pyrrhus and Cynéas" that self-definition was determined by responses to external events such as trials, strife, and setbacks: "So man can and must act. He exists only in transcending himself. By risks and defeats he acts."[9] (She shared this position with Sartre, who wrote in *Being and Nothingness* that "to *act* is to modify the *shape* of the world.")[10] Rosenberg also immersed subjectivity in history, averring that *action* grew out of adversity. In "The Stages," he had exhorted, "the hero is he who has the power to return to the stage after he has been carried off it — the power to be re-born."[11] Yet, he would never admit as de Beauvoir had that psychopathology was a root cause of alienation. Through their discussions,[12] Rosenberg's theory of *action* became more topical, moving beyond Shakespearean archetypes such as Hamlet to the contemporary artist (as in his tract on the intrasubjectives). "The Stages" was padded with mentions of "nothingness" and the absurdity and "nausea" of existence, a nod to Sartre's novel, *Nausea*, which had been excerpted in the same issue of *Partisan Review* that ran de Beauvoir's article. When Lionel Abel solicited a contribution to *Instead*, Rosenberg responded with a short story, "The Messenger," in which the central character is overcome with a sickness or "sensations," much like Roquetin in *Nausea*.[13]

De Beauvoir became enthralled with Rosenberg's intellect as she encountered him at various gatherings in New York. At one party, she argued with him until she was "half-dead from exhaustion."[14] (Her proficiency in English was limited and hence taxing.) Where her discussions with the *Partisan Review* editors on politics had "simply turned her stomach,"[15] Rosenberg's predisposition to existentialism, and his questioning of the disappearance of the individual within Marxism, were issues she also engaged with. Soon after her visit to the United States in 1947, *Les Temps* published "The Stages,"

thereby cementing a friendship, subsequent trials notwithstanding, that lasted into the 1960s. Greenberg had published a piece in Sartre's journal prior to de Beauvoir's American sojourn,[16] in which he stated that the United States had yet to produce a "major" movement in art, but thereafter he no longer appeared in the magazine.

the dirty hands

As one of the editors of *Les Temps*, de Beauvoir must have had a hand in reprinting "The Stages." It was probably her editorial decision.[17] Shortly after the essay appeared, Sartre acknowledged a reciprocal debt to Rosenberg. His analysis of Hamlet became a prototype for the predicament of Sartre's character Hugo in his anti-Stalinist play, *The Dirty Hands*, which was first produced in Paris in 1948. Sartre rendered Hugo as a tragic figure whose downfall followed from his fidelity to the Communist Party. Hugo recognizes too late that "as for men, it's not what they are that interests [him], but what they become."[18] Lionel Abel, who translated the play into English, remembered Sartre affirming Rosenberg's influence "with customary generosity."[19] Rosenberg later reminded a few of his interviewers of the similarities between the texts.[20] Significantly, Sartre's respect for "The Stages" netted Rosenberg further submissions to *Les Temps*, adding to his growing international visibility as a writer.

In 1949 and 1950, *Les Temps* reprinted two of Rosenberg's essays from the *Kenyon Review* that reassessed the demise of Marxism through the failure of the proletariat to remake history. In "The Resurrected Romans," the first of these installments, Rosenberg was not shy about taking on Sartre by addressing his "miscalculation."[21] Sartre had refused to "name the actor,"[22] according to Rosenberg, and identify a historic figure who embodied *action*. Was either Marx or Lenin Sartre's hero? Who was he thinking about? Rosenberg wanted a concrete exemplar, even a fictive character like Hamlet.

For all of Sartre's dependence upon Rosenberg's representation of Hamlet, *The Dirty Hands* was an anomaly, a work he tried to suppress in the face of protest from the Communist Party. Hugo was too conflicted, someone who failed to realize that commitment to

communism had to be total: the party was intolerant of indepen-
dent thinking. On Sartre's appropriation of "The Stages," Rosenberg
went further in "The Pathos of the Proletariat," his second piece to
be reprinted in *Les Temps*, and stated that Sartre had failed to ac-
knowledge him, an accusation that implicated not only his relation-
ship with the Frenchman but also the fate of "The American Action
Painters."

a revival of the mystique of genius

Sometime early in 1952, just as the debates that related to a name for
the new American painting reheated, Rosenberg received a letter
from Maurice Merleau-Ponty asking him to write "a regular monthly
column for *Les Temps* about what was going on in American cul-
ture."[23] Rosenberg had met Merleau-Ponty on a trip to New York in
1949.[24] As the editor on politics, Merleau-Ponty oversaw the trans-
lation and production of his two pieces on Marx. Rosenberg toyed
with the idea for an article on the state of art in New York and con-
veyed to de Beauvoir that "I should like to write something about
the painting here—in which the act or the gesture on canvas is the
dominant tendency of the new movement—resulting for the most
part in a total antagonism to thought, indifferent to politics, manner
or mores (since the only true act is, in any case, the one of painting);
and a revival of the mystique of genius . . . But this too will have to
await its moment."[25] Once Merleau-Ponty presented him with the
opportunity, the article did not take long to gestate. In fact, he got to
work on it almost immediately.

Once *The Intrasubjectives* had been staged at the Samuel Kootz
Gallery, Rosenberg began to focus on the hallmarks of contem-
porary art. He was puzzled why Motherwell, as art editor, had left
de Kooning out of *possibilities*. According to Rosenberg, Mother-
well "didn't think much of [him] at that time; he didn't have a show
yet."[26] After they abandoned the second issue, de Kooning deliv-
ered a brief lecture in February 1949 at the School of the Subjects
of the Artist, a short-lived venture at 35 East 8th Street founded by
Motherwell, Newman, Rothko, Baziotes, and Hare. Newman was

responsible for organizing the Friday-evening lecture series with his wife, Annalee.[27] (The venue was later taken over by New York University and became Studio 35, the site of the "Artists' Sessions" in 1950.) Rosenberg gave a lecture for the program on "The Furies" that dwelled on the "invisible" in painting. But his notes for the presentation went astray, something he later regretted.[28] He must have also attended de Kooning's talk, and perhaps even had a hand in its writing. For he retained the manuscript for the artist's lecture and retyped it, subtly altering key words and phrases. He integrated the manuscript into his files and referenced it at length in a monograph that he wrote on the artist toward the end of his life.[29]

De Kooning declared at the outset of his lecture, "I am surprised to be here this evening reading my piece, for I do not think that I am up to it."[30] His uneasiness came with the awareness that he was entering a charged theoretical arena. He acknowledged that Newman had given the evening its name—"A Desperate View"—and that his own talk of some five hundred words represented more a statement on the inadequacies of "style" as an interpretative model. De Kooning stated with professed hesitation but in resolute prose that

> Art should *not* have to be a certain way. It is no use worrying about being related to something, it is impossible not to be related to something. Style is a fraud. I always felt that the Greeks were hiding behind their columns . . . It is impossible to find out how a style began. I think it is the most bourgeois idea to think that one can make a style beforehand.[31]

Through Newman's, and perhaps Rosenberg's, urging, de Kooning sought to counter the formalist schema for art by obliquely referencing the Danish philosopher Søren Kierkegaard and his idea of "trembling." It was a roundabout way to argue that art could be effectively unified around the artist's subjectivity, and the anxiety that came from exercising "free will"[32] in hostile economic and political situations. He went on to suggest that contemporary American painting and sculpture did not have a common language, that no one name was adequate to convey its meanings.

Rosenberg had written on Kierkegaard for *View* magazine in 1946. He started visiting de Kooning in his studio around the time of his lecture, frequently three to four days a week.[33] They would tackle topics such as the current revival of Kierkegaard's writing, its proto-existentialist features, and its hold on Sartre, de Beauvoir, and Camus, often over a bottle of whiskey in the mid- to late afternoon. These were the kinds of exchanges Rosenberg once had with Motherwell; after their friendship unraveled, Rosenberg found in de Kooning an artist who more strenuously objected to a material account of painting. De Kooning became not just a fill-in for Motherwell—Rosenberg had been his studio assistant on the WPA and their relationship deepened around the time of his talk—but also one of the few artists, along with Newman, with whom Rosenberg could converse on Kierkegaard and Sartre.

Although the editors of the *Partisan Review* had devoted a special issue in 1946 to French existentialism, to which Sartre and de Beauvoir contributed, and *PR* solicited a follow-up article by Hannah Arendt, who outlined the distinctions between existentialism and German Existenz philosophy, a century-old movement that, as Arendt noted, "begins with Kierkegaard . . . [who] starts from the forlornness of the individual in the completely explained world,"[34] not all avant-garde artists in New York were drawn to these texts. The conversations that Rosenberg had with de Kooning and Newman were unique. William Barrett, who wrote a two-part series of articles on existentialism for *Partisan Review* in 1947, just as de Beauvoir toured the United States, talked about the sensation of existentialism in "the art world of Fifty-Seventh Street, as well as the fashion world."[35] His description suggested that Left Bank discourse constituted a craze similar to the popularization of Freudian ideas from the mid-1910s to the 1920s, but few artists in New York actually read Kierkegaard and Sartre's addendums.[36]

Clement Greenberg made a passing nod to the topicality of the movement when he penned a review of Jean Dubuffet's work for *The Nation* in 1946. "Whatever the affectations and philosophical sketchiness of existentialism, it is aesthetically appropriate to our age," he acknowledged, "and may make up in art for what it lacks

as a complete philosophy."[37] But this "sketchiness" ultimately prevented him and his peers at *PR* from applying existentialist ideas to American painting: they never pursued the implications of "free will" that de Kooning touched on in his talk in 1949. There was nothing tangible in existentialism that could be pinned down and developed into a method. By the time Rosenberg formed a bond with de Beauvoir and Sartre, *Partisan Review* already deemed existentialism not only modish but irresponsive to the aesthetic features of literature and art. Barrett would negatively review Sartre's *Being and Nothingness* for the journal, finding its moralizing overbearing. Whatever interest he once had in existentialism's emphasis on the contingency of human *action*, and the requirement that literature be *engagé*, waned. He bemoaned that Sartre's Marxism had stymied appreciation of the novels that grew from the middle class, such as works by Proust or Joyce.[38]

Many New York intellectuals' interest in French existentialism was as fleeting as the coverage in the popular press. When Elaine de Kooning, an artist and writer (who married Willem in 1943), asked Barrett to deliver a lecture on existentialism at The Club, the gathering spot where many artists convened as of the late 1940s, he found that his monologue failed to rally discussion. While "attentive,"[39] his audience seemed unacquainted with the movement's basic precepts. Jack Tworkov, whose studio adjoined de Kooning's, and who was a founding member of The Club, remembered that "the people immediately around me didn't bother much with it."[40] As Barrett discovered, New York artists had diverse literary, theological, and philosophical interests—part of their argument against a collective identity or name—that incorporated not only existentialism, but also Zen Buddhism, "Gestalt therapy" as expounded by Paul Goodman, and the "process philosophy" of Alfred North Whitehead.[41] All of these investigations deployed the self within a wider cultural sphere. The discussions that Rosenberg and de Kooning had on Kierkegaard were not commonplace, then, and came at the end of America's brief attraction to the new French philosophy.

Existentialism provided Rosenberg and de Kooning with a springboard to tie literature to current concepts of fate and to re-endow,

for example, the fiction of Dostoevsky, a writer whom they both admired, with relevance. Additionally, Rosenberg embarked on isolating pockets of American literature that predated the phenomenon of existentialism. In 1952, he wrote to de Beauvoir that Melville and Whitman "experienced the *newness* of modern man in America both as marvel and as horror . . . the whole contemporary drama is already present in these writers."[42] The conversations in de Kooning's studio sifted through writing to alight on the right metaphors for American art, to connect the condition of "trembling" to painting. Beyond Kierkegaard, Dostoevsky, and Sartre, they also explored de Kooning's pronouncement that "style is a fraud." The claim had an impact on Rosenberg, enlarging his understanding that an alternative theory was needed to explain mid-century American art.

Outside of Motherwell's decision not to include de Kooning in *possibilities*, Rosenberg must have been incensed by Greenberg's review of the artist's first show at the Charles Egan Gallery, in 1948. Greenberg thought that de Kooning "[had] it in him to attain to a more clarified art and provide more viable solutions to the current problems of painting."[43] But he fell short of the critic's expectations. If only he could give up on his draftsmanship and interest in the figure, he could match the resolute abstractions of Pollock. Still, the review was largely affirmative, laudatory in Greenberg's sparse lexicon of approbation. He would later establish de Kooning's work as "belonging to the most advanced in our time."[44] (Greenberg would also retract the statement, just like his reversal on Pollock.)

Greenberg's interest in the "problems of painting" had met with resistance from numerous artists in Manhattan. Barnett Newman had written to him in 1947 that "American artists . . . create a truly abstract world which can be discussed only in metaphysical terms."[45] As with the misgivings raised later at the "Artists' Sessions" relating to a collective identity, Newman apprised Greenberg that the American avant-garde's preoccupation with abstraction was not the result only of experimentation. He cautioned that any reading should consider its themes. De Kooning's lecture italicized that the artist's intentionality should be made the centerpiece of interpretation. Greenberg was not about to give up on aesthetics, however.

As Rosenberg thought about Greenberg's seamless, airtight reasoning, the contrast of de Kooning continued to surface. Greenberg had concluded that there were still "contradictions"[46] in de Kooning's work. His bodies were never fully absorbed in his swaths of paint. Rosenberg would pass off these deductions as reductive, endgame theory. In the lag time between de Kooning's lecture at the School of the Subjects of the Artists in 1949 and Merleau-Ponty's invitation to write a piece on American culture for *Les Temps*, Rosenberg pondered why a critical stance predicated on progress was able to hold sway. By 1952, he was ready to address the issue, as well as to name the new movement, despite the antipathy of artists. After all, Motherwell had done the same with his designation of the New York School.

15
an explanation to the french of what was cooking
"the american action painters"

the club

As the debates over a name for the new American art fermented, Rosenberg immersed himself in the lectures and events that took place at The Club. When it was founded in late 1948, he was the one of the first nonartists to become a voting member. The Club was located in a rented loft at 39 East 8th Street and paid for through initiation fees and dues. It was intended to be both a private haunt and a forum for discussion. It was also a fraternity of sorts that initially only admitted men. However, it was frequently open to guests, and women such as Elaine de Kooning and Mercedes Matter were early, active participants in its programs. The Club served coffee at its evening gatherings, but liquor soon became a staple and intensified the always animated conversation. Its charter members included Franz Kline, Willem de Kooning, Ibram Lassaw, Conrad Marca-Relli, Philip Pavia, Ad Reinhardt, Milton Resnick, Jack Tworkov, Charles Egan, and others. Within three years, the voting committee (which proposed new members) had expanded significantly to include Rosenberg as well as Leo Castelli, John Ferren, Philip Guston, Perle Fine, and Matter.[1] The Club was a remarkable gathering place, known for its erudite talks and as a place to assemble, gossip, and take part in shoptalk. During its early years, it instilled a sense of social unity, one that was adumbrated in Motherwell's constellation of a New York School. Moreover, it was avowedly nonpartisan, a place where politics was left at the door, and no single aesthetic credo dominated.

Rosenberg recalled The Club fondly as a space "to hang around

and talk,"[2] one that oozed "exuberance."[3] Its lineup of presentations and panel discussions was always heady and stoked continuous debate as to the originality of the new American art. Just like his interactions with artists on the WPA and in The Springs, Rosenberg felt at home at The Club among artists, unlike his more contentious exchanges with writers. He also felt admired by the company that gathered there, and boasted that a speech he gave to the "boys"[4] spawned the idea for a regular Wednesday-night lecture series. In the fall of 1949, he had been invited by Pavia, a sculptor and the driving force behind The Club, to conduct a roundtable discussion with twelve members on the tie-ins between poetry and painting. He had just published "French Silence and American Poetry" and had begun to think about their common stake in rendering experience abstractly. Rosenberg might have given up on poetry, but he allied its experiments with the same goals of vanguard American painting. His subject elicited such a huge response that the colloquium morphed into an extemporaneous talk that he delivered alone before more than a hundred people. The idea for a weekly program of either lectures or panel discussions took hold.[5] Thereafter, Rosenberg became a habitué and a mainstay of The Club's program.[6]

the unwanted title

In mid-January 1952, a few months before Rosenberg embarked on "The American Action Painters," he was invited to moderate the first of a series of panels at The Club that centered on the relevance of terms, specifically "Expressionism." Pavia, who became the scheduler at The Club, had organized the discussions in response to Thomas Hess's recent publication, *Abstract Painting: Background and American Phase*. To Pavia and many members, Hess's book was provocative. He had declared that the work of Kline, de Kooning, Pollock, and others had merged two seemingly disparate directions in modern painting: abstraction and expressionism. His synthesis offended many at The Club, especially those still devoted to nonobjective painting. Reinhardt, who appeared in Hess's book as well as on the panel that Rosenberg moderated, countered, "The artist's

presence should be suppressed. Painting is special, a separate mat-ter of meditation."[7] Hess had not recommended developing a phrase out of the two words, as Robert Coates had done in the *New Yorker*, but he presumed that de Kooning's and Pollock's painterly gestures made the case for connection. In the end, he exacerbated what Pavia called the "unwanted title."[8]

As "Abstract Expressionism" became increasingly used as a term, many members of The Club were irked by what they referred to as the "Hess problem,"[9] which was odd given that the tag had already circulated for almost six years. The indignation mounted to such a degree that Pollock walked into The Club soon after the release of Hess's volume and hurled a copy at Pavia, just missing his head. The linkages to artists such as Kandinsky and the *Blaue Reiter*, or Blue Rider, group, whom Hess alluded to throughout his volume, were deemed far-fetched, a contrived historic scheme for contem-porary American art. There were aspects of Hess's treatment that should have appeased the group, however. Despite the "problem" that he was seen to have created, Hess had been forthright in argu-ing, "There is no 'New York School' of the 1950s, for the action of the background is that it releases, instead of imposing."[10] He had been forthright in stating that American painting was unfettered by leg-acy, unlike contemporary European modernism. With his telltale mention of *action*, there was enough fodder in his book for read-ers to overlook the German analogies and focus on the content of American art, and its distillation of the anxiety that beset the United States during the Cold War.

Hess had wondered in a separate essay, "Is abstraction un-American?,"[11] if the United States could fully embrace modernism, what with its entrenched traditions of figuration that became full blown during the Depression. He believed, however, in the poten-tial for a progressive art, summarizing that "painting, although a so-cial act, is of, not for the time."[12] He presupposed that abstract paint-ing was a reflex of the artist's alienation in a transformed postwar era. Through the polemic stirred by his book, and the subsequent panel discussions at The Club, Rosenberg saw an opportunity to table Hess's formal analogies to Kandinsky and others while retain-

ing features of his social history. He seized on The Club's commu-
nal desire to settle on the right descriptions for the new movement.

In a coda to "The American Action Painters," Rosenberg be-
moaned how "so far, the silence of American literature on the new
painting all but amounts to a scandal."[13] The claim was a backhanded
jab at critics such as Clement Greenberg and at the growing formal-
ist spin on art in the media. What Rosenberg wanted was more anal-
ysis of the cultural predicament of the artist, of what being an *action*
painter entailed and meant. "Silence," with its allusion to his intro-
duction to Marcel Raymond's volume, suggested that he had a poet in
mind to correct this imbalance, someone who could get beyond the
specialized languages of formalism and follow in the footsteps of ei-
ther Charles Baudelaire or a more contemporary figure, such as Wil-
liam Carlos Williams, who took to American art in the 1920s as part
of the grain of cultural life, rather than as a separate activity. Rosen-
berg thought he was up to this job. His combined experience of writ-
ing poetry and literary commentary, along with his omnipresence in
the New York art scene, made him the ideal interpreter to address
the "silence" that accompanied mid-century American painting.

the american action painters

At the outset of "The American Action Painters," Rosenberg an-
nounced:

> What makes any definition of a movement in art dubious is that it
> never fits the deepest artists in the movement—certainly not as
> well as, if necessary, it does the others. Yet without the definition
> something essential in those best is bound to be missed. The at-
> tempt to define is like a game in which you cannot possibly reach
> the goal from the starting point but can only close in on it by pick-
> ing up each time from where the last play landed.[14]

Rosenberg knew that the "game" of naming and expounding on
the meanings of art was fraught. Catchalls such as the "New York
School" presumed painting was sewn into distinct stylistic episodes,

even though Motherwell claimed his phrase was not based on aesthetics. Rosenberg resisted the idea of a "school" entirely,[15] believing that any explanation of the new American art should emphasize the "act" or process of painting: its unfolding in the studio, as he described, was "inseparable from biography."[16] Although many artists who congregated at The Club seemed engaged in a common project, the idea of a collective was illogical to him. Art could be grasped only by considering each artist's individuality and its complex relationship to postwar society.

Like Hess, Rosenberg had wondered about derivation. Were these artists beholden to Parisian (or German) forerunners? He grappled with this issue early on in "The American Action Painters," yet concluded that their compositions were unanticipated by earlier French modernists. As Rosenberg saw it, their originality stemmed from not having to contend with the "battleground of [art] history."[17] The possibility existed for the American avant-garde to forge something new by drawing from the pioneering spirit engrained in the national psyche. He had already stated that time could no longer be construed in a linear fashion and the "end of art" had been a fallout of the occupation of Paris. A *tabula rasa* ensued, which provided the American artist "with the adventure over depths in which he might find reflected the true image of his identity."[18] He likened this experience to that of Ishmael in Melville's *Moby-Dick* and the self-knowledge gained from life on the open sea.

Many of the passages in "The American Action Painters" are maddeningly vague, what with Rosenberg's romantic trope of *action* always defying specificity. He never mentions a single artist by name, which makes for a quandary. Who was he thinking about? The absence of names had sent both Clyfford Still and Jackson Pollock into a tailspin. They wanted to be considered exemplars of *action*, such was the potency of its meanings. Rosenberg does tell us midway through his essay that the American avant-garde is not young. While most of the painters were "over forty," they were "re-born"[19] after the crisis of the Depression and the war, which made for their dynamism. As painting liberated itself from the figure, their Marxist politics became internalized as "personal revolt." Instead, these

artists became engaged in the enactment of what Rosenberg called "private myths,"[20] or the revelation of their interior lives.

In Rosenberg's account, the decision to forgo the past and embark on unknown aesthetic territory was the equivalent of religious epiphany. Confronted with a blank canvas, or the void, the process of self-discovery edged toward mysticism. At least, that was the rhetoric that some of the American *action* painters used to describe their work. "Bits of Vedanta and popular pantheism"[21] had seeped into their statements to convey their transcendent acts. Rosenberg was probably thinking about Ad Reinhardt and Ibram Lassaw, who were both drawn to Zen, as well as Barnett Newman, who had aligned his painting with spiritual concepts. In 1948, Newman had declared that "instead of making *cathedrals* out of Christ, man, or 'life,' we are making [them] out of ourselves, out of our own feelings."[22]

Rosenberg presumed there was no language in place for these artists to discuss their work; hence, their theological analogies. That was where the critic should have intervened, and where formalists, such as Greenberg and James Johnson Sweeney, had failed them. The Club had organized a few talks devoted to Zen beliefs, most notably John Cage's "Lecture on Somethings" in early 1951, and one by D. T. Suzuki, the preeminent Japanese translator and writer on Buddhist philosophies, who addressed the membership the following year.[23] However, when Rosenberg sat down to write "The American Action Painters" in 1952, he felt their work was better explained as falling within the gray zone between Christian Science and the poetry of Walt Whitman. He meant that the metaphysical content of their work had precursors in the idealism of nineteenth-century American religions and the euphoric verse of Whitman's "Song of Myself." These juxtapositions underscored that painting the "ineffable" cleaved to "the outer spaces of the consciousness."[24] Not that Zen represented a contrary path, but its comparisons were too literal. If anything, an aura of indeterminacy surrounded *action* painting, rather than the stark self-negation associated with Eastern thinking. Not all *action* painters were taken with Zen.

A short way into "The American Action Painters," Rosenberg announced that "at a certain moment the canvas began to appear to

one American painter after another as an arena in which to act—
rather than as a space in which to reproduce, re-design, analyze or
'express' an object, actual or imagined. What was to go on the can-
vas was not a picture but an event."[25] Painting was performative in
his estimation, a physical activity. The ephemeral unfolding of lines,
gestures, and brushstrokes all grew from the artist's psyche. The
outcome, or composition, was secondary in this drama of creation.
Rosenberg dispensed with aesthetics, believing that postwar art did
not aspire to a state of perfection or purity. The self-definition of the
artist was all that mattered.

But what about the remnants of this encounter with the void
or nothingness? How was the critic to explain what existed on the
canvas? Rosenberg insisted that "anything is relevant" to art, such
as "psychology, philosophy, history, mythology, hero worship."[26]
There was one practice, however, that had no bearing on the new
painting: art criticism. Here Greenberg was indirectly impugned.
Although not mentioned by name, his reading of modern art as the
resolution of abstract form was sterile to Rosenberg (as he had al-
ready revealed a decade earlier to Dwight Macdonald). In Green-
berg's hands, art was reduced to a discussion of taste, whereby the
critic's judgment prevailed. He had exclaimed in the late 1940s that
the "dissolution of the picture into sheer texture, sheer sensation . . .
seems to answer a deep-seated contemporary sensibility."[27] How-
ever, Rosenberg thought it was up to critics to recognize that the
artist had released his inner life on the canvas through duration and
spontaneity. This was key to understanding the exigencies of the
postwar era.

Rosenberg believed that self-expression had become challenged
by 1952. The new culture of conformity had little interest in the soul,
especially as materialist values ascended. He had already written in
"The Herd of Independents Minds" that mass culture posed a threat
to art, and that subduing the artist's voice through the intercession
of business foreshadowed the end of modern painting and sculp-
ture. As Rosenberg warned at the end of "The American Action
Painters," "vanguard art needs a genuine audience—not just a mar-
ket."[28] It required an enlightened public that could read the artist's

gestures, brushstrokes, drips, and marks as extensions of the anxiety and awe he felt in the studio. Otherwise, "the taste bureaucracies," as Rosenberg sardonically called the formalists, would continue to package art through superficial stylistic unities, a branding device tantamount to "canned meats in a chain store."[29]

There had been a great deal of talk about process at the "Artists' Sessions" in 1950. Ibram Lassaw asserted that "it would be better to consider a work of art as a process that is started by the artist. In that way of thinking a sculpture or painting is never finished, but only begun."[30] William Baziotes observed that "American painters 'finish' a thing that looks 'unfinished,' and the French, they 'finish' it."[31] While Baziotes thought that painting aimed toward compositional clarity, making took precedent over outcome. Barnett Newman took his stance to a more radical conclusion, proclaiming, "I think the idea of a 'finished' picture is a fiction."[32] Rosenberg siphoned from this discussion, but he still felt that his conceit of *action* transcended the studio and was tied to a wider social context.

As the new American art became known in Europe—Hyman Bloom, Lee Gatch, Arshile Gorky, Willem de Kooning, Rico Lebrun, John Marin, and Jackson Pollock were exhibited at the US Pavilion at the Venice Biennale in 1950, and Pollock was the subject of a solo show at the Museo Correr that year—Rosenberg believed that criticism had to become responsive to the metaphors embodied in these canvases. The crisis was not about contending with illusion and the picture-plane, as Greenberg interpreted, but about the dilemma of modernism itself. How to redirect analysis of art after the revelation of the Holocaust, and the US rebuilding of Europe through the Marshall Plan? He believed the critic's mission was to link self-expression with a changed world. And *action* was the best way to convey these meanings.

an explanation to the french of what was cooking

"The American Action Painters" was written in the early summer of 1952 for *Les Temps modernes* in Rosenberg's new capacity as an American correspondent.[33] It represented the first of a proposed

series of columns that provided, as he said, "an explanation to the French of what was cooking and what this *had* to do with the temper of the time."[34] Unlike his reprinted submissions on Hamlet and Marx, the article was pitched for a foreign audience that was still acquainting itself with mid-century American art. (Sidney Janis and Leo Castelli had organized *American Vanguard for Paris* for the Galerie de France in February, an exhibit that included Baziotes, de Kooning, Motherwell, and Reinhardt. The following month, Pollock was exhibited at Studio Paul Frachetti.) The absence of names of artists was strategic, passed off by Rosenberg as superfluous detail that would get lost in his thesis. The tract was ruminative, codifying the threads of his conversations with artists and friends, such as de Kooning, Newman, and Motherwell. Its parameters were meant to be elastic and broad, a synopsis of the trials confronting subjectivity in the early 1950s.

Rosenberg had actually planted a few names of artists in his preliminary drafts but deleted them upon reflection. He felt they might give the essay a specificity that was distracting. "I was going to put some names in, you know like Pollock, Hofmann and de Kooning," he stated later, "but then I didn't want to put in too many names because it would sort of confuse the issue, you know people would begin to compare this painter with that painter . . . so I took all the names out."[35] Instead, he built on "the space between art and politics," the zone where art unraveled. Yet he never mailed his text to Merleau-Ponty. He became miffed at what he thought was Sartre's use of his ideas in "The Communists and Peace," a lengthy article that appeared in the July 1952 issue of *Les Temps* in which he revealed his support of the French Communist Party (PCF). In short, he had become a fellow traveler. Sartre's new allegiance to the PCF reversed the nonaligned stance he had laid out in an editorial statement in the first issue of the magazine in 1945: "our journal will be devoted to defending [the] autonomy and the rights of the individual . . . We have no political or social program."[36] His conversion to revolutionary politics now stood in opposition to Rosenberg's rejection of party dogma.[37] All the same, Rosenberg insisted that "The Communists

and Peace"[38] was indebted to "The Pathos of the Proletariat," his second essay on Marxism reprinted in the journal.[39]

The charge was not only a stretch but naïve and hubristic. Few resemblances exist between the two essays. Rosenberg's discussion centered on Marx's image of the proletariat as "a tool deprived of humanity,"[40] a fixture of a social class "dedicated to affirming itself in the material world."[41] But he was equally interested in how American culture had become dehumanized through its intense obsession with the commodity. Sartre, by contrast, had applied Marx to a demonstration that took place in Paris on May 28, 1952, organized by the PCF to protest the arrival of Matthew Ridgway, a US general and the new commander of NATO. The event led to a riot and the subsequent arrest of PCF leader Jacques Duclos. This provided Sartre with grounds to condemn France's oppressive history of the working class and its obstruction of the party through "bourgeois jurisprudence."[42] He argued, "Today, all violence comes directly or indirectly from the proletariat, which is merely paying us back."[43]

Sartre had attacked Lenin, Rosenberg's hero, in "The Communists and Peace" and characterized his advocacy of pacifism as a "setback."[44] Lenin's desire to contain the revolution within Russia was to Sartre a violation of the "the *necessary* condition for World Revolution."[45] Rosenberg concurred that Lenin's ideal of uprising was too confined. But he could not condone the Hitler-Stalin pact of 1939, as Sartre now did, by justifying that Russia had no other option. As an exponent of Lenin and nonviolence, Rosenberg had stated that it was up to the "proletariat . . . to resolve the tragic conflict and introduce the quiet order of desired happenings."[46] He could never submit to Sartre's impression that Russia was the victim of bungled political alliances and had become "a distrustful and hemmed in nation."[47] The barbarism of the labor and death camps under Stalin overshadowed any possibility for the proliferation of Marx's revolution.

Rosenberg's assumption that "The Pathos of the Proletariat" had made a dent in Sartre's thinking revealed a limited acquaintance with the politics of French publications. What evaded him was a

growing rift among writers at *Les Temps* over the threat of a civil war in France by communist sympathizers and the opposition by the supporters of General Charles de Gaulle. Sartre, who never actually enlisted in the French Communist Party, had drawn more from Merleau-Ponty's "The Yogi and the Proletarian," an essay that examined the execution of the Bolshevik leaders during the Moscow Trials, and his follow-up tract, "Humanism and Terror: An Essay on the Communist Problem." Sartre found here a way into the perversion of Marxism by Stalin that made sense, particularly as Merleau-Ponty had speculated whether socialism was spent and whether revolutionary change was even possible in France after the war.[48]

In July 1951 Rosenberg made his first trip to Paris, where he reconnected with Lionel Abel, who had moved to France a few years earlier, and renewed his acquaintance with Sartre, de Beauvoir, and Merleau-Ponty. As he wrote to Barnett Newman, his "whole approach to Paris [was] strictly tourist."[49] He remained out of the intellectual fray, reveling in the museums and cafés where the "Pernod cost less than a dime,"[50] and checking out the installations of Impressionism at the Jeu de Paume. He attended parties hosted by the American painter Janice Biala and her husband, Daniel "Alain" Brustlein, who was a cartoonist for the *New Yorker*. Typically, he took over on these occasions. Still, Biala recounted in a letter to her brother, Jack Tworkov, that unlike many of the other Americans who visited, "his conversation . . . gave us so much pleasure."[51]

Rosenberg's visit took place a few months before Sartre's political transformation. Shortly after, in October 1951, Albert Camus, who had been lionized by Sartre in a lecture in New York in 1945 as the "writer of the day,"[52] published *The Rebel*, another twist on the outcome of recent political revolutions and ensuing dictatorships that consolidated the power of the state. These inevitabilities underscored for Camus that *action* had to be internalized rather than realized through collective endeavor. Camus had been angered by Merleau-Ponty's "The Yogi and the Proletarian," with its rationalization of violence and presumption that capitalism should be fought at any cost, even if it meant succumbing to execution.[53] Sartre backed

Merleau-Ponty, a stand that slowly set in motion his own embrace of communism and disavowal of Camus's humanism.

By April 1952, Francis Jeanson, a young Marxist writer and actor who had written a book on Sartre, reviewed *The Rebel* for *Les Temps modernes* in his new capacity as managing editor. Sartre was initially hesitant to repudiate Camus in print. Despite his aversion to the essay, he did not want to jeopardize a substantial though complex friendship. Jeanson, who volunteered for the assignment, expanded his essay to cover Camus's stature as one of France's leading postwar leftist writers. His review was a hard-hitting attack on the eloquence of Camus's prose, which he dismissed as the mark of the writer's ego. Jeanson also alleged that Camus had a feeble grasp of political and economic history, especially of writers such as Hegel.[54] Sartre let the piece run, albeit with reservations about its bluntness. Jeanson managed to discredit Camus to most of the readers of *Les Temps*— Sartre's *sub rosa* motive—by passing him off as a facile and fashionable writer. Jeanson was suspicious that novels such as *The Plague* and *The Stranger* had garnered huge sales and had been translated internationally, while seducing even those on the right. He countered that Camus's success had enabled his view that revolution was no longer viable because *action* had become the realm of the individual.

Camus responded to the editors of *Les Temps* with a letter that omitted any reference to Jeanson. His primary target was Sartre, who Camus knew lurked behind the excoriation. He used the forum to take on Sartre's new embrace of communism, arguing that "if one is of the opinion that authoritarian Socialism is the principal revolutionary experiences of our time, it seems to me difficult to not come to terms with the terror that it presupposes, particularly . . . with the fact of concentration camps."[55] The volley drew a rebuttal from Sartre who attacked his friend personally for his "dreary conceit and vulnerability."[56] The put-down contrasted with Camus's more temperate treatment of Sartre's acceptance of the PCF. Sartre had been unsparing. The exchange spiraled into one of the most sensational quarrels in French literary history, widely covered by the press. Partisan fallout was extraordinary.

Rosenberg knew something was afoot at *Les Temps* before Jeanson's review of *The Rebel* appeared. He had written to Merleau-Ponty on two occasions to convey that it was "rather difficult to obtain the magazine here,"[57] and that he "should like to read [it] more regularly."[58] The remark suggested that his familiarity with the publication's contents was piecemeal, and any knowledge of a contretemps hazy. He knew from de Beauvoir that she felt compelled to refrain from taking on communism and advised her in a letter in March 1952, "I can understand why you don't want to attack the Communist Party if it means joining the pack. If you need an argument on your side, the spectacle of our professional anti-Stalinist intellectuals here would provide it for you. Most of these people are ex-Communists, and their style hasn't changed in the least since the time they stopped the Party."[59]

Rosenberg's mention of "anti-Stalinist intellectuals" was another jab at his colleagues at *Partisan Review*. However, contrary to the advice he parceled out to de Beauvoir, he wanted credit from Sartre for "The Communists and Peace" as he had not been acknowledged in the text. He felt entitled to a counterargument and wrote to Merleau-Ponty demanding the opportunity to reply to the French philosopher in print. But he never heard back from him. He retaliated by not sending off his manuscript for "The American Action Painters."

Unknown to Rosenberg, Merleau-Ponty was in the midst of extricating himself from *Les Temps*. He would resign from the editorial board in early 1953, having rethought his position on the Soviet Union. He now opposed Sartre. Merleau-Ponty detailed his about-face in *The Adventures of the Dialectic*, where Sartre is characterized as an "ultra-bolshevik":[60] someone who acts without conscience and backs revolution at any cost. After all, Sartre endorsed Russia's aggressive expansionism in northern Korea. It was not until Rosenberg spotted a letter to the editor of the *New York Times* in late November 1952 denouncing Sartre that he became aware of their conflict.[61] And by that time, Rosenberg had begun to pursue another home for "The American Action Painters."

the basic conception

George Lichtheim had reprinted Rosenberg's "The Resurrected Romans" in *Twentieth Century,* a British literary and political journal that he edited.[62] In the summer of 1952, Lichtheim wrote to Rosenberg that his article had "failed to convert Jean-Paul."[63] He also was appalled by Sartre's conversion, believing that "he had definitely reached second childhood with a fifty-page essay defending the Communist Party against all loners and masochistically identifying it (and himself) with the 'revolutionary proletariat' (a non-existing entity)."[64] As the fight between Merleau-Ponty and Sartre rocketed, he advised Rosenberg not to get involved, implying he would have no impact. He asked, "Aren't you taking these two gentlemen a little too seriously? Admittedly Sartre has a large following, and he is in some ways a considerable figure, but there is a certain air of Left Bank parochialism about these internal quarrels."[65] Lichtheim's trivialization should have dissuaded Rosenberg from tangling with Sartre, even through his intermediary, Merleau-Ponty. Still, Rosenberg felt that he and Merleau-Ponty shared a "basic conception of Marxism"[66] that justified his taking on Sartre, especially now that he had been asked to submit a regular column. They both knew that Marxism no longer had any political utility.

In fact, Marx all but disappears from their correspondence. Rosenberg wanted to educate Merleau-Ponty—who traveled once to the United States to deliver a series of lectures at the University of New Mexico in early 1949—on what preoccupied Americans, such as their lifestyle choices and priorities. In one letter, he reveals to Merleau-Ponty that *action* and the expression of subjectivity sometimes ran on differing courses in the United States, by dwelling on the failure of Americans to take their cues from sexual liberation:

> There is a split in America between action and consciousness, the action of the American carrying him constantly forward, while his consciousness either lags behind or turns deliberately toward the past. This is evident in even the most intimate detail of daily

life. For instance, the American tends to think of the good life in terms of marriage and the home, in the most traditional sense of fidelity, eternal love, many children—at the same time the Kinsey Report showed, he is constantly engaged in "extra-marital activities" and is likely to be divorced two or three times in the course of his lifetime. This disparity between the ideal and the fact is not owing to hypocrisy, but to the inability to formulate in radical terms the radical reality of his sexual and domestic relations.[67]

Once *action* became depoliticized, Rosenberg believed, American culture was molded by yearning for material stability, a desire that stymied the imagination where transformation could take place, such as in the bedroom and one's sexual life. Coming from someone who had begun to stray beyond his own marriage, who was involved in three affairs simultaneously in the early 1950s, Rosenberg's observations about the libido stemmed from experience. (They also represented the holdover of bohemian convictions where modern love defied the institution of marriage.)

It is unlikely that Rosenberg read Merleau-Ponty's major philosophical tract, *The Phenomonology of Perception*, when it was published in France in 1945—at least, not during his association with *Les Temps modernes*.[68] The text was not known in this country until 1962, the year after the author's death, when it was translated into English. However, many of its precepts, especially those relating to painting, are recycled in "Cézanne's Doubt," an essay published by *Partisan Review* in 1946 in its issue devoted to French existentialism. Rosenberg would become acquainted here with the author's attack on behaviorism, rationalism, and objective thought, as well as his substitution of the body as a site of perception. He no doubt responded enthusiastically to Merleau-Ponty's takedown of Freudian psychoanalysis, which "brought in sexuality everywhere."[69] Rosenberg had a similar view, not seeing how Freud could fully explicate individual experience. A few months before "Cézanne's Doubt" ran in *PR*, he had published "Notes on Identity" in *View*, where he proclaimed that in therapy, "the patient hands over the process of discloserer [*sic*] to another, instead of struggling toward it though action. He

makes himself passive and begs to have his suffering wiped out; he does not see in it a path and a clue to identity himself."[70]

The parallels between Rosenberg's and Merleau-Ponty's thinking revolved primarily around identity formation. Both men wondered how the artist could achieve social liberation through their work. Merleau-Ponty thought of this as a process (the word later bandied about at The Club and at the Artists' Sessions at Studio 35). In "Cézanne's Doubt," he singled out color as the agent: "It is in the world still on canvas, with colors, that [the artist] must realize his freedom."[71] Painting, for Merleau-Ponty, was a medium superior to both sculpture and photography, as color acted on the retina to trigger subjective response. But he also believed that painting required a viewer to deliver its meanings. He wrote, "It is from others, from their assent, that [the artist] must await proof of his worth."[72]

Rosenberg surely drew upon Merleau-Ponty's elevation of painting for "The American Action Painters" some six years later. By the late 1950s, he would rethink his position, however, when he compared Aaron Siskin's black-and-white photographs to contemporary painting.[73] Later, sculpture would also be integrated into his platform when he wrote about Lee Bontecou, Gabrielle Kohn, Ibram Lassaw, Michael Lekki, Barnett Newman, and Claes Oldenburg in the 1960s.[74] Still, his empowerment of painting must have been influenced by his French editor's theorizing on the role of the body in the making of art.

Rosenberg must also have read Merleau-Ponty's dismissal of critical evaluation in his article "Marxism and Philosophy," which Dwight Macdonald published in *Politics* in 1947. Merleau-Ponty had proposed that "one understands the perceived object only after having seen it, and no analysis nor any verbal description can replace his vision."[75] A correspondence obtains with Rosenberg's pronouncement that art can be accessed by "anything other than art criticism" in "The American Action Painters." Few writers working in America at mid-century—except Lionel Abel, Hannah Arendt, Kenneth Burke, and Paul Goodman—crusaded against a critique of art. They focused more on what Burke referred to as an "intrinsic criticism," or a close reading of the semantic features of a text or painting.[76]

This tactic congealed into the New Criticism, the Anglo-American movement that made formalism its core method. Through Merleau-Ponty's piece in *Politics*, Rosenberg found additional ballast to later assail Greenberg's reliance on observation and judgment.

It would take Merleau-Ponty almost three years to respond to Rosenberg's fuss over Sartre's "The Communists and Peace," long after he had left *Les Temps* to become a professor of philosophy at the Collège de France. In 1955, he finally sent Rosenberg a copy of *Adventures of the Dialectic*, the book in which he denounced Sartre as an "ultra-bolshevik." Rosenberg was glad to be reacquainted and wrote back:

> I must confess that I had been troubled that my preliminary re-marks on Sartre's defense of the Communists and their "theatre" of the streets should have produced not discussion but a blanket of silence. The American Communists and their friends used to assert their seriousness and superiority to argument by turning their backs. I found it hard to believe that you had been overcome by their style, which so little resembles yours. What better news than to learn from your book that from "quarantining" criticism you had been engaged in a major criticism of your own.[77]

As he conveyed to the French writer, he had already concluded that Sartre's writing was riddled with shortcomings that issued from "his incapacity to grasp the difficulty of a true act."[78] His support of the PCF revealed a failure to comprehend the stamina that went into *action*. Later, in the 1960s, he described Sartre as a writer who is "between the acts," someone who is role-playing and "still starting with words rather than with realities."[79]

Despite their erratic correspondence, Merleau-Ponty and Rosenberg eventually acknowledged their shared interests. In 1955, Rosenberg was invited to write an essay for an anthology that Merleau-Ponty edited, *Les philosophes célèbres*. He was handed Marx as the assignment. Rosenberg mischievously chose to expand on "The Pathos of the Proletariat," the piece for which he still felt Sartre owed

him credit. But he reversed his earlier representation and made the worker into an individual "who arrives at an ethical existence."[80] Marx was now characterized as someone who had defined himself through his writing: Rosenberg made the analogy that "criticism is the beginning of an action; one that demands completion by social transformation."[81] The description also described the path of his own work, where criticism surpassed poetry.

more in the french tradition

Notwithstanding his travails with Sartre, whom he later referred to as "a very good friend,"[82] Rosenberg did find a place for "The American Action Painters." In the midst of the *Les Temps* scuffle, he showed the manuscript to Elaine de Kooning, "who got very enthusiastic about it."[83] Elaine, who began writing for *ARTnews* in 1948, passed on Rosenberg's essay to Tom Hess, whom he met at The Club.[84] Rosenberg knew Elaine through her husband, Willem, and had met her sometime around the time of their marriage, in early 1943. But the connection was more than social. He was sleeping with her in 1952. Their brief affair was incestuously triangulated with Hess, who was Elaine's long-term paramour. Pillow talk, no less, played into the publication of "The American Action Painters." Elaine's relationship with Willem had ceased to be intimate. Even so, Hess and Rosenberg would become Willem's main critical proponents.

Hess found room for the piece in the December 1952 issue of *ARTnews* over the objections of the editor, who violently opposed it.[85] Rosenberg was pleased with Hess's "marvelous editing."[86] The sensitive handling of his text led to a lifelong friendship that flourished partially from a shared aversion to formalist criticism, which Hess thought to be faddish. Once Rosenberg's episode with *Les Temps modernes* ended, he declared he "could scarcely be identified with existentialism."[87] He always reminded his readers that his early essay, "Character Change and the Drama," had outlined proto-existential ideas long before Sartre and de Beauvoir hit America. "I took up the question of action as a basis for the transformation of

the individual," he said, and "a lot of people have said that I got my ideas about action from the existentialists. This was about fifteen years before any existentialist ever appeared in the world."[88]

Yet Rosenberg clearly felt an intellectual connection with the editors of *Les Temps modernes* that he had not established with many writers in New York. He was never moored through a long-standing association with a journal in the 1940s, after his connection with *Poetry* folded. Most editors thought that his ideas were unassimilable. William Phillips of *Partisan Review* later characterized Rosenberg's independence "as being [more] in the French tradition, given to rhetoric of free association, startling contrasts and witty parallels . . . one whose theories were stronger than his observations."[89] Phillips was partially right. Sartre, de Beauvoir, and Merleau-Ponty viewed him as kin. Hess also valued Rosenberg's analogic line of inquiry and always welcomed his contributions to *ARTnews*.

everyone wanted to be an action painter

Clement Greenberg remembered that when "The American Action Painters" was published in *ARTnews*, "everybody wanted to be an Action Painter"[90]—except Clyfford Still, who now questioned Rosenberg's "motives."[91] Pollock, who had been the subject of a film and spread of photographs by Hans Namuth in *ARTnews* in 1951,[92] felt with some justification that he had become the paragon of *action* now that his process was publicly known. But when Rosenberg failed to confer the status on him, he stood outside Rosenberg's bedroom window one night in The Springs and howled, "I'm the best fucking painter in the world!"[93] Speculation as to whom Rosenberg had in mind built to the extent that much of the buzz centered on de Kooning. Stuart Davis, who had known both figures from the WPA, wrote to congratulate Rosenberg on his "good article on de Kooning."[94] The assumption was shared by many members of The Club who knew of his weekly visits to the artist's studio. But despite all of the ruckus over "The American Action Painters," Rosenberg did not get around to disclosing names until Abstract Expressionism (as it was finally called) began to wane. With an essay on Hans

Hofmann for *ARTnews* in 1957, a corpus of "action artists" slowly emerged that included Guston, Kline, de Kooning, Newman, Pollock, and Siskind.

Greenberg, who had begun to lose faith in Pollock around 1952, as the artist alluded to the body in his new compositions, later contemptuously responded to Pollock's desire to become Rosenberg's subject, scoffing, "Jackson himself knew it was bullshit, but he was ready to accept any explanation of what they did because they were hard up for words about their own art."[95] The admission was more about his own vulnerability, and fading authority. For the phrase "action painting" would be used extensively over the next decade. Alfred Barr considered it as a title for what eventually became *The New American Painting: As Shown in Eight European Countries, 1958–59*, an exhibition orchestrated by the Museum of Modern Art that included Pollock, de Kooning, Kline, Newman, Rothko, Still, and others, and the first such overview to circulate internationally.[96] Barr knew that Rosenberg's designation of *action* had gained widespread usage,[97] having been picked up by British critics, such as Lawrence Alloway, John Berger, Herbert Read, and David Sylvester, who drew on the word, sometimes along with "Abstract Expressionism," to describe the work by the Americans they saw in *ARTnews*, and later in exhibitions at the Tate and Whitechapel Galleries.[98] But Barr thought Rosenberg's label was overly tilted toward "the physical act of painting."[99] In his reluctance existed the long shadow of a disputatious art scene that refused to be named and was never critically resolved.

16
guilt to the vanishing point
commentary magazine

the springs' most celebrated philosopher

Whatever visibility Rosenberg acquired through publishing in *Partisan Review*, *Les Temps modernes*, and *Commentary*, in the early 1950s he still felt at sea. He had yet to secure an editorial appointment. Robert Alan Aurthur, a screenwriter, director, and television producer who was part of Rosenberg's social set in East Hampton, recalled a moment in the winter of 1950–51 when the two "were driving into New York together on a freezing February afternoon"[1] and Rosenberg revealed his frustrations about failing to land a full-time literary job. Aurthur, who was more than fifteen years younger than Rosenberg, described him reverentially in an article in *Esquire* in 1972, as "the Springs most celebrated philosopher."[2] He found him to be generous and available, at least to younger writers. Yet in 1951, Rosenberg was awaiting greater acclamation from editors and publishers.

His diffidence reflected the turmoil in his domestic life. Ralph Manheim had suggested as much in his *roman à clef*, "The Perspectors." By the early 1950s, Rosenberg was involved with several women. Besides his brief tryst with Elaine de Kooning, he had been seeing Mercedes Matter for two years. The affair tested his marriage. Matter was a painter and a lithe, dark-haired woman of arresting beauty (fig. 20). She was the daughter of an artist father—Arthur B. Carles, who had studied with Matisse—and a Spanish mother, who had posed for Edward Steichen. Her childhood embraced Paris, Philadelphia, and Manhattan; she was fluent in French. As an adult,

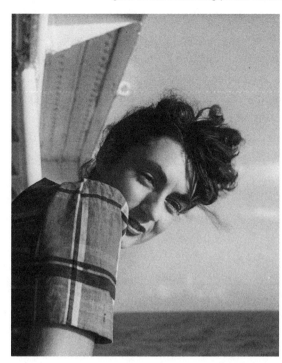

Fig. 20. Herbert Matter (1907–84), *Portrait of Mercedes Matter on Boat; Looking Off Camera Right*, 1941. Photographic print. Courtesy of the Department of Special Collections, Stanford University Libraries.

she had worked on the WPA with Willem de Kooning, George McNeil, and Fernand Léger on a mural for a French passenger ship while Léger was in New York in the mid-1930s. In addition, she was a founding member of the American Abstract Artists group. The contrasts between her upbringing and May Natalie Tabak's were striking: her cosmopolitan education redounded in sophistication. Moreover, Matter's prowess as a seductress was legendary.

Tabak left for Paris with Patia before Rosenberg in the summer of 1951. He had revealed to her that he wanted to pursue an open relationship, that he was not in love with her. He wanted to stay in New York to sort out his feelings. Tabak lamented in a letter, "You've been crying all winter that I am trying to keep you from expressing yourself with Girls, that I am jealous of your success at Parties."[3] She was also hurt when Manheim and Abel, whom she saw in Paris before Rosenberg arrived, intimated that these dalliances had been going on for some time. She was humiliated that they knew about her hus-

band's liaisons. The spectacle of talk and Rosenberg's indifference to her suffering emboldened her resolve to keep him, however. Janice Biala, whom Tabak hooked up with in Paris, described her interactions with Tabak as a "nightmare."[4] The upheaval of her emotional life and need for empathy was taxing. Although Biala liked Tabak, she found her to have too many "problems,"[5] implying that infidelity should not have resulted in desperation. She was more captivated by Rosenberg and his intellectual assurance. At least he did not offload his anxieties and make them the focal point of conversation.

Rosenberg was uncertain if he could continue to work as a writer with Tabak in his life. She confronted him by asking, "Did I have to come to Paris to hear that you're trying to find out if you can express yourself on paper with me in the offing!"[6] But she renewed her love to him at every turn, which clearly tugged at his sense of guilt. Matter, who was married to Herbert Matter, a noted Swiss photographer and graphic designer, referred to Tabak as "mommy,"[7] the third element in their semi-clandestine relationship. She was able to separate her work from her sexual life, even though she had drawn on an extraordinary pool of lovers, including Arshile Gorky, Jackson Pollock, and Philip Guston. She wrote to Rosenberg that she was disturbed that he was impinging on her "muse," or studio time, and that his view of marriage was too "conventional"[8] for their affair to endure. She felt deeply about him, wanted him in her bed on Avenue A at night, but was ready to jettison him given the trials of his indecision. There was one request, however: The Club was her domain, and she wanted him and Tabak to stay away.[9]

Rosenberg could not resist The Club, however. The camaraderie was too alluring, its panels and talk too necessary to his theory of *action*. Even though he and Tabak rented their apartment on East 10th Street to Biala and Daniel Brustlein in the late fall of 1952 for almost a year, while they spent time in The Springs working on their union, he frequented The Club whenever he could, despite Matter's stricture. His affair with her might have ended, but there would be other late-night rendezvous with women. He thought his bohemianism freed him from monogamy. He would travel through life with multiple partners, but he would never leave his marriage.

the red poet

Robert Alan Aurthur reminisced that during their trip into Manhattan, Rosenberg "claimed that to date his greatest moment had come in the prewar WPA days when a raging Neanderthal Congressman had made a speech in the House denouncing the entire federal arts program, with a special reference to 'Red poet, Rosenberg.'" "At least," said Harold, "the bastard made it official I was a poet."[10] Rosenberg still located his glory days in the late 1930s, when he waged his political battles with the Communist Party and worked on *Art Front* and *American Stuff*. Once he returned to New York after a five-year hiatus, he felt he had yet to net the professional gains that he wanted. On being called out on the floor of Congress—and erroneously identified as a "Red Poet"—he took much delight and retold the story well into the 1970s.[11] However, in the early 1950s, when his conversation with Aurthur took place, the misrepresentation of his political identity was not comedy—rather, it was framed by the indictments of the McCarthy era when the outing of communists became a fixture of postwar patriotism and conservative fervor.

As Rosenberg entered a decade of professional uncertainty, the mistaken tag of the "Red Poet" overshadowed the gradual attenuation of Marxist thought in his essays. He was never subjected to the trials in Congress that set back or destroyed the careers of many artists, writers, actors, and intellectuals. But the Federal Bureau of Investigation did follow him. In fact, Tabak later wrote in a reminiscence of Parker Tyler that "when the FBI sent interrogators to ask Parker when Harold had resigned from the John Reed Club (of which neither Harold nor he had ever been a member) . . . Parker drew himself up in artless hauteur and demanded, 'How dare you! Aren't you ashamed of yourselves, using such old bromide? When did you stop beating your wife indeed.' At which the two pros must have realized they were licked, for they left at once."[12]

As the United States prolonged its standoff with the Soviet Union during the Cold War, like many of his peers, Rosenberg questioned if the First Amendment had ceased to be urgent, even though the government sloganeered to protect cultural freedom both domes-

tically and abroad. Bound up in his quandary was the new state of Israel and the displacement of more than 750,000 Palestinians. How to construe individual *action* within the context of Zionism? Rosenberg's responses to the question appeared in a new journal, *Commentary*.

the presence of the jewish past within

Rosenberg began to write for *Commentary* magazine in 1945, just as his relationship with *Partisan Review* stagnated. The journal, which was edited by Elliot E. Cohen until 1959, was a reincarnation of the *Contemporary Jewish Record*, and an organ of the American Jewish Committee (AJC). Cohen transformed the *Record* from a stodgy, academic bimonthly that concentrated on Jewish affairs into a periodical that "was free from partisanship and hospitable to divergent views,"[13] as the AJC put it. It was here that Rosenberg published texts such as "The Herd of Independent Minds," which Delmore Schwartz had passed on for *Partisan Review*. Cohen was known to be an obsessive, demanding, yet frequently indecisive editor and writer—traits that frequently immobilized him. Rosenberg, however, remained aloof, even though he found Cohen's interventions in his prose annoying. He got along with most of his peers at *Commentary*, and ignored Clement Greenberg, who also wrote for the journal. Ironically, with *Commentary*, he did not become involved in the kind of competitive and ideological battles that had divided so many writers at *PR*.

Prior to Cohen's appointment, Philip Rahv had served as managing editor of the *Record* while doubling duty with *PR*. In mid-1944, a few months before leadership changed, Greenberg was brought in to succeed him. As the *Record* morphed into *Commentary*, Greenberg was kept on by Cohen and made an associate editor, a position that gave him more input.[14] Cohen also maintained Nathan Glazer as editorial associate and added Robert Warshaw as managing editor. Later, in 1947, Irving Kristol, a friend of Glazer, was also given an editorial appointment.[15]

While the AJC had a mandate "to fight bigotry and protect human

rights and to promote Jewish cultural interest and creative achievement in America,"[16] under Cohen's direction, *Commentary* aimed to become a rival of *Partisan Review*. He was interested in covering modernist literature and attracting a wide, nonsectarian base of subscribers. Although the magazine was ultimately less highbrow, and remained oblivious to the avant-garde culture associated with Ezra Pound, T. S. Eliot, and Gertrude Stein that *PR* fostered, Cohen advanced a progressive, anti-Stalinist agenda that remained initially autonomous from the AJC. He took over the journal just as V-E Day was declared and knew that with the shift in geopolitics, intellectual debate had to encompass the implications of the atomic bomb that had ended the war and America's stalemate with the Soviet Union. Zionism and the new nation of Israel (created in 1948) would also become mainstays of the journal's coverage. However, the leftist leanings of *Commentary* were tested and its mandate rethought after Cohen committed suicide in 1959. Norman Podhoretz would take over and gradually steer the magazine's political content toward the conservative right, adumbrating its present-day agenda.

Rosenberg was not asked to participate in a symposium that Rahv orchestrated for the *Record* in 1944 on "Under Forty: American Literature and the Younger Generation of American Jews,"[17] which was largely made up of submissions from writers associated with *Partisan Review*, such as Lionel Trilling, David Daiches, Alfred Kazin, Isaac Rosenfeld, Muriel Rukeyser, Delmore Schwartz, and Clement Greenberg, many of whom became part of the *Commentary* stable. But Rosenberg did pen a few book reviews through this period of editorial realignment. One of these was given to Ben Hecht's *A Guide for the Bedevilled*, an account of anti-Semitism during the Holocaust. Rosenberg thought that, rather than focusing on "what it is *about the Jews* that causes people to hate and attack them,"[18] Hecht should have tackled the anti-Semite alone. The juxtaposition with the Germans, especially, redounded in needless caricature. The Jew had been subjected to too many grotesque personifications throughout history, Rosenberg felt. But then he reminded the reader that Hecht was a Hollywood type, a screenwriter and director, who had capitulated to psychological clichés to plumb the

sadism of the Nazis. There was not enough history in his analysis to get at the depths of Nazi racism.

Before Cohen's appointment, representation of Jewish identity had become a fraught issue for many of the *Record*'s contributors. Clement Greenberg had addressed the "liabilities" that faced the Jewish writer in the "Under Forty" symposium, contending that "no people do so completely and habitually what is expected of them: doctor, lawyer, dentist, businessman, school teacher, etc."[19] Glazer elaborated on this conformity, later stating in *Commentary*, "We could see no connection between Judaism and the Jewish life we knew—none of us came from educated Jewish homes—and the culture, politics and civilization to which we aspired."[20] Glazer, as well as Greenberg and others who participated in the symposium, grappled with the rift between their intellectual striving and family design for a stable, middle-class life. As writers, they were deeply aware that they were caught up in a moment of historic transition where the Jewish intellectual now had a prominent voice. Cohen's goal was to capitalize on this epic situation. Under his direction, *Commentary* was largely responsible for positioning the Jewish intellectual in mid-century America. He accomplished this in part by enlarging his core group of Jewish contributors to include gentiles, such as Jean-Paul Sartre, who provided a broader literary stage.

In rare agreement with Greenberg, Sidney Hook, and Rahv,[21] Rosenberg construed Judaism pluralistically in a number of articles written for the *Record* and *Commentary* between 1944 and 1950. Cultural identity, he believed, was not narrowly inscribed by adherence to a faith or lifestyle. As someone who thought of the Jew in cosmopolitan terms, who was an assimilationist, and who never embraced religion, let alone stepped into a synagogue after he left his parents' home,[22] he could not wholly sanction the creation of a Jewish state in Palestine. He empathized with the Jew, who in the wake of genocide "showed," as he said, "that Jewishness had a historical content . . . by turning toward *his* history instead of toward the history or the ideas of others."[23] But he remained conflicted by the prospect of a Jewish nation, believing there were too many possibilities for tyranny and rigid ideology to take over.

When Sartre took up the "Jewish question" in 1944 in *Anti-Semite and Jew*, a chapter of which was published in *Commentary*, Rosenberg defended his friend for "his act of generosity, feeling, courage, and good sense."[24] He had approached the subject as a gentile while the Nazi persecution of the Jews was still under way. There were differences in their outlooks, however. Sartre understood Jewish identity as defined by anti-Semitism in France, at least during the war, and avowed that "it is neither their past, their religion, not their soil that unites the sons of Israel."[25] From Rosenberg's American perspective, this stance had little meaning. Too many people had been subjected to racism in the United States. "Being singled out by an enemy"[26] could not account for the difference of the Jew. Ethnicity issued from a connection to culture and its history.

In response to Sartre, Rosenberg wrote that Judaism, like all "collective identities," was "undergoing deep changes and could no longer exist in individuals as firmly and persuasively as it once did."[27] Designations such as the "authentic" and "inauthentic" Jew that Sartre had used in *Being and Nothingness* and extended in *Anti-Semite and Jew*[28] were no longer pertinent. He must have been thinking about the contrasts posed by his grandfather, who both represented a contradiction to Judaism and was a stalwart member of his faith, and the ways in which his grandfather's life was imprinted by the values of the country to which he immigrated. He was a phenomenon of the United States: his opposition to organized religion and willful independence an analogue to *Moby-Dick*. It was not just his grandfather's massive girth that linked him to the whale, but the theme of defiance at the heart of Melville's narrative.

static concept of judaism

In "Pledged to the Marvelous," one of his first submissions to *Commentary*, Rosenberg assessed the relationship of Judaism to Marxism through an open letter to Will Herberg, a social philosopher and a columnist for the journal, who later became the first editor of religion at *National Review* and who had recently addressed the subject. Rosenberg proposed that "no philosophy can match the powers

of distortion of a great religion."[29] He was distrustful of Herberg, an ex-communist who sought refuge in Old Testament scriptures after snubbing Marx in the late 1930s.[30] His theological conversion was provocative and rebuked not only by Rosenberg but eventually by Irving Howe and Daniel Bell as well. As a "sworn foe of the totalitarian state,"[31] Herberg had an epiphany, like others of his generation, that Marx's paragon had devolved into an "amoral cult of power at any price."[32]

Rosenberg was resistant to any form of collectivism, but the moral relativism of Marxist writing never disturbed him. He argued that Herberg was deluded to assert "the values of democracy and socialism as the fundamental *interest* of Jewish history and thinking."[33] In his estimation, Herberg had imposed a radical meaning on Jewish theology that was exaggerated, part of a yearning to establish continuity with his youthful passions. Even though Herberg later stated that Judaism and Christianity were both part of the "American Way of Life,"[34] and that the melting pot was transcultural, he believed in the statehood of Israel, such was his devotion to biblical destiny. Elliot Cohen was initially responsive to the expansiveness of Herberg's thinking, particularly his notion of American plurality. But he felt it needed to be counterbalanced by Rosenberg's opposition. Yet as Herberg embraced the political right in the mid-1950s, Cohen could no longer cotton to his ideas. He responded by maintaining the journal's anti-Zionist position.

As a secular Jew, Rosenberg, like most of his colleagues, such as Cohen, questioned Zionism. He argued in other pieces for *Commentary* that any mix of religion and nationalism could result only in a "static concept of Judaism."[35] He had already confronted anti-Semitism and its violence in his piece on Hecht for the *Record*. But a Jewish homeland, he thought, was not the answer, too tied to the recent "crisis in Europe."[36] He feared that the new government would leave the individual with little agency. A potential existed for racism to be unleashed from bordering nations, as well as for conflict with the displaced Palestinians.

Rosenberg's response to Israel was akin to that of Hannah Arendt, who had elaborated on the subject in 1944 in the *Menorah Journal,*

which Elliot Cohen had edited before overseeing *Commentary*. She more pointedly stated that "the Zionists, if they continue to ignore the Mediterranean peoples and watch out only for the big faraway powers, will appear only as their tools, the agents of foreign and hostile interests. Jews who know their own history should be aware that such a state of affairs will inevitably lead to a new wave of Jew-hatred."[37] Arendt continued to maintain her position in *Commentary* when she expounded on the consequences of Theodor Herzl's imagination of Israel in the late nineteenth century. She bemoaned the creation of a Jewish nation, believing that it would unsettle existing inhabitants and perpetuate anti-Semitism.[38]

In 1948, after Palestine was partitioned into Jewish and Arab states, Arendt relented and wrote again in *Commentary*, "Palestine and the rebuilding of a Jewish homeland constitute the great hope and the great pride of Jews all over the world."[39] But privately, she conveyed in a letter to Cohen that "the land that would come into being would be something quite other than the dream of world Jewry."[40] Although Rosenberg was ambivalent about a new Jewish republic, he publicly advocated, like Arendt, for a binational state. But he wondered about the implications of the end of the Jewish Diaspora and of a life that was once spent in exile. As he tentatively put it in 1950, "perhaps it is just like those Jews who arrive from nowhere who will come to resemble most closely their remotest and most venerable grandfathers."[41] Nonetheless, both Rosenberg and Arendt experienced the new nation as a loss.

Shortly after contemplating the meanings of Israeli statehood, Rosenberg took up teaching at the New School for Social Research in New York. In the spring of 1952, he gave a course on Whitman and Melville, writers whose imagery he had stitched into many of his essays.[42] He was drawn to the contrasts of good and evil, innocence and depravity that infused Melville's narratives. Arendt also developed a love of Melville once she moved to the United States in 1941. She later depicted Melville's character Billy Budd, and his antagonist John Claggart, as "both . . . outside of society,"[43] a description that she and Rosenberg had applied to the Jews before the creation of a homeland. *Billy Budd*, with its plot of injustice that ended

in a criminal hearing, moreover, shadowed their interpretations of the trial of Adolf Eichmann in Jerusalem, which began in the winter of 1961. Eichmann had been a lieutenant colonel in the SS and a major architect of Hitler's plan for exterminating the Jews (the Final Solution). He was responsible for overseeing the deportation of Jews to killing centers in Europe through the Department of Jewish Affairs, which he headed. He escaped to Argentina after the war, where he worked for Mercedes-Benz before being captured by Mossad operatives. He thereby escaped the Nuremberg Trials of 1945–46. Through her reading of *Billy Budd*, Arendt observed that a trial "spells doom to everyone when it is introduced into the political realm."[44]

guilt to the vanishing point

Rosenberg was assigned to cover the Eichmann trial for *Commentary* by its new editor, Norman Podhoretz. In his article, "Guilt to the Vanishing Point," he asked why Jerusalem had become the site to try the case. As he reckoned, it could only "lead to distortions, as is always the case when a moral 'message' is imposed upon a tragic drama."[45] He invoked Hamlet (who thought of Denmark as a prison) to argue that the stage should have been less geographically charged. As it was, the emotional testimony from survivors, and their harrowing accounts of victimization and escape, went on for two months. They overwhelmed the trial to the point where Eichmann himself was diluted in the evidence. The prosecutor failed to establish that Eichmann was an anti-Semite, such was Eichmann's dexterous evasion of involvement in the Final Solution. Instead, he emerged as an "ordinary man,"[46] a patriot who acted upon orders from his superiors and willingly became a company man. By doing his job, he had forfeited whatever individuality he might have had: his commitment to the Nazi party was total.

The trial represented a missed opportunity, Rosenberg felt, to home in on the racism implicit in Eichmann's acts. The defense had foregrounded his passivity to the extermination of 6 million people, yet it deflected any narration of the horror of the Holocaust. The

problem, as Rosenberg explained, was the legal system itself, which sought "an atmosphere of balanced discussion,"[47] whereby Eichmann was able to dodge his interlocutors and remind them that it was the Gestapo that had carried out the killings. He was just an efficiency expert who excelled at mass transportation. Although Eichmann was found guilty on fifteen criminal charges and was executed in Jerusalem, it was the "grotesque"[48] deformation of history that Rosenberg deplored in *Commentary*. Anti-Semitism got lost in Eichmann's declarations of powerlessness, rendered as a backstory. A coherent, systemized plan to exterminate the Jews never surfaced in its entirety in the trial. Eichmann had been found guilty almost by default, Rosenberg concluded, and the trial left Israel's new citizens prey to repeated acts of racism.

Hannah Arendt had been struck also by the "banality of evil,"[49] or Eichmann's seemingly benign persona. She used the metaphor to unify her five-part series of articles on the trial for the *New Yorker*, which appeared after Eichmann had been executed and the huge international media coverage of the spectacle had begun to dwindle. Her lengthy pieces emerged almost as a rumination.[50] Unlike Rosenberg, whose factual understanding of the trial was informed by mass media publications such as the *New York Times*, as well as the trial transcripts, Arendt was present for part of the court case in Jerusalem. From her proximity to Eichmann, who was installed in a glass booth in the courtroom, she never perceived him as a "monster,"[51] as most other reporters did. Rather, she found him to be a "clown,"[52] an officious bureaucrat with an arrogant demeanor who flaunted his ambition to succeed in the Third Reich.

Rosenberg similarly emphasized Eichmann's status as a functionary. But unlike Arendt, he felt that there was a direct correlation between his job and his anti-Semitism that the legal system was incapable of unraveling, such was its absolutism. Arendt knew that modern law was not inscribed to try humanity. She never disapproved of the guilty verdict. However, the judgment raised serious issues for her that related to justice, especially since the death sentence was imposed within a few hours and carried out without a stay of execution. Arendt thought there were complications to this out-

come, especially since the trial had been construed by the prosecution as "a tragedy of Jewry as a whole,"[53] rather than as Eichmann's specific crimes committed on behalf of the Nazis. Why was Eichmann made the centerpiece of prosecution, when the primary enforcers of the Final Solution, such as Hitler, Heinrich Himmler, and Joseph Goebbels, were dead? The conviction was a foregone conclusion, Arendt argued, adding to its travesty.

Unlike the Nuremberg Trials of 1945–46, in which both leading and minor officials associated with Hitler's regime were tried by prosecutors from countries associated with the Allied Forces before an international group of justices, Eichmann appeared before three judges in the district court of Jerusalem. His trial had been linked by David Ben-Gurion, the first prime minister of Israel, to the Nuremberg Trials, which he deemed an obvious precedent. In her essays, Arendt portrayed Ben-Gurion as the "invisible stage manager of the proceedings,"[54] responsible for arranging the event as theater. As a politician, he believed only an Israeli court could effect justice for crimes against the Jews. Arendt believed, like Rosenberg, that the location was too incendiary for an impartial verdict to be rendered. She also had objections to information that was left out of the proceedings, such as the complicity of the European Jewish councils in abetting the Third Reich, which had shown no sign of opposition to the roundup of victims. She felt this was an egregious omission that should have been factored into Eichmann's role in the Holocaust. It would have instilled measure. Complicity was a moot point to Rosenberg, however. It had no place in a monstrous story of racism.

Unlike Rosenberg's shorter piece in *Commentary*, Arendt's chronicle of the Eichmann trial aroused phenomenal backlash within the international Jewish community. She had a few champions, such as Daniel Bell, Bruno Bettelheim, George Lichtheim, and Stephen Spender, as well as Mary McCarthy, who responded to the brilliance of her essays and her representation of Eichmann as a heartless official in the machinery of totalitarianism. McCarthy lauded the series for its "boldness."[55] Yet she lamented, as a gentile herself, that her acclamation would get lost in a sea of Jewish dissension. Although Rosenberg had also treated Eichmann as an unthinking administra-

tor, he became one of Arendt's many detractors. He felt that she had gone too far. In her nuanced interpretation, anti-Semitism got lost in the ironies of injustice. Their friendship was tested by her coverage of the trial. When Rosenberg visited Arendt in the Midwest, where she taught at the University of Chicago in the mid-1960s, and he reproved her, she just listened and responded by asking him to fix them a drink, intimating that her articles should not stand in the way of a relationship that she valued.[56] Her compassion caught Rosenberg off guard. He acquiesced, though not used to capitulating, especially in the absence of contradiction. It was more typical that he wore down a listener. Arendt had responded with equanimity to the intense hostility to her Eichmann series. Her dignity was never rattled. She always exuded extraordinary self-possession in televised interviews, as well as warmth, what with her ever-present smile, alluring gray eyes, and gravelly voice modulated by a lifetime of chain-smoking. (She routinely appeared on camera and in photographs with a cigarette, a prop that added to her animated manner of speaking.)

Despite their differing summations of the Eichmann trial, both Rosenberg and Arendt responded to Zionism similarly. Each writer upheld a self-reliant view of Jewish ethnicity and was opposed to its institutionalization, especially through a republic. This had also been Elliot Cohen's position. But by the time that Rosenberg wrote "Guilt to the Vanishing Point" in 1961, *Commentary* was in transition, overseen by Podhoretz. Podhoretz was initially on the same page, not wholly convinced that Israel was a remedy to the catastrophe of the Holocaust. But his stand changed once he took over the magazine.

uniforms and ideology are magical substitutes

Once Norman Podhoretz became editor of *Commentary*, the measured tone that Cohen had established was quickly altered. The political rhetoric was pumped up and became decidedly confrontational, a trait that mirrored Podhoretz's pugilistic personality.[57] Under his direction, the magazine became an organ of dissent, a throwback

to the radical content of the little magazines of the 1930s. Even so, Podhoretz was no leftist. He had never been attracted to socialism, and after the Six-Day War in 1967 that resulted in Israel's conquest of neighboring territories, he became an aggressive ally of the country. He now queried the politics of writers who had not declared fealty.

At first, Podhoretz's renewal of *Commentary* involved realigning leftist allegiance. He made it editorially clear that during the Cold War, anticommunist thinking was not only tired but had been misconstrued by the Truman and Eisenhower administrations to shape foreign policy. Any threat from the Iron Curtain, he thought, had been spun into hyperbole as communism was incapable of undermining the United States through revolutionary activism. Rosenberg adhered to this position, believing that "there was a Communist menace in 1938 . . . Today [in 1962] the menace is nuclear war. To abate this menace, a realistic politics is essential, a politics which would get rid once and for all of the fraud of freedom versus Socialism and put ideals and facts on the table."[58] Both Rosenberg and Podhoretz were put off by the sham of political theater, knowing that it relied too heavily upon propaganda. For the first seven years of Podhoretz's tenure, Rosenberg's politics were interlocked with the editorial overhaul of *Commentary*.

After 1967, *Commentary* become a mouthpiece for the nascent neoconservative movement and rejected not only the counterculture of the 1960s but the New Left that emerged in the wake of the Kennedy era through resistance to the Vietnam War. The magazine now made the protection of Israel and American foreign economic interests a focal point. One carryover of the publication from Cohen's tenure was commitment to fighting racial inequities, especially as the civil rights movement gained momentum. Podhoretz perpetuated Cohen's legacy through publishing writers and activists such as Bayard Rustin and Julian Mayfield, while ensuring that Stokely Carmichael and Eldridge Cleaver appeared in interviews and articles by Robert Penn Warren and Jervis Anderson.[59] This coverage waned, however, especially once the Black Power movement became militant.

On the subject of Israel, Podhoretz became fiercely demanding of

his writers after the Six-Day War. He was no longer conflicted by the left's concerns that the country was an ersatz state. Israel's security now became a pervasive topic. Rosenberg, like many Jews on the left, such as Arendt, had differing responses. But they were aired outside of *Commentary*, such was Podhoretz's growing intolerance of any criticism of his editorial agenda. As the Six-Day War unfolded, Rosenberg wrote to his daughter, Patia, who was by then in graduate school in Santa Barbara, California, stating that the continued displacement of the Palestinians was hard to countenance, and that Israel was acting as an oppressor by subjugating long-entrenched peoples to its laws and imperialist behavior.[60]

Rosenberg's letter was written against the backdrop of the burgeoning student protest movement, another iteration of the New Left. As a radical reaction to the Establishment, their protests appeared to Rosenberg to be just a repetition of the 1930s, when communism was sought as a salvation to correct labor disparities. But in the 1960s, unemployment had ceased to be a cause of the new movement. Rosenberg thought the resemblances between the two eras were transparent, however, revealed through a similar mindset and regalia. In "What's Happening to America," he distilled these likenesses as an inability to grasp the rudiments of power:

> The essential question in politics is the question of power. The Old Left veiled this question by its faith in Communist cliches. It thought it was interested in the working class—actually, each Leftist was concerned with identity. The Communists gave their adherents a uniform and a set of ideas through which they could obtain group cohesion. Today, the same effect is achieved through blue jeans, beards, marches, electronic music . . . But uniforms and ideology are magical substitutes for thinking about the problem of political power.[61]

His article was written for *Partisan Review*, not *Commentary*, which he had largely given up on by 1967. Podhoretz's advocacy for Israel had devolved into fulmination that was about to be appropriated by the Nixon administration.[62]

William Phillips, who became the sole editor of *Partisan Review* after Philip Rahv left to teach at Brandeis, had made overtures to Rosenberg in the late 1950s, seeking the occasional book review or political commentary.[63] Despite their earlier battles, Rosenberg and Phillips had a more collegial relationship once Rahv was out of the picture. Their thinking was more in sync, shaped by opposition to the Vietnam War and the requirement for rigorous political analysis that was gradually diminished in *Commentary*.[64] Once Podhoretz bewailed the anti-American ethos at the heart of the 1960s counterculture, his stake in Israel intensified. Rosenberg wrote a piece on Nixon's administration for *PR*, shortly after the president's re-election and as the Watergate scandal ensued, in which he drew contrasts with the fate of the Third Reich. The tack undercut Podhoretz's adulation of the president and his cabinet. He compared Watergate's Haldeman and Ehrlichman to Eichmann to illustrate how guilt was displaced:

> By the time leading Nazis were tried at Nuremburg [*sic*], Hitler was dead. This left a vacuum at the top, comparable to Nixon's ignorance but opposite in its effects on those below. In Jerusalem, Eichmann invoked the missing leader, as had Nazis of all ranks, to argue that he was only a "little man," a "cog in the wheel." All the Nazis were "innocent" because their guilt ascended to Hitler. In the Watergate affair the guilt was not allowed to rise but was shoved down as far from the White House as possible. As the main line of defense, Haldeman and Ehrlichman were charged with preventing the chain of command from passing through the Oval Room. But since no one above them would assume responsibility, they could not claim to be "cogs." The guilt would fall on them.[65]

Vice President Spiro Agnew was a reader of *Commentary*, drawn to its conservatism and uncompromising position on Israel, which in turn fed Nixon's advocacy of Zionism. Through his supple juxtaposition of Eichmann with Haldeman and Ehrlichman, Rosenberg underscored that the political divisions between him and *Commentary*

had become too deep.[66] That Podhoretz had supported the Six-Day War, and had later become a Republican, became nonnegotiable to him and many other writers, such as Arendt, Daniel Bell, and Irving Howe, who had written for his publication. His political conversion was insidious to Rosenberg. The old right had long since been a stronghold of anti-Semitism in the United States. The WASP specter of an ethnocentric Establishment that preserved the continuity of its families and ties through Ivy League schools and country clubs was still too palpable. When Podhoretz defected from the left, he took with him a new, conservative, Jewish middle-class readership for whom Israel represented a historic fulfillment, embodying the values of liberty. As he now saw it, these were akin to the founding principles of the United States, entwining the two countries in disturbing mythology.

There were other betrayals in this tale of patriotism. During Elliot Cohen's tenure, *Commentary* had construed the Cold War as trumped up and exaggerated. Communism was not viewed as a threat to US borders or as an ideological contagion. However, Podhoretz upended this editorial stance once Nixon was reelected in 1972. To Rosenberg and the "family"—or what Podhoretz thought of as the largely Jewish members of the New York intellectual community who had written for bookish publications such as *Partisan Review*—Nixon and his foreign policies were always anathema.[67] (Podhoretz used the tag "family" to describe the leftist, once Marxist figures, who were self-identified modernists.) He thought of his own about-face as more challenging, "much more difficult intellectually and much more painfully emotionally than opposing centralization or economic growth or even integrationism."[68]

As Podhoretz rethought his political devotions, Israel became the recurring centerpiece of his neoconservatism, particularly once he sensed the left was inimical.[69] Rosenberg's reservations about the new nation were subtler. His views were never as unilateral or anti-Zionist as Podhoretz imagined. Nor were they focused only on the displacement of the Palestinians. The left had been perennially ambivalent about a Jewish state. This dilemma resulted from deeper probing than Podhoretz proved capable of. It related not only to

Israel's role as a colonialist but also to the implications of a Jewish voice tempered by an elected government with a sectarian agenda. Had the fundamental traits of Jewish identity been diluted in this consolidation of power?

Hannah Arendt would continue to question the outcome of Jewish nationalism. She felt that "the specifically Jewish humanity signified by their worldlessness was something very beautiful . . . Of course, a great deal was lost with the passing of all that."[70] Rosenberg never fully addressed Jewish statehood after "Guilt to the Vanishing Point" because there was little opportunity once he started to write full time for the *New Yorker*. Not that political commentary ceased to concern him. He had proposed pieces and submitted manuscripts to the *New Yorker* on topics such as the exile of Alexander Solzhenitsyn, but they were never published.[71] He had a new identity as the publication's art critic.

Podhoretz complained that Rosenberg later became "neutral"[72] on his notion of a "herd" of alienated leftists because the premise— posited in *Commentary* in 1948—was never fully developed in subsequent articles. He was off here. Rosenberg did continue to use the metaphor of a "herd" to take on institutional politics at every turn in the *New Yorker*, just as he had in the 1950s. But articles on conformist culture could no longer serve *Commentary*'s middle-class, Jewish readership, which sought affirmation in mainstream America. Podhoretz chose to ignore these facets of Rosenberg's writing. The preservation of individuality ceased to be relevant to him.

17
a triangle of allegiances
arendt and mccarthy

now who will i have to talk to?

Rosenberg met Hannah Arendt a few years after she and her husband, Heinrich Blucher, moved to New York in 1941.[1] By 1949, their friendship had become tight. Blucher, who was a poet and philosopher, had become a regular at The Club, where they frequently saw each other. The two couples socialized often outside of the gathering spot. On a prolonged trip to Europe—Arendt served as the executive director of the Jewish Cultural Reconstruction from 1948 to 1952[2]—she would ask about Rosenberg in her letters to Blucher, and press him, "Did you get to see Harold?"[3] She adored Rosenberg's company, their banter and exchanges—although his surfeit of "self-confidence"[4] did not escape her. Arendt preferred spending time with Rosenberg alone. Like Mary McCarthy, she found May Natalie Tabak insufferable and the novels that she embarked on writing in the late 1950s "devoid of talent."[5] Their relationship grew closer over the years and even survived his upbraiding *The Banality of Evil*. When Arendt died in 1975, Rosenberg experienced her passing as a great loss and wondered, "Now who will I have to talk to?"[6]

It took Arendt and Blucher a few years to settle into Manhattan with her mother, who followed from Paris. There was the obstacle of learning a new language, and then securing enough gigs to support the household while she worked on her manuscript for *The Origins of Totalitarianism*, which was eventually published in 1951. Arendt had been interned in 1940 at Gurs, a camp in southwestern France, where she awaited liberation papers after she and Blucher fled Germany.[7] From there, they received passage from Marseilles after sev-

eral near misses to outwit the Nazis. By 1944, just as Rosenberg and Tabak became reintegrated in New York, Arendt began to publish in magazines such as *Partisan Review, Commentary, Menorah Journal,* and *Kenyon Review,* all of which brought her into contact with leftist New York intellectuals. She and Blucher became fixtures at their parties and were incorporated into the intimate, partisan scene. She became particularly close to Mary McCarthy with whom she felt a great rapport. Arendt was amused by McCarthy's *The Oasis,*[8] her satire of the *PR* circle that generated hostile reaction from the editors when it was published in 1945. Philip Rahv, in particular, was livid over her characterization of "their survival with the arms of Western capitalism."[9] McCarthy's squib became a catalyst for their lifelong friendship. They found themselves mostly on the same side of the political fence.

Rosenberg bonded with both women. He had known McCarthy from *Partisan Review,* where she was a founding editor. As McCarthy's friendship with Arendt grew, a triangle of allegiances was indelibly drawn. Both were among the few supporters of Rosenberg's work during the 1950s, a decade of professional wandering. He was equally devoted to them. When Rahv threatened to file a libel suit before *The Oasis* was published, Rosenberg offered to retake his bar exams so that he could defend McCarthy, such was his loyalty to her.[10] Dwight Macdonald convinced Rahv to drop the suit, as McCarthy's caricatures in *The Oasis* all had pseudonyms. Rosenberg never got the chance to brush up on the law!

Much later, when McCarthy covered the war in Vietnam for the *New York Review of Books*—wearing a Chanel suit, no less, an image that set off wild derision in the press, as did her defense of the North Vietnamese and call for an American exit strategy—he was there to safeguard her again, praising her "alert sensibility."[11] Her sartorial choices withstanding, Rosenberg did acknowledge that she was not an impartial reporter. Yet he concurred with her "on the rot produced by the American presence in Saigon."[12] (Arendt was noticeably withholding on McCarthy's role as a war correspondent. Her silence suggests that she disapproved of McCarthy's conclu-

sions about the US political stake in Southeast Asia. Arendt more keenly understood the workings of totalitarianism.)

McCarthy probably blundered in her choice of an outfit to wear on her Vietnamese trip, but she was always stylishly dressed, her wardrobe a reflection of her poise and worldly bearing. In addition to being always done up, she was quite attractive: her chiseled features were accentuated by her light brown hair that was sometimes loosely tied into a bun that fell at her shoulders. Her self-presentation and designer clothes affirmed her stature as America's most prominent mid-century woman writer. While a formidable intellect, McCarthy also had a pointed wit that oozed malice and sarcasm. When her semi-autobiographical novel, *The Group*, came out in 1963—a takedown of her undergraduate chums at Vassar—its blunt handling of sexual mores proved sensational, unsettling those who could not get with the sexual revolution.

McCarthy was a candid and frank storyteller, her prose characteristically relentless and uncompromising. Rosenberg was spared her acid-tongued approach, as was Arendt, especially when McCarthy advocated on her behalf for *Eichmann in Jerusalem*. (McCarthy's venom was perpetually unleashed on Tabak whom she never considered an equal.) Was her relationship with Rosenberg carnal? McCarthy never admitted to a romance, but she did think that Arendt had an affair with him around 1960. There is a suggestive passage in their correspondence where Arendt conveys that she prepared dinner for Rosenberg one evening, adding that she "has never felt so comfortable with him before. It was very nice."[13] She reiterates the latter phrase in subsequent letters to McCarthy, hinting that her nights spent with Rosenberg may have become physically intimate. Her language is tempting, yet ambiguous. Perhaps McCarthy's instinct was right.

McCarthy reviewed Rosenberg's first collection of essays, *The Tradition of the New*, for *Partisan Review* when it was released in 1959. Unlike him, she maintained a relationship with the editors despite her friction with Rahv, which faded when their love affair ended and they each settled into marriage. Besides, Rahv had left the jour-

nal; although he remained on the masthead until 1970, Phillips was now the primary editor. Around the time that McCarthy's review appeared, Phillips reached out to Rosenberg, which suggests that she may have had a hand in his return to the journal.

In her write-up of *The Tradition of the New*, McCarthy observed that for "all of his life, as these essays show, he has been influenced only in action, in the 'act,' a favorite word with him, succinct as a pistol-shot."[14] She vivified the independence of Rosenberg's thought, characterizing him as a maverick contemptuous of intellectual fads. Still, McCarthy playfully questioned his aversion to connoisseurship and asked if *action* painting "deliberately renounces the esthetic as its category."[15] Her approbation went a long way in establishing Rosenberg as an exceptional writer. Still, she thought there were inherent contradictions in his argument: alienation was too elusive a criterion to gauge the originality of art. In "The American Action Painters" Rosenberg had left presumably out artists for whom tussling with life was not a priority (such as Fairfield Porter, whose landscapes and portraits were more inclined to stillness and beauty). However, these omissions were not touchstones for McCarthy, who did not want to detract from the singularity of his thinking.

american committee for cultural freedom

The Tradition of the New comprised essays that addressed topical subjects, such as the demise of communism in the United States, the Cold War, and the specter of an Iron Curtain. Even though McCarthy focused on "The American Action Painters," she alluded to these essays in her review, as politics was part of their shared history and interests. Both she and Rosenberg were actively engaged in issues relating to civil liberties in the postwar United States, as were manifold dissidents, former fellow travelers, and liberals. But the two never became members of organizations such as the American Committee for Cultural Freedom (ACCF), an affiliate of the Congress for Cultural Freedom. The ACCF was chaired by Sidney Hook and included a huge group of writers and artists, such as George Balanchine, Thomas Hart Benton, Saul Bellow, Alexander Calder,

Elliot Cohen, John Dewey, Clement Greenberg, William Phillips, Dwight Macdonald, Jackson Pollock, Arthur Schlesinger Jr., and Lionel Trilling. Unknown to them, the ACCF was underwritten by the Central Intelligence Agency (CIA). (Funding was covertly channeled through various fronts, such as the Farfield Foundation, established by the CIA to support anticommunist publications and writers who opposed Stalin and the USSR.)

Rosenberg was not offered membership in the ACCF.[16] And Hannah Arendt refused an invitation. Still, he and McCarthy were seduced into publishing in *Encounter,* which was sponsored by the ACCF and co-edited by Irving Kristol and Stephen Spender in London. When the first issue appeared, McCarthy wrote to Arendt, "Have you seen *Encounter*? It is surely the most vapid thing yet, like a college magazine got out by long-dead and putrefying undergraduates."[17] Yet her disdain was short-lived. She appeared in the journal in 1954 with a reflection on her relationship to the Communist Party in the 1930s.[18] The piece established her connection with *Encounter,* which lasted into the 1960s.

Encounter was a prop of the CIA, just like the ACCF, much to the later surprise of its American co-editor, Irving Kristol, a one-time Trotskyite who had worked at *Commentary.* Kristol had been discontented with Elliot Cohen's chronic depression and ceaseless waffling, and wanted to move on, believing his "editorial interventions had become even more capricious and arbitrary."[19] There had been too many rewrites that altered his intention. He left the magazine in 1952 to work with Sidney Hook as executive secretary of the ACCF. Shortly thereafter, he moved to London to team up with Spender.

Rosenberg too had tired of Cohen's tampering, even though he continued to submit articles to *Commentary.* After his falling-out with Jean-Paul Sartre, when *Les Temps modernes* ceased to be an option, he began to scout for new places for his work. A few of his pieces, such as "The Resurrected Romans," had been reprinted with new titles in *Twentieth Century,* which George Lichtheim edited. As he formed a relationship with Kristol in 1953, Rosenberg told Lichtheim that he was "surprised at how interesting *Encounter* is."[20] He was taken by the editorial contrast with *PR* and *Commentary,*

dissing to this British friend, "there is no use talking about them."[21] He went on to warn Lichtheim that

> an old contributor to both, I made the mistake of considering them as intellectual undertakings and their editors as people whose only shortcomings were a lack of imagination. What I did not grasp was that they were engaged in doing something else, that is, of creating an instrument of self-aggrandizement and power to replace the Stalinism they had abandoned. As a result of this obtuseness on my part, I engaged with them for a long time in all sorts of irrelevant arguments of principle ... I advise you to treat them as if they were the Luce publications or the municipal gas company.[22]

The quip about magazine magnate Henry R. Luce referred to a subsidy of $10,000 made to *Partisan Review* in 1952 to rescue the journal from financial collapse.[23] A few months before Rosenberg wrote to Lichtheim, the ACCF had also channeled $2,500 via the Farfield Foundation to bail out the imperiled magazine. Paradoxically, William Phillips, who was cultural secretary of the ACCF, claimed that *PR* never benefited from CIA sponsorship.[24] The information was not public and was probably passed on to Rosenberg via McCarthy, who was still a contributor to the journal, however at odds with its centrist politics.

Rosenberg had hoped to appear in the first number of *Encounter*, but his essay "Revolution and the Idea of Beauty" was not published until the third issue.[25] Kristol had put him off, feeling that he needed a strong tract for the new journal. As he explained it, "I'm afraid we can't get your piece into the first number. Leslie Fiedler came through with a splendid article on the Rosenberg case—and how many Rosenbergs can the first international magazine carry?"[26] Fiedler, a former Trotskyite and once member of the Communist Youth League, had written a sensational piece on Julius and Ethel Rosenberg, who had just been tried, convicted, and executed in the United States for Soviet espionage. Kristol felt the story made for good copy and sales. Rosenberg was disappointed; he also wanted

to write about urgent political issues for *Encounter*. When he later approached Kristol to consider an article on Senator Joseph McCarthy and the House Un-American Activities Committee (HUAC), Kristol deferred to Fiedler, who had put in a bid to write about the senator. Kristol was more inclined to use Rosenberg for cultural pieces. Moreover, he stumbled over Rosenberg's prose, finding it too aphoristic. He had no desire to "reform"[27] him as a writer, not willing to invest the time. He sensed he would get nowhere.

Rosenberg's essay for *Encounter* was part denunciation of Piet Mondrian, whose "revolutionary impersonality"[28] he thought an obstacle to *action*, and part musing on the British anarchist, poet, curator, and writer Herbert Read whom he described as a "revolutionary critic . . . who is also for aesthetic values."[29] He wondered if Read's dual interests could be reconciled in the mid-twentieth century. Could pictorial invention be read through the lens of Marxist theory? Rosenberg decided that Read had wrongly ascribed revolutionary ideas to contemporary art, which weakened his proposition that modern painting was in decline. There was no aesthetic downturn in the United States in the 1950s, even though the Abstract Expressionists had given up on socialist ideas. Rosenberg presumed Read's thinking was suffused with nostalgia, "a cork that popped out of an old bottle of French wine."[30] That he was an existentialist, however, redeemed him. They became collegial and mutually supportive of each other's work, particularly once *The Tradition of the New* was released.

Kristol recommended Rosenberg's writing to other editors, such as Jason Epstein of Doubleday & Company. He urged Epstein to consider Rosenberg for a book on modern art, which never materialized.[31] Kristol later reprinted Rosenberg's "French Silence and American Poetry" in *Encounter* in 1954.[32] By then, Rosenberg's interests had migrated to publications such as *Dissent,* where his ideas on politics and culture were courted by Irving Howe. He never forgave Kristol for not including him in the first number of *Encounter* and for making an offhand crack that Rosenberg could be taken as a "brother to Julius."[33] Kristol had hoped he would review books such as Albert Camus's *The Rebel,* but these assignments failed to interest

him. Rosenberg wanted to take on the big issues, such as the escalation of the Cold War, continued red-baiting, and communist fear fanned by the Eisenhower and Nixon administrations, as well as the phenomenon of the "orgman," a reference to the conformists who "reproduce like fruit flies in whatever is organized, whether it be a political party or museum of advanced art."[34] There was also an explosive backstory to his reneging on Kristol's overtures that implicated both Sidney Hook and the priorities he had set for the ACCF, as well as Leslie Fiedler's portrayal of Julius and Ethel Rosenberg. Further, by 1955, Kristol's rising conservatism became unacceptable to Rosenberg, and he backed off from *Encounter* completely.

hook and company

Mary McCarthy's association with *Partisan Review* ultimately became almost as complicated as Rosenberg's. Even though she and Rahv made amends over *The Oasis*, her contributions to the journal remained largely confined to reviews of literature and theater. Her opinions on politics were rarely sought, even though she was aligned with the anticommunist bent of the journal. That was the boys' prerogative, the editors implied. Her political advocacy had other outlets, however. In 1949, she appeared with Rahv, Phillips, and Hook, as well as Dwight Macdonald, Elizabeth Hardwick, Robert Lowell, Nicola Chiaramonte, and others, as a dissenter at the first "Waldorf conference," or the Cultural and Scientific Conference for World Peace as it was formally known. Organized by the Council of the Arts, Sciences and Professions, the event drew numerous foreign delegations — among them many Eastern Bloc countries — to Manhattan, ostensibly to broker peace on behalf of Stalin even though he continued to exile Soviet intellectuals to the Gulag.[35]

The talks turned out to be a naïve gathering of artists, intellectuals, and scholars. Sidney Hook was appalled by the transparent infiltration of the communists to promote Stalinist propaganda. (In one sad instance, Dmitri Shostakovich, the Russian composer, was made to uphold the Soviet Union. He was used as a puppet to unite progressive thinkers against global fascism, an act over which he had

no control, having lost his independence as an artist to the so-called Red Tsar.) True to his anti-Stalinism, Hook formed an ad hoc group for the occasion that became known as Americans for Intellectual Freedom (AIF). He co-chaired his own event with Mary McCarthy and others in a suite at the Waldorf Astoria where the conference convened.

Rosenberg ignored both the Waldorf conference and the AIF, as did other writers, such as Lewis Coser, Paul Goodman, and Alfred Kazin. (Unlike Rosenberg, Coser and Kazin were not invited to participate; their disdain for communism was not pronounced enough for the AIF.)[36] Irving Howe, one of Coser's editorial partners at *Dissent*, made the cut and did join in Hook's protest. Hook was perplexed by Rosenberg's indifference, finding his distance from the AIF "a mystery."[37] He had written off Kazin because he had yet to become a "big shot"[38] who was incapable of dissuading sponsors such as Leonard Bernstein, Marlon Brando, Aaron Copland, Albert Einstein, Norman Mailer, and numerous others who gathered for fruitful discussion at the colloquium.[39] As Rosenberg had never been a fellow traveler, Hook reckoned that he should have immersed himself in the AIF's antitotalitarian activity. Rosenberg's coolness resulted in Hook not extending an invitation to him to join the ACCF when it was formed in 1952. Yet he had misread Rosenberg's position on communism, as had other ex-radicals in the group. Rosenberg was never convinced that the Soviets were a threat to the United States after the war. He was fixated more on the rehabilitated leftists and former communists who atoned for their "guilt" after opposing the Roosevelt administration during the 1930s. Their conversion to liberalism had elicited a patriotism that he found smarmy and unconscionable.

Rosenberg had given up on Hook when he supported US intervention in the war, and by the time the ACCF organized a second counterprotest at the Waldorf Astoria in 1952, so too had Mary McCarthy. Both were aghast at the blacklist of intellectuals, artists, union activists, government employees, and writers that grew out of the first Waldorf conference and that was used by Senator McCarthy and FBI director J. Edgar Hoover. In a speech delivered at

the ACCF conclave, Mary McCarthy's barbed remarks were largely aimed at Hook: "The term 'cultural freedom' is on everyone's tongue today. It is contended that we in American have it and the Russians don't, that we in America . . . are losing it; a committee exists to defend it [the ACCF], yet even within that committee there appears to be disagreement as to what cultural freedom is and hence whether it is imperiled, say by Senator McCarthy or by the activities of Communist schoolteachers or by both or neither."[40] McCarthy went on with Dwight Macdonald and Richard Rovere, an ex-communist and associate editor of the *New Yorker*, to question the reluctance of ACCF members—such as Hook, Daniel Bell, Clement Greenberg, and Williams Phillips—to denounce Senator McCarthy, who had outed numerous Americans accused by the HUAC and the FBI of association with the Communist Party. She was disturbed that "Hook and Company"[41] had changed the theme of the conference from "The Witch Hunt" to "Who Threatens Cultural Freedom in America?"—a shift that shied away from discussion that took on the senator's program.

Hook, who was once a supporter of William Z. Foster, the Communist Party's candidate for president in 1932, had forsworn his allegiances with the Comintern in 1933 after the election of Hitler. He had nothing to fear from Joe McCarthy's hearings in Congress, especially as his own politics had become centrist. He not only worked for the ACCF but maintained his teaching position in the Philosophy Department at New York University. Hook had no interest in looking backward to the failed implementations of Marxism. In fact, by 1942, his early socialist zeal had so receded that he informed on Malcolm Cowley—who had been drawn to Marxist thought—to J. Edgar Hoover.[42]

Mary McCarthy was disappointed that *Partisan Review* had failed to address the extreme measures that McCarthy and Hoover adopted to hunt down unrepentant and alleged communists and subject them to trials and congressional hearings, mostly without evidence and always with great humiliation. In the process, the victims' professional lives were destroyed. She believed democracy itself was at stake. Her old colleagues at *Partisan Review* seemed oblivious. As

she sat down to write a story on the second Waldorf conference,[43] she wrote to Arendt,

> I can't believe that these people seriously think that Stalinism on a large scale is latent here, ready to revive at the slightest summons; but if they don't think that what *do* they "really" think or are they simply the victims of momentum? My impression is that the fear is genuine, but so to speak localized. They live in terror of a revival of the situation that prevailed in the Thirties, when the fellow-travelers were powerful in teaching, publishing, the theatre etc., when Stalinism was the gravy-train and these people were off it and became the object of social slights, small economic deprivations, gossip and backbiting.[44]

witness

As the ACCF pumped up Cold War fear of the Soviet Union, McCarthy, Arendt, and Rosenberg began to focus on a new literary craze for confessional writing that expressed public remorse for old communist sins. These autobiographies emerged at the end of the war but gained momentum around the time of the two Waldorf conferences, providing part of the raison d'être for Hook's agenda at the ACCF. One popular example was Whittaker Chambers's *Witness*, in which the former CPUSA member and Soviet spy pondered in theological terms questions relating to his fate. How to choose between the bifurcated path that led to the pursuit of either communism or freedom in the early twentieth century? He defined these alternatives as the "two irreconcilable faiths of our time."[45] Chambers knew both creeds were capable of corruption. But once he found Christianity in the late 1930s, he could no longer reconcile communism's denial of God. There was also the problem of Stalin's warped installation of Marxism that had led to the purges of intellectuals. Once he became a senior editor for *Time* magazine in 1939, Chambers identified with the academics and the learned class.

Witness was a colossal literary success. It articulated an ethical quandary that grew from Chambers's account of his appearance

before HUAC, where he bore "witness" against former colleagues. Primary among them was Alger Hiss, a government attorney appointed by President Roosevelt, who Chambers alleged was engaged in espionage for the USSR, and therefore a closet communist. In his role as a cooperating witness, Chambers exposed Hiss to Congress in 1948. He thereby absolved his guilt for what could have been construed as treason. While Sidney Hook empathized with Chambers and was taken by his redemptive narrative, Mary McCarthy thought the whole episode specious. She wrote to Arendt that she was particularly aghast at Richard Nixon's alliance with Chambers. As a committee member of HUAC, Nixon had worked to undermine Hiss and find evidence to indict him of perjury.

McCarthy asserted that *Witness* could not "be treated simply as a book, among other books to be reviewed."[46] There was a more pressing concern that related to "the great effort of this new Right . . . to get itself accepted as *normal*, and its publications as a *normal* part of publishing."[47] And this new right had to be stopped. She hoped to remedy the situation by launching a new publication, *Critic*, with Arendt, Rovere, Dwight Macdonald, and Arthur Schlesinger Jr. to address civil liberties. As she expressed to Arendt, this "repetition in history . . . [or] the curious amalgam of left elements, anarchist elements, opportunist elements, all styling themselves conservative, is a regular *Narrenschiffe* [ship of fools]."[48] *Critic* would have drawn on writing by its core editorial team and by Rosenberg, Kazin, and others. But it never happened, a casualty of McCarthy's failure to secure adequate funding. She found that the magazine had little place in the postwar economy. The Farfield Foundation had initially expressed interest but wanted to see a journal that would drive home its commitment to anti-Stalinism.[49] (McCarthy, like most writers and editors, Rosenberg included, was still unaware of the ties between the Farfield Foundation and the CIA.)

Arendt felt that the new industry of expiating a communist past had to be put into historic perspective, particularly as many confessors became involved in reactionary, conservative politics after the war. She countered the exculpations HUAC had bestowed upon Whittaker Chambers and others in her article "The Ex-Communist,"

published in *Commonweal* in 1953. Arendt more humanely observed that "this century is full of dangers and perplexities; we ourselves do not always, and never fully, know what we are doing."[50] Her own husband, Heinrich Blucher, had been a communist, and she felt that those who were not engaged in espionage or responsible for putting away old Bolsheviks should be exonerated. However, Arendt drew a distinction between leftists who gave up on the socialist experiment at the time of the Moscow Trials and those who waited until after 1945. As she saw it, the ex-communists of the postwar period represented a new breed of penitents who had never been drawn to the nuances of Marxism. Rather, they had a personality type that gravitated toward "totalitarian thinking."[51] Therein lay the danger. Unlike the communists who repudiated the party before the Hitler-Stalin pact, horrified by fascism, these individuals retained the same mindset after their renunciation of socialism. They would never change, such was their investment in power.

Arendt argued that it was convenient for Chambers to use the Hitler-Stalin pact as the moment for his own epiphany and to warn the United States about other Western undercover operatives. He was too self-serving to have keen political convictions. Her book *The Origins of Totalitarianism* had been released two years earlier, and she was now fearful that McCarthyism, with its demagogic dread of Stalinism, represented a new iteration of repressive governing. Chambers and other confessors had allied themselves with the insidious programs of Senator McCarthy and J. Edgar Hoover to vindicate their wrongdoing. They reinforced the notion that their politics was expendable.[52]

As these autobiographical tell-alls continued to proliferate, Rosenberg also jumped in and elaborated on the conformist testimonies of Chambers and others. Although he had unsuccessfully petitioned Irving Kristol to commission him to write on Senator McCarthy for *Encounter*, his debut article for *Dissent* in 1955 took on Leslie Fiedler, Kristol's star contributor, who had fessed up in *An End to Innocence*—a collection of essays on Chambers, Hiss, and Julius and Ethel Rosenberg—that it was time to take responsibility for his early interest in Marx and to mature politically.[53] Unlike Chambers,

with whom he sided, Fiedler had not found God in the course of his repentance.[54] Moreover, he had neither embraced counterintelligence nor appeared before HUAC to testify against alleged communists, such as Hiss. His contrition was expressed in numerous articles written from his new standpoint as a liberal. As Rosenberg declared in "Couch Liberalism and the Guilty Past," Fiedler's political transformation was absurd. If anything, his politics had become conservative, and also dangerous, especially as Fiedler had praised Chambers as a hero. What to make, then, of Fiedler's claim that he had landed in liberal territory by upholding Chambers's recantations before HUAC?

Fiedler's political orbit to the right was patently transparent to Rosenberg. For starters, he thought the writer had committed a grave error by assuming that everyone on the left had been a communist in the 1930s. Rosenberg knew the situation to be more complex than Fiedler let on. He was also bewildered that Fiedler had crossed a line by entreating all liberals to acknowledge their guilt as followers of communism. Rosenberg knew from experience that there were leftists who had been able to operate separately from the Communist Party. More than that, they had succeeded in stifling the spread of its doctrine locally. As a result, he believed that Fiedler had succumbed to "slander ex-Communist style,"[55] making him the equal of Chambers in cowardice and villainy.[56] For all Fiedler's insistence that he now operated as a liberal, Rosenberg remained utterly perplexed. How had Fiedler's communist retractions placed him to the left of center? He was also at a loss as to how Fiedler represented Chambers as a latter-day liberal when there was nothing in his history to suggest such affinity. As he pressed Fiedler on his identification with Chambers, he asked: "Whom ... is [he] describing, except possibly Stalinists who haven't confessed yet . . . His "all liberals" is a made-up character with an attributed past . . . Chambers who was never a liberal, who in his book gave no hint of having ever criticized the Communist Party in his radical days from a libertarian position and who after he broke with Communism became something quite different from a liberal."[57] Rosenberg also knew that *An End to Innocence* was published late in the game and was therefore dated.

While HUAC continued to hold hearings into 1957–58, and did not disband until 1975, the heyday of the blacklist and red-baiting had waned, especially once Senator McCarthy was censured in 1954.

So why did Rosenberg write the essay for *Dissent* if Fiedler was such a latecomer? Besides wanting to weigh in on an intellectual trend, he had motive: Fiedler had originally published his essay on the countersurveillance of Julius and Ethel Rosenberg in the first issue of *Encounter*, the journal that found no room for Rosenberg's political commentary.[58] At best, Fiedler's article was highly inflammatory. Fiedler found the duo loathsome—unlike his idol Whittaker Chambers—culpable of passing on information to the Soviets that related to the manufacture of nuclear weapons. He believed they deserved the death sentence. Fiedler was alienated not only by their spying but by the private correspondence they wrote once imprisoned and awaiting execution. As a writer, he found their prose sophomoric and wanting: their letters should have exhibited tenderness and more contrition at the end of their lives. In addition to these literary expectations, there was the problem of their purported mendacity. As Fiedler proclaimed, "We have grown used to Communist spies lying in court ... but we had always hoped that to their wives at least, in darkness and whispers, they spoke the truth."[59] He ended his account of the Rosenbergs' undercover activity and subsequent trial on an arrogant note, contending they were not educated enough to rise to the status of "martyrs or heroes—or even human beings ... What was there left to die for?"[60]

Even before the first issue of *Encounter* hit the newsstands, Kristol was cautioned by Sidney Hook, his old boss at the ACCF, that Fiedler ought to write a disclaimer at the outset of his text; Hook sensed that it would appear reckless. Although the Farfield Foundation was pleased with the piece, Fiedler's capitulation to tabloid journalism alarmed Hook. He thought it could impact the reception of the magazine, as well as the ACCF, its sponsor.[61] Kristol acted on Hook's suggestion: Fiedler toned down his rhetoric in one passage and advised the reader that his depiction of the Rosenbergs should be read as a synecdoche of "political symbols."[62] But the dilution of his prose was too minor, his meanness still profuse. The maga-

zine exceeded its print run of ten thousand copies and sold out in Britain within a week, all of which stoked discussion across the international literary community. It also engendered considerable irritation from Stephen Spender, who felt that he had to acquiesce to Kristol and become an apologist for US Cold War propaganda. However frayed their relationship, Spender stayed on at *Encounter* until 1967, when it was finally revealed that the CIA had been the publication's funder. Kristol later averred that if he had known of the subsidies from the CIA, he would never have become an editor at *Encounter*. This was not because he disapproved of the organization; rather, he valued his recognition as an "independent writer and thinker" and did not want to be thought of as "a functionary in a large organization."[63]

When Rosenberg brought out his rebuke to Fiedler in *Dissent*, he incorporated a long letter that he had sent to *Encounter* that concentrated on the injustice of the Rosenbergs' sentence. His aim was to undercut Fiedler's emphasis on their disconnected humanity. They did not deserve death, he argued. Rosenberg faulted Fiedler for his inability to recognize that their trial had rendered them as communist caricatures.[64] The law, he said, was not administered with fairness and proportion. "Rather," as Rosenberg saw it, "the government took up the slack in its case by creating its own fictional person, that of the fiendishly efficient underground incendiary capable of setting whole continents on fire."[65]

Rosenberg had written to Kristol before the debut of *Encounter* to express concern that Fiedler would distort the Rosenbergs' public image and depict them as drones with no individuality, which he did.[66] Kristol wrote back to assure him that he should "have no fear of Fiedler—he comes out on the side of the angels, though taking some polemic detours on the way."[67] Kristol did not publish Rosenberg's missive; he thought that it had been sent to him personally and not to *Encounter* in an official capacity. But once Rosenberg's article was published in *Dissent*, an blistering exchange of letters followed. Kristol claimed in one salvo that Rosenberg had provided him with insight as to "how it was that, in New York, you had a reputation of being so 'difficult,' for I had always found you perfectly ami-

able. Now, having seen the autumn issue of *Dissent*, I know how—
though, for the life of me, I cannot figure out *why* you work so hard at
converting your friends into enemies."[68] Rosenberg was puzzled as
to how a letter with no private content, that got straight to the point
about Fiedler's political reversals, had been misread by Kristol. How
could he not have assumed it was intended for publication?[69]

Writers such as Leslie Fiedler, Sidney Hook, and Whittaker
Chambers (Chambers briefly wrote for the *National Review*) had
become in Rosenberg's estimation frighteningly conservative. Al-
though Fiedler's political convictions were less reactionary, he had
become a conformist through his contrition for his old communist
ways. Rosenberg was unwilling to admit, however, that there were
still radical dimensions to Fiedler's thought. Fiedler had given up on
essentialist features of literary modernism to address gender, sexu-
ality, and race with unabashed directness in the late 1940s, when he
set off a sensational response with "Come Back to the Raft Ag'in,
Huck Honey!" an article in which he imagined a homoerotic rela-
tionship between the two lead characters in *Huckleberry Finn*.[70] This
was a groundbreaking interpretation for the period, flying in the
face of the New Criticism with its closed textual readings. Later, in
1960, Fiedler provocatively declared that the "great American novel"
was a myth, indebted to European prototypes grafted onto unique
American experiences. Rosenberg would never accept that Ameri-
can fiction was indentured. Fiedler had applied his interest in male,
sometimes interracial, bonding to tenebrous settings in the West
to destabilize traditional heterosexual explanations of male pair-
ings and acts of heroism.[71] Rosenberg also gravitated to the mise-
en-scène where individuality was enacted. Yet his narratives were
always sited in the East where Melville and Whitman had lived.
Fiedler's early inquiry into the representations of human sexuality
basically eluded him: Rosenberg never questioned whether Whit-
man was gay or delved into the layered meanings of "brotherhood."

Fiedler saw Rosenberg as a blowhard, as well as an entitled wom-
anizer. At least that is how he portrayed him in "Nude Croquet," a
short story published in *Esquire* in 1957, two years after Irving Kris-
tol fired off his salvo to *Dissent*. In his fictionalized account of a

dinner party set on Long Island, Rosenberg is represented by the character Howard Place, an abstract painter who is about to represent the United States at the Venice Biennale.[72] Place is overly surefooted about his professional success, yet envious of his friends with younger wives. At one point, he and his middle-aged cronies are demeaned by their coquettish hostess "as silly friends . . . [with] silly Socialist ideas."[73] They share a Marxist past, the only glue that remains of their sagging friendships. To this ingénue, their confraternity is laughable, their ideas dilapidated and stale. Marxism, as Fiedler satirized it, had long since been put to rest.

shameless opportunist

Dissent, as its name suggested, was committed to progressive thinking, as well as to socialist, nondoctrinaire discourse, or what Rosenberg thought of as "one-of-a-kind brand of Marxism."[74] Once his relationship with *Encounter* imploded in 1955, he was protected by the editors of *Dissent*, who were chary of both the ACCF and Irving Kristol, knowing that their politics had strayed from the left. When *Dissent* proposed to run Kristol's reply[75] to "Couch Liberalism and the Guilty Past," they cautioned Rosenberg to act with restraint. They believed that Kristol would do himself in with a long diatribe and that they could use it to "smoke out the Committee Against Cultural Freedom boys."[76] It all fizzled out. Kristol only wanted it made known that Rosenberg had duped him: he thought that their correspondence regarding Fiedler was private. His reply was short and to the point.

As the *Encounter* episode climaxed, Sidney Hook, who had been mystified why Rosenberg had not joined the Americans for Intellectual Freedom and boycotted the second Waldorf conference, was done with doping out his political alignments. Long after "Couch Liberalism and the Guilty Past" was published, Hook questioned Rosenberg's own radicalism. He claimed he was a "shameless opportunist . . . [his] remarks about people like Chambers and others who suffered as a result of telling their story . . . [were] shameless in the light of his work for the American Advertising Council glo-

rifying America when we were being considered 'conformists.'"[77] Hook's attempts to undermine Rosenberg through his association with the Ad Council came after news of the subvention from the CIA to the ACCF and *Encounter* was made public. By this point it had little effect. Rosenberg was now ensconced at the *New Yorker* where he had a stage to enact his prophecy of a "herd of independent minds."

18
the tradition of the new

the geography of modern art

Mary McCarthy singled out "The American Action Painters" in her review of *The Tradition of the New,* even though the anthology included essays such as "The Fall of Paris" and "French Silence and American Poetry," in addition to Rosenberg's key pieces on Marxism. Her emphasis revealed the article's lingering currency: it was still much discussed when the book was published in 1959. McCarthy knew that Rosenberg's growing reputation as an art critic hinged on the piece. Yet after "The American Action Painters" was published in *ARTnews*, Rosenberg wrote only a handful of pieces for the journal. The opportunity clearly existed, but he never became a regular contributor. Unlike Fairfield Porter and poets such as James Schuyler, Frank O'Hara, and John Ashbery, who were mainstays of the publication, as well as a new generation of curators and art historians, such as E. C. Goossen and Robert Rosenblum, Rosenberg remained aloof from writing profiles or exhibition reviews. The format of the essay, where he could expand on the social context of art was always more compelling. And even there, he was disinclined to take on assignments or pitch a piece to Tom Hess. As he expounded in "Parable of American Painting," which ran in 1954, the American avant-garde had become a "coonskin" or renegade culture that was "in danger of becoming a style."[1] This situation may have thwarted his enthusiasm for think pieces on an art scene that was fast becoming an institution.

As in any parable, Rosenberg had a lesson to tell. He cautioned New York artists that their pictorial advances could go the way of the

"Redcoats," or their European peers, whose postwar art siphoned their look but not its vigor. Rosenberg may have been thinking about the discussion that Pollock's painting engendered after it was exhibited at Studio Paul Frachetti in Paris in 1952. Michel Tapié had written in the accompanying brochure that Pollock was someone the French could learn from.

Rosenberg capitalized on his emergent authority as an art critic to canalize the critical reception to *The Tradition of the New*. While the volume was organized into four thematic sections, his essays on art were foregrounded and given priority over poetics, Marxism, and cultural politics. Notwithstanding this ordering, he cautioned his readers in the introduction that "criticism cannot divide itself into literary criticism, art criticism, social criticism, but must begin in establishing the terms of conflict between the actual work or event and its illusory context."[2] He was telling readers that he had collapsed old essentialist boundaries to expose the crises that continually confronted the socially attuned artist and writer. In settling on a title for his corpus, he slyly invoked his old beef with formalism, maintaining that style as an organizing principle had become the expectation of the marketplace and consequently no longer possessed any verve. The title suggested, moreover, that the "coonskins," or American frontiersmen, no longer operated on the sidelines of culture but had become history. That Willem de Kooning designed the cover (fig. 21), with its energetically scribbled title in black and white, furthered the perception that Rosenberg was now mostly an art critic.

Shortly before *The Tradition of the New* was published, Rosenberg wrote a piece on Hans Hofmann for *ARTnews* in which he applied his trope of *action* to gauge the effectiveness of the artist's canvases to "restore art to an ethic beyond mass ideals and taste."[3] Hofmann scored high marks on morality: he had refused to conform to the prevailing aesthetic status quo in the 1930s through his reworking of abstract shapes. Two years later, Rosenberg similarly penned an introduction for Aaron Siskind's photography in which he likened Siskind's work to "reproductions of advanced contemporary painting" that involved the same "act of choice."[4] In the photographer's

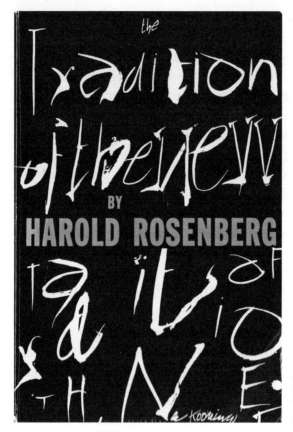

Fig. 21. Cover of *The Tradition of the New* (1959), featuring a drawing by Willem de Kooning (1904–97).

decidedly nonrepresentational compositions, he found defiance of the prevalent practice of straight photography. These two essays inaugurated a spate of monographic approaches from Rosenberg. After *The Tradition of the New* appeared, he tackled Jackson Pollock in *ARTnews*, largely to counter the artist's presumption that Rosenberg had pilfered the concept of *action* from him. Rosenberg wanted to broadcast that he had been involved with the idea since the early 1930s.[5] While he conceded that Pollock's painting embodied *action*, and that Pollock was one of the artists he had in mind when he wrote his signature essay, he did not think Pollock was capable of articulating the philosophical elements of *action*, what with "literary discoveries outside of his range."[6] Pollock was no intellectual, Rosenberg declared, and was too bound up in his own self-mythology. He had

become an "abstract Buffalo Bill"[7] through his redundant references to his birthplace in Cody, Wyoming. Rosenberg went on to state that Pollock was so caught up in enacting his own legend, so interested in "playing cowboy,"[8] that it was impossible to discern who he really was. He pointed out that there was no mention of *action* in any of Pollock's public interviews or statements. The artist had never used the word in conversation. How could he claim it was his property?

By the time *The Tradition of the New* was released, Rosenberg had written himself into the narrative of *action* painting, not only as its spokesman but as a denizen of Tenth Street in the East Village, the place where he lived and which had recently become an "art colony."[9] In a semi-autobiographical essay for the *ARTnews Annual* titled "Tenth Street: The Geography of Modern Art," he mapped out the distinctions between the neighborhood where he had lived since 1943 and the erstwhile art scene of Greenwich Village, which had always been an "imitation on Paris . . . [and the] GENUINE COPY by the Arc de Triomphe on Washington Square"[10] (fig. 22). Rosenberg felt that unlike Paris, Tenth Street would never yield to nostalgia—at least not in 1959—its architecture and streets were undistinguished, dotted with pawnshops and populated by the homeless. Yet it was attractive to artists and galleries that resisted the modish haunts of the West Village. Its individualism was still intact, in part because its character had not been vaunted by writers such as D. H. Lawrence and Eugene O'Neill, who had turned to Taos, New Mexico, and Provincetown, Massachusetts, respectively. Rosenberg liked that Tenth Street "belonged exclusively to painters and sculptors."[11] These people made up his community and intellectual life. But given the shifting demographics of modernism, he knew that the Tenth Street scene would eventually expire. The neighborhood would never be gentrified as Greenwich Village had been; rather he sensed that it would be bulldozed by developers and its real estate either destroyed or altered. The trope became one of his many spins on the demise of modernity, its authenticity done in by commerce.

In the notes on the contributors in the 1959 issue of *ARTnews Annual*, Rosenberg was billed as "an avant-garde poet before becoming

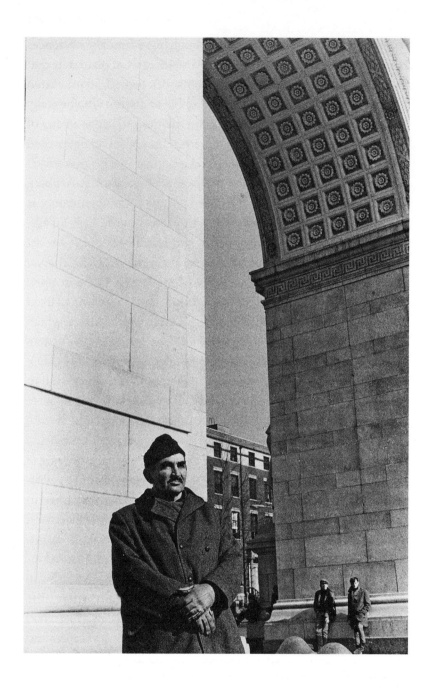

Fig. 22. Unknown photographer, *Portrait of Harold Rosenberg in Washington Square Park*. Date unknown. Photographic print. Harold and May Tabak Rosenberg Papers, Archives of American Art, Smithsonian Institution.

an avant-garde literary and art critic."[12] His role as a player on Tenth Street was now consolidated.

apollinaire of action painting

Like Mary McCarthy, many other reviewers emphasized "The American Action Painters" in their coverage of *The Tradition of the New*. With the accrued weight of the essay, most writers wanted to deal with its meanings and get to the heart of how *action* was present in painting. Dudley Fitts, in the *New York Times*, thought Rosenberg had never successfully explained what *action* signified; its ambiguity could have been cleared up by mentioning a few names of artists and providing accompanying illustrations. Although Fitts felt that there were occasional "brilliant"[13] passages in the book, they were brought down by Rosenberg's overwrought language and avoidance of description. However, Fitts was an anomaly when it came to the issue of Rosenberg's clarity. There were numerous well-disposed journalists who had no truck with his explanations of ideas.

Chief among them was Herbert Read, who wrote enthusiastically about *The Tradition of the New*.[14] Rosenberg had been averse to his formalism, but they were on the same page when it came to extolling modernism's subversive tendencies. Both writers were interested in the existential overtones of contemporary art and what it meant to be caught on the margins of society. Read dubbed him the "Apollinaire of Action Painting," an accolade that underscored how his conceit had gone a long way in situating Abstract Expressionist artists, just as his French counterpart had done for Cubism decades earlier.

Paul Goodman also wrote a homage in *Dissent,* to which he regularly contributed. Goodman prefaced his review by announcing that the genre of the anthology was absurd as it offered little opportunity to include fresh material. But Rosenberg got around this limitation, he was convinced, because *The Tradition of the New* was an extension of his "intellectual being."[15] Goodman was one of the few reviewers to consider the full range of essays in the volume. He admitted that "The American Action Painters" defined Rosenberg and that he had become a spokesman for a new generation of art-

ists. Still, he thought Rosenberg was a "lousy critic" largely because "there is hardly a single art-work or poem made vivid for us, its structure laid bare, its beauty underlined, its flaw explained."[16] Goodman understood this was the outcome of Rosenberg's stress on the social estrangement of the painter. But he added that Rosenberg was nonjudgmental and protective of the artist. He admired him for slugging away at Leslie Fiedler and for reproaching conservatives such as Irving Kristol. Who else, he asked, can "grab them by the scruff of the neck and make them answer or shut up?"[17] Maybe Rosenberg should have taken a few jabs at the painters.

Rosenberg and Goodman were friends but never aligned politically. While they were both vehemently anticommunist, Goodman was an anarchist and pacifist. He had been scornful of Marxism, which he thought could intrude on his autonomy.[18] Goodman had worked as a social theorist and critic, novelist, poet, and playwright, reimagining narrative structures. His plays were routinely staged at the Living Theatre, an experimental playhouse in Manhattan. He was also a co-founder of Gestalt therapy and practiced as a psychotherapist for two decades. Despite his criticisms of Marxism, Rosenberg was drawn to Goodman's status as "the traditional outsider." He was in perpetual yet poignant conflict with corporate bureaucracies and the whole fabric of advanced capitalism. He was "oppressed," Rosenberg wrote, "not by any restraints put upon him but by the condition of being incommensurate."[19] Goodman was not a rebel. But he was so insistent on his individualism that he found himself on the outs with most New York intellectuals who wanted some degree of kinship around politics.

Unlike their old associates at the *Partisan Review*, Goodman and Rosenberg were alone in asking why the left had converted to either liberal or conservative politics in the 1950s. Why had these middle-aged ex-Marxists retrenched on their activism and become rigid and complacent when it came to social reform? As Goodman saw it, the *PR* crowd, like the editors later at *Dissent*, were too mired in their repudiation of communism. Consequently, their journals were no longer relevant to younger audiences. Rosenberg observed in

the preface to Goodman's novel *Empire City* that he was an eternal optimist who perpetually "hungered for miracles"[20] but knew his "task was hopeless."[21] Still, Goodman remained exemplary for him; his all-consuming need for self-affirmation was unusual. Similarly, Rosenberg stood out for Goodman as an intellectual who abided by his convictions, who was not afraid to speak out, and who was "an honest rational gentleman."[22] Few dubbed Rosenberg a "gentleman." His direct, contrarian manner was too overbearing for most of his peers; yet, Goodman thought his description was appropriate as it denoted a moral commitment that he found wanting in most criticism. *The Tradition of the New* was courageous, he felt, a book that took risks, even if Rosenberg refused to subject most artists to his scrutiny. But that would change once he began to write for the *New Yorker*.

"how art writing earns its bad name"

Unlike the raves from Mary McCarthy, Herbert Read, Paul Goodman, and other writers such as Irving Howe and Alfred Kazin, *The Tradition of the New* was not universally exalted, even though it attracted substantial coverage in the media. In fact, Rosenberg's book of essays was polarizing and divided many writers and a younger generation of art critics. "The American Action Painters" had determined his professional destiny and would continue to do so until the end of his life. As he reflected on McCarthy's witticism, "you cannot hang an event on the wall," he shot back, both in the preface to the second edition in 1960, and in a reply in *Encounter*, that "action painting holds up 'history' as the supreme value to the neglect of the aesthetic. . . . we forget the multiple existence which a painting now enjoys in separation from its physical body: its ghostly presence through reproduction in books and magazines."[23] The "aesthetic," he made abundantly clear, had no place in the discussion of art. A painting was not an idle commodity awaiting the projection of a "spectator's taste"[24] but a complex object whose reception was continually altered by history. Like the facsimile, art was doomed to become a

phantom of the past where the intentionality of the artist was specu-
lative and never entirely retrievable. Rosenberg asked, How could
the critic's "taste" mediate these ironies?

The Tradition of the New occupied the critical limelight for almost
three years. In 1962, Clement Greenberg had finally had enough
of Rosenberg's omnipresence and could no longer contain his an-
ger. He had been waiting for a decade to avenge himself upon "The
American Action Painters," knowing that he had been obliquely
targeted in the essay. His riposte, "How Art Writing Earns Its Bad
Name," originally appeared in a student magazine, *The Second Com-
ing,* launched out of Columbia University. But Stephen Spender and
Melvin J. Lasky (who succeeded Irving Kristol) knew that the piece
would be good copy and requested a condensed version for *Encoun-
ter.* It ignited sensation there, particularly since Greenberg impli-
cated the British as contributing to Rosenberg's critical success. As
if his title were not maleficent enough, Greenberg wanted to know
why the "widening gap between art and discourse solicits . . . perver-
sions and abortions of discourse."[25] In short, how was it that existen-
tialism could function as a guidepost?

Greenberg attributed the endurance of "The American Action
Painters," by a circuitous route, to the British critic and curator Law-
rence Alloway, who by then worked as a curator at the Solomon R.
Guggenheim Museum and who had just coined the phrase "Pop
Art." His explanation was wildly off base, more a repudiation of Allo-
way than an account of Rosenberg's new prominence as an art critic.
Alloway had been the British correspondent for *ARTnews* from 1953
to 1957; thereafter, he moved on to become the editor of *Art Inter-
national.* He met both Rosenberg and Greenberg on his first trip to
the United States in 1958 in the latter capacity.[26] Alloway had been
taken by Rosenberg's ideas but now thought that Greenberg had
been able to predict the course of abstract painting, its high points
and blunders, with an "extraordinary prescience and accuracy"[27]
through concentration on visual features. He later backtracked on
Greenberg's sagacity, asserting there were weaknesses in both crit-
ics' views: they had devolved into being "one half of an argument
between content and form."[28] Aside from these quarrels, Greenberg

never forgave Alloway for questioning his aversion to kitsch culture, which Alloway now acclaimed as part of the dominion of contemporary art.

When Greenberg sat down to review *The Tradition of the New*, he was unable to fathom how Rosenberg had become so ascendant, how his writing had become capable of influence and had reached England at that. Unlike Rosenberg, he himself had traveled to London in 1954 and 1959, and met with British artists, including the painter and critic Patrick Heron, who wrote for the *New Statesman* and was a correspondent for the American publication *Arts Digest*. Greenberg expressed little interest in the British art scene. He was dismissive not only of Alloway but also of critics such as Herbert Read and David Sylvester.[29] Heron fared better because he had written about Jackson Pollock with enthusiasm. By 1959, however, he had rejected Greenberg. During a studio visit, Greenberg had recommended that he simplify his compositions though formal reduction and expose the edges of his canvases, just like the Americans.

Because Greenberg focused on Alloway in his review of *The Tradition of the New*, he deflected analysis of Rosenberg's ideas about *action*. Besides, he was more interested in their appeal than in their core meaning. He wrote off Rosenberg's rhetoric as "racy and demotic"; catch phrases such as "action painting" were likened to "a new dance step."[30] He never mentioned any of Rosenberg's essays on politics. Greenberg knew that Rosenberg had not only invaded but usurped his territory as an art critic. As he later childishly complained, "I wrote first, but then he got bigger, so now they say Rosenberg and Greenberg instead of alphabetically."[31]

Through attacking Alloway and the British critics, Greenberg fired his first salvo to maintain his reputation as a prominent writer. But he ensnared others, such as Michel Tapié, who had arranged for Pollock's first exhibition in Paris in 1952. Greenberg regarded Tapié to be equally inadequate, unable to account for the strengths of the new American painting he had written about at length in *Un Art Autre*. Like Alloway, Tapié was passed off as a "comedian,"[32] who had been overly seduced by the prospect that *action* had "millennial"[33] overtones. Put another way, Greenberg was ticked off by their obser-

vation that modernism had begun to expire as a historic period, in part because popular culture threatened the future of abstract painting. He declared himself to be a tastemaker who still had it in him to direct the discourses on art. In his bombast on Rosenberg, he implicated most critics and even bagged Robert Goldwater, a renowned art historian, for not having a sufficient "grounding of aesthetics."[34]

Part of Greenberg's rage stemmed from the modest reception to his own collection of essays, *Art and Culture*, which was published in 1961. He had opened his book with "Avant-Garde and Kitsch," his seminal essay that delineated the contrasts between modernist art and its parasitic opposite, mass culture. Greenberg's volume failed to stir even lighthearted interest. Reviewers, such as Goldwater and Tom Hess, were unable to muster the praise that had been piled onto *The Tradition of the New*. By this point, Greenberg's reflection on the menace of popular art was thought to be pious if not irrelevant. There were other issues that impeded enthusiasm for his summa or life work. As Goldwater wrote in *Partisan Review*, "art has meaning beyond the purely formal relationship of its internal parts."[35] He implied that style was not the surest way to get to the gist of art. Other interpretative models were more inclusive. Goldwater had found too many land mines in Greenberg's approach. His assumption that the medium of painting developed successively over time with "an inevitable historical process"[36] broke down in too many instances. The linear plan that Greenberg projected onto modern art from analytical Cubism to Jackson Pollock was riddled with inconsistency.

Once "How Art Writing Earns Its Bad Name" appeared in *Encounter*, the situation exploded. Rosenberg shot back with a rebuttal in *ARTnews*, claiming Greenberg was a mere "tipster on masterpieces, current and future."[37] The portrayal alluded to his short-term appointment at French & Co., where he worked in 1959 mounting exhibitions of Barnett Newman, Morris Louis, Kenneth Noland, Jules Olitski, and others. Apparently formalism and its prop, historic determinism, could now come in handy as a sales tool. Like Goldwater, Rosenberg was intent on exposing the pitfalls of formalism's strategies. He had never bought into Greenberg's credo that "art of our time is a fulfillment of the art of the ages,"[38] knowing that his-

toric crises were scrubbed from the equation. This was pure sophistry to Rosenberg, foolhardy even. He wrote in bewilderment, "to a collector being urged to invest in a canvas he can neither respond to nor comprehend, it must be reassuring to be told it has a pedigree only a couple jumps from Giotto."[39]

The real issue was how subjectivity was expressed in an age of anxiety. Rosenberg admitted that the risk of nuclear war had been minimized by the early 1960s and no longer weighed on the artist. Yet there were urgent situations to contend with, such as the proliferation of mass culture and the rise of a marketplace, all of which impinged on "consciousness."[40] Rosenberg worried that these crises were no longer deeply felt by the artist. Gains for a livelihood had been considerably reversed in the postwar United States as the commerce for art escalated. He was now concerned that the artist was required to be a professional, a status that resulted in social integration.

No sooner had Rosenberg published his rejoinder in *ARTnews* than Herbert Read and Greenberg engaged in an exchange in *Encounter* that stoked a debate on the best critical method to construe art. Read believed that Greenberg's vendetta stemmed from awareness that "Rosenberg had of late challenged Mr. Greenberg's supremacy in the field."[41] Greenberg hit back at Read's smirch, contending that he had only added to the "confusion" by skirting the question: "was the new American painting art,"[42] or was it just an existential gesture? The editors at *Encounter* gave Rosenberg the last word by reprinting his sally from *ARTnews*. Redoubling on his view that aesthetics was a moribund model, he retorted, "art criticism is probably the only remaining intellectual activity, not excluding theology, in which pre-Darwinian minds continue to affirm value systems dissociated from any observable phenomena."[43]

"the twilight of the intellectuals"

Besides Clement Greenberg, there was one other notable detractor of *The Tradition of the New*. Hilton Kramer, an editor for *Arts Magazine*, wondered if "there was a conspiracy afoot to annihilate

this book with praise."[44] To Kramer, the admiration of Mary Mc-Carthy and others seemed excessive and unfounded. He could not fathom the widespread acclamation, particularly since he thought that Rosenberg, as well as Parker Tyler, bore "responsibility for transforming the literary style of *ARTnews* into a comedy of bad poetry and intellectual pretense."[45] (Tyler began writing for the publication in the mid-1950s; *Arts Magazine* had long since been a rival.) Neither man had influenced Hess's decision to hire poets, such as Frank O'Hara, James Schuyler, and John Ashbery, but Kramer was hell-bent on bringing down Rosenberg, to the limited extent he could so in 1959. He had yet to move on to the *New York Times* where he became the chief art critic in 1965. Ironically, he had made his debut in the *Partisan Review* by assailing "The American Action Painters."

Kramer used the release of *The Tradition of the New* to embellish his initial doubts about the text's premise. He had earlier queried Rosenberg's "unwillingness to allow . . . masters (Europeans) much of a place in a discussion of the new American art"[46]—thereby allying himself with Greenberg's thesis that postwar American art was given to liberating itself from Cubism. Now, Kramer built on the accumulated aspersions that had been projected onto Rosenberg's corpus of work. He sounded like Sidney Hook, who still served on the advisory board of *PR* during the early 1950s, when he claimed that Rosenberg's "aphorisms are often marked by the verbal economy of the copy-editor rather than the philosopher."[47]

In his kick-off piece for *Partisan Review*, Kramer became an unwitting pawn of Rahv. He had met Rahv while a student at Indiana University in 1951 and remembered that what "I didn't know was that Rahv had 'broken' . . . with Rosenberg some years earlier and had no doubt been eager to publish my article because of its attack on action theory."[48] He ascribed his opportunity to contribute to the magazine as "dumb-luck,"[49] having no sense of Rahv's designs to get even with Rosenberg. Rahv had never forgiven Rosenberg for trouncing the anthology that he edited of Henry James's work in the mid-1940s, and Rosenberg's gnomic response, "the Henry James's Delicatessen." The jest evaded Rahv, who was stung by the implica-

tion that James was conventional. James's wallowing in the victimization of upper-class American women was written off by Rosenberg as too shallow a subject for the post-Depression era.

In the early 1950s, Rahv was on the lookout for another art critic for *Partisan Review*, wanting to cut into Greenberg's eminence as a writer. Kramer attributed the move to resentment and envy. Rahv's scheme backfired, however. Kramer fulfilled his expectations by taking aim at Rosenberg but spared Greenberg. He was too beholden to Greenberg's theory that all resolved art was bound up in the articulation of quality. By this he meant painting that was refined and that required no further finessing. This attribute would become the yardstick of Kramer's critical platform. Even so, Kramer's understanding of art was inherently conservative and exhibited a slavish reverence for tradition. Unlike Greenberg, he could not grasp most New York School painting. His writing on the movement was thin and frequently laced with venom. In one spiteful description, he described Jackson Pollock's work as "a triumph of ambition and short-lived inspiration over a severely handicapped and unruly personality."[50]

Kramer eventually parted company with Rahv over his jealousy of Greenberg. But he renewed his relationship with *Partisan Review* after Rahv left to teach at Brandeis and founded his own journal, *Modern Occasions*, where Greenberg and writers such as Lionel Trilling became targets. But Kramer never reversed his position on Rosenberg's existentialism. When Greenberg's *Art and Culture* was published, he submitted, "Unlike Mr. Harold Rosenberg ... Mr. Greenberg has never attempted to make rhetoric do the work of analysis. His writing may not always be the most gracious instrument one can conceive for its purposes, but it has the indispensable characteristics of clarity, coherence, and logical argument."[51] He reasoned that Rosenberg's explanation of the mid-century "did more to confuse the public about the accomplishments of the Abstract Expressionists than any other critic of his day."[52]

For all of Kramer's reservations about Rosenberg's aphoristic phrasing, he later pilfered one of his most potent titles, "The Twilight of the Intellectuals," finding it apt for his collection of studies on Cold War culture. When his volume was published in 1999, he

belittled Rosenberg, as well as Mary McCarthy, Irving Howe, and Norman Mailer, as opponents of the "secret believers in the radical dream":[53] those New York intellectuals who never gave up on their leftist politics. Kramer surely read Rosenberg's essay with the same pithy title when it appeared in *Dissent* in 1958; there Rosenberg admonished Raymond Aron, the French philosopher and one-time friend of Jean-Paul Sartre, for his "utopian view of American life."[54] The ties between Rosenberg's piece and Kramer's thoughts on the demise of liberalism were too close for any lapse of memory or slippage.[55] Although Kramer was disdainful of any publication with a socialist perspective, Rosenberg's witticisms never went unnoticed by him. They impressed, if not overwhelmed, him.

Most of Rosenberg's aphorisms were colored by his early reading of Marx. Kramer did not mature as a writer during the Great Depression, the period in which Marxism was rejuvenated. A difference in age accounts for part of the wide gulf in their thinking. Yet, for someone who was an equally facile verbal craftsman, and not averse to the hard-hitting blow or waggish quip, he was a lifelong adversary of Rosenberg and continued to portray him as "intellectually fraudulent."[56]

19
pop culture and kitsch criticism

kitsch criticism

There was more than one area of discord between Rosenberg and Hilton Kramer. Like Clement Greenberg, Kramer was antagonistic to popular culture; he assumed its kitsch aspects had been handily appropriated by the middle class. Rosenberg was not entirely dismissive of kitsch; he knew that *action* painting was dialectically implicated in the proliferation of mass-produced products in the twentieth century. He was more interested in how this situation had become endemic within the academy, which he construed—just as Pop Art was gestating in the late 1950s—as a domain of "mass-culture specialists."[1] Rosenberg had in mind a new breed of cultural anthropologists interested in "adding to kitsch an intellectual dimension."[2] In "Pop Culture: Kitsch Criticism," which was published in *Dissent*, he cast a wide net for culprits. David Riesman, Nathan Glazer, and Reuel Denney—co-authors of *The Lonely Crowd*, a sociological study of the middle class—were targeted, as well as the Spanish philosopher José Ortega y Gasset and Dwight Macdonald, Rosenberg's old editor and one-time friend. Although he admired Ortega's "wit,"[3] his mourning over the demise of high culture in the nineteenth century seemed silly. It represented the outpouring of an esthete rather than of an engaged mid-century intellectual.[4] Rosenberg mischievously lampooned him and others who clung to an old patrician social model as "*Mass-Culture* authors [who] sound as aggrieved as King Alfonso by the Industrial Revolution. One might as well take walks on Fifth Avenue leading a pair of greyhounds."[5]

Where he characterized Ortega y Gasset as a throwback, he was

tougher on Macdonald, who had begun to theorize about mass culture in the early 1950s, nearly a decade after writing articles on the Soviet cinema for *Partisan Review*.[6] (Riesman and his co-authors were written off entirely without any expatiation of *The Lonely Crowd*, such was his disdain for their book.)[7] Rosenberg felt that a certain hypocrisy attended Macdonald's rekindled interests, that no writer who took on kitsch was capable of critical distance, such was its insinuation into all areas of life. Why not just acknowledge it? he asked. Additionally, he feared that art was ignored in these reflections on popular culture, with the upshot that criticism itself ran the risk of becoming doctrinaire.

Rosenberg knew that his own account of kitsch was not dissimilar to those of Macdonald and of academics such as Riesman. But there were key differences in their handling of the subject; they operated on the premise that high art was superior. As he outlined:

> Popular art is their meat, whether as a clue to current social relations, as an object of moral protest, as an occasion for self-expression, or just for the grinder. No doubt they believe that the true material of their psychic existence is poetry, paintings, concertos. Such self-delusion can be enormously stultifying. Though every intellectual regards himself as an animated counter concept to it, the discussion of popular art in America is thrown out of shape by the vacuum of positive interest in art. As against the symbol of searchers, on the one hand, and the wailing women of culture, on the other, I'll take a TV actress any day.[8]

Rosenberg figured that there were too many contradictions in their jeremiads about the loss of authenticity. Macdonald had made much of his antipathy to mass art, especially since he now published in the *New Yorker*, a magazine that Clement Greenberg had decried two decades earlier as the embodiment of kitsch: a watered-down intellectual platform that could not hold its own against the more earnest *Partisan Review*. Rosenberg never had any reservations about the editorial program of the *New Yorker*, but he reminded Macdonald that "*Time-Life* [where Macdonald worked before *Partisan Review*], *The*

New Yorker, Hollywood are full of lovers of Gris, Braque, Picasso."[9] He thought this fact complicated Macdonald's argument that mass culture was a threat to modern art. Rosenberg knew that Macdonald's grasp of modernism was limited to Paris in the 1920s, that he had little feeling for the avant-garde, let alone interest in contemporary painting. Why, then, pose as an expert on the insidious features of kitsch in the late 1950s? His question centered on how this "herd" of interlocutors had become coopted by their topic. They failed to note their own involvement in the markets that churned out the ersatz products they deplored.

Rosenberg argued in "Pop Culture: Kitsch Criticism" that there were genuine pleasures to be had from movies, musicals, and plays that were otherwise ignored in their bleak analyses of the imitations of subjective experience.[10] Moreover, why had *action* painting been shunned by these explanations, especially if high art represented the flip side? Another issue weighed on Rosenberg's takedown of Macdonald. A few months before he wrote his article, Macdonald had openly declared in *Liberation*, a New York–based leftist journal, that he had given up on socialism because the labor movement had made too many compromises with governments and corporations.[11] Rosenberg was no champion of the state or big business, but he was not about to denounce the worker.

In his reply in *Dissent*, Macdonald called out Rosenberg's position on pop culture as cliquish, too rooted in his personal interactions with *action* painters. He thought that Rosenberg had become "a member of a very exclusive little club, and by the term art he means simply (or merely) the New York School, or abstract expressionism or action painting or drip'n dribble."[12] He agreed that "there is perhaps too much written about mass culture,"[13] but retaliated, "it's become almost as much of an intellectual fad as action painting."[14] He confided to Hannah Arendt that he thought Rosenberg "may be a marvelous guy (I'll admit I like talking to him and even rather like HIM but . . . [he] certainly is a power-man who conceives of thought and art as pugilistic arenas."[15]

Arendt had a contrary reaction to "Pop Culture: Kitsch Criticism." She thought that Rosenberg's essay was "brilliantly witty."[16]

She also believed that mass culture had engrossed too many writers over the decade. The pervasiveness of its discourse had escalated into a catastrophe, revealing the shortcomings of the overly enthralled academic. Just after Rosenberg published his piece, Arendt concluded that there was something pretentious about the endless pontifications on the lowbrow features of mass culture. In short, there had been too much protesting. In contradiction to Macdonald, she contended in "Society and Culture" in 1961 that

> it has always been the mark of educated philistinism to despise entertainment and amusement because no "value" can be derived from them. In so far as we all stand in need of entertainment and amusement in some form or other, and it is sheer hypocrisy or social snobbery to deny that we can be amused and entertained by exactly the same things which amuse the masses of our fellow men. As far as the survival of culture is concerned, it certainly is less threatened by those who fill vacant time with amusement and entertainment than by those who fill it with some haphazard educational gadget in order to improve their social standing.[17]

Arendt did not name any of the offenders in her essay. But her ideas built on Rosenberg's assertion that the "mite of the Ph.D. and literary critic" succeeded in little else than "adding to kitsch an intellectual dimension."[18]

There was one other thinker who hovered in the background of Arendt's consideration of the aloofness of academics and their narrow themes. "Society and Culture" was an oblique reply to *Dialectic of Enlightenment*, the collaborative text written by Max Horkheimer and Theodor Adorno while in exile in the United States in the mid-1940s. It was here that the idea of a retrogressive "culture industry" was formulated. (The term is known to be Adorno's, despite their teamwork.) Arendt did not mention Adorno by name in her piece, nor did she mention his key phrase, an omission that subtly diminished one of his major intellectual projects.[19] Armed with Rosen-

berg's view that writing on art had been eclipsed by multitudinous tomes on popular culture, Arendt's article was a sally to Adorno.

Arendt knew most of the members of the Frankfurt School through her first marriage, to Gunter Anders Stern, whose ideas on the philosophy of music were spurned by Adorno while he was a student. She had ceased to have any contact with the group with the exception of Adorno. When the school was temporarily in residence at Columbia University during World War II,[20] they resumed connection. Horkheimer and Adorno arrived in New York three years in advance of Arendt and Heinrich Blucher—her marriage to Stern had ended in 1937—and by that time the Institute for Social Research, Horkheimer's core program, was located in Morningside Heights, where it thrived under the auspices of Columbia's Sociology Department. Arendt was linked to Adorno not only through the misfortunes of Stern but through Walter Benjamin, with whom she and Blucher were close. Arendt had met Benjamin in Berlin, but their friendship evolved in France, where she lived as of 1933. Their lives became entwined through their quest for asylum from the Third Reich. The three fled Paris together in 1940, traveling through the Pyrenees to Marseille. In Marseille, Benjamin learned that he did not have the requisite French exit permit and returned to the Spanish border, only to be frustrated by customs officials, whereupon he took his own life. He had entrusted Arendt and Blucher to carry his manuscripts to New York, where his colleagues at the Institute for Social Research had arranged for a US travel visa. Arendt was reluctant to fulfill Benjamin's request, knowing that his relationship with Adorno was also strained after his essays had been subjected to Adorno's heavy-handed edits for the institute journal.

As Arendt was tussling with Adorno on the propriety of handling Benjamin's unpublished manuscripts, Adorno had started to think about the cultural impact of mass communications, or media outlets such as radio, television, and advertising, as well as the whole film and entertainment industry. Three years into his stay in the United States, he moved to Los Angeles, where he and Horkheimer took up positions at the University of California, Los Angeles (UCLA.) His

experience of the institutions of mass media intensified there. In a city dominated by one industry, he vividly saw how the solitary consumption of film and broadcast programs contributed to a heightened sense of mid-century alienation. His dependence upon a car to navigate the freeways of southern California from his bungalow in Santa Monica compounded, moreover, his sense of a society bereft of human interaction.[21] Adorno had never liked New York—its towering buildings were oppressive representations of the monopoly of capital—but Los Angeles more transparently revealed how culture was commodified. As he stated it in *Dialectic of Enlightenment*, the film market induced "a constant sameness," the "untried" squelched as too risky.[22] The industry capitulated to proven formulas, such as a script derived from a recent best-selling novel or the reworking of a popular musical score. Walter Benjamin's trope of the "work of art in the age of mechanical reproduction," the title of his 1936 essay, was a recurring subtheme in *Dialectic of Enlightenment* where technology was the drone that purveyed a language of sameness. (Benjamin's essay first appeared in the French section of the institute's journal in 1936 and was reworked thereafter into German.)[23]

It is unlikely that Rosenberg read the *Dialectic of Enlightenment* when it was published in 1944; even though it was written in the United States, the Frankfurt duo had made no provisions for an English-language edition. (A translation of the text did not come out until 1969.) The Frankfurt School never thought of American audiences for their work: they wanted to safeguard their unity as an independent think tank. And although Rosenberg knew Yiddish, his understanding of written German was minimal. Arendt may have acquainted him with the gist of the "culture industry" in their discussions. There are parallels with the "Herd of Independent Minds," particularly the disconnections between the homogeneous expressions of mass culture and the autonomous avant-garde. Both writers stuck close to Marx in their accounts, with the notable exception that Rosenberg argued that the artist had never been alienated from his materials. He thought that was the predicament of the "factory worker, the business-man, the professional . . . through being hurled into the fetish-world of the market."[24] But the artist did

experience pathos through social marginalization. It is unlikely that Rosenberg met Adorno and Horkheimer; both scholars had moved to Los Angeles before he returned to New York from Washington in 1943. However, besides Arendt, he may have known about their work from Dwight Macdonald.

Macdonald had made numerous overtures to the exiled Frankfurt School to publish in *Partisan Review*, especially in 1941 as he plotted to oust William Phillips and Philip Rahv as editors. After meeting with Macdonald, Adorno abided by Horkheimer's stricture not to associate with *Partisan Review* or any other political publication in the United States. Instead, Adorno referred Macdonald to Gunter Anders Stern, Arendt's former husband, who had secured passage to New York around the time of their divorce. He taught at the New School for Social Research as a cultural critic, as would later both Arendt and Rosenberg.[25] Adorno probably thought that Stern's more neutral aesthetics would appease *PR*, especially as it was in transition, having given up on its earlier Marxist program. Once Macdonald founded *Politics*, the Frankfurt School's investigations into the ties between mass culture and totalitarian governments became felt within his editorial program. He revisited the use of propaganda by the movie industry in his new journal, a field that he had occasionally mined since his days as a student at Yale. Irving Howe also openly expressed a debt to Adorno when he took up the monotony of popular culture in "Notes on Mass Culture," a piece that Macdonald commissioned from him in 1948. It was written around the same time that Rosenberg penned "The Herd of Independent Minds" for *Commentary*.

However inflected with Frankfurt School thinking, Howe remained distant from Adorno's characterization of the deleterious effects of the "culture industry," and his insistence that "the individual . . . is tolerated only so long as his complete identification with the generality is unquestioned."[26] He was more sanguine, feeling that discerning individuals could evaluate the diluted expressions of Hollywood and Madison Avenue. While Howe was resigned to the inevitability of these expressions, he thought, much like Rosenberg, that the study of mass culture would become an industry in itself. As

he predicted, "so long as we live in a class society, mass culture will prove useful even to those who have learned to scorn it."[27]

monologues and hallucinations

Rosenberg was convinced that turning a blind eye to popular culture was not the answer. It deepened a sense of exclusivity that contributed to the isolation of modern art. Clement Greenberg had inveighed against kitsch in the late 1930s, contending that it posed a grave threat to the progress of civilization. All the same, it never became a sustained subject for him. After 1939, when he published "Avant-Garde and Kitsch" in *PR*, he moved on to describe the final phase of the "decline of Cubism"[28] and the ascendance of American painting. The word "kitsch" dropped out of his vocabulary. In his retreat from revolutionary politics, Greenberg assumed that all modernist art and literature was engaged in defying popular expression. He now understood that great art was driven by a will to articulate new aesthetic territory. And he was committed to describing these breakthroughs. Rosenberg never had use for Greenberg's rhetoric of refinement. He still felt Marx was serviceable. Greenberg's formalism was to him just another example of a "herd" instinct: he had become one of T. S. Eliot's numerous imitators. Additionally, Greenberg augured a chain of emulation within art criticism itself that was perpetuated by writers such as Hilton Kramer. Their avoidance of social context only resulted, Rosenberg believed, in forcing the hand of the marketplace and abetting modernism with relentless commodification.

Unlike Greenberg's dialectic of the "avant-garde and kitsch," Rosenberg opposed the idea that *action* painting was a "counter-concept."[29] Many in the "herd" had explained the relationship in terms of antithesis. But these juxtapositions issued from moral high-mindedness, he avowed. They also operated on a false premise. Through his work at the Ad Council, Rosenberg knew that kitsch was so ingrained in the texture of daily life that it could not be described as an antipode to art. Hence his rejoinder to Dwight Macdonald that many movie moguls lived with works by Picasso.

Rosenberg had questioned in "Pop Culture: Kitsch Criticism" why the adversaries of mass culture overlooked artists such as Stuart Davis, who had turned to the billboard for new forms, as well as Willem de Kooning, who drew from advertising's image of the modern sex goddess in his *Woman* series (fig. 23). How had the formalists become visually obtuse? As he thought about art and its future in the late 1950s, he announced that

> art drinks the corn of the popular, takes it in limited doses as a poison, as a vaccine. It deals with life in the same way. Art also attempts to hurl itself outside of life and popular art, to enter its own realm, that of creation liberated from things. But art never makes the mistake of regarding itself as counterconcept. Academicians insist on a separation and an opposition, on the counterconcept to kitsch of an idealistic art. The result is, of course, kitsch.[30]

Fig. 23. Willem de Kooning (1904–97), *Monumental Woman*, 1954. Charcoal on paper, 28 ¼ × 22 ½ inches. Glenstone Museum, Potomac, MD.

When Rosenberg applied these ideas to a specific artist, de Kooning was always exemplary for him. In the mid-1960s, as Pop Art was taken up by many critics, he wrote in *Vogue* that de Kooning was "aware to an unexcelled degree how superficial it is to separate the natural world from the world of human artifice." The artist was still devoted to painting women and "today's cuties,"[31] he noted. Rosenberg's colloquialism was intended to drive home his knowledge of street language, or kitsch (even though he risked treading on the toes of the burgeoning feminist movement). By contrast, Greenberg's dualism of high and low art never enabled him to reconcile de Kooning's imagery derived from the mass media. It posed too many violations to his prescriptions for abstract purity. Artists who were devoted to cartooning and caricature got an even harder rap.

When Greenberg wrote about William Steig, a cartoonist for the *New Yorker*—and later a children's book illustrator and author who dreamed up the character Shrek—he passed off the cartoonist as someone who worked in philistine country. He acknowledged that the psychological acuity of Steig's "symbolic drawings," collected in *The Lonely Ones*, grew out of private fears and obsessions, such as failure, diffidence, rejection, betrayal, cowardliness, depression, and conformity.[32] Greenberg admitted that "Steig has got us all down, the whole well-informed class of us who read the liberal magazines, the *New Yorker*, and Modern Library books, whose hearts are in the right things."[33] Yet he could not grant any modicum of art to Steig's work. As smart as it was, it didn't measure up. No matter that Steig had liberated satire from convention through his wide understanding of contemporary art. (Steig also worked as a sculptor and was up on current directions.) His work fell short because Greenberg thought his "line in cartooning is not felt for its own sake but used for conveying concepts."[34] Even Steig's employer, the *New Yorker*, would not publish his drawings because they were "not funny enough."[35] Evidently, the neurosis on display required more obvious humor. The radicality of Steig's creations escaped Greenberg entirely. That Steig had dodged the traditional hierarchy of author to illustrator by writing his own material was of no interest to him. He could not get beyond the kitsch component of Steig's caricatures.

Rosenberg, in contrast, was interested in cartoons and recognized their subversive traits. He became friendly with Saul Steinberg and Hedda Sterne, his wife, in the early 1950s.[36] They had socialized occasionally at The Club, where Steinberg was a member, and at openings at the Betty Parsons Gallery where Sterne exhibited, as well as at frequent dinner parties at the couple's duplex on East 71st Street, where a lively mix of *New Yorker* writers, editors, and cartoonists gathered, along with artists such as Ad Reinhardt, Mark Rothko, Alexander Calder, and David Hare. By 1960, when Steinberg and Sterne had separated, Rosenberg and Steinberg had become close. Rosenberg came to dub him as a "forerunner of Pop art,"[37] so much did he think of his farsightedness. He was struck by Steinberg's recurring image of the native New Yorker whose uniqueness could never be touched by the anonymity of the vast urban sprawl in the postwar United States. Steinberg portrayed Rosenberg in numerous caricatures. He depicted his friend as an industrious writer, and as a self-assured, imposing personality, his game leg stretched out in one cartoon to emphasize his conquest of physical frailty (fig. 24), or as a raconteur, his voluble conversation caught in a speech bubble. He also featured Rosenberg on his fictional "Leopard Record" label (fig. 25), where Rosenberg's "monologues and hallucinations" were comically etched for posterity.

Steinberg called the rambling conversations that he enjoyed with Rosenberg "free-speech."[38] He liked that their talk was unencumbered by agenda and had no structure and no unifying thread. He thought he was "inventing" while their dialogue unfolded.[39] For Rosenberg, their exchanges offered insight as to how artists such as Steinberg fell through the cracks: Steinberg could not be typecast merely as an illustrator. He was liberated from critical expectation. Where to place him, though? Rosenberg knew that, like the Abstract Expressionists, he "conceived of art as autobiography. But autobiography of whom? The hidden metaphysical self? Man today? The immigrant? The stranger?"[40]

Steinberg similarly thought of Rosenberg as an "artist" with whom he conducted a "daily symposium,"[41] especially once they became neighbors in The Springs in 1961 and would "spend the best two

hours of the afternoon together," over a "couple of drinks."[42] In a kindred vein, Rosenberg likened the graphic traits of Steinberg's "line" to "organized talk," and considered him to be "a kind of writer . . . who has worked out an exchange between the verbal and the visual that makes possible all kinds of revelations."[43] He was not thrown off by what he called the "old-fashioned"[44] look of Steinberg's work, knowing these traits were offset by his existential topics. Steinberg had turned to the linear features of children's drawings to defy the precincts of high art. Social isolation, one of his major themes, weighed on him, just as it had for Steig in *The Lonely Ones*. To this mid-century trope, he brought his own identifiable imagination.

It did not matter to Rosenberg that Steinberg's cityscapes of Manhattan and scenes of the United States beyond the Hudson River—

Fig. 24. Saul Steinberg (1914–99), *Harold Rosenberg*, 1964. Colored pencil, crayon, pencil, ink on paper; 9 ½ × 10 ¼ inches. Private collection.

Fig. 25. Saul Steinberg (1914–99), *Monologues and Hallucinations*, 1961. Ink, watercolor, colored pencil on paper; 10 ½ × 11 ½ inches. Private collection, New York.

an unfathomable mythos for most New Yorkers—were sometimes drawn from postcards and photographs, or that his imagery and faces were occasionally obliterated by the repetitive use of a rubber stamp. So much the better to reinforce the tedium of a society that had conceded to corporate efficiency and organization. Rosenberg liked that Steinberg's identity was wrapped up in asserting his "political"[45] inclinations, and that he could ingenuously reuse commonplace material. He wrote in the catalogue for Steinberg's retrospective show at the Whitney Museum of American Art in 1978 that Steinberg "sees kitsch as the legacy inherited by the modern world

from the art of earlier centuries. Religious and romantic motifs—
Madonnas, a lion attacking a mounted African warrior, a stag re-
flected in a lake—are made into low-priced designs."[46] His ability to
incorporate popular forms of expression in his endearing, touching
caricatures of the desolation and mystery of late modern life made
him deeply relevant to Rosenberg. He reconciled the idea that kitsch
could not be ignored. After Rosenberg's death in 1978, Steinberg
hung a photograph of him in his meditation room so that "the con-
versation with Harold could continue."[47]

Greenberg found Steinberg, who was part of Dorothy Miller's
14 Americans show at the Museum of Modern Art in 1946, too "lim-
ited"[48] to have any lasting impact on the mid-twentieth century. His
inclusion alongside Arshile Gorky, David Hare, Mark Tobey, and
Robert Motherwell was a stretch, Greenberg thought, and set back
the project's "seriousness."[49] To boot, he concluded that "even if he
were much better, he would be relatively unimportant in terms of
modern art."[50] These disclaimers contrasted with Rosenberg's belief
in Steinberg's ingenuity and added to the growing chasm between
aesthetically focused and socially engaged criticism.

Rosenberg was also connected to other artists drawn to carica-
ture. Primary among them was Philip Guston, who pursued car-
tooning throughout the decade of the 1950s, alongside his elegiac,
lyrical abstractions. Guston's sendups of artists such as de Kooning,
Pollock, Motherwell, and Newman, in addition to Rosenberg, not
only pinned down the likeness of each figure with comic brevity but
represented irrepressible satiric statements. That these images coex-
isted with his elegant canvases that suspended any reference to the
body always intrigued Rosenberg. When Guston repudiated this
"beautiful land"[51]—as he referred to his abstract compositions—
and reintroduced cartoon-type imagery in his work in the late 1960s,
Rosenberg saw this seeming about-face not as a break but as part of
a continuous strand of development. The same "nervous line"[52] de-
fined his crude depictions of the Ku Klux Klan. He observed that
Guston's imagery was clustered in the center of the canvas, as it al-
ways had been. But these were now political statements: the artist
was narrating the violence of contemporary America through his

use of disjunctive, autobiographical objects to distill the conjunction of the war in Vietnam, widespread social protest, police brutality, and the election of Richard Nixon.

In 1971, Guston embarked on one of his most condemning series of caricatures, a corpus of more than eighty drawings that represented a loose chronicle of Richard Nixon's life, centering on his presidency and association with Spiro Agnew and Henry Kissinger. His put-down of Nixon was ruthlessly phallic, a play on the diminutive form of his name: Richard, or Dick, is cast as a literal dickhead given to perpetual mendacity (fig. 26). Guston never exhibited or published *Poor Richard*, as he called his mockery, during his lifetime, such was his fear of reprisal from critics such as Hilton Kramer who had gone after his post-1968 work with critical vengeance, never able to explain its intentional crudity. But he did write to Rosenberg after he published "Thugs Adrift," his stab at Nixon and Watergate, in *Partisan Review*, stating that he wished "that one of my NIXON drawings had been used in it."[53] Moreover, in 1976, Guston, who

Fig. 26. Philip Guston (1913–80), *Untitled*, from Poor Richard series, 1971. India ink on paper, 10 ½ × 13 7/8 inches. The Guston Foundation.

had collaborated with numerous poets during the last decade of his life, enshrined Rosenberg in one of his cartoons. In a self-portrait of the artist's brain that hovers over a stanza from a poem by Stanley Kunitz, Rosenberg's name is prominently written in black, overpowering the muted word "Greenberg," which is spelled backward and inscribed in ochre. Guston's feelings about Greenberg's aesthetics is offset by the equally faint mention of Kramer. There is no mistaking him, however: a gun is pointed to his name. Like *Poor Richard*, this drawing was never shown during the artist's life and was meant more as a private inventory of loyalties and irritations.[54]

Greenberg never reviewed Guston's work and rarely mentioned the artist's name in his essays. But when he did, he had no praise for what he thought of as Guston's "academically modern" painting that "covered up a diversity of influences so skillfully."[55] Much like de Kooning, Guston was dismissed by Greenberg as holding onto the figure, even in his post-1949 canvases in which the body was dissolved into bunched skeins of luminous color.[56] The insight was prescient but grew from a bias that imagery had no place in contemporary art. As Rosenberg argued, the figure was not the issue. Abstract Expressionism had served its purpose; it had transcended the "social-consciousness dogma of the thirties."[57] Nonetheless, its preoccupation with abstract forms had become recondite and boring. By 1968, Rosenberg thought it was time for art to reverse course and respond to "political realities."[58] And if that involved cartooning and kitsch, so be it.

20
play acting
arshile gorky

1962

Nineteen sixty-two was a momentous year for Rosenberg. *The Tradition of the New*—which had been translated into French and Italian shortly after it was released, and had been issued in paperback by Grove Press—continued to be featured in the media, stoked in part by Clement Greenberg's review, "How Art Writing Earn Its Bad Name." Rosenberg also published a short book on Arshile Gorky and was approached by William Shawn, editor of the *New Yorker*, to fill in for Robert Coates, who took medical leave for almost a year. Rosenberg was also on the lecture circuit, now in demand to propound his ideas about *action* at the Baltimore Art Museum, Brandeis University, Oberlin College, Princeton University, and the University of California, Berkeley; at Berkeley he gave the Regent's Lectures, one of the university's highest honors. While he continued to write for *Commentary*, and occasionally for *Dissent* and *Partisan Review*, art became a priority. Outlets beyond *ARTnews* emerged for his ideas.

As Rosenberg became recognized as an authority on art, his quarrel with formalism intensified. He wondered how its prevalence as a critical method had contributed to the apparent death of modernism. In turning to Arshile Gorky, he adumbrated a position that anticipated aspects of a subsequent historic phase, or "postmodernism" as it came to be tagged. His inquiry centered less on risk and invention than on their eventual impossibility, on what it meant to quote from preexisting sources and mime the work of artists such as Picasso and Miró. In 1962, Rosenberg was intrigued by how Gorky

had undermined the notion of originality and based his practice on parody. He was not a full-fledged *action* painter like Willem de Kooning for whom the gesture was essential. Still, Rosenberg felt that Gorky was allied with Abstract Expressionism through the emphasis he placed on self-discovery, however unmediated his Cubist and Surrealist references.

Rosenberg's monograph on Gorky represented his first sustained study of an artist, even though the volume only amounted to 135 pages. It was an opportunity to link the ingredients of an artist's life not only to his painting but to the waning of the modernist period. Gorky represented an interesting test case to Rosenberg. He had prophesied in "Parable of American Painting," his allegory of decline, that mid-century American art could succumb to the fate of the "Redskins" and become hackneyed if it continued to induce imitation. By focusing on Gorky, he enlarged this observation by proposing that the languages of the avant-garde themselves were bereft, too fixated on newness and invention.

arshile gorky and the question of identity

Rosenberg met Gorky sometime around 1931 on the steps of the New York Public Library where he had congregated with Kenneth Burke, Lionel Abel, and Sidney Hook in the late 1920s.[1] However, he never became close to the artist; nor did he visit his studio or watch him work as he had with de Kooning. They saw each other at Artists' Union meetings when Rosenberg worked at *Art Front*, but they rarely socialized or met for coffee at one of the neighboring cafeterias. He remembered periodically running into Gorky in Washington Square Park, where they talked about ideas but not about art and politics, until that ended in 1948 when Gorky committed suicide. Rosenberg also recalled that the ideas they discussed were mostly speculative, that they involved topics such as "boredom." Rosenberg was fascinated that Gorky believed his artistic practice was "stimulated by the impulse of not having anything to do,"[2] that he worked from morning to night to ward off feelings of ennui that contributed to his sense of despair.

How did boredom relate to *action* painting, if at all? At the very least, it seemed antithetical, particularly since Rosenberg admitted that for Gorky "the gesture is never a sufficient starting point."[3] He was too avid a student of art history to engage in any spontaneity, let alone plumb the depths of his own consciousness through painting. Yet, as Rosenberg contrasted Gorky's work with de Kooning's, immediacy receded as a criterion to test his bona fides as an Abstract Expressionist. He had stated in "The American Action Painters" that "at a certain moment the canvas began to appear . . . as an arena in which to act,"[4] but Gorky proceeded in reverse fashion by lifting and paraphrasing forms from others' paintings. Picasso's *The Studio* (1927–28), as well as his *Painter and Model* (1928), for example, were transposed in works such as *Organization* (1934–35). In addition to duplicating the compositional armature that Picasso had traced in a prominent black outline, Gorky emulated his use of primary colors. Rosenberg thought that these reenactments did exclude Gorky from the New York School. "For him, as for the Action Painters," he wrote, "the canvas was not a surface upon which to present an image, but a 'mind' through which the artist discovers, by means of manual and mental hypotheses, signs of what he is or might be."[5]

Rosenberg noticed that originality had dogged Gorky from the beginning. The artist had made no effort to disguise his citations. His reverence for Picasso and others had overshadowed any need to transform what he borrowed. He was happy to remain connected to another's identity. As Rosenberg saw it, Gorky was "play-acting."[6] As an immigrant from Armenia, he had taken the name of a famous Russian writer and lived in the New World pseudonymously. And while there were other immigrants who made up the Abstract Expressionist movement—de Kooning, Guston, Hofmann, and Rothko among them—Gorky stood apart, as he chose to exist as a link to an earlier phase of modernism rather than as a pioneer. It did not bother him that he was dubbed the Picasso of Washington Square. To illustrate his point, Rosenberg recounted an anecdote concerning Gorky's relationship to pictorial ingenuity. In 1934, de Kooning had invited Gorky to his studio on Union Square to show him his new work. Gorky quizzed him about his interest in advancing the

styles of Cubism. After looking at few of de Kooning's drawings, Gorky remarked, "Aha, so you have some ideas of your own."[7]

The response rattled de Kooning, who was left wondering if departing from known compositions was a good idea. Like Gorky, he was taken by Picasso's *The Studio* and *Painter and Model*, which they had both seen at the Museum of Modern Art. After seeing Gorky's *Organization* (1933–36), he synthesized all three paintings in a series of studies.[8] The same black palette that Gorky had situated focally in *Organization* was repurposed by de Kooning, along with stray architectural features from other paintings by Picasso. But he moved on shortly thereafter to portraits of men and women, finding Cubism an endgame. The memory of Gorky's studio, with its tidy array of brushes and cans of paint, "immaculately clean space,"[9] and of the reproductions of Ingres and Uccello on the wall, stuck with him, however, underscoring the seriousness that Gorky attached to his vocation. No matter that he cribbed from other paintings. "His interpretations were always Gorky,"[10] de Kooning reflected. His assimilation of art history had resulted in more than a copy.

When Rosenberg thought about Gorky's appropriations, he realized they not only involved reverence but also extended a culture of copying that had been vital for decades. Therein lay part of his originality. Gorky had not been given his critical due for perpetuating the custom of quotation. The fault lay with his interpreters, or the "ideologists of Expressionism," as Rosenberg called them, "for whom the ultimate is the fingerprint."[11] He did not have to be construed as an artist who had refined Cubism through his deft draftsmanship and who found himself only at the end of his life through his more "painterly"[12] compositions, as Clement Greenberg described them. Even then, Greenberg thought his late canvases did not sufficiently transcend Matta and Miró, artists whom also studied. Rosenberg retorted that "art as resurrection of art"[13] could also lend itself to invention. He knew that Gorky had been a "quoter"[14] throughout the 1930s. But later in his career, his excerpts no longer operated as mimicry: they had become allusions, a significant difference. As such, they had entered the realm of poetry.

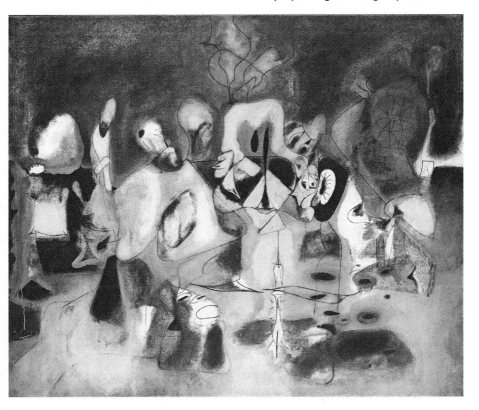

Fig. 27. Arshile Gorky (1904/5–48), *Diary of a Seducer*, 1945. Oil on canvas, 50 × 62 inches. The Museum of Modern Art, Gift of Mr. and Mrs. William A. M. Burden.

In *Diary of a Seducer* (fig. 27), a painting that Rosenberg declared his "masterpiece,"[15] Gorky was not entirely dependent upon mirroring Matta and the Surrealist artists exiled in New York during the war. His domestic life had stabilized—he momentarily evaded loneliness through marriage and a move to Sherman, Connecticut—and he became a US citizen in 1939, a key development, according to Rosenberg, in the formation of his identity. (The event enabled Gorky to become associated with the international reception of American art after 1945.) The Surrealists were "decisive,"[16] nonetheless, in his transformation. Not only did they provide him with a repository of images, but also their distrust of aesthetics reinforced that European modernism had been "played out and that a new

move had to be made,"[17] as Rosenberg wrote. Their approach emanated from the self, something that made an indelible impression on Gorky, freeing him from the veneration of artists such as Picasso. He was subsequently liberated from scavenging, and his work became private, moody, reflective, and no longer self-conscious. He had internalized his subjects and rendered them spontaneously; his line was now freer and more animated. Compositions such as *Diary of a Seducer* were less labored and pondered.

Rosenberg acknowledged that Gorky's post-1940 work was still imprinted by theft. His borrowings were not as obvious, however. They existed more as trace elements of the jottings and automatic drawing of André Masson and Matta, both of whom Gorky socialized with during this period. In sum, as with Miró, who still exerted a hold on him, their all-over compositions did not take over the layout of his paintings. Rather, their mark making was subsumed into passages that, as Rosenberg described, "descend to the drawing board by way of the hand rather than the head."[18] The disembodied fragments in the *Diary of a Seducer* had become wholly his own.

But this freedom was also part of the artist's self-destruction. He became intensely jealous of Matta who had a tryst with his wife. Rosenberg remembered a conversation with Gorky the last year of his life in which he seemed overcome by the "bitterness and uneasiness"[19] of the New York art world. He had always been volatile and given to outbursts, but his personal life had degenerated into chaos, brought on by a sad confluence of events that resulted from a diagnosis of cancer, the loss of his studio through a fire, and a car accident that left him with a broken neck and collarbone. On top of these personal setbacks in the artist's life, Rosenberg described an overall "post-war feeling of futility and antagonism"[20] among the New York avant-garde that eroded a sense of camaraderie. Gorky told him that he no longer experienced fellowship with his peers because the art scene had become intensely competitive. It was, as he recounted, all about "bite, bite, bite."[21] His self-knowledge had become part of his fate.

Rosenberg made clear in his book that Gorky was not interested in predicting the next horizon for art. His foraging, even when diluted,

was bound up in his own identity as an artist. His appropriations were always an inventory of historic devotions. Eventually, Rosenberg deduced that Gorky, like de Kooning, was an artist who defied formalism's progressive or linear continuum. He was an "outsider."[22] But Rosenberg also knew there were distinctions that separated the two men. Although they both siphoned from other artists, de Kooning recontextualized his citations as problems, which he evaluated to see if they could be of use. The portraits of male subjects that he began in the late 1930s, for instance, integrated his study of Ingres's modeling with Cubist-type fracturing. De Kooning eventually realized that mixing these disparate styles was fruitless. He moved on to his *Women* series and *Pink Angels* (1945), which were less beholden to sources. His looking was distilled into "impressions,"[23] as Rosenberg noted, rather than retained as excerpts. Unlike Gorky, whose debts were conspicuous, de Kooning's plundering became part of his "protracted acts"[24] and immersed in his increasingly frenzied brushwork. While study of the past was also bound up in de Kooning's identity, a primary difference obtained for Rosenberg: he kept his contact with tradition alive and painted the human body to state "his continuing skepticism toward vanguardist dogma."[25] Gorky was never a doubter or skeptic. His citations grew from adulation.

to keep art and identity in flux

Rosenberg's book on Gorky emerged just as Pop Art became an international sensation. Pop's cool anonymity posed not only a contrast but a threat to *action* painting and its gestural intensity. During this period, Rosenberg hit his stride as an art critic. No sooner had *Arshile Gorky* been released and widely reviewed in the press,[26] than he accepted William Shawn's invitation to temporarily relieve Robert Coates as art critic for the *New Yorker*. Coates, who was suffering from cancer, thought Rosenberg was "a good choice . . . [but] a little biased in favor of the Abstract Expressionists."[27] True to Coates's prediction, Rosenberg wrote about artists whom he knew in his articles for the magazine and used the venue to establish the New York School as a distinct, watershed event. He began, moreover, to refer

to *action* painting in the past tense, knowing it had become a mannerism in the hands of younger imitators. As he announced in 1962, "Action Painting was the last 'moment' in art on the plane of dramatic and intellectual seriousness."[28] He understood that its historic relevance had been tied to the political crises of the 1930s, when the assertion of individuality was viewed as a rejoinder to totalitarian collectives. Once that urgency was no longer felt, Abstract Expressionist art existed as an echo of "defiance,"[29] unlike Pop and the New Abstraction (or Color Field Painting and Minimalism, as it was later dubbed) that was the product of "a new kind of esthetically sophisticated craftsman."[30]

In his coverage of exhibitions of Gorky, Mark Tobey, and Franz Kline for the *New Yorker*, Rosenberg conceded that "Abstract Expressionism *is* the Establishment, and the retrospectives make it plain that its present advantage is not going to last forever."[31] He bemoaned that the upstaging of *action* painting was in part the outcome of an undiscerning press and museum community, whose members now giddily discussed art in formalist terms as a "continuous experiment."[32] There were a few mid-century artists who were also culpable for the new retrenchment of the self. The New Abstraction was too indebted to Ad Reinhardt, an artist who Rosenberg believed had "combined historic inevitability . . . with esthetic objectives."[33] In a combined review of *Americans 1963* at the Museum of Modern Art and *Toward a New Abstraction* at the Jewish Museum, he found scant evidence of a drip or a stroke. Reinhardt, who appeared in the MoMA show, had become pivotal for a generation of younger artists who emerged at the height of the Cold War. His austere canvases that eliminated any hint of brushwork predicted the new radical art that Rosenberg understood "to exclude from painting all values except those of art."[34] In short, it was patently ideological. The artist's psyche had ceased to be an agency. The deadpan, emotionless work of Morris Louis, Kenneth Noland, and Frank Stella, in addition to Andy Warhol, left Rosenberg wondering whether these artists were pandering to audiences. Just as troublesome was whether the New Abstractionists were enacting the dogma of formalist criticism. As he argued in one of his last pieces before Coates returned, these new

movements were hell-bent on opposing the life force of Abstract Expressionism. They were regarded more for the "novel state it induces in the spectator."[35]

As Rosenberg assessed the art scene for the *New Yorker*, he observed that a new professionalism had taken hold that was expressed through an art-about-art stance. It seemed to portend the death of modernism itself. For Rosenberg, as a writer who had matured during the Depression, the presence of the artist's subjectivity would remain a benchmark to offset the traits of Pop Art and the New Abstraction. He remained devoted to those *action* painters whose work exhibited some degree of "humanity."[36] It was his criterion. He continued to write about Gorky, Hofmann, de Kooning, Newman, Guston, Kline, and Saul Steinberg at every turn. They were his stalwarts who were committed to "keep . . . art and identity in flux"[37] by resisting what he considered the sensational and faddish trends that had beset the 1960s.

After Coates returned to the *New Yorker* in 1963, Rosenberg was invited to write a series of articles for *Vogue* magazine in which he built on his observation that the modernist period was rapidly collapsing. He knew its overarching unities, such as faith in progress, had ceased to be meaningful. But he also defended his buddies. In response to the pervasive criticism that de Kooning's work was in "a state of decline,"[38] he stated that the artist had always stood apart from his peers. De Kooning had gone his own way, even when he returned to his *Women* series in 1961 after a hiatus. How could his critics presume that the continuation of his series represented stagnation, given their ongoing invention? There were changes to his women, or *Clam Diggers*, as the artist now called them. Gone was the dominant, gestural black outline and its intimations of violence. The series capitalized on the light in his huge glass-walled studio in East Hampton—which he built during this period—which resulted in heightened luminosity.

Beyond evidence of renewal in de Kooning's *Clam Diggers*, Rosenberg used the metaphor of "decline" to explain how Pop Art and the New Abstraction accentuated "objectivism," as he called it, to appeal to new audiences who were perplexed by the private content

of Abstract Expressionism. He wrote about Jasper Johns, a transitional artist, whose paintings of American flags, targets, letters, and numbers inverted the personal codes of New York School painting. ("Transitional" in the sense that he bridged Abstract Expressionism and Pop Art.) As he expressed it in *Vogue*, in Johns, "the adventurer or autobiographer in paint has been replaced by the strategist of ends and means."[39] His work, like Robert Rauschenberg's, operated more effectively in the public arena than de Kooning's and Gorky's paintings. Even though Johns and Rauschenberg had raided the catalogue of *action* painting for remnants of its core elements, such as the drip, smear, skein, smudge, and swath of paint, these features were delivered with studied self-consciousness.

Rauschenberg's *Factum I* and *Factum II* (1957; figs. 28 and 29), for example, perfectly illustrated this externalization. His pair of near-identical paintings mocked the trademark spontaneity of Abstract Expressionist art through duplication and pseudo-anonymity. They were no longer about angst but about parodies of the artist's subjectivity. Similarly, Johns's insignia, despite their textured surfaces and "willful messiness,"[40] were unruffled reflections on the immediacy of *action* painting. Through his inscrutable use of mundane images, Johns had coyly quelled exposure of his inner life and transformed this reserve into an object such as a target. Despite the banality[41] of his imagery, Rosenberg cottoned to his work because it had none of the "grossness favored by the Pop artists."[42] It did not surrender to the brand name of a Campbell's Soup can or to a Ben Day dot in a comic book. He recognized that Johns had successfully negotiated a new type of viewer through his restraint. The meanings of his paintings were paradoxically more available.

Rosenberg would return to the *New Yorker* on a permanent basis in early 1967. His first article after his return resumed his conversation about the Neo-Dada jest that lay at the heart of Johns's and Rauschenberg's tactics. The issue of "art's denial of its identity"[43] continued to press on him. As he surveyed the New York scene in the late 1960s, he thought about the iconoclasm of Rauschenberg's erasure of a drawing made by de Kooning in 1953 and its connections to Marcel Duchamp's graffitied *Mona Lisa*. Through

his performance of rubbing out as much of de Kooning's imagery as he could, *action* painting became silenced, just as in Duchamp's jab at a Renaissance masterpiece. Rosenberg noted that this blank object took the air out of Expressionism by demolishing the age-old practice of drawing. Rauschenberg's act of obliteration was the consummate embodiment of anti-art. What was equally remarkable was that his mischief appealed directly to the guardians and interpreters of culture, an empowered audience. It was, as Rosenberg later wrote, "the first work with an exclusively art-historical content and produced expressly for art historians."[44] How else to explain its prominence as a fixture in museum exhibitions? How else to explain its evocation of Dadaist history? It was, ironically, as Rosenberg exclaimed in 1967, "the most significant creative gesture of the past two decades."[45] Rauschenberg's *Erased de Kooning Drawing* unwittingly presaged the process-oriented work of Minimalism in the mid-1960s, where there was little or no accommodation of the artist's interiority. But that did not mean that Rosenberg was a convert or even faintly predisposed to this changed situation.

When Rosenberg wrote about Rauschenberg's and Johns's provocations, it was always through the lens of antithesis, measuring their defiance with artists such as Gorky and de Kooning who had taken to art history with sincerity. He acknowledged the far-reaching effects of Rauschenberg's and Johns's work and the way they had altered the discussion of art as well as its audiences. As an old dialectician who got his start as a Marxist, he knew that once anti-art strategies were revived in the 1960s, the avant-garde had had its last act. The age of self-discovery and transformation was over. The resulting void left artists with "an eye on the museum, and on their place in history."[46]

Rosenberg knew when he began his study on Gorky that the artist's fate—that is, his suicide—could be spun as a trope for the end of the modernist period. During his lifetime, there would be few subsequent chapters in which subjectivity could be an inroad for interpretation. As postmodernism unfolded after 1968, Rosenberg's critical interests shifted to the American cultural establishment: to the museums, commercial galleries, and the academy, which were

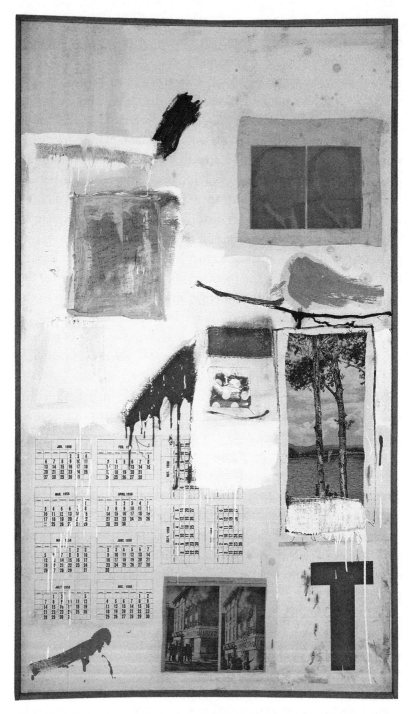

Figs. 28 and 29. Robert Rauschenberg (1925–2008), *Factum I* and *Factum II*, 1957. Oil, ink, pencil, crayon, paper, fabric, newspaper, printed reproductions, and painted paper on canvas; each 61 3/8 × 35 ½ inches. The Museum of

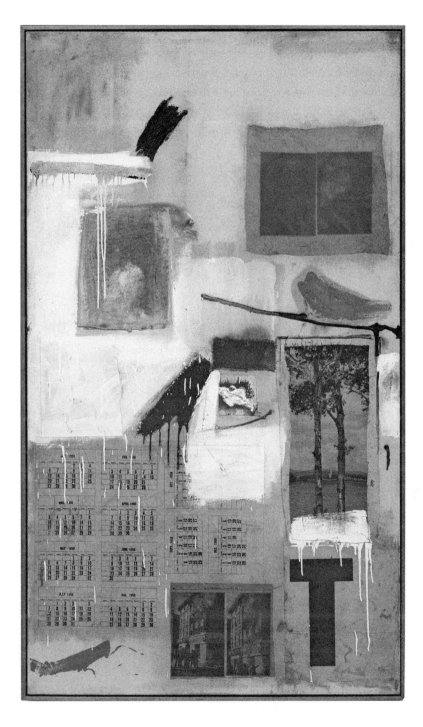

Contemporary Art, Los Angeles; and The Museum of Modern Art, Purchase and an anonymous gift and Louise Reinhardt Smith Bequest (both by exchange).

still committed to the preservation of modernist history.[47] There was another interlude, however, that honed his focus on these institutions. With the emergence of *Artforum* in 1962, Rosenberg had reason to become concerned about the destiny of his conceit of *action*. Formalist criticism not only made a comeback in the magazine, but its new imitators used its pages to avenge Rosenberg's prominence as a writer.

21
problems in art criticism
artforum

Artforum was co-founded by Philip Leider in San Francisco in 1962, just as Rosenberg published his volume on Arshile Gorky. Leider had no formal education in the fine arts, but he was an avid reader of poetry and a self-declared humanist who believed that he had a calling to become an editor. While working as an assistant at the Bolles Gallery, where he wrote the monthly bulletin, he hatched *Artforum* to cover the Bay Area art scene. With John P. Irwin, a printer who initially underwrote the publication, and John Coplans, a self-taught artist from South Africa, Leider quickly made *Artforum* into a viable entity. Within two years, it was relocated to Los Angeles where it grew substantially in size, and eventually to New York in 1967, where it is based today.

Leider was the presiding editorial voice until he resigned in 1971 and Coplans took over.[1] He had a headstrong, obsessive personality, the force of which was felt in his editorial decisions and support of key writers. Rosenberg wrestled with Leider soon after *Artforum* was launched. Leider had reviewed his study *Arshile Gorky* for one of the first issues and was typically forthright in stating his disagreements. Ostensibly, he tried to be circumspect by declaring his affinity with Rosenberg's "sympathetic interest"[2] in the artist. He was relieved that the biography was unconventional and spared the reader a drawn-out chronology that related to Gorky's life, such as his family, wives, children, and old lovers. Still, he felt there was not enough analysis of Gorky's painting. The book could have benefited from sustained description of major works. Leider also wanted to

see more evidence of art history, such as sources and comparisons, to round out the otherwise exemplary book. Ultimately, his reservations revealed more about the editorial direction that he set for *Artforum* than his perception of the shortcomings of Rosenberg's take on an artist who did not fit the modernist canon. Under Leider's leadership, the magazine embraced a distinctly formalist agenda that placed Rosenberg on the outside of its program.

Rosenberg quibbled with Leider's review and followed up by sending a letter to Irwin[3] (who was listed on the masthead as publisher and editor) that was published in a subsequent issue. Unlike Leider's expectation that he probe more thoroughly the references that informed Gorky's *Diary of a Seducer*, Rosenberg felt that he had done his job. There was no need to amplify what he had written. His rejoinder infuriated Leider, who responded privately in a letter regarding what he deemed missing in Rosenberg's handling of the artist:

> All right. I don't know why you didn't go more deeply into Gorky's iconography; I don't know why you backed away from doing anything exhaustively; I don't know why you didn't give any detailed consideration to Gorky's role in the lives and work of the subsequent action painters, de Kooning in particular; I don't know why you refused to discuss his last months and his death. All of these matters, and others, were in my mind when I wrote my review of your book, but I mentioned none of them, because I'm pretty certain that you do know why and I wasn't about to start getting wise about a book that came closer to doing the job, and showing how the job should be done, than any other I've read.[4]

Ironically, Leider's blast included an overture to Rosenberg to write for *Artforum*. Since Rosenberg was visiting the Bay Area to give the Regent's Lectures at Berkeley, he thought that he might want "to gather . . . [his] impressions of West Coast art."[5] But he also threw out a disclaimer: it was not clear to him if Irwin paid for contributions by outside contributors. Rosenberg did not respond to the offer. During Leider's tenure, Rosenberg's presence in *Artforum*

was confined to a single Q&A taken from a talk that he gave to the Contemporary Art Council of the Los Angeles County Museum of Art (LACMA) in 1963, as well as a few letters to the editor. The absence of his voice was telling.

Rosenberg was treated somewhat deferentially by Leider in the early years of the magazine. In the introduction to the Q&A, he was billed as a "distinguished American art critic."[6] But this praise was out of scale with Leider's distillation of his remarks on the recent preoccupations of art criticism to just two pages. Rosenberg clearly must have goaded him with his observation that the writing in journals such as *Art International*—a much read publication that came out of Lugano, Switzerland—had adopted the traits of the New Criticism. He argued, "One looks at the painting over and over again and is unable to *see* what the writer is writing about—perhaps it isn't there. The critic sees it because it is his thesis."[7] By contrast, he felt that his own writing was the outcome of talking with artists. This was the only time that Leider afforded Rosenberg a platform. Under his direction, he soon made it clear that *Artforum* was not interested in intentionality and process. As the magazine rethought its focus on the San Francisco arts scene and grew to become international in scope, Leider advanced an editorial project that took its cues partially from Clement Greenberg. Greenberg published on only three occasions in *Artforum,* but his influence on a younger generation of East Coast writers who became contributors was transparent.

problems in art criticism

From the beginning, *Artforum* had engaged a few writers from New York to review exhibitions. Among them was Max Kozloff, who became an associate editor in 1964. Kozloff, who wrote the Art Column for *The Nation* during most of the 1960s, also served as a New York correspondent for *Art International* from 1961 to 1964, but left after an altercation with its publisher and editor, James Fitzsimmons. Kozloff's relationship with Fitzsimmons was always tense but became particularly strained over his response to Greenberg's essay, "After Abstract Expressionism," which ran in the magazine in 1962.

He found the text "smothering in its adherence to historical determinism,"[8] and its praise of just two artists, Morris Louis and Kenneth Noland, both of whom Greenberg had proclaimed revealed no debt to the painting of predecessors To Kozloff, this was an absurd explanation for the path of postwar art. As he spelled out in his long rebuttal in *Art International,* Greenberg's "tyrannical view of knowledge" and the "quasi-religious tone"[9] of his writing had resulted in the dismissal of too many artists, such as Jasper Johns, who broke with the bloodline of Abstract Expressionism. (By contrast, Kozloff was not swept up by Pop Art; he felt that its "relations with market values and fashion turns their work frequently into mere commodities."[10] He nonetheless felt Pop was worth writing about, as its departure from the New York School pointed to a crisis in painting.)

Kozloff's letter represented the first major attack on Greenberg and appeared before Rosenberg's rejoinder to "How Art Writing Earns Its Bad Name" in *Encounter.* He felt not only that Greenberg's explanation of modernity was exclusionary but also that his logic was flimsy. Greenberg's account of a seamless art history, tied through peak stylistic episodes, had been used primarily to support his own aesthetic preferences and was not as empirical as he implied. Shortly after his letter was published, Kozloff contacted Michael Fried, with whom he shared duties as a New York correspondent. He recounted that Fried, who was pursuing a PhD in art history at Harvard, responded with hostility and announced, "I don't think that I want to talk to you. You are, in my opinion, the enemy. And I dislike intensely what you've done."[11] He was, of course, referring to Kozloff's takedown of Greenberg.

Fried's fealty to Greenberg was forged in 1958 while he was an undergraduate at Princeton. He became acquainted with the critic's formalist thinking through his classmates, Walter Darby Bannard and Frank Stella, and subsequently sought him out in New York. Greenberg in turn recommended Fried to Fitzsimmons for *Art International.* Fried joined *Artforum* in 1965, a year after Kozloff became the New York associate editor. Yet once he became affiliated with Leider's journal, he had a direct hand in determining its edi-

torial mission. Leider acknowledged his "hero-worship"[12] for the young student. He was swayed by Fried's "brilliance"[13] and ability to hold forth not only in his writing but also in conversation, attributes that Leider claimed changed his life. He believed Fried was responsible for elevating the magazine through his considerable reflections on art criticism. He was also impressed that he treated criticism as an intellectual discipline. It redounded on him as an editor. As a result, Fried set the bar for all submissions to the magazine. Kozloff, by contrast, never made the cut. Leider admitted that "most writers had *carte blanche* . . . except maybe Max. I didn't like the way Max wrote, always." His objections stemmed from the "poetics"[14] that Kozloff brought to contemporary art.

Fried's rigor derived from emulation of Greenberg. As Leider averred, Fried "admired Clem for being proud of the fact that he was an art critic, he wasn't ashamed of it. He thought that it was a noble thing to be."[15] Yet, Fried's regard for Greenberg's literary commitments was not to last. Art criticism never become his lifelong calling. He drew substantially from Greenberg's evaluative approach, but the approval he sought from the patriarch was short-lived and the parting dramatic.

Unlike Fried, Leider was never drawn to Greenberg; he never revered his writing. Although Fried had rethought Greenberg's reasoning on modernity's unfurling, by the early 1970s he gave up on art criticism and the field that he had found so uplifting. As a trained art historian, he had come to realize that "with the eclipse of high modernism in the later 1960s and 1970s (and after) the role of criticism became transformed—into cultural commentary, 'oppositional' position taking, exercises in recycled French theory, and so on."[16] Greenberg ceased to be useful, let alone current. Despite his adulation of Fried, Leider never bought into Greenberg's critical position. He commented in 1967 that "while I find . . . Clem's talk about 'modernism' interesting, I find none of it convincing and none of it enriching."[17] In fact, Leider was not persuaded that Greenberg's judgments constituted a model for *Artforum*. He was more interested in what he called "genuine appreciations," whereby an author expounds on "*how* he likes or dislikes a work of art."[18]

Leider tried to exercise these preferences as an editor, but his execution was always contradictory. Fried remained his paragon: he was capable of arguing for the coherence of modernism and for artists such as Louis, Olitski, or Stella who added to the paradigm. Although Leider professed to have reservations about Greenberg, the critic's ideas were abundantly embodied in Fried's lengthy essays. (In 1969, Leider devoted the entire March issue of *Artforum* to Fried's dissertation on "Manet's Sources" because he thought "he was doing the world a favor.")[19] There were times, moreover, when Greenberg bullied Leider into trying out a "third string of writers,"[20] such as Kermit Champa, Terry Fenton, and Kenworth Moffett, who mimicked Greenberg. Leider eventually gave up on them—they were too "boring."[21]

Greenberg's ideas were also seeded in the writing of Rosalind Krauss, a classmate of Fried's at Harvard, as well as of Barbara Rose, a friend who introduced Fried to Leider. Rose had also written for *Art International*. Leider recalled that Rose "brought in everybody"[22] from the Switzerland-based magazine, except Max Kozloff who introduced her to *Artforum*. Rose had been Tom Hess's assistant at *ARTnews* in the late 1950s while a graduate student at Columbia, an association she hid until 1962 when she read Greenberg's "How Art Writing Earns Its Bad Name." She claimed to have been "nauseated by what was passing for art writing, it was obviously total garbage: mental doodling by poets and Harold Rosenberg's sociology."[23] Fried had a similar view of *ARTnews*, and later declared that "what was filling the space was all that fustian writing—Hess and the others . . . it was actually useful to have that to react against."[24] Rose insisted that she had been seduced by Greenberg's criticism for only a year, but by the time she became associated with *Artforum* in 1965, he had ceased to have a hold on her. His writing had become "so clearly dogmatic and unresponsive to what was going on that it didn't hold water anymore."[25] That he privileged few younger artists also tinged her reaction. (His many omissions included Frank Stella, Rose's then husband, whom Greenberg never wrote about at length.)

Yet Rose's prose grew out of a close reading of Greenberg and Hilton Kramer, his acolyte, as well as Meyer Schapiro (Schapiro was her teacher at Columbia but, according to Rose, resisted disciples). Her initial attraction to Greenberg's ideas was bound to his mandate for observing how a painting functions compositionally. She acknowledged that she "wanted to get rid of all those adjectives and all that stuff that stood between . . . the thought and the words."[26] Krauss similarly talked about a "breakthrough" after reading Greenberg's explanations of modernism in *Art and Culture*. "Until then," she said, "I had been very frustrated by the vagueness and unverifiability of *opinion* that characterized the writing of Sidney Janis, Tom Hess, Harold Rosenberg and those people. Dore Ashton. Everybody."[27]

the politics of art, part 1

Prior to their meeting in 1965, Leider reviewed Fried's exhibition *Three American Painters* (focused on Noland, Olitski, and Stella), which he curated for the Fogg Art Museum at Harvard University. He equivocated over Fried's long preamble in the catalogue on Pollock, where he argued that "the tendency of art writers such as Harold Rosenberg and Thomas Hess to regard Pollock as a kind of natural existentialist has served to obscure the simple truth that . . . his art was not with any fashionable metaphysics of despair but with making the best paintings of which he was capable."[28] Leider did not understand the remark, finding it "gratuitous and full of hidden hostilities."[29] He was still open to Rosenberg and maintained that "The American Action Painters" was a seminal text that not only captured the aspirations of a generation of artists but was relatively free of ideology.[30] But once Fried and Rose had Leider's ear, his impassioned defense of Rosenberg's existentialism would have no future in *Artforum*. Leider later admitted that he was "afraid" of Barbara Rose, that she "really had no loyalties,"[31] being prone to demean and ridicule most people. While he acknowledged that she had convinced many writers to abandon *Art International* for *Artforum*, and was crucial in the decision to move the magazine from Los Angeles to

New York, he thought her ultimate ambition was to become an "art world star."[32] He questioned whether her writing was a means to dominate the transformed art scene of the mid-1960s.

The same month that Leider reviewed *Three American Painters*, Rose published a piece on the connections between Rosenberg's criticism and a second generation of Abstract Expressionist painters she deemed indentured to de Kooning and Kline. Unlike Leider's approbation of Rosenberg's metaphysics, Rose maintained that "The American Action Painters," while important in "winning public recognition for native art,"[33] had inspired too much bad painting. His emphasis on the "act" had culminated "in the worst excesses of self-indulgence."[34] What was needed was less gestural bombast and more cerebration. Rose thought that the painting of Grace Hartigan, Alfred Leslie, Joan Mitchell, and Larry Rivers was particularly handicapped by "facile illustration"[35] of de Kooning's brushwork. Leslie's and Rivers's canvases suffered, furthermore, from too many displaced allusions to the landscape and the figure. Instead, she felt the spare deliberations on geometric form and vibrant use of color in the work of Ellsworth Kelly, Noland, and Olitski were more far-reaching.

In the late 1950s, there had been considerable discussion as to whether Abstract Expressionism had devolved into an academy. Had de Kooning's frenzied swaths of paint engendered a flock of imitators? *ARTnews* devoted two articles to the issue, in which Irving Sandler, a contributing editor, solicited statements from artists such as Helen Frankenthaler, Ad Reinhardt, Milton Resnick, and Jack Tworkov. Frankenthaler presumed that most work associated with a second generation of Ab Ex painters was "derivative"[36] of de Kooning. Reinhardt explained that the omnipresence of these emulations was due to "a big market."[37] (Reinhardt had already published "Twelve Rules for a New Academy" in *ARTnews* in 1953, advocating for "no texture, no brushwork, no forms, no design, no colors, no light, no space, no time, no size or scale, no movement, no object, no subject matter.")[38] There were a few holdouts who maintained that gestural painting renewed a key moment in American art. Res-

nick and Herman Cherry, for instance, disclaimed any notion of an academy, believing the suggestion to be both speculative and trivial.

Barbara Rose was aware of the debate in *ARTnews*. It appeared around the time of her brief tenure as Tom Hess's assistant. In fact, she invoked these statements in her essay in *Artforum* in 1965 when she blamed Rosenberg's idea of *action* for perpetuating the New York School though a group of younger painters. Three years later, Rose developed her theme into "The Politics of Art," a feature that was part of a new series that Leider inaugurated called "Problems of Criticism." Leider had hoped the series "would open up the differences on the staff"[39] to *Artforum*'s readership so that he could mine the aesthetic tensions that existed between writers such as Kozloff and Fried. Fried was not interested in contributing to the column, but Rose used the stump to protest what she deemed Rosenberg's befuddled rhetoric and passé political interests. She believed that since Rosenberg had returned to the *New Yorker* in 1967, his Marxism had become ill-placed. As she had it, his "idealism had turned to cynicism, and the critic of the mass media had become its employee."[40] However, Rose's biggest blow was reserved for Greenberg and Fried. Where she once found Greenberg's comparative aesthetics liberating, she now complained that both writers' prose was larded with the same hyperbole and out-of-touch Marxism that she located in Rosenberg's commentary.

To think of Fried as a Marxist was a huge leap given his emphasis on the autonomy of art. Yet Rose felt his narrative of modernism was spiked with political language. Terms such as "dialectical" and "perpetual revolution" had no place in formalist writing, she thought. They detracted from criticism's larger purpose to find descriptive equivalents for the paintings of Noland, Poons, and Stella, none of which issued from political upheaval. In Rose's hands, criticism was to be a "relatively dispassionate and morally and politically neutral activity."[41] Both Fried and Greenberg were too polemical: they behaved like tired Trotskyites, just like Rosenberg.

Leider had also invited Greenberg to contribute to "Problems in Criticism." His response was published before Rose's and centered

on the meanings of "formalism," a word that he was dismayed to find had become favored by his younger imitators. Rose must have felt rejected by Greenberg, especially since "formalism" was a label she deployed with frequency. He thought the term had been abused, particularly by writers unacquainted with its history as a Russian literary movement in the early twentieth century. As he said, a certain "vulgarity"[42] resulted from indiscriminately wielding such terminology. Most recently, it had degenerated into a simplistic, two-sided argument that placed "form and content" in opposition. (Lawrence Alloway was one of these offenders who drew on the polarity to distinguish the views of Greenberg and Rosenberg.)[43] Content, Greenberg countered, was too "indefinable, unparaphrasable, undiscussable"[44] to stand as a separate category, immersed as it was in form. Art upheld "quality"[45] only if successful as composition. Greenberg applied his dictum to all painting, even Renaissance art that had a prescribed iconography. According to him, there was no reason to parse symbols: that was never the artist's intention. An image was something required by an academy or patron until the modern period. The real story had always been pictorial invention.

Rose's differences with Greenberg were basically about semantics—holdover words he had used since his days as a socialist. What really irked her, however, was Greenberg's aversion to Minimalism, a trend that Fried felt had succumbed to theater.[46] Rose was keen on Carl Andre, Dan Flavin, Donald Judd, and Robert Morris, and had used their vocabulary of crisp, repeated geometric shapes to craft a moniker she called "ABC Art." The term was open-ended, broad enough to include Richard Artschwager, Anne Truitt, and Andy Warhol, as well as other artists involved in reductivist strategies that loosely adhered to the precepts that Ad Reinhardt had set forth in "Twelve Rules for a New Academy." These artists had rejected the painterly traits of Abstract Expressionism, specifically the legacy of Willem de Kooning.

Greenberg was never in league with Reinhardt or de Kooning. In his estimation, Minimalist sculpture was "very small stuff"[47] when compared to the painting of Noland and Olitski. It was too much of an idea to be taken seriously. Its sobriety was motivated by an inter-

est in being "far out,"[48] rather than by a searching investigation of visual experience. Fried went one step further and fussed over Minimalism's insistent "presence," another concept lifted from Greenberg. Presence was denoted by size, among other factors, and its "objecthood"[49] only ended up overpowering and confounding the viewer. The requirement for "purity" intervened in both critics' appraisals of Minimalism. Purity was also Rose's tack, but she got to ABC Art through another route: Reinhardt's monochromatic painting (which Greenberg regarded as overly "slick.")[50]

Greenberg, and by extension Fried, had never been able to reconcile the third dimension in contemporary art. The lone exceptions were David Smith and Anthony Caro; they made the grade because their sculpture was thought to be composed like painting. Both critics were unsettled to find, moreover, that Minimalism had disrupted the contemplative relationship a viewer had with a picture. In their view, artists such as Carl Andre and Robert Morris had transgressed by asking audiences to take in their huge, mass-produced units of aluminum, copper, concrete, plywood, or steel in real time. That their sculpture required circumnavigation was evidence to both writers that the sculptors had crossed an aesthetic line: their work had become "non-art."[51] Minimalism defied opticality, the fundamental axiom of their critical platform.

the politics of art, part 2

Rosenberg also had reservations about the Minimalist movement, believing that, like Pop Art, it was too "dull"[52] to engage the viewer. His thesis flew in the face of Fried's notion of theater. Instead of evidence of the artist's self-transformation, the audience was given "radical self-presentation."[53] As Minimalist sculpture was outsourced, Rosenberg suggested that the artist's ego had been displaced, now conveyed as persona. The same situation applied to Andy Warhol whose Factory produced his paintings. The deemphasis on the self and the cool look made for an entirely different approach to art, Rosenberg concluded. Minimalist and Pop artists had become "maker[s] not of objects but of a public image."[54]

There were a few exceptions in Rosenberg's account: Claes Old-enburg's soft sculptures of hamburgers, ice-cream cones, and Pepsi Cola signs from the early 1960s were laden with messy skeins of paint or the residue of his process. However, Rosenberg never doubted that Minimalism and Pop had fallen into the category of nonart, as Fried had stated. "It is art inasmuch as it is an incident in the formation of an art-world protagonist,"[55] he averred. He was more interested in how the artist had become both a performer and an orchestrator of commodities in the 1960s. Warhol was particularly suspect here, as he had become a "celebrity who had no relationship to the meaning of his work."[56]

Rosenberg observed that the new formalist writers, or Greenbergians, were partly responsible for this changed situation. Without naming Rose directly, he excoriated her explanation of Minimalism and Pop Art as socially disengaged. Why not contend with the implications of a repressed subjectivity in contemporary art? he wondered. Her criticism was the result of flabby thinking. Once he was appointed art critic for the *New Yorker*, he indirectly evoked Rose after reading her piece in *Artforum*:

> Some people deny this ABC of advanced art; they believe that art is carrying on business as usual, that de Kooning or Newman or Judd is engaged in the same enterprise as Grunwald and Rembrandt . . . This perfect art lover is an amusing personage of fiction, customarily identified with the eighteen-nineties. The aesthete today, however, is a specialist who has adopted his suprahistorical aestheticism for professional reasons; like specialists in other fields, he wants to limit the substance of his study in order to be able to deal with it more effectively.[57]

Rosenberg never outed any of these aesthetes in print unless he was addressing Greenberg. He always referred to them euphemistically. However, he had plenty to say later in unpublished interviews about the fracas that Greenberg and his disciples had created in the 1960s. Once Fried became an academic, Rosenberg lashed out at the "spe-

cialists" who had codified formalism. He thought of them as "careerists,"[58] who had tried to spin Greenberg's belief in an art continuum into science. As he said of Fried and Henry Geldzahler, a curator of modern art at the Metropolitan Museum and another early contributor to *Artforum*, they are "professional types [who] want art to proceed logically on an upgrade so they can say this comes out of that, and this is a development of that."[59] Their writing had become jargonistic and perpetuated the myth that formalism's languages were verifiable. Rosenberg worried that the aesthetes had become a "very conservative element in the art world,"[60] latter-day connoisseurs who made value judgments rooted in essentialist theory. On a personal basis, he found them to be "disgusting individuals,"[61] particularly since their writing abetted a marketplace they chose to ignore. He had never met one whom he liked, most of all his nemesis, Clement Greenberg.

the american art establishment

Philip Leider has stated that Harold Rosenberg "hated *Artforum* from the beginning because it was in competition with *ARTnews*."[62] However, Leider's contrast with a rival publication omits the backstory of *Artforum*'s pronounced ideology and internal politics. John Coplans, an editor at large and Leider's eventual successor, had a more nuanced take on Rosenberg's relationship to the magazine. When the publication was still based in Los Angeles, he met with Greenberg's coterie in Manhattan, hoping to interest them in joining its team of writers. Coplans had just written a review, which was about to be published in *Artforum,* of *Post Painterly Abstraction,* an exhibition that Greenberg had assembled for LACMA that drew on the work of Jack Bush, Gene Davis, Ellsworth Kelly, Frankenthaler, Noland, Olitski, Stella, and others. He had reservations about the show's thesis as well as its artists, arguing that it represented Greenberg's "personal notion of style . . . to reveal what . . . the major ambitious art after Abstract Expressionism *ought to look like.*"[63] Not only did Coplans's conversation with the New York group touch on

Greenberg's show, but it also extended to Rosenberg, whom he met on the same trip. Upon returning home, he was up front in reporting to Rosenberg that he was perceived as an "enemy":

> The enemy camp invited me to lunch on my last Sunday in New York—Fried, Rose, [Robert] Rosenblum, Judd, Geldzahler . . . Their attitude towards you is so illogical—I pulled their legs, they took it well. I found Fried bright, but think he has a poor eye and gets far too involved in putting people down to try and establish his intellectual superiority . . . Rose has (I think) a much better eye, but she has Stella right behind her . . . They all detest Alloway. I feel cautious about discussing them—they have great energy and will power and their tendency to hunt in a pack makes them dangerous. I think they are very scared of you. It would seem to me that to a considerable extent the future of American art can be very strongly influenced by this group . . . I don't know enough about the N.Y. scene but it would seem to me if Greenberg has created this pool of young critics, it is a terrifying situation, since I have never seen a similar group before. Usually critics maintain an independent position writing for different journals. And I really cannot say how loyal they are to Greenberg—they knew his show was terrible.[64]

Coplans also portrayed *ARTnews* as a competitor but in inverse order to Leider's rating: he considered it more ascendant.[65] Rosenberg had no animosity to *Artforum* at the outset. He had agreed to have his Q&A at LACMA run in the magazine a few months before Coplans met with Fried, Rose, and company. It was only as the "aesthetes" began to wield power that he questioned their indebtedness to Greenberg. They became an iteration of the "herd of independent minds," writers who followed a predictable pattern of staking out their intellectual authority, only to become mainstream. It is revealing that Coplans thought they were "dangerous." The "pack" mentality was also off-putting to him. They had tried to push out Rosenberg and Alloway from *Artforum* but had no loyalty to Greenberg, their erstwhile guru.

Shortly after Coplans returned to Los Angeles, Rosenberg published a much discussed piece in *Esquire* called "The Art Establishment." From the many art-world types in his monolith—artists, dealers, collectors, critics, and curators—emerged the "functionary [with] the temptation to be the independent instigator of trends, styles, and reputations, with the artist as his submissive instrument and grateful beneficiary."[66] He announced that "even the art of the past seems susceptible to establishment control through the practice of assembling works under tendentious labels."[67] Rosenberg mentioned few of these "functionaries" by name. Those who did appear in his article, such as Dorothy Miller of the Museum of Modern Art, were the result of pressure from the publisher to make his power structure clearer (much to his annoyance).[68] *Artforum* was implicitly woven into Rosenberg's cultural behemoth: he mentioned the phenomenon of the newly minted art historian as well as the formalist lingo required to be influential. The magazine was listed, furthermore, in a two-page chart that dwarfed Rosenberg's article (fig. 30a–b), which *Esquire* constructed to highlight the institutions and players that were part of the Establishment. Long lists of galleries and key artists were included alongside arbiters like Miller. The chart also wittily dispensed advice to wannabes, such as where not to be seen: the Tuesday-night openings at the Museum of Modern Art and the communities of Woodstock, New York, and Ogunquit, Maine, in the summers were passé. The Hamptons was where it was at.

Max Kozloff appeared in *Esquire*'s diagram as the New York correspondent for *Artforum* and as the art critic for *The Nation*, alongside numerous other writers, such as John Canaday and Stuart Preston of the *New York Times* and Robert Coates, Geoffrey Hellman, and Calvin Tomkins of the *New Yorker*. *ARTnews* and Tom Hess were positioned at the top of the list, as was *Art International* and its writers Michael Fried and Barbara Rose. It was too early in its history for *Artforum* to have an expanded entry, especially given its base in Los Angeles, which was still perceived by diehard New Yorkers as a provincial outpost. However, Coplans's prophecy about Greenberg's followers proved to be right: the magazine

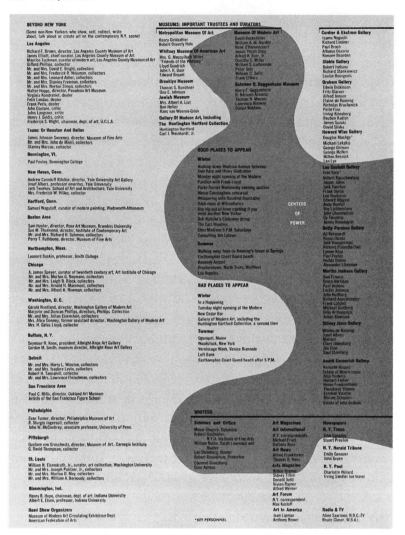

Fig. 30a–b. Chart to accompany "The Art Establishment," *Esquire*, January 1, 1965.

would soon occupy this dominion of power when it moved to New York in 1967.

That Coplans recounted to Rosenberg how he was perceived as an "enemy" by the Young Turks at *Artforum* no doubt affected Rosenberg's impressions of the magazine. That Greenberg hovered over the editorial direction was enough to muster his doubt about its critical priorities. Rosenberg refrained from responding to Barbara

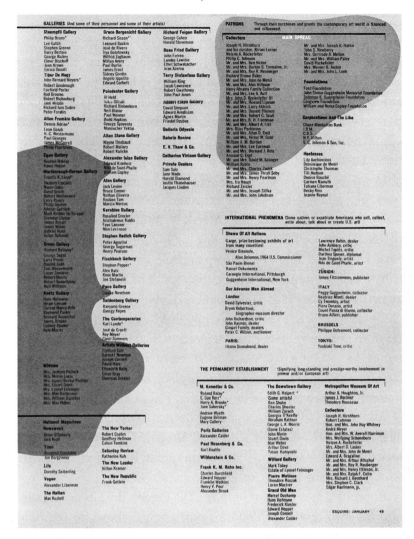

Rose's diatribe about his Marxism, but he did not hold back when it came to William Rubin, another formalist art historian who became a curator of painting and sculpture at the Museum of Modern Art in 1967. Rubin had trouble with the recurring application of *action* to Jackson Pollock, whose work was the subject of a major retrospective at MoMA just prior to his own appointment. He wrote four long articles in *Artforum* to proclaim that there were more solid ways to

elucidate the mid-century painter. Although Rubin felt that *action* was a suitable label for a second generation of New York School artists, of whom he was dismissive,[69] it could not explain Pollock. He adhered to the now party line that Rosenberg had appropriated his key trope from Pollock's dancelike movements, as well as from Dada poets, such as Raoul Huelsenbeck. As a result, Rubin thought that *action* theory amounted to a "myth"[70] whereby Pollock was wrongly implicated.

In a reply to *Artforum*, Rosenberg charged Rubin with repeating "gossip"[71] gleaned from Parker Tyler and Robert Motherwell. Ironically, there was little original content in Rubin's essay as it related to Rosenberg. Rather than recycling the assumptions that Fried and Rose had voiced about Rosenberg's retro existentialism, he mimed without attribution Mary McCarthy's adage of "how can you hang an event on the wall?"[72] To Rosenberg, Rubin's attack represented a cheap shot. This was the second time that he responded with a letter to the editor of *Artforum*. He protested: "I'd gotten tired of attempts like Rubin's to knock down a piece of writing ["The American Action Painters"] by ignoring ideas in it which one wishes to present themselves."[73] He thought that Rubin had lifted a passage about "line"[74]—Pollock's signature device—from his text, but his allegations were off. Rubin was not interested in expounding on Pollock's "body-movements."[75] But by this point, Rosenberg had had it with the ongoing attacks on *action*.

Rosenberg wove bits of his altercations with the Greenbergians into his own review of Pollock's posthumous show, for the *New Yorker*. It represented one of his first articles as the publication's art critic. Pollock was still depicted as a "cowboy, or the legendary he-man of the West,"[76] but he was also now a shaman who knew how to effect visual magic. This was the first time Rosenberg had written at length about Pollock's work.[77] It gave him the opportunity to flesh out his thinking on Pollock's process and finally declare his paintings to be rituals wherein he exercised his demons. The formalists, Rubin among them, had gotten it wrong, in part because of their closed reading that discounted external influences. Rosenberg invoked Rimbaud's "A Season in Hell," an extended poem read

both by the Surrealists and Pollock, to compare the artist to a "seer [whose]creativity was entwined in notions of madness."[78] Pollock was someone whose accomplishment was caught up in enacting his tormented psyche with elegance through his balletic application of paint. In the end, Rosenberg considered him an exemplar of *action*. There were key differences, however, from the work of his peers. Where de Kooning brought figuration and abstraction into a "balance of antagonistic factors,"[79] there was little overall formal tension in Pollock's canvases. Rosenberg noted that when Pollock began to drip paint in 1946, his compositions were no longer given to mythic references and had attained a "pure state [which] joined painting to dance and to the inward action of prayer."[80]

To the perennial charge from the formalist camp that his essays were devoid of looking, there was ample compositional analysis in Rosenberg's writing. How else to explain observations such as Pollock's "forms are contoured or cut by thick black lines, and the dark and heavy pigment is upon a ground of sinister grey."[81] *Artforum*, nonetheless, was not just a stronghold of formalism. There were enough differing viewpoints to counterbalance Greenberg's dogma. The magazine was less doctrinaire than its received history. Its coverage of the contemporary scene was actually expansive and included artists who worked in a variety of media, such as Donald Judd and Robert Smithson, both of whom were also contributors. The same applied to writers such as Kozloff and Lucy Lippard, who were not indebted to Greenberg and whose political advocacy had far-reaching reverberations in the art world during the height of the Vietnam War. (Lippard, for instance, co-founded Printed Matter, the artists' bookstore, and her feminism extended to the creation of the Heresies Collective.)

Leider has stated in hindsight that "the magazine was much, much more inclusive of the scene at any given time than for some reason we've gotten credit for . . . The reason for that was this overwhelming effect of Michael's writing. Every time Michael published anything it gave a tone to the whole issue."[82] But the glow that Fried brought to *Artforum* resulted in numerous defections, including his own in 1973. The fallout began in 1971 with Leider's departure as

editor. Part of his decision to quit grew out of Greenberg's retaliation for having been outed as a dealer in a posthumous interview with Ad Reinhardt that Leider ran in the October issue.[83] Fried had cautioned him not to publish the piece, fearing retribution. True to form, Greenberg responded with a skunky, name-calling letter. Leider was offended and expected support from Fried. When it did not come, Leider said he "began to feel my respect for Michael dropping, because I realized that he didn't share the value I placed on loyalty."[84] Leider felt it was time to exit New York. The scene had changed and become too rarefied.

In his farewell essay, "How I Spent My Summer Vacation," he revealed a quandary: he wondered if art could be reconciled with the counterculture politics of the era. Was revolution in art separate from history, after all? He had traveled to Berkeley with his family and from there took two road trips, to Nevada and Utah, to see Michael Heizer's *Double-Negative* and Smithson's *Spiral Jetty*. In his report for *Artforum*, Leider juxtaposed his impressions of these vast, site-specific works with revolutionary quotes from Abbie Hoffman, the political and social activist and a founder of the Youth International Party (or the Yippies). He was taken by Hoffman's synthesis of theater and insurgency, such as his performance tossing money onto the floor of the New York Stock Exchange in 1967. Hoffman had thought of his provocation as a "Happening."[85] But despite linking the earthworks with Hoffman's incendiary lines, Leider remained wedded to Fried's belief, as he paraphrased, that "the conventional nature of art was its essence."[86] In the end, he remained subservient to his most privileged writer.

Leider explained that his offbeat report of his holiday, with its first-person, rambling narrative, stemmed from his admiration of the so-called gonzo journalism promoted by Michael Lydon, a founding editor of a new Bay area publication, *Rolling Stone*. Gonzo art criticism, however, would never congeal into a literary movement, and once John Coplans took over *Artforum*, formalists like Fried and Rose migrated to other magazines and academic platforms. Max Kozloff and Lawrence Alloway, two of Coplans's mainstays, now benefited from increased prominence. Although Green-

berg was unable to exert his authority over the less impressionable Coplans, the turf wars and opposing camps continued. Rosalind Krauss and Annette Michelson, who had been a contributing editor since 1966, were now squared off against Kozloff and Alloway, their views on culture, aesthetics, and aesthetic experience vastly divergent. The sparring was still just as heated as when Leider had been the editor. Although Coplans had expressed incredulity to Rosenberg a few years earlier about the "pack" of formalist writers who wanted to control *Artforum*, there was no room for him in his editorial program.

Coplans did not want the old rivalry between Rosenberg and Greenberg casting a shadow over the magazine. Nor did he want to reverse course and switch allegiances. Besides, Rosenberg was no longer available. He now wrote for the *New Yorker*. Even so, *Artforum* became a home for political discourse under Coplans's direction. As Barbara Rose, who had moved on to *New York* magazine observed, *Artforum* "began criticizing not art but museums."[87] This had been part of Rosenberg's shtick since he touched on the "taste bureaucracies of Modern Art"[88] in "The American Action Painters." Not long after Coplans assumed the helm, Kozloff wrote "American Painting during the Cold War," a landmark article that upended aesthetic analysis by asking why "the context of American political ideology"[89] had not been factored into recent accounts of postwar art. He purposely invoked Rosenberg's idea of a "taste bureaucracy." Rosenberg's essay had not addressed politics, exactly, although he developed this subtext in numerous subsequent pieces, especially once he got to the *New Yorker*. Kozloff, however, noted the delayed impact of Rosenberg's signature article: he had "ended with an attack on the taste bureaucracy, the enemy without, which was witlessly drawn to modern art for reasons of status."[90]

Philip Leider thought the new political identity of *Artforum* under Coplans's tenure was a "foolish"[91] mistake. Leider was never interested in the larger context of art, let alone the impact of new movements, such as feminism on critical writing. After the magazine's factions were redrawn and Greenberg receded, Kozloff recalled that he had "felt closer to Harold, that big, beetling Turk, with

the high-pitched voice, who just loved to argue. If you weren't as devious and hyper-political and wisecracking in dispute as he was, you'd be beaten up—all in good cheer of course. But if you stood your ground, he'd listen, and if you used common sense, he'd respect you."[92] Rosenberg's temperament had never been an issue with Leider. It was his unwillingness to countenance a formalist perspective. For Rosenberg, Leider's essentialism was out of touch. As the 1970s unfolded with its new political crises, such as America's intensified involvement in the war in Vietnam and Nixon's Watergate, he was largely right.

22
location magazine and the long view

the words

When Robert Coates returned to the *New Yorker* in late 1963, William Shawn asked Rosenberg to write a few book reviews for the magazine, an offer that sustained their relationship. None of these reviews was to address contemporary art, however. That remained Coates's domain. Rosenberg used the opportunity to elaborate on his theme of a "herd" mentality in postwar culture. In a critique of Lewis A. Coser's *Men of Ideas: A Sociologist's View*, he questioned the future of independent thought, doubting that a university with its "institutional obstacles"[1] was the way to advance intellectual life. (Another taste bureaucracy.) He also took on *Understanding Media* by Marshall McLuhan, whose theories were bound up with the machines of mass culture and a resulting communications-saturated world. Rosenberg was on the fence about McLuhan. He described him as a "crisis philosopher," but liked that he viewed the artist as "an antidote to the numbness induced by changeover."[2] He was troubled, however, that McLuhan approached television and film as art, and by the monotony of his prose. Further, there was no revelation of McLuhan himself in the book. Rosenberg found reading him a slog. For all of the crises McLuhan adumbrated, his study of contemporary culture was too literal. If only he had tackled the *meanings* of the ubiquity of mass media. These tradeoffs made *Understanding Media* not only tiresome but ominous and scary.

Rosenberg knew that an anti-autobiographical trend had settled in the arts in the 1960s. The work of Warhol and the Minimalists was proof. He was perplexed, however, by Jean-Paul Sartre's memoir of

his childhood, *The Words*, which he reviewed for the *New Yorker* in 1965. Despite Sartre's claims to the contrary, the memoir revealed a glimpse of his ego through the self-analysis threaded throughout the book. Rosenberg could not buy that Sartre was driven at a young age to become a great writer only to fulfill family expectation. There was more to it than that. The French writer attributed a sense of emptiness to the early loss of his father. To compensate, he poured himself into reading fiction, a pastime he loved. He may have assumed that this retreat resulted in avoiding his interior life, but he left the door to his past half-open, transiting, as Rosenberg described, "from play acting to self."[3] There was more revelation about his psyche in his book than he admitted. But then Sartre had rebuked literature as a bourgeois institution, which Rosenberg did not accept. It had played a huge role, after all, in his formation as a writer. He "imagines," Rosenberg wrote, "that he quit the theater of the self forever."[4] The exit was half-hearted, incomplete.

By the time Rosenberg commented on *The Words*, he had repaired his relationship with Sartre after having abruptly withdrawn "The American Action Painters" from *Les Temps*. Sartre began reprinting many of his articles from *Dissent* and *Commentary* in the late 1950s, eager to restore his American perspective on political events, such as the Eichmann trial. They reconnected in person when he and Simone de Beauvoir visited New York in 1960. Still, Rosenberg's sense of Sartre would always be shaded by Sartre's endorsement of the French Communist Party. Consequently, he characterized the architect of alienation in the *New Yorker* as "one of the most original performers of the century,"[5] meaning that Sartre had executed the role of public intellectual with brilliance by adapting his words to the zeitgeist.

Rosenberg did not cover art for the *New Yorker* again until early 1967, but *Vogue* and *ARTnews* remained outlets where he wrote about the "aesthetics of boredom"[6] and the boom in critical writing that bolstered new anonymous art forms, such as Pop Art and Minimalism. The interpretations of these movements were overly partisan and dependent upon exegesis, Rosenberg felt, all of which added to their tedium. To illustrate his point, he alluded to a woe-

begone plea from Saul Bellow asking reviewers to spare his novels. Bellow was annoyed by the academics, or the "deep readers"[7] as he called them, who projected superfluous theory onto his work. On this widespread prolixity, Rosenberg opined that "antagonism to [Bellow's] *Herzog* came in large part from critics who found it too interesting in itself to require their services."[8] To boot, most of these explanations were written in a bland, nondescript tone.

location magazine

In 1963, Rosenberg and Tom Hess—who was still on the masthead of *ARTnews*—launched a short-lived publication named *Location* as an antidote to this perceived monotony. Donald Barthelme, a young writer, was hired as managing editor. In his draft notes for the project, Rosenberg stated that *Location* was to be of "people not of pieces," or individual works of art, and their subjects or "collaborators."[9] He had in mind a journal that would revive the "tradition of *The Dial, transition, View,* and the great European collaborations."[10] Barthelme had other ideas for *Location*, however, and the magazine languished for two years after it was founded. Like Rosenberg, Barthelme was concerned that "a sort of tyranny of great expectations obtained" in contemporary criticism through "a refusal to allow a work that mystery which is essential to it."[11] This "not-knowing," as he later called it, had initially drawn him to Rosenberg's writing. He liked that Rosenberg felt a certain anxiety attended art making, that its meanings were for the most part fluid and unstable. As someone who matured as a writer in the 1950s, Barthelme wanted to publish literary and artistic figures of his own generation in *Location*. Although he remembered his time at the magazine as a "happy experience,"[12] and relished intellectual debates with Rosenberg and Hess, editorial tension soon erupted that centered on Rosenberg's concentration on an older group of artists who upheld his idea of *action*. (Hess let Rosenberg assume the silent lead on *Location* as *ARTnews* demanded the lion's share of his own attention.) Like Robert Motherwell and *possibilities*, Barthelme would walk away from *Location*, tired of accommodating Rosenberg's ego.

Besides, his career as writer ascended in the mid-1960s when op-
portunities came to publish his fiction in magazines such as the
New Yorker.

Donald Barthelme was reared in Texas where his father, an archi-
tect, taught at the University of Houston. He attended the school
but never graduated. However, as a student, he wrote for the *Hous-
ton Post,* where he established his interest in pursuing a career as
a writer. In 1956, he launched *Forum,* a multidisciplinary quarterly
published by the university, where he subsequently worked as a
speechwriter for the president and oversaw the faculty and staff
newsletter. The journal drew on an impressive range of writers and
artists, including Gregory Bateson, William Gass, Kenneth Koch,
Marshall McLuhan, Robert Rauschenberg, and Sartre. Barthelme
also served on the board of trustees of the Contemporary Arts Mu-
seum (CAM) in Houston and later became its director. In 1959,
Rosenberg was invited to write the preface for *Out of the Ordinary,*
an exhibition at CAM that featured work by Joseph Cornell, H. C.
Westermann, Allan Kaprow, Jasper Johns, Ray Johnson, Rauschen-
berg, and others. In his short piece, he contended that much of this
Neo-Dada art was "not the 'answer' to abstraction . . . [but] is full of
pep in having found out how to make materials talk back in unex-
pected ways."[13] He thought Rauschenberg, especially, had "sought
out the clutter of souvenirs and legacies to which the common heart
is attached."[14] Barthelme was taken by Rosenberg's emphasis that
most risk taking was a response to tradition, existing simultaneously
as refutation and extension. Rauschenberg's work was more than
just a departure from the Ab Ex movement: it had turned the tables
on art history by using unorthodox materials, such as commonplace
newsprint and glossy magazine reproductions.

Barthelme reprinted Rosenberg's introduction in *Forum,* and
once he became the director of CAM in 1961, one of his first moves
was to bring Rosenberg to Houston to lecture. He had been reading
Rosenberg since "French Silence and American Poetry" was pub-
lished in the late 1940s and thought of him as the consummate in-
tellectual. The essay had a profound influence on him: as late as 1987
he stated in "Not-Knowing" that the goal of contemporary writ-

ing was "silencing of the existing rhetoric."[15] Prior to traveling to Texas, Rosenberg and Hess thought about jumpstarting *Location*. They had been discussing the project since the late 1950s. Rosenberg and Barthelme hit it off, and after conferring with Hess, Rosenberg offered Barthelme the job as managing editor with the stipulation that he move to Manhattan. Barthelme did not need any coaxing to leave Texas and his new job at CAM. He wrote to Rosenberg that he could be "packed in about 30 minutes."[16] Not only was he eager to immerse himself in a literary mecca, but also he was contemplating jettisoning his marriage. However, he presumed he would have complete control of the magazine, especially given his extensive editorial experience at *Forum*.[17]

Location was planned as a quarterly. Yet as Barthelme remembered, "Tom and Harold were not worried about putting the magazine out on time and certainly never put any pressure on me. We waited until we had enough decent stuff for a good issue."[18] He worked part time editing, overseeing the typography, and soliciting advertising from art dealers and publishing houses. Barthelme worked alone in rented offices at 16 East 23rd Street that overlooked Broadway. They were cramped and dingy, and had not been cleaned in years, unlike Rosenberg's upscale quarters at the Ad Council. Part of Barthelme's day was spent writing fiction that appeared in *Harper's Bazaar* and in the *New Yorker* where he would publish regularly. In New York, he quickly established himself as a short-story writer noted for his spare style and absence of plot structures that were committed to invention. (He was an ardent reader of Samuel Beckett.) But even with time permitted for his own work, his job at *Location* left him unchallenged and frustrated. Not only was he paid a meager salary, he also felt compromised by the outcome of the first issue. He wrote to his wife, who had returned to Houston after a few months, this is "the first time I haven't been sole proprietor, and it's difficult to adjust to the committee system, especially when the other members are formidable thinkers."[19]

The problem, as Barthelme saw it, was that *Location* had no thematic core around which to cluster statements, essays, poems, and reproductions of painting and sculpture. It represented more a

meandering tribute to its editors' interests by rehearsing old names from the 1940s and 1950s, such as William Baziotes, Saul Bellow, Kenneth Burke, Willem de Kooning, Hans Hofmann, and Saul Steinberg, even though Rosenberg wanted to craft a magazine that would collapse distinctions between "artists and writers," and treat their work "more or less expansively."[20] By that, he meant an off-beat look at how their creative projects, or "acts," played out in their lives. To vivify his plan, Rosenberg advocated for photo spreads on most of the featured figures. He thought that Larry Rivers, a proto-Pop painter who also worked as a musician, actor, and filmmaker, "should be perhaps, photographed more than the others."[21] "Let's get the Rivers' sideshow feeling in its lyricism every bit as up to date as tomorrow's juggle," he wrote in the guidelines for the first issue.[22] Rosenberg liked Hess's suggestion that *Location* feature details of the postcards and images from Reuben Nakian's studio wall, as they "will give us Nakian." He asked, "Would it be unfair to have a photo also of his house and his wife? And let him talk. If his words are sappy, what of it, so long as his line is divine."[23]

As Barthelme carried out these ideas, he realized that the scheme was "an uneasy collection of good things which don't seem to cohere in any meaningful synthesis."[24] He still hoped, however, that editorial unity could be effected "with a little more tinkering and shifting out."[25] But he never got a shot at intervening. In the end, he thought that the layout, which Rivers was commissioned to design, and his cover drawing were "awful."[26] Moreover, he believed the title of the magazine was "most ungraceful, flat and pedestrian," and a poem included by Burke, about which Rosenberg was keen, "fantastically poor."[27] Barthelme felt the best features of the inaugural issue stemmed from his own few contributions. *Location* had the overall look of a collage, with its contrasting, disorienting typefaces that were floated around photos, articles, and poems. This was the conceit of his own prose with its stark emphasis on discontinuity and fragmentation. He was also pleased with the photographs of Robert Rauschenberg's studio by Rudy Burkhardt, where "the windows overlooking Broadway were dark gray with our good New York grime,"[28] just like his own offices. He felt the correspondences

between Rauschenberg's black-and-white silkscreen prints and the grit on the windows did not need any explanation, as they were "instant art history."[29]

Despite Barthelme's diminished role as managing editor, Rosenberg and Hess continued to astonish him with "the ferocity of their enthusiasm, both positive and negative."[30] He was seduced by their "remarkable wit," and spent "the first several years of [their] friendship listening to [them] . . . tell these ferocious, man-eating, illuminating jokes, art-jokes, and politics, usually at lunch."[31] He had a hard time keeping up with their ruthless banter because he had yet to meet many of the players whom they enjoyed skewering. Still, it was not in Barthelme's nature to lambast colleagues; he was refined and formal, a "gentleman,"[32] as he was often described. But he could be acerbic if pushed and did not hold back about the future of *Location*. At lunch, which usually took place at The Smorgasbord on West 57th Street—Rosenberg's and Hess's favorite haunt—Barthelme could compete with his bosses' copious drinking. He had started boozing at age sixteen, which led to a life of alcoholism. Where Rosenberg and Hess prided themselves on holding their liquor, Barthelme knew he was an addict. The awareness contrasted with their grandiosity.

Once the inaugural issue hit the bookstores and reached subscribers in 1963, Barthelme attempted to become an equal partner in *Location*. He had been unable to assert his own interests apart from a few writers, such as Kenneth Koch and Marshall McLuhan. Rosenberg had his "doubts"[33] about Koch, but Barthelme prevailed, which emboldened him to propose a complete overhaul of the second number. Rosenberg had been protective of Barthelme even though he felt shortchanged when it came to editorial input. When Barthelme subjected an article solicited by Rosenberg from Robert Bly to "rather violent"[34] editing, Rosenberg stood up for him. (The piece has gone astray.) Bly withdrew his submission, and Rosenberg followed up with a letter stating that he was dumbfounded by his "mental rigidity" and "moral superiority."[35] While he thought that *Location* ought to include Bly, he supported Barthelme in the standoff because Bly had not acquiesced to Rosenberg as the "older

writer."[36] Rosenberg still proposed that they run Bly's piece as "an off-side prejudiced statement that a passionate man might make,"[37] but Bly was too incensed to participate. Barthelme felt supported, and as they contemplated the next issue of *Location,* he wrote a memorandum intended to shake up what he considered the magazine to be.

Barthelme's missive was an extraordinary piece of excoriation. "We are heavily committed to the leading figures of an achieved revolution," he wrote, elaborating that "most art-literary magazines come into being as the organs of revolutionary parties and see their missions in terms of promulgation of a radical doctrine, destruction of the existing order, and establishment of a new regime. *Location* enters as an apologist for an existing order. We are not defending a stockade but guarding a bank."[38] Rosenberg had written an article for the first number on "The Stockade Syndrome," his metaphor for the academy. Barthelme found his title handy to lobby for a revised publication that would rethink its relationship to the Establishment.[39] If the magazine was to continue to invest in figures such as de Kooning and Bellow, why not get beyond the "love-feast"[40] and embark on real criticism, such as questioning if their careers remained relevant. Barthelme thought this could be accomplished by inviting various artists and writers to take on their peers, rather than soliciting statements about their own work. If "de Kooning wrote on Newman, David Smith on Nakian, Rauschenberg on Warhol, Bellow on Nabokov, Robert Lowell on Richard Wilbur,"[41] some of the lively exchanges that took place in their studios and in bars could be replicated as an alternative critical model. The outcome would be more casual but also pointed and hard-hitting.

Barthelme knew that his memorandum would induce a fight. But when the second issue of *Location* was brought out in the summer of 1964, few of his ideas were executed. The only dialogue that appeared was Saul Bellow's reply to an essay Rosenberg wrote on "Form and Despair" in which he lamented the "extinction of the Self"[42] and the tedium that resulted from reading discourse that downplayed the writer's personality and opinions. Rosenberg blamed this condition on the "phalanx of latecomers to modernism"[43] who had narrowly

focused on Bertolt Brecht and Samuel Beckett: the "hollow-men tradition," as he called them (invoking T. S. Eliot's poem), whose "emptiness and inability to act have become an irrefragable cliché."[44] Bellow agreed with Rosenberg on the literary coolness that had emerged in the 1950s. He had it in particularly for Natalie Sarraute whose novels he saw as "boring and humorless,"[45] flat-footed descriptions of objects and facts that impacted the treatment of her characters. There were no heroes in her work, no one who overcame adversity.

Bellow was also struck that this had been Hannah Arendt's strategy in *Eichmann in Jerusalem*, where Adolf Eichmann was rendered as a mediocre functionary.[46] He shared Rosenberg's conviction that the academy, or "stockade," was largely responsible for this dreary state of writing. From his perch as a newly appointed professor on the Committee on Social Thought at the University of Chicago, Bellow complained, "No wonder this kind of vanguardism appeals to university professors or that respectable department chairmen call, in the Quarterlies, for post-Renaissance, post-Christian, post-Copernican, post-everything antinovels."[47] He was not convinced, however, that *Location* had the potential to redress new specializations, let alone bring on a renewal of narrative fiction. What was needed, Bellow averred, was for the writer to "find the strength to consider this transformed world of ours, and the imagination will free itself from the clichés of 'culture-history.'"[48]

Despite Barthelme's disapproval of the "love-feast" mode, it pervaded the second—and last—issue of *Location*. Still, he subversively reinforced Rosenberg's and Bellow's despair of the "aesthetics of boredom" in his own piece, "After Joyce," which addressed the *nouveau roman*—a French literary movement that included Sarraute, Michel Butor, Alain Robbe-Grillet, and Philippe Sollers—and its fractured plots and absence of psychology. He concluded that they had "arrived at inconsequence, carrying on that French war against the bourgeois which ends by flattering him: what a monster!"[49] Barthelme believed there were writers who had succeeded in producing experimental literature that was iconoclastic but not emotionally lean like the *nouveau roman*. Unlike Bellow, who had

little use for Joyce and his successors such as Beckett, Barthelme assumed writing could become a "literary object"[50] by radically altering the "medium" itself (McLuhan's term) to create a world rich with subjective nuance and irony. He did not agree that fiction had to tell a forward-moving story, as Bellow required literature to perform. Barthelme thought that Kenneth Koch's work was a case in point, and that it could not exist without Joyce: both authors waived development of a storyline and character. But Koch's experimental novels and poems were filled with "pure linguistic play with abrupt changes of mood and intentionality."[51] In his musings on modern life and culture, Koch did not hesitate to combine sentiment and references to lowbrow literature. Koch's method was not far off from Roy Lichtenstein's paintings of comic strip frames. (Koch had produced funnies as a child.) As far as Barthelme was concerned, both Koch and Lichtenstein made poetry out of their mix of pastiche and cliché.

"After Joyce" was a defiant stab at Bellow. So was Barthelme's short story "For I'm the Boy," which was also published in the last issue of *Location*, and whose central character was named Bloomsbury, a variant both of Joyce's Leopold Bloom from *Ulysses* and a nod to the Bloomsbury writers for whom literary epiphany sprang from personal experience. The story, with its taut structure, fused references to Barthelme's failed domestic life and adulteries with mention of Mallarmé and pop culture, all to prove that there was life after Joyce. Writing could be revitalized through formal experimentation and yet retain feeling. Koch, a literary heir, was the model that he wanted to set for *Location*. But that never happened, even though the second number did publish poems by John Ashbery and a piece by William Gass, both of whom Barthelme brought in. He had hoped the journal would "take a radical position with regard to American literature, admit its minor virtues and announce that it lacks necessity and point out its shortcomings."[52]

Barthelme was flustered that *Location* continued to perpetuate Rosenberg's reverence for established figures, such as Baziotes, Hofmann, and de Kooning, as well as Bellow, none of whom needed bolstering. He asked Rosenberg and Hess, "Why are we deliberately

walking softly and carrying a big bouquet?"[53] By the time the second issue appeared, Barthelme had a "first-reading agreement" with the *New Yorker* with the result that his short stories were published frequently. Yet in the fall of 1965, he was still discussing a third issue. When Rosenberg was out of town, Hess wrote to him about a meeting he had with Barthelme during which they discussed a change in editorial direction. He reported that "Don and I think that Location should be devoted to a single theme. And after several martinis, decided that YOUTH is the burning topic."[54] Hess had finally cottoned to Barthelme's idea that the publication should engage more contemporary writers, as well as presenting frank criticism from the editors and contributors, such as Bellow. Hess asked, why not "give lots of pages to young poets, painters, novella-churners, neon-tube benders, and Aboveground, Over-Broadway filmmakers? Then toss in some cranky comments of our own with elicitations from Peter Pan [Paul] Goodman, Caliban [Kenneth] Burke, and Dishpan [Saul] Bellow."[55] (Hess was habitually prone to giving his colleagues nicknames, most of them derogatory.) However, despite the strides Barthelme made in convincing Hess that *Location* ought to unsettle the cultural establishment, Barthelme deserted the magazine to focus on his career.

Bill Berkson, a poet who had studied under Koch and who had worked as an editorial associate at *ARTnews* with Hess, was brought in to succeed Barthelme as managing editor. Before Barthelme left, the two met for lunch. Barthelme counseled Berkson that "what we needed was a 'bomb.' Something . . . to really shake things up."[56] At Berkson's first editorial meeting with Rosenberg and Hess at The Smorgasbord, he was as reluctant as Barthelme had initially been to counter Rosenberg's aggression. He recounted that

Harold seemed impatient through the lunch. "What's your point of view?" he demanded of me. I generalized: "I just want to publish the best poetry I can find." Rosenberg pressed me for names. Not wanting to name only New York poets, of whose work HR anyway may not have approved, I left off "Charles Olson." "That Fascist!" said Harold with one of his bear's claw dismissals. Alas,

I had neither the presence of mind nor the nerve to ask what he meant.[57]

Rosenberg facetiously alluded to Olson's relationship to Ezra Pound in his inquisition with Berkson (even though Olson had denounced Pound's politics). Beyond the quip, Berkson never got to work on an issue for *Location*. The project was eventually abandoned because Rosenberg and Hess felt constrained by their writing for other publications. But its demise signaled difference with the priorities of a younger generation of writers. Notwithstanding the provocation of his memorandum, Barthelme would retain admiration for Rosenberg by skirting another skirmish. Still he knew that Rosenberg and Hess had slipped into another era through upholding artists and writers who had largely matured in the 1940s.

the longview foundation

Rosenberg conceived of *Location* for the Longview Foundation, where he became program director in 1958. The Edgar B. Stern Family Fund of New Orleans had made monies available to devise a program that would support contemporary writing and art. Edgar and Edith Stern were the parents of Hess's wife, Audrey. (Her maternal grandfather was Julius Rosenwald, a president of Sears, Roebuck & Company, who was among the foremost American philanthropists of the early twentieth century.) Together with Hess, who served as Longview's president, Rosenberg hatched the idea for a literary award program that would disburse grants to writers, as well as an art purchase fund for works by living American artists to be placed at institutions to which the Stern family had ties. The job, along with his part-time position at the Ad Council, added to the multiple sources of income that fueled his economic life. The position was a godsend: his daughter, Patia, had just entered Wesleyan University as a freshman, and his salary at Longview helped pay her tuition.

As Rosenberg wrote in a press release, the literary awards were to provide "compensation for good writings appearing in publications which cannot pay for contributions or which pay inade-

quately."[58] Only published articles were eligible in a competition that was overseen by a panel that included Saul Bellow, Alfred Kazin, Louise Bogan, Charles Boni (a publisher) and Henri Peyre (a professor at Yale), in addition to Hess. The subsidy amounted to $300 and was awarded to writers of fiction, poetry, and critical essays whose work had appeared the previous year in "little magazines," such as *Poetry, Hudson Review,* and *Noble Savage* (which Bellow had launched in 1960). Some of the beneficiaries included Charles Olson, for "The Maximus Poems," which were brought out in Jargon/Corinth Books; James Schuyler, for "Current Events," in *Locus-Solus;* and LeRoi Jones (later Amiri Baraka), for an essay "On Cuba" that was printed in *Evergreen Review.* Rosenberg tussled with Bellow on whether contributions to periodicals such as *Partisan Review* and *Kenyon Review* qualified, as he "once got $312 for an article from Kenyon."[59] Bellow prevailed, although Rosenberg and Hess drew the line with monthlies such as the *Atlantic* and *Harpers,* where the pay scale was more substantial. Rosenberg remembered that the selection process was a "big job, you had to read all this stuff."[60] Applications were not accepted: only editors could forward names of candidates to the committee.

Longview's art purchase program, by contrast, had a mandate to form four collections of painting and sculpture, which overlapped with repeat artists such as Norman Bluhm, Lois Dodd, Mary Frank, Sam Gilliam, Al Held, Carl Holty, Norman Lewis, Alice Neel, Robert De Niro Sr., Ad Reinhardt, Milton Resnick, Leon Polk Smith, and George Sugarman. Unlike the literary awards, which had an external committee, acquisitions were vetted by a rotating jury that included artists and art historians such as James S. Ackerman (then of Berkeley), Walter Bareiss (a collector and Longview board member), Adolph Gottlieb, Philip Guston, Hans Hofmann, Franz Kline, Willem de Kooning, Meyer Schapiro, and Gordon Smith (director of the Albright-Knox Art Gallery). Hess playfully referred to this group as "our eminent jury of lushes and has-beens [chosen] for their nepotistic suggestions."[61]

Longview's literary component was disbanded in 1961,[62] in part to move forward with *Location* magazine, but the purchase program

remained intact until the early 1970s.[63] The intent was to shape collections for Dillard University (of which Stern was a trustee); the Kalamazoo (Michigan) Institute of Arts; University of California, Berkeley; and the Union Sanatorium Association of the International Ladies' Garment Workers' Union. The odd mix extended the Stern family connections and interests. Longview relied upon the jury and an outside panel to forward names of mature artists who were known in the art world but who were "broke or had some kind of crisis," as Rosenberg portrayed it.[64] Or, as the mission statement more formally stated, artists "who are often unable to support themselves owing to the time-lag of the market."[65] Both Rosenberg and Hess followed up with studio visits and purchased work for each of the designated institutions. (Later, museums began to request money for specific acquisitions by artists such as Sam Gilliam and Reinhardt.) The International Ladies' Garment Workers' Union (ILGWU) was the first collection assembled and initiated through Tom and Audrey Hess's close association with its president, David Dubinsky.

The ILGWU collection was exhibited at the Whitney Museum of American Art in 1959, before heading to the union's convalescent home for workers in New Jersey. Rosenberg then wrote that "like artists themselves, sponsors of art need to have strong convictions, if their support is to mean more than a mere transfer of cash — without such convictions the generosity of foundations tends to light on the borderline artist whose chief qualification is that nobody will object to his being chosen."[66] Such had become the current predicament of the Guggenheim fellowships, he thought. Too much consensus was brought about by the committee process, all of which led to "giving money to the wrong people."[67]

Rosenberg was not always pleased with the fate of the collections that he and Hess assembled. When he spent time in the Bay Area to give the Regents' Lecture at the University of California, Berkeley, in 1962, he wrote to Hess that "Longview's Cal[ifornia] Collection is in the cellar — except for a Holty in the Chancellor's palace. Have proposed they lend the collection to ILGWU — Seriously, we'll have to think about getting it away from them & get it used."[68]

The collection remained at Berkeley and was never merged with the holdings of the union. It was consigned to the basement until the Berkeley Art Museum was established in 1970, and work by Peter Agostini, De Niro, and Holty came to be exhibited on a more regular basis. Beyond these obstacles, Rosenberg continued to laud Longview's program as the "most perfect scheme . . . that has ever been worked out."[69] He argued the template had been emulated in the early 1960s by the Ford Foundation until it became encumbered by bureaucracy and a large administrative staff, unlike Longview's smaller scale that eliminated an application process. Consequently, he believed that the Ford Foundation "gave money to people who ceased to need it,"[70] especially as it limited awards to just ten artists.

After the literary component of the Longview Foundation folded and *Location* got under way, Rosenberg applied to the Ford Foundation's Program for Reporters, Editors and Critics to support an anthology of his writing published after *The Tradition of the New*. He was flatly rejected. The foundation decided that it could not reward "editorial projects by a man of his stature and experience."[71] Ironically, this was the same criterion that he and Hess had adopted for Longview. Since the Ford Foundation had contacted him through the *New Yorker*, he felt that he "had been drawn by the unsolicited announcement into making a fool of myself."[72] (Beyond reworking newer essays for the proposed volume, Rosenberg requested funds to travel to museums in European cities and Tokyo. He was "conscious of [his] weakness in regard to details of art history."[73] He knew there were deficits in his education.) It was Rosenberg's first and only application to a foundation.

a friendly thing he worked out

During Rosenberg's spell at the Longview Foundation, his involvement in the art world intensified. No sooner had he teamed up with the Stern family than he began to find himself more in demand to attend "openings, visits to artists' studios, parties, conferences, round tables, etc."[74] His week was busy, with a minimum of five dinners

and lunches, not to mention drinks with "people who are an inescapable part of this whole business."[75] His cab bills alone came to $30 per week, a considerable sum for him. The reception of *The Tradition of the New* also played into this flurry of activity. But so did another role that he assumed in 1959: he became a consultant to the Graham Gallery in New York, where he advised on its contemporary program, not unlike the role that Clement Greenberg had assumed at French & Company.[76] Even so, there were significant differences in their arrangements. Rosenberg did not organize exhibitions; nor did he receive a weekly salary and expenses to travel abroad to scout new material.[77] Joan Washburn, who worked at the gallery, described Rosenberg's job as a "friendly thing he worked out" with Bob Graham, the owner, whereby he "suggested names of artists"[78] that the gallery should consider as it incorporated living figures into its inventory of nineteenth and early twentieth-century art.[79] There was little more to the arrangement than an occasional meeting where Rosenberg would make recommendations such as "take a look at Perle Fine."[80] But he did receive a consulting fee for his counsel. Occasionally his advice resulted in purchases for the Longview Foundation; some of the artists that the Graham Gallery exhibited, such as Elaine de Kooning, De Niro, Holty, Alice Neel, and Reinhardt, were woven into the collections that Rosenberg and Hess assembled.

Rosenberg stated that an advantage of the Longview Foundation was that it eliminated the middleman, or dealer. He and Hess bought work directly at market prices from the artist. He claimed these casual transactions rarely left the dealers feeling cut out or angry. The dealers knew "that artists would get a little support, they would be relieved of having to round up the money [for stipends]." But there were "a few who made a little underhanded deal by which their artist could give them a drawing or something else in return for the fact that they weren't collecting his commission."[81] When Rosenberg accused Greenberg of being "a tipster on masterpieces," and operating as an "'expert' who purveys to the bewildered,"[82] in his rebuttal to "How Art Writing Earns Its Bad Name," he left out his own short-term relationship to the marketplace.[83] Even if his

fees from the Graham Gallery were not for orchestrating shows, he must have thought that his association with Bob Graham was more upright since he assisted artists, many of whom were friends, having a hard time eking out a living.

Unlike Greenberg's formal relationship with French & Company, Rosenberg's status as a consultant was kept private, concealed though conversation. It never amounted to more than talk, some of which was acted upon by Graham through his roster of exhibitions. What Rosenberg most objected to in Greenberg's role at French & Company was the way his formalist ideas were illustrated through exhibitions of younger artists, such as Friedel Dzubas, Morris Louis, Kenneth Noland, and Jules Olitski, in addition to old stalwarts like Gottlieb, Newman, and David Smith, all to round out his chain of modernist developments. This was nothing more than a "burlesque of art history," wherein Color Field Painting was tied to the New York School without the test of prolonged critical scrutiny. Determinist reasoning, it appeared, had found a niche in commerce.

Once Greenberg became allied with French & Company, it was generally assumed that he had become a dealer. This identity circulated to the extent that it was reported in the *Washington Star*, a hometown newspaper of Louis and Noland. Greenberg felt slandered and threatened legal action.[84] He succeeded in eliciting a retraction, but the image stuck, especially once the business folded in 1960 and he moved on to become an unofficial consultant to the André Emmerich Gallery, to which Dzubas, Louis, Noland, and Olitski migrated. Rosenberg's representation of Greenberg as a "tipster" certainly did not help.[85] If anything, it added to the public impression that he had ceased to be a disinterested player. His critical writing had become enmeshed in a nexus of dealers and collectors who upheld his coterie of artists. By 1970, when Philip Leider ran Ad Reinhardt's posthumous monologue in *Artforum*, in which the artist charged Greenberg with being on Emmerich's payroll, enmity had mushroomed. Whether he received kickbacks for the advice that he dispensed to Emmerich's clients, or a cut of the sales from the gallery's exhibitions, is unknown. But he did amass a warehouse of gifts from its artists, paintings that he periodically sold.[86]

Rosenberg was acutely aware that "artists must function in an economic situation."[87] Part of the goal of the Longview Foundation purchase plan was to augment new audiences for contemporary artists. He was less interested in the marketplace per se than in adding to public collections. This tactic, he thought, could generate sales for artists to alleviate their financial woes. Rosenberg was proud that this actually did happen: sixty-eight artists funded over a three-year period no longer required assistance from the foundation.[88] He was quick to note that none of the artists who benefited from the program constituted a "school."[89] The foundation had avoided an agenda. There were other tangible outgrowths of Longview's largesse, such as the founding of the Berkeley Art Museum. Rosenberg had complained to Hans Hofmann, a foundation committee member, that the Berkeley collection was not on view. It prompted the artist to make a sizable donation for a building. (He had taught at Berkeley in the summers of 1930 and 1931, and valued the association.) There was also the advice that Rosenberg parceled out to the Graham Gallery, where a few artists, such as Elaine de Kooning and Alice Neel, found representation.

Rosenberg, like Greenberg, received gifts from many artists over the years. But they were not large enough to require storage in the Santini warehouse in Manhattan. They remained installed on the walls of his home office and house in The Springs, where they were double- and triple-hung, and they ranged in scale. The paintings represented a roster of friends. Outside of the caricatures that Saul Steinberg gave to Rosenberg on numerous occasions, and drawings and paintings given by Baziotes, Guston, and de Kooning there were presents from other notables, such as Hartigan, Hofmann, Motherwell, Newman, and Pollock, and a few surprises from artists such as Marc Chagall and Jean Hélion. Some of these presents were informally solicited by Rosenberg's wife. Philip Pavia, whom Rosenberg had known since the early days of The Club, recounted that Tabak had directed him to honor her husband with something for Rosenberg's birthday in 1964. She announced that "artists give their work to Harold to show their appreciation to Harold for what he has done for their condition."[90] Pavia cautiously responded, "What if he

does not like the work?"[91] She assured him, "It is irrelevant, Harold respects your work and speaks well of it."[92] His confidence boosted, Pavia made Rosenberg a gift of a drawing.

Pavia was never a beneficiary of the Longview purchase plan. By the time of his exchange with Tabak, the program had fizzled out and Rosenberg's relationship to the Graham Gallery had also ended. Still, Rosenberg was someone whom Pavia had sought out to contribute to *It Is*, a magazine he founded in 1958 devoted to artists' writings.[93] Pavia had always thought Rosenberg had the "best mind"[94] of the critics of his generation and had continuously showered him with accolades since the founding of The Club.[95] Yet Rosenberg retaliated against him when Pavia's dealer, Bertha Schaefer, listed the drawing as part of Rosenberg's collection in a press release for a one-person show. Pavia knew that the gallery had blundered, that it was wrong to flaunt his association with Rosenberg, who had, after all, not bought his work. Rosenberg returned the drawing to Schaefer rather than to the artist, a reaction that Pavia considered to be "out of proportion," particularly since "he did not pick on anybody his own size."[96]

Pavia, who had a hard time paying his bills in the early 1960s, felt diminished by a "giant"[97] of Rosenberg's stature, believing that his aggression was unfair. He would never have considered a gift without Tabak's urging—and then to be spurned by a writer he revered. Part of what had drawn Pavia to Rosenberg was their mutual emphasis on "location," the metaphoric place where the American artist was situated mid-century. All was forgiven, however. By 1973, when Rosenberg and Tabak exhibited their collection at the Montclair Art Museum, Pavia was represented by a watercolor that he had given to them a few years earlier.[98]

23
the *new yorker*

what are they going to do with an article of mine in my style?

After Rosenberg substituted for Robert Coates at the *New Yorker* in 1962, he never expected to be brought back as the magazine's art critic a few years later.[1] Coates, who had occupied the position since 1937, always regretted not devoting more time to his fiction writing. He felt that his art columns and book reviews impinged on his other interests. He considered himself a novelist, but in the 1930s he took up short-form fiction, much of which was published in the *New Yorker* and subsequently in the annual O. Henry collections. Still, his books and short stories appeared infrequently. They had never gained enough momentum to attract an audience, being constantly interrupted by his day job. So he left in 1967 to pursue his short stories and autobiographical essays.

Shawn had been impressed with the contributions that Rosenberg wrote in Coates's absence. After Rosenberg's first review of exhibitions by Tobey, Gorky, and Kline was published, Shawn wrote to Rosenberg that he thought his piece was "beautiful."[2] Rosenberg was incredulous. May Natalie Tabak remembered that he was "flabbergasted"[3] that Shawn had even asked him to write the Art Galleries column while Coates was on leave. Rosenberg was concerned that his writing would elude the *New Yorker*'s readers, especially since publications such as *Partisan Review* had complained about his "difficult"[4] style. He also worried about whether he had a distinctive voice: the *New Yorker* had a substantial subscription base and demanded not only a unique voice but also clarity. He conveyed to Tabak, "What are they going to do with an article of mine in my

style? Besides, I don't know what my style is."[5] It was one of the
few times Tabak heard him express trepidation. He had always been
confident about his work. He kept the faith through volatile interac-
tions with *PR, Les Temps modernes, Commentary,* and *Encounter,* and
never brooded about his quarrels with editors, let alone his public
image. When Shawn originally offered him a high-profile platform
for a twelve-month period, he contemplated whether at age fifty-six
he was up to making sense of the modern period on a monthly basis
for an audience that incorporated curators, collectors, and dealers,
as well as the lay public. The specter of a readership weighed on him.
He was apprehensive about taking the job, even temporarily.

Saul Steinberg most likely suggested that Shawn consider Rosen-
berg as Coates's replacement in 1962.[6] They had been close friends
for nearly a decade and conducted a "daily symposium" during the
weekends in The Springs. Steinberg loved the unpremeditated na-
ture of their exchanges and thought that Rosenberg had a "poetic
mind [yet] his speech was sometimes normal"[7] (fig. 31). What he
meant was that Rosenberg's talk had none of the mannerisms of an
academic whose pontifications could be labored, unlike their free-
form repartee. Steinberg also knew that these features characterized
his writing. Parallels existed with his own cartoons of figures with
speech bubbles filled with elegant, abstract script. As Rosenberg
thought about whether he could elucidate the art scene for the *New
Yorker,* he dispensed with his qualms about being too "obscure"[8] and
treated Shawn, like Steinberg, as his ideal reader. He came to revere
Shawn in large part because he was an "idea man,"[9] as Gardner Bots-
ford, who later became one of Rosenberg's editors, characterized
him. Rosenberg connected to his intellectual nature and analytical
mind. He felt protected by Shawn, unlike his relations with other ed-
itors with whom he had worked.

In early 1966, Rosenberg wrote to Coates to impart that "review-
ing is not my dish . . . I'm up to my ears in 'the cultural situation'
and its acts of creation."[10] The review format may not have been his
thing, but a year later, when he became the art critic for the *New
Yorker,* it was prescribed. He was never a writer to follow rules, how-
ever. He continuously nurtured his anti-authoritarian streak. The

Fig. 31. Saul Steinberg (1914–99), *Portrait of Harold Rosenberg*, 1972. Water-color, crayon; 14 1/16 × 10 ¼ inches. Yale University Art Gallery.

review became a springboard to discuss the waning effects of subjectivity in the late 1960s and the institutionalization of art.

before long what had been startling
seemed merely true

For all of Rosenberg's initial reticence to write for the *New Yorker*, the experience was transformative. The magazine's Art Column provided him with a regular beat he had never before had. It also provided him with financial stability: he no longer had to cobble

together his income from writing, lecturing, occasional teaching, consulting for the Longview Foundation or Graham Gallery, and working part time at the American Ad Council (which he stepped down from in 1973). Rosenberg had always thought he would lead a bohemian life to the end. He feared association with "bourgeois ambitions and thinking"[11] that would compromise his Marxist beliefs and a lifestyle he valued. He had survived the Depression with his ideals intact and had not succumbed to unrestrained materialism in the United States in the 1950s, unlike many of his peers.

There were a few moments during his eleven-year association with the *New Yorker* when Rosenberg thought of quitting, believing that he was "outstaying his welcome"[12] and that he should resume his freelance practice. He fretted about being rejected by a magazine with a huge circulation and forfeiting his critical independence. Shawn reminded him that he had never been as prolific as he became at the *New Yorker*. He reassured Rosenberg that he had drawn him into the magazine because of his insight and ability to nail down the implications of the current cultural predicament. "Before long," Shawn remarked of his reviews," what had been startling seemed merely true."[13]

Shortly after Rosenberg's death in 1978, Tabak drafted a letter to Shawn to convey how grateful Rosenberg had been to him. He knew that the offer to take over from Coates was fortuitous. Once he settled into his position, Tabak recognized that Shawn had done "something much more marvelous than any other magical evocation of FAITH . . . It released Harold from a tension even I had never suspected."[14] She thought that Shawn's confidence in Rosenberg was "the single, absolutely gratuitous gesture of kindness [extended] toward him."[15] After decades of wrangling and squabbling with editors, Rosenberg finally had a guardian. He no longer had to fight to defend his ideas and prose with its aphoristic phrasing. Moreover, he no longer had to justify his aversion to the new generation of "aesthetes" who were published in monthlies such as *Artforum*. Tabak wrote to Shawn that "the Partisan Review and the other 'intellectual' mags never ceased to moan that Harold was too complicated, too obscure for most of their readership. They were eager to

drag an article out of him, but then they always whined, one way or the other, carping."[16] She pondered whether the nonstop imbroglios were necessary. "How come," she asked, "it was clear to you and escaped so many others? . . . How come you alone weren't daunted by his style?"[17] Besides Shawn, she noted that only Europeans, such as Sartre, had no issue with his writing.

However, Rosenberg's prose did change at the *New Yorker*. It became less compact, more agile, and easier to read, partially because of working with the magazine's editors.[18] The presence of a faceless audience was also a factor, despite his protestations to the contrary. After he stood in for Coates in 1962, he wrote for mass-media publications, such as *Esquire* and *Vogue*, where his sentences were similarly clipped into crisper, more lucid statements, unlike the densely poetic rhetoric of essays such as "The American Action Painters." His epigrammatic phrasing remained a staple, but the presence of the artist became more tangible, no longer ancillary to his argument. His pieces on Jasper Johns and Willem de Kooning for *Vogue* never seemed diluted to accommodate a huge subscription base. He had learned to write for a broader public. Granted, he was irritated by the editorial concessions he had to make when "The Art Establishment" was published in *Esquire*. Yet his response was never to write for them again.

Rosenberg's job at the *New Yorker* was to write about major exhibitions that opened in New York's major showcases during the year. His choices were limited to artists and movements that curators deemed worthy of exposure. As a body, his Art Columns represent a discrete overview of the central figures and cultural preoccupations of the late 1960s and 1970s.

the cultural situation

Robert Coates's decision to leave the *New Yorker* was not only based on a desire to write fiction full time. He also had become frustrated by the state of criticism, feeling it had not exhibited enough deference to the artist or writer. In 1966, he wrote to Kenneth Burke that he thought critical writing "should be based on humility toward

the artist, as justified by the fact that the artist usually turns out to be right in the end, but also by the ever-present fact that the artists can get along without the critic, but if it turns out to be vice-versa . . . no-no!"[19] Burke differed strenuously and wrote back, "I by no means think that such a liberal attitude toward the work of art implies the secondary role of criticism which you insult yourself by accepting."[20] Coates had reservations about the jargon that stultified most art criticism through the omnipresence of formalist writing. In contrast, he thought of himself more as an "evaluator, and (at best) explainer."[21] Rosenberg had voiced similar concerns about cant, but "humility" was not one of his virtues.

Once Rosenberg started to work at the *New Yorker*, his reviews were given to elucidation of the "cultural situation." He did not think it was his job only to describe and judge art as Coates had done. As he told Coates in early 1966, he felt an ethical responsibility to lay bare the failures of art criticism itself, a prime contributor to the cultural quagmire. He had a deep scorn for the Arts and Leisure writers at the *New York Times*, especially John Canaday and Hilton Kramer, the latter of whom prattled nothing more than "ass-kissing ideas."[22] (Dore Ashton and Brian O'Doherty were exceptions, but they had left their posts by the mid-1960s.) As he saw it, Kramer had become the *Times's* "tireless meter-maid of the arts,"[23] a writer who maintained no critical distance from the market that mediated art. Rosenberg brushed him aside as an old-style aesthete whose attack mode was his defining characteristic. Besides, Kramer could never fathom mid-century abstraction, such was his requirement for technical virtuosity in the studio.

Kramer was too much of a crank for Rosenberg to take seriously—though Kramer's huge visibility at the *Times* irked him. Beyond Kramer, Rosenberg targeted formalist writing itself—his recurring beef—and the influence it exerted within the academy and museum. The "professors," as he contemptuously referred to them, and the custodians of culture, such as curators at the Museum of Modern Art and the Metropolitan Museum of Art, were his primary focus. William Rubin, Henry Geldzahler, and Michael Fried stood out as complicit in enacting Clement Greenberg's ideas. Two years into

his job at the *New Yorker*, Rosenberg wrote that they had become "tone-deaf"[24] to the complexity of modernist art, too bent on packaging art history as a monument to stylistic evolution. Artists and episodes that did not conform to their formalist thesis were left out of their analysis. The curator, moreover, had become a showman or impresario who dazzled the public with pseudo-scholarly acumen. The downside was that modern art was no longer construed as a story of social and aesthetic struggle: the cultural moment had become too giddy to sustain talk of alienation.

Rosenberg's summations on the "cultural situation" were never presented as jeremiads or longing for the days when *action* had been meaningful. Even though he experienced the negation of subjectivity as a loss, he was reconciled to the changed circumstances for art making, knowing that the artist now had to contend with a phalanx of critics, curators, and dealers to show their work. The only recourse, he believed, was to name the offenders, especially if art criticism was to be renewed. And that meant ditching Greenberg's legacy. Art discourse had become too inflexible and doctrinaire, as well as smug and imperious. As he looked back at the 1960s, he observed that "the new stars of the art world refused to talk. This attitude was encouraged by formalist criticism, which discounted the artist's ideas and feelings as irrelevant to the success of the work."[25] By that, Rosenberg meant talking about the self rather than the rhetoric of forms.

Unlike Robert Coates, who claimed that artists always "got it right," Rosenberg knew there were writers upon whom the artist had become dependent. He was particularly disaffected from Frank Stella and Kenneth Noland, whose painting was "inseparable"[26] from the ideas of their advocates. Through biographical detachment, they had articulated art as a problem-solving project. Rosenberg argued that "Stella's compositions are the most professorial paintings in the history of art."[27] He had made the seamless transition from art school to gallery to museum in less than a decade. (Stella had his first one-person exhibition at the Museum of Modern Art in 1970 at the age of thirty-six.) The contrast with Hans Hofmann, who had waited until he was in his mid-eighties for a retrospective at MoMA, was emblematic to Rosenberg of the artist's immediate integration

into the middle class. The trajectory was unheard of three decades earlier.

the perilous state of art criticism

One of Rosenberg's last pieces for *ARTnews* was "Homage to Hans Hofmann," which was published in January 1967, nearly a year after Hofmann's death. His painting had been exhibited posthumously at the André Emmerich Gallery, and Rosenberg's article ostensibly ran as a tribute. He became irritated, however, by the title the magazine gave to his piece. It was never intended to celebrate Hofmann's work and life, unlike the salute he had written a year earlier for *ARTnews* in which the artist's achievement as an Ab Ex forerunner was properly acknowledged.[28] Someone at *ARTnews* had written a misleading title and added a sidebar mentioning the Emmerich show, without consulting him. He was mad about the mistagged "homage" and contacted Tom Hess. His article had been condensed from a lecture on "trends in criticism" that he had given at a symposium at New York University dubbed "Homage to Hans Hofmann." Hence, the misnomer. But he had not discussed Hofmann's painting, let alone his late work exhibited at Emmerich. He was more interested in Hofmann's embodiment of the "truth," an "old-fashioned view," he admitted, especially since "truth" had been stolen by the "art-for-art's-sakeists, art-for-art-history's-sakeists, science-fiction sculptors [and] mixed-medium missionaries."[29]

Rosenberg alighted on Hofmann as a contrast to what he considered the distortions of critics such as Lawrence Alloway, who had assembled a recent exhibition for the Solomon R. Guggenheim Museum called *Systemic Painting* that consisted of geometric abstractions by Stella, Noland, Jo Baer, Paul Feeley, Ellsworth Kelly, Agnes Martin, and others. He considered Alloway's term gibberish. The spartan forms of contemporary American art could not be interpreted, as Alloway stated, as "covert or spontaneous iconographic images" whose meanings were derived by the "experiential"[30] response of the viewer. It was a backhanded way, Rosenberg thought, to top "the School of Clement Greenberg."[31]

Rosenberg was vitriolic, although brilliantly funny, as he assaulted the "veritable circus of clowns"[32] at the forefront of art criticism. None of the newcomers, such as Alloway, was clued in to history, which made their ideas about progress shallow and specious. He felt their reading of the twentieth century had degenerated into "dogma . . . that Picasso, de Kooning, Giacometti have been put in the shade by—Kenneth Noland! By Helen Frankenthaler! By stripes!"[33] What happened to subject matter? he responded. Rosenberg could not accept that content could exist solely in the repetition of shapes, sometimes compounded through series of paintings. There had to be other ways to parse this new art. Alloway's idea that systemic painting had a "lavish presence"[34] achieved through scale did not cut it for him. That was where Hofmann and his counterpoint of transcendence came in.

There were many writers and artists who concurred with Rosenberg. James Fitzsimmons of *Art International* wrote that he "fully agreed with [him] as to the perilous state of art criticism."[35] Nonetheless, he was put off by Rosenberg's ad hominem attacks on their mutual colleagues. He wondered, why did Rosenberg find it "necessary to be so personal?"[36] But these attacks only intensified once Rosenberg got to the *New Yorker*. He now felt completely justified to name his game, believing it was his duty and a matter of integrity. He replied to Fitzsimmons, "I was attacking not only 'views' but intellectual manners. I have no objection to Greenberg developing a fantasy of art history that consists of Pollock to Frankenthaler to Noland-Louis-Oltisky [*sic*]. When this fantasy is repeated on every occasion by the claque . . . it becomes not only an insolent falsification, but a species of force directed against thought as well as against artists."[37] Beyond the copious clichés in this new writing, Rosenberg thought that Alloway's label "systemic" was just plain "idiotic,"[38] a canard that begged to be questioned.

Rosenberg was left with the impression that his article in *ARTnews* had cleared the air and stood as "an act of liberation."[39] Alloway had a contrary reaction, however, and wanted to publish a rejoinder. Upon hearing of Alloway's request and Tom Hess's plan to string out the polemic with a reply from him, Rosenberg scolded Hess that he

was violating *ARTnews* policy: there was no precedent for such an exchange in the magazine's history. Rosenberg felt betrayed by Hess, believing that Hess was using him to undermine their shared interest in opposing Alloway as well as other members of Greenberg's inner circle. "Why should I be forced," he asked, "to defend myself in a magazine in which I have been appearing for fifteen years? I may not mind mopping up the floor with Alloway, but there's no reason why I should be *forced* by you to carry out this chore . . . If he attacked me elsewhere I have the choice of ignoring it. In *Art News* to exercise such a choice would amount to capitulation."[40] Rosenberg was mad that a correction in *ARTnews* noting his piece was not a "homage" had gone without much notice. He was still paying for their error, he maintained. Hess's scheme to pit him against Alloway was "another instance of providing the rope to hang his friends."[41]

Hess never ended up placing Alloway and Rosenberg in juxtaposition. But Rosenberg had used the noose metaphor in other letters to him. Once Hess became the editor of *ARTnews* in 1965, Rosenberg believed the magazine had begun to suffer from a dearth of intellectually minded critics. He complained that the staff of writers lacked nerve and were unable to provide a viable alternative, let alone edge, to the writing that appeared in *Artforum*. "If only your magazine had half the GISM of your letters [editorials]," he wrote, asking, "Why don't you fire all those goons, forget the shows and write a letter every day about what's going on in New York, Paris, etc."[42]

Rosenberg thought Hess ought to offer a rope to Irving Sandler, feeling he could not hold his own in the fraught aesthetic battles during the mid-1960s.[43] Sandler had always thought of Hess as a "mentor"[44] and realized that he himself had become Hess's "disciple,"[45] at least during the early years when he wrote for *ARTnews*. (Sandler was a reviewer and editorial associate from 1956 to 1962.) That represented more reason for Rosenberg to proclaim that the magazine had degenerated into a lowbrow affair. The publication had become too interested in the market value of art, which forfeited serious engagement of the "cultural situation." Gone were the probing art criticism and reviews that once accounted for the rise of new movements such as the New York School.

the swinging curator

Rosenberg's frustration with Hess's handling of the Alloway incident was exacerbated by physical distance. In the fall of 1966, he assumed a part-time teaching position at the University of Chicago, where he served on the Committee of Social Thought. He too had become a "professor." He never thought of himself as an academic, however: his professional identity was always bound up in his writing. Rosenberg would spend three months in Chicago each fall and spring, which took him away from Manhattan for half the year. As he read Alloway's catalogue for *Systemic Painting*, where *action* painting was dismissed as a "seismic record of the artist's anxiety,"[46] he began to feel alienated. The omnipresence of these attacks put him on the defensive. They skirted, he thought, explanation of the social constraints that encroached upon the creative act.

As soon as Rosenberg arrived in Chicago, he wrote to Hess to say that he had given a talk at Northwestern University in nearby Evanston, Illinois, only to find that "in the question period a guy, art-department faculty, jumps up with, 'What about the fact that you don't care for any artists after Action Painters and other critics say your terminology is out of date?'"[47] Rosenberg thought the inquisition was a "perfect setup to let your correspondents have it."[48] By "correspondents," he was thinking of a letter that Hess had recently published in *ARTnews* from Danny Dries, an artist from Brooklyn, who complained that while *The Tradition of the New* spoke for all vanguard artists, Rosenberg's second volume of essays, *The Anxious Object*, had succumbed to "snobbishness."[49] Dries observed that it was limited to artists who had frequented the Cedar Tavern, such as Ad Reinhardt and Barnett Newman, and did not account for his generation. Rosenberg felt that Hess had pulled out his "rope" again by printing the objection. He retaliated in a letter privately: "Give 'em your magazine and they'll prove they can't discuss ideas but only drip slanders?"[50] His tongue-in-cheek reference to Reinhardt was meant as a dig that the readers of *ARTnews* were incapable of depth, let alone irony.

The tension between Rosenberg and Hess did not last forever, even though an unacknowledged rivalry between the two ensued. Once Rosenberg became art critic for the *New Yorker,* and began to spend time in Chicago, any future for *Location* faded. But they remained close and met for lunch when Rosenberg was in town, and they continued to share interests in artists such as de Kooning and Newman. Their mutual scorn for the changed art world of the 1960s, and the gossip it generated, still animated their letters and conversation. When *ARTnews* ran a questionnaire on the Metropolitan Museum of Art for its centenary in 1970, Hess reached out to Rosenberg, noting that he represented the "Voice of Authority" in the list of contributors, which also included "the good art historians,"[51] such as George Heard Hamilton, Linda Nochlin, and Meyer Schapiro, as well as artists like Fairfield Porter and Newman. He reassured Rosenberg that he was "always thinking"[52] of him. During the Met's anniversary year, Hess wrote Rosenberg a long letter recounting the opening of "Henry's Show," as it was colloquially known, or Geldzahler's *New York Painting and Sculpture: 1940–1970.* He described getting "dressed in my tux, smelling of patchouli [and] having a few choice remarks ready from Macrobius on my lips."[53] He was pleased to find the reception had "about 6 bars nicely spaced out so there was no crowding around the booze, and at least 2 Rock Bands."[54] He also took glee in noting that "Frank Stella was not wearing his teeth. Like all the other artists, he stayed in his own 'room' and checked the house peripherally in the adjoining galleries."[55] Hess could not resist mischievously commenting on Geldzahler's sartorial choice of a "deep bright velour blue T.V. jacket,"[56] attire that contrasted with his own tuxedo.

When Rosenberg completed his third volume of essays, *Artworks and Packages,* which included reviews that had largely appeared in the *New Yorker,* he dedicated the collection to Hess. Hess engaged Marvin Mudrick, a well-known essayist and provost of the College of Creative Studies at the University of California, Santa Barbara, to review the book for *ARTnews.* Rosenberg's daughter, Patia, was enrolled in the graduate program there, and Mudrick thought so highly

of Rosenberg that he invited to him to teach in early 1970. (He declined.)[57] Mudrick was effusive in his praise of Rosenberg and exclaimed, "If there were anybody else like him, it might even be possible to read the art journals."[58] Rosenberg stood apart because his writing represented "an antidote to trends" and was endowed with a "sense of art as something humane."[59]

Yet this warmhearted display of allegiance did not extend to Rosenberg and Hess sharing their professional connections. Soon after *ARTnews* was sold in 1972, Hess contacted Donald Barthelme to inquire if he thought there might be room for another art critic at the *New Yorker*. Barthelme counseled Hess that "Harold's dangerously mangerous [sic] behavior needn't be the last word on the subject. If you wanted to write pieces for the magazine I think all you'd have to do would be to have a conversation with Shawn and I'd be delighted to set that up if you are interested."[60] Rosenberg evidently held his ground by blocking competition. Barthelme's plan was either never put in place or did not attract Shawn. Hess moved on to *New York* magazine, where he worked for two years before taking over Geldzahler's position as curator of the Department of Twentieth-Century Art at the Metropolitan Museum.

Rosenberg and Hess died within two days of each other in July 1978. Hilton Kramer paired them in the *New York Times* where he commented with characteristic jaundice that Rosenberg was the "more formidable and combative—in many respects the quintessential New York intellectual . . . [who] about purely aesthetic matters [was] impatient and even contemptuous." By contrast, Hess was more "catholic and open-minded."[61] As an editor, Hess had been more evenhanded and responsive to covering the new art of the 1960s, even if it was not to his taste. Rosenberg was, in fact, more partisan in terms of his fidelities and in undermining the pretensions of formalist criticism. Yet, he never looked backward to a refuge of anticonformists who emerged in New York mid-century. Around 1970, the word *action* dropped out of his vocabulary, signaling that he had moved on. The "taste bureaucracies," another iteration of the "cultural situation," now occupied his attention.

école de new york

"Henry's Show" at the Metropolitan Museum was a mega-event that occupied thirty-five galleries with more than four hundred objects that spanned Pollock and Newman through Noland and Warhol. Most artists were allocated an individual room. Paradoxically, "The American Action Painters" was reprinted in the exhibition catalogue alongside essays by Clement Greenberg, Robert Rosenblum, and William Rubin. However, Rosenberg's concept of *action* was never mentioned in Geldzahler's explanation of New York's postwar ascendancy as a cultural center. His essay was an anomaly, especially as Geldzahler declared that he was indebted to Greenberg's "greatness" and "historical approach."[62] Geldzahler assumed that his exhibition provided ample evidence of formal continuity with the early twentieth century and that any debt to Paris had long since been resolved.

In his review for the *New Yorker,* Rosenberg facetiously called the Met's show the "École de New York." He argued that the project was predicated upon a dubious conceit: these artists were not "aesthetic and intellectual blood-brothers."[63] If anything, the extravaganza was a "phenomenon of art-world politics, chauvinism, and institutional reputation-building"[64] with Geldzahler, the showman, at its center. As Rosenberg scoured the press material with its photo of "Geldzahler in shirt-sleeves, as if he were a movie director on location,"[65] he decided the scale of the event mattered most as it was the largest modernist exhibition to date. (Earlier in 1969, William Rubin had mounted *New American Painting and Sculpture: The First Generation* at the Museum of Modern Art, a show of 157 works that claimed to be the largest ever devoted to postwar American art.) The bigness of Geldzahler's endeavor, however, only succeeded in exhausting the viewer. There were also notable exclusions. Where were artists such as William Baziotes, Larry Rivers, Ruben Nakian, Saul Steinberg, and Marisol? Geldzahler's notion of "heroes" and "giants"[66] in a chronicle of outsized aesthetic feats was just flaccid thinking. He hit back by arguing that "all giants do is throw rocks down hills."[67]

Rosenberg's review was not the only negative assessment of "Henry's show." In fact, the mass media had torn into the event with rancor. John Canaday observed in the *New York Times* that the exhibition represented the "museum's sponsorship of an esthetic-political-commercial power combine."[68] Hess, in his editorial for *ARTnews*, compiled a long list of omissions, such as Allan Kaprow, Herbert Ferber, David Hare, and Richard Lippold, as well as categories like "non-Pop figurative painting." Except for Helen Frankenthaler, women—such as Joan Mitchell, Louise Nevelson, Lee Krasner, and Eva Hesse—were largely missing.[69] Geldzahler had made it clear that his criterion was work that had "commanded critical attention or significantly deflected the course of recent art,"[70] tacitly conceding to the yardstick of commerce. Hess admitted that the exhibition was "gorgeous,"[71] but he also faulted it for focusing too heavily on the 1960s, the era in which Geldzahler matured professionally. It was misleading to claim that he had staged a historic survey. He could have saved his show from daunting negative publicity by using a different title, such as "43 Americans."

Hess was a francophile and undisturbed by the show's association with the School of Paris. He thought that the fracas stirred up by "Henry's Show" was "nobody's fault,"[72] even though the Metropolitan had confused reviewers by marketing Geldzahler rather than his topic. In the museum's defense, Hess noted that the press "always wants a personality on which to hang a story."[73] Rosenberg and Hess parted company on this point. Rosenberg did not believe that Geldzahler's showmanship could transcend the spectacle of his mammoth project. Rather, Geldzahler's projection of his ego onto the late modern period had resulted in a misalignment of history.

Rosenberg remembered that as a child he had reluctantly visited the Met each Sunday with his family and was always put off by its sense of stasis where disparate cultures coexisted in forced harmony. As the museum turned to contemporary art, he felt strongly that many curators had abrogated their function as scholars and adopted the public relations strategies of P. T. Barnum. When he replied to Hess's questionnaire on the relevance of the Metropolitan Museum in 1970, he averred that "*a museum is not an artist . . .* and a great

museum ought to conceive a philosophy appropriate to its func-
tion instead of being guided by a pastiche of fashionable clichés."[74]
Geldzahler was unmoved by Rosenberg's squib. At least, he made no
mention of it in a profile on him that Calvin Tomkins published in
the *New Yorker* more than a year later. Tomkins acknowledged that
there had been few favorable responses to Geldzahler's gargantuan
venture. But the writer also suggested that there was no conspiracy
afoot at the Metropolitan Museum to "manipulate the market."[75]
The press had been unduly critical. "Henry's Show" was actually
"valedictory to the decade"[76] of the 1960s, Tomkins stated. That
Geldzahler became the subject of a biographical sketch in the *New
Yorker* reinforced to Rosenberg that the Metropolitan had taken a
wrong turn. As he wrote, "the Swinging Curator"[77] was someone
more concerned with his public persona than with a trenchant re-
trieval of history.

Even before Geldzahler's curatorial survey, Rosenberg had warned
readers of this new museological phenomenon. He thought that the
Whitney Museum of American Art had erred with *The 1930s: Paint-
ing and Sculpture in America*. There was not enough intellectual heft
to the show to get across a sense of the impact of the Great Depres-
sion on art. Instead, the decade was processed through the lens of
the present. A stylistic sameness resulted, with the exhibition repre-
senting a predictable lineup of artists, such as Thomas Hart Benton,
John Steuart Curry, Ben Shahn, and Grant Wood, and their modern-
ist counterparts, Arshile Gorky, Willem de Kooning, and Jackson
Pollock. Rosenberg noted that the exhibition had locked out paint-
ers who had receded from fashion, such as Isabel Bishop, Alexander
Brook, and Louis Eilshemius, and had thrown in inappropriate for-
eigners, such as Fernand Léger who had visited the United States for
extended stays before fleeing the Nazis in 1940. There was no social
history in the catalogue, which robbed the period of its texture. Of
an era besieged by enormous upheaval, Rosenberg retorted, "to use
the past as one likes is a crime against the dead, a species of grave
robbery, that prevents the living from understanding themselves."[78]

In Rosenberg's estimation, the Whitney Museum was guilty of
distortion, all for the cause of "higher ideals and higher attendance

figures."[79] Its historic gloss was troubling to him, tantamount to the dead being overlooked in Eichmann's trial in Jerusalem. The equation was admittedly starkly moralistic. Rosenberg held the museum accountable for its rendering of history, just like the actions of politicians and government officials. Otherwise, he thought it would be doomed to become another bureaucracy that yielded to endless mediocrity. Rosenberg went further with his analogy of the Holocaust and inveighed that "Goebbels envied the Americans their skill in turning the past into a tool or weapon of the present. A museum is an institution designed to retard this talent."[80] What he wanted was for the curator to assume more responsibility for the past. There should be less show biz, careerism, and conformity. He himself had lived through the 1930s and World War II, and he had seen what happened when artists and public intellectuals gave in to totalitarian dictatorships. With the rise of the "Art Establishment" in the 1960s, these lessons were lost, diffused by an upbeat, resilient economy.

Rosenberg felt that when curators tackled historic periods to excavate unknown territory, they were frequently hamstrung by didacticism. His case in point was *French Painting 1744–1830: The Age of Revolution,* an exhibition put on by the Metropolitan Museum in 1975. Rosenberg had hoped that the immense undertaking might be relevant to a culture still reeling from the protest movements of the 1960s. He was disappointed to find that the selection of paintings revealed little impact of the French Revolution. He wondered what the "'Eruption of Mount Vesuvius' by Pierre-Jacques Voltaire, who had settled in Naples in the seventeen-sixties, had to do with the overthrow of the Old Regime?"[81] Robert Rosenblum, one of the curators who had lobbied for these inclusions, proposed that Delacroix, Ingres, Géricault, and David were not the only players. Rosenberg considered Rosenblum's premise a distraction and the catalogue more informative than the show. But how many viewers would read the scholarly tome? How deep was their understanding of a tumultuous, violent moment caused by a populist uprising?

Rosenberg had it in for Rosenblum's revisionist plan to reset the origins of modernism to the late eighteenth century.[82] Rosenblum's theory of resemblances was bunk to him, a contrived aesthetic unity

that bordered on theater. He was averse to the assumption that the avant-garde could be linked to a much earlier period. When the Museum of Modern Art mounted *The Natural Paradise: Painting in America 1800–1950*, a show organized by Kynaston McShine to celebrate the US Bicentennial, Rosenberg homed in on Rosenblum's role and stated in the *New Yorker* that he was the directive force or "presiding genius."[83] Rosenberg claimed that the broad sweep of painting from Thomas Cole through Edward Hopper to Jackson Pollock was fundamentally misguided, "based on the conception of a continuity of feeling that seeps out of the soil like oil out of Texas."[84] There were too many superficial comparisons that centered on the scale of the Hudson River School and Abstract Expressionist paintings. The contemporary section, Rosenberg argued, grew out of an intensely urban experience rather than from the wilderness. What's more, Barnett Newman's originality was internalized rather than pictured through the sublimity of a landscape.

Rosenberg countered that there were other profound factors that separated Newman, Rothko, and Gottlieb from the nineteenth century: as immigrants, or children of immigrants, their relationship to Europe and the vast expanses of the West was tenuous, disrupted by upheaval. As he wrote in the *New Yorker*, "the profundity of Abstract Expressionism lies not in the 'translation' by Still of Cole into abstraction but in the means by which the abstractionists of postwar New York succeeded in salvaging metaphysical feelings from the debris of natural imagery and the international warehouse of accumulated symbols."[85] The *New Yorker* never printed the letters that Rosenblum wrote to the magazine's editor, in which he attempted to dissuade Rosenberg from his assumption that he had "masterminded"[86] McShine's exhibition. But after Sanford Schwartz published a piece for *Art in America* in which he described Rosenblum as the "programmatic brains,"[87] Rosenblum had the opportunity to publish a reply.[88] Rosenblum wanted to ensure that Rosenberg had read his rebuttal and mailed him a copy. Rosenberg responded privately that Rosenblum was being "disingenuous"[89]—the orchestration of *The Natural Paradise* was heavily dependent upon his ideas, even though Barbara Novak and John Wilmerding had contributed

to the catalogue. "After all," he pointed out, "I backed up most of my assertions by direct quotation from your essay, and all of them were consistent with the formula of the exhibition."[90]

a new intellectual order

Rosenberg's reviews for the *New Yorker* remained polemical throughout the 1970s—they always trod on the institutional politics and formalist agendas behind the extravagant-projects at New York's venues for art. Even though Robert Rosenblum departed from Greenberg's canon by delving into less-known and minor figures— many of whom violated received notions of taste—transformations of style in the modern period were his primary interest. The social history that Rosenberg required was not searching enough in his writing. There were other figures who did not live up to his expectations, such as Rosalind Krauss and Margit Rowell, who had co-curated an exhibition of Miró's "field paintings" of the 1920s and 1960s for the Guggenheim in 1972. Their checklist—which excised Miró's Surrealist period to establish ties with Color Field Painting— was a contrived gloss to ascribe pictorial reduction as the artist's main program, Rosenberg declared. He wondered about Miró's metaphysics and concern with the unconscious. There was also the issue of Freud, who hovered over Surrealism. Why did these features get lost in the curators' discussion? Rosenberg bemoaned that they had "falsified the manner in which original art is created."[91] It was not enough for Krauss to presume that she "had the right to replay an artist in the key of her own values."[92] The outcome was that most curators—Geldzahler, Rubin, Rosenblum, and Krauss among them—were packaging history by creating a neutral brand that was acceptable to mass audiences. It was intellectually reckless, Rosenberg inferred: they had no critical awareness of how their egos intervened, let alone scholarly obligation to the artists they treated.

By 1970, Rosenberg contended that the museum had become "resolutely non-political."[93] As he quoted John Hightower, then director of MoMA, its primary goal was to provide "fun."[94] When McShine organized *Information*, for which Hans Haacke created his

MoMA Poll—a piece that criticized Nelson Rockefeller, a trustee, for his failure to denounce Richard Nixon's escalation of the war in Vietnam—Rosenberg allowed that "recognition of the existence of historical crises by artists and critics is a welcome change from the sealed-off formalism of the nineteen-sixties."[95] Revealingly, Rosenberg did not identify Haacke by name in his review; he described his ballot box (in which viewers were encouraged to voice their position on Rockefeller) as an object, as a negation of painting.

Rosenberg had little interest in the growing use of new technologies in contemporary art, believing they were hostile to traditional art forms. Even though he considered McShine's exhibition a significant departure from the ongoing installations of Minimalism and Color Field Painting—such as in "Henry's Show"—he did not feel that it galvanized political action. As he saw it, "'Information' was in no sense a call to join up and fight against tyranny and war, as left-wing works in the thirties urged people."[96] Haacke's box was "a visually stimulating artifact," he wrote, but could not be compared with "a Black Panther distributing literature . . . [that] would be ruled out as beyond the frontier of the aesthetic."[97] The show ironically perpetuated the assumption that art was distanced from political events. He was baffled, then, when McShine subsequently teamed up with Robert Rosenblum to mount *The Natural Paradise* for the US Bicentennial. "Apparently," he wrote, "when leftism reaches its extreme, it tends to go over into nationalist nostalgia."[98] There was something worrisome, he implied, in this curatorial reversal that paralleled the neoconservative agenda adopted by once progressive publications such as *Commentary* after 1968 when Nixon was elected.

it was not a quarrel anyone could win with a stripe

The curator was not the only victim in Rosenberg's reviews for the *New Yorker*. Entangled in the museum's "dilemma"[99] were artists such as Frank Stella and Kenneth Noland: on them he was particularly hard-hitting. Rosenberg could never separate Stella's painting from the didacticism of museum programming. He presumed that his success as a painter was caught up in his enactment of a "visual

debate."[100] When he covered Stella's first retrospective at the Museum of Modern Art in 1970, he credited Stella with being a "gifted designer."[101] He was an artist who could operate within the arena of geometric abstraction with considerable aplomb, as he had a "natural talent for ornament."[102] Yet again, Rosenberg surmised that Stella's work was involved only in propounding formal problems.

Rosenberg thought Stella's *Jasper's Dilemma* (1962–63), a diptych of identical geometric paintings — one rendered in bright, saturated color, the other monochromatic — operated on the assumption that the spatial paradoxes in Johns's work involved the fiction of illusion. Structured as a maze, Stella's composition of torqued boxes presented its own paradox: it reneged on his earlier commitment to flatness and repetition. To Rosenberg, Stella's reply to Johns represented a yeoman's answer: why fiddle with something so resonant and reduce it to pleasing decoration and pattern? He had submitted to art criticism by echoing the critical imperatives of his supporters, such as William Rubin (the curator of his MoMA show), and Michael Fried and Rosenblum (the catalogue's contributors). Rosenberg was more interested in Stella's rapid rise and how it was achieved by this "new intellectual order"[103] that had winnowed art to a discussion of opticality.

Rosenberg similarly thought that Kenneth Noland's paintings of targets and stripes were shored up by the aesthetics of his champions. But in one of his last reviews for the *New Yorker*, he was pleased to affirm that by the late 1970s formalism was losing its ground. Critics such as Robert Hughes, who began writing for *Time* magazine in 1970, also had little tolerance for the "intimidating effect of the supporting criticism"[104] that propped up Noland's color investigations. While there were still diehard subscribers to Greenberg's views, such as Diane Waldman at the Guggenheim Museum who organized the Noland overview, Rosenberg observed that few younger artists had latched onto formalism's premises. He no longer felt like the lone objecter to the aesthetic theology of the 1960s. Too many cracks in its epiphanies had begun to surface.

Hughes, an Australian, had been in touch with Rosenberg starting in the mid-1960s, just as he began to freelance for British pub-

lications, such as the *Observer* and *Sunday Times.*[105] He cut a rebellious, hip image—Hughes was frequently photographed with long hair, wearing a leather jacket, seated astride his motorcycle. Initially, he admired artists mostly of an earlier generation, such as the Abstract Expressionists, especially Robert Motherwell. There were exceptions to his enthusiasms, such as Barnett Newman and Clyfford Still. While Hughes wanted it both ways—he required clear evidence of the ability to draw in addition to invention in painting— his lacerating prose was frequently directed at the art market and museum, as well as the academy where he felt most educators hide behind jargon. He had it in for the adherents of the "paranoia-driven theories of the Frankfurt school"[106] and poststructuralists thinkers, such as Michel Foucault and Jacques Derrida, who asserted that individual agency was impossible to exert within current repressive power structures.

Hughes stated, a few years after Rosenberg's death, that Rosenberg's writing from the 1960s and 1970s made up his "intellectual legacy," not the "foolish pseudo-existentialist remarks"[107] in his earlier essays. When he gave the first annual Harold Rosenberg Memorial Lecture[108] on "Art and Money" in Chicago in 1984, he invoked not only Rosenberg's "The Art Establishment," but his catchall of a dominant "herd":

> Nobody, and I least of all, would deny that there are admirable collectors and dealers—people who really can and really do think and look; whose sense of responsibility is not inflated into pompousness; whose eyes have histories, and who buy from informed love rather than herd-instinct.
>
> But they are not necessarily the ones on whom the contemporary art market, in its present form, depends. The ones that market needs are the people whose apartments are shifting anthologies of the briefly new. They buy large quantities of art because they are infatuated with the artworld as a system.[109]

Rosenberg also quoted from Hughes in his piece on Noland to reinforce the "intellectual context of his canvases."[110] He was rarely

inclined to cite other writers unless he wanted to expose the flaws in their thinking—hence, the long-drawn-out passages from essays by Rubin, Geldzahler, and Rosenblum. But there were clear differences between Rosenberg and Hughes. Hughes, who was thirty-two years younger, never became a Marxist. He remained a leftist until the late 1980s, when multiculturalism penetrated the academy. He regarded the new pedagogy as excessively rigid, a "strange, nostalgic, Marxist never-never land."[111] His pokes at the bumptious behavior of art world denizens and academics were mordantly funny, as well as brutal, not unlike Rosenberg's canny phrasing. Still, there was no overarching metaphor or theory that governed Hughes's invective, unlike Rosenberg's concept of *action*. While he wrote for a populist publication, he himself was decidedly patrician, his cocky diction a reflex of the entitlement he felt as the scion of a prominent Sydney family (whose brother became the attorney general of Australia). Hughes breathed high culture; it was part of his being and determined his epicurean lifestyle (he loved good food, fast living, and copious amounts of wine). No wonder he had little use for Rosenberg's existentialism.

Both Hughes and Rosenberg believed that part of the mission of criticism was to unpack the paradoxes of culture. However, Hughes's writing was not indebted to Rosenberg's authority. There were other sources whom he acknowledged as influences, such as Alan Moorehead, George Orwell, John Berger, and Kenneth Clark.[112] He operated primarily as a journalist, a profession Rosenberg never entertained. Unlike Hughes, Rosenberg never launched a television series, such as Hughes's *The Shock of the New* and *American Visions*, that generated huge audiences. This visibility, along with his column at *Time*, earned Hughes the distinction of being "the most famous art critic in the English-speaking world."[113] For all his work with the Ad Council, Rosenberg rarely appeared in front of a camera.[114] His métier remained his pen. He did not aspire like Hughes to be a latter-day Kenneth Clark, whose BBC production, *Civilisation*, aired in 1969. His ego did not need the airwaves for gratification.

Rosenberg had allegiances to artists that were not shared by Hughes. One of his last monographs was devoted to Barnett New-

man (fig. 32), whom Hughes never extolled after a tempered start, such was his antipathy to the painter.[115] To Newman's statement that he thought his generation's "quarrel was with Michelangelo," Hughes shot back, "it was not a quarrel anyone could win with a stripe."[116] Both writers understood that Newman's reputation hinged on Noland, Stella, and other abstract artists who had emerged in the late 1950s. Yet Rosenberg believed this to be a misreading: Newman's work was not dependent for its longevity upon younger figures. He was differentiated from the Color Field painters, and from Stella, by the way in which he used the "zip," as Newman called his stripes. His vertical canvases were emphasized by bands, or a lone line, set in an unmodulated expanse of contrasting hues. Rosenberg interpreted Newman's ascetic gesture as a "type of crucifix against the sky, but without the arms, that is to say, without the specifics of history or mythology."[117] He realized that "in this negation of signs within

Fig. 32. Barnett Newman (1905– 70), *Untitled*, 1961. Lithograph, 13 ¾ × 9 ½ inches. The Barnett Newman Foundation.

evocation of sublime feeling, the modern imagination achieves its fullest authenticity."[118] Hughes thought that Rosenberg, as well as Tom Hess (who authored two exhibition catalogues on Newman), had gone overboard in his exaltation of his "zip." He had read an interview in *Art in America* in 1962 in which Newman stated, "Almost fifteen years ago Harold Rosenberg challenged me to explain what one of my paintings could possibility mean to the world. My answer was that if he and others could read it properly it would mean the end of all state capitalism and totalitarianism."[119] The Australian wrote off Newman's proclamation as "bullshit."[120]

If Hughes had researched Newman more thoroughly, he might have encountered a published letter from the artist to Rosenberg in 1963, in which Newman expressed appreciation for a piece Rosenberg had written on him for *Vogue*. He affirmed, "I and my work are one."[121] Rosenberg announced in his tribute that Newman "is a man of spiritual grandeur,"[122] a portrayal that was more expansive than Hughes's flat repudiation of signification. More than that, Hughes presumed that both Rosenberg and Hess had imputed cabalistic meanings to Newman's paintings to "reconnect to their own Jewishness."[123] Hughes should have read Rosenberg more carefully. He would have learned that he took issue with Hess's application of Newman's interest in Jewish mysticism to his painting.[124] In fact, Rosenberg felt Hess had committed an "indiscretion," believing that "regardless of their sacred associations, Newman's concepts are secular in meaning, and his thoughts can be understood only in the language of contemporary experience."[125]

you belong to the slicks now but you still talk to the working class stiffs

In the 1960s, as Newman's work gained traction, the artist tried to stifle any connection to the New Abstraction by limiting the contexts in which his work was shown. In 1965, he wrote to Walter Hopps, who curated the US section of the eighth Bienal de São Paulo, to express concern that the advance publicity had misconstrued his painting. He wanted it understood that he was not a for-

malist like Larry Bell, Donald Judd, Larry Poons, and Stella, with whom he would appear in Brazil. He complained to Hopps, "It is my impression that you were organizing a kind of train, full of young men of high purpose, who, not being too well known, needed me as a locomotive. However, instead, of a locomotive, I have become a cog in a formalist machine."[126] Hopps subsequently adjusted his script to accommodate Newman's apprehensions. Newman made it known in the catalogue that "the self, terrible and constant, is for me the subject matter of painting and sculpture."[127]

After Newman's death in 1970, Rosenberg feared that the artist's intentionality had ceased to be considered, that the formalist interpreters had gotten the upper hand. He knew that Newman's lean aesthetics had been a formidable influence on Stella, Noland, and others who had wrestled with the residue of illusion in painting. Still, there were differences. As Rosenberg defined them, a Newman painting "has the tension of a creative act. A Noland, in which personality has been renounced in favor of theory and method, lacks the variousness of actual experience."[128] In their emphasis on the material presence of art—its paint texture, shape, and ground—these artists had deliberately avoided allusion through radical compositional simplification.

Barnett Newman was not the only New York School artist who Rosenberg thought had been misinterpreted in the 1960s. The same held for Ad Reinhardt. Rosenberg's relationship with Reinhardt had been initially challenged by Rosenberg's predilection toward mark making in painting. How did Rosenberg insist upon the presence of a personality in Reinhardt's work in the face of asceticism? In Newman, he could always default to the artist's recurring references to his self. Reinhardt was more of a conundrum. Rosenberg and Reinhardt had known each other since the late 1930s, when they met at the Artists' Union and on the WPA.[129] Later, they met up at The Club. Their exchanges had always been characterized by playful antagonism.

Reinhardt goaded most people in the art world through 3 1/2 × 5 1/2 inch, standard issue USPS postcards on which he inscribed, in black calligraphic script, taunting, mischievous provocations. In one

missive sent soon after Rosenberg began writing for the *New Yorker*, he exhorted, "You belong to the slicks now yet you still talk to working class stiffs like me, you're ok, ad."[130] Rosenberg had named Reinhardt "a black monk"[131] in a review of *Americans 1963*, a group exhibition that Dorothy Miller assembled at MoMA that included one of his black, nearly monochrome canvases with the shape of a barely discernible cross. The moniker perplexed Reinhardt. "I'm not one at all," he responded.[132] What Rosenberg meant was not just the purifying impulse that drove Reinhardt's disciplined, serial project, but also his role as a "would-be executioner of Abstract Expressionism,"[133] or his muting of the movement that was rejected by the Cool School in the 1960s.

Reinhardt had sent Rosenberg an advance copy of "Art-as-Art," one of his many manifestos published in *Art International* in 1962.[134] Rosenberg quoted from the last two lines of the tract in his piece on *Americans 1963*. He was held by the artist's declaration that "the one thing to say about art is its breathlessness, lifelessness, deathlessness, contentlessness, formlessness, spacelessness and timelessness. This is always the end of art."[135] Was this so? Rosenberg found poetry in Reinhardt's end-game promulgations, his assumption that painting had arrived at a point of stasis through its entombment in the museum—the only place, in the artist's words, where "soundlessness, timelessness, airlessness, and lifelessness"[136] could be ensured. But his fulminations, Rosenberg felt, were filled with too many contradictions, and his virtuosity was too self-serving, whatever his Zen-like posture on self-abnegation. Reinhardt's argument was too tidy, too based on conjecture that abstract art had reached a natural culmination point.

Shortly before "Art-as-Art" was published, Reinhardt prodded Rosenberg with a question on one of his postcards by quizzing: "You think that art does not evolve in a timeless-stylistic-Focillonist-Sypherical-Progressive-Malrauxian-YGassetian-Marxist-Historical-Dialectical-Maritanist-Materialist-Toynbean-Taineist-Mondrianism-Malevichist Cycles?"[137] In his list of notations—which ironically alluded to his own biography, something Reinhardt aimed to suppress—he omitted, Rosenberg felt, too many vital chapters

and thinkers who had contributed to modernist history, the unraveling of which was more varied and messier, less absolutist than Reinhardt had sketched.

To Rosenberg, Reinhardt's ongoing act of denunciation was rooted in his hostility to other artists. Art was not only a series of oppositions, as Reinhardt had it, not the "struggle of artists against artists, of artist against artist"[138] that he pronounced in "Art-as-Art" and reiterated in other statements and essays.[139] In his dark, nearly monotone canvases of the 1960s (all 60 × 60 inches), black was used not as a symbol (such as death or foreboding) but for its "aesthetic-intellectual"[140] value (fig. 33). The elimination of color connoted anonymity, the condition that Reinhardt observed beset all the Islamic

Fig. 33. Ad Reinhardt (1913–67), *Abstract Painting*, 1960–61. Oil on canvas, 60 × 60 inches. The Museum of Modern Art, Purchase (by exchange).

and Asian art that he began to study in the late 1940s. Rosenberg would have none of this dogma, believing that Reinhardt's sense of alienation had not been used as effectively. Rather than struggling with his existential predicament, he had turned on his brethren. "The artist community is completely dissolved and artists aren't even talking to each other," Reinhardt lamented a few months before his death. "They're all geared to the public, at least intellectually."[141] Rosenberg knew this to be the case, but it did not justify Reinhardt's blaming specific figures, such as Jackson Pollock, whom Reinhardt passed off as wanting "to become a celebrity"; Willem de Kooning, who lived "like Elizabeth Taylor"; and Andy Warhol, who "ran together all the desires of artists to become celebrities, to make money, to have a good time."[142]

Rosenberg felt these artists were not at "fault,"[143] as Reinhardt had described on one panel at The Club. In his estimation, the artist of his generation was the least reprehensible figure. It was the effect more of the "Art Establishment" that had contributed to the fading of a community and left the artist with a sense of demoralization. This new megalith explained the careerism and lifestyle choices that took hold in New York in the 1960s. Besides, Reinhardt was not the loner or bohemian outcast he made himself out to be. He may have felt at odds with the Abstract Expressionists, but he was aggressively ambitious for his work. It was more Reinhardt's sense of superiority, Rosenberg deduced, that set him apart from artists such as Pollock, de Kooning, and even Newman. Newman sued him in 1954 for having placed him in a category that Reinhardt defined as "the latest up-to-date popular image of the early fifties, the artist-professor and traveling design salesman, the *Art Digest* philosopher-poet and Bauhaus exerciser, the avant-garde huckster-handicraftsman and educational shopkeeper, the holy-roller explainer-entertainer-in-residence."[144] Josef Albers, Burgoyne Diller, Carl Holty, George L. K. Morris, and Robert Motherwell were also lumped into this group of presumed sellouts. Why, then, did he insist that his own work resisted classification? Was it enough to broadcast that he had withdrawn from the art world because "the standards became too foolish or

oppressive"?[145] What, specifically, if anything, set him apart from his peers?

Rosenberg considered Reinhardt a "pivot"[146] between the New York School and progressive art of the early 1960s. Unlike the artist's self-posturing, he did not think of him as an anomaly or outsider. In fact, he identified with his spiel that both the marketplace and academy fostered the methods of formalism. Rosenberg also realized that the prosperity of the artist in the postwar United States had been achieved too rapidly, to the detriment of a confraternity. He missed the feelings of solidarity he had known at The Club and in organizations such as the WPA and the Artists' Union, even though the latter had been fraught with political dissension. Lifelong commitments had been made that were important to him. Reinhardt apparently retained no sense of loyalty to his confreres at the *New Masses*, where he had worked as an editor and cartoonist during the Depression, or at the WPA and the American Abstract Artists group, of which he was an early member—and, especially, at The Club, where he inveighed against the depravity of the artist. (Reinhardt was involved with the CPUSA during the era of Popular Front and until its demise during the Truman administration. This set him apart from Rosenberg, whose Marxism was not tied to the party. However, Reinhardt made little public display of his commitment to the CPUSA. His cartoons for the *New Masses* and *Soviet Russia Today* appeared under a pseudonym, Darryl Frederick, which tells of the psychological complexity surrounding his political ties.)[147]

Rosenberg and Reinhardt were further allied when it came to Clement Greenberg. Reinhardt never believed that his own "art as art" posture dovetailed with the critic's mandate for compositional purity. Rather, he arrived at the immutability of the canvas through anti-art deduction. The stratagem partly explained why Greenberg never wrote at length about Reinhardt. By 1967, when his work had been linked as a precursor to Minimalism, Greenberg described him as "a trite artist"[148] who had been overly influenced by Newman, Rothko, and Still. By contrast, Rosenberg wrote about Reinhardt's work on numerous occasions for the *New Yorker*, stating by

the mid-1970s, that humor had been a salient but overlooked dimension of his work. He had worked, after all, both as a painter and satirist during the Depression and after. His caricatures had been either glossed over or interpreted as a sideline by most critics and commentators, with the notable exceptions of Tom Hess and Peter Schjeldahl.[149]

The cartoons of Hitler, Mussolini, and other dictators that Reinhardt produced for the *New Masses*, and those on the art world for *Partisan Review*, were integral to his practice. While he gave up on satire in 1961—just as he took to his black paintings—his excoriations against his generation of artists never diminished in his writings. In his last caricature for *ARTnews* in 1961—a reprise of a spoof on *How to Look at Modern Art in America*—half of the branches and leaves on his genealogical tree of modern art have become either withered, rotted, or broken through the weight of "business," "prizes," "foundations," and "visions, impulses, sensations, representations." Reinhardt's tart put-downs had a distinct comedic edge.[150] Rosenberg considered this a strength. The format added to his moral scourge, just like his jabs at the Museum of Modern Art and *ARTnews*, both of which he wrote off as timid institutions.[151] But when it came to his peers, Rosenberg felt that Reinhardt's battle had been misplaced. In other words, he had become too malevolent, if not an ideological crank. His rhetoric echoed the old propaganda of the Communist Party.

Rosenberg wrote in the *New Yorker* that it was the "omnipresent memory"[152] of Dada iconoclasm that allowed for Reinhardt's antipathy to painting's future. He was not alone here: since the mid-1960s, writers such as Richard Wollheim had conjoined Reinhardt and Duchamp in a mash of philosophical questions that related to the essential nature of art.[153] Were the conceptual hallmarks of both artists' work enough to deflect queries that related to labor and craft? Was the minimal presence of Reinhardt's hand, and its complete absence in Duchamp's ready-mades, a violation of art's core ingredients? Wollheim concluded they were not, but his line of inquiry failed to hold Rosenberg's interest. He was more attuned to the "negative substance"[154] of Reinhardt's goal to bring painting to

a *terminus ad quem*. Reinhardt disputed that his work was informed by Duchamp; he had other modernist ancestors in mind, such as Kazimir Malevich and Piet Mondrian, who had perfected geometry.[155] "Painting comes from painting," he averred, not from "accidents or ready-mades."[156]

In Reinhardt's last postcard to Rosenberg, sent in 1967 shortly before his death, he nudged him with a question: "[Robert] Coates wrote his next to last article on Pavia and me? Me and Pavia? How about you writing your last article on me? Without the Pavia?"[157] Ironically, one of Rosenberg's final art columns for the *New Yorker* was indeed on Reinhardt. Reinhardt probably would have been chagrined to read that he described his painting as having "the aura of individual mystery characteristic of American Abstract Expressionism."[158] It was a connection he had worked to derail. Rosenberg maintained that his art had a role in spawning Minimalism. Curiously, Reinhardt never distanced himself from the new movement, unlike Barnett Newman. Perhaps his dictum, "the struggle of artists against artists," prevented him from skewering younger artists, many of whom he knew, such as Judd and Stella. He did, however, admit that their looking was too confined to a specific chapter in modern art. Unlike his own understanding of the void and emptiness, which was the result of intense study and travel to the Middle East and Asia, Reinhardt asked in one of his last published statements, "How are the new 'cool,' 'mechanical,' 'series,' 'optical,' abstracts artists, ignorant of Islamic art history, doomed to repeat the all-over constructivist arabesques, an impressionist, cubist honeycombs?"[159] It was almost as if he had the last word, as Rosenberg acknowledged.

art is not the spiritual side of business

Duchamp and Mondrian were also artists who loomed large in Rosenberg's writing for the *New Yorker*. They hovered over his discussion of Reinhardt and the new anonymity that characterized advanced art of the 1960s. That both artists had spent time in New York was intriguing to him. Barbara Rose might have had Malevich, rather than Mondrian, in tandem with Duchamp in her "ABC Art"

to explain the forerunners of Minimalism, but Rosenberg understood from Reinhardt and Newman that Mondrian was an equally relevant figure, perhaps more so since he had produced paintings such as *Broadway Boogie Woogie* in Manhattan. Except when it came to self-abnegation, Mondrian and Duchamp could not naturally be paired. Not only had they exerted their influences differently in the United States, but Mondrian's work, unlike Duchamp's, never addressed the question of "what art could be, and could not be."[160] That quandary, Rosenberg thought, had been parried by the Minimalists who finessed the viewer's experience as pure visual engagement. Duchamp's found objects, by contrast, revealed a certain confusion, if not enmity, that grew out of this constraint. There were drawbacks to aesthetic terms, however, that made no allowance for resonance. For one, they necessitated the intercession of words and the critic's voice. "The less there is to see, the more there is to say,"[161] Rosenberg said. Reinhardt's mute black canvases were a good example: evenly textured to expunge the emotive handwriting of *action* painting, they engendered such anger from some onlookers when exhibited at MoMA in 1963 that they were placed behind platforms. Their smooth, matte surfaces had to be protected from touching. Even so, their announcement of art's end was dependent upon the artist's sloganeering. "Repetition of formula over and over again until loses all meaning / Nothing left except monotonous disappearing image,"[162] Reinhardt intoned to canalize his message of boredom.

When it came to Mondrian, Rosenberg believed he had been wrongly subjected to Reinhardt's notion of aesthetic fate. In a review of a retrospective of his work at the Solomon R. Guggenheim Museum in 1971—the first in the United States—he put forth that Mondrian's intentionality, just like Barnett Newman's, had been skirted to resurrect him as "the patron saint of formalism."[163] Mondrian had a utopian vision for art and for man, one that sprang from an idealism nurtured in the glow of the Bolshevik Revolution, and from an early commitment to Madame Blavatsky's Theosophical Society, which supposed absolute laws governing the universe. His so-called Neo-Plastic grids of black-and-white lines with rectangular fill-ins of primary colors banished all trace of ego. (Neo-Plasticism

was a term Mondrian coined that denoted the reduction of art to a perfected, recognizable style.) His abstractions were symbolic of a new world order in which subjectivity was subsumed into a harmonious whole. As such, they were meant as icons of uplift.

Rosenberg acknowledged there was lip service paid to these ideas in the Guggenheim's catalogue. But it amounted to a "shallow aestheticism"[164] that failed to fully understand Mondrian's program for art's role in effecting a revolutionary new society. One of the shortcomings of the show, he said, lay in its chronological arrangement of paintings, the order of which suggested stylistic headway. Mondrian's late work, he observed, made a complete break with the past. It constituted a beginning, not an endpoint. The condition of flatness that he achieved had few precedents in painting. Unlike the Minimalists, he broke from history. Granted, his work was aesthetically oriented, but his mission was to produce a grand futuristic society. Rosenberg noted that if the curators had probed Mondrian's writing, they might have learned that his theories of compositional symmetry were bound to his faith in the restructuring of human destiny.

Rosenberg believed that Mondrian was an artist whose work depended upon his utterances, much like Newman and Reinhardt. Mondrian might have imagined a time when his painting could stand on its own and dispense with the accessory of writing. However, world events conspired against him when Hitler expanded Germany's territories, and he was forced to leave Paris. "Like Marx, Mondrian anticipated the end of the tragedy of history," Rosenberg wrote, "and attainment of 'the great repose of philosophy.'"[165] His idealism could never surmount the intercession of fascism. His words, or beliefs, failed to matter. His painting alone, and its influence on the applied arts (where personality could more easily be diluted), had the biggest impact. In the early 1970s, when Rosenberg covered the Guggenheim survey for the *New Yorker*, the reductivist movements of the previous decade revivified Mondrian's concept of painting as aesthetic pursuit.[166] That made Rosenberg not only uneasy but wary of the way in which history had been used to uphold the values of a new generation of artists.

Rosenberg thought Duchamp, unlike Mondrian, had never been

misunderstood. There was no mistaking that his work was conceptual, and devoted to shunning the marketplace. As an artist who lived until 1968, he had been able to see what his followers were up to. Little of it he liked. Like Reinhardt, he despised the whole process of art's commodification. Through his resistance to making an original object, he deemphasized labor and the perfection of craft— the features that make art salable. His ready-mades subverted the notion of authenticity with such wit that he had even bested the museum, which treated his multiples of shovels, urinals, and bottle racks as unique works of art.

To Rosenberg, who considered Duchamp to be "one of the most forceful and necessary figures of our time,"[167] this outcome represented "the fatuousness of an institution that had lost its bearings."[168] There was more to Duchamp's nihilism than anti-art jest. Not only had he debunked the romance of creation, he had also posed the question of what it meant to be a professional artist. That identity seemed to him too tied to the material presence of painting. Instead, he announced there were more liberating ways to deliver a message that stemmed from the imagination. "Enslavement by art, he was convinced, is no different from enslavement by other tyrannies of work,"[169] Rosenberg wrote in a long review of a retrospective of his work held at MoMA in 1973.

Duchamp worked episodically—rather than systematically— and as a result dispensed with the studio entirely. It was that very space, however, which Rosenberg believed gave rise to the expression of art. The studio was a solitary arena that still distanced itself from commercial entities, even if art was destined for the gallery. Rosenberg was aware that Duchamp's stance deflated his motif of *action*. From the *Nude Descending the Staircase* through his found objects, the mechanistic traits of his work purposefully downplayed the modernist will to invention. While they still remained individualistic, it was his signature that became paramount. Put another way, in Duchamp's gambit the personality of the artist overwhelmed the object to the extent that it became secondary. How else to explain his pseudonymous performances as Rrose Sélavy and R. Mutt?

Duchamp was a provocateur, and a comedian; his jest enlarged

the parameters of art by introducing alternative options. Rosenberg recognized that he was an artist who acted out of principle, who upended bourgeois notions of taste to preserve his own requirement for freedom. But in the end, his agitations did not alter the face of art. That future was stymied by his "disciples,"[170] Warhol foremost among them. He ran with Duchamp's spoof on originality and flipped it into celebrity while pandering to middle-class patrons who flocked to his Factory. Rosenberg argued that Warhol's motive was never about aesthetic debasement. Nor was it about liberation from the downsides of capitalism.

"death in the wilderness"

Rosenberg was never scornful of Duchamp, unlike other writers, such as Greenberg, Hess, and Kramer, who wrote about the artist in derogatory terms.[171] Within the context of Duchamp's revival in the 1960s—he had not been in the limelight since the early 1940s after a self-imposed exile from the art world—Rosenberg stood apart from his peers. He was not offended by Duchamp's assault on aesthetics. Hess had launched an all-out attack on Duchamp's work in 1965 and lambasted the artist for being an ineffectual painter.[172] It did not matter to Hess that Duchamp gave up on painting because he believed its days were over. He was too undone by what he thought of as the "Camp" traits of the ready-mades. He deemed them the workings of an artist who acted "effeminately,"[173] much like a homosexual. When Hess made his allegation, Susan Sontag had just published "Notes on 'Camp'" in *Partisan Review,* where she trumpeted "a peculiar relation between Camp taste and homosexuality."[174] Still, Hess's homophobic response to Duchamp's found objects had few parallels with Sontag's "Camp" sensibility. Duchamp operated from the reverse position that "Camp is a certain mode of aestheticism."[175] Hess had misread Sontag's connection. Duchamp upheld her terms of "artifice" but not its goal toward "stylization."[176] His whole enterprise ran counter to repurposing objects of beauty.

Hilton Kramer was just as vituperative in the *New York Times,* though with none of the misaligned prejudice that characterized

Hess's eruption. It was not only Duchamp's painting that was deficient to Kramer, but also his ready-mades, which made no aesthetic sense.[177] Like Hess, he found him guilty of spawning a generation of fame seekers during the Pop era. Rosenberg's review of Duchamp's posthumous retrospective at MoMA contrasted with the machismo threaded through Hess's outburst as well as with Kramer's notion of the artist's "triviality."[178] Instead, Duchamp's performance as Rrose Sélavy, and the photos of him in drag, were seen as antipathetic expressions of "middle-class and professional (grown-up) postures of dignity."[179]

In 1966, Rosenberg was quoted in an article on "The Homosexual in America" in *Time* magazine on the phenomenon of the "banding together of homosexual painters and nonpainting auxiliaries."[180] The line had been lifted without context from "The Art Establishment," the piece he had written for *Esquire* a year earlier. Unlike Hess, Rosenberg was not echoing Sontag's observation that "homosexuals, by and large, constitute the vanguard—and the most articulate audience—of Camp."[181] He had already taken on Camp culture in "Death in the Wilderness" for *Midstream* in 1959 where he allied its features with the "look" of a generation that was expressed through clothes and lifestyle. Rosenberg thought that "the opinions of a generation never amount to more than fashion," and that "the regretted 'generation of [F. Scott] Fitzgerald' shared few ideas deeper than raccoon coats, hip flasks and Stutz Bearcats."[182] In his estimation, Camp had devolved during the 1950s into a "notorious conservatism"[183] that was the outgrowth of nostalgia. This conservatism could be read in the return to the church, renewed reverence for family, and the security of a regular paycheck: the countercourse of bohemianism. The paradigm also incorporated the "enthusiastic participation of the homosexuals in the Reconstructed Family movement; indeed fairies and near-fairies were in the vanguard of the new domesticity—witness the epidemic of marriages among homosexuals."[184] Conformity to belong had silenced the most radical expressions of individuality.

Sontag must have read Rosenberg's "Death in the Wilderness." In her journal for 1959, she had an entry to "look at"[185] *The Tradi-*

tion of the New, which included the essay. There were few similarities in their takes on Camp, especially as she was more interested enumerating its sensibilities and aesthetic features. Rosenberg had no investment in style, let alone in compiling a catalogue of its effects. Quite the opposite. In a later journal, Sontag commented that Rosenberg was "too political"[186] to be subsumed within the new antiliterary movements that characterized the 1960s. (She was thinking about figures such as Buckminster Fuller, Marshall McLuhan, and Reyner Banham.) Nor did he belong there: the 1960s were not his entry point as a writer. There was no room, moreover, for politics in "Notes on 'Camp.'" Sontag had written that "the Camp sensibility is disengaged, depoliticized—or at least apolitical."[187] But that was Rosenberg's principal objection in "Death in the Wilderness." He had argued that "there is more to history than costume and fashion."[188] Unlike Sontag's aloof itemization, Rosenberg believed that "you cannot *fit* into American life except as a 'camp.'"[189] The forces of conventionality had become too overwhelming.

Rosenberg's essay preceded Sontag's more polemical piece by almost six years. It was one of the first published instances where Camp was addressed as a subject in the United States. But the idea that middlebrow culture fed from the sanctum of exalted styles had been around in the United States since the late 1930s when Clement Greenberg published "Avant-Garde and Kitsch." By 1960, Dwight Macdonald resurrected this schism in an article in *Partisan Review* where he rephrased the phenomenon as "Masscult and Midcult."[190] Macdonald's eulogy for highbrow intellectual culture through his extensive use of contrasts—such as Edgar Allan Poe and Erle Stanley Gardner—might have informed Sontag's clipboard of Camp's characteristics. Certainly, her piece was provocative for *PR,* which still had a stake in social content (the missing trait in Camp), and came on the heels of Macdonald's list of antipathies. She had little to say about Macdonald in her journals other than that it was "revealing"[191] to meet him. But she did cotton to Rosenberg even though she found his work "too political."

Once she returned from Paris in 1963, Sontag wrote to Rosenberg to state that she admired his work.[192] As late as 1975, she quoted in

her notebooks a line from his "Parable of American Painting": "to be legitimate, a style in art must correct itself with a style outside of art, whether in palaces or dance halls or in the dreams of saints and courtesans."[193] By this date, politics had entered into her work. She had come to the realization that "taste is context, and the context has changed."[194] Where she had once considered Duchamp's ready-mades as embodying a "philosophical point,"[195] rather than aspiring to art, she later dissed his stance as "modernist nihilist-wise-guy bullshit."[196]

What had changed for Sontag? For one, she had taken on the recent rehabilitation of Leni Riefenstahl—a Nazi propagandist and friend of Adolf Hitler—whose recent photographs of the Nuba people of Sudan were used to rewrite her biography and insidious political associations. (The copy on the book jacket reimagined a life that placed Riefenstahl at odds with the Third Reich.) To Sontag, the same old fascist aesthetic pervaded her rapturous images with their emphasis on "physical perfection."[197] The Noble Savage was now a "casebook of primitive virtue."[198] Sontag no longer felt that photographs such as these could be explained by their Camp traits. Her study of form had ceased to be a viable hermeneutical method. She might have once thought that content had been overused as exegesis—the basis of her much discussed essay "Against Interpretation" in 1964—but she reversed course and lobbied for a "much denser notion of historical context."[199] She became more in sync with Rosenberg, at least theoretically. Sontag now believed that consideration of the social circumstances that surround an artist's practice was the only way to unpack meaning. How else to get at Riefenstahl's disturbing use of beauty? (There were, of course, other factors that intervened in Sontag's political transformation, such as her growing weariness of the idealism of the New Left and its powerlessness to end the Vietnam War.)

Despite the "wise-guy bullshit" that Sontag thought Duchamp had deployed, she understood, like Rosenberg, that he was "too smart to be a painter."[200] His transgressions had enabled a richer analysis of the nature of art. He was a nihilist who had invaded the precincts of philosophy by disposing of craft along the way. As

Rosenberg had stated a few years before her realizations, "Duchamp established himself as a squatter in the outskirts of art and devoted himself to one-shot projects."[201] He did not change the profession, but at least "he did explore with the most realistic acuity what art could be, and could not be, in the twentieth century."[202]

24
the professor of social thought

no longer such a thing as "disinterested seeker of truth"

May Natalie Tabak's memoir, "A Collage," concludes with a story of how she and Rosenberg returned home to The Springs after a ten-day trip to Provincetown in the late 1960s to find an invitation to one of the numerous summer parties in the Hamptons. It was billed as an "informal drop-in,"[1] but the soirée proved to be anything but. As she had it, the annual event had become extravagant. A huge crowd had gathered on the "enormous lawn which felt like a padded rug [and] lanterns [were] dangling from the branches of trees"[2] among twenty tables set for dinner. While Rosenberg sat— by this point he suffered from severe arthritis in his hip—Tabak combed the group looking for friends. She knew everyone at the event, "the lawyers, the designers, the architects, the critics, the museum staffers, the shrinks, the collectors, the dealers, even the big-time framers." "It looked," she wrote, "as if everyone in the art world was there."[3] Everyone, that is, except for artists—their companions. So they skipped dinner and went home. The contrast with Provincetown, where they had just spent time in a colony of creative people, was striking. They no longer felt they were part of the scene, even though Rosenberg wrote for the *New Yorker*. Tabak remembered that they sat in silence as they drove off.

Tabak's reminiscence of the party stands as a metaphor for both the rapidly changed art world in the late 1960s and the late phase of Rosenberg's professional life. His stature as one of the foremost critics of the postwar period had been established by his writing for the *New Yorker*, but his interactions with artists were now delim-

ited. Many of the friends whom he had cherished, such as Hans Hofmann and Barnett Newman, and even Ad Reinhardt, had died by 1970. The avant-garde had withered, along with its bohemian values, which meant that the free-form parties where debate was a staple had dissipated, replaced by more formal events where talk had become ritualized and polite.

Rosenberg had observed facetiously in "The Art Establishment" that "to drop names effectively one must, of course, drop them in the right places."[4] He never felt that he belonged in this new scene. Not only had business become the rallying point of conversation, but the "virtuosos of boredom," as he called Andy Warhol and other Pop and Color Field painters, had taken over. His deep preoccupations had always been decidedly political, as Sontag observed, unlike theirs. He continued to insist on a dialectical understanding of culture — another profound disconnect. During this period, his old friend Philip Guston, who spent most of his time in Woodstock, New York — having pulled out of Manhattan around the time of his last show at the Marlborough Gallery in 1970 — wrote to Rosenberg, "It's all over for the likes of us — I see the *handwriting on the wall* . . . I feel like a sliding of values — institutions and groups won't stay put."[5]

Rosenberg was under contract to review exhibitions exclusively for the *New Yorker*. He could not accept invitations to publish elsewhere unless the subject did not pose a conflict with his role as art critic.[6] James Fitzsimmons had approached him on numerous occasions to write for *Art International* and had hoped to reprint a review that he had written on the Barnett Newman retrospective at MoMA in 1972, as well as future articles from the *New Yorker*, all of which he proposed to illustrate.[7] Yet Rosenberg was unable to act on Fitzsimmons's offer. The only reprints that appeared during his lifetime were collected in three anthologies brought out by the University of Chicago Press. He was liberated to write on nonart topics for other publications, but his output was primarily concentrated in his new literary home. His nearly monthly submissions were mandated to run between 2,500 and 4,000 words, which constrained his time for other writing. How to squeeze in time to produce a book?

He did manage to work on monographs on Newman, de Kooning, and Steinberg that were modeled on his volume on Gorky (which was basically a long essay). They did not fall under the *New Yorker's* restrictions for outside assignments.

In the mid-1970s, Rosenberg agreed to produce a short volume on Dostoyevsky for a series of pocket books that Frank Kermode, a British literary critic, edited on Modern Masters for Fontana, an imprint of William Collins & Company. (Kermode had interviewed Rosenberg for the BBC in 1963.) However, he was never able to deliver the manuscript.[8] By the time existentialism became a brief rage in the United States in the late 1940s, Dostoyevsky had become his go-to reference, replacing even Shakespeare's Hamlet.[9] The Russian author's sense of the crisis of individual fate stuck with him over the decades.[10] He had even written several chapters on the novelist in the early 1950s for a volume that was never completed. That circumstance differed, however: he could not find a publisher, and his interest flagged.[11]

Just before he took up his job at the *New Yorker*, Signet commissioned Rosenberg to write an introduction for a new edition of *The Idiot*. William Shawn published the essay first in 1968 (representing one of Rosenberg's few literary tracts to appear in the weekly). In it, he explained that Myshkin, the book's hero, is a "removed character": his passivity and detachment have rendered him "an outsider, an 'idiot' in the classical meaning of a private or unrelated person."[12] After Rosenberg revisited Dostoyevsky's corpus in the late 1960s, the word *action* began to recede from his writing, its absence emblematic of the diminished subjective presence in American culture and its reincarnation as sentiment. He noted that the author had used the term *action* "to disseminate the aura of a new state of being."[13] Myshkin is an innately good and innocent man but powerless to alter the turmoil of late nineteenth-century Russian social life. For Rosenberg, the depiction also doubled for the circumstances of art.

In the few political pieces that Rosenberg had the off time to write, numerous comparisons abound between Dostoyevsky and the downfall of Richard Nixon, as well as the duplicities of the Watergate players and subsequent bathos of Gerald Ford's administration. Nixon's

collaborators in Watergate are likened in "Thugs Adrift" to Smerdy-akov in *The Brothers Karamazov* who commits murder for Ivan.[14] Similarly, his supporters on the House Judiciary Committee—who presided over his impeachment hearings—resemble the defense attorney who claims in Dostoyevsky's novel that "there is an overwhelming chain of evidence against the prisoner, and at the same time not one fact that will stand criticism, if it is examined separately."[15] And like the government clerk in *The Double*, one of Dosto-yevsky's early novellas, Rosenberg used the image of a lookalike to draw a deadpan contrast with the outgoing president: "Nixon had no Mr. Hyde; his alter ego was just another Nixon."[16]

Rosenberg also used the trope of a double to expound on the portraits of Richard Avedon when they were published in 1976. Long before Avedon became the staff photographer for the *New Yorker*, Rosenberg commented on the "objective cruelty"[17] of his work. He was struck that Avedon felt no need to unmask a split personality as Dostoyevsky had done. Avedon's austere black-and-white pictures, which dispensed with props and incandescent lighting, got to the core of his subjects—such as Rosemary Woods, Nixon's secretary—with minimal artifice. They wore, as Rosenberg described, "a face that is a product of nature and his own act."[18] Avedon's sitters were ultimately unknowable, their interior lives sublimated by self-consciousness of being in front of a camera. They were just like Nixon who knew that he was constantly "up against the news"[19] or the media.

It was partially through his intense rereading of Dostoyevsky that Rosenberg came to represent the intellectual as a vanishing species in the mid-1960s. The disappearance, he reckoned, had been adumbrated in the Russian author's notebooks and fiction. Dostoyevsky understood, as Rosenberg explained, "that to cover the colony of intellectuals" during the mid-nineteenth century "the net definition had to be wide enough to encompass counterfeits and hangers-on."[20] He was acutely aware of the bureaucracies that had beset Russia, and the new phenomenon of a nameless "underground man," who festers out of boredom in a society reorganized by post-Enlightenment reformers. As Rosenberg gathered from Dostoyevsky, perfection-

ism spawned not only lassitude and misery but sometimes rebellion. Similarly, there was little that could renew the intellectual community as it disintegrated in the 1960s: there had been no recognition that it teetered on the "verge of being taken over by its Tartuffes, pedants and con men."[21] Or by those ubiquitous formalists! It had become nearly impossible to be a "disinterested seeker after truth."[22] That ideal had not existed since the 1920s.

The *New Yorker* published Rosenberg's introduction to *The Idiot* during a year in which he gave a graduate seminar on Dostoyevsky through the Committee on Social Thought at Chicago. It was his only syllabus devoted to a single author.[23] As late as the autumn of 1976, he continued to teach the work of the Russian writer. Each of his courses was confined to the study of just three novels. He no doubt felt this would be a way to fuel the book he hoped to write for Frank Kermode.

some action, for once

Rosenberg was made a professor of social thought at the University of Chicago (U of C) in the fall of 1966 (fig. 34). His friends Saul Bellow and Hannah Arendt, who were members of the Committee on Social Thought, arranged for his appointment.[24] Rosenberg does not appear in the course catalogue until the spring of 1967, but during the previous semester he co-taught a seminar with Bellow on Valéry's aesthetics.[25] The committee, which was formed in 1942, encouraged interdisciplinary study and remains an elite graduate program within one of America's foremost universities. At the time of Rosenberg's appointment, students were inspired "to transcend overspecialization . . . by asking the sorts of questions which carry any inquiry to its human roots."[26] In addition, the program aspired "to cooperate with the artistic and intellectual world beyond the University."[27] With no specific course requirements, students could build their own curriculum. The primary trait sought from applicants was demonstration of intellectual independence.

Chicago was the perfect academic fit for Rosenberg. He had long since written "The Twilight of the Intellectuals" and intoned in the

Fig. 34. Hedda Sterne, *Harold Rosenberg*, 1964–65. Ink and graphite on paper, 10 7/8 × 14 inches. The Museum of Modern Art, The Joan and Lester Avnet Collection.

New York Times that the "despair of today's university student consists in facing a life confined to the corporation, the government agency, the campus."[28] At least the Committee on Social Thought acknowledged that "academic inquiry was becoming less relevant to the total life of society."[29] Rosenberg had taught classes on Whitman and Melville at the New School for Social Research in New York in the early 1950s, but that appointment was never sustained annually, unlike Chicago. Teaching had always been an occasional gig for him. He had been invited to deliver the Christian Gauss Lectures in Criticism at Princeton University in the spring of 1963, but a month before the six-part weekly series was to begin he withdrew as his writing commitments had become too burdensome. Princeton required

his lectures weeks in advance, and then William Shawn's invitation to sub for Robert Coates intervened. Since the director of the Gauss Lectures thought it was too late to find a replacement, a compromise was struck. Instead of scripted presentations, he gave "informal talks"[30] on the "Problems of Contemporary Art." Rosenberg had hoped to focus on "art, non-art and anti-art," themes that he was currently exploring for a book "on critical theory relating primarily to modern art and literature."[31] The volume never materialized, but these ideas must have informed his talks at Princeton. They were ideas that he pursued in the *New Yorker* relating to the new "aesthetics of impermanence,"[32] or "Happenings," which transformed *action* into a fugitive statement by relinquishing the object.

Rosenberg accepted the offer from the Committee on Social Thought before Shawn proposed he join the *New Yorker*. Unlike the pressure he felt to produce the Gauss Lectures, he was able to balance his teaching with his monthly Art Columns by commuting from Manhattan and spending summers in East Hampton. The University of Chicago, with its four-quarter system and shorter terms, made it possible to maintain his writing schedule. He spent approximately ten weeks in the spring and again in the fall in Hyde Park, while flying to New York monthly to take in exhibitions. As a faculty member, Rosenberg was integrated into the university community. He socialized almost nightly with members of the committee, which included David Gren, Herman Sinaiko, and the novelist Richard Stern, in addition to Bellow. He wrote to Tom Hess shortly after arriving: "You can't believe how much intellectual activity goes on around here. And how many parties (you thought I was going to [stay] home and do my homework?), plays, com. meetings." "Come to Chi," he playfully urged him, "and see the world."[33] Rosenberg was uncharacteristically effusive about the "marvelous classicists, writers, social anthropologists, [and] terrific students,"[34] as well as the local art collectors whom he was encouraged to meet. Most of all, he responded to the open-ended structure and the unique environment of the committee, where "students come around," as he told Hess, "who want to be intellectuals, read books, look at pic-

tures." "The hell with departments," he added.[35] In short, he thought Chicago was "paradisaical."[36] But he missed the art scene in New York, especially when Hess wrote to give him the lowdown on the opening for "Henry's Show" at the Metropolitan Museum of Art.

Michael Denneny, a student of Rosenberg's, who later edited two volumes of his criticism for the University of Chicago Press, remembered that "as a teacher, Harold Rosenberg was at first disconcerting. He didn't actually teach in any way that we were used to. Rather he drew you into a conversation, a very lively conversation and somehow you became more intelligent through his talk."[37] Denneny was taken by the performative traits of Rosenberg's teaching and the way that he skillfully lured students into discussion. He found his teacher's disputations mesmerizing. His pedagogical style, though, was not that unconventional: he was basically enacting the Socratic method. Yet what made Rosenberg's seminars so alluring, Denneny recounted, was that students saw an intellectual at work. He was more "interested in thinking than knowing," in that he took "such joy" in talk.[38] This was just what the committee wanted. That, combined with his desire to engage anyone who demonstrated an aptitude for serious discourse, who could read history dialectically, made for "his radically democratic spirit,"[39] something that Denneny felt few students at Chicago had ever experienced.

Within the classroom, Rosenberg exhibited no sense of superiority. He never pontificated, and exhibited a "profound respect"[40] for any student who leaped into conversation (unlike his demeanor with his peers). He could also be caustically funny within this forum. Jonathan Fineberg, who sat in on many of Rosenberg's classes while he was a young professor of art history at the University of Illinois, Champaign-Urbana, recollected that one time a "student got up her courage and launched into a long explanation of something or other and then said 'and that's the truth!' To this Harold said 'if that's the truth, I don't want any part of it!'"[41] Even though Rosenberg was not academically credentialed—he did not have a PhD,[42] nor any graduate education—he was the quintessence of a writer who had made it on his own. As a result, his classes attracted huge

followings. What the students did not know, Fineberg has told, is that the plastic juice bottle that Rosenberg brought to class was frequently filled with gin![43]

For all the democracy of his dialogic approach, Rosenberg sought a select student who could not only produce but make teaching exhilarating for him: that is, someone who was worth his time. He apprised the committee that he wanted it made known at registration that he was interested only in "students who will work and not simply come to see me [to] put on an act."[44] Furthermore, he was offended when students failed to turn in work on time.[45] When Buzz Spector, who was enrolled in the MFA program, petitioned Rosenberg to be relieved of a writing assignment for his seminar on Dostoyevsky, fearing that he did not have the same skill set as the PhD students, Rosenberg jocularly responded, "We don't offer idiot's discounts here!"[46] (Spector ended up taking two of his courses.) Fineberg also recalled one moment in class when "a student [was] presenting an argument and Harold, in order I think to give himself time to formulate his thoughts about it, held things off for a moment by saying to him, 'Did you just make that up, or do you really believe it?'"[47] He wanted to see not only evidence of reasoned analysis, but conviction.

Just before Rosenberg's arrival in Chicago, Saul Bellow wrote to Richard Stern: "some action, for once."[48] He hoped that Rosenberg would be unrestrained with faculty members, and that he would rethink the curriculum for the program—or, at the minimum, would have some suggestions. Rosenberg's first term was spent easing into his appointment and getting the hang of teaching. Outside of the seminar that he co-taught with Bellow, he took the time to familiarize himself with the campus and students. He also became acquainted with the local art scene through Vera Klement, whom he had known since the late 1950s.[49] (Klement moved to Chicago from New York in 1965 and began teaching at U of C four years later.) While in town he stayed at the Windermere House, a behemoth of a building that overlooked Jackson Park, which by the 1970s had become shabby and rundown. As soon as he began to feel acclimated, he advised Marshall Hodgson, the chair of the committee,

that the "fundamentals list" was "imbalanced."[50] Even though the list changed yearly, Rosenberg felt there were too many notable omissions: the Old Testament component was inadequate and writers such as Racine, Milton, Rabelais, and Voltaire were missing. Just as importantly, he thought that Trotsky should appear "if Durkheim and Freud qualify by their cultural weight."[51]

As Bellow predicted, Rosenberg held forth in Chicago. During his first month in Hyde Park, he was invited to give a paper at a conference organized by the Humanities Division on "The Arts and the Public." He was aghast to find that Clement Greenberg's views threaded the discussion. He had not come to Chicago to endure a rival. He conveyed to Tom Hess, "everyone thinks he runs everything."[52] However, he found an ally in Joshua Taylor, who had taught in the Art History Department since the early 1960s. (Greenberg later dismissed Taylor's emphasis on "content"[53] in his book, *The Fine Arts in America*.) It was imperative, Rosenberg thought, that his denunciations of formalism be known at the outset and that there were other ways to interpret painting.

Rosenberg's first course for the Committee on Social Thought was "Post-War American Painting," taught in the spring of 1967. Thereafter, he rotated seminars on art with those on Dostoyevsky and occasional stand-alone courses such as "Three Poets: Wallace Stevens/William Carlos Williams/E. E. Cummings." These classes were the outgrowth of his thinking about modernism over the course of three decades. By the time of Rosenberg's death, he had been made both a professor of art in the Art History Department and professor emeritus of social thought and art. Although he kept up a regular two-quarter schedule, the commute to Hyde Park eventually became too arduous. He was now afflicted with diabetes as well as severe arthritis. He decided to give up Chicago and arranged to teach in the English Department at Hunter College in the fall of 1978.[54] But then he died of a stroke in July.

Did Rosenberg become part of the academic establishment that he deemed responsible for the homogeneity of intellectual life? Did he become one of these "professors," such as Robert Rosenblum and William Rubin, whom he took on in the *New Yorker*? Rosenberg

had stated in his paper for the "Arts and the Public" symposium at U of C that "criticism is related to scholarship, but it is also joined to *action*. Scholarship is valuable for its own sake, criticism for its effects."[55] He had always thought his job was to keep debate alive even as public dissent dissipated in the late twentieth century. However, because he was an anomaly in the Art History Department, he was never absorbed as kin—his intellect was unrecognized by his colleagues as the outgrowth of erudition.

Rosenberg was a finalist for a National Book Award in 1973 and was inducted into the American Academy of Arts and Sciences two years later. Yet, he was not immune from academic politics. (But then, whoever is?) Unlike the Committee on Social Thought, where he was sought after and valued, the older art history faculty members were threatened by his public stature. Jonathan Fineberg has portrayed them as a "petty, narcissistic" lot who were "self-conscious about their failures."[56] They could not match Rosenberg's long string of accomplishments; few had published more than a few articles.[57] Frank Lewis, who worked on a PhD in the late 1970s, was thwarted by his advisors for receiving credit for a course that he took with Rosenberg. They wrote off Rosenberg's pedagogy as "too anecdotal,"[58] not grounded in connoisseurship and commitment to archival detail. At one point, the department scheduled the visiting lecture series at the same time as Rosenberg's class,[59] a transparent message that his teaching was not only questionable but specious.

Rosenberg was on to their behavior. He knew their competitiveness had made for malevolence, that he was unwanted.[60] But he was also profoundly aware that art history now directed criticism, that it had become overly specialized and narrow, mimicking the recondite methods of some scholars. It had dwindled quickly into a position of subservience, allowing for the aloofness of the faculty who dismissed his classes. Rosenberg was less interested in their jealousies than in their implementation of an aesthetics-based method. Where was the discussion of the big events that had impacted art, such as the occupation of Paris and the proliferation of mass culture in the 1950s? He wondered what the implications of their didactic model

were for his profession. Was criticism's destiny to be perpetually dependent upon the academy? Had it become so self-reflexive that it lost sight of the humanities? These were the issues that separated Rosenberg from the academics who thought his classes trite and unsubstantial. Yet, however appreciated as a teacher, he never wanted to become part of the family.

Buzz Spector remembers that when an exhibition of Abstract Expressionism was mounted at the Smart Museum of Art as a posthumous tribute to Rosenberg—for which Spector designed the catalogue, poster, and announcements—Edward Maser, a professor of Baroque painting, represented the event as "fulfilling an obligation,"[61] a justification that resonated with defensiveness and tension. Saul Bellow, who was still on the faculty, wrote in the catalogue about his first encounter with Rosenberg: "I knew that I had met a most significant person who did not, however, behave as significant persons generally do."[62] His perception had been lost on the Art History Department.

"what kind of day did you have?"

Shortly after Rosenberg's death, both Richard Stern and Bellow wrote short stories that spoofed his lifestyle in Chicago. Rosenberg is conspicuous in Bellow's "What Kind of Day Did You Have?" as the art critic Victor Wuply with his "leg extended like one of Admiral Nelson's cannon under wraps," who read and reread *The Eighteenth Brumaire* and was "convinced that Marx had America's present number."[63] In Stern's "Double Charley," an equally comedic play on Dostoyevsky's *The Double*, Rosenberg is cast as Charley Schmitter, a songwriter who has seen better times and the sidekick of his collaborator, Charley Rangel. He is less transparent here, his identity condensed as "immense, passionate, mad for his own spiels and his own learning, [someone who] couldn't be contained by any métier."[64] As a double, there are also bits of Rosenberg in Rangel. He is both a "spieler" and "self-contented"[65] in this fusion of alter egos.

Despite the differences in treatment, both authors' stories dwell on the same theme—Rosenberg's reputation as a Lothario. In Bel-

low's short story, which appeared in the February (Valentine's Day) issue of *Vanity Fair* in 1984, Wulpy conducts an affair while on the road and away from his marriage. While May Tabak accompanied Rosenberg on a few trips to Hyde Park, he frequently spent the academic quarter on his own, making his trysts more possible. Rosenberg's womanizing was no secret; in fact, it was legend. There had been scores of stories and a string of women from Elaine de Kooning and Mercedes Matter onward that preceded his arrival, all of which provided fodder for Stern and Bellow, as it had earlier for Ralph Manheim and Leslie Fiedler.

Bellow accounts for Wulpy as a "bohemian, long before bohemianism was absorbed into everyday life"[66] to justify Rosenberg's philandering. Both authors tell us that although Rosenberg was unconventional when it came to marriage, he strayed furtively rather than in the open. Bellow writes with indifference that Wulpy's partnership with his wife was "weak,"[67] so her "opinions didn't count."[68] Stern sees her more as a realist who is aware of her husband's adulteries yet remains stalwart. Their antipathy is reserved for Rosenberg's mistress whom Bellow describes as an object. "She had a full figure, a little on the plump side, but she handled it with some skill,"[69] who forsakes her children to please him. Stern, more cruelly, likens her to a "cretinous broad."[70] Notwithstanding Rosenberg's identity as a bohemian, his relationship to marriage was complex. He would never leave Tabak, no matter how much pain his liaisons caused her.[71] Bellow proffers a reason for Rosenberg's cheating: while Tabak was possessed of a "tremendous . . . silent air of self-respect,"[72] his lover "kept him going."[73]

Tabak became a published novelist and later wrote articles for *Craft Horizons* in the 1970s. Still, she was not nearly as achieved as her husband was. She encountered considerable rejection after the release in 1960 of *But Not for Love*, a satire of the East Hampton art scene. One of her characters, Cooper, is based on Jackson Pollock, whose wife Amy, or Lee, schemes to ensure he is esteemed as the foremost living artist in the United States. (The lascivious Vaidel, clearly patterned on Mercedes Matter, also appears in the novel.) For all Tabak's devotion to writing and months spent in residence at

Yaddo, she was willingly fettered to Rosenberg. His betrayals were always overlooked, his protection her primary reason for living. Her submissiveness was viewed contemptuously by some of his peers and close female friends. Hannah Arendt found *But Not for Love* to be "rather nasty and unpleasant."[74] In her letters to Mary McCarthy, she complains that she could not find Tabak "bearable."[75] A month after Rosenberg's death, Susan Sontag made a bluntly catty entry in her journal: "May Taback [*sic*], coming home, stepping over naked one-legged Harold Rosenberg fucking girl on living room floor, to HR: 'Dinner in one hour.'"[76]

Ironically, Tabak had wanted to write a rumination on marriage in 1964. The book was to expound on the demise of the covenant of obedience within partnerships in the modern period, and the effects not only on love and sex but also on the institution of the family. Her account was never published, just like her autobiographical memoir, "A Collage." Tabak cheerfully maintained in her outline that "the tradition of unique and marvelous marriages cannot die."[77] Despite her suffering, she believed she had a rare arrangement with Rosenberg. As she wrote in *But Not for Love*, when Herbert (Rosenberg's counterpart) comes home to his wife after a night with Vaidel, "he returned because he knew her sudden panics, that was all. He was troubled about her because they two belonged together. Neither time nor distance nor the flexures of love would alter that."[78] Tabak yielded to her husband's adultery, and Rosenberg to her pain and insecurity: the ongoing rhythm of their relationship.

Tabak's book proposal was most likely a response to McCarthy's *The Group*, which was published a year earlier. In a synopsis of the novel, Tabak argued that McCarthy was either "terrified or revolted"[79] by sex or regarded the carnal act as love's polarity. McCarthy's cast of women who grapple with both independence and loyalty, as well as sexual liberation, contraception, and breastfeeding, was too hard-hitting for Tabak, its erotic scenes too "grotesque."[80] She yearned for less candor, more "literature"[81] or gloss, a state that replicated the better moments in her own marriage.

However, Tabak's private journals and notebooks interestingly contain long lists of women artists and writers, such as Alice Neel,

Perle Fine, Lee Krasner, Loren MacIver, Emily Dickinson, Jane
Addams, and Rosa Luxemburg. They represent a proto–Guerrilla
Girls type of tally of names, but with no account of the professional
statistics that set back women. Many of Tabak's articles in *Craft
Horizons* addressed gender equality, moreover. She contended in
one essay that the concept of "genius"[82] should be tossed out as it
was basically a male construct that had resulted in too many exclu-
sions of women. She knew that gender had played a huge role in
typecasting women. But body politics and second-wave feminism
was not an awareness she brought to her marriage. No wonder she
felt threatened by *The Group*.

Shortly after Rosenberg arrived at the University of Chicago,
he published two essays in *Vogue* that dealt with sexual democ-
racy and the "present uneasiness of masculinity"[83] in the United
States. He paradoxically used the emblem of the odalisque to de-
scribe the social predicament of women by likening her liberation
from the home to the workplace as an act of "transcendence."[84] Un-
like the odalisque of old, whose domain was the harem and who
is nearly always portrayed alone, nude, and awaiting her lover, the
contemporary woman, in Rosenberg's summary, now "directs her
seductiveness not toward any individual but to the public at large."[85]
He sees this as a tradeoff, her feelings of gratification now derived
partly from strangers. Within a reconfigured world of equality, her
lover also remains absent, or hidden, and the late modern woman
exists in a state of constant alienation. She is caught up in the di-
lemma as to how to incorporate love into a life with a career. Can
she have it both ways?

In Rosenberg's allegorical retelling of the odalisque, there is an
implicit assumption that women are still bound to a culture in-
scribed by men. This assumption emanates from the fallacy that
man "possesses powers that women lack."[86] Rosenberg thinks that
women have always had the power of seduction. Seduction, he goes
on, was the method by which Socrates taught philosophy, mak-
ing this supposed prowess ennobling. Yet Rosenberg is way off the
mark, his sense of patriarchy abundant. That he attributes the sta-

tus of contemporary women to seduction is both irrelevant and demeaning. That he utilizes a stale metaphor undercuts his argument.

Around the time Rosenberg wrote on the modern woman for *Vogue*, Hedda Sterne, who remained close to the Rosenbergs, drew Tabak as an odalisque (fig. 35), no doubt a response to his article. Tabak appears as a pun on a nineteenth-century romantic figure, a slave whose life is dependent upon marriage. She has not been liberated or sprung from domesticity into an autonomous professional world but opts for allegiance to her mate. To use Rosenberg's words from his essay, like her "grandmother," she maintains the "continuity of feeling in her suitor or husband."[87] In his terms, she is not a modern seductress. If so, she would have left the serail. But where does that leave his own mistress? In "What Kind of Day Did You Have?" the perpetually obliging Katrina beseeches Wulpy to say, "I love you," something he will not do.[88] "It would have been *mauvaise foi*,"[89] Bellow interjects in his story. No matter how unstable

Fig. 35. Hedda Sterne, *Untitled* (Portrait of May Rosenberg), c. 1964. Graphite, ink on paper, 8 1/2 × 11 inches (21.59 × 27.94 cm). The Hedda Sterne Foundation.

Rosenberg's marriage, love was bound up in duty, and that was reserved for his wife.

Rosenberg was far less confused when it came to the parallel crisis of men. The "cult of masculinity,"[90] he averred in a subsequent article in *Vogue*, was under siege in the mid-1960s. Representations of he-men in the mass media had contributed to a fictionalized view of virility. (He was thinking of the Marlboro Man and of the Black Panthers, both of which had a precedent in Ernest Hemingway's imagery of manhood.) "Total masculinity," he wrote, "is an ideal of the frustrated, not a fact of biology."[91] Maleness, Rosenberg implied, had been set back by ridiculous play-acting and theater. In advertising, the leather gear and half-shaven, rugged look, along with omnipresent references to the Wild West, had turned the American man into a stud. "It is hard to believe that Americans would be worse off by becoming more gentle,"[92] he countered. Rosenberg was able to see through a stereotype here. That he could not understand women similarly represents the one area of his thought that was retro.

the point of departure may be a lucky catch-word

In an interview with Melvin M. Tumin published posthumously in *Partisan Review*, Rosenberg contemplated whether his writing had had any prolonged effect. He responded, "I've had influence in certain places and for a certain length of time. I don't know what comes of that."[93] He was thinking primarily about how *action* had served as a metaphor for postwar painting. He admitted that "very often people say to me, I was very much influenced by you, and then I see what they're doing. *Es vehrt mir nit gutt.* [I do not feel well.] How do you know what other people do with your way of looking at things? Some of the worst art around today is definitely owing to my theories."[94] (He was referring to the gestural style of many of de Kooning's followers.) If he had any hope for the staying power of his ideas, it would be that they were "related to a center of discussion."[95] That center existed not in the academy but in the studio and was enlarged through talk at artist-run organizations, such as The Club.

Rosenberg knew that his ideas could not be spun into lasting

theory. Unlike formalism, *action* was evanescent. He also knew that his signature term had run its course with the demise of the avant-garde in the late 1960s. With this demise, intense debate had ceased to matter. Rosenberg's moment was the mid-century. However, his thought anticipated aspects of the postmodernist era. Not only did his analysis of Gorky foreshadow the culture of copying—appropriation is now a routine, unquestioned studio practice—but he assumed that all postwar art existed in a state of crisis, its authenticity constantly tested by the marketplace.

Allan Kaprow, an artist, writer, and teacher who spawned the Happenings movement in the late 1950s, was a close reader of Rosenberg's work (fig. 36). In 1968, he wrote to Rosenberg that terms such as *action* and "Happenings" "gave people a way to grapple with something they couldn't focus on before. And best of all, *we* were able to use these words to fabricate a quasi-system."[96] Kaprow had been attracted to the "verbal link-ups"[97] in Rosenberg's essays and wondered if they were convincing because "persuasion begins with a poetic act, the disclosure of one or two metaphors which appear to capsule an artist's or theorist's sense of things. Later, they may transform into other guises or media, or into genuine discourse, but the point of departure may be a lucky catch-word."[98] Kaprow had tied *action* to "Happenings" as early as 1958 in a much read article that he wrote for *ARTnews* dubbed "The Legacy of Jackson Pollock." His title was both mischievous and ironical. He actually set out to metaphorically bury Pollock, contending that "he created some magnificent paintings. But he also destroyed painting."[99] Kaprow's piece was part panegyric, part manifesto. He predicted that after Pollock's death art would be about "events,"[100] echoing Rosenberg's rhetoric. He ventured that through the act of painting, or the performance of dripping and pouring paint, Pollock had come close to dispensing with the canvas entirely. Happenings took this incident or "act" one step further. Through the collection of detritus and castoffs by various participants to create fugitive installations, the ontological nature of painting and sculpture was undermined. In Kaprow's reimagined script for art, the studio disappears and the street beckons. Craft, history, and the marketplace retreat.

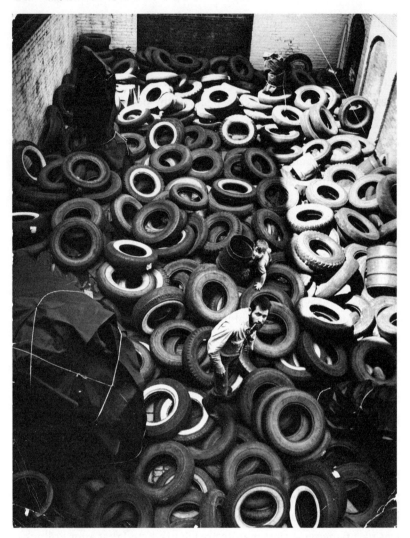

Fig. 36. Ken Heyman (1930–2019), *Allan Kaprow's Yard*, 1961. Photographic print. Allan Kaprow Estate.

Rosenberg was not initially sure about the "esthetics of imperma-nence," as he called Kaprow's movement, especially as it implicated his concept of *action*. He announced in 1963, just as Happenings pro-liferated internationally, that "art cannot transform the conditions of its existence."[101] Kaprow's ideas, it seemed, had trodden into theater and left no tangible evidence other than a few directions or words on

a typescript. Yet five years later, when Kaprow wrote to him about their "lucky catch-words," Rosenberg was on board with the connections between their signature terms. "Allan Kaprow, who has a penetrating understanding of the art world," he penned, "realized that once Action painting had left the seclusion of the studio the old art game was going on as usual."[102] What he meant was that Kaprow understood that art was bound to become a commodity no matter its confrontation with conformity. Kaprow asserted that the museum was also complicit in this process: "One may generalize that the environmental context of the artwork today is of greater importance than its specific forms; and that it is this surrounding . . . which will determine the nature and shape of the container of these forms."[103]

Even so, Rosenberg questioned whether Happenings were heirs to *action*. "It is always a mistake to push a concept to its logical conclusion," he claimed, because "art comes into being not through correct reasoning."[104] Determinism could never be effectively rallied as a factor in his calculation. It veered too close to formalism's credo. There were too many unknowns that could impede any direct line of succession. Rosenberg also worried that Kaprow had not thought through the audience for Happenings. It seemed to him that it represented the face of the marketplace, even with the elimination of an object. Claes Oldenburg, who had participated in the movement, was a case in point. His early embrace of the commodity in *The Store* and other environments reinforced Rosenberg's observation. Moreover, Rosenberg believed the experience of a Happening had a limited reach. There was no contact with the subjectivity of the artist as in the work of de Kooning, Pollock, Guston, and even Oldenburg.

Kaprow knew that the audience had become an issue, particularly as many of his performances took place at museums and commercial galleries. His answer was not only to reduce the numbers of participants in his Happenings—who were involved in activities such as "building a tower of used Coca-Cola cans, making a lot of noise, tearing it down"—but also to engage them in what he called "unarting."[105] By that, he meant giving up on the cultural context for art entirely and "just-doing," or becoming more engaged in "playing with everyday life."[106] Outside of the White Cube, or gallery, he

was freed from being identified as an artist, so as to just have fun at exercising his creativity through experimenting with mundane incidents, such as "crossing the street or tying a shoelace."[107] Kaprow still thought of these events as "acts," a holdover from Rosenberg.[108] However radically austere and commonplace, they did involve a process. But when they became interpreted as art, he decided it was time to move on to new investigations.

liberation from detachment

If there was one artist who Rosenberg felt had any bearing on the course of art in the 1970s, it was Philip Guston. He was avowedly enthusiastic about Guston's resurrection of cartoon-type imagery around 1968, not stymied by his decision to forgo abstract painting. Rosenberg was almost alone in his conviction that Guston's act was necessary to redirect painting.[109] Few other critics immediately saw his dramatic about-face—with its incongruous combination of Ku Klux Klan heads, paintbrushes, clocks, ropes, nails, and boots—as a reiteration of the caricatures that had made up part of his work until 1949. Most interpreters were aghast at his abrogation of modernism. Hilton Kramer, for one, was relentless in his attack on Guston's renewed use of autobiographical forms, their willful transgression, and apparent crudeness. His review in the *New York Times* bore the headline "A Mandarin Pretending to Be a Stumblebum."[110] Like Rosenberg, Guston believed that modern painting had dwindled into a "genre"[111] and had become hackneyed and predictable. As he stated at the end of his life, "contemporary American art is [not] much worth talking about. It's college art . . . Totally mannerist."[112]

In 1971, Guston averred in a letter to Dore Ashton, who was at work on his biography, "I am back to 1950 again except that it is worse—because of the extreme codification of beliefs and the institutionalization of everything."[113] He was as averse to the monadic mindset of the art world as Rosenberg was. He had always perceived the loss of the figure in mid-century painting as part of the "pathos"[114] that drove vanguard art. When he could no longer stifle the hooded figures that surfaced in his drawings in the late 1960s, he

recognized that he had contributed to the incomprehensible beauty of abstract art. Guston had likened the image of the Ku Klux Klan, a symbol of malice, to a "self-portrait,"[115] an analogy that speaks of his internal conflict with modernist art. Moreover, the image doubled as a representation of the art critic. Rosenberg, his steadfast advocate, was not a target, however. It was Clement Greenberg who personified his feelings of contempt for the aesthetic impasses that hastened the end of the modern period.

Greenberg never reviewed Guston's work at length, even at the height of the New York School. Guston was an artist who had submitted to "badness"[116] in painting, unable, like de Kooning, to resolve the figure and advance his lingo of purity. Behind his elegiac, graceful canvases with their clusters of pink and red brushstrokes, Greenberg thought, lurked a body. On that score he was right. Guston had worked hard in the 1950s to neutralize the narratives that had once been the mainstay of his paintings. But the suggestion of a story was always there. Rosenberg knew this to be the case: Guston's subjects were just internalized, never made specific. When he reversed course and produced compositions that were recognizable, Rosenberg regarded this move as a "liberation from detachment" whereby the "problems of painting seem secondary."[117] Finally, painting had a shot at regaining its strut. "Painting," Rosenberg wrote, "needs to purge itself of all systems that place so-called interests of art above the interests of the artist's mind."[118] But were Guston's charged personal symbols, particularly of the Klan, political enough? Rosenberg asserted that these violent figures could be read as stand-ins for the social upheaval that beset the United States around 1968.

Caricature had its historic origins in political satire, and through the image of the hood, Guston was ridiculing not just himself and doctrinaire modernism, but also the authoritarian tactics of politicians such as Richard Nixon. (Hence his series *Poor Richard*, the ascetic storyboard of corruption gone amok in the White House.) But the visceral immediacy of his imagery still revealed a commitment to experimentation. The combination allowed for Rosenberg's tentative prediction that Guston "may have given the cue to the art of the nineteen-seventies."[119] The artist's recapitulation of a universe of

idiosyncratic objects lifted the "ban on social consciousness"[120] in art in the late twentieth century.

Guston did have a huge impact on painting. High Art subsequently lost its foothold, and insurgent forms such as caricature and cartooning made a comeback along with the revival of storytelling in the mid-1970s. Although he had written to Rosenberg that "it's all over for the likes of us," they both played a role in easing the aesthetic strictures that had canalized art for more than two decades. For Guston, this process was both cathartic and painful. The critical wrath foisted on his late canvases led to his retreat from Manhattan to rural Woodstock, New York. For Rosenberg, it was business as usual.

"being outside"

In one of his last pieces for the *New Yorker*, Rosenberg readdressed what it meant to be an outsider. This had been a theme that had run through this writing since "The American Action Painters." By 1977, he realized that the artist was no longer set back by a limited audience. The situation paralleled his own career. "On the one hand," he announced in "Being Outside," the artist "is moved to end his segregation and reconcile himself to the ways of life of the majority; on the other, he is aware that the qualities that make him what he is are contingent on his separated state."[121] Where the artist had once boldly declared his originality from the margins of society, this border had become more porous, especially with an advanced commercial infrastructure in place by the early 1960s. Rosenberg understood that the social integration of the artist risked a loss of his individuality. As he thought through these implications, he asked what it meant to a "minority artist," or "victim of a twofold alienation":[122] What happened, that is, when an African American, Hispanic, or woman artist was subjected to the dominant white male culture?

"Being Outside" is a review of *Two Centuries of Black American Art*, an exhibition organized by the Brooklyn Museum. Rosenberg noted that the show had been overlooked by numerous critics, in part because it put "aesthetic standards"[123] on the back burner. (Hil-

ton Kramer bemoaned this so-called paucity in the *New York Times*.)
The show was intended to be consciousness-raising and to consider
an occluded chapter of artistic activity. But Rosenberg wanted to
know what criteria had resulted in the ongoing deprivation of the
Black voice. Why was the work of Robert S. Duncanson and Henry
Ossawa Tanner still underknown in 1977, when they had become
accomplished artists during their lifetimes? He knew that the di-
minishment of any disenfranchised artist by "aesthetics standards"
was mired in bias and contradiction. Duncanson and Tanner had
engaged mainstream subjects, such as landscape and history paint-
ing, in the nineteenth century and had attracted considerable audi-
ences. Tanner's work was admittedly old-school; he had spurned
the radical expressions that he saw in Paris, where he lived as an ex-
patriate.[124] As Rosenberg pointed out, Tanner's response was simi-
lar to those of many American artists who made the trek to Europe.
But unlike their white confreres, the African Americans failed to be
folded into the discussions of a national art. "Apparently," Rosen-
berg concluded, "aesthetics can function as a tool of racism."[125] Its
requirements for compositional perfection had devolved into omis-
sion and prejudice.

This was not the first time that Rosenberg had written about a
Black figure or collective. In the mid-1930s, he reviewed a collection
of verse by James Weldon Johnson for *Poetry* magazine. He found
Johnson's poems to be "conservative,"[126] even though he engaged
race and social injustice in his work. These topics were not enough,
Rosenberg thought, to redeem the academic style of his writing. In
Johnson's "Saint Peter Relates an Incident of the Resurrection Day,"
with its rhyming couplets and sonorous beat, he saw little evidence
of imagination, more a nineteenth-century literary template. But in
1977, when he wrote "Being Outside," he no longer stumbled over
the disciplined symmetries that ordered Johnson's verse. He was
more concerned with the issue of Black identity and how it com-
peted with being an artist. "In the cultural revolution of the twenti-
eth century," he stated, "the individual is supposed to transcend the
social category to which he belongs. But this revolution has not been
accomplished for minorities or for others, and individuals cannot

purge themselves of their backgrounds and the demands that those backgrounds make upon them."[127] There were some African American artists who he believed had handled this tension creatively, such as Romare Bearden and Jacob Lawrence, who immersed their experience of Blackness within vanguard languages. Alma Thomas, furthermore, "brought new life to abstract painting in the 1970s."[128] The exclusion of African Americans from mainstream cultural programming had been foregrounded by political activist movements in the 1960s and early 1970s. Given Rosenberg's intense focus on the institution of the museum, it was not a giant leap to ask what happened to lesser known artists. That he allied these imbalances with racism was significant. He had exposed another limitation of the formalist model through its indifference to social context.

For all his understanding of racial disparity, Rosenberg was repeatedly impervious to the reversals of women. He argued in "Being Outside" that "no conceivable expansion of female equality can achieve for the individual what has been gained by a Cassatt, an O'Keeffe, a Bourgeois."[129] He had read Linda Nochlin's "Why Have There Been No Great Woman Artists?"[130] published in *ARTnews* in 1971, where she stated that female accomplishment had to be measured in relationship to social institutions. But Rosenberg felt that biography was also bound up in originality. As he had stated in "The American Action Painters" twenty-five years earlier, "the gesture on the canvas was a gesture of liberation, from Value—political, esthetic, moral."[131] That liberation did not consciously extend to gender in the early 1950s. Feminism had not fully seeped into the ether. Yet it continued to evade him more than two decades later when the women's movement became assertive. The revelation of the (female) self was basically ineffable, even mysterious to him, a quasi-numinous act. So too was the Black voice, although Rosenberg knew that it had been wrongfully subjected to oppression.

that's a very mysterious thing

In an interview published posthumously in *Portfolio*, Rosenberg conceded to Jonathan Fineberg that modernism had receded nearly

a decade earlier. As he reminisced about Abstract Expressionism, the trend he had a huge hand in framing, he alluded to his neighborhood, which included a stretch of artist studios along East 10th Street and encompassed Washington Square—or, the "geography of modern art," as he poetically called it in 1959. In this tiny locus emerged an enclave of (initially) convivial artists who had redirected art through their far-reaching "acts" in the post-Depression era. He recounted how

> they sat there, went to studios, hung around cafeterias—and they changed art all over the world. That's a very mysterious thing. It has nothing to do with the policy of commissars, and it has nothing to do with Paramount Pictures wanting to make money or a movie . . . It's a kind of gratuitous activity and nobody knows what the consequences of an art movement will be. Artists are people who do things without knowing what they will bring about.[132]

This enclave always held Rosenberg. Not only were his own fortunes as a writer bound up with these artists, but so was his intellectual and social life. They fulfilled his view that expression of their subjectivity was the cornerstone of modernity, that it alone had a chance of withstanding the forces of conformity. And for him, that was an audacious, daunting prospect.

Like the artists he wrote about, Rosenberg knew that he had been an outsider for the better part of his career. He had landed a job at the *New Yorker* late in the game, but he never became part of the "Art Establishment," as he had called it. During his lifetime, that was formalist turf. His trope of *action* had ceased to be meaningful in the early 1960s, even though artists such as Allan Kaprow thought otherwise. However, Rosenberg's ideas were never based on a one-liner. They were not only tied to the studio. They encompassed more than process and the act of making. During his stint at the *New Yorker*, he had also focused on the showcases for art and demanded explanations for the authority they exerted. He wanted curators to be attuned to how subjectivity is eviscerated by institutional programming and its alliances with the marketplace. Ultimately, he required

sharper, more informed decision-making that takes its cues from history—not just the flabby carryovers of essentialist thinking with its herd instincts. Within this arena, Rosenberg's writing does remain enduring as well as profoundly relevant. As an outsider, he knew that the edge was the only place to straddle.

acknowledgments

This book has been in the making for more than fifteen years. Along the way, my research has been assisted by numerous individuals, archives, libraries, and foundations to whom I am deeply indebted. But first of all, I want to set the stage: my interest in Harold Rosenberg was generated by two earlier projects on the late modernist artist Philip Guston. As I assembled the exhibition *Philip Guston's Poem-Pictures* for the Addison Gallery of American Art in the mid-1990s, which spawned my later publication *Philip Guston's Poor Richard*—the artist's acerbic takedown of Richard Nixon—I became struck by the sustained advocacy of Rosenberg, a writer who, unlike his formalist rivals, had no antipathy toward Guston's resurrection of satiric, cartoon-type imagery late in his career. Why was it, I wondered, that Rosenberg was not a better known figure, especially as his signature trope of *action* had defined a generation of New York School painters in the early 1950s, of which Guston was an integral member? In short, why had his criticism receded, especially when he was able to get to the existential core of Guston's new narrative like few other writers had? His adversary, Clement Greenberg, has, after all, engendered over the past four decades a veritable industry of interpreters who continue to expound on the meanings and authority of his words, institutionalizing them within the academy. That Rosenberg has been eclipsed by the lingering forces of formalism intrigued me. So, I set to work examining his prolific output and found a critic whose thinking not only foreshadowed many of the key ingredients of the postmodern period, but which also bear

striking resemblance to the debates surrounding cultural establishments such as the museum today.

At the outset, a friend, Leonard Langman, engineered my introduction to Rosenberg's daughter, Patia, in order to solicit her interest and imprimatur. Patia gave me access to a few critical archival pieces that she had retained, and to her memories, but most importantly she gave me her blessing to revive her father's intellectual project. To Leonard and Patia, who have both recently passed away, I will always remain grateful. From there, my research evolved through consulting over fifty archival collections to piece together the arc of Rosenberg's literary life, as well as at numerous libraries for critical secondary source materials. At the start, I was fortunate to have received an inaugural Visiting Clark Fellowship from the Sterling and Francine Clark Art Institute in Williamstown, Massachusetts, where I explored the possibilities for mapping the structure of my book. To Michael Ann Holly and Darby English, then director and assistant director, respectively, of the Research and Academic Programs at the Clark, I extend my special thanks for the opportunity. My residency in Williamstown became an important catalyst to secure funding from additional sources for my nascent venture. I offer my deep appreciation to Jack Flam, director of the Dedalus Foundation, for a senior fellowship, as well as to the Getty Research Institute for a Library Research Grant to assess the Harold Rosenberg papers it holds, to the Rockefeller Foundation for a fellowship to spend time at the Bellagio Study and Conference Center, where I wrote an early chapter, and to Margaret Sundell, founding director, and Pradeep Dalal, director, of the Andy Warhol Foundation Arts Writer's Grant which sustained part of my research through major funding. Moreover, the Society for the Preservation of American Modernists provided assistance for the reproduction of photographs that appear in this book, as did the Rhode Island School of Design Professional Development Fund, which also over the years underwrote part of my travel to consult archival collections.

Of the innumerable archivists and librarians who helped with access to materials, I would like to highlight the following: the staff of the Special Collections Division of the Getty Research Institute for

providing ongoing entrée to the Harold Rosenberg papers, which I consulted almost annually over the duration of this project; Marisa Bourgouin, head of reference services at the Archives of American Arts, whose rich holdings of artists' papers informed my interpretation of Rosenberg's interactions with various mid-century figures; Mary Warnement, head of readers services at the Boston Atheneum, whose research skills in tracking obscure and out-of-print journals were invaluable; Karen Bucky, head of interlibrary loans at the Clark Art Institute Library, for locating manifold scholarly texts that became essential to my research; and Helen Harrison, director of the Pollock-Krasner House and Study Center in East Hampton, New York, who generously lent me taped interviews with May Natalie Tabak, Rosenberg's wife, that were crucial to my understanding of their life together on Long Island. Additionally, my ongoing research benefited from the expertise of the reference staffs at the Fleet Library at the Rhode Island School of Design and at the John R. Hay and John D. Rockefeller, Jr. Libraries at Brown University. While in residence as a Visiting Clark Fellow at the Clark Art Institute, Katy Price photocopied all of Rosenberg's columns that appeared in the *New Yorker*, a daunting task that eased my writing once it began in 2005. Similarly, I am indebted to Catrina Neiman, who shared with me her unpublished annotations of Parker Tyler's correspondence with Charles Henri Ford, which is held by the Harry Ransom Center at the University of Texas, Austin. Jason Andrew, who oversees both the Jack Tworkov Estate and the Janice Biala Estate, kindly acquainted me with letters that relate to both artists' relationship with Rosenberg in the early 1950s. And, the late Bill Berkson, a friend who was always generous with his time, dug into his own archive on numerous occasions to summon recollections of Rosenberg that helped shape my grasp of Rosenberg's role as co-editor of *Location* magazine.

In spring 2005, I was honored to return to Williamstown to serve as the Robert Sterling Clark Visiting Professor in Art History in the Williams College Graduate Program in the History of Art. It was an uplifting experience, and I am grateful to Mark Haxthausen, former director of the program, for the invitation. Mark made

two part-time graduate research assistants available to me, one of whom, Rachel Hopper, worked actively to trace secondary sources that advanced my investigation of Rosenberg's career as a writer. Thereafter, as my research progressed, I reached out to numerous scholars, artists, writers, and archivists with questions relating to aspects of Rosenberg's life, his dealings with mid-century figures, and his place in postwar culture. Of these, the following were particularly helpful with insights and information: Renata Adler, Deborah Bright, Phong Bui, Taylor Carman, Tim Clifford, Michèle C. Cone, Michael Denneny, Herbert Drefus, Charles Duncan, Jennifer Field, Jonathan Fineberg, Connie Fox, Heidi Colesman-Freyberger, Ann George, Eleanor Heartney, Valerie Hellstein, Robert Hobbs, J. Hoberman, Robert Hughes, Caroline A. Jones, Hilton Kramer, Frank Lewis, Janet Malcolm, Charles McGrath, Daniel Menaker, Matt Rohn, Peter Schjeldahl, Sheila Schwartz, Jack Selzer, Daniel A. Siedell, Buzz Spector, Michael Solomon, Michael R. Taylor, Joan Washburn, Michele Solomon Young, and Virginia Zabriskie.

As word spread that I was at work on a Rosenberg tome, several colleagues invited me to participate in symposia or lecture programs, or to contribute to publications. These provided invaluable opportunities to test my thinking on Rosenberg as it evolved over the project. I extend my thanks to Michael Brenson for the invitation to deliver a lecture on Greenberg and Rosenberg for a symposium he organized, "Criticism, History and Power," at the University of Wisconsin–Madison in 2004; to the International Art Critics Association (AICA / USA), who asked me to deliver a talk on Rosenberg for their annual Clement Greenberg Memorial Lecture held at the New York Studio School in 2005; to Norman Kleeblatt for the invitation to contribute an essay on Harold Rosenberg and the American action painters for his exhibition devoted to *Action/Abstraction, Pollock, de Kooning, and American Art, 1940–1976* at the Jewish Museum, New York, in 2008; to David Levi Strauss, chair of the MFA Writing Program at the School of Visual Arts for inviting me to speak on "Harold Rosenberg and the Twilight of the Intellectuals" in 2012; to Helen Harrison, director of the Pollock-Krasner House and Study Center, for asking me to present a lecture in 2013;

to Ann R. Reynolds, associate professor in the Department of Art and Art History, University of Texas at Austin, for inviting me both to lecture on Rosenberg and to meet with students in her graduate seminar in 2014; and to Lindsay Pollock and Richard Vine at *Art in America*, who reached out to ask me to write on "Harold Rosenberg versus the Aesthetes" in 2014.

To the two anonymous peer reviewers who assiduously read my manuscript, I extend my appreciation for their precise feedback and close scrutiny of my elucidation of Rosenberg's ideas. And to Jessie Sentivan, who both copyedited and proofread my manuscript in its early and final stages, I remain grateful for her ongoing meticulous attention to detail.

I was sustained throughout this project by the support of friends and particularly want to acknowledge the warm encouragement of the late Arthur C. Danto (to whom this book is partially dedicated), while extending my heartfelt thanks to Victoria I. and Philip Lamb, Nell Painter, and Geoffrey Young. Many of these chapters were written and fine-tuned at the Arcadia Summer Arts Program on Mount Desert, Maine, or Kamp Kippy, as was it was affectionately called by the guests of its founder. I will always be beholden to Kippy, who passed in 2015, for her matchless generosity and unwavering close friendship over the years.

Lastly, my colleagues at the University of Chicago Press have added to this literary biography in immeasurable ways. Jenni Fry, managing editor, expertly oversaw the production of what became *Harold Rosenberg: A Critic's Life*, while Lys Weiss, who worked under her direction, tended to copyediting these six hundred pages, a formidable task. James Whitman Toftness, assistant editor, was extraordinarily helpful in guiding me through the sometimes murky process of securing photographs, rights, and permissions for this volume. My special gratitude, however, is reserved for my editor, Susan Bielstein, who has been a great pleasure to work with. Susan remained steadfastly supportive throughout this long project, offering sage advice through multiple drafts of my manuscript. For her unswerving commitment, I will always be indebted.

notes

prologue

1. Harold Rosenberg, "The Herd of Independent Minds," *Commentary* 6, no. 3 (September 1948); reprinted in Rosenberg, *Discovering the Present: Three Decades in Art, Culture, and Politics* (Chicago: University of Chicago Press, 1973), 23.
2. Rosenberg, "The Herd of Independent Minds," in *Discovering the Present*, 21.

chapter 1

1. Harry Roskolenko, "Harold Rosenberg: 1906–1978," *Art International* 22, nos. 5–6 (September 1979): 62.
2. Roskolenko, "Harold Rosenberg."
3. The Brooklyn Law School was a division of St. Lawrence University during the period when Rosenberg was enrolled.
4. Harold Rosenberg, "Character Change and the Drama," *Symposium* 3, no. 3 (July 1932), reprinted in *The Tradition of the New* (New York: Da Capo, 1994), 136.
5. Harold Rosenberg, in Paul Cummings, Interview, December 17, 1970, 3, Archives of American Art, Smithsonian Institution.
6. Cummings, Interview, December 17, 1970, 3.
7. Patia Rosenberg Yasin, Rosenberg's daughter, remembered her father telling her that he read *The Magic Mountain* while convalescing. Telephone conversation with the author, June 30, 2004.
8. May Natalie Tabak, "A Collage," unpublished MS, n.d., 160, Estate of May Natalie Tabak. A call to the Office of Court Administration for the State of New York, August 4, 2005, revealed that no record exists of Rosenberg passing the bar exam. Tabak recalled Rosenberg writing the bar exam in the early 1930s, which is reiterated in a letter she wrote to Mary McCarthy, September 19, 1980, Mary McCarthy Papers, Vassar College Library.
9. Harold Rosenberg, in Dorothy Seckler, Interview, June 28, 1967, 32, Archives of American Art, Smithsonian Institution.
10. Roskolenko, "Harold Rosenberg."

11. Harold Rosenberg, "Notes accompanying annotated copy of *What Is to Be Done?* by V. I. Lenin," Harold Rosenberg Papers, Getty Research Institute. The Getty Research Institute claims that these annotations were made around 1929. While I have abided by this date, Rosenberg himself referred to "Character Change and the Drama" as the first text in which he used the word "action." See Cummings, Interview, December 17, 1970, 7. His annotations to Lenin's pamphlet may have been made later. In the context of his conversations at the New York Public Library, and their emphasis on Marx, the date of these annotations may make sense, however.
12. Roskolenko, "Harold Rosenberg."
13. Lionel Abel, "New York City: A Remembrance," *Dissent* 8, no. 3 (Summer 1961): 257.
14. Rosenberg, in Seckler, Interview, 13.
15. Rosenberg, in Seckler, Interview, 11.
16. Rosenberg, in Seckler, Interview, 11–12.
17. Rosenberg, in Seckler, Interview, 13.
18. Rosenberg, in Seckler, Interview, 13.
19. A call on June 11, 2014, to the registrar at Erasmus Hall yielded no information about Rosenberg's academic standing, let alone confirmation of his attendance from 1919 to 1923. The school's records from this period no longer exist.
20. Rosenberg, in Seckler, Interview, 12.
21. In the various interviews conducted with Rosenberg that dwell on his childhood and youth, he does not specify the nature of these summer jobs. His short employment at the Charles Williams Stores is the only job mentioned by name.
22. Rosenberg, in Seckler, Interview, 16.
23. Rosenberg, in Seckler, Interview, 14.
24. On the curriculum and teaching at City College—formerly known as the College of the City of New York—see Neil Jumonville, *Critical Crossings: The New York Intellectuals in Postwar America* (Berkeley: University of California Press, 1991), 8 and following.
25. A call to the registrar at City College revealed no record of Rosenberg's attendance at the university around 1923.
26. Harold Rosenberg, in Raymond Rosenthal and Moishe Ducovny, Interview, 1960, 53, William E. Wiener Oral History Library of the American Jewish Committee. A copy of this interview is held by the New York Public Library.
27. Rosenberg, in Seckler, Interview, 5.
28. Rosenberg's father worked in the garment industry as a tailor. However, I have not been able to establish the name of the company for which he worked. Patia Rosenberg Yasin, in a telephone conversation on October 2, 2005, told me that her grandfather was not an owner or partner in the business that employed him. She also recalled that his position was "low on the totem pole."
29. Rosenberg, in Rosenthal and Ducovny, Interview, 53.
30. Rosenberg, in Rosenthal and Ducovny, Interview, 53.
31. Rosenberg, in Seckler, Interview, 2.

32. No mention is made in any of the interviews with Rosenberg of the specific city in Poland where his father lived before immigrating to the United States.
33. Rosenberg, in Rosenthal and Ducovny, Interview, 68.
34. Harold Rosenberg, "Reverence Is All," *ARTnews* 68, no. 9 (January 1970): 27. Rosenberg's chronology of his childhood moves here contradicts what he sketches in Cummings, Interview, December 17, 1970.
35. Rosenberg, "Reverence Is All," 27.
36. Rosenberg, in Seckler, Interview, 9.
37. Rosenberg, in Rosenthal and Ducovny, Interview, 55.
38. I have not been able to establish the first name of Rosenberg's maternal grandfather. In a telephone conversation on October 2, 2005, Patia Rosenberg Yasin recalled that his surname was Edelman. A search of the Ellis Island immigration records yielded no entry for Edelman's daughter, Fannie Edelman (or for her Hebrew name, Fige-Be). Rosenberg stated that she immigrated with her family from Vilna, Lithuania, at the age of six in the latter part of the nineteenth century. Rosenberg, in Rosenthal and Ducovny, Interview, 4.
39. Rosenberg, in Seckler, Interview, 6.
40. Rosenberg, in Seckler, Interview, 7.
41. *Commentary* magazine ran numerous articles on the issue of Jewish identity from its inception in 1945 through the early 1950s. As a liberal, progressive publication (unlike its present incarnation), *Commentary*, like *Partisan Review*, resisted the idea of "organized groups," as Rosenberg put it, in determining Jewish identity. See Terry A. Cooney, *The Rise of the New York Intellectuals: Partisan Review and Its Circle, 1934– 1945* (Madison: University of Wisconsin Press, 1986), 243–45; Alexander Bloom, *Prodigal Sons: The New York Intellectuals and Their World* (New York: Oxford University Press, 1986), 158 and following; and Jumonville, *Critical Crossings*, 64–65. Joseph Dorman, in *Arguing the World, The New York Intellectuals and Their Own Words* (Chicago: University of Chicago Press, 2001), 11, has noted that *Commentary* "was assimilationist and, at least initially, opposed the Zionist."
42. Harold Rosenberg, "Jewish Identity in a Free Society," *Commentary* 9, no. 6 (June 1950); reprinted in Harold Rosenberg, *Discovering the Present: Three Decades in Art, Culture, and Politics* (Chicago: University of Chicago Press, 1973), 267.
43. Rosenberg, "Jewish Identity in a Free Society," in Rosenberg, *Discovering the Present,* 268–69.
44. Rosenberg, in Rosenthal and Ducovny, Interview, 18.
45. Rosenberg, in Rosenthal and Ducovny, Interview, 20.
46. Again, Rosenberg does not identify his uncles by name in any of the various interviews conducted with him; nor has his daughter, Patia, retained any memory of their names.
47. Rosenberg, in Rosenthal and Ducovny, Interview, 13.
48. Rosenberg, in Seckler, Interview, 4.
49. Rosenberg notes this episode in Seckler, Interview, 4. I assume the uncle in question

must have been part of the cavalry forces led by General John Pershing in the Mexican Expedition of 1916, whose mission was to hunt down Pancho Villa. In Rosenthal and Ducovny, Interview, Rosenberg has this date as 1912, which does not square with Villa's raid in New Mexico and the subsequent US punitive expedition.

50. Rosenberg, "Jewish Identity in a Free Society," in Rosenberg, *Discovering the Present*, 269. The word "venerable" is one that Rosenberg applied to grandfathers in general.

51. Rosenberg, "Jewish Identity in a Free Society," in Rosenberg, *Discovering the Present*, 259.

52. Patia Rosenberg Yasin, in our conversation of October 14, 2005, recalled that her uncle David (b. 1904) was largely supported by his wife, Teresa, whom he later divorced. The painter Connie Fox, in a telephone conversation with me, January 28, 2005, stated that David had worked for the Camino Gallery. Fox knew Rosenberg from New York where she met him in the early 1950s, most likely through Elaine de Kooning. The few records from the gallery that are held by the Archives of American Art do not note this employment.

53. Rosenberg, in Seckler, Interview, 19.

54. Rosenberg, in Cummings, Interview, December 17, 1970, 3.

55. Rosenberg claimed (Cummings, Interview, December 17, 1970, 3) that he started frequenting Siegmeister's studio around 1925 or 1926. This date may be off by a year or so, as it does not square with the discussions he claims to have had there that pertained to *transition* magazine, which was founded in April 1927. Also, Siegmeister left for Paris in 1927. It may be that Rosenberg encountered *transition* elsewhere.

56. Tabak, "A Collage," 113.

57. On Rosenberg introducing Baumbach to painting, see James Baker Hall, "Harold Baumbach," in *Harold Baumbach* (New York: Shock of Color Press, 2006), n.p.

58. Rosenberg, in Cummings, Interview, December 17, 1970, 3.

59. The run of *transition* was irregular. It appeared as a monthly publication when it was launched in 1927 but within a year became a quarterly. Thereafter, until its demise in 1938, it became erratic, suspending publication from July 1930 to February 1932. For a history of the publication, see Douglas McMillan, *Transition: The History of a Literary Era, 1927–1938* (New York: George Braziller, 1975).

60. Rosenberg, in Cummings, Interview, December 17, 1970, 4.

61. Rosenberg, in Seckler, Interview, 19.

chapter 2

1. Harold Rosenberg, "A Fairy Tale," *transition* 19–20 (June 1930): 264–69.

2. Rosenberg, "A Fairy Tale," 264.

3. Parker Tyler to Charles Henri Ford, July 19, 1930, in "Parker Tyler: Correspondence, 1929–1974," edited with an introduction by Catrina Neiman, in preparation, Catrina Neiman Papers.

4. Saul Bellow, "What Kind of Day Did You Have," in *Him with His Foot in His Mouth and Other Stories* (Harmondsworth, UK: Penguin, 1974), 65.

5. For a study of *Hound & Horn*, see Leonard Greenbaum, *The Hound & Horn: The History of a Literary Quarterly* (The Hague: Mouton, 1966).

6. There is no copy of this manuscript in the Rosenberg Papers, nor in the Harold Rosenberg and May Natalie Tabak Papers at the Archives of American Art.

7. Harold Rosenberg, "A Relative Case of Absolute Collaboration," *Blues : A Magazine of New Rhythms* 9 (Fall 1930): 13.

8. Parker Tyler to Charles Henri Ford, August 12, 1930, Parker Tyler Papers, Harry Ransom Research Center, University of Texas at Austin.

9. Parker Tyler, "The Essay 1," in an unpublished manuscript of "Acrobat in the Dark: A Metaphysical Autobiography," 1940, Tyler Papers.

10. Tyler, "The Essay 1," n.p., Tyler Papers.

11. For an account of the narrative composition of the book, see Steven Watson, introduction to Charles Henri Ford and Parker Tyler, *The Young and the Evil* (New York: Richard Kasak Book Edition, 1996), n.p.

12. Tyler, "The Essay 1," n.p., Tyler Papers.

13. Charles Henri Ford to Parker Tyler, December 9, 1931, cited in Neiman's annotations to "Parker Tyler: Correspondence, 1929–1974."

14. Parker Tyler to Charles Henri Ford, c. November 9, 1931, Tyler Papers.

15. Parker Tyler to Charles Henri Ford in response to a letter from Ford of December 5, 1932, Tyler Papers.

16. Charles Henri Ford, *Water from a Bucket, A Diary 1948–1957* (New York: Turtle Point Press, 2001), 126. Tyler remains unmentioned in Lionel Abel's memoir, *The Intellectual Follies: A Memoir of the Literary Venture in New York and Paris* (New York: W. W. Norton, 1984).

17. Tyler, "Acrobat in the Dark," n.p., Tyler Papers.

18. All the figures in *The Young and the Evil* are given pseudonyms, with Lionel Abel cast as "Louis."

19. May Natalie Tabak, "Parker Tyler," *Christopher Street* 1, no. 8 (February 1977): 41.

20. Tabak, "Parker Tyler," 41.

21. Tyler's core literary interests have been delineated by Watson, Introduction to Ford and Tyler, *The Young and the Evil*.

22. Tabak, "Parker Tyler," 41.

23. Abel, in *The Intellectual Follies*, 17, states that he moved to Greenwich Village in 1930 with an advance from a publisher, Joseph Felshin, to translate the poetry of Rimbaud. His translation appeared later in the decade. See Arthur Rimbaud, *Some Poems of Rimbaud*, trans. Lionel Abel (New York: Exile's Press, 1939).

24. Rosenberg, in Tabak, "Parker Tyler," 42.

25. Tabak, "Parker Tyler," 42. I believe she was probably referring to Parker Tyler, *The Hollywood Hallucination* (New York, 1942).

26. For a sampling of essays by Tyler from this period, see the collection: Parker Tyler, *Every Artist His Own Scandal: A Study of Real and Fictive Heroes* (New York: Horizon Press, 1964).

27. Parker Tyler, "Introduction to the Cell," in *Every Artist His Own Scandal*, 17.

28. Harold Rosenberg, review of *Counter-Statement* and *The Human Parrot and Other Essays, Symposium* 3, no. 1 (January 1932): 118. Rosenberg had also written an earlier piece for *Symposium* that tackled Carl Jung's use of psychology as means to interpret myth. See "Myth and Poem," *Symposium* 2, no. 2 (April 1931): 179–91.

29. Kenneth Burke, *Counter-Statement*, 2d ed. (Berkeley: University of California Press, 1986), 106.

30. Rosenberg, review of *Counter-Statement*, 118.

31. Rosenberg, review of *Counter-Statement*, 117.

32. Parker Tyler's poem, "Shipshape Climber," and his review of *Beyond Desire* by Sherwood Anderson, *Light in August* by William Faulkner and *Summer Is Ended* by John Herrmann, appeared in *The New Act* 1 (1933): 23 and 37–39; "Dawn Angel" was published in the next issue (p. 94).

33. Parker Tyler to Ezra Pound, December 29, 1932, Tyler Papers.

34. Parker Tyler to Charles Henri Ford, November 23, 1932, Tyler Papers.

35. Tyler to Ford, November 23, 1932, Tyler Papers.

36. Rosenberg kept in touch with H. R. Hays at least through 1944, perhaps longer, writing him on several occasions, to apprise him, for instance, of the reception of Rosenberg's book of poetry, *Trance above the Streets* (New York: Gotham Books, 1942), and to congratulate Hays on the appearance of his novel, *Lie Down in Darkness* (New York: Reynal & Hitchcock, 1944). See letters from Rosenberg to Hays, July 21, 1943, and August 17, 1944, Berg Collection, New York Public Library.

37. Burke, *Counter-Statement*, 26.

38. Harold Rosenberg, "Prayer for a Prayer," *Pagany* 2, no. 2 (Spring 1931): 56–57. The correspondence between Parker Tyler and Richard Johns from 1929 to 1932, now in the *Pagany* Archives, University of Delaware Library, Newark, makes no mention of Rosenberg. It is my supposition that he may have engineered the introduction.

39. For a history of *Pagany: A Native Quarterly*, see Samuel Halpert and Richard Johns, eds., *A Return to Pagany: The History, Correspondence, and Selections from a Little Magazine, 1929–1932* (Boston: Beacon Press, 1969). With the exception of Jean Cocteau, Emanuel Carnevali, and H. D., all of whom Ezra Pound encouraged Johns to print, the publication never strayed from its mandate to focus on American writers, within its short three-year history.

40. Parker Tyler to Charles Henri Ford, c. January 17, 1931, Tyler Papers.

41. Parker Tyler to Charles Henri Ford, c. March 28 or April 1, 1931, Tyler Papers.

42. Tyler to Ford, c. March 28 or April 1, 1931, Tyler Papers.

43. See letters from Harold Rosenberg to Richard Johns, January 23, 1930, to December 9, 1932, *Pagany* Archives.

44. Parker Tyler to Richard Johns, undated letter, Tyler Papers.

chapter 3

1. Harold Rosenberg to Harriet Monroe, June 26, 1931, Harriet Monroe Papers, University of Chicago Library.
2. May Natalie Tabak, "My Grandmother Had Yichus," *Commentary*, April 1949, 368–72.
3. May Natalie Tabak, "A Collage," unpublished manuscript, n.d., Estate of May Natalie Tabak, 125.
4. Tabak, "A Collage," 127.
5. Tabak, "A Collage," 149.
6. Harold Rosenberg to May Natalie Tabak, n.d., Harold Rosenberg Papers, Getty Research Institute.
7. Tabak, "A Collage," 151.
8. Tabak, "A Collage," 151.
9. Tabak, "A Collage," 160.
10. For a history of *Poetry: A Magazine of Verse*, see Ellen Williams, *Harriet Monroe and the Poetry Renaissance: The First Ten Years of Poetry, 1912–22* (Urbana: University of Illinois Press, 1977); and Jayne E. Marek, *Women Editing Modernism: "Little" Magazines & Literary History* (Lexington: University of Kentucky Press, 1995), 23 and following.
11. For a discussion of Pound's relationship with Monroe, see Marek, *Women Editing Modernism*, 25–41, and 176 and following. On Pound's contest with Amy Lowell on Imagist poetry and as it related to *Poetry: A Magazine of Verse*, see Williams, *Harriet Monroe and the Poetry Renaissance*, 82–84 and 129–31.
12. Harriet Monroe, "The Open Door," *Poetry: A Magazine of Verse* 1, no. 2 (November 1912): 62–64.
13. Monroe, "The Open Door."
14. *Blues* and *Pagany* paid modest fees for writers' submissions. However, they did not match those of *Poetry*, not having developed a subscription base such as the one that Monroe had set in place.
15. The poem induced a round of negative response from the readership, with Monroe defending Pound in an editorial noting that the publication encouraged critical dialogue. See Harriet Monroe, "That Mass of Dolts," *Poetry: A Magazine of Verse* 1, no. 5 (February 1913): 110.
16. Harold Rosenberg, "Elegiac with a Difference," *Poetry: A Magazine of Verse* 39, no. 111 (December1931): 158–61.
17. Harold Rosenberg to Morton D. Zabel, August 31, 1931, Morton D. Zabel Papers, University of Chicago Library.
18. Dorothy Parker, *Death and Taxes* (New York: Viking Press, 1931).
19. I have not been able to verify if Dorothy Parker knew of Rosenberg's poem in *Pagany*. The titles of their pieces may be coincidental.
20. Rosenberg, "Elegiac with a Difference," 159.

21. Rosenberg, "Elegiac with a Difference," 159.

22. See Helen Hoyt, "For One Who Died in Spring," *Poetry: A Magazine of Verse* 37, no. 6 (March 1931): 310–12.

23. See Rosenberg's correspondence to Monroe, May 28, 1931, to December 6, 1933, Harriet Monroe Papers, University of Chicago Library.

24. See letter from Rosenberg to Monroe, March 4, 1932, in which he states, "I have, as you see, acquired a typewriter again, and so I return to you a more legible script of the poem, *Note for a Sunset,* that disappeared behind my handwriting" (Monroe Papers).

25. Harold Rosenberg, "Brain of Happy Fable," *Poetry: A Magazine of Verse* 41, no. 5 (February 1933): 264.

26. Parker Tyler to Charles Henri Ford, c. December 8, 1931, Parker Tyler Papers, Harry Ransom Research Center, University of Texas at Austin.

27. Parker Tyler to Charles Henri Ford, c. January 4, 1933, Tyler Papers.

28. Parker Tyler, ed., *Modern Things* (New York: Gallen Press, 1934), 10.

29. Ezra Pound to Parker Tyler, February 13, 1933, Tyler Papers.

30. Parker Tyler to Ezra Pound, February 25, 1933, Tyler Papers.

31. Harold Rosenberg, "Character Change and the Drama," in Harold Rosenberg, *The Tradition of the New* (New York: Da Capo, 1994), 138.

32. Rosenberg, "Character Change and the Drama," in Rosenberg, *The Tradition of the New,* 147.

33. Rosenberg, "Character Change and the Drama," in Rosenberg, *The Tradition of the New,* 148.

34. Harold Rosenberg, review of *The Knife of the Times and Other Stories, Fifth Floor Window* 1, no. 4 (May 1932): n.p.

35. Marianne Moore, *The Selected Letters of Marianne Moore,* ed. Bonnie Costello (New York: Alfred A. Knopf, 1997), 277. "The Fifth-Floor Window" was also the title of a poem by Lola Ridge that appeared in *Poetry: A Magazine of Verse* in March 1923. I have come across no reference to indicate that Hays and his colleagues took their title from Ridge.

36. Moore, *Selected Letters,* 277.

37. A full run of the *Fifth Floor Window* is contained in the Ezra Pound Papers, Beinecke Rare Book and Manuscript Library, Yale University.

38. H. R. Hays, "Classicist and Regionalist," *Fifth Floor Window* 1, no. 4 (May 1932): n.p.

39. Louis Zukofsky, in Barry Ahern, ed., *Pound/Zukofsky: Selected Letters of Ezra Pound and Louis Zukofsky* (New York: New Directions, 1987), 131.

40. Tabak, "A Collage," 38.

41. H. R. Hays and Harold Rosenberg, "Introduction to a Literary Review," *The New Act: A Literary Review* 1 (January 1933): n.p.

42. Harold Rosenberg, "Death in the Wilderness," *Midstream,* Summer 1957; reprinted in Rosenberg, *The Tradition of the New,* 250.

43. See Elaine O'Brien, "The Art Criticism of Harold Rosenberg: Theaters of Love and Combat," PhD diss., City University of New York, 1997, 180.

44. Sandy McIntosh, "Remembering H. R. Hays," www.poetrybay.com/autumn2000.

45. Harold Rosenberg, "Note on Class Conflict in Literature," *The New Act: A Literary Review* 1 (January 1933): 9. Fred Orton claims that Rosenberg saw the artist as a type of proletarian, a position with which I disagree, knowing that he viewed the proletarian as someone identified with his class. See Orton, "Action, Revolution and Painting," reprinted in *Avant-Gardes and Partisans Reviewed*, ed. Orton and Giselda Pollock (Manchester: Manchester University Press, 1996), 178. For a rebuttal of Orton, see Hee-Young Kim, "The Tragic Hero: Harold Rosenberg's Reading of Marx's Drama of History," *Art Criticism* 20, no. 1 (2005): 7–21.

46. I am paraphrasing Marx's preface to *A Contribution to the Critique of Political Economy*, trans. N. I. Stone (New York: International Library Publishing, 1904).

47. Rosenberg, in Seckler, Interview, 48.

48. Rosenberg, "Note on Class Conflict in Literature," 5.

49. Harold Rosenberg, "Sanity, Individuality and Poetry," *The New Act: A Literary Review* 2 (June 1933): 61.

50. Rosenberg, "Sanity, Individuality and Poetry," 61.

51. Sandy McIntosh, "H. R. Hays: The Theater of Disappointment," *Talisman* 41–43, https://talismanarchive.weebly.com/.

52. Ezra Pound, "Rimbaud," *The New Act* 3 (May 1934): 103.

53. Rosenberg, "Sanity, Individuality and Poetry," 60.

54. René Taupin," The Poetry of Ezra Pound," *The New Act* 3 (May 1934): 105–12.

55. See Tyler to Pound, February 25, 1933, Tyler Papers.

56. Harold Rosenberg, "Epos," *Poetry: A Magazine of Verse* 40, no. 6 (March 1935), www.poetryfoundation.org.

57. Harold Rosenberg to Ezra Pound, December 6, 1933, Pound Papers.

58. Ezra Pound, ed., *Active Anthology* (London: Faber & Faber, 1933), 9.

59. Pound had earlier considered Tyler for his anthology of contemporary American poetry, *Profiles*, but similarly reneged. Ezra Pound, *Profiles* (Milan, 1932).

60. Parker Tyler to Ezra Pound, April 20, 1933, Tyler Papers.

61. Parker Tyler, *Modern Things* (New York: Gallen Press, 1934), 9.

62. Harold Rosenberg, "Poets of the People," *Partisan Review* 3, no. 6 (October 1936): 23.

63. Rosenberg, "Poets of the People," 23.

64. Rosenberg, "Poets of the People," 22.

65. Harold Rosenberg, "The God in the Car," *Poetry: A Magazine of Verse* 52, no. 6 (September 1938): 336.

66. Harold Rosenberg, "Truth and the American Style," *Poetry: A Magazine of Verse* 49, no. 1 (October 1936): 50.

67. Harold Rosenberg to Nat Wolff, c. 1942, Rosenberg Papers. Wolff was an American playwright whom Rosenberg met in Washington, DC.

68. Despite his statement that poetry had become spent around 1936, Rosenberg occasionally contradicted his position, for example, in a piece in 1942 holding out for the possibility of its renewal. See Harold Rosenberg, "The Profession of Poetry, Or, Trails through the Night of M. Maritain," *Partisan Review* 9, no. 5 (September–October 1942): 413.

69. "The Question of the Pound Award," *Partisan Review* 16 no. 5 (May 1949).

70. Louis Zukofsky, *Autobiography* (New York: Privately printed, 1971).

71. Louis Zukofsky, "Sincerity and Objectification," *Poetry: A Magazine of Verse* 37, no. 5 (February 1931): 273.

72. Tyler to Ford, c. January 17, 1931, Tyler Papers.

73. Harold Rosenberg, in Parker Tyler to Charles Henri Ford, c. March 16, 1931, Tyler Papers.

74. In a letter from Parker Tyler to Charles Henri Ford, c. November 3, 1931, Tyler Papers, Tyler stated that "Rosenberg was to see me last night and we laid out every corpse . . . miss zky smelt the worst."

75. Rosenberg later considered Zukofsky for the second issue of *possibilities*, a publication that was eventually aborted. However, by this point Rosenberg's relationship to poetry was tenuous. See Louis Zukofsky to Harold Rosenberg, November 12, 1948, Rosenberg Papers.

76. For a discussion of the plagiarism charges brought against Greenberg, see Florence Rubenfeld, *Clement Greenberg: A Life* (New York: Scribner, 1997), 43.

77. William Carlos Williams, in Charles Norman, ed., *The Case of Ezra Pound* (New York: Bodley Press, 1948), 47.

78. Harold Rosenberg, "The 'Jew' in Literature," reprinted in Harold Rosenberg, *Discovering the Present: Three Decades in Art, Culture, and Politics* (Chicago: University of Chicago Press, 1973), 245. Rosenberg's article was part of a two-part "symposium" orchestrated by the editors of *Commentary* on "The Jewish Writer and the English Literary Tradition," in which each respondent was asked, "As a Jew and a writer within the Anglo-American tradition, how do you confront the presence in that tradition of the mythical or semi-mythical figure of the Jew, as found in the works of writers such as Chaucer, Marlowe, Shakespeare . . . Do you find this an important block or barrier to your full participation and integration . . ." (*Commentary* 7 [September and October, 1949]: 209). The "symposium" was generated in response to an article by Leslie Fiedler, "What Can We Do about Fagin? The Jew-Villain in Western Tradition," *Commentary* 7 (May 1949): 411–18. Rosenberg felt that Fiedler's essay was more "dangerous in its interpretation" than Shakespeare's rendition of Shylock in *The Merchant of Venice* or Eliot's portrayal of the Jew in "Gerontion." Besides Rosenberg, contributors to part one of the "symposium" included Paul Goodman, Howard Nemerov, William Phillips, Diana Trilling, Isaac Rosenfeld, and Stephen Spender, among others. See *Commentary* 7 (September 1949).

79. See Hugh Witemeyer, ed., *Pound/Williams, Selected Letters of Ezra Pound and William Carlos Williams* (New York: New Directions, 1996), 211 and following.

80. For a discussion of anti-Semitism in T. S. Eliot's work, see Anthony Julius, *T. S. Eliot, Anti-Semitism, and Literary Form* (Cambridge: Cambridge University Press, 1995).

81. Rosenberg, "The 'Jew' in Literature," in Rosenberg, *Discovering the Present*, 245.

82. On the critical reception to "Gerontion" from the community of Jewish writers mid-century, see Julius, *T. S. Eliot, Anti-Semitism, and Literary Form*, 49 and following.

83. Rosenberg, "The 'Jew' in Literature," in Rosenberg, *Discovering the Present*, 246. The reference to "Rachel née Rabinovitch" is a line from Eliot's "Sweeney among the Nightingales." Rosenberg's description conflates both this poem and "Gerontion."

84. T. S. Eliot, *After Strange Gods: A Primer of Modern Heresy* (New York: Harcourt, Brace, 1934), 20.

85. Rosenberg, "The 'Jew' in Literature," in Rosenberg, *Discovering the Present*, 246–47.

86. For a discussion of T. S. Eliot's dependence on "pills and potions," see Herbert Read, "T. S. E.—A Memoir," in Allen Tate, ed., *T. S. Eliot: The Man and His Work* (New York: Delacorte Press, 1966), 32. Two of Eliot's biographers build on this description, although they situate his dependency later, in the early 1950s, long after his nervous breakdown in 1921. See Peter Ackroyd, *T. S. Eliot, A Life* (New York: Simon & Schuster, 1984), 304; and Lyndall Gordon, *T. S. Eliot: An Imperfect Life* (New York: W. W. Norton, 1998), 492. Even though these authors note that Eliot's use of drugs took place around 1951, I assume that Rosenberg would have known of his "dope-taking" from Herbert Read.

87. Rosenberg, "French Silence and American Poetry," introduction to Marcel Raymond, *From Baudelaire to Surrealism* (New York: Wittenborn, Schultz, 1949); reprinted in Rosenberg, *The Tradition of the New*, 93.

88. Rosenberg, "French Silence and American Poetry," in Rosenberg, *The Tradition of the New*, 91.

89. Ezra Pound, "Patria Mia," in William Cookson, ed., *Ezra Pound: Selected Prose, 1909–1965* (New York: New Directions, 1950), 107.

90. Ezra Pound, "Eleven New Cantos, XXXI–XLI," in *The Cantos of Ezra Pound* (New York: New Directions, 1934), 3–56.

91. Rosenberg, "French Silence and American Poetry," 92. I am assuming that the reference to a "fascist ideology" pertains to Pound. To whom else, after all, could it apply, especially in the wake of the Bollingen Prize? Eliot never embraced Hitler and Mussolini; nor was he a fascist. He was identified more as a "political idealist" by Herbert Read. See Read, "T. S. E.—A Memoir," in Tate, ed., *T. S. Eliot: The Man and His Work*, 18. Notwithstanding Read's description, Eliot's politics were generally read as being conservative.

92. Harold Rosenberg, "Hans Hofmann: The 'Life Class,'" reprinted in Harold Rosenberg, *The Anxious Object* (Chicago: University of Chicago Press, 164), 131–32.

93. On T. S. Eliot's relationship to the lower classes, see John Carey, *The Intellectuals and The Masses: Pride and Prejudice among the Literary Intelligentsia, 1880–1939* (Chicago: Academy Chicago Publishers, 2002), 71.

chapter 4

1. Harold Rosenberg to Harriet Monroe, January 12, 1934, Harriet Monroe Papers, University of Chicago Library.

2. Monroe appears to have been "embarrassed" by Rosenberg's request but had agreed to a $20 advance, which she subsequently declined for "budgetary matters." Rosenberg to Monroe, January 12, 1934, and Rosenberg to Geraldine Udell, April 8, 1934, Monroe Papers.

3. Harold Rosenberg, in Paul Cummings, Interview, December 17, 1970, 14, Archives of American Art, Smithsonian Institution.

4. May Natalie Tabak, "A Collage," 242, unpublished manuscript, n.d., Estate of May Natalie Tabak.

5. Alice Neel, interview by Werner and Yetta Groshans, Werner and Yetta Groshans Papers, Archives of American Art.

6. Rosenberg, in Cummings, Interview, December 17, 1970, 16.

7. For discussion of Willem de Kooning and his involvement with the WPA, see Mark Stevens and Annalyn Swan, *De Kooning: An American Master* (New York: Alfred A. Knopf, 2004), 121 and following; and Willem de Kooning, in Cummings, Interview, December 17, 1970.

8. Rosenberg, in Cummings, Interview, December 17, 1970, 195.

9. Harold Rosenberg to Harriet Monroe, March 18, 1934, Monroe Papers.

10. Rosenberg to Monroe, March 18, 1934, Monroe Papers.

11. Patia Rosenberg Yasin, telephone conversation with the author, July 21, 2005, retained no memory of her father's painting when she was a child, or of seeing his work in their home. Alice Neel, in Groshans and Groshans, interview, Werner and Yetta Groshans Papers, claimed that Rosenberg "couldn't paint, he never painted any pictures," an exaggeration of his early avocational interest in art.

12. Harold Rosenberg to Harriet Monroe, July 10, 1935, Monroe Papers.

13. Harold Rosenberg, "The American Writers' Congress," *Poetry: A Magazine of Verse* 46, no. 4 (July 1935): 224.

14. On the *New Masses*, see Andrew Hemingway, *Artists on the Left: American Artists and the Communist Movement, 1926–1956* (New Haven: Yale University Press, 2002), 7 and following.

15. "Call for an American Writers' Congress," *New Masses*, January 22, 1935, 20.

16. Quoted in Daniel Aaron, *Writers on the Left: Episodes in American Literary Communism* (New York: Harcourt, Brace & World, 1961), 284.

17. Waldo Frank, quoted in Casey Nelson Blake, *Beloved Community: The Cultural Criticism of Randolph Bourne, Van Wyck Brooks, Waldo Frank and Lewis Mumford* (Chapel Hill: University of North Carolina Press, 1990), 278. On Frank's relationship to communism and the Soviet Union, see Blake, *Beloved Community*, 277 and following.

18. Diana Trilling in Joseph Dorman, *Arguing the World: The New York Intellectuals in Their Own Words* (Chicago: University of Chicago Press, 2001), 55.

19. Rosenberg, "The American Writers' Congress," 224.

20. Harold Rosenberg to Harriet Monroe, July 10, 1935, Monroe Papers.

21. Harriet Monroe to Harold Rosenberg, July 12, 1935, Monroe Papers.

22. Harold Rosenberg to Harriet Monroe, July 19, 1935, Monroe Papers.

23. The manuscript that Rosenberg submitted to *Poetry* reveals that a sentence on page 2 was omitted by Monroe. The overall editing, however, contrary to his protestations, was quite minimal, confined primarily to a few semantic alterations, in addition to Browder's title (although that exclusion was significant). See Rosenberg's original typescript in the *Poetry* Magazine Papers, University of Chicago Library.

24. Rosenberg to Monroe, July 19, 1935, Monroe Papers.

25. Harriet Monroe, "Art and Propaganda," *Poetry: A Magazine of Verse* 44 (July 1934): 210.

26. Monroe, "Art and Propaganda," 210.

27. Morton D. Zabel to Harold Rosenberg, May 25, 1937, Morton D. Zabel Papers, University of Chicago Library.

28. Harold Rosenberg to Morton D. Zabel, May 18, 1937, Zabel Papers.

29. David Schubert, "Correspondence," *Poetry: A Magazine of Verse* 50, no. 6 (September 1937): 357–58.

30. On the dissociation of *Partisan Review* from the Communist Party, see Terry Cooney, *The Rise of the New York Intellectuals: Partisan Review and Its Circle, 1934–1945* (Madison: University of Wisconsin Press, 1986), 95–119.

31. Rosenberg, "The American Writers' Congress," 224.

32. For a transcription of the reaction to the paper that Burke delivered at the congress, see "Discussion and Proceedings," in Henry Hart, ed., *American Writers' Congress* (New York: International Publishers, 1935), 167–70.

33. On Kenneth Burke and the American Writers' Congress, see Aaron, *Writers on the Left*, 288 and following. For a more recent discussion, see Ann George and Jack Selzer, "What Happened at the American Writers' Congress? Kenneth Burke's 'Revolutionary Symbolism in America,'" *Rhetoric Society Quarterly* 33 (2003): 47–56.

34. Kenneth Burke, "Revolutionary Symbolism in America," in Hart, ed., *American Writers' Congress*, 87–94.

35. Burke, "Revolutionary Symbolism in America," in Hart, ed., *American Writers' Congress*, 93.

36. My research has yielded no information as to the identity of Allen Porter.

37. Kenneth Burke, in "Thirty Years Later: Memories of the First American Writers' Congress," *American Scholar* 35, no. 3 (Summer 1966): 507. Gold is not listed in the "Discussion and Proceedings" section of *American Writers' Congress*; it may be that Burke conflated this event with another altercation with Gold. Two other versions of this story are quoted: one in Malcolm Cowley, "1935: The Year of Congresses," *Southern Review* 15 (1979): 279–80; and one in Ben Yagoda, "Kenneth Burke: The Greatest Literary Critic since Coleridge?" *Horizon* 23 (June 1980): 68.

38. Kenneth Burke, "Counter Gridlock: An Interview with Kenneth Burke," *All Area* 2 (Spring 1983): 16.

39. Burke, "Counter Gridlock," 16.

40. Kenneth Burke, "The American Writers' Congress," *The Nation*, May 15, 1935, 571.

41. Richard Wright, "I Tried to Be a Communist," *Atlantic Monthly* 174, nos. 2–3 (August–September 1944): 61–70, 48–56.

42. For a study of Burke and Wright and the American Writers' Congress, see John Logie, "WE WRITE FOR THE WORKERS": Authorship and Communism in Kenneth Burke and Richard Wright," *KB Journal* 1, no. 2 (Spring 2005): 1–43. Logie builds on George and Selzer, "What Happened at the American Writers' Congress?" and argues that Burke exaggerated the level of hostility at the conference. Yet Logie, like George and Selzer, fails to acknowledge Burke's interview in *All Area*, where he notes his interactions with Rosenberg after the event. Instead, Logie focuses primarily on rebutting Frank Lentricchia's claim in *Criticism and Social Change* (Chicago: University of Chicago Press, 1983), 21, that Burke struggled with the aggression of the conference. Once Rosenberg's account of Burke's bruised feelings is considered, Lentricchia's position remains credible. Some degree of hyperbole must have been involved in Burke's retelling of the episode in *The American Scholar*, as his memory was colored by a revised view of Stalin and the American Communist Party more than thirty years later.

43. Richard Wright, *American Hunger* (New York: Harper & Row, 1945), 69–70. The book is drawn largely from "I Tried to Be a Communist."

44. On Richard Wright's relationship to the John Reed Club in Chicago, see Hazel Rowley, *Richard Wright: The Life and Times* (New York: Henry Holt, 2001), 85 and following.

45. Richard Wright, in "Discussions and Proceedings," in Hart, ed., *American Writers' Congress*, 178–79.

46. Wright, *American Hunger*, 119.

47. Earl Browder, "Communism and Literature," in Hart, ed., *American Writers' Congress*, 68.

48. Burke, "Counter Gridlock," 16.

49. Cowley, "1935: The Year of Congresses," 279, also stated that he was "amused" by the "diatribes" at the session in which Burke participated at the American Writers' Congress, although "disturbed" on his behalf. He himself had endured similar attacks by members of the CP.

50. Ibram Lassaw, in Elaine O'Brien, "The Art Criticism of Harold Rosenberg: Theaters of Love and Combat," PhD diss., City University of New York, 1997, 203.

51. Stevens and Swan, *De Kooning*, 222, taking their cues from an interview with Ibram Lassaw, have Rosenberg as one of Max Spivak's assistants on the WPA. Rosenberg never mentions working with Spivak in any of his interviews. However, Tabak does in her memoir, "A Collage," 311. Conversely, neither Stevens and Swan, nor Tabak, mention Rosenberg's appointment as de Kooning's assistant.

52. Rosenberg, in Cummings, Interview, December 17, 1970, 60.

53. Ibram Lassaw, in Stevens and Swan, *De Kooning*, 222.

54. Lassaw, in Stevens and Swan, *De Kooning,* 223.

55. Lassaw, in Stevens and Swan, *De Kooning,* 223.

56. Rosenberg, in Cummings, Interview, December 17, 1970, 60.

57. Rosenberg was identified as such in his contributions to *Poetry.*

58. Florence Rubenfeld, *Clement Greenberg: A Life* (New York: Scribner, 1997), 44, 46.

59. On Max Spivak, Lee Krasner, and the Artists' Union, see Hemingway, *Artists on the Left,* 86.

60. Lee Krasner, in O'Brien, "The Art Criticism of Harold Rosenberg," 204.

61. Annalee Newman, in O'Brien, "The Art Criticism of Harold Rosenberg," 87.

62. Mark Rothko, "Art as a Form of Action," in *The Artist's Reality: Philosophies of Art* (New Haven: Yale University Press, 2001), 9–13.

63. Harold Rosenberg, *Barnett Newman* (New York: Harry Abrams, 1978), 42.

64. On de Kooning's lack of interest in politics, see Stevens and Swan, *De Kooning,* 113.

65. Rosenberg, in Cummings, Interview, February 7, 1972, 139.

66. Rosenberg, in Cummings, Interview, February 7, 1972, 140.

67. Rosenberg, "Note on Class Conflict in Literature," *The New Act: A Literary Review* 1 (January 1933): 10.

68. James Farrell, in O'Brien, "The Art Criticism of Harold Rosenberg," 235.

69. Harold Rosenberg to Jim Farrell, September 11, 1936. James Farrell Papers, University of Pennsylvania. In this letter, Rosenberg thanks Farrell for a copy of his recently published book, *A Note of Literary Criticism* (London: Constable, 1936).

70. Kenneth Burke, *Attitudes toward History,* vol. 1 (New York: New Republic, 1937), 99.

71. Harold Rosenberg, in Tabak, "A Collage," 213.

72. Harold Rosenberg to Kenneth Burke, January 17, 1936, Kenneth Burke Papers, Pennsylvania State University Libraries.

73. Donald E. Pease, in "Ralph Ellison and Kenneth Burke: The NonSymbolizable (Trans)Action," *Boundary* 3, no. 2 (Summer 2003): 65–46, claims that Burke gave a seminar at the New School for Social Research on "The Rhetoric of Hitler's 'Battle,'" in June 1935. Burke wrote an essay with that title that was published in 1939 in *Southern Review* (reprinted in *The Philosophy of Literary Form* (New York: Vintage Books, 1961). Pease's claim with regard to the 1935 seminar is not accompanied by evidence. This date must be off, as Burke's essay opens with a reference to *Mein Kampf,* which was translated and published in English in 1939, the year he wrote his article on Hitler.

74. Sidney Hook, "The Technique of Mystification," *Partisan Review* 4, no. 1 (December 1937): 62.

75. Kenneth Burke, "Correspondence," *Partisan Review* 4, no. 2 (January 1938): 142.

76. Burke ceases to reference Stalin and the Soviet Union after 1938. His epiphany on Stalin may have occurred after World War II.

77. Kenneth Burke, review of Henri Barbusse, *Stalin: A New World Seen through One Man, Book Union Bulletin,* November 1935, n.p.

78. Kenneth Burke, in Tabak, "A Collage."

79. Burke "Thirty Years Later," 50.

80. Cowley, "1935: The Year of Congresses," 279.

81. Kenneth Burke, in "Discussion and Proceedings," in Hart, ed., *American Writers' Congress*, 279.

82. Cowley, "1935: The Year of Congresses," 279.

83. Unlike Burke, Rosenberg never wavers or equivocates on the issue on Marx. His position is clear from the outset, tested and challenged only as it relates to Stalin and to the Communist Party. For discussion of Burke's relationship to Marxism, see Logie, "WE WRITE FOR THE WORKERS," 31 and following.

84. Harold Rosenberg, "What We Demand," *New Masses*, March 23, 1937, 17.

85. Michael Gold, "The Moscow Trials: An Editorial," *New Masses*, February 9, 1937, 17–18. On Rosenberg's relationship to the *New Masses* during the period of the Moscow Trials, see Fred Orton and Griselda Pollock, eds., *Avant-Gardes and Partisans Reviewed* (Manchester: University of Manchester Press, 1996), 281–82n29.

86. The Popular Front was a complex social movement of labor unions, socialists, progressive liberals, and communists. My use of the term is restricted to its relationship to the American Communist Party, as this was the component that most engaged Rosenberg. For a discussion of the history of the Popular Front and for the factions incorporated under its rubric, see Michael Denning, *The Cultural Front: The Laboring of American Culture in the Twentieth Century* (London: Verso, 1998).

87. Rosenberg, "American Writers' Congress," 2. Orton, in Orton and Pollock, eds., *Avant-Gardes and Partisans Reviewed*, 281, claims that Rosenberg acquired the phrase "no red uniforms" from Max Eastman's book, *Artists in Uniform: A Study of Literature and Bureaucratism*, which had been published in 1934. Orton's extrapolation is far-fetched, as the phrase was widely circulated in the mid-1930s.

88. Norman Podhoretz, *Ex-Friends* (New York: Free Press, 1999), 14.

89. Tabak, "A Collage," 212.

90. Tabak, "A Collage," 212.

91. Burke, "Thirty Years Later," 501.

92. William Phillips, in Burke, "Thirty Years Later," 501.

93. Harold Rosenberg to Kenneth Burke, January 9, 1936, Burke Papers.

94. Harold Rosenberg, in Gerald M. Monroe, "Art Front," *Archives of American Art Journal* 31, no. 3 (1973): 17.

95. Harold Rosenberg to Kenneth Burke, January 17, 1936, Burke Papers.

96. Harold Rosenberg, "Notes on Fascism and Bohemia," *Partisan Review* 11, no 2 (1944); reprinted in *Discovering the Present: Three Decades in Art, Culture, and Politics* (Chicago: University of Chicago Press, 1973), 292.

97. Harold Rosenberg, "The Fall of Paris," *Partisan Review* 7, no. 5 (November–December 1940); reprinted in Rosenberg, *The Tradition of the New* (New York: Da Capo, 1994), 219. Rosenberg wrote a short review of Anna Segher's novel, *The Seventh Cross*, which focused on seven figures who escape from a Nazi concentration camp, for *View* magazine in 1943. See "On the Art of Escape," reprinted in Rosenberg, *Discovering the Present*, 298.

98. Rosenberg, "On the Art of Escape," reprinted in Rosenberg, *Discovering the Present*, 299.

99. Rosenberg, in Cummings, Interview, February 7, 1972, 135. Rosenberg has the title of Trotsky's tract somewhat off, referring to the text as "What Next in Germany?" It appears as "What Next? Vital Questions for the German Proletariat," in www.marxists .org/archive/trotsky/index.htm.

100. Rosenberg to Burke, January 17, 1936, Burke Papers.

101. Jean Pucelle, in Francine Tyler, "Artists Respond to the Great Depression and the Threat of Fascism: The New York Artists' Union and Its Magazine 'Art Front' (1934–1937)," PhD diss., New York University, 1991, 352. Pucelle places Rosenberg at the May Day parade in 1936. O'Brien also situates Rosenberg at the event in 1936. The latter overlooks his participation in the 1935 parade, which is substantiated by the memory of William Phillips and by Rosenberg's mention of the parade in his review of the American Writers' Congress in *Poetry*.

102. Harold Rosenberg, "A Respectable Accomplishment," *Poetry: A Magazine of Verse* 42, no. 2 (May 1936); www.poetryfoundation.org.

103. Harold Rosenberg, "The Education of John Reed," *Partisan Review & Anvil* 3, no. 5 (June 1936): 29.

104. Harold Rosenberg, "The Men on the Wall," *Poetry: A Magazine of Verse* 44, no. 1 (April 1934): 3–4. Rosenberg also recycled the image of the fist in "The Front," *Partisan Review* 2 (January–February 1935): 74.

105. Harold Rosenberg, "1776," *Poetry: A Magazine of Verse* 42, no. 2 (May 1936).

106. William Phillips and Philip Rahv, "Private Experience and Public Philosophy," *Poetry: A Magazine of Verse* 48, no. 2 (May 1936): 104.

chapter 5

1. I do not agree with Orton, who has stated that Rosenberg was "probably a fellow traveller of the C.P.U.S.A," however "short-lived." Fred Orton and Griselda Pollock, eds., *Avant-Gardes and Partisans Reviewed* (Manchester: University of Manchester Press, 1996), 265. Too much indecision is revealed in his references to communism and made plain in his letter to Kenneth Burke, January 9, 1936, Kenneth Burke Papers, Pennsylvania State University Libraries. Moreover, Annette Cox's claim, in *Art as Politics: The Abstract Expressionist Avant-garde and Society* (Ann Arbor, MI: UMI Press, 1982), 131, that "the cultural program of the Communist Party offered him the means to join American cultural life," is contradicted by Rosenberg's interactions with figures on the WPA.

2. Harold Rosenberg, "Artists Increase Their Understanding of Public Buildings," *Art Front*, November 1935, 3, 6.

3. The Artists Committee of Action continued to be listed on the masthead of *Art Front* until December 1936 even though it ceased sponsorship after two issues. See Gerald M. Monroe, "Art Front," *Archives of American Art Journal* 13, no. 3 (1973): 13.

4. On the Artists Committee of Action, see the Hugo Gellert Papers, Archives of American Art, Smithsonian Institution. Gellert, an artist, became the chairman of the committee when it was founded in early 1934. None of the records from the Gellert Papers reveal that Rosenberg was active on the committee, either at its inception or after, through its petitions to Mayor LaGuardia for a permanent exhibition space at the Municipal Arts Gallery and Center.

5. Harold Rosenberg to Mary McCarthy, July 30, 1959, Mary McCarthy Papers, Vassar College Library.

6. Rosenberg to McCarthy, July 30, 1959, McCarthy Papers.

7. Harold Rosenberg, in Paul Cummings, Interview with Harold Rosenberg, February 7, 1972, 129, Archives of American Art, Smithsonian Institution.

8. May Natalie Tabak, "A Collage," unpublished manuscript, n.d., Estate of May Natalie Tabak, 360, states that Rosenberg, Spivak, and Weinstock were responsible for the editorial overhaul of *Art Front*. Weinstock does not appear in Rosenberg's reminiscence of the editorial takeover of the magazine, primarily because Weinstock did not become editor-in-chief until January 1937, after Rosenberg was no longer active at the publication. However, he was responsible, as Monroe states ("Art Front," 16), for his "role of harmonizer at the lengthy board meetings and often voted with the dissidents."

9. See Monroe, "Art Front," 15.

10. Rosenberg, in Monroe, "Art Front," 12.

11. Harold Rosenberg, "Review of *Conquest of the Irrational*," *Art Front*, April 1936, 5.

12. Tabak, "A Collage," 360–61.

13. On Gorky and his relationship to the Artists' Union, see Hayden Herrera, *Arshile Gorky: His Life and Work* (New York: Farrar, Straus & Giroux, 2003), 256.

14. Stuart Davis, "Arshile Gorky in the 1930s: A Personal Recollection," reprinted in Diane Kelder, ed., *Stuart Davis* (New York: Praeger, 1971), 183.

15. Rosenberg, in Cummings, Interview, February 7, 1972, 139–40. Rosenberg's attribution of Gorky's "play" is clearly derived from Davis's description (Davis's essay was originally published in 1951).

16. Harold Rosenberg, *Arshile Gorky: The Man, the Time, the Idea* (New York: Sheepmeadow Press, 1962), 95.

17. Rosenberg rarely used the term "progress" during the 1930s. Rather, it is used retrospectively here, long after he had assessed the decade in which he intellectually matured. On Davis's use of the words "continuation and expansion," see Stuart Davis, "Why an Artists' Congress?" 160, reprinted in Kelder, ed., *Stuart Davis*. On the term "continuity," which he favored in the 1950s, see Davis, "Visa," reprinted in Kelder, ed., *Stuart Davis*, 102. On the antifascist activities of artists during this period, see Cecile Whiting, *Anti-fascism and American Art* (New Haven: Yale University Press, 1989), 271 and following.

18. Rosenberg, *Arshile Gorky*, 92.

19. Rosenberg, *Arshile Gorky*, 92–93.

20. On Davis's relationship to the Moscow Trails and to the Dewey Commission, cf. Matthew Baigell and Julia Williams, eds., *Artists Against War and Fascism: Papers of the First American Artists' Congress* (New Brunswick, NJ: Rutgers University Press, 1986), 30.
21. For Rosenberg's review of the Van Gogh exhibition at the Museum of Modern Art, see "Peasants and Pure Art," *Art Front*, January 1936, 5–6; for his coverage of the Gropper exhibition at the A.C.A. Gallery, see "The Wit of William Gropper," *Art Front*, March 1936, 7–8.
22. Rosenberg, "Wit of William Gropper," 5–6.
23. Balcomb Greene, "The Function of Léger," *Art Front*, January 1936, 9.
24. Clarence Weinstock, "Freedom in Painting," *Art Front*, January 1936, 10.
25. Stuart Davis, in Sidney Simon, "Stuart Davis: Interview 1957," www.walkerartcenter.org.
26. Fernand Léger, "The New Realism," *Art Front*, trans. Harold Rosenberg, December 1935, 10.
27. Léger, "The New Realism," 11.
28. Harold Rosenberg, "Movement in Art," *Vogue*, February 1, 1967; reprinted in Harold Rosenberg, *Art and Other Serious Matters* (Chicago: University of Chicago Press, 1985), 15.
29. Rosenberg had little interest in the medium of film and battled with Dwight Macdonald in the late 1950s, when he became the *New Yorker*'s film critic, over its uneasy alliances with mass culture. He also later battled with Renata Adler, whom he advised to forgo her role as the film critic for the *New York Times* in the late 1960s. Renata Adler, interview with the author, March 2005. He maintained an admiration for Charlie Chaplin, however, whom he referred to as an "artist," in "The Herd of Independent Minds," *Commentary*, 6, no. 3 (September 1948); reprinted in Harold Rosenberg, *Discovering the Present: Three Decades in Art, Culture, and Politics* (Chicago: University of Chicago Press, 1973), 21.
30. Rosenberg, "Movement in Art," in Rosenberg, *Art and Other Serious Matters*.
31. Léger, "The New Realism."
32. Léger, "The New Realism."
33. Harold Rosenberg, "Book Review: *Cubism and Abstract Art*," *Art Front*, June 1936, 15.
34. Rosenberg, "Book Review: *Cubism and Abstract Art*," 15.
35. Stuart Davis's rebuttal to Clarence Weinstock's editorial on Léger's "The New Realism" appeared in *Art Front* a month earlier than Rosenberg's review of Barr's *Cubism and Abstract Art*. Davis states in this rebuttal that Léger's work was anything but ideal, possessing an "objectivity." See Davis, in *Art Front*, May 1936. His stance may have colored Rosenberg's review of Barr's project, underscoring the necessity for some social analysis of art.
36. Rosenberg, in Monroe, "Art Front," 17.
37. *Art Front* continued to publish reviews and essays that related to the activities of the Artists' Union, as well as pieces on social scene painting. See, for example, Moses Soyer, "The Children's Exhibition," *Art Front*, March 1936, 12–13; and Louis Lozo-

wick, "Towards Revolutionary Art," *Art Front,* July–August 1936, 12–14. For a history of the range of articles included in the publication, see Monroe, "Art Front"; and Virginia Hagelstein Marquandt, "Art on the Political Front in America: From *The Liberator* to *Art Front," Art Journal* 52 no.1 (Spring 1993): 72–81.

38. Monroe's chronology of events that led to the special meeting where Rosenberg and Spivak were chastised by the union's membership differs slightly from Rosenberg's and Tabak's recollections. Although neither of them cites the event where Joe Jones lambasted Rosenberg, Rosenberg does note (with glee) that he and Spivak were accused of "Robespierrism." I assume they are describing the same incident. See Monroe, "Art Front."

39. Rosenberg, in Cummings, Interview, February 7, 1972, 129–30.

40. Tabak, "A Collage," 310.

41. Tabak, "A Collage," 310–11.

42. Tabak, "A Collage," 312.

43. Adolph Gottlieb, in Lee Dembart, "Adolph Gottlieb, Abstractionist, Dies," *New York Times,* March 5, 1974, 36.

44. For a list of artists who signed the call for the American Artists' Congress, see Matthew Baigell and Julia Williams, eds., *Artists against War and Fascism: Papers of the First American Artists' Congress* (New Brunswick, NJ: Rutgers University Press, 1986), 47–52.

45. "An American Artists' Congress," *Art Front,* November 1935, 3.

46. See Baigell and Williams, eds., *Artists against War and Fascism,* 4; and Gerald Monroe, "The American Writers' Congress and the Invasion of Finland," *Archives of American Art Journal* 15, no. 1 (1975): 14.

47. "The League of American Artists," *Art Front,* December 1935, 13.

48. Stuart Davis, in Harlan Phillips, "An Interview with Stuart Davis," *Archives of American Art Journal* 31, no. 2 (1991): 11.

49. Joe Jones, "Repression of Art in America;" reprinted in Baigell and Williams, eds., *Artists against War and Fascism,* 75.

50. Aaron Douglas, "The Negro in American Culture," reprinted in Baigell and Williams, eds., *Artists against War and Fascism,* 84.

51. Meyer Schapiro, "The Social Bases of Art," reprinted in Baigell and Williams, eds., *Artists against War and Fascism,* 105.

52. Schapiro, "The Social Bases of Art," reprinted in Baigell and Williams, eds., *Artists against War and Fascism,* 106.

53. Nat Werner, in "Proceedings and Discussion," in Baigell and Williams, eds., *Artists against War and Fascism,* 147.

54. Louis Lozowick, in "Proceedings and Discussion," in Baigell and Williams, eds., *Artists against War and Fascism,* 146.

55. Meyer Schapiro, "Race, Nationality, and Art," *Art Front,* March 1936, 11. Schapiro's title was taken from Lynn Ward's paper given at the American Artist's Congress, reinforcing my assumption that it was written as a reply. Ward notes his "indebtedness

to Mr. Meyer Schapiro for part of the material contained in this paper." See Ward, "Race, Nationality, and Art," reprinted in Baigell and Williams, eds., *Artists Against War and Fascism*, 114.

56. See Andrew Hemingway, "Meyer Schapiro and Marxism in the 1930s," *Oxford Art Journal* 17, no. 1 (1994): 13–29.

57. On Schapiro's involvement with *Art Front*, see Patricia Hills, "1936: Meyer Schapiro, *Art Front*, and the Popular Front," *Oxford Art Journal* 17, no. 1 (1994): 72–81; and Hemingway, "Meyer Schapiro and Marxism in the 1930s."

58. Rosenberg met Schapiro in New York through meetings at the Artists' Union, but almost no correspondence survives between the friends. Schapiro's widow, Dr. Lillian Milgram Schapiro, recalled that the two would see each other socially and spoke on the phone infrequently. Recounted to Phong Bui, May 21, 2004, in a conversation conducted on behalf of the author.

59. Rosenberg, in Cummings, Interview, February 7, 1972, 130–31.

60. Meyer Schapiro, in Helen Epstein, "A Passion to Know and Make Known, Part 2," *ARTnews* (Summer 1983): 86.

61. On Dewey and Marx, see Alan Ryan, *John Dewey and the High Tide of American Liberalism* (New York: W. W. Norton, 1995), 299 and following.

62. Greenberg's tenuous relationship to Marxism has been observed by Alice Goldfarb Marquis, *Art Czar: The Rise and Fall of Clement Greenberg* (Boston: MFA Publications, 2006), 32.

63. Outside of Schapiro's "The Social Bases of Art," Greenberg must have known of "The Nature of Abstract Art," which appeared in *Marxist Quarterly*, January–February 1939.

64. Rosenberg dubbed Pollock a member of the Communist Party, both in his letter to Mary McCarthy and in his interview with Cummings, 1972, a claim that must have been based on his memory of Pollock's early encounters with the CP in Los Angeles and his later relationship with David Alfaro Siqueiros in New York.

65. Jackson Pollock, in Steven Naifeh and Gregory White Smith, *Jackson Pollock: An American Saga* (New York: Clarkson N. Potter, 1989), 288.

66. Greenberg, "Jackson Pollock," reprinted in *Clement Greenberg: The Collected Essays and Criticism*, ed. John O'Brian, 4 vols. (Chicago: University of Chicago Press, 1986–93), 4:44–45.

67. Unlike Caroline Jones, *Eyesight Alone: Clement Greenberg's Modernism and the Bureaucratization of the Senses* (Chicago: University of Chicago Press, 2006), 80 and following, I am not convinced that Greenberg embarked on a deep reading of Marx and Hegel while writing "Avant-Garde and Kitsch," even if filtered, as she argues, through an intermediary such as Mikhail Lifshnitz and the "formalist-inflected Marxism" that shaded his book *The Philosophy of Art of Karl Marx*, or through the socialist interests of Greenberg's parents. When you place Rosenberg and Schapiro in the discussion, Greenberg's commitment to Marxism changes, becoming less trenchant and devoted.

68. Clement Greenberg, "Americanism Misplaced," reprinted in *Clement Greenberg: The Collected Essays and Criticism*, 2:64. Greenberg had read Kant since the early 1930s. In a letter to his former roommate from Syracuse University, Harold Lazarus, he wrote that he had "discovered the only *good* German philosophers who weren't poet *manqué* were Leibnitz, Wolff and Kant." See Clement Greenberg, *The Harold Letters, 1928–1943: The Making of An Intellectual* (Counterpoint Press: Washington, DC, 2000), 43.

69. Clement Greenberg, "Towards a Newer Laocoön," in *Clement Greenberg: The Collected Essays and Criticism*, 1:35.

70. Clement Greenberg, "An American View," in *Clement Greenberg: The Collected Essays and Criticism*, 1:41.

71. Clement Greenberg, "The Question of the Pound Award," in *Clement Greenberg: The Collected Essays and Criticism*, 2,:304.

72. Valéry is mentioned first in "Avant-Garde and Kitsch," 9.

73. Clement Greenberg, "Valéry, the Littérateur in Essence: Review of *Reflections of the World Today* by Paul Valéry," in *Clement Greenberg: The Collected Essays and Criticism*, 2:252.

74. Paul Valéry, "On the Subject of Dictatorship," in *Reflections of the World Today*, trans. Francis Scarfe (New York: Pantheon Books, 1948), 76.

75. Paul Valéry, "Our Destiny and Literature," in *Reflections of the World Today*, 133.

76. Greenberg, "The Present Prospects of American Painting and Sculpture," in *Clement Greenberg: The Collected Essays and Criticism*, 2:169–70.

77. Rosenberg, in Cummings, Interview, January 4, 1972, 156.

78. Rosenberg, "Hans Hofmann: Nature into Action," *ARTnews*, 56, no. 3 (May 1957); reprinted in Harold Rosenberg, *The Anxious Object* (Chicago: University of Chicago Press, 1964), 155.

79. Rosenberg, "Hans Hofmann: The "Life" Class," *ARTnews Annual*, no. 6 (Autumn 1962); reprinted in Rosenberg, *The Anxious Object*, 133–34.

80. Rosenberg, "Hans Hofmann: The 'Life' Class," 133.

81. Rosenberg, in Cummings, Interview, January 20, 1973, 51.

82. Patia Rosenberg Yasin, in a conversation with the author, June 5, 2005, stated that her mother destroyed all of Rosenberg's correspondence with the "officials" of the *New Masses*, such was the vitriol of his encounters with the editors and with the Communist Party during the mid-1930s.

83. Tabak, "A Collage," 361.

84. Rosenberg, in Cummings, Interview, February 7, 1972, 140.

chapter 6

1. Lee Krasner, in Deborah Solomon, *Jackson Pollock: A Biography* (New York: Cooper Square Press, 2001), 112.

2. Harold Rosenberg, in Paul Cummings, Interview with Harold Rosenberg, December 17, 1970, 29, Archives of American Art, Smithsonian Institution.

3. May Natalie Tabak, in Solomon, *Jackson Pollock,* 114.

4. Tabak, Interview with Jeffrey Potter, July 27, 1982, Pollock-Krasner House Archives.

5. Tabak, in Solomon, *Jackson Pollock,* 145.

6. Tabak, in Solomon, *Jackson Pollock,* 145.

7. Tabak, in Solomon, *Jackson Pollock,* 161.

8. May Natalie Tabak, "A Collage," 212, unpublished manuscript, n.d., Estate of May Natalie Tabak. I assume this building was on Greenwich Avenue as this was one of the locations where they lived around 1936. This chronology is difficult to construct: Tabak purposely omits dates in her memoir as part of her antichronological approach. Burke's biography yields no clues. Letters from Rosenberg to Burke in 1938 indicate that Burke lived on West 11th Street.

9. Tabak, "A Collage," 295.

10. Tabak, "A Collage," 298.

11. Tabak, "A Collage," 298.

12. Rosenberg, in Cummings, Interview, January 7, 1973, 182.

13. Florence Rubenfeld, *Clement Greenberg: A Life* (New York: Scribner, 1997), 44, has a different description of Rosenberg's first meeting with Greenberg. She states they met at one of Sonia's "at home" parties that Tabak and Rosenberg attended. Tabak's recollection seems more accurate: Rubenfeld's chronology is off, and she confuses the timing of their move to Washington, DC, with Lee Krasner's move to East 9th Street. Clement's brother, Martin, claims in an interview with Elaine O'Brien, "The Art Criticism of Harold Rosenberg: Theaters of Love and Combat," PhD diss., City University of New York, 1997, 110, that he introduced Rosenberg to Greenberg in "his father's living room in Brooklyn," compounding the ambiguity.

14. Tabak, Interview with Potter.

15. Tabak, Interview with Potter.

16. Clement Greenberg, *The Harold Letters, 1928–1943: The Making of an Intellectual* (Washington, DC: Counterpoint, 2000), 181.

17. Greenberg, in O'Brien, "The Art Criticism of Harold Rosenberg," 118.

18. Tabak, Interview with Potter.

19. Clement Greenberg, in Gail Levin, *Lee Krasner, A Biography* (New York: William Morrow, 2011), 169.

20. Jerre Mangione, *The Dream and the Deal: The Federal Writers' Project, 1935–1943* (Boston: Little, Brown, 1972), 56.

21. Alsberg, "Foreword," in *American Stuff: An Anthology of Prose and Verse by the Members of the Federal Writers' Project* (New York: Viking Press, 1937), vi.

22. Mangione, *The Dream and the Deal,* 248; and Rosenberg, in Cummings, Interview, February 7, 1972, 131.

23. Rosenberg, in Cummings, Interview, February 7, 1972, 131.

24. I have not encountered any published work by George David Petry.
25. Rosenberg, in Cummings, Interview, February 7, 1972, 131.
26. Rosenberg, "Literature without Money," *American Stuff*, special issue of *Direction* 3 (1938): 9.
27. Dorothy Kaufman to Henry Alsberg, April 19, 1938, WPA/Federal Writers Project Correspondence, National Archives and Records Administration, Washington, DC.
28. Rosenberg, in Cummings, Interview, February 7, 1972, 134.
29. Rosenberg, in Cummings, Interview, February 7, 1972, 134.
30. Rosenberg to Burke, February 23, 1938, Kenneth Burke Papers, Pennsylvania State University Libraries.
31. Mangione, *The Dream and the Deal*, 249.
32. Burke's letter to Rosenberg is lost. My interpretation of its content builds on Rosenberg's reply. See Rosenberg to Burke, May 23, 1938, Harold Rosenberg Papers, Getty Research Institute.
33. Rosenberg to Burke, May 23, 1938, Rosenberg Papers.
34. Mangione, *The Dream and the Deal*, 252.
35. Rosenberg, in Cummings, Interview, February 7, 1972, 130.
36. Recounted by Patia Rosenberg Yasin to O'Brien, "The Art Criticism of Harold Rosenberg: Theaters of Love and Combat," 248. I abide by O'Brien's interpretation that this recollection relates to *American Stuff*, given that little ruckus was stirred by the four pieces Rosenberg wrote for the *New Masses*. Rosenberg had locked horns with Granville Hicks, as O'Brien suggests (236 and following), over the issue of Hicks editing his review of Jules Romains, *The Boys in the Back Room*.
37. Rosenberg, "The Education of John Reed," *Partisan Review & Anvil* 3, no. 5 (June 1936): 28–29.
38. Rosenberg, typescript for "Aesthetic Assault," Rosenberg Papers. Hicks's editorial tampering with Rosenberg's review has been noted by O'Brien, "The Art Criticism of Harold Rosenberg," 244–45.
39. Recounted in O'Brien, "The Art Criticism of Harold Rosenberg," 282n201.
40. Edith Kurzweil, "William Phillips: A Partisan Memoir," *Provincetown Arts* 21 (2006–7): 103.
41. Editors' Statement, *Partisan Review* 1, no. 1 (December 1937): 1.
42. Dwight Macdonald to Harold Rosenberg, June 7, 1938, Dwight Macdonald Papers, Yale University Library.
43. Harold Rosenberg to Dwight Macdonald, May 25, 1938, Macdonald Papers.
44. Rosenberg to Macdonald, May 25, 1938, Macdonald Papers.
45. Recounted by Tyler to Charles Ford, c. 1938: "Dinner Friday night with Harold May Lionel and Sherry at a genuine and cheap Chinese restaurant, then to Thomas Mann's lecture at Carnegie Hall. They all had passes and suggested I might find a pass wandering around the lobby. There we saw Will Phillips who had a whole box." He states that he joined Rosenberg, Macdonald and his wife, Nancy, and Eleanor Clark in the "box." Thomas Mann, in his *Diaries 1918–1939*, trans. Richard and Clara

Winston (New York: Harry N. Abrams, 1982), 299, noted that his lecture at Carnegie Hall was delivered on May 6, 1938.

46. Tyler to Ford, c. May 1938, Parker Tyler Papers, Harry Ransom Center, University of Texas at Austin.

47. Tyler to Ford, May 20, 1938, Tyler Papers.

48. Macdonald to Rosenberg, June 7, 1938, Macdonald Papers.

chapter 7

1. On George L. K. Morris and his theories of art, see Debra Bricker Balken and Robert Lubar, *The Park Avenue Cubists*, exh. cat. (New York and London: Grey Art Gallery, New York University, and Ashgate, 2002). Morris was one of the first writers to apply Clive Bell's idea of "significant form" to American art.

2. George L. K. Morris, in Paul Cummings, Interview with George L. K. Morris, December 11, 1968, Archives of American Art, Smithsonian Institution, 12.

3. Leon Trotsky, "Art and Politics," *Partisan Review* 5, no. 3 (August–September 1938): 4.

4. Trotsky, "Art and Politics."

5. On Trotsky and the *Partisan Review*, see Alexander Bloom, *Prodigal Sons: The New York Intellectuals and Their World* (New York: Oxford University Press, 1986), 108 and following; Terry Cooney, *The Rise of the New York Intellectuals: Partisan Review and Its Circle, 1934–1945* (Madison: University of Wisconsin Press, 1986), 126–32; and Alan Wald, *The Rise and Decline of the Anti-Stalinist Left from the 1930s to the 1980s* (Chapel Hill: University of North Carolina Press, 1987), 144 and following.

6. Leon Trotsky, "The Future of *Partisan Review*: A Letter to Dwight Macdonald," reprinted in *Leon Trotsky on Literature and Art*, ed. and introd. Paul Siegel (New York: Pathfinder Press, 1970), 101–2.

7. William Phillips and Philip Rahv, "In Retrospect," in *The Partisan Reader: Ten Years of Partisan Review, 1934–1944: An Anthology*, ed. Phillips and Rahv (New York: Dial Press, 1944), 685.

8. William Phillips [Wallace Phelps], "Eliot Takes His Stand," *Partisan Review* 1 (April–May 1934): 52.

9. On Allen Tate's relationship to abolition and slavery, see his book, *Stonewall Jackson: The Good Soldier* (New York: Minton, Balch & Co., 1928), 54 and following. Jack Tworkov, whose wife Wally spent late spring of 1937 with Tate and his wife, Caroline Gordon, at their home "Banefully" in Clarksville, Tennessee, wrote of Tate and Gordon: "What they really stand up for is slavery . . . They believe in a slavocracy with themselves at the top enjoying complete freedom from work so they might cultivate their leisure to the end of making a beautiful life—for themselves." Jack Tworkov to Wally Tworkov, May 25, 1937, Tworkov Papers, Estate of Jack Tworkov, New York.

10. On Allen Tate and his relationship to *Partisan Review*, see David Laskin, *Partisans:*

Marriage, Politics, and Betrayal among the New York Intellectuals (New York: Simon & Schuster, 2000), 50 and following.

11. Philip Rahv, "Twilight of the Thirties," reprinted in *Essays on Literature and Politics,* ed. Arabel J. Porter and Andrew J. Dvosin (Boston: Houghton, Mifflin, 1978), 305.

12. Rahv, "Twilight of the Thirties," in Porter and Dvosin, eds., *Essays on Literature and Politics,* 305.

13. See Cooney, *The Rise of the New York Intellectuals,* 141.

14. On Einstein, Mann, and the "Jewish problem," see Anthony Heilbut, *Exiled in Paradise: German Refugee Artists and Intellectuals in America from the 1930s to the Present* (New York: Viking Press, 1983), 298 and following, and 385 and following. I assume that Dwight Macdonald and the editors of *Partisan Review* had been thinking about the resistance posed by immigration quotas and the ensuing "Jewish problem" when they floated the topic for "This Quarter" in their editorial meetings. I also assume that Macdonald wanted to pursue the topic, as Rosenberg mentioned "the refugee" problem in his reply to Macdonald.

15. Harold Rosenberg to Dwight Macdonald, June 14, 1938, Dwight Macdonald Papers, Yale University Library.

16. Rosenberg to Macdonald, June 14, 1938, Macdonald Papers.

17. Harold Rosenberg to Dwight Macdonald, October 15, 1938, Macdonald Papers.

18. Rosenberg to Macdonald, October 15, 1938, Macdonald Papers.

19. Dwight Macdonald to Harold Rosenberg, October 22, 1938, Macdonald Papers. Macdonald's reference to the "semantics piece" pertained to his editorial, "Semantics Is the Opium of Stuart Chase," *Partisan Review* 6, no. 1 (Fall 1938): 11–13.

20. Harold Rosenberg to Dwight Macdonald, June 30, 1938, Macdonald Papers.

21. Dwight Macdonald to Harold Rosenberg, June 30, 1938, Macdonald Papers.

22. Macdonald to Rosenberg, June 30, 1938, Macdonald Papers.

23. Macdonald to Rosenberg, June 30, 1938, Macdonald Papers.

24. William Phillips, "Thomas Mann: Humanism in Exile," *Partisan Review* 4, no. 6 (May 1938): 9.

25. Philip Rahv, in Cooney, *The Rise of the New York Intellectuals,* 51.

26. Rosenberg to Macdonald, October 15, 1938, Macdonald Papers.

27. Einstein, who immigrated to the United States in 1933, was one of the founders of the International Rescue Committee, as well as an ardent civil liberties advocate, associated with figures such as Charlie Chaplin, Upton Sinclair, and Jane Addams either before or soon after his arrival. He was drawn to their public positions on human rights, as well as to legal issues that extended to labor and gender equality in the workplace. However, Rosenberg's response to Macdonald's proposed inclusion of Einstein in his editorial revealed a glaring misunderstanding of Einstein's politics. For a recent discussion of Einstein's relationship to politics and its American extensions, see Walter Isaacson, *Albert Einstein: His Ideas and Universe* (New York: Simon & Schuster, 2007).

28. Macdonald to Rosenberg, October 22, 1938, Macdonald Papers.

29. Dwight Macdonald, "Reflections on a Non-Political Man," *Partisan Review* 6, no. 1 (Fall 1938): 15.

30. Mann, in Macdonald, "Reflections on a Non-Political Man," 14.

31. Thomas Mann, *Reflections of a Nonpolitical Man*, trans. and introd. Walter D. Morris (New York: Frederick Ungar Publishing, 1983).

32. Macdonald, "Reflections on a Non-Political Man," 16. Macdonald's editorial was written anonymously. However, after the fall 1938 issue of *Partisan Review*, all editorials in the journal appeared with a signature, making the political position of each writer known.

33. Rosenberg to Macdonald, October 15, 1938, Macdonald Papers.

34. Dwight Macdonald to Harold Rosenberg, January 1, 1939, Harold Rosenberg Papers, Getty Research Institute.

35. Observed by Morris, introduction to Mann, *Reflections of a Nonpolitical Man*, xiii.

36. Rosenberg to Macdonald, June 14, 1938. Macdonald Papers.

37. On the treatment of Thomas Mann in *Partisan Review*, see Cooney, *The Rise of the New York Intellectuals*, 153–60. I am indebted to Cooney's analysis of the journal's depiction of Mann and his relationship to politics, although my own conclusions differ somewhat, in that I state William Phillips's implication in the "Mann controversy" more emphatically. In fact, I feel Phillips was far more willful and complicit in his role in orchestrating the discussion on Mann in the *Partisan Review* than Cooney lets on, allowing James Burnham to become a mouthpiece for him and the other editors, notwithstanding Macdonald's editorial.

38. William Troy, "Thomas Mann: Myth and Reason," *Partisan Review* 5, nos. 1–2 (June–July 1938): 24–32 and 51–64. Cooney, *The Rise of the New York Intellectuals*, 154, has also observed that "Phillips wrote with an acute consciousness of what Troy had already said in an article on 'The Lawrence Myth' and quite probably with an editor's awareness of what Troy was about to say in his celebration of Mann." Troy had written an earlier piece on Mann about which Phillips surely knew, and which added to his growing aversion to Mann's reliance upon myth in developing the characters in his various novels. See William Troy, "Myth as Progress," *The Nation* 140, (May 22, 1935): 606.

39. For a discussions of Thomas Mann's relationship to the middle class, see Hermann Kurzke, *Thomas Mann: A Life in Art* (Princeton, NJ: Princeton University Press, 2003).

40. Phillips, "Thomas Mann: Humanism in Exile," 9.

41. James Burnham, "William Troy's Myths," *Partisan Review* 5, no. 3 (August–September, 1938): 65–68.

42. Burnham, "William Troy's Myths."

43. William Troy, "A Further Note on Myth," *Partisan Review* 6, no. 1 (Fall 1938): 95–100, reprinted in Stanley Edgar Hyman, ed., *William Troy: Selected Essays* (New Brunswick, NJ: Rutgers University Press, 1967), 35.

44. Troy, "A Further Note on Myth," in Hyman, ed., *William Troy: Selected Essays*, 223.

45. Macdonald to Rosenberg, January 1, 1939, Macdonald Papers.
46. Rosenberg sent a corrected manuscript to Macdonald in mid-January 1939 with an accompanying letter in which he stated that "most of my corrections deal with punctuation, so that very little re-setting will be required." Rosenberg to Macdonald, January 19, 1939, Macdonald Papers.
47. Macdonald to Rosenberg, January 1, 1939, Macdonald Papers.
48. On Phillips and Rahv's reaction to Eliot's *After Strange Gods*, see Cooney, *The Rise of the New York Intellectuals*, 75.
49. I do not agree with Cooney that Rosenberg's essay on Mann represented a "characteristic evaluation of literary modernism from the viewpoint of the *Partisan Review* circle," *The Rise of the New York Intellectuals*, 159. Too many subtle differences obtain between his emphasis and that of Phillips, Burnham, and Macdonald, with Rosenberg not satisfied with "science," in particular, as a methodology for literature.
50. Rosenberg, "Myth and History," *Partisan Review* 6, no. 2 (December 1939): 25.
51. Rosenberg, "Myth and History," 28.
52. On Mann's involvement with *Mass und Wert*, see Ronald Hayman, *Thomas Mann: A Biography* (New York: Scribner, 1995), 433–35.
53. Rosenberg, "Myth and History," 19.
54. Rosenberg, "Myth and History," 20.
55. Rosenberg, "The Politics of Art," *New Yorker*, May 25, 1963; reprinted in Harold Rosenberg, *The Anxious Object* (Chicago: University of Chicago Press, 1966), 216.
56. Rosenberg, "Fertile Fields," *New Yorker*, December 23, 1972; reprinted in Harold Rosenberg, *Art on the Edge* (Chicago: University of Chicago Press, 1975), 22.
57. Rosenberg, "Fertile Fields," in Rosenberg, *Art on the Edge*, 23.

chapter 8

1. Dwight Macdonald to Harold Rosenberg, June 7, 1938, Dwight Macdonald Papers, Yale University Library. Macdonald reiterated the "brilliance" of Rosenberg's essay in his letter to Rosenberg, January 1, 1939, Macdonald Papers.
2. Harold Rosenberg to Dwight Macdonald, July 26, 1938, Macdonald Papers.
3. Harold Rosenberg, "Poetry and the Theatre, "*Poetry, A Magazine of Verse* 39, no. 7 (January 1941): 262.
4. Harold Rosenberg, "The Unlearning," *Partisan Review* 7, no. 5 (September–October 1940): 354–55.
5. Reprinted in Editor's Note, in *Clement Greenberg: The Collected Essays and Criticism*, ed. John O'Brian, 4 vols. (Chicago: University of Chicago Press, 1986–93), 1:96.
6. Editor's Note, in *Clement Greenberg: The Collected Essays and Criticism*, 1:96.
7. Clement Greenberg, "Poems: A Note by the Editor," in *Clement Greenberg: The Collected Essays and Criticism*, 1:97.
8. Greenberg, "Avant-Garde and Kitsch," in *Clement Greenberg: The Collected Essays and Criticism*, 1:5–22.

9. Greenberg, "Avant-Garde and Kitsch," in *Clement Greenberg: The Collected Essays and Criticism*, 1:13.

10. Florence Rubenfeld, *Clement Greenberg: A Life* (New York: Scribner, 1997), 56, notes the influence of Theodor Adorno on Greenberg, as does Caroline Jones, *Eyesight Alone: Clement Greenberg's Modernism and the Bureaucratization of the Senses* (Chicago: University of Chicago Press, 2006), 360.

11. Harold Rosenberg to Dwight Macdonald, June 14, 1938, Macdonald Papers.

12. Rosa Luxemburg, "Letters from Prison," trans. Eleanor Clark, *Partisan Review* 5, no. 1 (June 1938), 3–16. Later, in 1943, the journal published a subsequent installment of her letters.

13. Rosenberg to Macdonald, June 14, 1938, Macdonald Papers.

14. Harold Rosenberg to Dwight Macdonald, February 28, 1939, Macdonald Papers.

15. Rosenberg, "Criticism-Action," 143. For Rosenberg's uncompleted article on Rosa Luxemburg, see Harold Rosenberg Papers, Getty Research Institute.

16. Harold Rosenberg, "The Fall of Paris," *Partisan Review* 7, no. 5 (November–December 1940); reprinted in Harold Rosenberg, *The Tradition of the New* (New York: Da Capo, 1994), 209.

17. Rosenberg, "The Fall of Paris," in Rosenberg, *The Tradition of the New*, 220.

18. Rosenberg, "The Fall of Paris," in Roenberg, *The Tradition of the New*, 212, 214.

19. Harold Rosenberg, "Notes on Fascism and Bohemia," *Partisan Review* 11, no. 2 (1944); reprinted in Harold Rosenberg, *Discovering the Present: Three Decades In Art, Culture, and Politics* (Chicago: University of Chicago Press, 1973), 296.

20. Rosenberg, "The Fall of Paris," in Rosenberg, *The Tradition of the New*, 220.

21. T. S. Eliot, "Notes Towards a Definition of Culture," *Partisan Review* 11, no. 2 (Spring 1944): 146.

22. William Phillips, "Mr. Eliot and Notions of Culture: A Discussion," *Partisan Review* 11, no. 3 (Summer 1944): 307.

23. Clement Greenberg, "Mr. Eliot and Notions of Culture: A Discussion," reprinted in *Clement Greenberg: The Collected Essays and Criticism*, 1:218.

24. Rosenberg to Macdonald, March 28, 1943, Macdonald Papers.

25. Harold Rosenberg to Philip Rahv, August 3, 1943, *Partisan Review* Papers, Howard Gotlieb Archival Research Center, Boston University.

26. Rosenberg, "The Case of the Baffled Radical," *Partisan Review* 11, no. 1 (Winter 1944); reprinted in Harold Rosenberg, *The Case of the Baffled Radical* (Chicago: University of Chicago Press, 1985), 3–9.

27. Rosenberg, "The Case of the Baffled Radical," in Rosenberg, *The Case of the Baffled Radical*, 7.

28. William Barrett, *The Truants: Adventures among the Intellectuals* (New York: Anchor Press/Doubleday, 1982), 57.

29. Barrett, *The Truants*, 59.

30. For three slightly differing views of Rosenberg's relationship to Marxism in the late 1940s, see Fred Orton, "Action, Revolution and Painting," in Fred Orton and

Griselda Pollock, eds., *Avant-Gardes and Partisans Reviewed* (Manchester: University of Manchester Press, 1996); Nancy Jachec, *The Philosophy and Politics of Abstract Expressionism, 1940–1960* (Cambridge: Cambridge University Press, 2000); and Hee-young Kim, "The Tragic Hero: Harold Rosenberg's Reading of Marx's Drama of History," *Art Criticism* 20, no. 1 (2005): 7–21. I disagree with Orton, who relates Rosenberg's theory of "action" to social revolution. As I have discussed in chapter 2, despite Rosenberg's early romance with Marx, his idea of *action* had been depoliticized by the late 1940s. While I find Jachec's analysis of Rosenberg's relationship to Marx more sensible, I cringe at the number of factual errors in her book, ranging from mistakes in key titles (for example, she has Trotsky's article as "Art & Revolution," rather than "Art and Politics") to mistakes in artist's names (for example, she gives Wifredo Lam's first name as "Alfonso").

31. For a discussion of the influence that T. S. Eliot's criticism wielded on the editors and writers of *Partisan Review,* see Terry Cooney, *The Rise of the New York Intellectuals: Partisan Review and Its Circle, 1934–1945* (Madison: University of Wisconsin Press, 1986), 30, 73–75, 88–89.

32. Philip Rahv edited *The Great Short Stories of Henry James* (New York: Dial Press) in 1944. Rosenberg's quip about the "Henry James delicatessen" was told by Delmore Schwartz to Barrett. See Barrett, *The Truants,* 58–59. Lionel Abel claimed that Rosenberg and Rahv had sparred as early as 1935 and that Rosenberg had proclaimed Rahv "as dumb as the Soviet Union." See Abel, *The Intellectual Follies: A Memoir of the Literary Venture in New York and Paris* (New York: W. W. Norton, 1984), 37. Abel's recollection is based on an erroneous memory of Rosenberg visiting the Soviet Union that year.

33. Clement Greenberg and Dwight Macdonald, "10 Propositions on the War," *Partisan Review* 8, no. 4 (July–August 1941): 271–78.

34. Philip Rahv, "10 Propositions and 8 Errors," *Partisan Review* 8, no. 6 (November–December 1941): 499–502.

35. For a discussion of the "affirmers" and the "dissenters" on US involvement in World War II, see Neil Jumonville, *Critical Crossings: The New York Intellectuals in Postwar America* (Berkeley: University of California Press, 1991), 49 and following.

36. Mary McCarthy, in David Laskin, *Partisans: Marriage, Politics, and Betrayal among the New York Intellectuals* (New York: Simon & Schuster, 2000), 139.

37. Mary McCarthy, *The Oasis* (New York: Random House, 1949), 19.

38. Diana Trilling, in Joseph Dorman, *Arguing the World: The New York Intellectuals in Their Own Words* (Chicago: University of Chicago Press, 2001), 63.

39. Rahv, in Jumonville, *Critical Crossings,* 52.

40. Rahv, in Jumonville, *Critical Crossings,* 52.

41. Macdonald, "The American People's Century," *Partisan Review* 9, no. 4 (July–August 1942): 294.

42. Macdonald, in Cooney, *The Rise of the New York Intellectuals,* 189.

43. Henry R. Luce, "An American Century," *Life,* February 7, 1941.

44. George L. K. Morris to Dwight Macdonald, May 12, 1943, in Michael Wreszin, *A Rebel in Defense of Tradition: The Life and Politics of Dwight Macdonald* (New York: Basic Books, 1994), 123.

45. For a discussion of the events that led to George L. K. Morris withdrawing his funding from *Partisan Review* and Macdonald leaving the publication, see Cooney, *The Rise of the New York Intellectuals*, 190 and following; and Wreszin, *A Rebel in Defense of Tradition*, 122 and following.

46. On Macdonald and *Politics*, see Jumonville, *Critical Crossings*, 55–61.

47. Harold Rosenberg, "The Herd of Independent Minds," *Commentary* 6, no. 39 (September 1948); reprinted in Rosenberg, *Discovering the Present*, 21.

48. Delmore Schwartz to Harold Rosenberg, May 6, 1948, Rosenberg Papers. I assume that Schwartz's rejection of Rosenberg's manuscript related to "The Herd of Independent Minds," as the limited correspondence that survives from this period indicates that texts such as "The Resurrected Romans," published in 1948, had already been committed to the *Kenyon Review*.

49. Rosenberg, "The Herd of Independent Minds," 21.

50. Rosenberg made the rather naïve claim that "Marx . . . conceives of the artist as the man of the future" in "The Herd of Independent Minds," 16, perpetuating his view that the artist could be made the focal point of Marxist theory.

51. Rosenberg, "The Herd of Independent Minds," 22.

52. Noted by Wreszin, *A Rebel in Defense of Tradition*, 135.

53. Harold Rosenberg, "The Creation of an Identity," *Commentary* 1, no. 1 (November 1945): 94.

54. Randall Jarrell to Rosenberg, n.d., Rosenberg Papers.

chapter 9

1. For a study of the American Guide book series, see Christine Bold, *The WPA Guides: Mapping America* (Jackson: University Press of Mississippi, 1999).

2. Harold Rosenberg, in Paul Cummings, Interview with Harold Rosenberg, June 30, 1971, 38, Archives of American Art, Smithsonian Institution.

3. Rosenberg, in Bold, *The WPA Guides*, 167.

4. Harold Rosenberg, in Jerre Mangione, Interview with Harold Rosenberg, August 20, 1968, n.p., Jerre Mangione Papers, University of Rochester Library.

5. Rosenberg, in Mangione, Interview, 43, Mangione Papers.

6. Harold Rosenberg, "A Risk for the Intelligence," *New Yorker*, October 27, 1962, 163.

7. Harold Rosenberg, in Bold, *The WPA Guides*, 4.

8. On the discord between state and local officials, see Monty Noah Penkower, *The Federal Writers' Project, A Study in Government Patronage of the Arts* (Urbana: University of Illinois Press, 1977), 217–19.

9. Harold Rosenberg, in Parker Tyler to Charles Henri Ford, c. August 26, 1940, Parker Tyler Papers. Harry Ransom Center, University of Texas at Austin.

10. Rosenberg, in Mangione, Interview, Mangione Papers.
11. On Thomas Hart Benton's return to the heartland, see Debra Bricker Balken, *After Many Springs: Regionalism, Modernism and the Midwest*, exh. cat. (Des Moines and New Haven: Des Moines Art Center and Yale University Press, 2009).
12. Harold Rosenberg, "Anyone Who Could Read English," *New Yorker*, January 20, 1973, 102.
13. Rosenberg, in Bold, *The WPA Guides*, 176.
14. Rosenberg, in Bold, *The WPA Guides*, 176.
15. Charles van Ravenswaay, "The Making of the Missouri Guide Book: Reminiscences of the One-Time State Supervisor," unpublished manuscript, 1985, 11, Charles van Ravenswaay Papers, Western Historical Manuscript Collection, University of Missouri, Columbia.
16. Billie Jensen, in Bold, *The WPA Guides*, 176.
17. Rosenberg, "Anyone Who Could Read English."
18. Rosenberg, "Anyone Who Could Read English."
19. Rosenberg, in Mangione, Interview, Mangione Papers. He recounts a slightly different version of this party in Cummings, Interview, February 7, 1972, 132. He did not name Mangione there as his conduit, but an "old friend . . . who at that time was a Communist." He noted that Thurman Arnold referred to him as a "leftist."
20. Rosenberg, in Cummings, Interview February 7, 1972, 132.
21. May Natalie Tabak to Mr. and Mrs. A. B. Rosenberg, July 12, 1938, Harold Rosenberg Papers, Getty Research Institute.
22. May Natalie Tabak, "A Collage," 388, unpublished manuscript, n.d., Estate of May Natalie Tabak.
23. Rosenberg, in Cummings, Interview, February 7, 1972, 133.
24. Harold Rosenberg to May Natalie Tabak, c. May 1938, Rosenberg Papers.
25. Harold Rosenberg to Nancy Macdonald, June 6, 1940, Dwight Macdonald Papers, Yale University Library.
26. Rosenberg to Macdonald, June 30, 1938, Macdonald Papers.
27. Dwight Macdonald to Harold Rosenberg, July 22, 1942, Rosenberg Papers.
28. Rosenberg, Notes written on Macdonald to Rosenberg, July 22, 1942, Rosenberg Papers.
29. Jerre Mangione, *The Dream and the Deal: The Federal Writers' Project, 1935–1943* (Boston: Little, Brown, 1972), 100–101.
30. John Cheever, in Scott Donaldson, *John Cheever: A Biography* (New York: Random House, 1988), 73.
31. On Cheever "sharing the somewhat compulsive social life of FWP workers," see Donaldson, *John Cheever*, 73.
32. Rosenberg in Mangione, Interview, Mangione Papers.
33. Rosenberg to Tabak, c. May 1938, Rosenberg Papers.
34. Rosenberg in Mangione, Interview, Mangione Papers. Rosenberg's annual salary of $2,400 was adjusted in March 1940 when his duties and title were raised to assistant

editor at a salary of $2,900. See "Qualifications Statement for Promotion and/or Reassignment," Rosenberg Papers. His title was changed in spring 1938 to principal editorial assistant and in October 1939 to assistant editor.

35. On Roderick Seidenberg's activity as a writer, see Richard Stivers, "Roderick Seidenberg," *Bulletin of Science, Technology and Society* 24, no. 2 (2004). 151–55.

36. Rosenberg, in Mangione, Interview, Mangione Papers.

37. Rosenberg, in Mangione, Interview, Mangione Papers.

38. The University of North Carolina Press published Seidenberg's *Post-historic Man: An Inquiry* in 1950, and his *Anatomy of the Future* in 1961. See Stivers, "Roderick Seidenberg."

39. Lewis Mumford, *Art and Technics,* new ed. (New York: Columbia University Press, 2000), 5.

40. Rosenberg, in Mangione, Interview, Mangione Papers.

41. Harold Rosenberg, "The Bureaucrats," in *Trance above the Streets* (New York: Gotham Books, 1942), 21–22. In his interview with Mangione, Rosenberg states that he cast Roderick Seidenberg as a "cold bird" in one of his poems, but no such phrase, let alone title, appears in any of the poems in *Trance.* "The Bureaucrats" is the best match for his depiction of Seidenberg, especially given his frequent references to him as a "bureaucrat" in his interview with Mangione.

42. Rosenberg, in Mangione, Interview, Mangione Papers.

43. Rosenberg, in Mangione, Interview, Mangione Papers.

44. Although Rosenberg knew of Hofmann's work and teaching from Lee Krasner, he had no recollection of him before the late 1940s. It seems likely that he may have looked him up that summer through their overlapping contacts and friends.

45. Clement Greenberg to Harold Lazarus, June 27, 1939, in Clement Greenberg, *The Harold Letters, 1928–1943: The Making of an American Intellectual,* ed. Janice Van Horne (Washington, DC: Counterpoint, 2000), 203.

46. Greenberg to Lazarus, March 27, 1939, in Greenberg, *The Harold Letters, 1928–1943,* 197.

47. Greenberg to Lazarus, April 18, 1939, in Greenberg, *The Harold Letters, 1928–1943,* 199.

48. Greenberg to Lazarus, June 27, 1939, in Greenberg, *The Harold Letters, 1928–1943.*

49. Rosenberg to Macdonald, October 15, 1938, Macdonald Papers.

50. In her memoir, "A Collage," 433, Tabak states that she "had no idea what his job was at the Veteran's Administration, but grievances from ex-soldiers came across his desk." Neither Florence Rubenfeld, *Clement Greenberg: A Life* (New York: Scribner, 1997), nor Alice Goldfarb Marquis, *Art Czar: The Rise and Fall of Clement Greenberg* (Boston: MFA Publications, 2006), identifies Lazarus's profession. Clement Greenberg, in *The Harold Letters, 1928–1943,* 156, notes he worked at the Civil Service Commission as of 1936.

51. Greenberg to Lazarus, August 23, 1939 in Greenberg, *The Harold Letters, 1928–1943,* 207. Neither Rubenfeld, *Clement Greenberg,* nor Marquis, *Art Czar,* notes that

Greenberg spent time on Cape Cod finishing his essay, "Avant-Garde and Kitsch." I have been unable to pinpoint the town where he stayed but assume it was Truro.

52. McCarthy, in Rubenfeld, *Clement Greenberg*, 53. Marquis, *Art Czar*, 55, also quotes McCarthy and recounts the same story.

53. Mangione, *The Dream and the Deal*, 337.

54. Archibald MacLeish, "In Challenge Not Defense," *Poetry: A Magazine of Verse* 52, no. 4 (July 1938): 214–20. The two other works in MacLeish's trilogy were "Public Speech and Private Speech in Poetry," a lecture that he delivered at Yale University on January 7, 1938, which was subsequently published in *Yale Review* 27, no. 547 (March 1938); and "Poetry and the Public World," the third installment, which appeared in *Atlantic Monthly* 163, no. 826 (June 1939). Scott Donaldson, *Archibald MacLeish: An American Life* (Boston: Houghton Mifflin, 1992), 273–75, mentions the first and third parts of the trilogy but not "In Challenge Not Defense." The best analysis of these speeches is still that of Eleanor M. Sickels, "Archibald MacLeish and American Democracy," *American Literature* 15, no. 3 (1943): 230–32. John Timberman Newcomb, "Archibald MacLeish and the Poetics of Public Speech: A Critique of High Modernism," *Journal of the Midwest Language Association* 23, no. 1 (Spring 1990): 9–26, also analyzes MacLeish's public addresses, but he fails to mention "In Challenge Not Defense."

55. Harold Rosenberg, "The God in the Car," *Poetry: A Magazine of Verse* 52, no. 6 (September 1938): 334.

56. Rosenberg, in Mangione, *The Dream and the Deal*, 337.

57. Mangione, *The Dream and the Deal*, 337.

58. Rosenberg, in Mangione, Interview, Mangione Papers.

59. Rosenberg to Mr. and Mrs. Abraham Rosenberg, November 8, 1939, Rosenberg Papers.

60. MacLeish, in Sickels, "Archibald MacLeish and American Democracy," 235.

61. Rosenberg to Tabak, c. May 1938, Rosenberg Papers.

62. Rosenberg to Mr. and Mrs. Rosenberg, February 13, 1940, Rosenberg Papers.

63. Archibald MacLeish, *Archibald MacLeish: Reflections*, ed. Bernard A. Drabeck and Helen E. Ellis (Amherst: University of Massachusetts Press, 1986), 136.

64. MacLeish, *Archibald MacLeish*, 84.

65. Holger Cahill, "Preface," in Edwin O. Christensen, *The Index of American Design* (New York and Washington, DC: Macmillan and National Gallery of Art, 1950), xi.

66. See Clarence P. Hornung, *Treasury of American Design*, exh. cat. (New York: Abrams, 1970); and Virginia Tuttle Clayton et al., *Drawing on America's Past: Folk Art, Modernism, and the Index of American Design*, exh. cat. (Chapel Hill: University of North Carolina Press, 2000.)

67. Rosenberg, in Cummings, Interview, December 17, 1970, 19.

68. Although Rosenberg states in Cummings, Interview, December 17, 1970, 19, that he was to have assumed the role of editor of the six volumes of the *Index of American Design* to be published by Crown, Cahill fails to mention Rosenberg's role in his "Preface" to Christensen Christensen, *Index of American Design*. I assume that their

joint partnership was not put in place until after Rosenberg completed his work on the Missouri volume of the American Guides in August 1940 and that he had no hand in the publishing phase of the Index.

69. Rosenberg, in Cummings, Interview, December 17, 1970, 21.

70. Rosenberg, in Cummings, Interview, December 17, 1970, 21.

71. Mangione, *The Dream and the Deal*, 56.

72. Harold Rosenberg to George Dillon, August 2, 1938, *Poetry* Magazine Papers, University of Chicago Library.

73. Harriet Monroe to Ezra Pound, 1934, quoted at www.poetrymagazine.org.

74. MacLeish, "In Challenge Not Defense," 215.

75. George Dillon to Archibald MacLeish, 1937, George Dillon Papers, Syracuse University Library.

76. Morton D. Zabel, "Cinema of Hamlet," *Poetry: A Magazine of Verse* 44 (1934): 153–54. Newcomb, "Archibald MacLeish and the Poetics of Public Speech," 23, also notes Zabel's position on MacLeish's politicization during the mid-1930s and cites the same quote in an endnote.

77. Morton D. Zabel "The Poet of Capitol Hill," *Partisan Review* 8, no. 1 (January–February 1941): 145–68.

78. MacLeish, "In Challenge Not Defense," 220.

79. Harold Rosenberg, "The God in the Car," *Poetry: A Magazine of Verse* 52, no. 6 (September 1938): 336.

80. "A Letter from Archibald MacLeish," *Poetry: A Magazine of Verse* 52, no. 6 (September 1938): 343. MacLeish's reference to Marx was not confined to his rebuttal of Rosenberg's response to his speech. He had written earlier on "The Poetry of Karl Marx," *Saturday Review of Literature*, February 17, 1934, 485–86.

81. Archibald MacLeish to George Dillon, undated, *Poetry* Magazine Papers.

82. Harold Rosenberg to George Dillon, July 21, 1938, *Poetry* Magazine Papers.

83. Archibald MacLeish to Amy Bonner, November 17, 1937, Dillon Papers.

84. See George Dillon to Walter Jessup, February 13, 1942, *Poetry* Magazine Papers.

85. Archibald MacLeish to George Dillon, July 9, 1942, Dillon Papers.

86. Macdonald, in Donaldson, *Archibald MacLeish*, 293.

87. This story is recounted by Tabak, "A Collage," 241. However, I have not been able to substantiate it through the *Congressional Record*.

88. Parker Tyler to Charles Henri Ford, April 9, 1939, Parker Tyler Papers, Harry Ransom Center, University of Texas at Austin.

89. Tyler to Ford, April 9, 1939, Tyler Papers.

90. Harold Rosenberg to Archibald MacLeish, February 28, 1939, Macdonald Papers.

91. Harold Rosenberg to Archibald MacLeish, March 9, 1939, Macdonald Papers.

92. Dwight Macdonald, "Reading from Left to Right: The Monopoly Committee—First Year," *New International* 5, no. 4 (April 1939): 105–8. The publication, an organ of the Trotskyite Socialist Workers Party, was edited by James Burnham and Max Shachtman. For a discussion of Macdonald's participation in the paper, see Michael

Wreszin, *A Rebel in Defense of Tradition: The Life and Politics of Dwight Macdonald* (New York: Basic Books, 1994), 70–71.

93. Rosenberg, in Lionel Abel, *The Intellectual Follies: A Memoir of the Literary Venture in New York and Paris* (New York: W. W. Norton, 1984), 148.

94. Dwight Macdonald, "The Bomb," *Politics*, September 1945, 258. For a discussion of Macdonald's reaction to the bombing of Hiroshima and its treatment in *Politics*, see Wreszin, *A Rebel in Defense of Tradition*, 160–64.

95. Macdonald, "The Bomb," 258.

96. Rosenberg, "Notes on Fascism and Bohemia," 291.

97. Greenberg to Lazarus, June 11, 1928, in Greenberg, *The Harold Letters, 1928–1943*, 2.

98. Greenberg to Lazarus, June 2, 1938, in Greenberg, *The Harold Letters, 1928–1943*, 182.

99. Lazarus, in Greenberg to Lazarus, August 23, 1938, in Greenberg, *The Harold Letters, 1928–1943*, 185.

100. Lazarus, in Greenberg to Lazarus, August 4, 1938, in Greenberg, *The Harold Letters, 1928–1943*, 184.

101. Tabak, "A Collage," 432.

102. Tabak, "A Collage," 432.

103. Tabak, "A Collage," 432.

104. Greenberg to Lazarus, August 4, 1938, in Greenberg, *The Harold Letters, 1928–1943*, 184.

105. Greenberg to Lazarus, August 4, 1938, in Greenberg, *The Harold Letters, 1928–1943*, 184.

106. Greenberg conveyed to William Phillips that "when I first knew him, I was struck by his enormous confidence and will. He had, I felt, what used to be known as a strong character—definitely stronger than mine" (William Phillips, *A Partisan View: Five Decades of the Literary Life* [New York: Stein & Day, 1983], 166).

107. Greenberg to Lazarus, February 16, 1939, in Greenberg, *The Harold Letters, 1928–1943*, 194.

108. Greenberg to Lazarus, January 13, 1939, in Greenberg, *The Harold Letters, 1928–1943*, 189.

109. Greenberg to Lazarus, November 29, 1939, in Greenberg, *The Harold Letters, 1928–1943*, 212.

110. Greenberg to Lazarus, March 27, 1939, in Greenberg, *The Harold Letters, 1928–1943*, 198.

111. Greenberg to Lazarus, January 24, 1939, in Greenberg, *The Harold Letters, 1928–1943*, 193.

112. Rubenfeld, *Clement Greenberg*, 83. Marquis, *Art Czar*, 85, places this incident in 1946, although by that date Wahl had returned to France after his exile in the United States.

113. Greenberg, in Marquis, *Art Czar*, 135.

114. Greenberg to Lazarus, August 13, 1940, in Greenberg, *The Harold Letters, 1928–1943*, 219.

115. Greenberg to Lazarus, August 24, 1940, in Greenberg, *The Harold Letters, 1928–1943*, 220.
116. Greenberg to Lazarus, August 28, 1949, in Greenberg, *The Harold Letters, 1928–1943*, 222.
117. Greenberg to Lazarus, August 28, 1949, in Greenberg, *The Harold Letters, 1928–1943*, 222.
118. Greenberg to Lazarus, January 24, 1939, in Greenberg, *The Harold Letters, 1928–1943*, 222.
119. "The Unlearning" was reprinted in the anthology compiled by William Phillips, *The Partisan Reader: Ten Years of Partisan Review, 1934–1944: An Anthology* (New York: Dial Press, 1944), 257–58. Phillips felt not only that the poem was worthy of being published in *Partisan Review* in 1940 but that it had staying power four years later.
120. Greenberg, "Towards a Newer Laocoön," in *Clement Greenberg: The Collected Essays and Criticism*, 4 vols. (Chicago: University of Chicago Press, 1986–93), 1:33.
121. Greenberg, "Towards a Newer Laocoön," in *Clement Greenberg: The Collected Essays and Criticism*, 1:25.
122. Greenberg's two biographers, Rubenfeld and Marquis, give differing dates for his appointment. Marquis, *Art Czar*, 71, lists this date as January 1940, which is off; Rubenfeld, *Clement Greenberg*, 61–62, rightly assigns the date to December 1940.
123. Greenberg to Lazarus, January 6, 1941, in Greenberg, *The Harold Letters, 1928–1943*, 231.
124. Greenberg to Lazarus, January 6, 1941, in Greenberg, *The Harold Letters, 1928–1943*, 231–32.
125. Rosenberg to Macdonald, September 8, [1940], Macdonald Papers.
126. Rosenberg to Macdonald, September 8, [1940], Macdonald Papers. These were names, among others, such as James Agee and James Burnham, that Macdonald had also asked Rosenberg to respond to as potential editors of *Partisan Review*.
127. Terry Cooney, *The Rise of the New York Intellectuals: Partisan Review and Its Circle, 1934–1945* (Madison: University of Wisconsin Press, 1986), 186.
128. See, for example, Greenberg to Lazarus, November 29, 1939, in Greenberg, *The Harold Letters, 1928–1943*, 212.
129. Clement Greenberg to Harold Lazarus, September 25, 1940, in Greenberg, *The Harold Letters, 1928–1943*, 226.
130. Lionel Trilling, in Rubenfeld, *Clement Greenberg*, 91.
131. Greenberg's complex relationship to Judaism and his self-hatred has been discussed by Margaret Olin in "C[lement] Hardesh G[reenberg] and Company: Formalist Criticism and Jewish Identity," in *Too Jewish? Challenging Traditional Identities*, ed. Norman Kleeblatt, exh. cat. (New York and New Brunswick, NJ: Jewish Museum and Rutgers University Press, 1996), 39–59. Louis Kaplan, "Reframing the Self-Criticism: Clement Greenberg's 'Modernist Painting' in Light of Jewish Identity," in *Jewish Identity in Modern Art History*, ed. Catherine Soussloff (Berkeley: University of California Press, 1999), 180–99, argues against Olin's thesis that Greenberg's

repression of his Jewish subjectivity was conditioned by the pressures of assimilation. Kaplan believes that Greenberg's writing was informed by self-criticism that had its roots in Jewish humor. I side with Olin, especially given the racist cracks he hurled against his colleagues.

132. Greenberg, "Self-Hatred and Jewish Chauvinism: Some Reflections on 'Positive Jewishness,'" in *Clement Greenberg: The Collected Essays and Criticism*, 3:45.

133. Greenberg, "The Question of the Pound Award reprinted in *Clement Greenberg: The Collected Essays and Criticism*, 2:305.

134. Phillips, *A Partisan View*, 67–68.

chapter 10

1. Monty Noam Penkower, *The Federal Writer's Project: A Study in Government Patronage of the Arts* (Urbana: University of Illinois Press, 1977), 234–37, notes that the Federal Writers' Program was officially disbanded in early 1943. However, personnel were terminated as of March 1942. Rosenberg states in a government document, "Part C: Qualifications Statement for Promotion And/Or Reassignment," that his position as assistant editor at the Writers' Program ended in March 1942, Harold Rosenberg Papers, Getty Research Institute.

2. Harold Rosenberg, "The Profession of Poetry, Or, Trails through the Night of M. Maritain," *Partisan Review* 9, no. 5 (September–October 1942): 392. Rosenberg also referred to poetry as a "profession" in an undated letter to Parker Tyler, Rosenberg Papers.

3. Rosenberg, "The Profession of Poetry," 413.

4. Harold Rosenberg to Harry Roskolenko, September 8, 1942, Harry Roskolenko Papers, Syracuse University Library.

5. William Carlos Williams, "Preface to a Book of Poems by Harold Rosenberg," in *Something to Say: William Carlos Williams*, ed. James E. B. Breslin (New York: New Directions, 1985), 128.

6. Williams, "Preface to a Book of Poems by Harold Rosenberg," in *Something to Say*, 128.

7. See Breslin, "Introduction," in Williams, *Something to Say*.

8. Rosenberg to Roskolenko, September 21, 1942, Roskolenko Papers.

9. Harry Roskolenko, "Harold Rosenberg: 1906–1978," *Art International* 22, nos. 5–6 (September 1979): 62.

10. Harry Roskolenko, "Five Conditions," *Voices: A Quarterly of Poetry* 114 (Summer 1943): 60.

11. Compare, for example, Rosenberg to Roskolenko, April 25, 1943, Roskolenko Papers, where Rosenberg encourages Roskolenko to solicit review copies of his book from *New Republic* and *The Nation*.

12. Harold Rosenberg to Philip Rahv, August 3, 1943, *Partisan Review* Papers, Howard Gotlieb Archival Research Center, Boston University.

13. Alan Swallow, "A Review of Some Current Poetry," *New Mexico Quarterly* 13, no. 2 (Summer 1943): 217.

14. H. R. Hays, "In the American Tradition," *Poetry: A Magazine of Verse* 62, no. 6 (September 1943): 342.

15. Hays, "In the American Tradition," 344.

16. Hays, "In the American Tradition," 344.

17. Rosenberg to Roskolenko, August 27, 1943, Roskolenko Papers.

18. Schwartz owed as much to Rimbaud and Baudelaire as he did to Eliot. His influences also incorporated Marx and Freud. In addition, his intensely autobiographical work drew on his Jewish upbringing, countering the more remote approach of Eliot on which Rosenberg focused his essay. For a discussion of Schwartz's poetic models, see James Atlas, *Delmore Schwartz: Life of an American Poet* (New York: Farrar, Straus, Giroux, 1977), 132–35.

19. Rosenberg, in Delmore Schwartz, *Portrait of Delmore Schwartz: Journals and Notes of Delmore Schwartz, 1939–1959*, ed. Elizabeth Pollet (New York: Farrar, Straus, Giroux, 1986), 202. I assume that his confession, if Schwartz has it right, refers to his verse. It appears in a section of his journal that deals with poetry. The admission, however, is out of character for Rosenberg. He rarely admitted his failings to anyone. In fact, his omission of William Carlos Williams's introduction to *Trance above the Streets* was not even revealed to Roskolenko, whom he trusted.

20. Schwartz, *Portrait of Delmore Schwartz*, 143. While Rosenberg refrained from delving into his own biography and Jewish upbringing in his poems, he occasionally alluded to figures such as Hitler. Compare a stanza such as this: "In this brightness, Jews / let me sing to you / that the brassy Herr is finished." Referenced in Hays, "In the American Tradition," 343.

21. Harold Rosenberg, in Raymond Rosenthal and Moisele Ducovny, Interview with Harold Rosenberg, 1960, 74, William E. Weiner Oral History Library of the American Jewish Committee.

22. On Rosenberg and his essays, or "critical moments," that address the representation of the Jew and issues relating to Jewish identity, see Mark Godfrey, "That Old-time Jewish Sect Called American Art Criticism," in *Action/Abstraction: Pollock, de Kooning, and American Art, 1940–1976*, exh. cat. (New York and New Haven: Jewish Museum and Yale University Press, 2008), 247–67. Godfrey overlooks Rosenberg's reluctance to address the award of the Bollingen Prize to Ezra Pound in 1948, which is key to understanding the complexity of his relationship to issues of anti-Semitism.

23. Harold Rosenberg, "Jewish Identity in a Free Society," *Commentary* 9, no. 6 (June 1950); reprinted in Harold Rosenberg, *Discovering the Present: Three Decades in Art, Culture, and Politics* (Chicago: University of Chicago Press, 1973), 259.

24. Harold Rosenberg, "The Herd of Independent Minds: Has the Avant-Garde Its Own Mass Culture?" *Commentary*, September 1948, 25.

25. Saul Bellow, "Harold Rosenberg," in *Abstract Expressionism: A Tribute to Harold*

Rosenberg: Paintings and Drawings from Chicago Collections, exh. cat. (Chicago: David & Alfred Smart Gallery, 1979), n.p.

26. Bellow, "A Comment on Form and Despair," *Location* 1 (Summer 1964): 11. On Bellow's stance on T. S. Eliot, see James Atlas, *Bellow: A Biography* (New York: Random House, 2000), 354.
27. Bellow, in Atlas, *Bellow*, 290.
28. Noted by Atlas, *Bellow*, 112, 353, 390.
29. Observed by Atlas, *Bellow*, 82.
30. Harold Rosenberg, "The Fall of Paris," *Partisan Review* 7, no. 6 (November–December 1940); reprinted in Harold Rosenberg, *The Tradition of the New* (New York: Da Capo, 1994), 210.
31. Saul Bellow, "How I Wrote Augie March's Story," *New York Times*, January 31, 1954.
32. Saul Bellow, "What Kind of Day Did You Have?" in *Him with His Foot in His Mouth and Other Stories* (Harmondsworth, UK: Penguin Books, 1984), 65. Rosenberg may also have informed the figure of Gumbein, the art critic, in Bellow's novel *Humboldt's Gift*.
33. Bellow, "What Kind of Day Did You Have?" in *Him with His Foot in His Mouth and Other Stories*, 64–65.
34. Observed by Atlas, *Bellow*, 142.
35. Saul Bellow, *Humboldt's Gift* (New York: Penguin Classics, 2008), 5.
36. Bellow, "What Kind of Day Did You Have?" in *Him with His Foot in His Mouth and Other Stories*, 71.
37. *The Bourgeois Poet* was published in 1964 but recaps an early identity.
38. Karl Shapiro's verse and life has inspired little in the way of interpretation or biography in the past few decades. For an overview of his career and work, see Joseph Reino, *Karl Shapiro* (Boston: Twayne Publishers, 1981).
39. Rosenberg to Roskolenko, August 22, 1942, Roskolenko Papers.
40. Karl Shapiro was born in Baltimore and subsequently educated at the University of Virginia. He thought of himself as a southerner. As a Jew, he felt ostracized as an undergraduate, both by the Anglo-Saxon and by the German-Jewish students who attended the university.
41. Rosenberg to Roskolenko, May 1, 1942, Roskolenko Papers.
42. Rosenberg to Roskolenko, August 27, 1943, Roskolenko Papers.
43. Rosenberg to Roskolenko, August 27, 1943, Roskolenko Papers.
44. Rosenberg to Roskolenko, June 1, 1942, Roskolenko Papers.
45. Rosenberg to Roskolenko, August 22, 1942, Roskolenko Papers.
46. Rosenberg to Roskolenko, August 22, 1942, Roskolenko Papers.
47. Karl Shapiro, in Rosenberg to Roskolenko, August 22, 1942, Roskolenko Papers. I assume that this conversation took place in New York. Rosenberg traveled to New York frequently from Cooperstown, as his correspondence with Roskolenko reveals.
48. Rosenberg to Roskolenko, August 22, 1942, Roskolenko Papers.
49. Rosenberg to Roskolenko, August 22, 1942, Roskolenko Papers.

50. Roskolenko, *When I Was Last on Cherry Street* (New York: Stein & Day, 1965), 206, 207. Roskolenko also wrote the occasional war poem, which linked him indirectly to Shapiro.
51. Patricia Clarke, *NLA [National Library of Australia] News* 14, no. 9 (June 2004): 4.
52. Harry Roskolenko, review, *Accent: A Quarterly of New Literature* 6, no. 2 (Winter 1946): 140. Reino, *Karl Shapiro*, 26, briefly touches on Roskolenko's analysis of Shapiro's work.
53. Williams, in Reino, *Karl Shapiro*, 26.
54. "The Politics of W. C. Williams: An Editorial Note," *Partisan Review* 10, no. 5 (September–October 1943): 469.
55. On Williams's encounters with *Partisan Review* in 1936, see Milton A. Cohen, "Stumbling into Crossfire: Williams Carlos Williams, *Partisan Review*, and the Left in the 1930s," *Journal of Modern Literature* 32, no 2 (Winter 2009): 146–51.
56. William Carlos Williams, *The Selected Letters of William Carlos Williams*, ed. John C. Thirwall (New York: New Directions, 1957), 157.
57. Parker Tyler to William Carlos Williams, December 20, 1943, Parker Tyler Papers, Harry Ransom Research Center, University of Texas at Austin.
58. Tyler to Williams, December 20, 1943, Tyler Papers.
59. Rosenberg, in Tyler to Williams, December 20, 1943, Tyler Papers.
60. I have not uncovered any documentation that suggests that Rosenberg revealed any disappointment about Williams's dismissal of his work. I am assuming that he concealed this rejection from even his closest friends, such as Parker Tyler and Harry Roskolenko.
61. William Carlos Williams, "The Poem as a Field of Action," in *Selected Essays of William Carlos Williams* (New York: Random House, 1954), 284.
62. For a discussion of the parallels between Rosenberg's idea of "*action* painting" and Charles Olson's "projective verse," see Matthew Rohn, "'Action Painting' and American Poetics," paper presented at College Art Association, 2000. I don't agree with Rohn's contention that William Carlos Williams "had thought longer about [formalist and socially prescribed readings of modern poetry] than Rosenberg" (8). Rosenberg had been thinking about these issues since the 1930s, when they first surfaced in American poetry.
63. Originally published in 1952, the essay was reprinted in Rosenberg, *The Tradition of the New*.
64. For a discussion of Williams' influence on Olson, see Michael Hrebeniak, *Action Writing: Jack Kerouac's Wild Form* (Carbondale: Southern Illinois University Press, 2006.)
65. Charles Olson, "Projective Verse," in *Collected Prose*, ed. Robert Creeley (New York: New Directions, 1950), 16. Also noted by Rohn, "'Action Painting' and American Poetics."
66. Rosenberg, "The American Action Painters"; reprinted in Rosenberg, *Tradition of the New*, 25.
67. Fielding Dawson, *The Black Mountain Book* (New York: Croton Press, 1970), 71–74,

notes that he read Melville's *The Confidence-Man* while at Black Mountain College, suggesting that it was part of the curriculum.

68. Dawson, in Michael Hrebeniak, *Action Writing: Jack Kerouac's Wild Form* (Carbondale: Southern Illinois University Press, 2006), 234. This citation does not appear, as Hrebeniak states, in Dawson, *The Black Mountain Book*, 47–48.

69. Dawson, *The Black Mountain Book*, 47–48.

70. Olson, "Projective Verse," in *Collected Prose*, ed. Creeley, 26.

71. Robert Creeley, in Kevin Power and Robert Creeley, "Robert Creeley on Art and Poetry: An Interview with Kevin Power," in *Robert Creeley's Life and Work: A Sense of Increment*, ed. John Wilson (Ann Arbor: University of Michigan Press, 1987), 352.

72. Robert Creely to Rosenberg, January 28, 1955, Rosenberg Papers.

73. Creeley to Rosenberg, April 18, 1955, Rosenberg Papers.

74. James Schuyler, "Poet and Painter Overture," in *The New American Poetry: 1945–1960*, ed. Donald M. Allen (New York: Grove Press, 1960), 418. Quoted in Bill Berkson, "Poet and Painter Coda," in *Franz Kline: Art and the Structure of Identity*, ed. Stephen C. Foster, exh. cat. (Barcelona; Fundacio Tapies, 1994), 141–53. Berkson (146) also makes the comparison between William Carlos Williams's "The Poem as a Field of Action" and Rosenberg's subsequent essay, "The American Action Painters," similarly noting that both figures were probably unaware of these parallels. However, I would argue that Olson and Creeley transmitted these ideas to Rosenberg, at least initially, through intermediaries, such as Willem de Kooning.

75. Schuyler, "Poet and Painter Overture," in *The New American Poetry: 1945–1960*, 418.

76. For a study of Frank O'Hara's interactions with the New York art world, see Russell Ferguson, *In Memory of My Feelings: Frank O'Hara and American Art*, exh. cat. (Los Angeles: Museum of Contemporary Art, 1999). Brad Gooch, *City Poet: The Life and Times of Frank O'Hara* (New York: Alfred A. Knopf, 1993), is the first biography of O'Hara to appear. However, he makes little of the poet's relationship to *ARTnews* and the Museum of Modern Art.

77. Frank O'Hara, *Jackson Pollock* (New York: George Braziller, 1959), 21.

78. Rosenberg, "The American Action Painters," in Rosenberg, *Tradition of the New*, 28.

79. Berkson was brought to *ARTnews* by Alfred Frankfurter, not Hess; he met Frankfurter through friends of his parents. Bill Berkson to the author, October 7, 2010.

80. Frank O'Hara, in Irving Sandler, "Sweeping Up after Frank," in *Homage to Frank O'Hara*, ed. Bill Berkson and Joe LeSueur (Bolinas, CA: Big Sky, 1988), 10.

81. Frank O'Hara, in Irving Sandler, *A Sweeper-Up after Artists: A Memoir* (New York: Thames & Hudson, 2003), 40.

82. Rosenberg, "The American Action Painters," in Rosenberg, *Tradition of the New*, 38.

83. Frank O'Hara, "Having a Coke with You," in *The Collected Poems of Frank O'Hara* (New York: Alfred A. Knopf, 1995).

84. O'Hara, in Sandler, *A Sweeper-Up after Artists*, 40.

85. Charles Baudelaire, in Harold Rosenberg, "Discovering the Present," *New Yorker* 43,

no. 5 (February 10, 1968); reprinted in Harold Rosenberg, *Artworks and Packages* (New York: Delta Books, 1969), 173.

86. Thomas B. Hess, "The Poet in the Studio," Rosenberg Papers.

87. Rosenberg, "Discovering the Present," in Rosenberg, *Artworks and Packages*, 173.

88. Rosenberg, "Discovering the Present," in Rosenberg, *Artworks and Packages*, 173.

89. Rosenberg, "Discovering the Present," in Rosenberg, *Artworks and Packages*, 173.

90. Charles Baudelaire, *Painter of Modern Life and Other Essays*, trans. and ed. Jonathan Mayne (London: Phaidon, 1964).

91. Guston, in Debra Bricker Balken, *Philip Guston's Poem-Pictures*, exh. cat. (Andover, MA, and Seattle: Addison Gallery of American Art and University of Washington Press, 1994), 37.

92. Marjorie Perloff, *Frank O'Hara: Poet among Painters* (Austin: University of Texas Press, 1977), 86, notes that Apollinaire was O'Hara's "life-long hero." She also notes (89) that when his *Art Chronicles* (columns for *ARTnews* and *Kulchur*) was published after his death, some reviewers, such as Amy Golden and Eleanor Dickinson, thought his work was too tied to Rosenberg. Frank O'Hara, *Art Chronicles, 1954– 1966* (New York: George Braziller, 1974).

93. See Balken, *Philip Guston's Poem-Pictures*.

chapter 11

1. According to Rosenberg's resume, or "Part C—Qualifications Statement for Promotion and/or Reassignment," he worked in the Overseas Branch of the OWI, located in New York, from November to December 1942, Harold Rosenberg Papers, Getty Research Institute.

2. Harold Rosenberg, in Paul Cummings, Interview with Harold Rosenberg, December 17, 1970, 46, Archives of American Art, Smithsonian Institution.

3. Rosenberg, in Cummings, Interview, December 17, 1970, 45. On Breton's job for the OWI and his broadcasts for Voice of America, see Mark Polizzotti, *Revolution of the Mind: The Life of André Breton,* 2d ed. (Boston: Black Widow Press, 2009), 249.

4. Rosenberg, in Cummings, Interview, December 17, 1970, 46.

5. Rosenberg, "OWI, Special Features," Rosenberg Papers. Rosenberg stated in his interview with Cummings that his first assignment was a radio spot on the state of Alabama. The presence of the typescript on Georgia for the OWI in his papers suggests that he confused one southern state for another.

6. Rosenberg, "OWI, Special Features," Rosenberg Papers.

7. Rosenberg, in Cummings, Interview, December 17, 1970, 52.

8. Rosenberg, in Cummings, Interview, December 17, 1970, 50.

9. Rosenberg, in Cummings, Interview, December 17, 1970, 52.

10. See Allan M. Winkler, *The Politics of Propaganda: The Office of War Information 1942–1945* (New Haven: Yale University Press, 1978), 42.

11. See Gert Horten, *Radio Goes to War: The Cultural Politics of Propaganda during World War II* (Berkeley: University of California Press, 2002), 41–54.

12. Rosenberg, June 15, 1943, Office of War Information, Domestic Radio Bureau, Special Assignments Division, Rosenberg Papers.

13. Rosenberg to George Ludlam, April 8, 1943, Rosenberg Papers.

14. Office of War Information, Washington, "COPY, Chief, Special Assignment Section," Rosenberg Papers.

15. OWI, "COPY, Chief, Special Assignment Section," Rosenberg Papers.

16. Observed by Horten, *Radio Goes to War,* 114.

17. Horten, *Radio Goes to War,* 143.

18. Rosenberg to Nat [Wolff], undated [December 1942], Rosenberg Papers.

19. Rosenberg to Nat [Wolff], undated [December 1942], Rosenberg Papers.

20. For a description of Rosenberg's new job at the Domestic Radio Bureau once it was relocated to New York, see "Harold Rosenberg, Principal Liaison Officer, Domestic Radio, OWI," n.d., Rosenberg Papers.

21. Rosenberg, in Cummings, Interview, December 17, 1970, 54.

22. Rosenberg, in Cummings, Interview, December 17, 1970, 54.

23. Rosenberg began contributing to *View* on an irregular basis as of the second issue, in October 1940. For a list of the contents of the periodical, see Judith Young Mallin, "Index to View, 1940–47," in Catrina Neiman and Paul Nathan, *View, Parade of the Avant-Garde: An Anthology of View Magazine 1940–1947* (New York: Thunder's Mouth Press, 1991), 271–82.

24. See Robert Griffith, "The Selling of America: The Advertising Council and American Politics, 1942–1960," *Business Historical Review* 57, no. 3 (Autumn 1983): 388–412; Robert Jackall and Janice M. Hirota, *Image Makers: Advertising, Public Relations and the Ethos of Advocacy* (Chicago: University of Chicago Press, 2000); Daniel L. Lykins, *From Total War to Total Diplomacy: The Advertising Council and the Construction of the Cold War Consensus* (Westport, CT: Praeger, 2003); and Wendy L. Wall, *Inventing the "American Way": The Politics of Consensus from the New Deal to the Civil Rights Movement* (New York: Oxford University Press, 2008), 172–200.

25. The Advertising Council in consultation with the US Information Service of the Department of State, "ADVERTISING—A NEW WEAPON in the world-wide FIGHT FOR FREEDOM," 1948, Rosenberg Papers.

26. Ad Council, "ADVERTISING—A NEW WEAPON in the world-wide FIGHT FOR FREEDOM," Rosenberg Papers.

27. See Lykins, *From Total War to Total Diplomacy,* 7.

28. Rosenberg, in Cummings, Interview, January 20, 1973, 148.

29. Ludlam, paraphrased in Cummings, Interview, January 20, 1973, 148.

30. Rosenberg, in Cummings, Interview, January 20, 1973, 148–49.

31. Rosenberg, in Cummings, Interview, January 20, 1973, 149.

32. See "Harold Rosenberg—Program Consultant (part-time)," n.d., Rosenberg Papers.

33. "Harold Rosenberg—Program Consultant (part-time)," Rosenberg Papers.

34. In the interests of constructing national unity, the history of segregation was barely acknowledged in the Freedom Train. See Wall, *Inventing the "American Way,"* 231–35.
35. I assume that Rosenberg worked on the Freedom Train radio fact sheets and kit, given that the American Heritage Foundation allied with the Advertising Council to advance its programs as of 1947. I am dealing here with anonymously written material, fragments of which survive at the council's archives at the University of Illinois, Urbana-Champaign, and in the papers of the American Heritage Foundation at the National Archives. Rosenberg retained little of this material, and few documents from his job at the Ad Council are to be found in his papers.
36. Rosenberg and Carol Biba, "The Inventors Club," 1947, Rosenberg Papers.
37. Rosenberg and Biba, "The Inventors Club," Rosenberg Papers.
38. Ad Council, "ADVERTISING—A NEW WEAPON in the world-wide FIGHT FOR FREEDOM," Rosenberg Papers.
39. See David Scott, "BBC Puts the Inventors Club on TV," *Popular Mechanics,* July 1955, 101–5.
40. Rosenberg and Biba, "The Inventors Club," Rosenberg Papers.
41. Rosenberg and Biba, "The Inventors Club," Rosenberg Papers.
42. Harold Rosenberg, "The Herd of Independent Minds: Has the Avant-Garde Its Own Mass Culture?" *Commentary,* September 1948; reprinted in Harold Rosenberg, *Discovering the Present: Three Decades in Art, Culture, and Politics* (Chicago: University of Chicago Press, 1973), 28.
43. Rosenberg, "The Herd of Independent Minds," in Rosenberg, *Discovering the Present,* 18.
44. Rosenberg, in Cummings, Interview, February 7, 1972, 152.
45. Sidney Hook, in Neil Jumonville, *Critical Crossings: The New York Intellectuals in Postwar America* (Berkeley: University of California Press, 1991), 140.
46. Hook, in Jumonville, *Critical Crossings,* 140.
47. Observed by Jumonville, *Critical Crossings,* 141.
48. Harold Rosenberg, "The Orgamerican Phantasy," *Prospectus* (November 1957) and *Les Temps modernes* 14 (October 1958); reprinted in Harold Rosenberg, *The Tradition of the New* (New York: Da Capo, 1994), 277.
49. See Frances Stonor Saunders, *The Cultural Cold War: The CIA and the World of Arts and Letters* (New York: New Press, 1999), 157–62.
50. Harold Rosenberg, "Death in the Wilderness," *Midstream* 3 (Summer 1957); reprinted in Rosenberg, *The Tradition of the New,* 242.
51. Harold Rosenberg, in Raymond Rosenthal and Moishe Ducovny, Interview with Harold Rosenberg, 1960, William E. Weiner Oral History Library of the American Jewish Committee, 4. In addition, Hook wrote a homage to Dewey in 1939. See Sidney Hook, *John Dewey: An Intellectual Portrait* (New York: John Day Co., 1939).
52. Noted in Saunders, 194. It is not clear that Rosenberg knew that Hook was an FBI informant, although Hook's increasingly conservative politics in the 1940s and 1950s were evident in his writing and political affiliations.

53. See Jumonville, *Critical Crossings*, 141.

54. These ideas were republished in Daniel Bell, *The End of Ideology: On the Exhaustion of Political Ideas in the Fifties* (Glencoe, IL: Free Press, 1960).

55. Rosenberg, "Death in the Wilderness," in Rosenberg, *The Tradition of the New*, 254.

56. Rosenberg, "Death in the Wilderness," in Rosenberg, *The Tradition of the New*, 254.

57. Harold Rosenberg, "The Orgamerican Phantasy," *Prospectus* 1 (November 1957); reprinted in *The Tradition of the New*, 271.

58. On Bell and his role in the neoconservative movement, see Justin Vaïsse, *Neoconservatism: The Biography of a Movement*, trans. Arthur Goldhammer (Cambridge, MA: Belknap Press of Harvard University Press, 2010).

59. Rosenberg, "Death in the Wilderness," in Rosenberg, *The Tradition of the New*, 249.

60. Rosenberg, "Death in the Wilderness," in Rosenberg, *The Tradition of the New*, 250.

61. Bell had little interest in Rosenberg's intellectual position, and passed him off as a poseur when it came to politics. See Jumonville, *Critical Crossings*, 140. Bell did, however, credit Rosenberg as being a "formidably accurate prophet" when it came to art. See Daniel Bell, *The Cultural Contradictions of Capitalism* (New York: Basic Books, 1976), 125. My email to Professor Bell to query him on Rosenberg's depiction of him in "Death in the Wilderness" went unanswered.

62. See Terry Cooney, *The Rise of the New York Intellectuals: Partisan Review and Its Circle, 1934–1945* (Madison: University of Wisconsin Press, 1986), 228; and Jumonville, *Critical Crossings*, 53.

63. Irving Howe, "This Age of Conformity," *Partisan Review* 21, no. 2 (January–February 1954): 13.

64. Irving Howe, *A Margin of Hope: An Intellectual Biography* (New York: Harcourt, Brace, 1982), 140–41.

65. "Forest Fire Prevention," in *Annual Report*, 1947–48, Ad Council Archives, University of Illinois, Champaign-Urbana.

chapter 12

1. May Natalie Tabak, "A Collage," 442, unpublished manuscript, n.d., Estate of May Natalie Tabak.

2. Tabak, "A Collage," 442.

3. May Natalie Tabak to Harold Rosenberg, undated letter, 1970s, Harold Rosenberg Papers, Getty Research Institute.

4. See Debra Bricker Balken, *Debating American Modernism: Stieglitz, Duchamp and the New York Avant-Garde*, exh. cat. (New York: American Federation of Arts and D.A.P., 2003).

5. Clement Greenberg, "America Takes the Lead, 1945–1965," in *Clement Greenberg: The Collected Essays and Criticism*, ed. John O'Brian, 4 vols. (Chicago: University of Chicago Press, 1986–93), 4:212–17.

6. Rosenberg is mentioned as the Washington correspondent of *View* in the November 1940 issue (3).

7. Charles Henri Ford in Catrina Neiman, "Introduction, *View* Magazine: Transatlantic Pact," in Neiman and Paul Nathan, comps., *View, Parade of the Avant-Garde: An Anthology of View Magazine 1940–1947* (New York: Thunder's Mouth Press, 1991), xi.

8. Harold Rosenberg, "Breton: A Dialogue," *View* 2 (May 1942): 18.

9. André Breton and Diego Rivera, "Manifesto of an Independent Revolutionary Art," *Partisan Review* 6, no. 4 (Fall 1938): 49–53. The title was modified, and Rivera sat in as Trotsky, such was the need to disguise the latter's identity within Mexico as Stalin actively worked toward his assassination in 1940.

10. Rosenberg's "Dialogue" appeared in the same issue as Lionel Abel's translation of Breton's "What Tanguy Veils and Reveals," *View* 2 (May 1942): 4–7. Whatever the juxtaposition, it seems more likely that he was directly replying to Breton's notion of myth as it was reconstituted in the "Prolegomena to a Third Manifesto of Surrealism or Else," trans. Lionel Abel, *VVV* 1 (June 1942); reprinted in André Breton, *Manifestos of Surrealism*, trans. Richard Seaver and Helen R. Lane (Ann Arbor, MI: Ann Arbor Paperbooks, 1972), 279–94. In addition, Breton had earlier published "The Legendary Life of Max Ernst, preceded by a brief discussion on the need for a new myth," *View* 2 (April 1942); translated by Abel and reprinted in Neiman and Nathan, comps., *View, Parade of the Avant-Garde*, 33–37.

11. Rosenberg, "Breton: A Dialogue."

12. Rosenberg, "Breton: A Dialogue."

13. Breton, "Prolegomena," in Breton, *Manifestos of Surrealism*, 292.

14. For a discussion of this history, and Ford and Breton's complex relationship, see Neiman, "Introduction," in Neiman and Nathan, comps., *View, Parade of the Avant-Garde*, xv–xvi; Dickran Tashjian, *A Boatload of Madmen: Surrealism and the American Avant-Garde, 1920–1950* (New York: Thames & Hudson, 1995), 188–94; and Mark Polizzotti, *Revolution of the Mind: The Life of André Breton* (Boston: Black Widow Press, 2009), 453. Martica Sawin, *Surrealism in Exile, and the Beginnings of the New York School* (Cambridge, MA: MIT Press, 1995), 151–52, also looks at the founding of *View*.

15. Harold Rosenberg, "Life and Death of the Amorous Umbrella," *VVV* 1 (June 1942): 13.

16. Comte de Lautréamont, in Polizzotti, *Revolution of the Mind*, 66–67.

17. Breton, in Lionel Abel, *The Intellectual Follies: A Memoir of the Literary Venture in New York and Paris* (New York: W. W. Norton, 1984), 105.

18. Rosenberg, "Notes and Acknowledgments," in Harold Rosenberg, *Act and the Actor: Making the Self* (New York: World Publishing, 1970), 206.

19. Breton, "Prolegomena," in Breton, *Manifestos of Surrealism*, 282, does not mention Dalí by name, just like his veiled treatment of Trotsky. Rather, he refers to Dalí as "Avida Dollars."

20. Claude Lévi-Strauss, "Indian Cosmetics," trans. Patricia Blanc, *VVV* (June 1942): 33–37.

21. Charles Henri Ford, "The Poetry Flier," 1940; in Tashjian, *A Boatload of Madmen*, 177.

22. See Neiman, "Introduction," in Neiman and Nathan, comps., *View, Parade of the Avant-Garde*, xiv; and Tashjian, *A Boatload of Madmen*, 188–91.

23. Tashjian, *A Boatload of Madmen*, 188.

24. Charles Henri Ford, in Neiman, "Introduction," in Neiman and Nathan, comps., *View, Parade of the Avant-Garde*, xiv.

25. Ford, in Neiman, "Introduction," in Neiman and Nathan, comps., *View, Parade of the Avant-Garde*.

26. Nicolas Calas, "Anti-Surrealist Dalí, I say his flies are ersatz," *View* 6 (June 1941); reprinted in Neiman and Nathan, comps., *View, Parade of the Avant-Garde*, 15.

27. Parker Tyler to Charles Henri Ford, July 1, 1944, Parker Tyler Papers, Harry Ransom Research Center, University of Texas at Austin.

28. Phillips, in Tyler to Ford, July 1, 1944, Tyler Papers.

29. Tyler to Ford, July 1, 1944, Tyler Papers.

30. Clement Greenberg, "The Renaissance of the Little Mag: Review of *Accent, Diogenes, Experimental Review, Vice Versa* and *View*"; reprinted in *Clement Greenberg: The Collected Essays and Criticism*, 1:43.

31. Weldon Kees, in James Reidel, *Vanished Act: The Life and Art of Weldon Kees* (Lincoln: University of Nebraska Press, 2003), 79. The subject of Kees's sexuality has been questioned by Reidel, 118–19, 133, 245.

32. Noted by John O'Brian, in Greenberg, *Clement Greenberg: The Collected Essays and Criticism*, 1:43. Sawin, *Surrealism in Exile*, 152, claims that Calas's "first appearance in [*View*] . . . was in the form of a letter in which he threw down the gauntlet to *Partisan Review* and its art critic, Clement Greenberg." Calas appeared in the first issue of *View* with a piece titled "Mexico Brings Us Art"; see Mallin, "Index to View, 1940–47," in Neiman and Nathan, *View, Parade of the Avant-Garde*, 271. Calas was responding here to Greenberg's "Towards A Newer Laocoön," where Greenberg writes that Surrealism had, by 1939, "reacted against abstract purity and turned back to a confusion of literature with painting as extreme as any of the past" (reprinted in *Clement Greenberg: The Collected Essays and Criticism*, 1:36).

33. Harold Rosenberg, "Notes on Identity: With Special Reference to the Mixed Philosopher, Soren Kierkegaard," *View* 6, no. 3 (May 1946): 8.

34. Observed by Sawin, *Surrealism in Exile*, 152.

35. See "*Memorandum*, From the Advancement of Psychiatry to the Advertising Council," January 28, 1949, Rosenberg Papers. This is one of the few documents that survive in Rosenberg's papers from his tenure at the Ad Council, reinforcing the impression that it had some significance to his ideas on psychoanalysis and its relationship to identity.

36. Rosenberg, "Notes on Identity" (1946), 8.

37. Harold Rosenberg, "Notes on Identity," *Tulane Drama Review* 4, no. 2 (December 1959): 30. This essay is a reworking of "Notes on Identity: With Special Reference to the Mixed Philosopher, Soren Kierkegaard."

38. Rosenberg, "Notes on Identity" (1959).

39. Harold Rosenberg, *Arshile Gorky: The Man, the Time, the Idea* (New York: Sheepmeadow Press, 1962), 98.

40. Jean-Paul Sartre, "The Nationalization of Literature," *Les Temps modernes*, November 1, 1945; trans. Lincoln Kirsten and S. P. Bovie, and reprinted in *View* 2–3 (March–April 1946) and in Neiman and Nathan, *View, Parade of the Avant-Garde*, 201–9. For a discussion of this article, see Michael Kelly, "The Nationalization of the French Intellectuals in 1945," *South Central Review* 17, no. 4 (Winter 2000): 14–25.

41. William Barrett, *What Is Existentialism?* (New York: Anchor Books, 1982).

42. "Europe: Existentialism," *Time*, January 28, 1946.

43. Parker Tyler to Charles Henri Ford, after July 28, 1945, Tyler Papers.

44. See Parker Tyler to Charles Henri Ford, July 30, 1945, Tyler Papers. Tyler was responsible for making Rosenberg a contributing editor in fall of 1946. But this appointment was short-lived. Moreover, Tyler does not appear on the masthead as an assistant editor of *View* until April 1943. By March 1944, he was made an associate editor.

45. John Bernard Myers, *Tracking the Marvelous: A Life in the Art World* (New York: Random House, 1983), 60.

46. See Polizzotti, *Revolution of the Mind*, 274.

47. Sartre, in Polizzotti, *Revolution of the Mind*, 485.

48. Harold Rosenberg, in Paul Cummings, Interview with Harold Rosenberg, January 20, 1973, 1, Archives of American Art, Smithsonian Institution.

49. Abel, *The Intellectual Follies*, 108.

50. Rosenberg, in Cummings, Interview, January 7, 1973, 58.

51. Rosenberg, in Cummings, Interview, January 7, 1973, 58.

52. For a history of artists' settlements in the Hamptons, see Helen Harrison and Constance Ayers Denne, *Hamptons Bohemia: Two Centuries of Artists and Writers on the Beach* (San Francisco: Chronicle Books, 2002).

53. Michele Solomon Young, email to the author, July 29, 2017.

54. Mark Rothko to Barnett Newman, August 10, 1946, Barnett Newman Papers, Archives of American Art.

55. Joseph Liss, Interview with Dore Ashton, August 10, 1982, Dore Ashton Papers, Archives of American Art.

56. Rosenberg, in James E. B. Breslin, *Mark Rothko: A Biography* (Chicago: University of Chicago Press, 1993), 24.

57. Neiman speculates in her annotations to Parker Tyler's papers that this novel may have been *The Clairvoyante and the Crime* (1949). See her annotations to Parker Tyler's papers for October 1949, Catrina Neiman Papers, Private Collection.

58. Parker Tyler to Charles Henri Ford, pre-Thanksgiving, 1949, Tyler Papers.

59. Lionel Abel, "New York City, A Remembrance," *Dissent* 8, no. 3 (Summer 1961): 251–59, at 258.

60. Lionel Abel to Parker Tyler, c. July 7, 1951, Tyler Papers.

61. Ralph Manheim, "The Perspectors," 1948, 1–15, Dwight Macdonald Papers, Yale University Library.

62. Manheim, "The Perspectors," 6, Macdonald Papers.

63. Manheim, "The Perspectors," 11, Macdonald Papers.

64. Manheim, "The Perspectors," 7, Macdonald Papers.

65. Ralph Manheim to Dwight Macdonald, May 14, 1948, Macdonald Papers.

66. Ralph Manheim to Dwight Macdonald, April 23, 1948, Macdonald Papers.

67. Manheim to Macdonald, April 23, 1948, Macdonald Papers.

68. Manheim, "The Perspectors," 7, Macdonald Papers.

69. Manheim to Macdonald, April 23, 1948, Macdonald Papers.

70. Ralph Manheim to Dwight Macdonald, June 9, 1948, Macdonald Papers.

71. May Natalie Tabak to Harold Rosenberg, undated letter, c. 1951, Rosenberg Papers.

72. Dwight Macdonald to Ralph Manheim, August 17, 1948, Macdonald Papers.

73. Macdonald to Manheim, August 17, 1948, Macdonald Papers.

74. Macdonald, "The Bomb," *Politics*, September 1945, 258.

75. Macdonald, in Michael Wreszin, *A Rebel in Defense of Tradition: The Life and Politics of Dwight Macdonald* (New York: Basic Books, 1994), 321.

76. Rosenberg, paraphrased in Abel, *The Intellectual Follies*, 202.

77. Harold Rosenberg, "The Fall of Paris," *Partisan Review* 7, no. 5 (November–December 1940); reprinted in Harold Rosenberg, *The Tradition of the New* (New York: Da Capo, 1994), 220.

78. See Wreszin, *A Rebel in Defense of Tradition*, 346–50.

79. Henri de Kerillis, *I Accuse de Gaulle*, trans. Harold Rosenberg (New York: Harcourt, Brace, 1946).

80. See C. A. Micaud, Review of Henri de Kerillis, *I Accuse de Gaulle*, in *Annals of the American Academy of Political and Social Science* 247 (September 1946): 194–95.

81. See Rosenberg, in Cummings, Interview, January 7, 1973, 58. Rosenberg, of course, could not have been drawn to de Kerillis's conservative politics. It was de Kerillis's opposition to the Communist Party and its fascist incarnations that linked their political views.

82. Harold Rosenberg, "The Resurrected Romans," *Kenyon Review* 10, no. 4 (Autumn 1948); reprinted in Rosenberg, *The Tradition of the New*, 175.

83. Franklin Delano Roosevelt, in Rosenberg, "The Resurrected Romans," in Rosenberg, *The Tradition of the New*, 177.

chapter 13

1. Harold Rosenberg recalls in Cummings, Interview with Harold Rosenberg, January 7, 1973, 63, Archives of American Art, Smithsonian Institution, meeting Motherwell

"when we first came out to East Hampton," which was in 1943. Motherwell took up part-time residence in Amagansett the next year, later relocating to East Hampton. See Motherwell, *The Collected Writings of Robert Motherwell*, ed. Stephanie Terenzio (Berkeley: University of California Press, 1999), xxv. Both May Natalie Tabak and Motherwell have stated that Rosenberg and Motherwell met in 1939, when Motherwell returned from a trip to France. See Ann Eden Gibson, *Issues in Abstract Expressionism: The Artist-Run Periodicals* (Ann Arbor, MI: UMI Research Press, 1990), 33. By contrast, Terenzio sets Motherwell's return from Europe as 1940. While they could have met on one of Rosenberg's weekend trips to New York from Washington, DC, a reference to an encounter has not surfaced. For a recent discussion of Motherwell's time in the Hamptons, see Phyllis Tuchman, *Robert Motherwell: The East Hampton Years, 1944–1952*, exh. cat. (East Hampton, NY: Guild Hall, 2014).

2. Robert Motherwell, in Paul Cummings, Interview with Robert Motherwell, November 24, 1971, Archives of American Art, Smithsonian Institution.
3. Motherwell, in Cummings, Interview with Motherwell, November 24, 1971.
4. In an undated letter from Harold Rosenberg to Robert Motherwell, Rosenberg wrote to suggest *Transformations* as a title for the publication as it incorporated "the painting you go for, and the literature we've been talking about . . . And it stands for the transforming activities of modern painters and poetry which we can mention in a short programmatic note." Robert Motherwell Papers, Dedalus Foundation.
5. Robert Motherwell and Harold Rosenberg, "Editorial Statement," *possibilities* 1 (1947): 1.
6. See Motherwell, *The Collected Writings of Robert Motherwell*, ed. Terenzio, 45, for a discussion of the drafts that Motherwell wrote for the editorial statement for *possibilities* that were abandoned.
7. Robert Motherwell, "The Modern Painter's World," in *The Collected Writings of Robert Motherwell*, ed. Terenzio, 34.
8. Harold Rosenberg, "Introduction to Six American Artists," in *Six American Artists*, exh. brochure (Paris: Galerie Maeght, 1947).
9. Rosenberg, "Introduction to Six American Artists."
10. Williams Baziotes, "I Cannot Evolve Any Concrete Theory," *possibilities* 1 (1947): 2.
11. Harold Rosenberg, "The Shapes in Baziotes' Canvas," *possibilities* 1 (1947): 2.
12. Rosenberg to Motherwell, February 10, 1947, Motherwell Papers.
13. Harold Rosenberg's library was dispersed in 1998, at the time of the sale of his papers to the Getty Research Institute. Glen Horowitz, the broker for this sale, gave the majority of the books to the Ridgefield County Library in Colorado. My repeated requests to Mr. Horowitz for a copy of the inventory for the sale went unanswered. A letter to the library has similarly not been answered. The more valuable books in Rosenberg's collection were sold by Horowitz with a small sales catalogue titled *Books from the Rosenberg Library* (New York: Glen Horowitz Bookseller, Inc., 1998). No listing exists of Paul Valéry's *Monsieur Teste* in this volume or of any other book by Valéry. Rosenberg compiled a list of the favorite books he had read up until 1946,

which is held in his papers at the Getty. Two volumes by Valéry, *Variety 11* and *Poetic Sympathic* appear on the list, works that predate the English translation of *Monsieur Teste*.

14. Paul Valéry, *Monsieur Teste*, trans. Jackson Mathews (Princeton, NJ: Princeton University Press, 1973), 6.

15. Harold Rosenberg, "The Stages: Geography of Action," *possibilities* 1 (1947): 48. When this essay was reprinted in his *Act and the Actor: Making the Self* (New York: World Publishing, 1970), this sentence, along with others, was rephrased, with the result that the word "possible" no longer appears in the edited text.

16. George Cotkin, *Existential America* (Baltimore: Johns Hopkins University Press, 2003), 112, has observed that Jean-Paul Sartre met few American intellectuals on his first trip to America, in 1945, which was organized by the Office of War Information to bring a group of French journalists to America. Rosenberg worked for the OWI until 1944; it was unlikely that he met Sartre then. It is more likely their introduction occurred in 1946 when Sartre did interact with New York's community of writers. Ronald Aronson, *Camus and Sartre: The Story of a Friendship and the Quarrel That Ended It* (Chicago: University of Chicago Press, 2003), 55, notes that Sartre lectured in New York on his 1945 trip. Given the focus of his book, he does not elaborate on Sartre's access to American writers.

17. Rosenberg, "The Stages," 95.

18. Robert Motherwell, in Max Kozloff, "An Interview with Robert Motherwell," *Artforum* 4, no. 1 (September 1965): 37.

19. Richard Huelsenbeck, "En Avant Dada," *possibilities* 1 (1947): 42.

20. See George Wittenborn Papers, Museum of Modern Art. The correspondence suggests that the second issue of *possibilities* was to appear in 1949 and include pieces by Paul Goodman, Louis Zukofsky, and others. The project was to have been administered by George Wittenborn and others. See George Wittenborn to Harold Rosenberg, June 6, 1949, Wittenborn Papers.

21. Robert Motherwell to John Cage, Pierre Chareau, and Harold Rosenberg, January 29, 1948, Harold Rosenberg Papers, Getty Research Institute.

22. Motherwell, in Cummings, Interview with Motherwell, November 24, 1971.

23. Rosenberg, in Cummings, Interview, January 7, 1973, 63.

24. Lionel Abel, *The Intellectual Follies: A Memoir of the Literary Venture in New York and Paris* (New York: W. W. Norton, 1984), 89. Robert Motherwell refuted this story in a letter to Abel, August 12, 1982, Robert Motherwell Papers, writing, "What Rosenberg told you about me and psychoanalysis is simply false. I am astonished that anyone who knows Harold's egotism and bully qualities would take him at his word about such a thing. The facts here are that Wittenborn & Schultz, who published *possibilities*, detested Harold, whom I had appointed as literary editor and that my analysis had to do entirely with my sentimental life, not my professional life, with which I have had no neurotic problems." Abel stuck by Rosenberg's account, however, in his memoir. Whatever animosity Wittenborn and Schultz had toward

Rosenberg did not prevent them from publishing his preface to "From Baudelaire to Surrealism" in 1949.

25. Abel, *The Intellectual Follies: A Memoir of the Literary Venture in New York and Paris*.
26. Motherwell, in Gibson, *Issues in Abstract Expressionism*, 35.
27. Robert Motherwell to Joseph Cornell, March 4, 1948, Joseph Cornell Papers, Archives of American Art.
28. Motherwell, in Cummings, Interview with Robert Motherwell, November 24, 1971.
29. Motherwell, in Cummings, Interview with Robert Motherwell, November 24, 1971.
30. Motherwell dedicated a collage to Rosenberg in early 1948, titled *The Best Toys Are Paper (For Harold Rosenberg)*. The work was produced a few months before *Elegy*, and the title was derived from a poem by Rosenberg. The dedication to Rosenberg was dropped when it was first exhibited at the Samuel Kootz gallery in 1948. A letter from Robert Motherwell to Dorothy Miller, written in 1948, in the Robert Motherwell Papers, reveals that Motherwell wanted the acknowledgment noted. I am grateful to Tim Clifford, former senior researcher of the Robert Motherwell Catalogue Raisonné project, for bringing to my attention both the collage and Motherwell's letter to Miller.
31. Harold Rosenberg, "Art and Identity: The Unfinished Masterpiece," *New Yorker*, January 5, 1963; reprinted as "Arshile Gorky, Art and Identity," in Harold Rosenberg, *The Anxious Object* (Chicago: University of Chicago Press, 1966), 101.
32. Robert Motherwell to Harold Rosenberg, August 27, 1953, Rosenberg Papers.
33. Motherwell to Rosenberg, August 1953, Rosenberg. Papers. Motherwell gave Rosenberg and Tabak gifts on numerous occasions. See *The Harold and May Rosenberg Collection*, exh. cat. (Montclair, NJ: Montclair Art Museum, 1973), n.p. The Dedalus Foundation holds a letter from Rosenberg to Motherwell in which he notes that he took a drawing by Motherwell from the Samuel Kootz Gallery as payment for the foreword that he wrote for the *Six American Artists* exhibition that Kootz assembled at the Galerie Maeght, Paris, in 1947. Tim Clifford, email to the author, April 24, 2006, states that he "believes that this may have been *The Table* although it is not entirely clear until we see it in color and right now we don't know where this work is." (*The Table* is inscribed to May.) Motherwell wanted to trade *Portrait of Maria* (1948), which he had given to Rosenberg, stating, "I should like to trade you one of the black-and-white striped series of about the same size for the big oil you have of mine of a woman . . . I never liked the woman much anyhow, and perhaps you don't either, in which case I would like to retire it." Maria was Motherwell's first wife. Perhaps the trade that Motherwell had in mind was *Spanish Elegy: Malaga*, listed in the Montclair brochure but whose whereabouts is currently unknown.
34. Robert Motherwell invoked Rosenberg's essay, "The Herd of Independent Minds," in "A Personal Expression," noting "most 'intellectuals' I have seen were quite properly labeled by a friend of mine, Harold Rosenberg, the poet, as 'a herd of independent minds.'" See Motherwell, *Collected Writings of Robert Motherwell*, ed. Terenzio,

58. The phrase is one that Motherwell would cite in later lectures. See *Collected Writings of Robert Motherwell*, ed. Terenzio, 261–62.

35. Harold Rosenberg, "French Silence and American Poetry"; reprinted in Harold Rosenberg, *The Tradition of the New* (New York: Da Capo Press, 1994), 88.

36. Robert Motherwell mentions his admiration for Alfred Barr and Meyer Schapiro in *Collected Writings of Robert Motherwell*, ed. Terenzio, 60, and for Clement Greenberg in Kozloff, "An Interview with Robert Motherwell," 37.

37. Samuel Kootz, statement in *The Intrasubjectives*, exh. brochure (New York: Samuel Kootz Gallery, 1948), n.p.

38. Rosenberg, in Cummings, Interview, April 7, 1972, 165.

39. Robert Motherwell, "Reflections of Painting Now," in *The Collected Writings of Robert Motherwell*, ed. Terenzio, 68.

40. Motherwell, "Reflections of Painting Now," in *The Collected Writings of Robert Motherwell*, ed. Terenzio, 67.

41. Robert Motherwell, "The New York School," in *The Collected Writings of Robert Motherwell*, ed. Terenzio, 76–81.

42. Motherwell borrowed more than the word "acts" from Rosenberg in "Reflections on Painting Now." The use of the word of "herd" in the same sentence is lifted from "The Herd of Independent Minds."

43. "Artists' Sessions at Studio 35 (1950)," in Robert Motherwell and Ad Reinhardt, *Modern Artists in America* (New York: Wittenborn & Schultz, 1951), 9–22.

44. Barnett Newman, in "Artists' Sessions at Studio 35," 10.

45. David Hare, in "Artists' Sessions at Studio 35," 10.

46. Ad Reinhardt, in "Artists' Sessions at Studio 35," 10.

47. Alfred Barr, in "Artists' Sessions at Studio 35," 17.

48. Barr, in "Artists' Sessions at Studio 35," 21.

49. David Smith, in "Artists' Sessions at Studio 35," 21.

50. Willem de Kooning, in "Artists' Sessions at Studio 35," 22.

51. Harold Rosenberg, "Tenth Street: A Geography of Modern Art," *Art News Annual* 38 (1959); reprinted in Harold Rosenberg, *Discovering the Present: Three Decades in Art, Culture, and Politics* (Chicago: University of Chicago Press, 1973), 100–109.

52. Herbert Ferber, in "Artists' Sessions at Studio 35," 10.

53. Robert Motherwell, "The School of New York," in *The Collected Writings of Robert Motherwell*, ed. Terenzio, 76–81.

54. Motherwell, "The School of New York," in *The Collected Writings of Robert Motherwell*, ed. Terenzio, 76–77.

55. Motherwell was responding to negative assessments concerning the reception of the work of the artists associated with his tag, "New York School," in newspapers such as the *Richmond Times-Dispatch*. exhibitions such *American Painting 1950*, organized by James Johnson Sweeney, which traveled to the J. B. Speed Museum in Louisville, Kentucky. Motherwell, "The School of New York," in *The Collected Writings of Robert Motherwell*, ed. Terenzio, 77.

56. Motherwell, "The School of New York," in *The Collected Writings of Robert Mother-well*, ed. Terenzio, 77.

57. Robert Motherwell, "Preface ["The School of New York"], to *Seventeen Modern American Painters*," in *The Collected Writings of Robert Motherwell*, ed. Terenzio, 83.

58. See John O'Neill, ed., *Clyfford Still*, exh. cat. (New York: Metropolitan Museum of Art, 1979), 191–92. Still was under the misperception that Robert Motherwell had organized the show for Frank Perls (his step-sister's husband); hence, his claim that Motherwell was unsuited to act as a spokesman for the group. Rothko and Tomlin are also alleged to have co-authored this letter. The Frank Perls Gallery Papers at the Archives of American Art, however, does not have a copy of this letter, nor does the Dedalus Foundation (which holds the Robert Motherwell Papers).

59. Motherwell, "Preface," in *The Collected Writings of Robert Motherwell*, ed. Terenzio, 82.

chapter 14

1. Simone de Beauvoir, *Letters to Sartre*, trans. and ed. Quintin Hoare (London: Radius, 1991), 422.

2. De Beauvoir, *Letters to Sartre*, 422.

3. Simone de Beauvoir, *America Day by Day*, trans. Carol Cosman (Berkeley: University of California Press, 1999), 345. This quote appears to reconstruct Rosenberg's observation.

4. Maurice Merleau-Ponty, "Le yogi et le prolétaire," *Les Temps modernes* 16 (January 1947): 676–711; trans. John O'Neill and reprinted in Merleau-Ponty, *Humanism and Terror* (Boston: Beacon Press, 1969), 149–77.

5. Merleau-Ponty, *Humanism and Terror*, 150.

6. Merleau-Ponty, *Humanism and Terror*, 150.

7. De Beauvoir, *Letters to Sartre*, 422.

8. Simone de Beauvoir, "Pyrrhus and Cynèas," *Partisan Review* 13, no. 3 (Summer 1946): 334.

9. De Beauvoir, "Pyrrhus and Cynèas," 337.

10. Jean-Paul Sartre, *Being and Nothingness*, trans. Hazel E. Barnes (New York: Washington Square Press, 1984), 559.

11. Harold Rosenberg, "The Stages: Geography of Action," *possibilities* 1 (1947): 47; reprinted in Harold Rosenberg, *Act and the Actor: Making the Self* (New York: World Publishing, 1970).

12. From the entries in *America Day by Day*, it seems that Rosenberg and de Beauvoir met at least twice while she was in New York in 1947.

13. Harold Rosenberg, "The Messenger," *Instead* 7 (1948): n.p.

14. De Beauvoir, *Letters to Sartre*, 456.

15. De Beauvoir, *Letters to Sartre*, 422.

16. Clement Greenberg, "L'Art américain au XXe siècle," *Les Temps modernes* 11–12

(August–September 1946): 340–52. Greenberg noted in 1961, with some pride, that he had been published in *Les Temps modernes* in 1946. Greenberg, "A Critical Exchange with Thomas B. Hess about *Art and Culture*," *New York Times Book Review*, July 9, 1961; reprinted in *Clement Greenberg: The Collected Essays and Criticism*, ed. John O'Brian, 4 vols. (Chicago: University of Chicago Press, 1986–93), 4:116. The essay from *Les Temps* does not appear in vol. 2 of *The Collected Essays and Criticism*.

17. I assume that de Beauvoir took the lead in reprinting Rosenberg's essay in *Les Temps modernes* given their interactions in New York. No letters have surfaced between Rosenberg and Sartre. That de Beauvoir wrote home to Sartre discussing Rosenberg with no assumption that he knew him suggests that she had some primary hand in engineering this situation.

18. Jean-Paul Sartre, "Dirty Hands," in *No Exit and Three Other Plays* (New York: Vintage International, 1989), 125–41.

19. Lionel Abel, *The Intellectual Follies: A Memoir of the Literary Venture in New York and Paris* (New York: W. W. Norton, 1984), 122–23.

20. See Rosenberg's statement in Paul Cummings, Interview with Harold Rosenberg, April 7, 1972, 117, Archives of American Art, Smithsonian Institution; and Rosenberg, *Act and the Actor*, 128.

21. Harold Rosenberg, "The Resurrected Romans," *Kenyon Review*, 10, no. 4 (Autumn 1948); reprinted in Harold Rosenberg, *The Tradition of the New* (New York: Da Capo, 1994), 175.

22. Rosenberg, "The Resurrected Romans," in Rosenberg, *The Tradition of the New*, 173.

23. Rosenberg, in Cummings, Interview, January 7, 1973, 2.

24. Harold Rosenberg to Maurice Merleau-Ponty, August 31, 1949, Harold Rosenberg Papers, Getty Research Institute.

25. Harold Rosenberg to Simone de Beauvoir, March 25, 1952, Rosenberg Papers.

26. Rosenberg, in Cummings, Interview, December 10, 1970, 67.

27. Irving Sandler, *A Sweeper-Up after Artists: A Memoir* (New York: Thames & Hudson, 2003), 26, notes that Robert Motherwell organized the first four lectures in the Friday-evening lecture program at the School of the Subjects of the Artists. Newman thereafter assumed responsibility for the series.

28. Sandler, *A Sweeper-Up after Artists*, 27, notes that Rosenberg titled his talk "The Furies." Rosenberg, in Cummings, Interview, January 7, 1973, 72, states that his notes for the talk are missing. No manuscript with the title of "The Furies" exists in the Rosenberg Papers.

29. There is a typescript titled "William [*sic*] de Kooning: A Desperate View" in the Rosenberg Papers at the Getty Research Institute, attributed to Rosenberg. The writing is clearly Willem de Kooning's and not his. However, the existence of this typescript is suggestive. The misspelling of de Kooning's first name seems to suggest that Rosenberg retyped the manuscript, as it differs from the manner in which the original transcript is typed and there are subtle word and syntax changes to the

text. See Willem de Kooning, "A Desperate View," Barnett Newman Papers, Barnett Newman Foundation. It might also suggest that Rosenberg assisted de Kooning in his talk. Mark Stevens and Annalyn Swan, *De Kooning: An American Master* (New York: Alfred A. Knopf, 2004), 279, note that Elaine de Kooning "urged de Kooning to frame a public talk, to step onto the soapbox, and declare his principles." Thomas Hess and Rosenberg probably did the same. Because de Kooning's English was imperfect, Elaine worked with him for several days, "copying down his observations." Perhaps Rosenberg also had a hand in the process. Rosenberg quoted from de Kooning's text at length in *De Kooning* (New York: Harry N. Abrams, 1973).

30. De Kooning, "A Desperate View." Sandler, *A Sweeper-Up after Artists,* 27, claims that Robert Motherwell delivered de Kooning's lecture.
31. De Kooning, "A Desperate View."
32. De Kooning, "A Desperate View." De Kooning was clearly referencing Kierkegaard's *Fear and Trembling* here.
33. Stevens and Swan, *De Kooning: An American Master,* 223.
34. Hannah Arendt, "What Is Existenz Philosophy?" *Partisan Review* 13, no. 1 (Winter 1946): 43.
35. William Barrett, *What Is Existentialism?* (New York: Grove Press, 1964), 19.
36. On the popularization of Freudian ideas in America from the mid-1910s through the 1920s, and their impact on contemporary artists and writers, see Debra Bricker Balken, *Debating American Modernism: Stieglitz, Duchamp and the New York Avant-Garde,* exh. cat. (New York: American Federation of Arts and D.A.P., 2003).
37. Clement Greenberg, "Jean Dubuffet and French Existentialism," in *Clement Greenberg: The Collected Essays and Criticism,* 2:92.
38. George Cotkin, *Existential America* (Baltimore: Johns Hopkins University Press, 2003), 123–24.
39. William Barrett, *The Truants: Adventures among the Intellectuals* (New York: Anchor Press/Doubleday, 1982), 133.
40. Jack Tworkov, Interview with Irving Sandler, August 11, 1957, Jack Tworkov Papers, Estate of Jack Tworkov.
41. This observation has been made by Daniel Belgrad, *The Culture of Spontaneity: Improvisation and the Arts in Postwar America* (Chicago: University of Chicago Press, 1998), 104.
42. Rosenberg to de Beauvoir, March 25, 1952, Rosenberg Papers.
43. Clement Greenberg, "Review of an Exhibition of Willem de Kooning," in *Clement Greenberg: The Collected Essay and Criticism,* 2:228.
44. Clement Greenberg, "Foreword to an Exhibition of Willem de Kooning," in *Clement Greenberg: The Collected Essays and Criticism,* 3:121.
45. Barnett Newman, "Response to Greenberg," in *Barnett Newman: Selected Writings and Interviews,* ed. John P. O'Neill (New York: Alfred A. Knopf, 1990), 163.
46. Greenberg, "Review of an Exhibition of Willem de Kooning."

chapter 15

1. Irving Sandler has Harold Rosenberg becoming a member of The Club in 1952; see Irving Sandler, "The Club," reprinted in *Abstract Expressionism: A Critical Record*, ed. David and Cecile Shapiro (New York; Cambridge University Press, 1960), 49. However, the records of Philip Pavia suggest otherwise. Pavia notes that Rosenberg was brought in as a "voting member" as early as 1950. See The Club Records Kept by Philip Pavia, Archives of American Art, Smithsonian Institution.
2. Harold Rosenberg, in Paul Cummings, Interview with Harold Rosenberg, December 10, 1970, 72, Archives of American Art, Smithsonian Institution.
3. Rosenberg, in Cummings, Interview, December 10, 1970, 74.
4. Rosenberg, in Cummings, Interview, December 10, 1970, 74.
5. Rosenberg, in Cummings, Interview, December 10, 1970, 69. There is no record of the first series of panels and talks at The Club. Valerie Hellstein, email to the author, April 29, 2018, stated that "the first speakers in the fall of 1949 were most likely William Barrett, Paul Goodman, and Tom Hess." Rosenberg did have a vivid memory of this talk, however, suggesting that his could have been the first of what became a series.
6. For example, on the heels of his talk on the interrelationship of poetry and painting, Rosenberg spoke on "Party and Painting/Planning the Future" in February 1950. Hellstein, email to the author, April 29, 2018.
7. Ad Reinhardt, in Natalie Edgar, ed., *Club without Walls: Selections from the Journals of Philip Pavia* (New York: Midmarch Arts Press, 2007), 110.
8. Philip Pavia, "The Unwanted Title: Abstract Expressionism," *It Is,* Spring 1960, 8–11.
9. Pavia, "The Unwanted Title," 9.
10. Thomas B. Hess, *Abstract Painting: Background and American Phase* (New York: Viking Press, 1951), 99.
11. Thomas B. Hess, "Is Abstraction Un-American?" *ARTnews* 49, no. 10 (February 1951): 38–41.
12. Hess, *Abstract Painting: Background and American Phase.*
13. Harold Rosenberg, "The American Action Painters," *Artnews* 51, no. 8 (December 1952): 22–23, 48–50; reprinted in Harold Rosenberg, *The Tradition of the New* (New York: Da Capo, 1994), 39.
14. Rosenberg, "The American Action Painters," in Rosenberg, *The Tradition of the New,* 23.
15. Rosenberg, "The American Action Painters," in Rosenberg, *The Tradition of the New,* 24–25.
16. Rosenberg, "The American Action Painters," in Rosenberg, *The Tradition of the New,* 27.
17. Rosenberg, "The American Action Painters," in Rosenberg, *The Tradition of the New,* 25.
18. Rosenberg, "The American Action Painters," in Rosenberg, *The Tradition of the New,* 30.

19. Rosenberg, "The American Action Painters," in Rosenberg, *The Tradition of the New,* 31.

20. Rosenberg, "The American Action Painters," in Rosenberg, *The Tradition of the New,* 31.

21. Rosenberg, "The American Action Painters," in Rosenberg, *The Tradition of the New,* 33.

22. Barnett Newman, "The Sublime Is Now," in *Barnett Newman: Selected Writings and Interviews,* ed. John O'Neill (New York: Alfred A. Knopf, 1990), 173.

23. On Cage and The Club, see Valerie Hellstein, "The Cage-iness of Abstract Expressionism," *American Art* 28, no. 1 (Spring 2014): 56–77.

24. Rosenberg, "The American Action Painters," in Rosenberg, *The Tradition of the New,* 33.

25. Rosenberg, "The American Action Painters," in Rosenberg, *The Tradition of the New,* 38.

26. Rosenberg, "The American Action Painters," in Rosenberg, *The Tradition of the New,* 28.

27. Clement Greenberg, "The Crisis of the Easel Picture," in *Clement Greenberg: The Collected Essays and Criticism,* ed. John O'Brian, 4 vols. (Chicago: University of Chicago Press, 1986–93), 2:224.

28. Rosenberg, "The American Action Painters," in Rosenberg, *The Tradition of the New,* 38–39.

29. Rosenberg, "The American Action Painters," in Rosenberg, *The Tradition of the New,* 38.

30. Ibram Lassaw, in Robert Goodnough, ed., *Artists' Sessions at Studio 35 (1950)* (Chicago: Soberscove Press, 2009), 18.

31. Williams Baziotes, in Goodnough, ed., *Artists' Sessions at Studio 35,* 22.

32. Newman, in Goodnough, ed., *Artists' Sessions at Studio 35,* 18.

33. The precise date that Rosenberg wrote "The American Action Painters" in 1952 is uncertain. It must have been written before the appearance of Jean-Paul Sartre's "The Communists and Peace," published in the August issue of *Les Temps modernes,* given his explanation for withholding the piece. However, Rosenberg contradicts himself in Cummings, Interview, January 4, 1972, where he claims he "wrote it about three days before it appeared . . . It was a brilliant piece of publishing as *Art News* ever accomplished . . . But I really wrote it for Sartre's magazine . . . So I wrote this piece with the idea of sending it to them. At this point, or shortly afterwards the Korean War was on and Sartre wrote a series of articles which later came out in a book which was called *Le communisme et la paix, Communism and Peace* [*sic*]." I abide by his memory in Cummings, Interview, January 20, 1973, where he states he responded to Merleau-Ponty's invitation to send an article to *Les Temps.*

34. Rosenberg, in Cummings, Interview, January 4, 1972, 128.

35. Rosenberg, in Cummings, Interview, January 4, 1972, 166–67.

36. Jean-Paul Sartre, "Introducing *Les Temps modernes,*" reprinted in *What Is Literature?*

and Other Essays (Cambridge, MA: Harvard University Press, 1988), 265. This introduction appeared in *Horizon* and in *Partisan Review* in advance of the first issue of *Les Temps modernes*.

37. For a study of Sartre's political transformation and embrace of communism, see Ronald Aronson, *Camus and Sartre: The Story of a Friendship and the Quarrel That Ended It* (Chicago: University of Chicago Press, 2003), 127 and following.

38. Jean-Paul Sartre, *The Communists and Peace*, with *A Reply to Claude Lefort*, trans. Martha H. Fletcher and Philip R. Berk (New York: George Braziller, 1968).

39. The last two articles in this intended quartet were never written, as Rosenberg could never secure a publisher.

40. Harold Rosenberg, "The Pathos of the Proletariat," *Kenyon Review* (1949); reprinted in Harold Rosenberg, *Act and the Actor: Making the Self* (New York: World Publishing, 1970), 31.

41. Rosenberg, "The Pathos of the Proletariat," in Rosenberg, *Act and the Actor,* 15.

42. Sartre, *The Communists and Peace,* 49.

43. Sartre, *The Communists and Peace,* 49.

44. Sartre, *The Communists and Peace,* 26.

45. Sartre, *The Communists and Peace,* 26.

46. Rosenberg, "The Pathos of the Proletariat," in Rosenberg, *Act and the Actor,* 14.

47. Rosenberg, "The Pathos of the Proletariat," in Rosenberg, *Act and the Actor,* 21.

48. On the issue of Sartre's debt to, and later falling-out with, Merleau-Ponty, see Monika Langer, "Sartre and Merleau-Ponty: A Reappraisal," in Jon Stewart, ed., *The Debate between Sartre and Merleau-Ponty* (Evanston, IL: Northwestern University Press, 1998), 93–117.

49. Harold Rosenberg to Barnett Newman, July 17, 1951, Barnett Newman Papers, Barnett Newman Foundation.

50. Rosenberg to Newman, July 17, 1951, Newman Papers.

51. Janice Biala to Jack Tworkov, August 10, 1951. With permission from the Estate of Janice Biala.

52. For a discussion of this lecture, see Aronson, *Camus and Sartre,* 55.

53. Aronson, *Camus and Sartre,* 66, cites a memory that de Beauvoir had of hearing Camus's reaction to "The Yogi and the Proletariat" at a party in Paris in 1946 where he expressed strong disapproval of Merleau-Ponty's rationalization of violence under Stalin's regime. He also notes Camus was similarly appalled by "Humanism and Terror: An Essay on the Communist Problem," which appeared the following year. Outside of Aronson, for accounts of the Camus/Sartre rift, see Germaine Brée, *Camus and Sartre: Crisis and Controversy* (New York: Delacorte Press, 1972); Peter Boyle, *The Sartre/Camus Controversy: A Literary and Philosophical Critique* (Ottawa: University of Ottawa Press, 1982); and Andy Martin, *The Boxer and the Goalkeeper: Sartre vs. Camus* (New York: Simon & Schuster, 2012).

54. Francis Jeanson, "Albert Camus ou l'Âme révoltée," *Les Temps modernes* 78 (April 1952): 2070.

55. Albert Camus, "Révolte et servitude," *Les Temps modernes* 80 (June 1952); translation here taken from Aronson, *Camus and Sartre*, 146.
56. Jean-Paul Sartre, "Reply to Albert Camus," reprinted in *Situations* (New York, 1965), 71.
57. Harold Rosenberg to Maurice Merleau-Ponty, August 31, 1949, Harold Rosenberg Papers, Getty Research Institute. Lionel Abel had a contrary memory of the availability of *Les Temps modernes* in New York, remembering that it was accessible. See Ann Eden Gibson, *Issues in Abstract Expressionism: The Artist-Run Periodicals* (Ann Arbor, MI: UMI Research Press, 1990), 42.
58. Harold Rosenberg to Maurice Merleau-Ponty, May 31, 1950, Rosenberg Papers.
59. Harold Rosenberg to Simone de Beauvoir, March 25, 1952, Rosenberg Papers.
60. Maurice Merleau-Ponty, *Adventures of the Dialectic*, trans. Joseph Bien (Evanston, IL: Northwestern University Press, 1973), 95.
61. Letter to the editor, *New York Times*, November 23, 1952, sec. 4, p. 8.
62. *Twentieth Century* was a permutation of the periodical *Nineteenth Century*, which was founded in 1877 by James Thomas Knowles Jr., an architect and member of the Metaphysical Society. In 1901, the journal was rechristened *Nineteenth Century and After*, and by 1951 it became *Twentieth Century*. Rosenberg's article was retitled "The Hero in History" and appeared in *Twentieth Century* in 1952.
63. George Lichtheim to Harold Rosenberg, August 25, 1952, Rosenberg Papers.
64. Lichtheim to Rosenberg, August 25, 1952, Rosenberg Papers.
65. George Lichtheim to Harold Rosenberg, October 27, 1952, Rosenberg Papers.
66. Rosenberg to Merleau-Ponty, May 31, 1950, Rosenberg Papers.
67. Rosenberg to Merleau-Ponty, May 31, 1950, Rosenberg Papers.
68. Robert Hobbs, in "Rosenberg's 'The American Action Painters' and Merleau-Ponty's Phenomenology" (unpublished paper delivered at College Art Association, 2000), has linked Rosenberg's text with *The Phenomenology of Perception*. He argues that it provided Rosenberg with "a way out of the impasse that both the Freudian and the Jungian unconscious as well as New Criticism posed for abstract expressionism." Given that Rosenberg bemoaned the fact that he failed to receive copies of Merleau-Ponty's essays, it seems unlikely that he read this seminal text. Herbert Dreyfus, who has studied the reception of Merleau-Ponty in America, notes (email to the author, July 14, 2005) that this text was not read in this country until the early 1960s. However, a lecture by Raymond Bayer of the University of Paris, delivered at the University of Buffalo in 1951, discusses *The Phenomenology of Perception*. Although the lecture was published by the university, it is unlikely that Rosenberg would have known of Bayer's text. At least, no mention of the lecture appears in any of the correspondence or interviews with Rosenberg. See Bayer, "Merleau-Ponty's Existentialism," *University of Buffalo Studies* 19, no. 3 (September 1951): 96–104. I am grateful to Taylor Carman of the Philosophy Department at Columbia University for this reference.
69. Maurice Merleau-Ponty, "Cézanne's Doubt," *Partisan Review* 13, no. 4 (September–October 1946): 477.

70. Harold Rosenberg, "Notes on Identity: With Special Reference to the Mixed Philosopher, Soren Kierkegaard," *View* 6, no. 3 (May 1946): 8. Like the word "action," which appears in Rosenberg's writing as early as 1932, mention of the limitations of psychology as a method is also voiced around this date. See Harold Rosenberg, "Counter-Statement" and "The Human Parrot and Other Essays," *Symposium* 3, no. 1 (January 1932): 117–18.

71. Merleau-Ponty, "Cezanne's Doubt," 478.

72. Merleau-Ponty, "Cezanne's Doubt," 488.

73. Harold Rosenberg, *Aaron Siskind: Photographs* (New York: Horizon Press, 1959), n.p.

74. See Harold Rosenberg, "Black and Pistachio," *New Yorker*, June 15, 1963; reprinted in Harold Rosenberg, *The Anxious Object* (Chicago: University of Chicago Press, 1966), 51 and following; and "Object Poems," *New Yorker*, June 3, 1967; reprinted in Harold Rosenberg, *Artworks and Packages* (New York: Delta Books, 1969), 75 and following.

75. Maurice Merleau-Ponty, "Marxism and Philosophy," *Politics* 4 (July–August 1947): 174.

76. Kenneth Burke, "Kinds of Criticism," *Poetry: A Magazine of Verse* 68 (1946).

77. Harold Rosenberg to Maurice Merleau-Ponty, June 29, 1955, Rosenberg Papers.

78. Rosenberg to Merleau-Ponty, June 29, 1955, Rosenberg Papers.

79. Harold Rosenberg, "From Play Acting to the Self," *New Yorker*, February 6, 1965; reprinted in Rosenberg, *Act and Actor Making the Self*, 134.

80. Harold Rosenberg, "Criticism—Action," English original in *Dissent* (1956); reprinted in Harold Rosenberg, *Act and Actor: Making the Self* (New York: World Publishing, 1970), 143.

81. Rosenberg, "Criticism—Action," in Rosenberg, *Act and Actor: Making the Self*, 140.

82. Rosenberg, in Cummings, Interview, January 7, 1973, 1.

83. Rosenberg, in Cummings, Interview, January 7, 1973, 2.

84. Rosenberg, in Cummings, Interview, January 7, 1973, 1, states that he "didn't remember when I met Tom Hess, but my real relationship began when I sent him the article called 'The American Action Painting [sic].'" Rosenberg, however, would have met Hess at The Club in early 1952, having participated on January 18 in the first of two panels on "Expressionism" on which both he and Hess served. See Pavia, in Edgar, *Club without Walls*, 110. Regarding who actually delivered the manuscript for "The American Action Painters" to *ARTnews*, Rosenberg contradicts himself in his interview with Cummings, January 20, 1973, first noting he sent the article to Hess, then recounting that Elaine de Kooning "took it to *Art News*," 2. I abide by the latter recollection.

85. Thomas B. Hess, in Barbara Lee Diamondstein, "Thomas Hess," in *Inside New York's Art World* (New York: Rizzoli, 1979), 140.

86. Rosenberg, in Cummings, Interview, January 7, 1973, 2.

87. Harold Rosenberg, "Notes and Acknowledgments," in Rosenberg, *Act and Actor: Making the Self*, 206.

88. Rosenberg, in Cummings, Interview, December 17, 1970, 7.

89. William Phillips, *A Partisan View: Five Decades of the Literary Life* (New York: Stein & Day, 1983), 67.

90. Clement Greenberg, in Elain O'Brien, "The Art Criticism of Harold Rosenberg: Theaters of Love and Combat," PhD diss., City University of New York, 1997, 2.

91. Clyfford Still to Harold Rosenberg, December 14, 1952, Rosenberg Papers.

92. Robert Goodnough, "Pollock Paints a Picture," *ARTnews* 50, no. 1 (May 1951): 38–41.

93. Jackson Pollock, in Deborah Solomon, *Jackson Pollock: A Biography* (New York: Cooper Square Press, 2001), 241.

94. Stuart Davis to Harold Rosenberg, February 13, 1953, Rosenberg Papers.

95. Clement Greenberg, in Saul Ostrow, "Clement Greenberg: The Last Interview," reprinted in Robert C. Morgan, ed., *Clement Greenberg: Late Writings* (Minneapolis: University of Minnesota Press, 2003), 233.

96. Alfred Barr, "The New American Painting," introduction to *The New American Painting: As Shown in Eight European Countries, 1958–59* (New York: Museum of Modern Art, 1959), 12. Barr had also considered using the term "Abstract Expressionism" as a title for his show, and claimed retrospective authorship of the phrase, noting that he had "re-invented" the term in 1929 to describe the work of Kandinsky. However, he opted not to perpetuate the name as "the painters in this show deny that their work is 'abstract,' at least in any pure, programmatic sense; and they rightly reject any significant association with German Expressionism."

97. "The American Action Painters" received the Award for Art Criticism from the American Federation of Arts in 1954, a mark of its widespread reception. Rosenberg Papers.

98. See John Berger, "The Battle," *New Statesman and Nation*, January 21, 1956, 70–72; Herbert Read, "The Apollinaire of Action Painting," *The Shavian, Journal of the Shaw Society*; and Lawrence Alloway, "Personal Statement," *Ark* 19 (Spring 1957): n.p., for references to the word "action." Similarly, David Sylvester used the word in "Expressionism German and American," *Twentieth Century* 160 (August 1956): 147, and "American Impact on British Painting," *New York Times*, February 10, 1957, 135.

99. Barr, "The New American Painting."

chapter 16

1. Robert Alan Aurthur, "Hitting the Boiling Point, Freakwise, at East Hampton," *Esquire*, June 1972, 205.

2. Aurthur, "Hitting the Boiling Point," 95.

3. May Natalie Tabak to Harold Rosenberg, undated letter from Paris, 1951, Harold Rosenberg Papers, Getty Research Institute.

4. Janice Biala to Jack Tworkov, October 7, 1951, Jack Tworkov Papers, Estate of Jack Tworkov.

5. Janice Biala to Jack Tworkov, August 10, 1951, Jack Tworkov Papers.

6. Tabak to Rosenberg, undated letter from Paris, 1951, Rosenberg Papers.

7. Mercedes Matter to Harold Rosenberg, undated, "Thursday evening," Mercedes Matter Papers, Estate of Mercedes Matter.

8. Matter to Rosenberg, undated, "Thursday evening," Matter Papers.

9. Mercedes Matter to Harold Rosenberg, draft of undated letter, Matter Papers.

10. Aurthur, "Hitting the Boiling Point," 205.

11. I have not been able to find a reference to the congressman who referred to Rosenberg as a "red poet," after combing through issues of the *Congressional Record*. However, this type of slur was routinely made by conservative politicians on the floor of the House during the period. See Bernard A. Weisberger, "Federal Art for Whose Sake?" *American Heritage*, December 1992, 20–21.

12. May Natalie Tabak, "Parker Tyler," *Christopher Street* 1, no. 8 (February 1977): 41–44, at 43. A letter I wrote to the US State Department, Office of Information and Privacy, September 14, 2004, to ascertain if a file was kept on Rosenberg by the FBI received the following response from Richard L. Huff on December 21, 2004: "the FBI searched both it [sic] automated and manual indices for main files but did not locate any records."

13. American Jewish Committee (AJC), in Benjamin Balint, *Running Commentary: The Contentious Magazine That Transformed The Jewish Left into the Neoconservative Right* (New York: Public Affairs, 2010), 17.

14. See Clement Greenberg, "Autobiographical Statement," in *Clement Greenberg: The Collected Essays and Criticism*, ed. John O'Brian, 4 vols. (Chicago: University of Chicago Press, 1986–93), 3:197.

15. For a history of this phase of *Commentary*, see Balint, *Running Commentary*, 19–21.

16. AJC, in Nathan Abrams, *Commentary Magazine, 1945–59: "A Journal of Significant Thought and Opinion"* (London: Vallentine Mitchell, 2007), 45.

17. "Under Forty: A Symposium on American Literature and the Younger Generation of American Jews," *Contemporary Jewish Record* 7, no. 3 (February 1944). For an account of the first fifteen years of *Commentary*, see Abrams, *Commentary Magazine, 1945–59*. Abrams's assessment of many of the figures in this book are inflated, if not inaccurate. For example, he states (32) that Philip Rahv was a "former editor" of *Partisan Review* during the period when he served as the managing editor of the *Contemporary Jewish Record* and (34) that Clement Greenberg "had already achieved fame and was recognized as one of the country's major art critics" by 1944. Greenberg's accolades were to come later. In addition, Abrams has Rosenberg contributing to the "Under Forty" symposium, which he did not do.

18. Harold Rosenberg, "'The Possessed,' A Review of Ben Hecht, *A Guide for the Bedevilled*," *Contemporary Jewish Record* 7, no. 3 (June 1944); reprinted as "Man as Anti-Semite," in Harold Rosenberg, *Discovering the Present: Three Decades in Art, Culture, and Politics* (Chicago: University of Chicago Press, 1973), 242. His review of Shola Asch's *The Apostle* also appeared in the same issue as the AJC symposium "Under Forty." See Rosenberg, "The Life and Times of St. Paul," *Contemporary Jewish Record* 7, no.1 (February 1944): 85–87.

19. Clement Greenberg, "Under Forty," reprinted in *The Collected Essays and Criticism*, 1:179.

20. Nathan Glazer, in Balint, *Running Commentary*, 26.

21. Each of these figures discussed the issue of Jewish identity from a different perspective, yet they remained unified through their opposition to Zionism resulting from their pluralist outlook. Subtle differences obtain in their secular positions. Neither Greenberg nor Hook, for example, abided by Rosenberg's idea of "repetitions that time after time brought Jews to act," their view of Jewish identity being more rational rather than romantically constructed. Or, as Greenberg put it in "Self-Hatred and Jewish Chauvinism: Some Reflections on 'Positive Jewishness,'" in *The Collected Essays and Criticism*, 3:57, "my relation to the Jewish community should be as much a personal and spontaneous expression of myself as anything else; that is, it should be a natural one and not legislated by ideology."

22. Patia Yasin Rosenberg, in a conversation with the author, October 5, 2005, stated that her father never took her to a synagogue while growing up, such was his aversion to organized religion. She has no recollection of him attending services during her upbringing. He did, however, observe Jewish holidays, such as Passover, Purim, and Yom Kippur, and occasionally said Kaddish at funerals for Jewish friends. Rosenberg noted (in Raymond Rosenthal and Moishe Ducovny, Interview with Harold Rosenberg, 1960, 139, William E. Weiner Oral History Library of the American Jewish Committee) that "I would rather die than go into a synagogue."

23. Harold Rosenberg, "Jewish Identity in a Free Society," in Rosenberg, *Discovering the Present*, 268.

24. Harold Rosenberg, "Sartre's Jewish Morality Play," *Commentary* 7, no. 1 (January 1949): 271.

25. Jean-Paul Sartre, "The Situation of the Jew," *Commentary* 5, no. 4 (April 1948): 310. The essay, derived from Sartre's book *Reflections on the Jewish Question*, was first published in France in 1944 and translated into English as *Anti-Semite and Jew*, trans. George J. Becker (New York: Schocken Books, 1948).

26. Rosenberg, "Sartre's Jewish Morality Play," 287.

27. Rosenberg, "Sartre's Jewish Morality Play," 287.

28. Bernard-Henri Levy, in *Sartre: The Philosopher of the Twentieth Century*, trans. Andrew Brown (Cambridge: Polity Press, 2003), 304, notes that Sartre built on the distinctions originally propounded by Heidegger that related to the "authentic" and "inauthentic" self.

29. Harold Rosenberg, "Pledged to the Marvelous," *Commentary* 3, no. 2 (February 1947); reprinted as "Letter to a Jewish Theologian," in *Discovering the Present*, 258. Rosenberg's essay was a reply to Will Herberg's "From Marxism to Judaism"; reprinted in Herberg, *From Marxism to Judaism: The Collected Essays of Will Herberg*, ed. and introd. David G. Dalin (New York: Markus Wiener Publishing, 1989), 22–37.

30. On Herberg and his transformation from a Marxist to a theologian to an eventual

neoconservative, see Abrams, *Commentary Magazine, 1945–59*, 99–101; and Balint, *Running Commentary*, 52–54.

31. Herberg, "From Marxism to Judaism," 31–32.

32. Herberg, "From Marxism to Judaism,"25.

33. Rosenberg, "Letter to a Jewish Theologian," 249.

34. Will Herberg, "The Religions in Americans and American Religion," excerpt from *Protestant-Catholic-Jew: An Essay in American Sociology* (New York: Doubleday, 1955); reprinted in *From Marxism to Judaism*, 259.

35. Rosenberg, "Jewish Identity in a Free Society," in Rosenberg, *Discovering the Present*, 268.

36. Rosenberg, "Jewish Identity in a Free Society," in Rosenberg, *Discovering the Present*, 268.

37. Hannah Arendt, "Zionism Reconsidered," *Menorah Journal*, October 1945; excerpted and reprinted in *Wrestling Zion: Progressive Jewish-American Responses to the Israeli-Palestinian Conflict*, ed. Tony Kushner and Alisa Solomon (New York: Grove Press, 2003), 25.

38. See Hannah Arendt," The Jewish State: Fifty Years After, Where Have Herzl's Politics Led?" *Commentary*, May 1946; reprinted in Arendt, *The Jewish Writings*, ed. Jerome Kohn and Ron H. Feldman (New York: Schocken Books, 2007), 375–87.

39. Hannah Arendt, "To Save the Jewish Homeland There Is Still Time," reprinted in *The Jewish Writings*, 394.

40. Hannah Arendt in Balint, *Running Commentary*, 39.

41. Rosenberg, "Jewish Identity in a Free Society," in Rosenberg, *Discovering the Present*, 259.

42. See Clara W. Mayer to Harold Rosenberg, December 27, 1951, Harold Rosenberg Papers, Getty Research Institute; and *New School Bulletin* 11, no. 15 (Spring 1952): 78. The following year Rosenberg gave a seminar on "Eight Modern Works On Death," which included Hemingway's *Death in the Afternoon*, Mann's *Death in Venice*, and Tolstoy's *Death of Ivan Ilych*, in addition to Sartres's *No Exit* and Melville's "Bartleby, the Scrivener," among others. See *New School Bulletin* 11, no. 19 (Spring 1953): 79.

43. Hannah Arendt, "Compassion and Goodness," from *On Revolution* (New York: Viking Penguin, 1963); excerpted and reprinted in *Melville's Short Stories*, ed. Dan McCall (New York: W. W. Norton, 2002), 397.

44. Arendt, "Compassion and Goodness," 397.

45. Harold Rosenberg, "Guilt to the Vanishing Point," *Commentary*, November 1961; reprinted in Harold Rosenberg, *Act and the Actor: Making the Self* (New York: World Publishing, 1970), 172–73. Rosenberg had amassed a scrapbook of clippings of both the Nuremberg and Eichmann trials, Rosenberg Papers.

46. Rosenberg, "Guilt to the Vanishing Point," in Rosenberg, *Act and the Actor: Making the Self*, 179.

47. Rosenberg, "Guilt to the Vanishing Point," in Rosenberg, *Act and the Actor: Making the Self*, 185.

48. Rosenberg, "Guilt to the Vanishing Point," in Rosenberg, *Act and the Actor: Making the Self*, 186.

49. Hannah Arendt, *Eichmann in Jerusalem: A Report on the Banality of Evil* (New York: Penguin Books, 1992).

50. For a discussion of Arendt's five articles on the Eichmann trial, which were published in the *New Yorker*, and the timetable and events that surrounded their appearance, see Elizabeth Young-Bruehl, *Hannah Arendt: For the Love of the World* (New Haven: Yale University Press, 1982), 328–78.

51. Arendt, *Eichmann in Jerusalem*, 54.

52. Arendt, *Eichmann in Jerusalem*, 54.

53. Arendt, *Eichmann in Jerusalem*, 6.

54. Arendt, *Eichmann in Jerusalem*, 5.

55. Mary McCarthy, "The Hue and Cry," *Partisan Review* 31, no. 1 (Winter 1964): 85.

56. Recounted by Young-Bruehl, *Hannah Arendt*, 252, situating this encounter in Chicago, rather than New York. I have found no evidence to suggest that Chicago was where their interaction on the Eichmann trial took place. It may have been in Manhattan, where Arendt spent part of her year.

57. For a discussion of Podhoretz's tenure at *Commentary*, see Balint, *Running Commentary*, 82–96.

58. Harold Rosenberg, "The Cold War," *Partisan Review* 29 (Winter 1962); reprinted in Rosenberg, *Discovering the Present*, 304.

59. See Balint, *Running Commentary*, 89–92.

60. Harold Rosenberg to Patia Rosenberg Yasin, undated, c. 1967, Rosenberg Papers.

61. Harold Rosenberg, "What's Happening to America," *Partisan Review* 34, no. 1 (Winter 1967); reprinted in Rosenberg, *Discovering the Present*, 314–15.

62. See Balint, *Running Commentary*, 116.

63. See William Phillips to Harold Rosenberg, September 28, 1960, Rosenberg Papers.

64. Podhoretz was opposed to the war in Vietnam until the early 1970s. See Balint, *Running Commentary*, 96; and Neil Jumonville, *Critical Crossings: The New York Intellectuals in Postwar America* (Berkeley: University of California Press, 1991), 200.

65. Harold Rosenberg, "Thugs Adrift," *Partisan Review* 40, no. 3 (Summer 1973); reprinted in Harold Rosenberg, *The Case of the Baffled Radical* (Chicago: University of Chicago Press, 1985), 72–73.

66. For a discussion of the intersections between *Commentary* magazine and the Nixon administration's position on the state of Israel, and how it divided those on the left, see Sol Stern, "Aligned with Liberty, Review of *Norman Podhoretz, A Biography* by Thomas L. Jeffers," *New Criterion*, September 2010, www.criterion.com.

67. Stern, "Aligned with Liberty. "

68. Norman Podhoretz, *Breaking Ranks* (New York: Harper & Row, 1979), 170.

69. Podhoretz, *Breaking Ranks*, 329.

70. Hannah Arendt, "'What Remains?' The Language of Remains: A Conversation with Gunter Gaus," in Arendt, *Essays in Understanding, 1930–1954*, ed. Jerome Kohn (New York: Harcourt, Brace, 1994), 17.

71. See Harold Rosenberg, *New Yorker* Papers, New York Public Library. Rosenberg had published a few book reviews in the magazine, such as "The Idiot: Second Century," *New Yorker* 44, no. 4 (October 5, 1968): 159–81; and "Beating the Game," *New Yorker* 53, no. 1 (March 14, 1977): 137–38.

72. Podhoretz, *Breaking Ranks*, 284.

chapter 17

1. Steven E. Zucker notes in "Art in Dark Times: Abstract Expressionism, Hannah Arendt, and the 'Natality' of Freedom," PhD diss., City University of New York, 1997, 55, that Rosenberg incorporated a passage from Arendt's "The Hole of Oblivion," from *The Jewish Frontier*, in his "The Stages," without citation, suggesting that he was a keen reader of her work by 1947 and most likely personally acquainted with her. Harold Rosenberg, "The Stages: A Geography of Human Action," *possibilities* 1 (1947–48): 60.

2. See Richard H. King, *Arendt and America* (Chicago: University of Chicago Press, 2015), 11.

3. *Within Four Walls: The Correspondence between Hannah Arendt and Heinrich Blucher*, ed. Lotte Kohler, trans. Peter Constantine (New York: Harcourt, 1996), 113.

4. Hannah Arendt to Mary McCarthy, May 20, 1962; reprinted in *Between Friends: The Correspondence of Hannah Arendt and Mary McCarthy 1949–1975*, ed. Carol Brightman (New York: Harcourt Brace, 1995), 132.

5. Hannah Arendt to Mary McCarthy, June 20, 1960; reprinted in Brightman, ed., *Between Friends*, 81.

6. Remembered by Patia Yasin Rosenberg, in conversation with Elaine O'Brien, "The Art Criticism of Harold Rosenberg: Theaters of Love and Combat," PhD diss., City University of New York, 1997, 73.

7. For the history of Arendt's internment and passage to the United States, see Elizabeth Young-Bruehl, *Hannah Arendt: For the Love of the World* (New Haven: Yale University Press, 1982), 164–84.

8. Young-Bruehl, *Hannah Arendt*, 197.

9. Mary McCarthy, *The Oasis* (New York: Random House, 1949), 19.

10. Noted by Frances Kiernan, *Seeing Mary Plain: A Life of Mary McCarthy* (New York: W. W. Norton, 2000), 304. Kiernan states that Rosenberg was "believed by many to be a former lover" of McCarthy. I have found no evidence to suggest such a relationship. Carol Brightman notes that McCarthy, in an interview, claimed that Arendt had the affair with Rosenberg (*Between Friends*, 667).

11. Harold Rosenberg, "Up against the News," *New York Review of Books*, October 31,

1974; reprinted in Harold Rosenberg, *The Case of the Baffled Radical* (Chicago: University of Chicago Press, 1985), 76–89. Also quoted in Kiernan, *Seeing Mary Plain,* 608. Rosenberg's piece for the *NYRB* was a two-part review of McCarthy's two collection of writings that appeared in 1974, *The Seventeenth Degree* and *The Mask of State: Watergate Portraits.* Of the latter, Rosenberg expressed reservation, claiming that here, unlike in her portrayals of Vietnam, she "missed a vital element," in part because she was "out of the country when Patrick Buchanan took the witness stand" ("Up against the News," in Rosenberg, *The Case of the Baffled Radical,* 88). Noted also by Carol Gelderman, *Mary McCarthy: A Life* (New York: St. Martin's Press, 1988), 317. Gelderman also observes that Rosenberg's review of McCarthy's writings was principally directed at James Fallows, who reviewed *The Mask of State* for *Washington Monthly* and questioned her earnestness as she took time off from the Watergate hearings.

12. Rosenberg, "Up against the News," in Rosenberg, *The Case of the Baffled Radical,* 86.
13. Brightman, ed., *Between Friends,* 70.
14. Mary McCarthy, "An Academy of Risk," *Partisan Review* 16, no. 3 (Summer 1959): 476.
15. McCarthy, "An Academy of Risk," 478.
16. My perusal of the ACCF archives at the Tamiment Library, New York University, yielded no correspondence with Rosenberg.
17. Mary McCarthy to Hannah Arendt, April 10, 1953; reprinted in Brightman, ed., *Between Friends,* 14.
18. Mary McCarthy, "My Confession," *Encounter* 2, no. 2 (February 1954): 43–56.
19. Irving Kristol, in Benjamin Balint, *Running Commentary: The Contentious Magazine That Transformed the Jewish Left into the Neoconservative Right* (New York: Public Affairs, 2010), 74.
20. Harold Rosenberg to George Lichtheim, October 16, 1953, Harold Rosenberg Papers, Getty Research Institute.
21. Rosenberg to Lichtheim, October 16, 1953, Rosenberg Papers.
22. Rosenberg to Lichtheim, October 16, 1953, Rosenberg Papers.
23. Claimed by Daniel Bell, and in Frances Stonor Saunders, *The Cultural Cold War: The CIA and the World of Arts and Letters* (New York: New Press, 1999), 162.
24. Noted by Saunders, *The Cultural Cold War,* 163.
25. Harold Rosenberg, "Revolution and the Idea of Beauty," *Encounter* 1, no. 3 (December 1953): 65–68. The piece was reprinted as "Revolution and the Concept of Beauty" in Harold Rosenberg, *The Tradition of the New* (New York: Da Capo, 1994).
26. Irving Kristol to Harold Rosenberg, August 18, 1953, Rosenberg Papers.
27. Irving Kristol to Harold Rosenberg, September 10, 1953, Rosenberg Papers.
28. Rosenberg, "Revolution and the Idea of Beauty," 66.
29. Rosenberg, "Revolution and the Idea of Beauty," 67.
30. Rosenberg, "Revolution and the Idea of Beauty," 67. Herbert Read subsequently wrote a negative assessment of the work of Jackson Pollock in "A Blot on the

Scutcheon," *Encounter* 5, no. 22 (1955). See David J. Gatsby, "Tactility or Opticality, Henry Moore or David Smith: Herbert Read and Clement Greenberg on the Art of Sculpture, 1956," in Michael Paraskos, ed., *Reading Read: New Views on Herbert Read* (London: Freedom Press, 2007), 154–57.

31. See Irving Kristol to Harold Rosenberg, May 12, 1954, Rosenberg Papers.

32. Rosenberg, "French Silence and American Poetry," *Encounter* 3, no. 6 (December 1954): 17–20.

33. Harold Rosenberg to Irving Kristol, November 29, 1955, Rosenberg Papers.

34. Harold Rosenberg, "The Orgamerican Phantasy," *Prospectus* 1 (November 1957); reprinted in *The Tradition of the New*, 283.

35. See Neil Jumonville, *Critical Crossings: The New York Intellectuals in Postwar America* (Berkeley: University of California Press, 1991), 13–17, 28–35; and Saunders, *The Cultural Cold War*, 45–60.

36. Observed by Jumonville, *Critical Crossings*, 29.

37. Sidney Hook, in Jumonville, *Critical Crossings*, 30.

38. Hook, in Jumonville, *Critical Crossings*, 30.

39. I am beholden to this list of sponsors in Jumonville, *Critical Crossings*, 31.

40. Mary McCarthy, "No News, *or*, What Killed the Dog," *The Reporter*, July 1952; reprinted in McCarthy, *On the Contrary* (New York: Farrar, Straus & Cudahy, 1961), 32.

41. Mary McCarthy to Hannah Arendt, March 14, 1952; reprinted in Brightman, ed., *Between Friends*, 5.

42. Noted by Saunders, *The Cultural Cold War*, 54.

43. See Brightman, *Between Friends*, 6n2, who states that "McCarthy's story, 'On the Eve,' was never finished to her satisfaction, and remained unpublished."

44. McCarthy to Arendt, March 14, 1952.

45. Whittaker Chambers, *Witness* (New York: Random House, 1952), 4.

46. Mary McCarthy to Hannah Arendt, December 2, 1952; reprinted in Brightman, ed., *Between Friends*, 11.

47. McCarthy to Hannah Arendt, December 2, 1952, 12.

48. McCarthy to Hannah Arendt, December 2, 1952, 11.

49. See Carol Brightman, ed., *Writing Dangerously: Mary McCarthy and Her World* (New York: Clarkson Potter, 1992), 308.

50. Hannah Arendt, "'The Ex-Communists"; reprinted in Arendt, *Essays in Understanding, 1930–1954*, ed. Jerome Kohn (New York: Harcourt, Brace, 1994), 399. Mary McCarthy, in a letter to Arendt, December 23, 1952, admonishes Arendt to take her "article … (possibly) on falsifications in [Chamber's] *Witness*" to *The Reporter*. See Brightman, ed., *Between Friends*, 13. Arendt's piece ended up becoming a much more ruminative and broader piece that focused on the distinctions between a "former communist" and an "ex- communist," with Chambers serving as an example of the latter.

51. Arendt, "The Ex-Communists," 399.

52. See Jeffery R. Isaac, "Hannah Arendt as Dissenting Intellectual," in Allen Hunter, ed., *Rethinking the Cold War* (Philadelphia: Temple University Press 1998), 277–78.

53. Leslie Fiedler, *An End to Innocence: Essays on Politics and Culture* (Boston: Beacon Press, 1955), 25–45.

54. Noted by Saunders, *The Cultural Cold War*.

55. Harold Rosenberg, "Couch Liberalism and the Guilty Past," *Dissent* 11 (1955); reprinted in Rosenberg, *The Tradition of the New*, 229.

56. See Jumonville, *Critical Crossings*, 143–50; and Saunders, *The Cultural Cold War*, 184–89, on Rosenberg's handling of Fiedler's *An End to Innocence*.

57. Rosenberg, "Couch Liberalism," in Rosenberg, *The Tradition of the New*.

58. Mark Royden Winchell, *"Too Good to Be True": The Life and Work of Leslie Fiedler* (Columbia: University of Missouri Press, 2002), 69, argues that Rosenberg's analysis of Fiedler's book was "strained and superficial," centering on old analogies with the Moscow Trials. Winchell has "Couch Liberalism and the Guilty Past" published in 1960, as opposed to 1955, and does not recount the history that surrounds Fiedler's article on Ethel and Julius Rosenberg for *Encounter*, and reservations expressed by writers such as Sidney Hook.

59. Leslie Fiedler, "A Postscript to the Rosenberg Case," *Encounter* 1, no. 1 (October 1953); reprinted as "Afterthoughts on the Rosenbergs," in *An End to Innocence*.

60. Fiedler, "A Postscript to the Rosenberg Case." Fiedler's "Postscript" has been covered by Saunders, *The Cultural Cold War*, 184–89.

61. For a discussion of Fiedler's "Postscript" and Rosenberg's engagement of his text, see James Seaton, "Innocence Regained," in *Cultural Conservatism, Political Liberalism: From Criticism to Cultural Studies* (Ann Arbor: University of Michigan Press, 1996), 110, 252. Seaton, a conservative and contributor to the *Weekly Standard*, takes issue with Rosenberg's "excoriation" of Fiedler, believing that it did little to clear up the distinction between "a problematic relation between many liberals and Communism" (252).

62. See Saunders, *The Cultural Cold War*, 186.

63. Irving Kristol, *Reflections of a Neo-Conservative: Looking Back, Looking Ahead* (New York: Basic Books, 1983), 15.

64. Andrew Ross, *No Respect: Intellectuals & Popular Culture* (New York: Routledge, 1989), 33–37, has examined Rosenberg's reaction to Fiedler's treatment of Ethel and Julius Rosenberg. I feel part of his discussion is derailed by an interest in linking Fiedler to the New Criticism. Fiedler dissociated himself from the movement as of the late 1940s.

65. Rosenberg, "Couch Liberalism," in Rosenberg, *The Tradition of the New*, 235.

66. This letter is missing from the Rosenberg Papers. I am building here on the content of Irving Kristol to Harold Rosenberg, September 10, 1955, Rosenberg Papers.

67. Kristol to Rosenberg, September 10, 1955, Rosenberg Papers.

68. Irving Kristol to Harold Rosenberg, November 17, 1955, Rosenberg Papers.

69. Harold Rosenberg to Irving Kristol, November 29, 1955, Rosenberg Papers.
70. Leslie Fiedler, "Come Back to the Raft Ag'in, Huck Honey!" *Partisan Review*, 15, no. 6 (June 1948): 664–71.
71. Leslie Fiedler, *Love and Death and the American Novel* (1960; rev. ed., 1966).
72. Winchell, *"Too Good to Be True,"* 195, has stated that Fiedler's character Howard Place was modeled on Rosenberg.
73. Leslie A. Fiedler, "Nude Croquet"; reprinted in Rust Hills, Will Blythe, and Erika Mansourian, eds., *Lust, Violence, Sin, Magic: Sixty Years of Esquire Fiction* (New York: Atlantic Monthly Press, 1993), 179.
74. Lewis A. Coser to Harold Rosenberg, December 20, 1954, Rosenberg Papers.
75. Irving Kristol, "Letter to the Editors," *Dissent* 3, no. 1 (January 1956): 212.
76. Irving Howe to Harold Rosenberg, undated, Rosenberg Papers.
77. Sydney Hook, in Jumonville, *Critical Crossings*, 141.

chapter 18

1. Harold Rosenberg, "Parable of American Painting," *ARTnews* 23, no. 9 (January 1954); reprinted in Harold Rosenberg, *The Tradition of the New* (New York: Da Capo, 1994), 14.
2. Harold Rosenberg, "The Tradition of the New," in Rosenberg, *The Tradition of the New*, 11.
3. Harold Rosenberg, "Hans Hofmann: Nature into Action," *ARTnews*, 56, no. 3 (May 1959); reprinted in Harold Rosenberg, *The Anxious Object* (Chicago: University of Chicago Press, 1964), 159.
4. Harold Rosenberg, *Aaron Siskind: Photographs* (New York: Horizon Press, 1959), n.p.
5. Harold Rosenberg, "The Search for Jackson Pollock," *ARTnews* 59 (February 1961). The piece was largely a review of Bryan Robertson's monograph, *Jackson Pollock* (New York: Abrams, 1960). Rosenberg used the opportunity to correct Robertson's misattribution of the concept of "action painting" to Pollock.
6. Rosenberg, "The Search for Jackson Pollock," 59.
7. Rosenberg, "The Search for Jackson Pollock," 35.
8. Rosenberg, "The Search for Jackson Pollock," 35.
9. Harold Rosenberg, "Tenth Street: The Geography of Modern Art," *ARTnews Annual*, 28 (1959); reprinted in Harold Rosenberg, *Discovering the Present: Three Decades in Art Culture, and Politics* (Chicago: University of Chicago Press, 1973), 102.
10. Rosenberg, "Tenth Street: The Geography of Modern Art," in Rosenberg, *Discovering the Present*, 102.
11. Rosenberg, "Tenth Street: The Geography of Modern Art," in Rosenberg, *Discovering the Present*, 107.
12. "Notes on Contributors," *ARTnews Annual*, 28 (1959): 8. Rosenberg's identity was not publicly consolidated until the late 1950s; for example, when *possibilities* ap-

peared in 1948, Rosenberg was the literary editor, and Robert Motherwell the art editor. In 1952, when "The American Action Painters" appeared in *ARTnews*, he was billed as a literary figure who wrote about American art.

13. Dudley Fitts, "Critic at Large in the Arts," *New York Times*, August 9, 1959. www .newyorktimes.com.

14. Herbert Read, "The Apollinaire of Action Painting," *The Shavian, Journal of the Shaw Society* 15 (June 1959): 22.

15. Paul Goodman, "Essays by Rosenberg," *Dissent* 6, no. 3 (Summer 1959): 305.

16. Goodman, "Essays by Rosenberg," 305.

17. Goodman, "Essays by Rosenberg," 307.

18. See Kevin Mattson, *Intellectuals in Action: The Origins of the New Left and Radical Liberalism, 1945–1970* (University Park: Pennsylvania State University Press, 2002), 105.

19. Harold Rosenberg, "Paul Goodman, 1911–1972," *Dissent* 20, no. 1 (Winter 1973): 3.

20. Harold Rosenberg, preface to Paul Goodman, *The Empire City* (New York: Vintage Books, 1977), ix.

21. Rosenberg, "Paul Goodman," 4.

22. Goodman, "Essays by Rosenberg," 307.

23. Harold Rosenberg, "Preface," in Rosenberg, *The Tradition of the New*, 5; and Harold Rosenberg, "Critics within the Act," *Encounter* 16, no. 6 (June 1961): 10.

24. Rosenberg, "Preface," in Rosenberg, *The Tradition of the New*, 5.

25. Clement Greenberg, "How Art Writing Earns Its Bad Name," in *Clement Greenberg: The Collected Essays and Criticism*, ed. John O'Brian, 4 vols. (Chicago: University of Chicago Press, 1986–93), 4:144.

26. On Alloway and his American connections, see John A. Walker, "A Vexed Trans-Atlantic Relationship: Greenberg and the British," *Art Criticism* 16, no.1.

27. Lawrence Alloway, "Easel Painting at the Guggenheim," *Art International* 5, no. 10 (December 1961): 34.

28. Lawrence Alloway, "Giddap, Paint!" *Herald Tribune Bookweek*, April 18, 1965, 14.

29. Alloway, "Giddap, Paint!" 45.

30. Greenberg, "How Art Writing Earns Its Bad Name," in *Clement Greenberg: The Collected Essays and Criticism*, 4:137.

31. Greenberg, in Florence Rubenfeld, *Clement Greenberg: A Life* (New York: Scribner, 1997), 236.

32. Greenberg, "How Art Writing Earns Its Bad Name," in *Clement Greenberg: The Collected Essays and Criticism*, 4:143.

33. Greenberg, "How Art Writing Earns Its Bad Name," in *Clement Greenberg: The Collected Essays and Criticism*, 4:143.

34. Greenberg, "How Art Writing Earns Its Bad Name," in *Clement Greenberg: The Collected Essays and Criticism*, 4:143.

35. Robert Goldwater, "Review of Art and Culture," *Partisan Review* 28, nos. 5–6 (1961): 694.

36. Goldwater, "Review of Art and Culture," 692.

37. Harold Rosenberg, "Action Painting: Crisis and Distortion," *ARTnews* 61, no. 8 (December 1962); reprinted in Harold Rosenberg, *The Anxious Object* (Chicago: University of Chicago Press, 1966), 43.

38. Rosenberg, "Action Painting: Crisis and Distortion," in Rosenberg, *The Anxious Object*, 44.

39. Rosenberg, "Action Painting: Crisis and Distortion," in Rosenberg, *The Anxious Object*, 44.

40. Rosenberg, "Action Painting: Crisis and Distortion," in Rosenberg, *The Anxious Object*, 44.

41. Herbert Read, "Letters: Greenberg's Action," *Encounter* 20, no. 2 (February 1963); reprinted as "A Critical Exchange with Herbert Read on 'How Art Writing Earns Its Bad Name,'" in Greenberg, *The Collected Essays and Criticism*, 4:145.

42. Greenberg, *The Collected Essays and Criticism*, 4:148.

43. Rosenberg, "Action Painting: Crisis and Distortion," in Rosenberg, *The Anxious Object*, 45.

44. Hilton Kramer, "Month in Review," *Arts Magazine* 33, no. 10 (September 10, 1959): 56.

45. Kramer, "Month in Review."

46. Hilton Kramer, "The New American Painting," *Partisan Review*, vol. XX, no. 4 (July/August 1953), 423.

47. Kramer, "Month in Review." Conversely, Hook could have appropriated Kramer's observation. I am primarily interested in drawing a parallel here.

48. Hilton Kramer, "RIP PR," *Bostonia* (Summer 2003), www.bostonia.com.

49. Hilton Kramer, in Charles Kaiser, "He Bites," *New York*, February 13, 1995, 78.

50. Hilton Kramer, *The Triumph of Modernism: The Art World, 1985–2005* (Chicago: Ivan R. Dee, 2006), 76.

51. Hilton Kramer, "A Critic on the Side of History: Notes on Clement Greenberg;" reprinted in *The Triumph of Modernism*.

52. Hilton Kramer, letter to the author, June 2, 2004.

53. Hilton Kramer, *Twilight of the Intellectuals: Culture and Politics in the Era of the Cold War* (Chicago: Ivan R. Dee, 1999), 124.

54. Harold Rosenberg, "Twilight of the Intellectuals," *Dissent* 5, no. 3 (Summer 1958); reprinted in Rosenberg, *Discovering the Present*, 171.

55. Kramer mentions Raymond Aron, and his essay "The Opium of the Intellectuals," in his introduction to his collection of essays, *Twilight of the Intellectuals*, xi–xii. He fails, however, to mention Rosenberg's earlier review of Aron's essay. Philip Rahv also used the word "twilight" in an essay two decades earlier. See "The Twilight of the Thirties," *Partisan Review* 6 (Summer 1939): 6, 10, 15. Rosenberg may have been thinking of Rahv when he wrote his piece for *Dissent*.

56. Hilton Kramer, in William Grimes, "Hilton Kramer, Art Critic and Champion of Tradition Dies at 84," *New York Times*, March 27, 2012, www.nytimes.com.

chapter 19

1. Harold Rosenberg, "Pop Culture: Kitsch Criticism," in Bernard Rosenberg and David Manning White, eds., *Mass Culture: The Popular Arts in America* (Glencoe, IL: Free Press, 1957); published in *Dissent* 5, no. 1 (Winter 1958); reprinted in Harold Rosenberg, *The Tradition of the New* (New York: Da Capo, 1994), 262.
2. Rosenberg, "Pop Culture: Kitsch Criticism," in Rosenberg, *The Tradition of the New*, 259.
3. Rosenberg, "Pop Culture: Kitsch Criticism," in Rosenberg, *The Tradition of the New*, 263.
4. José Ortega y Gasset, "On the Point of View of the Arts," *Partisan Review*, August 1949; reprinted in Ortega y Gasset, *The Dehumanization of Art and Other Writings on Art and Culture* (Garden City, NY: Doubleday Anchor Books, 1956).
5. Rosenberg, "Pop Culture: Kitsch Criticism," in Rosenberg, *The Tradition of the New*, 264.
6. Dwight Macdonald, "A Theory of Mass Culture," *Diogenes* (1953). See Thomas Wheatland, *The Frankfurt School in Exile* (Minneapolis: University of Minnesota Press, 2009), 182–84.
7. Rosenberg had written more fully about *The Lonely Crowd* a year earlier in "The Orgamerican Phantasy" in *Prospectus* 1 (November 1957); reprinted in Rosenberg, *The Tradition of the New*, 270–72.
8. Rosenberg, "Pop Culture, Kitsch Criticism," in Rosenberg, *The Tradition of the New*, 263.
9. Harold Rosenberg, Reply to Dwight Macdonald, "The Question of Kitsch," *Dissent* 5, no. 4 (Autumn 1958): 400.
10. Rosenberg does not mention Macdonald by name in "The Herd of Independent Minds." However, his references to Soviet modernist cinema, and questioning of its radical content to galvanize the masses, is a response to Macdonald's interest.
11. See Michael Wreszin, *A Rebel in Defense of Tradition: The Life and Politics of Dwight Macdonald* (New York: Basic Books, 1994), 337.
12. Dwight Macdonald, "The Question of Kitsch," *Dissent* 5, no. 4 (Autumn 1958), 397.
13. Clement Greenberg, "Review of an Exhibition of Arshile Gorky"; reprinted in *Clement Greenberg: The Collected Essays and Criticism,* ed. John O'Brian, 4 vols. (Chicago: University of Chicago Press, 1986–93), 2:220.
14. Greenberg, "Review of an Exhibition of Arshile Gorky," 398.
15. Dwight Macdonald to Hannah Arendt, November 3, 1962, Dwight Macdonald Papers, Yale University Library.
16. Hannah Arendt, "The Crisis in Culture," in *Between Past and Future: Eight Exercises in Political Thought* (New York: Viking Press, 1961), 197.
17. Hannah Arendt, "Society and Culture," in Norman Jacobs, ed., *Culture for the Millions? Mass Media in Modern Society* (Princeton, NJ: D. Van Nostrand, 1961), 48.

18. Rosenberg, "Pop Culture: Kitsch Criticism," in Rosenberg, *The Tradition of the New*, 260.

19. David Jenemann, *Adorno in America* (Minneapolis: University of Minnesota Press, 2007), has also observed that this is one area of overlap in the thinking of Arendt and Adorno. Arendt may not refer to Adorno's notion of a "culture industry" but she does describe, more specifically, an "entertainment industry" (48).

20. See Wheatland, *The Frankfurt School in Exile*, 162–64.

21. For a study of Adorno's sojourn in Los Angeles, see Jenemann, *Adorno in America*, xxii–xxiv.

22. Max Horkheimer and Theodor W. Adorno, *Dialectic of Enlightenment*, trans. John Cumming (New York: Continuum, 1969), 134.

23. See Richard Wolin, *Walter Benjamin: An Aesthetic of Redemption* (Berkeley: University of California Press, 1994), 183–84.

24. Rosenberg, "The Herd of Independent Minds: Has the Avant-Garde Its Own Mass Culture?" *Commentary*, September 1948; reprinted in Harold Rosenberg, *Discovering the Present: Three Decades in Art, Culture, and Politics* (Chicago: University of Chicago Press, 1973), 16.

25. See Wheatland, *The Frankfurt School in Exile*, 181.

26. Horkheimer and Adorno, *Dialectic of Enlightenment*, 154.

27. Irving Howe, "Notes on Mass Culture," *Politics* 5, no. 2 (Spring 1948): 121.

28. Clement Greenberg, "The Decline of Cubism," *Partisan Review*, March 1948; reprinted in *Clement Greenberg: The Collected Essays and Criticism*, 2:214.

29. Rosenberg, "Pop Culture: Kitsch Criticism," in Rosenberg, *The Tradition of the New*, 264. It should be pointed out that Clement Greenberg's notion of kitsch was initially indebted to Dwight Macdonald's writing and Macdonald's writing on Trotsky. Macdonald was also Greenberg's editor at *Partisan Review*, and Greenberg was therefore acutely aware of his work on the subject. Also observed by Wheatland, *The Frankfurt School in Exile*, 176.

30. Rosenberg, "Pop Culture: Kitsch Criticism," in Rosenberg, *The Tradition of the New*, 205.

31. Harold Rosenberg, "De Kooning: On the Borders of Art," *Vogue*, September 1964; reprinted in Harold Rosenberg, *The Anxious Object* (Chicago: University of Chicago Press, 1966), 129.

32. William Steig, *The Lonely Ones*, foreword by Wolcott Gibbs (New York: Duell Sloan & Pearce, 1942).

33. Clement Greenberg, "Review of *The Lonely Ones* by William Steig," in *Clement Greenberg: The Collected Essays and Criticism*, 1:137.

34. Greenberg, "Review of *The Lonely Ones* by William Steig," in *Clement Greenberg: The Collected Essays and Criticism*, 1:137.

35. Lee Lorenz, in Sarah Boxer, "William Steig Dies, at 95; Tough Youths and Jealous Satyrs Scowled in His Cartoons," *New York Times*, October 3, 2003, www .nytimes.com.

36. I am basing this date on the chronology in Joel Smith, *Saul Steinberg, Illuminations* (New Haven: Yale University Press, 2006). There is no mention of the timing of their initial meeting in Elaine O'Brien, Interview on Harold Rosenberg, March 24, 1993, Saul Steinberg Foundation. Nor does Deirdre Bair, *Saul Steinberg: A Biography* (New York: Doubleday, 2012), cite a specific date.

37. Harold Rosenberg, *Saul Steinberg*, exh. cat. (New York: Knopf and Whitney Museum of American Art, 1978); reprinted in Harold Rosenberg, *Art and Other Serious Matters* (Chicago: University of Chicago Press, 1985), 192.

38. Steinberg, in O'Brien, Interview on Harold Rosenberg, March 24, 1993, 22.

39. Steinberg, in Bair, *Saul Steinberg: A Biography,* 352.

40. Rosenberg, *Saul Steinberg,* 11.

41. Rosenberg, *Saul Steinberg,* 11.

42. Steinberg, in O'Brien, Interview on Harold Rosenberg, March 24, 1993.

43. Harold Rosenberg, "The Labyrinth of Saul Steinberg," in Rosenberg, *The Anxious Object,* 163. This essay was written as an introduction to Steinberg, *The Labyrinth* (New York: Harper, 1960), but was never published. A copy of the original typescript exists in the archives of the Saul Steinberg Foundation.

44. Rosenberg, *Saul Steinberg,* 190.

45. Saul Steinberg, in Rosenberg, *Saul Steinberg,* 203.

46. Rosenberg, *Saul Steinberg,* 212.

47. Steinberg, in Bair, *Saul Steinberg: A Biography,* 471.

48. Clement Greenberg, "Review of the Pepsi-Cola Exhibition; the Exhibition *Fourteen Americans*; and The Exhibition *Advertising American Art*," in *Clement Greenberg: The Collected Essays and Criticism,* 2:113.

49. Greenberg, "Review of the Pepsi-Cola Exhibition," in *Clement Greenberg: The Collected Essays and Criticism,* 2:113.

50. Greenberg, "Review of the Pepsi-Cola Exhibition," in *Clement Greenberg: The Collected Essays and Criticism,* 2:113.

51. This description was coined by John Cage and subsequently used by Guston. Philip Guston in Harold Rosenberg, "Recent Paintings by Philip Guston," *Boston University Journal* 22, no. 3 (Fall 1974); reprinted in Harold Rosenberg, *The Case of the Baffled Radical* (Chicago: University of Chicago Press, 1985).

52. Harold Rosenberg, "Liberation from Detachment: Philip Guston," *New Yorker,* November 7, 1970; reprinted in Harold Rosenberg, *The De-Definition of Art* (Chicago: University of Chicago Press, 1972), 135.

53. Philip Guston to Harold Rosenberg, January 11, 1974, Rosenberg Papers.

54. This image was a one-off from a poster that Guston made in collaboration with Stanley Kunitz for a (failed) series of poetry readings at the Smithsonian in 1976. The fill-in drawings were intended for the private delectation of the owner, David McKee.

55. Clement Greenberg, "Review of the Whitney Annual," in *Clement Greenberg: The Collected Essays and Criticism,* 2:267.

56. Clement Greenberg, "After Abstract Expressionism," in *Clement Greenberg: The Collected Essays and Criticism,* 4:125.
57. Rosenberg, "Liberation from Detachment: Philip Guston," 140.
58. Rosenberg, "Liberation from Detachment: Philip Guston," 140.

chapter 20

1. Karlen Mooradian, Interview with Harold Rosenberg, n.d., Karlen Mooradian Archive, Diocese of the Armenian Church of America (Eastern), New York.
2. Rosenberg, in Mooradian, Interview, n.d., Mooradian Archive. His remembrance of this date is slightly off.
3. Harold Rosenberg, *Arshile Gorky: The Man, the Time, the Idea* (New York: Sheepmeadow Press, 1962), 116–17.
4. Harold Rosenberg, "The American Action Painters," *ARTnews* 51, no. 8 (December 1952): 22–23, 48–50; reprinted in Harold Rosenberg, *The Tradition of the New* (New York: Da Capo, 1994), 25.
5. Rosenberg, *Arshile Gorky,* 118.
6. Rosenberg, *Arshile Gorky,* 66.
7. Arshile Gorky, in Rosenberg, *Arshile Gorky,* 66.
8. See Lauren Mahony, "WPA and Related Works," in *De Kooning: A Retrospective,* ed. John Elderfield, exh. cat. (New York: Museum of Modern Art, 2011), 68–75.
9. Willem de Kooning, "Remembrances of Gorky," in Karlen Mooradian, "A Special Issue on Arshile Gorky," *Ararat, A Quarterly* 12, no. 4 (Fall 1971): 48.
10. De Kooning, "Remembrances of Gorky," 49.
11. Rosenberg, *Arshile Gorky,* 44.
12. Clement Greenberg, "Review of an Exhibition of Arshile Gorky," in *Clement Greenberg: The Collected Essays and Criticism,* ed. John O'Brian, 4 vols. (Chicago: University of Chicago Press, 1986–93), 2:220.
13. Rosenberg, *Arshile Gorky,* 55.
14. Rosenberg, *Arshile Gorky,* 62.
15. Rosenberg, "Arshile Gorky, Art and Identity," *New Yorker,* January 5, 1963; reprinted in Harold Rosenberg, *The Anxious Object* (Chicago: University of Chicago Press, 1964), 106.
16. Rosenberg, *Arshile Gorky,* 98.
17. Rosenberg, *Arshile Gorky,* 100.
18. Rosenberg, *Arshile Gorky,* 106.
19. Rosenberg, in Mooradian, Interview, n.d., Mooradian Archive.
20. Rosenberg, in Mooradian, Interview, n.d., Mooradian Archive.
21. Gorky, paraphrased by Rosenberg, in Mooradian, Interview, n.d., Mooradian Archive.
22. Harold Rosenberg, "Painting Is a Way of Living," *New Yorker* 38, no. 4 (February 16, 1963); reprinted as "De Kooning, Painting Is a Way," in Rosenberg, *The Anxious Object,* 109.

23. Rosenberg, "Painting Is a Way of Living," reprinted as "De Kooning, Painting Is a Way," in Rosenberg, *The Anxious Object*, 115.

24. Harold Rosenberg, "De Kooning," *Vogue*, September 15, 1964; reprinted as "De Kooning, On the Borders of the Act," in Rosenberg, *The Anxious Object*, 125.

25. Rosenberg, "De Kooning, On the Borders of the Act," in Rosenberg, *The Anxious Object*, 128.

26. *Arshile Gorky* was widely reviewed with considerable enthusiasm. Fairfield Porter, "Criticism as an Abstract Art," *Dissent* 10, no. 1 (Winter 1963): 99, for example, referred to Rosenberg as a "brilliant critic." Thomas B. Hess, "History Discarded, Regained," *ARTnews* 61, no. 8 (December 1962), 66, moreover, praised the book for "keeping the contradictions alive," in Rosenberg's conjoining history and aesthetics. Paul Goodman, however, took issue with Rosenberg's use of history to explain Gorky's art. See Goodman, "Portrait of the Artist," *Partisan Review* 29, no. 3 (Summer 1962): 450. Goodman and Rosenberg subsequently participated in an exchange on Gorky, in the next issue of *Partisan Review*, in which they addressed Gorky's place in modernist history. This clash was reprinted as "Gorky and History: An Exchange," in Harold Rosenberg, *The Case of the Baffled Radical* (Chicago: University of Chicago Press, 1985), 15–21. Robert Goldwater agreed with Rosenberg that Gorky's late phase was his most adventuresome but did not believe that Gorky was an Abstract Expressionist. See Goldwater, "The Genius of the Moujik," *Saturday Review*, May 19, 1962, 38.

27. Robert Coates, in Mathilde Riza, *Following Strangers: The Life and Literary Works of Robert Coates* (Columbia: University of South Carolina Press, 2011), 224.

28. Harold Rosenberg, "Action Painting: Crisis and Distortion," *ARTnews* 61, no. 8 (December 1962); reprinted in Rosenberg, *The Anxious Object*, 46–47.

29. Harold Rosenberg, "Black and Pistachio," *New Yorker*, January 15, 1963; reprinted in Rosenberg, *The Anxious Object*, 50.

30. Rosenberg, "Black and Pistachio," in Rosenberg, *The Anxious Object*, 50.

31. Harold Rosenberg, "A Risk for Intelligence," *New Yorker*, October 27, 1962, 156.

32. Harold Rosenberg, "The New as Value," *New Yorker*, September 7, 1973; reprinted in Rosenberg, *The Anxious Object*, 234.

33. Rosenberg, "Black and Pistachio," in Rosenberg, *The Anxious Object*, 52.

34. Rosenberg, "Black and Pistachio," in Rosenberg, *The Anxious Object*, 53.

35. Harold Rosenberg, "The New as Value," in Rosenberg, *The Anxious Object*, 233.

36. Rosenberg, "De Kooning, On the Borders of the Act," in Rosenberg, *The Anxious Object*, 123.

37. Rosenberg, "De Kooning, On the Borders of the Act," in Rosenberg, *The Anxious Object*, 123.

38. Rosenberg, "De Kooning, On the Borders of the Act," in Rosenberg, *The Anxious Object*, 123.

39. Harold Rosenberg, "Jasper Johns, The Thing the Mind Already Knows," *Vogue*, February 1, 1964; reprinted in Rosenberg, *The Anxious Object*, 178.

40. Rosenberg, "Jasper Johns, The Thing the Mind Already Knows," in Rosenberg, *The Anxious Object*, 178.
41. Rosenberg resisted the use of the word "banal" in describing Johns's work, as he felt that his numbers, flags, letters, and so on lent themselves to abstraction. Rosenberg, "Jasper Johns, The Thing the Mind Already Knows"; reprinted in Rosenberg, *The Anxious Object*, 177. Unlike him, I don't feel that "banal" precludes "abstraction."
42. Rosenberg, "Jasper Johns, The Thing the Mind Already Knows," in Rosenberg, *The Anxious Object*, 177.
43. Harold Rosenberg, "Defining Art," *New Yorker*, February 25, 1967, 99.
44. Harold Rosenberg, "American Drawing and the Academy of the Erased de Kooning," *New Yorker*, March 22, 1976; reprinted in Rosenberg, *Art and Other Serious Matters* (Chicago: University of Chicago Press, 1985), 245.
45. Rosenberg, "Defining Art."
46. Rosenberg, "Defining Art."
47. There is no consensus as to when postmodernism emerged as a historic period. However, I situate it around 1968 with the occurrence of multiple historic events, such as the rise of the student protest movement, the escalation of the war in Vietnam, the election of Richard Nixon, and the assassinations of Martin Luther King Jr. and Robert Kennedy, all of which resulted in profound questioning of the so-called progressive traits of modernism.

chapter 21

1. Philip Leider was the editor of *Artforum* from the start. However, his name does not appear on the masthead until the fifth issue. See Amy Newman, *Challenging Art: Artforum, 1962–1974* (New York: Soho Press, 2000), 87–88.
2. Philip Leider, "Review of 'Arshile Gorky' by Harold Rosenberg," *Artforum* 1, no. 2 (July 1962): 47.
3. A copy of this letter is not in the Rosenberg Papers at the Getty Research Institute. But I assume that it was the one published in *Artforum* 1, no. 4 (September 1962): 2. Irwin was listed as the publisher/editor of *Artforum* in 1962. Until Leider's full role in the publication was revealed in the fifth issue, Rosenberg no doubt took the names on the masthead at face value.
4. Philip Leider to Harold Rosenberg, September 10, 1962, Rosenberg Papers, Getty Research Institute.
5. Leider to Rosenberg, September 10, 1962, Rosenberg Papers.
6. "Harold Rosenberg on Art Criticism," *Artforum* 2, no. 8 (February 1964): 28.
7. "Harold Rosenberg on Art Criticism," 28.
8. Max Kozloff, "Letter to the Editor," *Art International*, June 1963, 55.
9. Kozloff's "Letter to the Editor" was exceedingly long. As a result, James Fitzsimmons stated as a disclaimer that he would never run such a long rebuttal again.
10. Kozloff, "Letter to the Editor."

11. Michael Fried paraphrased in a recollection by Max Kozloff, in Newman, *Challenging Art: Artforum 1962–1974*, 56.

12. Philip Leider, in Newman, *Challenging Art: Artforum 1962–1974*, 150.

13. Leider, in Newman, *Challenging Art: Artforum 1962–1974*, 152.

14. Kozloff, in Newman, *Challenging Art: Artforum 1962–1974*, 287.

15. Leider, in Newman, *Challenging Art: Artforum 1962–1974*, 150.

16. Michael Fried, "An Introduction to My Art Criticism," in Fried, *Art and Objecthood: Essays and Reviews* (Chicago: University of Chicago Press, 1998), 15.

17. Philip Leider to Sidney Tillim, May 10, 1967, in Newman, *Challenging Art: Artforum 1962–1974*, 277.

18. Leider to Sidney Tillim, May 10, 1967, in Newman, *Challenging Art: Artforum 1962–1974*.

19. Leider, in Newman, *Challenging Art: Artforum 1962–1974*, 247–48.

20. Newman, *Challenging Art: Artforum 1962–1974*, 309.

21. Newman, *Challenging Art: Artforum 1962–1974*, 308.

22. Newman, *Challenging Art: Artforum 1962–1974*, 140.

23. Barbara Rose, in Newman, *Challenging Art: Artforum 1962–1974*, 59.

24. Fried, in Newman, *Challenging Art: Artforum 1962–1974*, 41.

25. Rose, in Newman, *Challenging Art: Artforum 1962–1974*, 60.

26. Rose, in Newman, *Challenging Art: Artforum 1962–1974*, 59.

27. Rosalind Krauss, in Newman, *Challenging Art: Artforum 1962–1974*, 77.

28. Michael Fried, *Three American Painters: Noland, Olitski, Stella*, exh. cat. (Cambridge, MA: Fogg Art Museum, 1965); reprinted in Fried, *Art and Objecthood*, 222–23.

29. Philip Leider, "The New York School: The First Generation," *Artforum* 4, no. 1 (September 1965): 4.

30. Leider, "The New York School: The First Generation," 4.

31. Leider, in Newman, *Challenging Art: Artforum 1962–1974*, 147.

32. Leider, in Newman, *Challenging Art: Artforum 1962–1974*, 147.

33. Barbara Rose, "The Second Generation: Academy and Breakthrough," *Artforum* 4, no. 1 (September 1965): 56.

34. Rose, "The Second Generation: Academy and Breakthrough," 55.

35. Rose, "The Second Generation: Academy and Breakthrough," 58.

36. Helen Frankenthaler, in "Is There a New Academy?, Part 1," *ARTnews* 58, no. 4 (Summer 1959): 34.

37. Ad Reinhardt, in "Is There a New Academy?, Part 1," 34.

38. Ad Reinhardt, "Twelve Rules for a New Academy," *ARTnews* 56, no. 3 (May 1957): 38.

39. Leider, in Newman, *Challenging Art: Artforum 1962–1974*, 239.

40. Barbara Rose, "Problems of Criticism, IV: The Politics of Art, Part 1," *Artforum* 7, no. 6 (February 1968): 79.

41. Rose, "Problems of Criticism, IV: The Politics of Art, Part 1," 79.

42. Clement Greenberg, "Complaints of an Art Critic," in *Clement Greenberg: The Collected Essays and Criticism*, 4:269.

43. See Alloway, "Giddup, Paint!" *Bookweek*, April 18, 1965, 12–14.
44. Greenberg, "Complaints of an Art Critic," in *Clement Greenberg: The Collected Essays and Criticism.*
45. Greenberg, "Complaints of an Art Critic," in *Clement Greenberg: The Collected Essays and Criticism.*
46. Barbara Rose, "ABC Art"; reprinted in Gregory Battcock, ed., *Minimal Art: A Critical Anthology* (New York: E. P. Dutton, 1968).
47. Clement Greenberg, in "Interview Conducted by Lily Leino," in *Clement Greenberg: The Collected Essays and Criticism*, 4:310.
48. Clement Greenberg, in Saul Ostrow "The Last Interview," World Art (November 1994); reprinted in Robert Morgan, ed., *Clement Greenberg: Late Writings* (Minneapolis: University of Minnesota Press, 2003), 241.
49. Michael Fried, "Art and Objecthood," *Artforum* 10 (June 1967); reprinted in Fried, *Art and Objecthood*, 148–72.
50. Greenberg, "Recentness of Sculpture," in *American Sculpture of the Sixties*; reprinted in *Clement Greenberg: The Collected Essays and Criticism*, 4:251.
51. Greenberg, "Recentness of Sculpture," in *Clement Greenberg: The Collected Essays and Criticism*, 4:152.
52. Harold Rosenberg, "Thoughts in Off-Season," *New Yorker*, July 24, 1971; reprinted in Harold Rosenberg, *Art on the Edge* (Chicago: University of Chicago Press, 1983), 250. Rosenberg had earlier addressed some of these issues that surrounded Minimalism in "The Nineteen-Sixties: Time in the Museum," *New Yorker*, July 29, 1967; reprinted as "Time in the Museum," in Harold Rosenberg, *Artworks and Packages* (New York: Delta Books, 1969), 100–112. This latter article appeared after Fried's "Art and Objecthood" was published in *Artforum*.
53. Rosenberg, "Thoughts in Off-Season," in Rosenberg, *Art on the Edge*, 250.
54. Rosenberg, "Thoughts in Off-Season," in Rosenberg, *Art on the Edge*, 248.
55. Rosenberg, "Thoughts in Off-Season," in Rosenberg, *Art on the Edge*, 250.
56. Harold Rosenberg, "After Next, What?" *Art in America* 2 (1964): 71.
57. Harold Rosenberg, "The Concept of Action," *New Yorker*, May 25, 1968; reprinted in Rosenberg, *Artworks and Packages*, 227.
58. Harold Rosenberg, in Paul Cummings, Interview with Harold Rosenberg, January 4, 1972, 120, Archives of American Art, Smithsonian Institution.
59. Rosenberg, in Cummings, Interview, January 4, 1972, 120.
60. Rosenberg, in Cummings, Interview, January 4, 1972, 170.
61. Rosenberg, in Cummings, Interview, January 4, 1972, 121.
62. Leider, in Newman, *Challenging Art: Artforum 1962–1974*, 113.
63. John Coplans, "Post-Painterly Abstraction," *Artforum* 2 (Summer 1964): 2–8.
64. John Coplans to Harold Rosenberg, May 27, 1964, Rosenberg Papers.
65. Coplans also represented *ARTnews* as "the enemy" in a later interview. See Paul Cummings, Interview with John Coplans, April 4–August 4, 1977, Archives of American Art, Smithsonian Institution.

66. Harold Rosenberg, "The Art Establishment," *Esquire* 62, no. 1 (January 1965); reprinted as "The American Art Establishment," in Harold Rosenberg, *Discovering the Present: Three Decades in Art, Culture, and Politics* (Chicago: University of Chicago Press, 1973), 118.

67. Rosenberg, "The American Art Establishment," in Rosenberg, *Discovering the Present*, 118.

68. Robert Brown to Harold Rosenberg, August 5, 1964, Rosenberg Papers.

69. William Rubin, "Younger American Painters," *Art International* 4, no. 1 (January 1960): 24–31.

70. William Rubin, "Jackson Pollock and the Modern Tradition," *Artforum* 5, no. 6 (February 1967): 16.

71. Harold Rosenberg, "Letter to the Editor," *Artforum* 5, no. 9 (May 1967): 4.

72. William Rubin has stated that his articles on Pollock were drafts for a book that was to be published by Harry N. Abrams. But the project was abandoned once he took up his post at MoMA. He noted that the articles were "written in great haste while traveling Europe," suggesting that he wanted to discount the various myths — *action* painting included—before the Pollock retrospective. See Rubin, notes to his revised "Jackson Pollock and the Modern Tradition," in Pepe Karmel, ed., *Jackson Pollock: Interviews, Articles, and Reviews* (New York: Museum of Modern Art, 1998), 171.

73. Harold Rosenberg, "Letter to the Editor," *Artforum* 5, no. 8 (April 1967): 6.

74. Rosenberg, "Letter to the Editor," 6.

75. Rubin, "Jackson Pollock and the Modern Tradition," in Karmel, ed., *Jackson Pollock*.

76. Harold Rosenberg, "The Mythic Act," *New Yorker*, May 6, 1967, 163.

77. Earlier, Rosenberg had reviewed Bryan Robertson's book on Jackson Pollock; see Rosenberg, "The Search for Jackson Pollock," *ARTnews* 59 (February 1961). But that piece, unlike his review of the artist in the *New Yorker*, was devoted primarily to what he thought of as the shortcomings of Robertson's book: the myths and clichés that it perpetuated relating to the artist. These myths included the notion that Rosenberg had based his concept of *action* on Pollock's painting.

78. Rosenberg, "The Mythic Act," 167.

79. Rosenberg, "The Mythic Act," 162.

80. Rosenberg, "The Mythic Act," 169–70.

81. Rosenberg, "The Mythic Act," 169.

82. Leider, in Newman, *Challenging Art: Artforum 1962–1974*, 245–46.

83. See Sidney Tillim, in Newman, *Challenging Art: Artforum 1962–1974*, 316.

84. Leider, in Newman, *Challenging Art: Artforum 1962–1974*, 318.

85. Leider, in Newman, *Challenging Art: Artforum 1962–1974*, 304.

86. Philip Leider, "How I Spent My Summer Vacation," *Artforum* 9, no. 1 (September 1970): 41.

87. Rose, in Newman, *Challenging Art: Artforum 1962–1974*, 375.

88. Harold Rosenberg, "The American Action Painters," *ARTnews* 51, no. 8 (December

1952): 22–23, 48–50; reprinted in Harold Rosenberg, *The Tradition of the New* (New York: Da Capo, 1994), 38.

89. Max Kozloff, "American Painting during the Cold War, *Artforum* 11, no. 9 (May 1973); revised and reprinted in Francis Frascina, ed., *Pollock and After: The Critical Debate* (New York: Routledge, 1985), 111.

90. Kozloff, "American Painting during the Cold War," 113.

91. Leider, in Newman, *Challenging Art: Artforum 1962–1974*, 367.

92. Kozloff, in Newman, *Challenging Art: Artforum 1962–1974*, 163.

chapter 22

1. Harold Rosenberg, "The Vanishing Intellectual?" *New Yorker*, June 26, 1965; reprinted as "The Intellectual and His Future," in Harold Rosenberg, *Discovering the Present: Three Decades in Art, Culture, and Politics* (Chicago: University of Chicago Press, 1973), 194.

2. Harold Rosenberg, "Philosophy in a Pop Key," *New Yorker*, February 27, 1965; reprinted in Harold Rosenberg, *The Case of the Baffled Radical* (Chicago: University of Chicago Press, 1985), 64.

3. Rosenberg, "Philosophy in a Pop Key," in Rosenberg, *The Case of the Baffled Radical*, 64.

4. Harold Rosenberg, "From Play Acting to Self," *New Yorker*, February 6, 1965; reprinted in Harold Rosenberg, *Act and the Actor: Making the Self* (New York: World Publishing, 1970), 134.

5. Rosenberg, "From Play Acting to Self," in Rosenberg, *Act and the Actor*, 134.

6. Harold Rosenberg, "Virtuosos of Boredom," *Vogue* 147 (September 1966); reprinted in Rosenberg, *Discovering the Present*, 123.

7. Saul Bellow, in Rosenberg, "Virtuosos of Boredom," in Rosenberg, *Discovering the Present*, 123.

8. Bellow, in Rosenberg, "Virtuosos of Boredom," in Rosenberg, *Discovering the Present*, 123.

9. Harold Rosenberg, "Notes on *Location*," Harold Rosenberg Papers, Getty Research Institute.

10. Rosenberg, "Notes on *Location*," Rosenberg Papers.

11. Donald Barthelme, "Not-Knowing," in Barthelme, *Not-Knowing: The Essays and Interviews*, ed. Kim Herzinger (New York: Random House, 1997), 19.

12. Donald Barthelme, "Interview with Jerome Klinkowitz, 1971–72," in Barthelme, *Not-Knowing: The Essays and Interviews*, 201.

13. Harold Rosenberg, "The Audience as Subject," *Forum* 3, no. 3 (Fall 1959): 31.

14. Rosenberg, "The Audience as Subject," 31.

15. Noted by Tracey Daugherty, *Hiding Man: A Biography of Donald Barthelme* (New York: St. Martin's Press, 2009), 61.

16. Donald Barthelme to Harold Rosenberg, March 28, 1962, Rosenberg Papers.

17. See Daugherty, *Hiding Man,* 201.

18. Donald Barthelme, "Interviews with Larry McCaffery, 1980," in *Not-Knowing: The Essays and Interviews,* 264.

19. Donald Barthelme, in Helen Moore Barthelme, *Donald Barthelme: The Genesis of a Cool Sound* (College Station: Texas A&M University Press, 2001), 148.

20. Rosenberg, "Notes on *Location,*" 1, Rosenberg Papers.

21. Rosenberg, "Notes on *Location,*" 1, Rosenberg Papers.

22. Rosenberg, "Notes on *Location,*" 1, Rosenberg Papers.

23. Rosenberg, "Notes on *Location,*" 1, Rosenberg Papers.

24. Donald Barthelme, "Thomas B. Hess, 1920–1978," *Art in America,* November/December 1978, 8–9.

25. Barthelme, in Moore Barthelme, *Donald Barthelme: The Genesis of a Cool Sound,* 145.

26. Barthelme, in Moore Barthelme, *Donald Barthelme: The Genesis of a Cool Sound,* 145.

27. Barthelme, in Moore Barthelme, *Donald Barthelme: The Genesis of a Cool Sound,* 145.

28. Donald Barthelme, "Being Bad," in Barthelme, *Not-Knowing: The Essays and Interviews,* 185.

29. Barthelme, "Being Bad," in Barthelme, *Not-Knowing: The Essays and Interviews,* 185.

30. Barthelme, "Thomas B. Hess."

31. Barthelme, "Thomas B. Hess."

32. Observed by Daugherty, *Hiding Man,* 345.

33. See Rosenberg, "Notes on *Location.*"

34. Barthelme, in Moore Barthelme, *Donald Barthelme: The Genesis of a Cool Sound,* 145.

35. Harold Rosenberg to Robert Bly, March 17, 1963, Rosenberg Papers.

36. Rosenberg to Bly, March 17, 1963, Rosenberg Papers.

37. Rosenberg to Bly, March 17, 1963, Rosenberg Papers.

38. Donald Barthelme, "Memorandum on *Location* Prospectus and Prospects," 1, Rosenberg Papers.

39. Harold Rosenberg, "The Stockade Syndrome, *Location* 1, no. 1 (Spring 1963): 7–9.

40. Barthelme, "Memorandum on *Location* Prospectus and Prospects," 2, Rosenberg Papers.

41. Barthelme, "Memorandum on *Location* Prospectus and Prospects," 3, Rosenberg Papers.

42. Harold Rosenberg, "Form and Despair," *Location* 1, no. 2 (Summer 1964): 9.

43. Rosenberg, "The Stockade Syndrome," 9.

44. Rosenberg, "The Stockade Syndrome," 9.

45. Saul Bellow, "Comment on 'Form and Despair,'" *Location* 1, no. 2 (Summer 1964): 12.

46. Bellow was responding here to a recent review that Arendt had written on Natalie Sarraute in the *New York Review of Books,* March 5, 1964. Rosenberg referenced the structure of the *Eichmann in Jerusalem* in "Form and Despair."

47. Bellow, "Comment on 'Form and Despair.'"

48. Bellow, "Comment on 'Form and Despair.'"

49. Donald Barthelme, "After Joyce," in Barthelme, *Not-Knowing: The Essays and Interviews*, 10.

50. Barthelme, "After Joyce," in Barthelme, *Not-Knowing: The Essays and Interviews*, 4.

51. Barthelme, "After Joyce," in Barthelme, *Not-Knowing: The Essays and Interviews*, 4.

52. Barthelme, "Memorandum on *Location* Prospectus and Prospects," 5, Rosenberg Papers.

53. Barthelme, "Memorandum on *Location* Prospectus and Prospects," 5, Rosenberg Papers.

54. Thomas B. Hess to Harold Rosenberg, c. November 1965, Rosenberg Papers.

55. Hess to Rosenberg, c. November 1965, Rosenberg Papers.

56. Bill Berkson, email to the author, October 4, 2013.

57. Bill Berkson, email to the author, March 21, 2005.

58. "Third Annual Longview Literary Awards," press release, Longview Foundation, Inc., Monday, April 3, 1961, Charles Olson Research Papers, University of Connecticut Library, Storrs.

59. Harold Rosenberg to Saul Bellow, February 15, 1958, Saul Bellow Papers, University of Chicago Library.

60. Harold Rosenberg, in Paul Cummings, Interview with Harold Rosenberg. January 7, 1973, 22, Archives of American Art, Smithsonian Institution.

61. Rosenberg, in Cummings, Interview, January 7, 1973, 17.

62. Harold Rosenberg to Saul Bellow, "Notice of Meeting," c. December 1960, Bellow Papers.

63. The Longview Foundation continued to provide funds for acquisitions after the formation of its collections. See Thomas B. Hess to Harold Rosenberg, undated (c. November 1965), Rosenberg Papers, in which Hess states that the foundation has just been approached for $10,000 from the Rochester University Museum. Moreover, the University of Iowa Museum holds work by Sam Gilliam and Ad Reinhardt that was acquired in 1970.

64. Rosenberg, in Cummings, Interview, January 7, 1973, 17.s

65. Quoted by Harold Rosenberg, in Rosenberg, "Introduction," *Project 1: An Exhibition at the Whitney Museum of American Art, June 9–21: Longview Foundation Purchases in Modern American Painting and Sculpture for the Union Sanatorium Association of the International Ladies' Garment Workers*, exh. brochure (New York: Whitney Museum of American Art, 1959), n.p.

66. Rosenberg, "Introduction," *Project 1*.

67. Rosenberg, in Cummings, Interview, January 7, 1973, 14.

68. Harold Rosenberg to Thomas B. Hess, March 14, 1962, Thomas B. Hess Papers, Archives of American Art, Smithsonian Institution.

69. Rosenberg, in Cummings, Interview, January 7, 1973, 19.

70. Rosenberg, in Cummings, Interview, January 7, 1973, 20.

71. W. McNeil Lowry to Harold Rosenberg, April 27, 1964, Rosenberg Papers.

72. Harold Rosenberg to W. McNeil Lowry, April 30, 1964, Rosenberg Papers.

73. Rosenberg to Lowry, April 30, 1964, Rosenberg Papers.

74. Harold Rosenberg to Larry[?], March 22, 1960, Rosenberg Papers. Larry was Rosenberg's accountant.

75. Rosenberg to Larry[?], March 22, 1960, Rosenberg Papers.

76. On Clement Greenberg's role as an advisor to French & Company, see Florence Rubenfeld, *Clement Greenberg: A Life* (New York: Scribner, 1997), 214–15; and Alice Goldfarb Marquis, *Art Czar: The Rise and Fall of Clement Greenberg* (Boston: MFA Publications, 2006), 166–73.

77. I have found no evidence that Rosenberg received a weekly salary from the Graham Gallery. There are no check stubs in the Papers of James Graham & Sons, Archives of American Art, Smithsonian Institution, to suggest such a financial arrangement. Moreover, in his letter to Larry, Rosenberg notes that he assumed the costs of his expenses and wants them deducted from his taxes as write-offs.

78. Joan Washburn, phone interview with the author, October 8, 2013.

79. See Betsy Fahima, *James Graham & Sons: A Century and a Half in the Art Business* (New York: James Graham & Sons, 2007).

80. Washburn, phone interview with the author, October 8, 2013.

81. Rosenberg, in Cummings, Interview, January 7, 1973, 18.

82. Rosenberg, "The Premises of Action Painting," *Encounter*, 116 (May 1963), 43.

83. I have been unable to determine how long Rosenberg worked as a consultant to the Graham Gallery. My sense is that the relationship came to an end when he worked at the *New Yorker* in the autumn of 1962.

84. For an account of this episode, see Rubenfeld, *Clement Greenberg: A Life*, 224.

85. Observed by Rubenfeld, *Clement Greenberg: A Life*, 239. I feel Rubenfeld overstates and misrepresents Rosenberg's association with the Graham Gallery through her defense of Greenberg. The situations were not parallel or equal, even though Rosenberg did accept money from the gallery. Rosenberg did not, moreover, refer to Greenberg as an "old salesman" in "The Premises of Action Painting," as Rubenfeld states, a phrase that underscores her exaggeration.

86. Rubenfeld, *Clement Greenberg: A Life*, 270–71.

87. Harold Rosenberg, untitled statement, in "Longview Foundation Grants 1962," *Kalamazoo Institute of Arts Bulletin* 8 (1862): n.p.

88. Rosenberg, untitled statement, in "Longview Foundation Grants 1962."

89. Rosenberg, untitled statement, in "Longview Foundation Grants 1962."

90. May Natalie Tabak, in Philip Pavia to Harold Rosenberg, November 1964, Rosenberg Papers.

91. Pavia to Rosenberg, November 1964, Rosenberg Papers.

92. Tabak, in Pavia to Rosenberg, November 1964, Rosenberg Papers.

93. Rosenberg's contribution to *It Is* drew from a panel that he moderated with Philip Guston, Robert Motherwell, Ad Reinhardt, and Jack Tworkov at the Philadelphia Museum of Art, March 1960. It was subsequently published as "The Philadelphia Panel," *It Is* 3 (1960): 34–38.

94. Philip Pavia, in Phong Bui, "The Club IT IS: A Conversation with Philip Pavia," *Brooklyn Rail*, February 2001, wwwbrooklynrail.org.
95. See, for instance, *Club without Walls, Selections from the Journals of Philip Pavia*, ed. Natalie Edgar (New York: Midmarch Press, 2007).
96. Pavia to Rosenberg, November 1964, Rosenberg Papers.
97. Pavia to Rosenberg, November 1964, Rosenberg Papers.
98. *The Harold and May Rosenberg Collection*, foreword by Kathryn Gamble, exh. brochure (Montclair, NJ: Montclair Art Museum), n.p.

chapter 23

1. See Harold Rosenberg to William Shawn, October 4, 1963, Harold Rosenberg Papers, Getty Research Institute.
2. William Shawn to Harold Rosenberg, October 24, 1962, Rosenberg Papers.
3. Draft of a letter from May Natalie Tabak to William Shawn, July 1978, Rosenberg Papers. It is unclear whether this letter was sent.
4. Draft of a letter from Tabak to Shawn, July 1978, Rosenberg Papers.
5. Rosenberg, in Draft of a letter from Tabak to Shawn, July 1978, Rosenberg Papers.
6. I am surmising this from Tabak's letter to Shawn in which she declares that "Harold loved Saul." She also speaks of his generosity, which probably included an introduction to Shawn.
7. Steinberg, in Elaine O'Brien, "The Art Criticism of Harold Rosenberg: Theaters of Love and Combat," PhD diss., City University of New York, 1997.
8. Draft of a letter from Tabak to Shawn, July 1978, Rosenberg Papers.
9. Gardner Botsford, *A Life of Privilege, Mostly* (New York: St. Martin's Press, 2003), 224.
10. Harold Rosenberg to Robert Coates, January 4, 1996, in O'Brien, "The Art Criticism of Harold Rosenberg," 351. I have not located this letter among the Rosenberg Papers. A search conducted by the Getty Research Institute to find the letter yielded no results.
11. Rosenberg, in Draft of a letter from Tabak to Shawn, July 1978, Rosenberg Papers.
12. Draft of a letter from Tabak to Shawn, July 1978, Rosenberg Papers.
13. William Shawn, in Draft of a letter from Tabak to Shawn, July 1978, Rosenberg Papers.
14. Draft of a letter from Tabak to Shawn, July 1978, Rosenberg Papers.
15. Draft of a letter from Tabak to Shawn, July 1978, Rosenberg papers.
16. Draft of a letter from Tabak to Shawn, July 1978, Rosenberg Papers.
17. Draft of a letter from Tabak to Shawn, July 1978, Rosenberg Papers.
18. The only mention of an editor that I have found in Rosenberg's papers at the Getty Research Institute is Gardner Botsford. I assume that he must have been Rosenberg's copy editor. An email sent to Roger Angell, August 28, 2013, at the *New Yorker*, asking him to confirm this, went unanswered. Janet Malcolm, Botsford's wife, stated in an email, July 20, 2016, that "as far I know, Gardner Botsford was not Harold

Rosenberg's editor at the New Yorker. My guess would be that William Shawn edited him, but it's only a guess." Charles McGrath, in a phone conversation with the author, October 27, 2016, stated that he doubted Shawn edited Rosenberg. McGrath worked at the *New Yorker* while Rosenberg was art critic there.

19. Robert Coates, in Mathilde H. Roza, *Following Strangers: The Life and Literary Works of Robert M. Coates* (Columbia: University of South Carolina Press, 2011), 231.

20. Kenneth Burke, in Roza, *Following Strangers,* 231.

21. Coates, in Roza, *Following Strangers,* 231.

22. Harold Rosenberg, "The Art Scene: Then and Now," *Partisan Review* 42 (Winter 1975); reprinted in Harold Rosenberg, *Art and Other Serious Matters* (Chicago: University of Chicago Press, 1985), 40–41.

23. Rosenberg, "The Art Scene: Then and Now," in Rosenberg, *Art and Other Serious Matters,* 40–41.

24. Harold Rosenberg, "École de New York," *New Yorker,* December 6, 1969; reprinted in Harold Rosenberg, *The De-Definition of Art* (Chicago: University of Chicago Press, 1972), 200.

25. Rosenberg, "The Art Scene: Then and Now," in Rosenberg, *Art and Other Serious Matters,* 42.

26. Harold Rosenberg, "Young Masters, New Critics," *New Yorker,* May 9, 1970, 108.

27. Rosenberg, "Young Masters, New Critics," 106.

28. Harold Rosenberg, "Hans Hofmann, 1880–1966," *ARTnews* 65, no. 2 (April 1966): 21.

29. Harold Rosenberg, "Homage to Hans Hofmann," *ARTnews* 65, no.9 (January 1967): 49.

30. Lawrence Alloway, *Systemic Painting,* exh. cat. (New York: Solomon R. Guggenheim Museum, 1966), 20.

31. Rosenberg, "Homage to Hans Hofmann."

32. Rosenberg, "Homage to Hans Hofmann."

33. Rosenberg, "Homage to Hans Hofmann."

34. Lawrence Alloway, "Background to Systemic," *ARTnews* 65, no. 6 (October 1966): 33.

35. James Fitzsimmons to Harold Rosenberg, February 26, 1967, Rosenberg Papers.

36. Fitzsimmons to Rosenberg, February 26, 1967, Rosenberg Papers.

37. Harold Rosenberg to James Fitzsimmons, March 15, 1967, Rosenberg Papers.

38. Rosenberg to Fitzsimmons, March 15, 1967, Rosenberg Papers.

39. Rosenberg to Fitzsimmons, March 15, 1967, Rosenberg Papers.

40. Harold Rosenberg to Thomas B. Hess, February 23, 1967, Rosenberg Papers.

41. Rosenberg to Hess, February 23, 1967, Rosenberg Papers.

42. Harold Rosenberg to Thomas B. Hess, Thanksgiving [1966], Hess Papers, Archives of American Art, Smithsonian Institution.

43. Harold Rosenberg to Thomas B. Hess, November 9 [1966], Hess Papers.

44. Sandler, *A Sweeper-Up after Artists: A Memoir* (New York: Thames & Hudson, 2003), 201.

45. Sandler, *A Sweeper-Up after Artists,* 202.

46. Alloway, *Systemic Painting*, 11.
47. Harold Rosenberg to Thomas B. Hess, December 1, 1966, Hess Papers.
48. Rosenberg to Hess, December 1, 1966, Hess Papers.
49. Danny Dries, "Editor's Letters," *ARTnews* 65, no. 7 (November 1966): 6.
50. Rosenberg to Hess, November 9 [1966], Hess Papers.
51. Thomas B. Hess to Harold Rosenberg, fall 1969, Rosenberg Papers.
52. Thomas B. Hess to Harold Rosenberg, fall 1969, "*ARTnews* Questionnaire," Rosenberg Papers.
53. Hess to Rosenberg, fall 1969, Rosenberg Papers.
54. Hess to Rosenberg, fall 1969, Rosenberg Papers.
55. Hess to Rosenberg, fall 1969, Rosenberg Papers.
56. Hess to Rosenberg, fall 1969, Rosenberg Papers.
57. Marvin Mudrick to Harold Rosenberg, August 12, 1969, Rosenberg Papers.
58. Marvin Mudrick, "Studying the Time," *ARTnews* 69, no. 1 (March 1970): 62.
59. Mudrick, "Studying the Time," 62.
60. Donald Barthelme to Thomas B. Hess, c. September 30, 1972, Hess Papers.
61. Hilton Kramer, "An Era in Art Comes to an End," *New York Times*, July 23, 1978, 23.
62. Henry Geldzahler, "New York Painting and Sculpture: 1940–1970," in *New York Painting and Sculpture: 1940–1970*, exh. cat. (New York: E. P. Dutton, 1970), 27.
63. Rosenberg, "École de New York," in Rosenberg, *The De-Definition of Art*, 189.
64. Rosenberg, "École de New York," in Rosenberg, *The De-Definition of Art*, 189.
65. Rosenberg, "École de New York," in Rosenberg, *The De-Definition of Art*, 190.
66. Rosenberg, "École de New York," in Rosenberg, *The De-Definition of Art*, 193.
67. Rosenberg, "École de New York," in Rosenberg, *The De-Definition of Art*, 193.
68. John Canaday, "Happy Birthday–Are You Relevant?" *New York Times*, October 12, 1969, 25.
69. Thomas B. Hess, "Editorial," *ARTnews* 68, no. 8 (December 1969): 23.
70. Geldzahler, "New York Painting and Sculpture: 1940–1970," 23.
71. Hess, "Editorial."
72. Hess, "Editorial."
73. Hess, "Editorial."
74. Rosenberg, "Reverence Is All," *ARTnews,* 68, no. 9 (January 1970); reprinted in Harold Rosenberg, *Discovering the Present: Three Decades in Art, Culture, and Politics* (Chicago: University of Chicago Press, 1973), 137.
75. Calvin Tomkins, "Profiles, Moving with the Flow," *New Yorker*, November 6, 1971, 58.
76. Tomkins, "Profiles, Moving with the Flow," 59.
77. Rosenberg, "École de New York," in Rosenberg, *The De-Definition of Art,* 190.
78. Rosenberg, "The Thirties," *New Yorker*, November 30, 1968; reprinted in Rosenberg, *The De-Definition of Art,* 183–84.
79. Rosenberg, "Reverence Is All," in Rosenberg, *Discovering the Present,* 137.
80. Rosenberg, "Reverence Is All," in Rosenberg, *Discovering the Present,* 135.

81. Harold Rosenberg, "History at the Met," *New Yorker*, November 8, 1975; reprinted in Rosenberg, *Art and Other Serious Matters*, 25.

82. Harold Rosenberg, "MoMA Package," *New Yorker*, November 1, 1976; reprinted in Rosenberg, *Art and Other Serious Matters*, 232.

83. Rosenberg, "MoMA Package," in Rosenberg, *Art and Other Serious Matters*, 230.

84. Rosenberg, "MoMA Package," in Rosenberg, *Art and Other Serious Matters*, 237.

85. Rosenberg, "MoMA Package," in Rosenberg, *Art and Other Serious Matters*, 235.

86. Robert Rosenblum to Harold Rosenberg, April 20, 1977, Rosenberg Papers.

87. Sanford Schwartz, "Trouble in Paradise," *Art in America*, January–February 1977, 103. O'Brien, "The Art Criticism of Harold Rosenberg," 449, has also noted that Schwartz assumed that Rosenblum had a major role in shaping McShine's thesis for *The Natural Paradise.*

88. Robert Rosenblum, "Letter to the Editor," *Art in America*, March–April 1977, 5.

89. Harold Rosenberg to Robert Rosenblum, May 1, 1977, Rosenberg Papers.

90. Rosenberg to Rosenblum, May 1, 1977, Rosenberg Papers.

91. Harold Rosenberg, "Fertile Fields," *New Yorker*, December 23, 1972; reprinted in Harold Rosenberg, *Art on the Edge* (Chicago: University of Chicago Press, 1983), 29.

92. Rosenberg, "Fertile Fields," in Rosenberg, *Art on the Edge,* 28.

93. Harold Rosenberg, "Dilemmas of a New Season," *New Yorker*, October 10, 1970; reprinted as "The Museum Today," in Rosenberg, *The De-Definition of Art*, 237.

94. John Hightower, in Rosenberg, "The Museum Today," in Rosenberg, *The De-Definition of Art*, 237.

95. Rosenberg, "The Museum Today," in Rosenberg, *The De-Definition of Art*, 239.

96. Rosenberg, "The Museum Today," in Rosenberg, *The De-Definition of Art*, 239.

97. Rosenberg, "The Museum Today," in Rosenberg, *The De-Definition of Art*, 238.

98. Rosenberg, "MoMA Package," in Rosenberg, *Art and Other Serious Matters*, 230.

99. See Rosenberg, "The Museum Today, in Rosenberg, *The De-Definition of Art*, 242, where he states that "the dilemma of the museum is that it takes its aesthetic stand on the basis of art history, which it is helping to liquidate."

100. Harold Rosenberg, "Young Masters, New Critics," *New Yorker*, May 9, 1970; reprinted as "Young Masters, New Critics: Frank Stella," in Rosenberg, *The De-Definition of Art*, 123.

101. Rosenberg, "Young Masters, New Critics: Frank Stella," in Rosenberg, *The De-Definition of Art*, 123.

102. Rosenberg, "Young Masters, New Critics: Frank Stella," in Rosenberg, *The De-Definition of Art*, 123.

103. Rosenberg, "Young Masters, New Critics: Frank Stella," in Rosenberg, *The De-Definition of Art*, 131.

104. Robert Hughes, *Time*, May 2, 1977, quoted in Harold Rosenberg, "Kenneth Noland," *New Yorker*, June 20, 1977; reprinted in Rosenberg, *Art and Other Serious Matters*, 117–24.

105. See Robert Hughes to Harold Rosenberg, 1964, Rosenberg Papers. Hughes wrote to Rosenberg from Venice where he traveled to attend the Venice Bienniale.

106. Robert Hughes, "Culture and the Broken Polity," in Robert Hughes, *Culture of Complaint: The Fraying of America* (Oxford: Oxford University Press, 1993), 70.

107. Robert Hughes, "Kramer v. Kramer," *New Republic*, April 14, 1986, www .newrepublic.com.

108. This lecture was sponsored by the Chicago New Art Association and the University of Chicago's Committee on Social Thought. Although planned as an annual series, it does not appear to have continued beyond this one event.

109. Robert Hughes, "Art and Money," *New Art Examiner*, October and November 1984; reprinted in Robert Hughes, *Nothing If Not Critical: Selected Essays on Art and Artists* (New York: Alfred A. Knopf, 1990), 401–2.

110. Rosenberg, "Kenneth Noland," in Rosenberg, *Art and Other Serious Matters*, 119.

111. Robert Hughes, "Multi-Culti and Its Discontents," in Hughes, *Culture of Complaint*, 113.

112. See Robert Hughes, *Things I Didn't Know: A Memoir* (New York: Alfred A. Knopf, 2006).

113. Richard Lacayo, "The Art of Being Critical: Robert Hughes (1938–2012)," *Time*, August 7, 2012, www.time.com.

114. There is little footage of Rosenberg on film. He did appear in an interview that Larry Rivers conducted with him on the WPA in 1977. See Rivers collection, Fales Library, New York University. Michael Blackwood, a documentary filmmaker, moreover, has footage of Rosenberg that he never used.

115. After an evenhanded review of Newman's posthumous retrospective at the Museum of Modern Art in 1971, Hughes reneged on his early, albeit tempered enthusiasm for Newman. See Robert Hughes, "Pursuit of the Sublime," *Time*, October 18, 1971, 66–69.

116. Robert Hughes, *American Visions* (New York: Alfred A. Knopf, 1997), 494.

117. Harold Rosenberg, *Barnett Newman: Broken Obelisk and Other Sculptures*, exh. cat. (Seattle: Henry Art Gallery and University of Washington Press, 1971), 15.

118. Harold Rosenberg, "Barnett Newman: A Man of Controversy and Spiritual Grandeur," *Vogue* 141, no. 3 (February 1963); reprinted as "Barnett Newman: The Living Rectangle," in Harold Rosenberg, *The Anxious Object* (Chicago: University of Chicago Press, 1966), 169.

119. Barnett Newman, "Interview with Dorothy Gees Seckler," *Art in America* 50, no. 2 (Summer 1962); reprinted in *Barnett Newman: Selected Writings and Interviews*, ed. John P. O'Neill (New York: Alfred A. Knopf, 1990), 251.

120. Hughes, *American Visions*, 493.

121. Barnett Newman to Harold Rosenberg, January 21, 1963; reprinted in *Barnett Newman: Selected Writings*, 222. This letter appeared in the same volume from which Hughes quoted Newman's reply to Rosenberg.

122. Rosenberg, "Barnett Newman: The Living Rectangle," in Rosenberg, *The Anxious Object*, 169.

123. Hughes, *American Visions*, 493.

124. Thomas B. Hess, *Barnett Newman*, exh. cat. (New York, Museum of Modern Art, 1971).

125. Harold Rosenberg, *Barnett Newman* (New York: Harry N. Abrams, 1978; reprinted 1994), 81. Much of his position on Hess's depiction of the cabalistic content of Newman's work grows out of a review of Hess, *Barnett Newman*. See Harold Rosenberg, "Meaning in Abstract Art (Continued)," *New Yorker*, January 1, 1972; reprinted as "Newman: Meaning in Abstract II," in Rosenberg, *Art on the Edge*, 50–59.

126. Barnett Newman to Walter Hopps, 1965; reprinted in *Barnett Newman: Selected Writings*, 186.

127. Barnett Newman, "Statement," in Newman, *Barnett Newman: Selected Writings*, 187.

128. Rosenberg, "Kenneth Noland," in Rosenberg, *Art and Other Serious Matters*, 122.

129. This is an assumption that I have made based on Rosenberg's and Reinhardt's intersecting chronologies.

130. Ad Reinhardt to Harold Rosenberg, 1967, Rosenberg Papers.

131. Harold Rosenberg, "Black and Pistachio," *New Yorker*, June 15, 1963; reprinted in Rosenberg, *The Anxious Object*, 53.

132. Mary Fuller, ed., "An Ad Reinhardt Monologue," *Artforum*, October 1970, 37.

133. Rosenberg, "Black and Pistachio," in Rosenberg, *The Anxious Object*.

134. Ad Reinhardt, "Art-as-Art"; reprinted in *Art-as-Art: The Selected Writings of Ad Reinhardt*, ed. Barbara Rose (Berkeley: University of California Press, 1975), 56. Typescript sent to Rosenberg. See *Art-as-Art*, Ad Reinhardt, 1962, Rosenberg Papers.

135. Reinhardt, in Rosenberg, "Black and Pistachio," in Rosenberg, *The Anxious Object*, 53.

136. Reinhardt, "Art-as-Art," in *Art-as-Art: The Selected Writings of Ad Reinhardt*, 54.

137. Ad Reinhardt to Harold Rosenberg, October 11, 1962, Rosenberg Papers.

138. Reinhardt, "Art-as-Art," in *Art-as-Art: The Selected Writings of Ad Reinhardt*, 55.

139. See for example, Reinhardt's review of George Kubler's *The Shape of Time*, "Art vs. History," *Art News* 65, no. 11 (January 1966); reprinted in *Art-as-Art: The Selected Writings of Ad Reinhardt*, 227.

140. Ad Reinhardt, "Black as Symbol and Concept," in *Art-as-Art: The Selected Writings of Ad Reinhardt*, 87.

141. Fuller, ed., "An Ad Reinhardt Monologue," 27.

142. Fuller, ed., "An Ad Reinhardt Monologue," 27.

143. Reinhardt, in Harold Rosenberg, "Purifying Art," *New Yorker*, February 1976; reprinted in Rosenberg, *Art and Other Serious Matters*, 73.

144. Ad Reinhardt, "The Artist in Search of an Academy, Part II: Who Are the Artists?," in *Art-as-Art: The Selected Writings of Ad Reinhardt*, 202.

145. Reinhardt, "The Artist in Search of an Academy, Part II: Who Are the Artists?," in *Art-as-Art: The Selected Writings of Ad Reinhardt*.

146. Rosenberg, "Black and Pistachio," in Rosenberg, *The Anxious Object,* 52.

147. On Reinhardt and his involvement with the CPUSA, see Michael Corris, *Ad Reinhardt* (London: Reaktion Books, 2008), 52–58.

148. Clement Greenberg, "Recentness of Sculpture," in *American Sculpture of the Sixties;* reprinted in *Clement Greenberg: The Collected Essays and Criticism,* ed. John O'Brian, 4 vols. (Chicago: University of Chicago Press, 1986–93), 4:255.

149. Tom Hess, who commissioned Reinhardt to update *How to Look at Modern Art in America* for *ARTnews* in 1961, was the first writer to collect his cartoons and comics into a volume, *The Art Comics and Satires of Ad Reinhardt,* exh. cat. (Düsseldorf: Kunsthalle, 1975). This publication came on the heels of his "The Art Comics of Ad Reinhardt," *Artforum,* April 1974, 45–51. The following year, Peter Schjeldahl brought out *Ad Reinhardt: Art Comics and Satires,* exh. cat. (New York: Truman Gallery), 1976.

150. Rosenberg, "Purifying Art," in Rosenberg, *Art and Other Serious Matters,* 77.

151. See Ad Reinhardt, "Art and Ethics," in *Art-as-Art: The Selected Writings of Ad Reinhardt,* 155.

152. Harold Rosenberg, "Defining Art," *New Yorker,* February 25, 1967, 33.

153. Richard Wollheim, 'Minimal Art"; reprinted in Gregory Battcock, ed., *Minimal Art: A Critical Anthology* (New York: E. P. Dutton, 1968), 387–99. Barbara Rose subsequently came out with "ABC Art"; reprinted in Battcock, *Minimal Art,* 274–97. For a discussion of Wollheim's article and its use by Rose, see James Meyer, *Minimalism: Art and Polemic in the Sixties* (New Haven: Yale University Press, 2001), 142–45.

154. Rosenberg, "Purifying Art," in Rosenberg, *Art and Other Serious Matters,* 97.

155. Bruce Glaser, "An Interview with Ad Reinhardt"; reprinted in Reinhardt, *Art-as-Art,* 19. Rosenberg also came to recognize that Mondrian was an influence on Reinhardt. See Rosenberg, "Purifying Art," in Rosenberg, *Art and Other Serious Matters,* 96.

156. Reinhardt, "Art-as-Art," in *Art-as-Art: The Selected Writings of Ad Reinhardt,* 56.

157. Reinhardt to Rosenberg, c. 1967, Rosenberg Papers.

158. Rosenberg, "Purifying Art," in Rosenberg, *Art and Other Serious Matters,* 77.

159. Reinhardt, "Art vs. History," in *Art-as-Art: The Selected Writings of Ad Reinhardt,* 225.

160. Harold Rosenberg, "Not Making It," *New Yorker,* October 16, 1971; reprinted as "Duchamp: Private and Public," in Rosenberg, *Art on the Edge,* 21.

161. Rosenberg, "Defining Art," 38.

162. Ad Reinhardt, "End," in *Art-as-Art: The Selected Writings of Ad Reinhardt,* 114.

163. Harold Rosenberg, "Meaning in Mondrian," *New Yorker,* November 20, 1971; reprinted as "Mondrian: Meaning in Abstract Art 1," in Rosenberg, *Art on the Edge,* 39.

164. Rosenberg, "Mondrian," in Rosenberg, *Art on the Edge,* 42.

165. Rosenberg, "Mondrian," in Rosenberg, *Art on the Edge,* 4.

166. For example, Barbara Rose in "ABC Art," 296, states that "Mondrian was certainly as much a mystic as Malevich. But it does seem unusual in America, where our art has always been so levelheaded and purposeful."

167. Rosenberg, in Harold Conant, "All about Everything," *Craft Horizons* (August 1975);

reprinted in Harold Rosenberg, *The Case of the Baffled Radical* (Chicago: University of Chicago Press, 1985), 220.

168. Harold Rosenberg, "L'histoire d'art touche à sa fin," *Preuves,* 1968; translated and reprinted as "Art and Its Double," in *Artworks and Packages* (New York: Delta Books, 1969), 23.

169. Rosenberg, "Duchamp: Private and Public," in Rosenberg, *Art on the Edge.*

170. Rosenberg, "Duchamp: Private and Public," in Rosenberg, *Art on the Edge.*

171. On the critical reception to Duchamp's work in the mid-1960s, see Francis Naumann, "Duchamp's Detractors," in *The Recurrent, Haunting Ghost: Essays on the Art, Life and Legacy of Marcel Duchamp* (New York: Readymade Press, 2014). Unlike Naumann, I do not consider Rosenberg as a "detractor" of the artist. Rather, his assessment of Duchamp was reflective and acknowledged Duchamp as a major twentieth-century figure. Duchamp may not have upheld Rosenberg's notion of *action,* but it did not delimit the critic's understanding of the way in which the artist attempted to steer art away from the marketplace by acting on his principles.

172. Thomas B. Hess, "J'accuse Marcel Duchamp," *ARTnews* 63, no. 10 (February 1965): 44.

173. Hess, "J'accuse Marcel Duchamp."

174. Susan Sontag, "Notes on 'Camp'"; reprinted in Sontag, *Against Interpretation and Other Essays* (New York: Farrar, Straus & Giroux, 1966), 290.

175. Sontag, "Notes on 'Camp,'" in Sontag, *Against Interpretation and Other Essays,* 277.

176. Sontag, "Notes on 'Camp,'" in Sontag, *Against Interpretation and Other Essays,* 277.

177. See Hilton Kramer, "Duchamp: Resplendent Triviality," *New York Times,* July 10, 1966, 93.

178. Kramer, "Duchamp: Resplendent Triviality."

179. Rosenberg, "Duchamp: Private and Public," in Rosenberg, *Art on the Edge,* 21.

180. Harold Rosenberg, in "The Homosexual in America," *Time,* January 21, 1966, www.time.com.

181. Sontag, "Notes on 'Camp,'" 290.

182. Harold Rosenberg, "Death in the Wilderness," *Midstream,* Summer, 1957; reprinted in Harold Rosenberg, *The Tradition of the New* (New York: Da Capo Press, 1994) 243.

183. Rosenberg, "Death in the Wilderness," in Rosenberg, *The Tradition of the New,* 243.

184. Rosenberg, "Death in the Wilderness," in Rosenberg, *The Tradition of the New,* 242–43. For an analysis of this article, see Jonathan Katz, "The Silent Camp: Queer Resistance and the Rise of Pop Art," www.queerculturalcenter.org.

185. Susan Sontag, *Reborn: Journals and Notebooks, 1947–1963,* ed. David Rieff (New York: Farrar, Straus & Giroux, 2008), 215.

186. Susan Sontag, *As Consciousness Is Harnessed to Flesh: Journals & Notebooks, 1964–1980,* ed. David Rieff (New York: Farrar, Straus & Giroux, 2013), 77.

187. Sontag, "Notes on 'Camp,'" 277.

188. Rosenberg, "Death in the Wilderness," in Rosenberg, *The Tradition of the New,* 255.

189. Rosenberg, "Death in the Wilderness," in Rosenberg, *The Tradition of the New,* 258.

190. Dwight Macdonald, "Masscult and Midcult," *Partisan Review*, Spring 1960; reprinted in Macdonald, *Masscult and Midcult: Essays against the American Grain*, ed. John Summers (New York: NYRB, 2011).
191. Sontag, *As Consciousness Is Harnessed*, 19.
192. Susan Sontag to Harold Rosenberg, c. 1963, Rosenberg Papers.
193. Rosenberg, in Sontag, *As Consciousness Is Harnessed*, 192.
194. Susan Sontag, "Fascinating Fascism," *New York Review of Books*, February 6, 1975; reprinted in Sontag, *Under the Sign of Saturn* (New York: Picador USA, 2002), 98.
195. Susan Sontag, *As Consciousness Is Harnessed to Flesh*, 41.
196. Sontag, *As Consciousness Is Harnessed to Flesh*, 407.
197. Sontag, *As Consciousness Is Harnessed to Flesh*, 93.
198. Sontag, *As Consciousness Is Harnessed to Flesh*, 89.
199. Susan Sontag, in Carl Rollyson and Lisa Paddock, *Susan Sontag: The Making of an Icon* (New York: W. W. Norton, 2000), 165.
200. Sontag, *As Consciousness Is Harnessed*, 425.
201. Rosenberg, "Duchamp: Private and Public," in Rosenberg, *Art on the Edge*, 11.
202. Rosenberg, "Duchamp: Private and Public," in Rosenberg, *Art on the Edge*, 21.

chapter 24

1. May Natalie Tabak, "A Collage," unpublished manuscript, n.d., Estate of May Natalie Tabak, 567.
2. Tabak, "A Collage," 568.
3. Tabak, "A Collage," 570.
4. Harold Rosenberg, "The American Art Establishment," *Esquire*, January 1965; reprinted in Harold Rosenberg, *Discovering the Present: Three Decades in Art, Culture, and Politics* (Chicago: University of Chicago Press, 1973), 114.
5. Philip Guston to Harold Rosenberg, undated letter from the 1970s, Harold Rosenberg Papers, Getty Research Institute.
6. See the letter of agreement sent from Milton Greenstein to Harold Rosenberg, December 14, 1973, Rosenberg Papers.
7. James Fitzsimmons to Harold Rosenberg, February 8, 1972, Rosenberg Papers.
8. See R. B. Woodings to Harold Rosenberg, March 21, 1975, Rosenberg Papers.
9. I throw this claim out lightly, as literary references to Melville, Kafka, and Whitman still appeared in his work.
10. Dostoyevsky was a figure to whom many mid-century writers gravitated, especially Philip Rahv, who wrote about the author as of the late 1940s. See George Cotkin, *Existential America* (Baltimore: Johns Hopkins University Press, 2003), 108–9. William Barrett, *The Truants: Adventures among the Intellectuals* (New York: Anchor Press/Doubleday, 1982), 172–75, also notes the widespread preoccupation with Dostoyevsky's proto-existential ideas in the work of Rahv and Delmore Schwartz.

11. See drafts for chapters on an unfinished book on Dostoyevsky in the Rosenberg Papers. The Getty Research Institute archive also contains an essay, "Dostoyevsky's Idea," which Rosenberg never published.

12. Harold Rosenberg, "Introduction" to *The Idiot*, trans. Henry and Olga Carlisle (New York: Signet Classic, 1969), viii. Published separately as "The Idiot: Second Century," *New Yorker*, October 5, 1968; reprinted as "A Psychological Case," in Harold Rosenberg, *Act and the Actor: Making the Self* (New York: World Publishing, 1970).

13. Rosenberg, "Introduction" to *The Idiot*, ix. Interestingly, Rosenberg notes that Dostoyevsky uses the phrase "field of action" (viii). This is the same phrase that William Carlos Williams used in 1949 to describe the state of American poetics.

14. Harold Rosenberg, "Thugs Adrift," *Partisan Review* 40, no. 3 (Summer 1973); reprinted in Harold Rosenberg, *The Case of the Baffled Radical* (Chicago: University of Chicago Press, 1976), 74.

15. Dostoyevsky, in Harold Rosenberg, "Up against the News," *New York Review of Books* 31 (October 1974); reprinted in Rosenberg, *The Case of the Baffled Radical*, 78.

16. Rosenberg, "Up against the News," in Rosenberg, *The Case of the Baffled Radical,* 78.

17. Harold Rosenberg, *Portraits: Richard Avedon* (New York: Farrar, Straus & Giroux, 1976); reprinted as "Portraits: A Meditation on Likeness," in Rosenberg, *The Case of the Baffled Radical*, 111.

18. Rosenberg, "Portraits: A Meditation on Likeness," in Rosenberg, *The Case of the Baffled Radical,* 121.

19. Rosenberg, "Up against the News," in Rosenberg, *The Case of the Baffled Radical.*

20. Harold Rosenberg, "The Intellectual and His Future," *New Yorker*, June 26, 1965; reprinted in Rosenberg, *Discovering the Present*, 190.

21. Rosenberg, "The Intellectual and His Future," in Rosenberg, *Discovering the Present*, 190.

22. Rosenberg, "The Intellectual and His Future," in Rosenberg, *Discovering the Present*, 190.

23. For a list of the seminars that Rosenberg gave at the University of Chicago, see *Graduate Programs in the Divisions, Announcements, 1967–1978* (Chicago: University of Chicago, 1967).

24. Michael Denneny, interview with the author, May 4, 2003. Joan Ullman Schwartz, in "My Harold Rosenberg: Saul Bellow Fictionalized My Love Affair—Here's My Version," August 9, 2012, Tabletmag.com, states that her former mother-in-law, Duffy Schwartz, a colleague of Rosenberg's at the American Ad Council, was responsible for his appointment. I abide by Denneny's recollection.

25. See Morris Philipson to Harold Rosenberg November 29, 1966, Rosenberg Papers.

26. *Graduate Programs in the Divisions*, 254.

27. *Graduate Programs in the Divisions*, 254.

28. Harold Rosenberg, "Missing Persons," *New York Times*, 1963; reprinted in Rosenberg, *Act and the Actor*, 201–2.

29. Rosenberg, "Missing Persons," in Rosenberg, *Act and the Actor*, 201–2.

30. Cornelia M. Borgerhoff to Harold Rosenberg, March 19, 1963, Seeley G. Mudd Manuscript Library, Princeton, New Jersey.

31. Harold Rosenberg to Edward T. Cone, February 19, 1962, Seeley G. Mudd Manuscript Library.

32. Harold Rosenberg, "The Art Object," *New Yorker*, August 10, 1963; reprinted as "The Art and the Esthetics of Impermanence," in Harold Rosenberg, *The Anxious Object* (Chicago: University of Chicago Press, 1966), 92.

33. Harold Rosenberg to Thomas Hess, October 22, 1966 Thomas Hess Papers, Archives of American Art, Smithsonian Institution.

34. Rosenberg to Hess, October 22, 1966, Hess Papers.

35. Rosenberg to Hess, October 22, 1966, Hess Papers.

36. Rosenberg to Hess, October 22, 1966, Hess Papers.

37. Michael Denneny, "Eulogy for Harold Rosenberg, New York Public Library," 1979, Michael Denneny Papers, Private Collection.

38. Denneny, "Eulogy for Harold Rosenberg" Denneny Papers.

39. Denneny, "Eulogy for Harold Rosenberg," Denneny Papers.

40. Denneny, "Eulogy for Harold Rosenberg," Denneny Papers.

41. Jonathan Fineberg, email to the author, January 30, 2015.

42. Shortly after his arrival in Chicago, Rosenberg was awarded an honorary doctorate of letters from Lake Forest College.

43. Jonathan Fineberg, interview with the author, January 30, 2015.

44. Harold Rosenberg to Mrs. Birdie Gold, February 13, 1968, Rosenberg Papers.

45. See Harold Rosenberg to Mrs. Birdie Gold, July 25, 1968, Rosenberg Papers.

46. Buzz Spector, interview with author, February 5, 2015.

47. Fineberg, email to author.

48. Saul Bellow to Richard Stern, August 11, 1966; reprinted in *Saul Bellow: Letters*, ed. Benjamin Taylor (New York: Viking, 2010), 265.

49. Vera Klement, "Harold Rosenberg: A Tribute," University of Chicago, 1979, Vera Klement Papers, Archives of American Art, Smithsonian Institution.

50. Harold Rosenberg to Marshall Hodgson, February 15, 1967, Rosenberg Papers.

51. Rosenberg to Hodgson, February 15, 1967, Rosenberg Papers.

52. Rosenberg to Hess, n.d., Hess Papers. It is hard to know who Rosenberg was referring to here as there is no mention of Greenberg in the published papers from the conference. See *The Arts and the Public*, ed. James E. Miller and Paul D. Herring (Chicago: University of Chicago Press, 1967). He must have been referring to remarks made during the colloquium.

53. Clement Greenberg, "The State of Art Criticism," *Partisan Review* 48, no. 1 (Winter 1981): 40.

54. See Gerald Freund to Harold Rosenberg, June 7, 1978, Rosenberg Papers.

55. Harold Rosenberg, "Spectators and Recruiters," in *The Arts and the Public*; reprinted in Rosenberg, *Discovering the Present*, 132.

56. Fineberg, interview with the author.

57. Fineberg was referring to Edward Maser and Frances Dowley.

58. Frank Lewis, interview with the author, January 30, 2015.

59. Remembered by Fineberg, email to the author.

60. To exemplify Rosenberg's understanding of academic politics, he commented in a letter to Edward Maser that "Kissler" had become the director of the Art History Department in 1974 through "intrigue and manipulation." He was referring to Herbert Kessler, a medievalist. Rosenberg's scorn was buttressed by keen understanding of the ways in which power was historically garnered. He had surely lobbied for Marx's *Eighteenth Brumaire of Louis Bonaparte* to be part of the "fundamentals list" so the text could serve as a model for the complex web of power that resulted in a dictatorship—Napoleon's coup d'état.

61. Spector, interview with the author.

62. Saul Bellow, "Harold Rosenberg," in *Abstract Expressionism: A Tribute to Harold Rosenberg: Paintings and Drawings from Chicago Collections*, exh. cat. (Chicago: David and Alfred Smart Gallery, 1979), n.p.

63. Saul Bellow, "What Kind of Day Did You Have?" reprinted in Bellow, *Him with His Foot in His Mouth and Other Stories* (Harmondsworth, UK: Penguin Books, 1998), 103.

64. Richard Stern, "Double Charley," in Stern, *Noble Rot: Stories 1949–1988* (Chicago: Another Chicago Press, 1989), 306–7.

65. Stern, "Double Charley," 307.

66. Bellow, "What Kind of Day Did You Have?" 64.

67. Bellow, "What Kind of Day Did You Have?" 67.

68. Bellow, "What Kind of Day Did You Have?" 69.

69. Bellow, "What Kind of Day Did You Have?" 63. Bellow's description of Rosenberg's affair, and his mistress, is based on Joan Ullman Schwartz. See Schwartz, "My Harold Rosenberg."

70. Stern, "Double Charley," 311.

71. See letters from the 1970s from May Natalie Tabak to Harold Rosenberg, Harold Rosenberg and May Natalie Tabak Papers, Archives of American Art, Smithsonian Institution.

72. Bellow, "What Kind of Day Did You Have?" 106.

73. Bellow, "What Kind of Day Did You Have?" 105.

74. Carol Brightman, ed., *Between Friends: The Correspondence of Hannah Arendt and Mary McCarthy, 1949–1975* (New York: Harcourt Brace, 1995), 81.

75. Brightman, ed., *Between Friends,* 76.

76. Susan Sontag, *As Consciousness Is Harnessed to Flesh: Journals & Notebooks, 1964–1980,* ed. David Rieff (New York: Farrar, Straus & Giroux, 2013), 467.

77. May Natalie Tabak, "Tabak," Rosenberg and Tabak Papers.

78. May Natalie Tabak, *But Not for Love* (New York: Horizon Press, 1960), 242.

79. May Natalie Tabak, "Mary McCarthy in the Look report on Vassar Alumnae," n.p., Rosenberg and Tabak Papers.

80. Tabak, "Mary McCarthy," Rosenberg and Tabak Papers.

81. Tabak, "Mary McCarthy," Rosenberg and Tabak Papers.

82. May Natalie Tabak, "If God Had Wanted a Woman to Be a Genius, He'd Have Made Her a Man," *Craft Horizons*, June 1978, 25, 68–69.

83. Harold Rosenberg, "Masculinity: Real and Put On," *Vogue* 150 (November 1967); reprinted as "Masculinity: Style and Cult," in Rosenberg, *Discovering the Present*, 47.

84. Harold Rosenberg, "The American Woman's Dilemma: Love, Self-Love, No Love," *Vogue* 149 (May 1967); reprinted as "The Erect Odalisque: Transcendence plus Liberation," in Rosenberg, *Discovering the Present*, 38.

85. Rosenberg, "The Erect Odalisque," in Rosenberg, *Discovering the Present*, 38.

86. Rosenberg, "The Erect Odalisque," in Rosenberg, *Discovering the Present*, 41.

87. Rosenberg, "The Erect Odalisque," in Rosenberg, *Discovering the Present*, 38.

88. Bellow, "What Kind of Day Did You Have?" 150. Schwartz, "My Harold Rosenberg," also corroborates this story.

89. Bellow, "What Kind of Day Did You Have?" 150.

90. Rosenberg, "Masculinity: Style and Cult," in Rosenberg, *Discovering the Present*, 47.

91. Rosenberg, "Masculinity: Style and Cult," in Rosenberg, *Discovering the Present*, 47.

92. Rosenberg, "Masculinity: Style and Cult," in Rosenberg, *Discovering the Present*, 47.

93. Harold Rosenberg, in "What Is Art? An Interview by Melvin M. Tumin with Harold Rosenberg," *Partisan Review* 45, no. 4 (Fall 1978); reprinted in Rosenberg, *The Case of the Baffled Radical*, 267.

94. Rosenberg, in "What Is Art? An Interview by Melvin M. Tumin with Harold Rosenberg," in Rosenberg, *The Case of the Baffled Radical*.

95. Rosenberg, in "What Is Art? An Interview by Melvin M. Tumin with Harold Rosenberg," in Rosenberg, *The Case of the Baffled Radical*, 268.

96. Allan Kaprow to Harold Rosenberg, August 10, 1968, Rosenberg Papers.

97. Allan Kaprow, video interview (Chicago: Data Bank, 1979).

98. Kaprow to Rosenberg, August 10, 1968, Rosenberg Papers.

99. Allan Kaprow, "The Legacy of Jackson Pollock"; reprinted in Kaprow, *Essays on the Blurring of Art and Life*, ed. Jeff Kelly (Berkeley: University of California Press, 2003), 2.

100. Kaprow, "The Legacy of Jackson Pollock," in Kaprow, *Essays on the Blurring of Art and Life*, 9.

101. Rosenberg, "The Art and Esthetics of Impermanence," in Rosenberg, *The Anxious Object*, 96.

102. Harold Rosenberg, "The Concept of Action in Painting," *New Yorker*, May 25, 1968; reprinted in Harold Rosenberg, *Artworks and Other Packages* (New York: Delta Books, 1969), 224.

103. Allan Kaprow, "Where art thou, sweet muse? (I'm hung up at the Whitney)," *Arts Magazine* 41, no. 4 (February 1967): 41.

104. Rosenberg, "The Concept of Action in Painting," in Rosenberg, *Artworks and Other Packages*, 226.

105. Allan Kaprow, "On the Way to Un-Art," in Kaprow, *Essays on the Blurring of Art and Life*, xxviii–xxix.

106. Allan Kaprow, "Just Doing," *TDR/The Drama Review* 41, no. 3 (Fall 1997); reprinted in Kaprow, *Essays on the Blurring of Art and Life*, 250.

107. Kaprow, "Just Doing," in Kaprow, *Essays on the Blurring of Art and Life*, 249.

108. John Dewey was a major influence on Kaprow's thinking. Dewey had written about "The Act of Expression" in *Art as Experience*, a text that Rosenberg also read.

109. On Guston's transition from abstraction to figurative painting, see Debra Bricker Balken, *Philip Guston's Poor Richard* (Chicago: University of Chicago Press, 2001), 92–97.

110. Hilton Kramer, "A Mandarin Pretending to Be a Stumblebum," *New York Times*, October 25, 1970, 22.

111. Philip Guston, in Harold Rosenberg, "On Cave Art, Church Art, Ethnic Art, and Art," *ARTnews*, December 1974; reprinted in Rosenberg, *The Case of the Baffled Radical*, 209.

112. Philip Guston, in Mark Stevens, "A Talk with Philip Guston," *New Republic*, March 15, 1980, 27.

113. Philip Guston to Dore Ashton, spring 1971, Dore Ashton Papers, Archives of American Art, Smithsonian Institution.

114. Philip Guston, in John Baur, *Nature in Abstraction*, exh. cat. (New York: Whitney Museum of American Art, 1958), 40.

115. Philip Guston, "Philip Guston Talking," in *Philip Guston: Paintings 1969–1980*, exh. cat. (London: Whitechapel Art Gallery, 1982), 52. For a discussion of these so-called self-portraits see Balken, *Philip Guston's Poor Richard*, 94–95.

116. Greenberg, "After Abstract Expressionism," *Art International*, October 25, 1962; reprinted in Greenberg, *Clement Greenberg: The Collected Essays and Criticism* (Chicago: University of Chicago Press, 1993), 4:124.

117. Harold Rosenberg, "Liberation from Detachment," *New Yorker*, November 7, 1970; reprinted in Harold Rosenberg, *The De-Definition of Art* (Chicago: University of Chicago Press, 1972), 134.

118. Rosenberg, "Liberation from Detachment," in Rosenberg, *The De-Definition of Art*, 140.

119. Rosenberg, "Liberation from Detachment," in Rosenberg, *The De-Definition of Art*, 140.

120. Rosenberg, "Liberation from Detachment," in Rosenberg, *The De-Definition of Art*, 140.

121. Rosenberg, "Being Outside," *New Yorker*, August 5, 1970; reprinted in Rosenberg, *Art and Other Serious Matters* (Chicago: University of Chicago Press, 1985), 270.

122. Rosenberg, "Being Outside," in Rosenberg, *Art and Other Serious Matters*, 271.

123. Rosenberg, "Being Outside," in Rosenberg, *Art and Other Serious Matters*, 272.

124. Noted by David Driskell, the curator of *Two Centuries of Black Art*, and cited by Rosenberg, "Being Outside," in Rosenberg, *Art and Other Serious Matters*, 276.

125. Rosenberg, "Being Outside," in Rosenberg, *Art and Other Serious Matters*, 272.

126. Harold Rosenberg, "Truth and the Academic Style," *Poetry* 49, no. 1 (October 1936): 50.

127. Rosenberg, "Being Outside," in Rosenberg, *Art and Other Serious Matters*, 277.

128. Rosenberg, "Being Outside," in Rosenberg, *Art and Other Serious Matters*, 275.

129. Rosenberg, "Being Outside," in Rosenberg, *Art and Other Serious Matters*, 271.

130. Rosenberg paraphrases the title of Nochlin's essay in "Being Outside," in Rosenberg, *Art and Other Serious Matters*, 273, when he asks, "Why are there no great black [Jewish, women] painters?"

131. Harold Rosenberg, "The American Action Painters," *Artnews* 51, no. 8 (December 1952): 22–23, 48–50; reprinted in Rosenberg, *The Tradition of the New* (New York: Da Capo, 1994), 30.

132. Harold Rosenberg, in Jonathan Fineberg, "Art of Our Time: Harold Rosenberg Interviewed," *Portfolio* 1, no. 1 (April–May 1979): 36.

bibliography

archival collections

Ad Council, University of Illinois, Urbana-Champaign
Archives of American Art, Smithsonian Institution
 Dore Ashton Papers
 The Club Records kept by Philip Pavia
 Joseph Cornell Papers
 Hugo Gellert Papers
 Harry Gottlieb Papers
 Werner and Yetta Groshans Papers
 Thomas B. Hess Papers
 Vera Klement Papers
 George L. K. Morris Papers
 Barnett Newman Papers
 Frank Perls Gallery Papers
 Jackson Pollock and Lee Krasner Papers
 Harold Rosenberg and May Natalie Tabak Papers
Saul Bellow Papers, University of Chicago Library
Janice Biala Papers, Estate of Janice Biala, New York
Kenneth Burke Papers, Pennsylvania State University Libraries
Michael Denneny Papers, Private Collection
George Dillon Papers, Syracuse University
James Farrell Papers, University of Pennsylvania Library
Clement Greenberg Papers, Getty Research Institute
H. R. Hays Letters, Berg Collection, New York Public Library
Dwight Macdonald Papers, Yale University Library
Jerre Mangione Papers, University of Rochester Library
Mercedes Matter Papers, Estate of Mercedes Matter
Mary McCarthy Papers, Vassar College Library
Harriet Monroe Papers, University of Chicago Library

Karlen Mooradian Archive, Diocese of the Armenian Church of America (Eastern), New York

Robert Motherwell Papers, Dedalus Foundation

Catrina Neiman Papers, Private Collection

Barnett Newman Papers, Barnett Newman Foundation

New Yorker Papers, New York Public Library

Charles Olson Papers, University of Connecticut, Storrs

Pagany Archives, University of Delaware Library, Newark

Partisan Review Papers, Howard Gotlieb Archival Research Center, Boston University

Poetry Magazine Papers, University of Chicago Library

Pollock-Krasner House Archives

Ezra Pound Papers, Beinecke Rare Book and Manuscript Library, Yale University

Charles van Ravensvaay Papers, Western Historical Manuscript Collection, University of Missouri, Columbia

Harold Rosenberg Papers, Getty Research Institute

Harry Roskolenko Papers, Syracuse University Library

Jack Tworkov Papers, Estate of Jack Tworkov, New York

Parker Tyler Papers, Harry Ransom Research Center, University of Texas at Austin

George Wittenborn Papers, Museum of Modern Art Archives and Library

WPA/Federal Writers Project Correspondence, National Archives and Records Administration, Washington, DC

Morton D. Zabel Papers, University of Chicago Library

archival sources

Cummings, Paul. Interview with John Coplans. April 4–August 4, 1977. Archives of American Art, Smithsonian Institution.

Cummings, Paul. Interview with George L. K. Morris. December 11, 1968. Archives of American Art, Smithsonian Institution.

Cummings, Paul. Interview with Robert Motherwell. November 24, 1971. Archives of American Art, Smithsonian Institution.

Cummings, Paul. Interview with Harold Rosenberg. Various dates. Archives of American Art, Smithsonian Institution.

Denneny, Michael. "Eulogy for Harold Rosenberg, New York Public Library" (1979). Unpublished manuscript. Denneny Papers.

Gruen, John. Interview with Harold and May Rosenberg. March 28, 1969. Archives of American Art, Smithsonian Institution.

Mooradian, Karlen. Interview with Harold Rosenberg. n.d. Karlen Mooradian Archive, Diocese of the Armenian Church of America (Eastern), New York.

Rosenthal, Raymond, and Moishe Ducovny. Interview with Harold Rosenberg.

1960. William E. Weiner Oral History Library of the American Jewish Committee.

Seckler, Dorothy. Interview with Harold Rosenberg. June 28, 1967, and July 8, 1968. Archives of American Art, Smithsonian Institution.

Tabak, May Natalie. "A Collage." Unpublished manuscript, n.d. Estate of May Natalie Tabak.

Tabak, May Natalie. Interview with Jeffrey Potter. July 27, 1982. Pollock-Krasner House Archives.

Tyler, Parker. "Acrobat in the Dark: A Metaphysical Autobiography," c. 1940. Unpublished manuscript. Tyler Papers, Harry Ransom Research Center, University of Texas at Austin.

books and articles

Aaron, Daniel. *Writers on the Left: Episodes in American Literary Communism*. New York: Harcourt, Brace & World, 1961.

Abel, Lionel. *The Intellectual Follies: A Memoir of the Literary Venture in New York and Paris*. New York: W. W. Norton, 1984.

Abel, Lionel. "New York City: A Remembrance." *Dissent* 8, no. 3 (Summer 1961): 251–59.

Abrams, Nathan. *Commentary Magazine, 1945–59: "A Journal of Significant Thought and Opinion."* London: Vallentine Mitchell, 2007.

Ackroyd, Peter. *T. S. Eliot: A Life*. New York: Simon & Schuster, 1984.

Ahern, Barry, ed. *Pound/Zukofsky: Selected Letters of Ezra Pound and Louis Zukofsky*. New York: New Directions, 1987.

Alloway, Lawrence. "Giddup, paint!" *Bookweek*, April 18, 1965, 12–14.

Alloway, Lawrence. "Personal Statement." *Ark* 19 (Spring 1957): n. p.

Arendt, Hannah. *Eichmann in Jerusalem: A Report on the Banality of Evil*. New York: Penguin Books, 1992.

Arendt, Hannah. *Essays in Understanding, 1930–1954*. Ed. Jerome Kohn. New York: Harcourt, Brace, 1994.

Arendt, Hannah. *The Jewish Writings*. Ed. Jerome Kohn and Ron H. Feldman. New York: Schocken Books, 2007.

Arendt, Hannah. "What Is Existenz Philosophy?" *Partisan Review* 13, no. 1 (Winter 1946): 3–56.

Aronson, Ronald. *Camus and Sartre: The Story of a Friendship and the Quarrel That Ended It*. Chicago: University of Chicago Press, 2003.

Ashton, Dore. "On Harold Rosenberg." *Critical Inquiry* 6 (Summer 1980): 615–24.

Atlas, James. *Bellow: A Biography*. New York: Modern Library, 2002.

Atlas, James. *Delmore Schwartz: Life of an American Poet*. New York: Farrar, Straus, Giroux, 1977.

Aurthur, Robert Alan. "Hitting the Boiling Point, Freakwise, at East Hampton." *Esquire*, June 1972, 94–95, 205.

Baigell, Matthew, and Julia Williams, eds. *Artists against War and Fascism: Papers of the First American Artists' Congress*. New Brunswick, NJ: Rutgers University Press, 1986.

Bakewell, Sarah. *At the Existentialist Café: Freedom, Being, and Apricot Cocktails*. New York: Other Press, 2016.

Balint, Benjamin. *Running Commentary: The Contentious Magazine That Transformed the Jewish Left into the Neoconservative Right*. New York: Public Affairs, 2010.

Balken, Debra Bricker. *Abstract Expressionism*. London: Tate Publishing, 2005.

Balken, Debra Bricker. *After Many Springs: Regionalism, Modernism, and the Midwest*. Exh. cat. Des Moines and New Haven: Des Moines Art Center and Yale University Press, 2009.

Balken, Debra Bricker. *Debating American Modernism: Stieglitz, Duchamp and the New York Avant-Garde*. Exh. cat. New York: American Federation of Arts and D.A.P., 2003.

Balken, Debra Bricker. "Harold Rosenberg and the American Action Painters." In *Action/Abstraction: Pollock, de Kooning and American Art, 1940–1976*. Exh. cat. New York and New Haven: Jewish Museum and Yale University Press, 2008, 205–14.

Balken, Debra Bricker. "Harold Rosenberg versus the Aesthetes." *Art in America* 101, no. 5 (May 2014): 49–52.

Balken, Debra Bricker. *John Marin: Modernism at Midcentury*. Exh. cat. Andover, MA, and New Haven, CT: Addison Gallery of American Art and Yale University Press, 2010.

Balken, Debra Bricker. *Mark Tobey, Threading Light*. Exh. cat. Andover, MA, and New York: Addison Gallery of American Art and Skira/Rizzoli Publications, 2017.

Balken, Debra Bricker. *Philip Guston's Poem-Pictures*. Exh. cat. Andover, MA, and Seattle: Addison Gallery of American Art and University of Washington Press, 1994.

Balken, Debra Bricker. *Philip Guston's Poor Richard*. Chicago: University of Chicago Press, 2001.

Balken, Debra Bricker, and Robert Lubar. *The Park Avenue Cubists*. Exh. cat. New York and London: Grey Art Gallery, New York University, and Ashgate, 2002.

Barr, Alfred. *The New American Painting: As Shown in Eight European Countries, 1958–59*. Exh. cat. New York: Museum of Modern Art, 1959.

Barrett, William. *The Truants: Adventures among the Intellectuals*. New York: Anchor Press/Doubleday, 1982.

Barrett, William. *What Is Existentialism?* New York: Grove Press, 1964.

Barthelme, Donald. *Not-Knowing: The Essays and Interviews.* Ed. Kim Herzinger. New York: Random House, 1997.

Battcock, Gregory, ed. *Minimal Art: A Critical Anthology.* New York: E. P. Dutton, 1968.

Baudelaire, Charles. *Painter of Modern Life and Other Essays.* Trans. and ed. Jonathan Mayne. London: Phaidon, 1964.

Beauvoir, Simone de. *America Day by Day.* Trans. Carol Cosman. Berkeley: University of California Press, 1999.

Beauvoir, Simone de. *Letters to Sartre.* Trans. and ed. Quintin Hoare. London: Radius, 1991.

Beauvoir, Simone de. "Pyrrhus and Cynéas." *Partisan Review* 13, no. 3 (Summer 1946): 330–37.

Belgrad, Daniel. *The Culture of Spontaneity: Improvisation and the Arts in Postwar America.* Chicago: University of Chicago Press, 1998.

Bellow, Saul. "Harold Rosenberg." In *Abstract Expressionism, a Tribute to Harold Rosenberg: Paintings and Drawings from Chicago Collections.* Exh. brochure. Chicago: David & Alfred Smart Gallery, 1979, n. p.

Bellow, Saul. *Him with His Foot in His Mouth and Other Stories.* Harmondsworth, UK: Penguin Books, 1984.

Bellow, Saul. *Saul Bellow: Letters.* Ed. Benjamin Taylor. New York: Viking, 2010.

Berkson, Bill. "Poet and Painter Coda." In Stephen C. Foster, ed., *Franz Kline: Art and the Structure of Identity.* Exh. cat. Barcelona: Fundació Tàpies, 1994.

Berkson, Bill, and Joe LeSueur, eds. *Homage to Frank O'Hara.* Bolinas, CA: Big Sky, 1988.

Blake, Casey Nelson. *Beloved Community: The Cultural Criticism of Randolph Bourne, Van Wyck Brooks, Waldo Frank and Lewis Mumford.* Chapel Hill: University of North Carolina Press, 1990.

Bloom, Alexander. *Prodigal Sons: The New York Intellectuals and Their World.* New York: Oxford University Press, 1986.

Bold, Christine. *The WPA Guides: Mapping America.* Jackson: University Press of Mississippi, 1999.

Books from the Rosenberg Library. New York: Glen Horowitz Bookseller, Inc., 1998.

Breslin, James. *Mark Rothko: A Biography.* Chicago: University of Chicago, 1993.

Brightman, Carol, ed. *Between Friends: The Correspondence of Hannah Arendt and Mary McCarthy, 1949–1975.* New York: Harcourt Brace, 1995.

Brightman, Carol, ed. *Writing Dangerously: Mary McCarthy and Her World.* New York: Clarkson Potter, 1992.

Burke, Kenneth. "The American Writers' Congress." *The Nation,* May 15, 1935, 571.

Burke, Kenneth. *Attitudes toward History.* Vol. 1. New York: New Republic, 1937.

Burke, Kenneth. "Counter Gridlock: An Interview with Kenneth Burke." *All Area* 2 (Spring 1983): 4–32.

Burke, Kenneth. *Counter-Statement*. 2d ed. Berkeley: University of California Press, 1986.

Burke, Kenneth. "'Henri Barbusse's Stalin': A New World Seen through One Man," *Book Union Bulletin*, November 1935, n. p.

Burke, Kenneth. "Thirty Years Later: Memories of the First American Writers' Congress." *American Scholar* 35, no. 3 (Summer 1966).

Burnham, James. "William Troy's Myths." *Partisan Review* 5, no 3 (August–September 1938): 65–68.

Camus, Albert. "Révolte et servitude." *Les Temps modernes* 80 (June 1952).

Carey, John. *The Intellectuals and the Masses: Pride & Prejudice among the Literary Intelligentsia, 1880–1939*. Chicago: Academy Chicago Publishers, 2002.

Chace, William M. *Lionel Trilling: Criticism and Politics*. Stanford, CA: Stanford University Press, 1980.

Coates, Robert. "The Art Galleries." *New Yorker*, March 30, 1946, 230.

Coates, Robert. "Assorted Moderns." *New Yorker*, December 23, 1944, 51.

Cohen, Milton A. "Stumbling into the Crossfire: William Carlos Williams." Special issue: *Partisan Review, and the Left in the 1930s. Journal of Modern Literature* 32, no. 2 (Winter 2009): 146–51.

Cookson, William, ed. *Ezra Pound: Selected Prose, 1909–1965*. New York: New Directions, 1950.

Cooney, Terry. *The Rise of the New York Intellectuals: Partisan Review and Its Circle, 1934–1945*. Madison: University of Wisconsin Press, 1986.

Cotkin, George. *Existential America*. Baltimore: Johns Hopkins University Press, 2003.

Cowley, Malcolm. "1935: The Year of Congresses." *Southern Review* 15 (Spring 1979): 277–87.

Cox, Annette. *Art as Politics: The Abstract Expressionist Avant-garde and Society*. Ann Arbor, MI: UMI Press, 1982.

Daugherty, Tracey. *Hiding Man: A Biography of Donald Barthelme*. New York: St. Martin's Press, 2009.

Davis, Stuart. "The New York American Scene in Art." *Art Front* 1 (February 1935): 6.

Dawson, Fielding. *The Black Mountain Book*. New York: Croton Press, 1970.

Denning, Michael. *The Cultural Front: The Laboring of American Culture in the Twentieth Century*. London: Verso, 1998.

Diamondstein, Barbaralee. *Inside New York's Art World*. New York: Rizzoli, 1979.

Donaldson, Scott. *Archibald MacLeish: An American Life*. Boston: Houghton Mifflin, 1992.

Donaldson, Scott. *John Cheever: A Biography*. New York: Random House, 1988.

Doob, Leonard W., ed. *"Ezra Pound Speaking": Radio Speeches of World War II*. Westport, CT: Greenwood Press, 1978.

Dorman, Joseph. *Arguing the World: The New York Intellectuals and Their Own Words*. Chicago: University of Chicago Press, 2001.

Edgar, Natalie, ed. *Club without Walls: Selections from the Journals of Philip Pavia.* New York: Midmarch Arts Press, 2007.

Eliot, T. S. *After Strange Gods: A Primer of Modern Heresy.* New York: Harcourt, Brace, 1934.

Eliot, T. S. *Notes Towards the Definition of Culture.* New York: Harcourt, Brace & Jovanovich, 1949.

Farrell, Jennifer. *The History and Legacy of Samuel M. Kootz and the Kootz Gallery.* Charlottesville: Fralin Museum of Art at University of Virginia, 2017.

Ferguson, Russell. *In Memory of My Feelings: Frank O'Hara and American Art.* Exh. cat. Los Angeles: Museum of Contemporary Art, 1999.

Fiedler, Leslie. "What Can We Do about Fagin? The Jew-Villain in Western Tradition." *Commentary* 8, no. 6 (May 1949): 411–18.

Fineberg, Jonathan. "Art of Our Time: Harold Rosenberg Interviewed." *Portfolio* 1, no. 1 (April–May 1979): 36.

Ford, Charles Henri. *Water from a Bucket: A Diary 1948–1957.* New York: Turtle Point Press, 2001.

Ford, Charles Henri, and Parker Tyler. *The Young and the Evil.* 2d ed. New York: Richard Kasak Book Edition, 1996.

Foster, Stephen C. *The Critics of Abstract Expressionism.* Ann Arbor, MI: UMI Research Press, 1980.

Fried, Michael. *Art and Objecthood: Essays and Reviews.* Chicago: University of Chicago Press, 1998.

Geldzahler, Henry. "New York Painting and Sculpture: 1940–1970." In *New York Painting and Sculpture: 1940–1970.* Exh. cat. New York: E. P. Dutton, 1970.

George, Ann, and Jack Selzer. *Kenneth Burke in the 1930s.* Columbia: South Carolina University Press, 2007.

George, Ann, and Jack Selzer. "What Happened at the American Writers' Congress? Kenneth Burke's 'Revolutionary Symbolism in America.'" *Rhetoric Society Quarterly* 33 (2003): 47–56.

Gibson, Ann Eden. *Issues in Abstract Expressionism: The Artist-Run Periodicals.* Ann Arbor, MI: UMI Research Press, 1990.

Godfrey, Mark. "That Oldtime Jewish Sect Called American Art Criticism." In *Action/Abstraction: Pollock, De Kooning, and American Art, 1940–1976.* Exh. cat. New York and New Haven: Jewish Museum and Yale University Press, 2008.

Gold, Michael. "The Moscow Trials: An Editorial." *New Masses,* February 9, 1937, 2.

Gooch, Brad. *City Poet: The Life and Times of Frank O'Hara.* New York: Alfred A. Knopf, 1993.

Goodnough, Robert, ed. *Artists' Sessions at Studio 35 (1950).* Chicago: Soberscove Press, 2009.

Gordon, Lyndall. *T. S. Eliot: An Imperfect Life.* New York: W. W. Norton, 1998.

Greenbaum, Leonard. *The Hound & Horn: The History of a Literary Quarterly.* The Hague: Mouton, 1966.

Greenberg, Clement. *Art and Culture: Critical Essays*. Boston: Beacon Press, 1961.

Greenberg, Clement. *Clement Greenberg: The Collected Essays and Criticism*. Ed. John O'Brian. 4 vols. Chicago: University of Chicago Press, 1986–93.

Greenberg, Clement. *The Harold Letters, 1928–1943: The Making of an Intellectual*. Washington, DC: Counterpoint, 2000.

Grief, Mark. *The Age of The Crisis of Man: Thought and Fiction in America, 1933–1973*. Princeton, NJ: Princeton University Press, 2015.

Griffith, Robert. "The Selling of America: The Advertising Council and American Politics, 1942–1960." *Business Historical Review* 57, no. 3 (Autumn 1983): 388–412.

Guilbaut, Serge. *How New York Stole the Idea of Modern Art, Abstract Expressionism, Freedom, and the Cold War*. Trans. Arthur Goldhammer. Chicago: University of Chicago Press, 1983.

Hall, James Baker. "Harold Baumbach." In *Harold Baumbach*. New York: Shock of Color Press, 2006.

Halpert, Stephen, and Richard Johns, eds. *A Return to Pagany: The History, Correspondence, and Selections from a Little Magazine, 1929–1932*. Boston: Beacon Press, 1969.

Hart, Henry, ed. *American Writers' Congress*. New York: International Publishers, 1935.

Hays, H. R. "In the American Tradition." *Poetry: A Magazine of Verse* 62, no. 6 (September 1943): 342.

Hays, H. R., and Harold Rosenberg. "Introduction to a Literary Review." *New Act: A Literary Review* 1 (January 1933): n. p.

Heilbut, Anthony. *Exiled in Paradise: German Refugee Artists and Intellectuals from the 1930s to the Present*. New York: Viking Press, 1983.

Hellstein, Valerie. "The Cage-iness of Abstract Expressionism." *American Art* 28, no. 1 (Spring 2014): 56–77.

Hemingway, Andrew. *Artists on the Left: American Artists and the Communist Movement, 1926–1956*. New Haven and London: Yale University Press, 2002.

Hemingway, Andrew. "Meyer Schapiro and Marxism in the 1930s." *Oxford Art Journal* 17, no. 1 (1994): 13–29.

Herbert, James D. *The Political Origins of Abstract Expressionist Art Criticism: The Early Theoretical and Critical Writings of Clement Greenberg and Harold Rosenberg*. Stanford, CA: Humanities Honors Program, Stanford University, 1985.

Herrera, Hayden. *Arshile Gorky, His Life and Work*. New York: Farrar, Straus & Giroux, 2003.

Hess, Thomas B. *Abstract Painting: Background and American Phase*. New York: Viking Press, 1951.

Hess, Thomas B. "Is Abstraction Un-American?" *ARTnews* 49, no. 10 (February 1951): 38–41.

Hess, Thomas B. "J'accuse Marcel Duchamp." *ARTnews* 63, no. 10 (February 1965): 44.

Hills, Patricia. "1936: Meyer Schapiro, *Art Front*, and the Popular Front." *Oxford Art Journal* 17, no. 1 (1994): 72–81.

Hines, Thomas Jensen. *Collaborative Form: Studies in the Relations of the Arts.* Kent, OH: Kent State University Press, 1991.

Hoban, Phoebe. *Alice Neel: The Art of Not Sitting Pretty.* New York: St. Martin's Press, 2010.

Hobbs, Robert. "Rosenberg's 'The American Action Painters' and Merleau-Ponty's Phenomenology." Paper presented at College Art Association, 2000.

Hoberman, J. "Harold Rosenberg's Magic Act." *Village Voice Supplement,* May 1986. Reprinted in Hoberman, *Vulgar Modernism: Writing on Movies and the Media.* Philadelphia: Temple University Press, 1991, 107–20.

Hoff, Lena. *Nicolas Calas and the Challenge of Surrealism.* Copenhagen: Museum Tusculanum Press, 2014.

Horkheimer, Max, and Theodor W. Adorno. *Dialectic of Enlightenment.* Trans. John Cummings. New York: Continuum, 1969.

Horten, Gert. *Radio Goes to War: The Cultural Politics of Propaganda during World War II.* Berkeley: University of California Press, 2002.

Howe, Irving. *A Margin of Hope: An Intellectual Biography.* New York: Harcourt, Brace, 1982.

Howe, Irving. "This Age of Conformity." *Partisan Review* 21, no. 2 (January–February 1954).

Hrebeniak. Michael. *Action Writing: Jack Kerouac's Wild Form.* Carbondale: Southern Illinois University Press, 2006.

Hughes, Robert. *Culture of Complaint: The Fraying of America.* Oxford: Oxford University Press, 1993.

Hughes, Robert. *Nothing If Not Critical: Selected Essays on Art and Artists.* New York: Alfred A. Knopf, 1990.

Jachec, Nancy. *The Philosophy and Politics of Abstract Expressionism, 1940–1960.* Cambridge,: University of Cambridge Press, 2000.

Jackall, Robert, and Janice M. Hirota. *Image Makers: Advertising, Public Relations, and the Ethos of Advocacy.* Chicago: University of Chicago Press, 2000.

Jeanson, Francis. "Albert Camus ou l'Ame révoltée." *Les Temps modernes* 78 (April 1952): 2070.

Jeffries, Stuart. *Grand Hotel Abyss: The Lives of the Frankfurt School.* London: Verso, 2016.

Jeneman, David. *Adorno in America.* Minneapolis: University of Minnesota Press, 2007.

Jewell, Edward Alden. "Toward Abstract or Away." *New York Times,* July 1, 1945, sec. X, 2.

Jones, Caroline A. *Eyesight Alone: Clement Greenberg's Modernism and the Bureaucratization of the Senses*. Chicago: University of Chicago Press, 2006.

Judt, Tony. *Past Imperfect: French Intellectuals, 1944–1956*. New York: New York University Press, 2011.

Julius, Anthony. *T. S. Eliot, Anti-Semitism, and Literary Form*. Cambridge: Cambridge University Press, 1995.

Jumonville, Neil. *Critical Crossings: The New York Intellectuals in Postwar America*. Berkeley: University of California Press, 1991.

Kaprow, Allan. *Essays on the Blurring of Art and Life*. Ed. Jeff Kelly. Berkeley: University of California Press, 2003.

Kaprow, Allan. "Where art thou, sweet muse? (I'm hung up at the Whitney)." *Arts Magazine* 41, no. 4 (February 1967): 41–48.

Karmel, Pepe, ed. *Jackson Pollock: Interviews, Articles, and Reviews*. New York: Museum of Modern Art, 1998.

Katz, Jonathan D. "The Silent Camp: Queer Resistance and the Rise of Pop Art." In Hans-Jörg Heuser and Kornelia Imesch, eds., *Visions of a Future: Art and History in Changing Contests*, 147–58. Zurich: Swiss Institute for Art Research, 2004.

Kazin, Alfred. *New York Jew*. New York: Alfred A. Knopf, 1978.

Kelder, Diane, ed. *Stuart Davis*. New York: Praeger, 1971.

Kelly, Daniel. *James Burnham and the Struggle for the World*. Wilmington, DE: ISI Books, 2002.

Kermode, Frank. "Tradition and the New Art: Interviews with Harold Rosenberg and Ernst Gombrich." *Partisan Review* 31, no. 2 (Spring 1964): 241–52.

Kiernan, Frances. *Seeing Mary Plain: A Life of Mary McCarthy*. New York: W. W. Norton, 2000.

Kim, Hee-Young. "The Tragic Hero: Harold Rosenberg's Reading of Marx's Drama of History." *Art Criticism* 20, no. 1 (2005): 7–21.

King, Richard H. *Arendt and America*. Chicago: University of Chicago Press, 2015.

Kleeblatt, Norman, ed. *Action/Abstraction: Pollock, De Kooning, and American Art, 1940–1976*. Exh. cat. New York and New Haven: Jewish Museum and Yale University Press, 2008.

Klinkowitz, Jerome. *Rosenberg, Barthes, Hassan: The Postmodern Habit of Thought*. Athens: University of Georgia Press, 1988.

Kootz, Samuel. *New Frontiers in American Painting*. New York: Hastings House, 1943.

Kramer, Hilton. "Duchamp: Resplendent Triviality." *New York Times*, July 10, 1966.

Kramer, Hilton. "The New American Painting." *Partisan Review* 20, no. 4 (July–August 1953): 421–27.

Kramer, Hilton. "RIP PR." *Bostonia*, Summer 2003, 3–6.

Kramer, Hilton. *The Triumph of Modernism: The Art World, 1985–2005*. Chicago: Ivan R. Dee, 2006.

Kramer, Hilton. *Twilight of the Intellectuals: Culture and Politics in the Era of the Cold War*. Chicago: Ivan R. Dee, 1999.

Krim, Seymour. "Remembering Harold Rosenberg." *Commentary*, November 1978, 65–67.

Kristol, Irving. *Reflections of a Neo-Conservative: Looking Back, Looking Ahead*. New York: Basic Books, 1983.

Kushner, Tony, and Alisa Solomon, eds. *Wrestling Zion: Progressive Jewish-American Responses to the Israeli-Palestinian Conflict*. New York: Grove Press, 2003.

Kurzke, Hermann. *Thomas Mann: A Life in Art*. Princeton, NJ: Princeton University Press, 2003.

Kurzweil, Edith. "William Phillips: A Partisan Memoir." *Provincetown Arts* 21 (2006–7): 103.

Kuspit, Donald. *The Critic as Artist: The Intentionality of Art*. Ann Arbor, MI: UMI Press, 1984.

Kuspit, Donald. "Two Critics: Thomas Hess and Harold Rosenberg." *Artforum*, September 1978, 32–33.

Landau, Ellen G., ed. *Reading Abstract Expressionism: Context and Critique*. New Haven: Yale University Press, 2005.

Landau, Ellen G. "To Be an Artist Is to Embrace the World in One Kiss." In Landau et al., *Mercedes Matter*. New York: MB Publishing, 2009.

Laskin, David. *Partisans: Marriage, Politics, and Betrayal among the New York Intellectuals*. New York: Simon & Schuster, 2000.

Leader, Zachary. *The Life of Saul Bellow: The Fame and Fortune, 1915–1964*. New York: Alfred A. Knopf, 2015.

"The League of American Artists." *Art Front*, December 1935, 13.

Léger, Fernand. "The New Realism." Trans. Harold Rosenberg. *Art Front*, December 1935, 10.

Lentricchia, Frank. *Criticism and Social Change*. Chicago: University of Chicago Press, 1983.

Levin, Gail. *Lee Krasner: A Biography*. New York: William Morrow, 2011.

Levy, Bernard-Henri. *Sartre: The Philosopher of the Twentieth Century*. Trans. Andrew Brown. Cambridge: Polity Press, 2003.

Logie, John. "WE WRITE FOR THE WORKERS": Authorship and Communism in Kenneth Burke and Richard Wright," *KB Journal* 1, no. 2 (Spring 2005): 1–43.

Lykins, Daniel L. *From Total War to Total Diplomacy: The Advertising Council and the Construction of the Cold War Consensus*. Westport, CT: Praeger, 2003.

Macdonald, Dwight. "The Bomb." *Politics*, September 1945.

Macdonald, Dwight. *Masscult and Midcult: Essays against the American Grain*. Ed. John Summers. New York: NYRB, 2011.

Macdonald, Dwight. "Reflections on a Non-Political Man." *Partisan Review* 6, no. 1 (Fall 1938): 15.

MacLeish, Archibald. *Archibald MacLeish: Reflections.* Ed. Bernard A. Drabeck and Helen E. Ellis. Amherst: University of Massachusetts Press, 1986.

MacLeish, Archibald. "In Challenge Not Defense." *Poetry Magazine* 52 (July 1938): 214–20.

Mangione, Jerre. *The Dream and the Deal: The Federal Writers' Project, 1935–1943.* Boston: Little, Brown, 1972.

Marek, Jayne E. *Women Editing Modernism: "Little" Magazines and Literary History.* Lexington: University of Kentucky Press, 1995.

Marquandt, Virginia Hagelstein. "Art on the Political Front in America: From *The Liberator* to *Art Front.*" *Art Journal* 52, no. 1 (Spring 1993): 72–81.

Marquis, Alice Goldfarb. *Art Czar: The Rise and Fall of Clement Greenberg.* Boston: MFA Publications, 2006.

Marx, Karl. *A Contribution to the Critique of Political Economy.* Trans. N. I. Stone. New York: International Library Publishing, 1904.

Mattson, Kevin. *Intellectuals in Action: The Origins of the New Left and Radical Liberalism, 1945–1970.* University Park: Pennsylvania State University Press, 2002.

McCarthy, Mary. "An Academy of Risk." *Partisan Review* 16, no. 3 (Summer 1959): 476–79.

McCarthy, Mary. "Ideas Were the Generative Force of His Life." *New York Times,* May 6, 1979, 30.

McCarthy, Mary. *The Oasis.* New York: Random House, 1949.

McIntosh, Sandy. "Remembering H. R. Hays." www.poetrybay.com/autumn2000. January 7, 2018.

McMillan, Douglas. *Transition: The History of a Literary Era, 1927–1938.* New York: George Braziller, 19.

Merleau-Ponty, Maurice. *Adventures of the Dialectic.* Trans. Joseph Bien. Evanston, IL: Northwestern University Press, 1973.

Merleau-Ponty, Maurice. "Cézanne's Doubt." *Partisan Review* 13, no. 4 (September–October 1946): 554–78.

Merleau-Ponty, Maurice. "Marxism and Philosophy." *Politics* 4 (July–August 1947): 174–78.

Merleau-Ponty, Maurice. "Le Yogi et le proletariat." *Les Temps modernes* 16 (January 1947): 676–711.

Miller, Dorothy. *15 Americans.* Exh. cat. New York: Museum of Modern Art, 1952.

Monroe, Gerald M. "Art Front." *Archives of American Art Journal* 13, no. 3 (1973): 13–19.

Monroe, Harriet. "Art and Propaganda." *Poetry: A Magazine of Verse* 44, no. 4 (July 1934): 62–64.

Monroe, Harriet. "The Open Door." *Poetry: A Magazine of Verse* 1, no. 2 (November 1912): 62–64.

Monroe, Harriet. "That Mass of Dolts." *Poetry: A Magazine of Verse* 1, no. 5 (February 1913): 110.

Moore, Marianne. *The Selected Letters of Marianne Moore.* Ed. Bonnie Costello. New York: Alfred A. Knopf, 1997.

Morgan, Robert, ed. *Clement Greenberg: Late Writings.* Minneapolis: University of Minneapolis Press, 2003.

Moser, Benjamin. *Sontag: Her Life and Work.* New York: Ecco, 2019.

Motherwell, Robert. *The Collected Writings of Robert Motherwell.* Ed. Stephanie Terenzio. Berkeley: University of California Press, 1999.

Motherwell, Robert, and Ad Reinhardt, eds. *Modern Artists in America.* New York: Wittenborn & Schultz, 1951.

Motherwell, Robert, and Harold Rosenberg. "Editorial Statement." *possibilities* 1 (1947): 1.

Myers, John Bernard. *Tracking the Marvelous: A Life in the Art World.* New York: Random House, 1983.

Naifeh, Steven, and Gregory White Smith. *Jackson Pollock: An American Saga.* New York: Clarkson N. Potter, 1989.

Naumann, Francis. *The Recurrent, Haunting Ghost: Essays on the Art, Life and Legacy of Marcel Duchamp.* New York: Readymade Press, 2014.

Neiman, Catrina, and Paul Nathan, comps. *View, Parade of the Avant-Garde: An Anthology of View Magazine 1940–1947.* New York: Thunder's Mouth Press, 1991.

Nelson, Deborah. *Tough Talk: Arbus, Arendt, Didion, McCarthy, Sontag, Weil.* Chicago: University of Chicago Press, 2017.

Newman, Amy. *Challenging Art: Artforum 1962–1974.* New York: Soho Press, 2000.

Newman, Barnett. *Barnett Newman: Selected Writings and Interviews.* Ed. John O'Neill. New York: Alfred A. Knopf, 1990.

Norman, Charles, ed. *The Case of Ezra Pound.* New York: Bodley Press, 1948.

O'Brien, Elaine. "The Art Criticism of Harold Rosenberg: Theaters of Love and Combat." PhD diss., City University of New York, 1997.

O'Hara, Frank. *Art Chronicles, 1954–1966.* New York: George Braziller, 1974.

O'Hara, Frank. *The Collected Poems of Frank O'Hara.* New York: Alfred A. Knopf, 1995.

O'Hara, Frank. *Jackson Pollock.* New York: George Braziller, 1959.

Olin, Margaret. "C[lement] G[reenberg] and Company: Formalist Criticism and Jewish Identity." In Norman Kleeblatt, ed., *Too Jewish? Challenging Traditional Identities.* Exh. cat. New York and New Brunswick, NJ: Jewish Museum and Rutgers University Press, 1996.

Olson, Charles. *Collected Prose.* Ed. Robert Creeley. New York: New Directions, 1950.

O'Neill, John, ed. *Clyfford Still.* Exh. cat. New York: Metropolitan Museum of Art, 1979.

Orton, Fred, and Griselda Pollock. *Avant-Gardes and Partisans Reviewed.* Manchester: University of Manchester Press, 1996.

Parisi, Joseph, and Stephen Young, comps. and eds. *Dear Editor: A History of Poetry in Letters: The First Fifty Years, 1912–1962*. New York: W. W. Norton, 2002.

Pavia, Philip. "The Unwanted Title: Abstract Expressionism." *It Is*, Spring 1960, 8–11.

Penkower, Monty Noam. *The Federal Writer's Project: A Study in Government Patronage of the Arts*. Urbana: University of Illinois Press, 1977.

Perl, Jed. *New Art City: Manhattan at Midcentury*. New York: Alfred A. Knopf, 2005.

Perloff, Marjorie. *Frank O'Hara: Poet among Painters*. Austin: University of Texas Press, 1977.

Phillips, William. *The Partisan Reader: Ten Years of Partisan Review, 1934–1944: An Anthology*. New York: Dial Press, 1944.

Phillips, William. *A Partisan View: Five Decades of the Literary Life*. New York: Stein & Day, 1983.

Phillips, William. "Private Experience and Public Philosophy." *Poetry: A Magazine of Verse* 48, no. 2 (May 1936): 98–104.

Phillips, William. "Thomas Mann: Humanism in Exile." *Partisan Review* 4, no. 6 (May 1938): 3–10.

Phillips, William, and Philip Rahv, eds. "Our Country and Our Culture." *Partisan Review* 19, no. 3 (May 1952): 282–386.

Podhoretz, Norman. *Breaking Ranks*. New York: Harper & Row, 1979.

Podhoretz, Norman. *Ex-Friends*. New York: Free Press, 1999.

Podhoretz, Norman. *Making It*. New York: Random House, 1967.

Poirier, Agnès. *Left Bank: Art, Passion, and the Rebirth of Paris, 1940–50*. New York: Henry Holt, 2018.

Polizzotti, Mark. *Revolution of the Mind: The Life of André Breton*. Boston: Black Widow Press, 2009.

Pollock, Jackson. "My Painting." *possibilities* 1, no. 1 (Winter 1947–48): 78.

Porter, Arabel J., and Andrew J. Dvosin, eds. *Essays on Literature and Politics*. Boston: Houghton Mifflin, 1978.

Potter, Jeffrey. *To a Violent Grave: An Oral Biography of Jackson Pollock*. New York: G. P. Putnam, 1985.

Pound, Ezra. *Active Anthology*. London: Faber & Faber, 1933.

Pound, Ezra. *Profiles*. Milan, 1932.

Pound, Ezra. "To Whistler, American." *Poetry: A Magazine of Verse* 1, no. 1 (1912): 14.

Power, Kevin, and Robert Creeley. *Robert Creeley's Life and Work: A Sense of Increment*. Ed. John Wilson. Ann Arbor: University of Michigan Press, 1987.

Rahv, Philip, ed. *The Great Short Stories of Henry James*. New York: Dial Press, 1944.

Ratcliff, Carter. *The Fate of a Gesture: Jackson Pollock and Postwar Art*. New York: Farrar, Straus & Giroux, 1996.

Read, Herbert. "The Apollinaire of Action Painting." *The Shavian, Journal of the Shaw Society* 15 (June 1959): 22.

Reidel, James. *Vanished Act: The Life and Art of Weldon Kees*. Lincoln: University of Nebraska Press, 2003.

Reinhardt, Ad. *Art-as-Art: The Selected Writings of Ad Reinhardt*. Ed. Barbara Rose. Berkeley: University of California Press, 1975.

Reino, Joseph. *Karl Shapiro*. Boston: Twayne Publishers, 1981.

Rimbaud, Arthur. *Some Poems of Rimbaud*. Trans. Lionel Abel. New York: Exile's Press, 1939.

Robbins, Christa Noel. "Harold Rosenberg and the Character of Action." *Oxford Art Journal* 35, no. 2 (2012): 195–214.

Rohn, Matthew. "'Action Painting' and American Poetics." Paper presented at College Art Association, 2000.

Rosenberg, Harold. *Aaron Siskind: Photographs*. New York: Horizon Press, 1959.

Rosenberg, Harold. *Act and the Actor: Making the Self*. New York: World Publishing, 1970.

Rosenberg, Harold. "Aesthetic Assault." *New Masses*, March 30, 1937, 25.

Rosenberg, Harold. "The American Writers' Congress." *Poetry, A Magazine of Verse* 46, no. 4 (July 1935): 222–25.

Rosenberg, Harold. *The Anxious Object*. Chicago: University of Chicago Press, 1966.

Rosenberg, Harold. *Arshile Gorky: The Man, the Time, the Idea*. New York: Sheepmeadow Press, 1962.

Rosenberg, Harold. *Art and Other Serious Matters*. Chicago: University of Chicago Press, 1985.

Rosenberg, Harold. *Art on the Edge*. Chicago: University of Chicago Press, 1975.

Rosenberg, Harold. *Artworks and Packages*. New York: Delta Books, 1969.

Rosenberg, Harold. "The Audience as Subject." *Forum* 3, no. 3 (Fall 1959): 31.

Rosenberg, Harold. *Barnett Newman*. New York: Harry N. Abrams, 1978.

Rosenberg, Harold. *Barnett Newman: Broken Obelisk and Other Sculptures*. Exh. cat. Seattle: Henry Art Gallery and the University of Washington Press, 1971.

Rosenberg, Harold. "Breton: A Dialogue." *View* 2 (May 1942): 18.

Rosenberg, Harold. "The Case of Absolute Collaboration." *Blues* 9 (Fall 1930): 13.

Rosenberg, Harold. *The Case of the Baffled Radical*. Chicago: University of Chicago Press, 1985.

Rosenberg, Harold. "Counter-Statement" and "The Human Parrot and Other Essays." *Symposium* 111, no. 1 (January 1932): 117–18.

Rosenberg, Harold. "The Creation of an Identity." *Commentary* 1, no. 1 (November 1945): 92–94.

Rosenberg, Harold. "Cubism and Abstract Art." *Art Front*, June 1936, 15.

Rosenberg, Harold. *The De-definition of Art*. Chicago: University of Chicago Press, 1972.

Rosenberg, Harold. *De Kooning*. New York: Abrams, 1973.

Rosenberg, Harold. *Discovering the Present: Three Decades in Art, Culture, and Politics*. Chicago: University of Chicago Press, 1973.

Rosenberg, Harold. "The Education of John Reed." *Partisan Review & Anvil* 111, no. 5 (June 1936): 29–33.

Rosenberg, Harold. "Elegiac with a Difference." *Poetry: A Magazine of Verse* 39, no. 1 (December 1913): 158–61.

Rosenberg, Harold. "A Fairy Tale." *transition* 19–20 (June 1930): 264–69.

Rosenberg, Harold. "The God in the Car." *Poetry: A Magazine of Verse* 52, no. 6 (September 1938): 336.

Rosenberg, Harold. *The Intrasubjectives*. Exh. cat. New York: Samuel Kootz Gallery, 1949.

Rosenberg, Harold. "Introduction to Six American Artists." In *Six American Artists*. Exh. brochure. Paris: Galerie Maeght, 1947, n. p.

Rosenberg, Harold. "Literature without Money." Special issue: *American Stuff. Direction* 3 (1938): 9.

Rosenberg, Harold. "The Messenger." *Instead* 7 (n.d.): n.p.

Rosenberg, Harold. "Myth and History." *Partisan Review* 6, no. 2 (December 1939): 19–38.

Rosenberg, Harold. "New Painting: Old Song and Dance." *Antioch Review* 14, no. 2 (June 1954): 252–58.

Rosenberg, Harold. "Note on Class Conflict in Literature." *New Act: A Literary Review* 1 (January 1933): 9.

Rosenberg, Harold. "Notes on Identity: With Special Reference to the Mixed Philosopher, Soren Kierkegaard." *View* 6, no. 3 (May 1946): 7–8, 24.

Rosenberg, Harold. "On the Art of Escape." *View*, April 1943, 27.

Rosenberg, Harold. "Paul Goodman, 1911–1972." *Dissent* 20, no. 1 (Winter 1973): 3.

Rosenberg, Harold. "Peasants and Pure Art." *Art Front*, January 1936, 5–6.

Rosenberg, Harold. "Poets of the People." *Partisan Review* 3, no. 6 (October 1936): 21–26.

Rosenberg, Harold. "Prayer for a Prayer." *Pagany* 2, no. 2 (Spring 1931): 56–57.

Rosenberg, Harold. "The Profession of Poetry, or, Trails through the Night of M. Maritain." *Partisan Review* 9, no. 5 (September–October 1942): 413–17.

Rosenberg, Harold. "A Relative Case of Collaboration." *Blues: A Magazine of New Rhythms* 9 (Fall 1930): 11–17.

Rosenberg, Harold. "Reverence Is All." *ARTnews* 68, no. 9 (January 1970): 27.

Rosenberg, Harold. "Sanity, Individuality and Poetry." *New Act: A Literary Review* 2 (June 1933): 61–65.

Rosenberg, Harold. *The Tradition of the New*. New York: Da Capo, 1994.

Rosenberg, Harold. *Trance above the Streets*. New York: Gotham Books, 1942.

Rosenberg, Harold. "Truth and the Academic Style." *Poetry: A Magazine of Verse* 49, no. 1 (October 1936): 49–51.

Rosenberg, Harold. "What We Demand." *New Masses*, March 23, 1937, 17.

Rosenberg, Harold. "The Wit of William Gropper." *Art Front*, March 1936, 8.

Roskolenko, Harry. "Harold Rosenberg: 1906–1978." *Art International* 22 (September 1979): 62–63.

Roskolenko, Harry. *When I Was Last on Cherry Street*. New York: Stein & Day, 1965.

Rothko, Mark. *The Artist's Reality: Philosophies of Art*. New Haven: Yale University Press, 2001.

Rowley, Hazel. *Richard Wright: The Life and Times*. New York: Henry Holt, 2001.

Roza, Mathilde H. *Following Strangers, The Life and Literary Works of Robert M. Coates*. Columbia: University of South Carolina Press, 2011.

Rubenfeld, Florence. *Clement Greenberg: A Life*. New York: Scribner, 1997.

Russell, John. "Harold Rosenberg Is Dead at 72, Art Critic for the *New Yorker*." *New York Times*, July 12, 1978.

Sandler, Irving. *A Sweeper-Up after Artists: A Memoir*. New York: Thames & Hudson, 2003.

Sartre, Jean-Paul. *Anti-Semite and Jew*. Trans. George J. Becker. New York: Schocken Books, 1948.

Sartre, Jean-Paul. *Being and Nothingness*. Trans. Hazel E. Barnes. New York: Washington Square Press, 1984.

Sartre, Jean-Paul. *The Communists and Peace, with A Reply to Claude Lefort*. Trans. Martha H. Fletcher and Philip Berk. New York: George Braziller, 1968.

Sartre, Jean-Paul. "The Nationalization of Literature." *Les Temps modernes*, November 1, 1945. Trans. Lincoln Kirsten and S. P. Bovie, and reprinted in *View* 2–3 (March 1946).

Sartre, Jean-Paul. *No Exit and Three Other Plays*. New York: Vintage International, 1989.

Sartre, Jean-Paul. *What Is Literature? and Other Essays*. Cambridge, MA: Harvard University Press, 1988.

Saunders, Frances Stonor. *The Cultural Cold War: The CIA and the World of Arts and Letters*. New York: New Press, 1999.

Sawin, Martica. *Surrealism in Exile, and the Beginnings of the New York School*. Cambridge, MA: MIT Press, 1995.

Schapiro, Lillian Milgram, comp. *Meyer Schapiro: The Bibliography*. New York: George Braziller, 1995.

Schapiro, Meyer. "Race, Nationality, and Art." *Art Front*, March 1936.

Schlesinger, Arthur M. *The Vital Center: The Politics of Freedom*. Boston; Houghton, Mifflin, 1949.

Schwartz, Delmore. *Portrait of Delmore Schwartz: Journals and Notes of Delmore Schwartz, 1939–1959*. Ed. Elizabeth Pollet. New York: Farrar, Straus, Giroux, 1986.

Shapiro, David, and Cecile Shapiro, eds. *Abstract Expressionism: A Critical Record*. New York: Cambridge University Press, 1960.

[Shawn, William]. "Harold Rosenberg." *New Yorker*, July 24, 1978, 80.

Sickels, Eleanor M. "Archibald MacLeish and American Democracy." *American Literature* 15, no. 3 (1943): 230–32.

Siegel, Paul, ed. *Leon Trotsky on Literature and Art*. New York: Pathfinder Press, 1970.

Slifkin, Robert. *Out of Time: Philip Guston and the Refiguration of Postwar American Art*. Berkeley: University of California Press, 2013.

Solomon, Deborah. *Jackson Pollock: A Biography*. New York: Cooper Square Press, 2001.

Sontag, Susan. *Against Interpretation and Other Essays*. New York: Farrar, Straus & Giroux, 1966.

Sontag, Susan. *As Consciousness Is Harnessed to Flesh: Journals & Notebooks, 1964–1980*. Ed. David Rieff. New York: Farrar, Straus & Giroux, 2013.

Sontag, Susan. *Reborn: Journals and Notebooks, 1947–1963*. Ed. David Rieff. New York: Farrar, Straus & Giroux, 2008.

Soussloff, Catherine, ed. *Jewish Identity in Modern Art History*. Berkeley: University of California Press, 1999.

Stern, Richard. *Noble Rot: Stories 1949–1988*. Chicago: Another Chicago Press, 1989.

Stevens, Mark, and Annalyn Swan. *De Kooning: An American Master*. New York: Alfred A. Knopf, 2004.

Stevens, Wallace. *The Necessary Angel: Essays on Reality and the Imagination*. New York: Alfred A. Knopf, 1951.

Stewart, Jon, ed. *The Debate between Sartre and Merleau-Ponty*. Evanston, IL: Northwestern University Press, 1998.

Swallow, Alan. "A Review of Some Current Poetry." *New Mexico Poetry* 13, no. 2 (Summer 1943): 217.

Sweeney, James Johnson. "Art Chronicle." *Partisan Review* 21, no. 1 (Spring 1945): 241–42.

Tabak, May Natalie. "My Grandmother Had Yichus." *Commentary*, April 1949, 368–72.

Tabak, May Natalie. "Parker Tyler." *Christopher Street* 1, no. 8 (February 1977): 41–44.

Tashjian, Dickran. *A Boatload of Madman: Surrealism and the American Avant-Garde, 1920–1950*. New York: Thames & Hudson, 1995.

Tate, Allen. *Stonewall Jackson: The Good Soldier*. New York: Minton, Balch & Co., 1928.

Tate, Allen, ed. *T. S. Eliot: The Man and His Work*. New York: Delacorte Press, 1966.

Taylor, Michael, ed. *Arshile Gorky, A Retrospective*. Exh. cat. Philadelphia: Philadelphia Museum of Art, 2009.

Trilling, Diana. *The Beginnings of the Journey: The Marriage of Diana and Lionel Trilling*. New York: Harcourt, Brace, 1993.

Troy, William. "Thomas Mann: Myth and Reason." *Partisan Review* 5, nos. 1–2 (June–July 1938): 24–32, 51–64.

Tuchman, Phyllis. *Robert Motherwell: The East Hampton Years, 1944–1952.* Exh. cat. East Hampton, NY: Guild Hall, 2014.

Tyler, Francine. "Artists Respond to the Great Depression and the Threat of Fascism: The New York Artists' Union and Its Magazine 'Art Front' (1934–1937)." PhD diss., New York University, 1991.

Tyler, Parker. *Every Artist His Own Scandal: A Study of Real and Fictive Heroes.* New York: Horizon Press, 1964.

Tyler, Parker. *The Hollywood Hallucination.* New York, 1942.

Tyler, Parker, ed. *Modern Things.* New York: Gallen Press, 1934.

Vaisee, Justin. *Neoconservatism: The Biography of a Movement.* Trans. Arthur Goldhammer. Cambridge, MA: Belknap Press of Harvard University Press, 2010.

Wald, Alan. *The Rise and Decline of the Anti-Stalinist Left from the 1930s to the 1980s.* Chapel Hill: University of North Carolina Press, 1987.

Wall, Wendy L. *Inventing the "American Way": The Politics of Consensus from the New Deal to the Civil Rights Movement.* New York: Oxford University Press, 2008.

Welish, Marjorie. "Harold Rosenberg: Transforming the Earth." *Art Criticism* 2, no. 1 (1985): 10–28.

Wheatland, Thomas. *The Frankfurt School in Exile.* Minneapolis: University of Minnesota Press, 2009.

Williams, Ellen. *Harriet Monroe and the Poetry Renaissance: The First Ten Years of Poetry, 1912–22.* Urbana: University of Illinois Press, 1977.

Williams, William Carlos. "A Fault of Learning." *Partisan Review* 10, no. 5 (September–October 1943): 466–68.

Williams, William Carlos. *The Selected Essays of William Carlos Williams.* New York: Random House, 1954.

Williams, William Carlos. *The Selected Letters of William Carlos Williams.* Ed. John C. Thirwall. New York: New Directions, 1957.

Williams, William Carlos. *Something to Say: William Carlos Williams.* Ed. James Breslin. New York: New Directions, 1985.

Winchell, Mark Royden. *"Too Good to Be True": The Life and Work of Leslie Fiedler.* Columbia: University of Missouri Press, 2002.

Winkenweder, Brian. "Art History, Sartre, and Identity in Rosenberg's America." *Art Criticism* 13 (1998): 10–28.

Witemeyer, Hugh, ed. *Pound/Williams: Selected Letters of Ezra Pound and William Carlos Williams.* New York: New Directions, 1996.

Wolfe, Tom. *The Painted Word.* New York: Bantam, 1976.

Wreszin, Michael, *A Rebel in Defense of Tradition: The Life and Politics of Dwight Macdonald.* New York: Basic Books, 1994.

Wright, Richard. *American Hunger*. New York: Harper & Row, 1945.

Wright, Richard. "I Tried to Be A Communist." *Atlantic Monthly* 174, nos. 2–3 (August–September 1944): 61–70, 48–56.

Yau, John. "The Poet as Art Critic." *American Poetry Review* 34, no. 3 (May–June 2005): 40–50.

Young-Bruehl, Elizabeth. *Hannah Arendt: For the Love of the World*. New Haven: Yale University Press, 1982.

Zukofsky, Louis. *Autobiography*. New York: Privately printed, 1971.

Zukofsky, Louis. "Sincerity and Objectification." *Poetry, A Magazine of Verse* 37, no. 5 (February 1931): 273–75.

illustration credits

index

Page numbers in italic indicate figures.

Dadaism, 116, 241–43, 388

The Dada Painters and Poets anthology (Motherwell), 240, 242–43

Daiches, David, 293

Daily Worker, 56, 98, 111–12

Dalí, Salvador, 80, 82, 215, 219–20, 223, 226, 531n.19

Darkness at Noon (Koestler), 140–41, 258–59

Daughters of the American Revolution, 168

David, Jacques-Louis, 428

Davis, Gene, 383

Davis, Stuart: American Artists' Congress and, 89; American Communist Party and, 64, 70; as *Art Front* editor, 78–82, 86–87, 89, 91, 502n.17; billboard art and, 349; Gorky and, 81; Greenberg and, 93; on Léger, 83–85, 503n.35; Rosenberg and, 110, 286; success of, 56

Dawson, Fielding, 191

Death and Taxes (Parker), 30, 491n.15

"Death in the Wilderness" (Rosenberg), 210–11, 448–49

Death in Venice (Mann), 125

De Beauvoir, Simone, 139; Camus and, 544n.53; existentialism and, 264, 266, 280; on *Partisan Review*, 256, 258–62; Rosenberg and, 225–26, 280, 286, 394, 540n.17

Debs, Eugene, 213

De Gaulle, Charles, 235–36, 278

Dehn, Alfred, 56

De Kerillis, Henri, 235–36, 534n.81

de Kooning, Elaine, 198, 229, 265, 268, 285, 288, 408, 464, 540n.29

de Kooning, Willem: Abstract Expressionism and, 378, 380; as Action Painter, 54, 65, 286–87, 389, 498n.51; *Art Front* and, 78, 82; Black Mountain poets and, 190–91; The Club and, 268; exhibitions of work by, 216, 249, 275, 276, 427; on existentialism,

265–66; in *Forum* magazine, 398, 400; Gorky and, 359–60, 363; Greenberg and, 266–67; Hess's discussion of, 269–70, 423; Longview Foundation and, 405; New York School and, 253; paintings given to Rosenberg by, 410; Pop Art movement and, 349–50; *possibilities* magazine and, 266; Rauschenberg and, 366–67; Reinhardt on, 440; Rosenberg and, 101, 103–4, 198, 262–64, 365, 389, 416, 423, 540n.29; Rose on, 378; Springs summer community and, 229; Studio 35 sessions and, 252; *Women* series of, 349, 363, 365; WPA Murals Project and, 98, 289, 498n.51

Delacroix, Eugène, 428

Demuth, Charles, 115

De Niro, Robert Sr., 405, 407–8

Denneny, Michael, 459

Denney, Reuel, 341–42

Deren, Maya, 16

Der Führer (Heiden), 136–37

Derrida, Jacques, 433

"A Desperate View" (de Kooning), 540n.29

Deutsch, Morton, 99–100

de Vries, Peter, 131

Dewey, John: American Committee for Cultural Freedom and, 311; Artists' Committee and, 78; Dewey Commission and, 69; Hook and, 210–11; Marx and, 37–38, 40; Rosenberg and, 22; social action concept of, 92

Dewey Commission, 69, 82, 92, 144

Diaghilev, Serge, 135

Dialectic of Enlightenment (Horkheimer & Adorno), 344–47

"Dialogue" (Rosenberg), 216–18, 220, 531n.10

Dialogues (Plato), 2–3

The Dial magazine, 1

Diary of a Seducer (Gorky), 361, 361–62, 372